D1232400

Avant-Gardes and Partisans Reviewed

The authors and publishers have made every attempt to clear
permission for reproduction, and would welcome communication
from those copyright holders they have not been able to contact.

Copyright © Fred Orton and Griselda Pollock 1996

Published by Manchester University Press
Oxford Road, Manchester M13 9NR, UK
and Room 400, 175 Fifth Avenue, New York, NY 10010, USA

Distributed exclusively in the USA
by St. Martin's Press, Inc., 175 Fifth Avenue, New York, NY 10010, USA

Typeset in Sabon and Syntax
Designed by Paul Harker

British Library Cataloguing-in-Publication Data
A catalogue record for this book is available from the British Library

Library of Congress Cataloguing-in-Publication Data applied for

ISBN 0 7190 4398 0 **hardback**
 0 7190 4399 9 **paperback**

First published in 1996

00 99 98 97 96 10 9 8 7 6 5 4 3 2 1

Printed in Great Britain
by Redwood Books, Trowbridge

avant-

GARDES

and

partisans

REVIEWED

FRED ORTON &
GRISELDA POLLOCK

MANCHESTER
UNIVERSITY PRESS

MANCHESTER AND NEW YORK
DISTRIBUTED EXCLUSIVELY IN
THE USA BY
ST. MARTIN'S PRESS

list of contents

PART TWO

PART THREE

Publication Details

Chapter 1
was first published as *Vincent van Gogh: Artist of his Time,*
Oxford: Phaidon Press, 1979. It has been edited for inclusion here

Chapter 2
was first published in *Art History*, 1980, vol. 3, no. 3, 314-44

Chapter 3
was first published in *Oxford Art Journal,* 1985, vol. 8, no. 2, 28-35

Chapter 4
was first published in *Dutch Crossing:*
Journal of Low Countries Studies, 1991, no. 44, 45-59

Chapter 5
was first published in *Art History*, 1982, vol. 5, no. 3, 341-8

Chapter 6
was first published in *Oxford Art Journal,* 1991, vol. 14, no. 2, 96-103

Chapter 7
was first published in *Art History,* 1981, vol. 4, no. 3, 305-27

Chapter 8
was first published in *Art History* 1983, vol. 6, no. 1, 114-22

Chapter 9
was first published in *Oxford Art Journal,* 1991, vol. 14, no. 2, 3-17

Chapter 10
was first published in *American Abstract Expressionism*, edited by David
Thistlewood, Liverpool: Liverpool University Press and Tate Gallery, 1993, 179-92

Chapter 12
was first published in *Art History*, 1988, vol. 11, no. 4, 545-64

Chapter 13
was first published in *Block*, 1989, no. 15, 5-15

List of Illustrations

Memories Still to Come...

An Introduction

A text is made of multiple writings, drawn from many cultures and entering into mutual relations of dialogue, parody, contestation, but there is one place where this multiplicity is focused and that place is the reader.
Roland Barthes, *'The Death of the Author'*

We met in 1972 as graduate students at the Courtauld Institute of Art, University of London, and kept in touch. During the 1970s we contributed to each other's lecture and seminar programmes in the Department of Fine Art at Leicester Polytechnic and the Department of Art History at the University of Manchester. When, in 1977, we were both appointed to the faculty of the Department of Fine Art at the University of Leeds we began teaching, researching and writing collaboratively.

The first piece we wrote together was a book-length essay for the Great Artists series published by Phaidon Press. Using the graduate research we had both independently undertaken on Vincent van Gogh, we wrote a book against the grain of the vast literature on 'Van Gogh' which, in its most popularised forms, focused exclusively on the relation between personality and its expression in the work of art. With certain exceptions of a documentary kind, very few studies were not shaped by this Romantic paradigm. We posed ourselves the question: what more could be said about 'Van Gogh', an artist so apparently well known and with everything seemingly there on the surface of his paintings and explained by volumes of autobiographical correspondence? Both of us had chosen to do doctoral research on Van Gogh and it seemed to us that, while he had become one of the most secure 'Great Artists' in the literature of art, his work was probably the least analysed and worst understood among all the early modernists.

The Van Gogh essay was aimed at a popular market and the task, which we set ourselves, was – we hinted at it a moment ago – to work against the most fixed of 'Great Artist' stereotypes and produce a different 'Van Gogh'. It was researched and written

around questions like: how was Van Gogh's artistic project and practice determined by his interest in contemporary literature and theology? What use did he make of the theoretical and practical resources available in The Hague, Antwerp and Paris? What did he take from the work of other artists and from what he read in the burgeoning 'literature of art'? Why was he interested in Japanese prints and how did he use them? How might one explain the oddities in the way he pictured space? How could the subject-matter and surface-matter of his art be seen and understood in relation to the changing stages and social relations of production in European capitalism in the 1880s?

Abjuring the conventions established for the Phaidon Great Artists series, we designed our text as a kind of 'visual track' or 'story board' of images, drawings, paintings and citations from Van Gogh's letters commented on by a critical essay conceived as an accessible second-order discourse. The quotations from the artist's letters were there not so much to explain the pictures or to effect their 'truth' – art history's usual ways with what it regards as documentary evidence provided in and by the artist's own words – as reminders of the gap between the art an artist makes and what he or she says about that art. It may be, as we wrote about what Van Gogh wrote about *La Berceuse*, that 'these letters provide the key to the meanings that it was meant to carry'. But we glimpsed that those meanings were not necessarily the meanings that were effected by the picture. Our text, then, was not a conventional essay with illustrations but a composite of Van Gogh's pictures, his commentary, and our critical commentary on both. There is little, if anything, in what we wrote or how we wrote it to make the reader think that a single, coherent meaning of a work of art is there to be found if only she can hit on the correct combination of signs and materials. Unfortunately, there is still a lot of would-be social history of art that has not progressed much beyond the assumption that there is.

Reconsidering the strengths and weaknesses of the Van Gogh essay, it is clear that we were trying to represent Van Gogh as an artist who knowingly and, at times, unknowingly pictured a particular moment of urban and rural, provincial and metropolitan modernity: 'a world in constant flux, a totality which demanded a transformation of the role of colour, the movement and meanings of line, and the conventions for the depiction of space'. We were trying to make sense of Van Gogh's pictures and letters in relation to the economic, political and social determinations of their moment of production and to the practical and theoretical innovations taking place within that relatively small fraction of the art community later known as the avant-garde. We had a more or less clear idea of what was wrong with the existing accounts of Van Gogh's art but, it must be admitted, we did not have any very developed ideas about how we could locate an artist and a work of art in social and historical practices. In a sense, the essay is indicative of a moment prior to our becoming social historians of art. Though it has gained a certain currency as a model-text for students of art-in-context kind of art history, it is not social history of art. Certain assumptions were not as transformed as they might have been – assumptions about artistic practice,

authorship, the radical instability of meaning, even about writing art history. Nevertheless, it still has its uses and value as a contribution to knowledge about the work of Van Gogh, to the historiography of 'Van Gogh' studies, and to the project of the social history of art.

The Van Gogh essay was where we began doing art history together, puzzling what was going on in pictures and reflecting critically on the problems of doing historical work on visual representation understood as an aspect of social and historical processes. The problem then as now was how to do that kind of art history. Without the means of self-criticism and theoretical development, the social history of art becomes only one more among several new approaches. The ambition must be not just to do better art history, not just to produce novel, interesting, convoluted or complex interpretations of what can be seen to be the case, but to move towards a continual reconceptualisation and reappraisal of the theories and methods appropriate to producing social and historical accounts of the production of art and art practice. This would and will involve articulating whatever relations can be found to exist between works of art, visual signs or texts, ideology and institutions, discourses of art, sociology, history, and so on. Reading the Van Gogh essay as it is reprinted here as the first chapter of this collection, you will be able to measure some of whatever progress we made together and independently in pursuit of this self-critical theoretical tendency in respect of the social history of art.

We titled our book *Rooted in the Soil: A Van Gogh Primer* and wanted a picture from Van Gogh's Drenthe sojourn of 1883, two peasants at work, dark against the skyline, reproduced on its cover. The title and the cover illustration were supposed to work against the total personalisation of art of which 'Van Gogh' is an extreme example. Someone in the publicity department at Phaidon liked neither our title nor our cover.

Both were changed, so that when the book was published in 1979 it appeared in the shops with a full-cover illustration of part of a self-portrait that Van Gogh had made in the hospital, Saint Paul de Mausole, at St Rémy, and the title *Vincent Van Gogh: Artist of His Time*. Here was an object-lesson in how art history produced in opposition to the dominant account could be so easily reframed and reappropriated by a publishing industry determined to keep that account in place. The relations between academic scholarship, knowledge and market-led publishers were made clear to us and we began to grasp our situation in the complex process of producing 'art history', a process whose production line ran across a series of intersecting institutions from universities and art schools to museums and galleries, publishers, bookshops, films, television and advertising. Art history is an effect of all of these processes and practices within capitalism. We were forced to ask: who produces or polices what is circulated and exchanged as 'Van Gogh'? What does that 'Van Gogh' in turn hold in place within culture?

The Van Gogh essay was at pains to see and understand the works of Van Gogh as having been made by an artist who was not a mentally-deranged genius isolated from

society. It begins with a simple statement about Van Gogh's epileptic condition and two epigraphs which raise, even where they were supposed to dismiss them, problematic questions about the status of the author, the relation of producer and work, the story of the life and its connection with the work of art – questions we would return to years later in essays written individually. Phaidon's publicity office couldn't allow that deviation from the conventional but complex reciprocal conflation of man and art that is signified by the name 'Van Gogh'. Without understanding it in quite these terms, we had run up against the power of what Michel Foucault had identified as the 'function of the author' in the distribution of knowledge in modern societies.[1] The paradigmatic commodity identity of 'Van Gogh' had to be re-established outside and around our text. The point, as far as Phaidon understood it, was, of course, that everyone knew that 'Van Gogh' went crazy, was locked up in a lunatic asylum, and killed himself. And there 'Van Gogh' had to be, plain for all to see and buy: mad, isolated – but still an 'artist of his time'. Artist of his time? The subtitle, it was explained to us, was supposed to direct the reader's attention to the novelty of our text as social history. It was a study of Van Gogh's art-in-context, wasn't it? The title was risible. What work of any artist is not of his or her time?

Vincent van Gogh: Artist of his Time – Phaidon's title says quite a lot about how far institutionally dominant art history is prepared to go to connect its privileged ideal, the 'Artist', with the mess of social life. And that's not a great distance. There are a series of euphemisms on which the title draws. 'Of his time' is one of them; 'in her context' is another; 'in his age' and 'and her contemporaries' are others that come to mind.[2] These mild or vague expressions substituted for an idea or actuality which is considered either too harsh or too direct are joined to the artist's name in a way that veils more or less everything the history of art should understand and direct attention towards. Euphemisms like 'time', 'context', 'age' or, to give two more of these characteristic terms, 'period' and 'society', function as complex abstractions that have to be broken down into simpler elements or determinations which correspond to concrete social processes, before one can proceed analytically to representing the concrete as 'a rich totality of many determinations and relations'.[3]

Writing about Flaubert and class consciousness, Sartre suggested that we do not necessarily recognise our place in class relations from inside our class. We come to social or class consciousness only when some external action breaks through our class positionality and forces us to see ourselves from an antagonistic point of view, as when a strike or a revolution exposes us to the class structures and conflicts of the social formation as a whole.[4] This trifling affair of the title in our first collaborative venture was deeply instructive as a confrontation with some of the powers that try to control the social production of knowledge. It precipitated some massive shifts in our thinking about 'doing art history' before we next wrote together.

Eight published collaborations – there was a lot of work that didn't reach publication – came out of that early project: a critical review of 'Post-Impressionism' as it was

constructed by the block-buster exhibition held at the Royal Academy of Art, London, in the autumn of 1979 ('Les Données Bretonnantes: La Prairie de Représentation'); an account of the early critical writing of Clement Greenberg ('Avant-gardes and Partisans Reviewed'); an essay on Hans Namuth's photographs of Jackson Pollock at work ('Jackson Pollock, Painting and the Myth of Photography'); and an essay on the way art history narrated the relation of 'Van Gogh' to 'Cloisonism', 'Synthetism', 'Emile Bernard' and 'Paul Gauguin'. We also wrote and presented two television programmes for the Open University's course on *Modern Art and Modernism: Manet to Pollock*: one on Van Gogh's *Potato Eaters* (a close study of an individual painting); the other on the Museum of Modern Art, New York (a brief study of what, arguably, was once the most important institution concerned with collecting, exhibiting and producing a knowledge of modern art and modernism). We also made two radio programmes for the same Open University course, one on peasant painting in the nineteenth century and one on art and U.S. imperialism. All these pieces, with the exception of the work done for the Open University, are collected here.

'Les Données Bretonnantes: La Prairie de Représentation' is quite unlike the Van Gogh essay. Its form reflects its process of production and our understanding of intellectual work as a kind of social production – of discourse, meaning, ideology and its critique. Its content incorporates insights gained from working for Phaidon Press and in that sense it represents the job of doing art history differently. What was new was the attention we paid to the institutional production of knowledge, to the exhibition understood as a spectacle mediated by objects that stages a set of social relations for the consumption of ideological meanings, and to the catalogue as a text that was to be subjected to close reading as a discourse produced within certain interests. These considerations signalled a new kind of direct address and challenge to the institution of art history. In 'Les Données Bretonnantes', we referred to the dominant discourse on modern art as 'modernist art history' and identified the relation between its character as discourse, the institutions that produced and disseminated it, and the objects of knowledge effected by it. In the Van Gogh book, the issue had been one of contesting certain interpretations of individual pictures or the oeuvre as a whole. In 'Les Données Bretonnantes', we focused on the way the apparatus of art history, operating across several related sites – the academy, the museum, the book – produces and disseminates ideas and beliefs about 'art' and 'the artist' which determine, define and name how 'art' and 'the artist' are then consumed or understood. This work was indebted to structuralism, especially to the idea that language does not represent a world that is somehow extant prior to representation. Language makes it possible to speak and write the world, and in doing so it produces the world as an object of knowledge.

The recognition that what art history speaks and writes about 'art' and 'the artist' does not reflect what 'art' and 'the artist' are, but, rather, produces particular representations of them within a specific discourse, has to be linked to the social conditions of the production of that discourse and its institutions and their place in a

social formation. For us, that meant reading as much of the writing of Marx and Engels as we could: *Theses on Feuerbach, The German Ideology, The Eighteenth Brumaire of Louis Bonaparte, Grundrisse, Capital*, etc., etc. – a corpus that still provides the most profound and enabling theorisation of social processes of production and consumption and insight into methodological procedures for thinking through various relations between different practices within a complex social totality. The appropriation of Marxist ideas about society, ideology and consciousness put and marked a difference between the Van Gogh essay and 'Les Données Bretonnantes'.

'Les Données Bretonnantes' took contemporary academic historians to task for dressing up old knowledge as new knowledge. And it contested that knowledge with a different way of seeing and understanding nineteenth-century pictures of Brittany by a few exemplary avant-garde artists. History was here taken to be a problematic object of knowledge that, by way of example, was contested in our essay with a kind of circling set of intersecting and dispersing histories of determining conditions, including the history of changes in the personnel and structure of the metropolitan avant-garde, tourism, agricultural improvement, seaweed farming and iodine manufacturing, costume, and so on, that often contradicted the academic and dominant account of Post-Impressionism.

Anyone reading this essay in order to get a clear fix on what Bernard's *Women in the Meadow* (1888) or Gauguin's *Vision After the Sermon* (1888) meant was bound to be disappointed. That kind of meaning-fixing was not on offer. Indeed, the role of the art historian as curator engaged in the management and fixing of meaning was partly what 'Les Données Bretonnantes' aimed to disturb. We were not developing just another hermeneutic method or approach to take its place in some easy pluralisation of art history. Rather, the Brittany essay was exploring another relation to the expanded materials of art history that was not so obviously part of the administration of the culture industry. We were developing ways of close reading verbal and visual texts and analysing the relations between current art historical practices and other representations of the past, not as a way of offering a programme for doing art history but of showing what might be involved in producing a social history of art. We wanted to explain what went on in the work of art without endowing it with the mystical centrality of an object that reflects art history's main concern – the 'artist'. As an act of representation in history, a painting operates on a field of representation. Hence the pun of our title, which borrows from the title of Bernard's *Breton Women in a Meadow* – '*prairie*' meaning meadow or field, a '*prairie*' made of certain '*données*', given assumptions, ideas and beliefs, ideologies. The *work* of representation may reconfirm or challenge and reconfigure the '*données*'. Thus we focused on one section of the exhibition *Post-Impressionism* titled 'Brittany', a section that could not be duplicated in and by the catalogue organised, as it was, around artists grouped into national schools. 'Brittany', a national geographic category, was represented at the exhibition by artists of many nationalities. In other words, it was a category and a place that transcended and resisted

the way the exhibition had been conceived and put together. That is why 'Brittany' had to be displayed in a gallery set somewhat apart from the others. We used 'Brittany' as a site within a field of representations that, in the context of the exhibition, was produced by paintings and, beyond the exhibition, by a range of other discourses and practices. We then specified the historically and culturally specific practices of the metropolitan Parisian avant-garde artists who colonised that already ideologically inscribed space as part of a competition with other artists both outside and within their avant-garde fraction, setting them in a field occupied and represented by other artists, other visual regimes, other discourses. In one movement, the avant-garde is located in a broader historical framework and its contingency, as well as its tactical manoeuvres, are identified without falling back into the art historical 'données' of avant-garde individualism, social isolation and stylistic autonomy.

We were, then, also addressing the museal model that underpins art history. The exhibition format is picture-focused and it denudes the pictures of their productive social relations in time and space. The exhibition is an example of what Marx called the fetishism of the commodity in which the labour process disappears as objects seem to communicate directly with each other. Fetishism is a curious business, for it both veils the role of social relations of production and it marks, or commemorates, the danger of that knowledge: this gives rise to the artist as a second-tier fetish, for which the object is a metaphor. One of the jobs that 'Les Données Bretonnantes' was intended to do was to reconstruct the politics of the representational field of 1888 as a basis for seeing and understanding the artistic strategies that generated certain paintings in certain dynamic relations of social practices and aesthetic practices. Each painting ceased to be a fetishised, commodified and displaced sign of the artist. It became a kind of text that disturbed art history's normative and mystifying categories, especially the idea of the oeuvre or the iconographic lexicon and with it the idea of genius.

The relations between what we had failed to dislodge by writing an innovatory monographic essay on Van Gogh and the space we needed to clear in order to go beyond that kind of work can be gauged in 'Les Données Bretonnantes: La Prairie de Représentation'.

'Avant-gardes and Partisans Reviewed', our third collaboration, was conceived as a study of the beginnings of Clement Greenberg's art criticism and as a contribution to historical writing about the avant-garde – in particular, to the history of that moment in New York in the late 1930s and 1940s when avant-garde practices had to be and were revivified and rearticulated. 'Les Données Bretonnantes' had been concerned with an earlier moment in the history of the avant-garde – a moment of redirection and dispersion in Paris in the mid-1880s. Each essay in this collection contributes in some way to the history of one or other of these two moments and beyond them to that other moment in Paris during the 1850s-70s when the defining parameters of the art that came to be ratified and valued as modern were outlined.

Modernist art history uses the term 'avant-garde' to mean something loosely

synonymous with the (teleological) development of advanced art since the mid-nineteenth century presented as a heroic chain of great men artists. In the 1970s social historians of art began to theorise the avant-garde and to account for its historical character as an effect of capitalism and a defence against that mode of immiseration in high culture. Far from seeing the avant-garde as a continuous process, analysis of its context and its critical writing in the 1930s suggested a series of discontinuous and historically determined 'avant-garde moments'. Greenberg was writing in and for a left art and literary community marked by the Depression and the mutation and modification of Marxism related to the Communist Party of the United States of America in reaction to the rise of Fascism in Europe, the United Front and the Popular Front. Writing in *Partisan Review* when it was beginning to identify with Trotskyism, Greenberg appropriated his understanding of the 'avant-garde moment' of late nineteenth-century Paris to the redefinition and redescription of another 'avant-garde moment' that was occurring, there and then in the late 1930s, in his own community, in New York, New York.

Avant-gardes and Partisans Reviewed, taken from our essay on Greenberg and the 'avant-garde moment' of the late 1930s-early 1940s, seems an appropriate title for this anthology.

Social history of art, at this stage of its development, is an engagement with history conceived not as a continuous *longue durée* but as a series of complexly configured moments of divers forces and relations, representations and effects, any one of which might come up for consideration in the way that Marx grasped the 'Eighteenth Brumaire of Louis Bonaparte'. We would suggest that our collaborations in writing and teaching – especially on the continuing and evolving programme for the M.A. in the Social History of Art that was inaugurated at the University of Leeds in 1979 and which is still a key element of our teaching projects - ought to be grasped as a historical intervention in, and effect of, a particular moment. We hope, also, that they will be read, as many of them were intended to be read, not as setting out a method or approach for doing art history but as contributions to the task of working out a new *Grundrisse* for the social history of art – a kind of art history associated with Leeds even before the 1970s.[5]

* * *

Setting beginnings and endings is a tricky business. They are always underway before they are recognised as such. Beginnings are always endings. And endings are always new beginnings. However, a certain coherence can be given to the moment of the social history of art in which these collected texts were produced if we place its beginning in 1972-3 and its end in 1982.

It was in 1972 that John Berger's *Ways of Seeing,* six television programmes and then a

book, was produced as an oppositional response to Kenneth Clark's *Civilisation* television series and book of 1969.[6] In the first episode of *Civilisation*, Clark went out of his way to disparage people who lived in prefabs and to assert that the *Apollo of the Belvedere* expressed a higher state of civilisation than a carved mask of the Sang tribe, Gabon, West Africa. In the final episode, 'Van Gogh', driven mad by the intensity of his feelings, recreated Millet's *Sower*. 'Carry on Creating'. It was important that Clark's aristocratic Tory view of 'civilisation' and his thoroughly conventional bourgeois art history as the celebration of a sequence of aesthetic and humanistic achievements was contested. And this is what Berger did with some success. *Ways of Seeing* showed in a very public way that the history of art mattered and that certain kinds of history had to be engaged with critically. It directed its viewers and readers to Walter Benjamin's 1936 essay 'The Work of Art in the Age of Mechanical Reproduction' and, beyond that, it adverted a certain Marxist tradition.[7] Its effects on teaching in art colleges and university art departments in the United Kingdom and the United States of America, where it was published in 1973, were considerable. However, though it stimulated discussion, *Ways of Seeing* was too carelessly aphoristic, elliptical and tautological in the way it presented its arguments to prove very useful for thinking about theory and method with regard to researching and writing art history. *Art & Language*'s guide to *Ways of Seeing* was much more useful.[8]

Michael Baxandall's *Painting and Experience in Fifteenth Century Italy: A Primer in the Social History of Pictorial Style*,[9] another book published in 1972, had something to offer also. Here was a non-Marxist history of art that, even if its narrative tended to occlude them, enabled you to see and understand, research and write class and ideology as historical actualities that had determined Quattrocento art and experience. It also gave some indication of how you might go about researching and writing those determinations in histories of the art of other times and places. The way Baxandall redefined 'style' as a concept that united both the representational activity of the artist and the representational skills of typical beholders seemed potentially useful. Did we take the idea of making the Van Gogh essay 'a primer' from Baxandall? Probably.

It was also in 1972 that the American journal *New Literary History* devoted its spring issue to a symposium on 'Literary and Art History'. The most interesting contribution to this was Kurt Forster's manifesto-like 'Critical Art History or the Transfiguration of Values'.[10] In this wide-ranging essay, Forster discussed art history's function in the university curriculum, museums, galleries, publishing and the educational industry. The work of art history, he pointed out, was founded on three concepts: the history of style, artistic biography and the tradition of imagery or iconography. Together, these concepts facilitated 'an extremely convenient separation of art from history' in a practice that only took history into account as 'a last cause and explanation of otherwise puzzling facts'. The reason for this separation, Forster said, had to be 'ideological'. All too often art historians identify with 'the powers that be' to provide a 'compensatory, better history - in contrast to the bloody struggles and chaotic events of history – [that] ascribes to art a powerful, redemptive role and sublimates the dark and disparate realities of the present'. Or to put it, as he did, another way: art

history works to produce 'affirmative values' which 'leave you with your head a little lighter and your heart a little more satisfied, ready to face another day of news and pressures'. Against this 'compensatory' and 'affirmative' art history, Forster wanted an art history that demonstrated 'a concern for the socio-historical basis of art' like that shown by 'the early Aby Warburg, Frederick Antal, Arnold Hauser, the earlier Meyer Schapiro, Donald Drew Egbert, Nicolai Rubinstein, Walter Benjamin [like Berger, Forster also adverted Benjamin's 'The Work of Art in the Age of Mechanical Reproduction'], Theodor W. Adorno, Leo Löwenthal and younger art historians like Martin Warnke and O. K. Werckmeister'. What was needed was an art history that redirected its scholarly practice towards 'the methodical effort at ideological critique'; it had to 'reflect critically the ideological function and nature of art'. For Forster, 'critical art history' was synonymous with 'social history of art', and both were synonymous with Marxist art history. This was heady matter back then. Though we have our quibbles with Forster's essay now, these can be put aside here. All we need to do is point to it as one more beginning of a revitalised interest in the project of the social history of art.

In 1973, an anthology called **Art and Sexual Politics,** *was edited by Thomas B. Hess and Elizabeth C. Baker.[11] It opened with an essay by Linda Nochlin, originally written in 1971, here titled 'Why Have There Been No Great Women Artists?'. Nochlin was one of a generation of American art historians trained during the legacy of the McCarthy witch hunts who, none the less, began to challenge the prevailing formalist orthodoxies in art history and pursue research into the social determinations of artistic production. She wrote a doctorate on a highly politically aware artist Gustave Courbet and braved saying so.[12] In the early 1970s, she brought this interest in the social formation of art and discourses on its history to bear on a new problem, that of the apparent absence of women artists.[13] The re-emergence onto the political stage of a revitalised women's movement had major repercussions in the cultural sphere. Social determination visibly intervened in the academy as women artists and art historians began to query the half-empty art galleries and half-empty bookcases where women's cultural production was not being shown, written about or conserved.*

In her article, one of the earliest calls for a radical shift in art history in response to feminism, Linda Nochlin proposed to use the case study of women's exclusion as a way to 'pierce cultural ideological limitations and inadequacies in the discipline as a whole'. Rather than seeing 'the woman question' as a sub-issue, she argued it could be a catalyst for shifting the paradigms of art history towards a renewed connection with history, the social sciences, literature and psychology. With this paper she created the possibility for a social history of art that would recognise the several structures and systems of power that constitute a social formation. Gender, ethnicity, sexuality and cultural difference are as much factors in and effects of social relations as is class in both making a career in art possible and in what was represented in its texts. Rather than arguing for a separate history of art with women artists in the unreconstructed place of genius (second rung), Nochlin's text adumbrated the dialogue within a social history of art between diverse

*interests and groups differently effected by relations of power. Together with Berger's famous essay in **Ways of Seeing** on the female nude in Western art – 'men look: women watch themselves being looked at' – Nochlin's arguments about the gender hierarchy in which the story of art tells only of great men making art by painting nameless women also conjoined the social analysis of institutions with the very processes and politics of the image itself. This has perhaps remained one of the critical contributions of a specifically feminist social history of art.*

*In 1972, Thomas B. Hess and Linda Nochlin published a major text by men and women in art history on the issue of sexuality in representation, **Woman as Sex Object**.[14] Nochlin's introductory essay criticised the lack of analysis of erotic themes in Western art in order to develop a compelling analysis of the effects of a dominant discourse of artistic representation of the female body which made it function as the cipher of masculine heterosexual desire, leaving women with neither a language nor a territory of desire in this field of representation. In a striking comparison between a Gauguin painting and a nineteenth-century pornographic photograph of a woman with her bare breasts nestling on a tray of apples, she struck through art history's carefully policed boundaries between various sites of visual representation. In a further move she exploded the 'natural' assumptions embedded in both high and low cultural sexualisation of the female body by contrasting them with a staged photograph of a hirsute naked young man offering a tray of bananas. The radical dissymmetry of gender in these images revealed the power relations structured into regimes of representation. Thus issues of the politics of representation of the body and sexuality were made topics of critical art historical analysis.*

T. J. Clark's *Image of the People* and *The Absolute Bourgeois* were published at this moment, in 1973.[15] These books, on the relations between art and politics during the Revolution of 1848 and its aftermath, provided a much-needed practical demonstration of the grasp of theory and depth and variety of archival research that was necessary if the social historian of art was going to reconnect or close the gap between history and art. Clark had researched his project between 1965 and 1970. The events in Paris of May 1968 and the various social movements and disturbances in British academic life just afterwards determined that project's drift and the books' final form. They were written in 1969-70. That was their moment. However, the first chapter of *Image of the People*, titled 'On the Social History of Art', is clearly of another moment. Rereading it now, it comes across as a text written not so much in relation to the book it introduces as a contribution to discussions already underway in *New Literary History* and elsewhere, for example in Nicos Hadjinicolaou's *Histoire de l'art et la lutte des classes*.[16] That is to say, it reads as one more contribution to the renewal of the social history of art. 'On the Social History of Art' was and still is a strategically important text, rich in theoretical and methodological possibilities for a conjunction of Marxism and art history – some of which have had to give way to other conjunctions, some of which remain to be puzzled and achieved. We were especially taken with the way Clark, following hints in

Pierre Macherey's *Pour une théorie de la production littéraire*,[17] suggested that art historians could undertake symptomatic readings of their objects of study. We also took note of what he had to say about the need to see and understand the making of a work of art as an action in and on history, as a practice of representation that worked with and, at certain moments, against ideology.

Mention must also be made of the conjunction of Marxism and art history within the internationalisation of the professionalisation of art history that occurred in the 1970s. U.S. art historians and artists had long had their professional association, the College Art Association, with its journals, the *Art Bulletin and Art Journal*, and annual conference. In the early 1970s British art historians began thinking about forming their own association on the American model, the Association of Art Historians. Its first annual conference was held in 1975 and three years later it began publishing its journal, *Art History*. There had always been some traffic of art historians and information between the U.S.A. and the U.K., but after the inauguration of the A.A.H. Conference it increased noticeably. American art historians started turning up at the A.A.H. Conference and British art historians started visiting the U.S. to attend the C.A.A. Conference. 'Small worldling' in art history really took-off in the 1970s. The space was there at the C.A.A. Conference for radical art historians to meet, discuss and present their work, and generally occupy an oppositional place in their profession. But that place was at the edge and there it was recognised, by the C.A.A., as a Caucus. A Women's Caucus of Art had been created in 1972, and in 1976 the Caucus for Marxism and Art held its first meeting at the Chicago conference. Because of the way art history had become thoroughly internationalised by then, the papers presented at the first Marxist Caucus had an almost immediate life and context in the U.K. We remember, in particular, David Kunzle's account of how he came to translate and write the introduction to *Para Leer al Pato (How to Read Donald Duck)* by Ariel Dorfman and Armand Mattelart; T. J. Clark's paper on seeing and understanding the work of art as ideology; and O. K. Werckmeister's presentation, engaging with and extending the arguments of Forster's *New Literary History* essay, on the way that art history – 'critical art history' - could turn against the functions it was assigned in capitalist institutions. The role of *Art History* under John Onians's editorship and Alex Potts's reviews editorship must also be acknowledged. After 1980 *Art History* regularly published the work of British and American Marxist art historians. Many of our collaborations were published in *Art History*.

So far we have presented our collaboration as a part of a project for a social history of art which was itself the product of a moment; characterised by a renewed engagement with the history of Marxism and art history, a history that included not only Antal, Hauser and Schapiro but also Max Raphael and Francis Klingender. The particular character of our moment, however, derived from the transformation of Marxism by the cultural politics of what had emerged in the later 1950s as the New Left. Post-war settlements in both the West and Eastern Europe seemed to proclaim 'the end of ideology'. Yet, it was argued by the New Left, ideology was becoming an ever more

potent mechanism for social incorporation.[18] *Economistic versions of Marx's theories were critiqued. What Perry Anderson called Western Marxism inspired a re-evaluation of the role of superstructures, that is, 'cultural' and ideological practices in capitalist social formations. We have already indicated that the project of the social history of art drew upon historic texts by Marx such as* **The Eighteenth Brumaire** *and* **Grundrisse**. *These texts offered exemplars of a kind of historical or theoretical writing that was acutely attuned to the problems of representation and the articulation of structural relations in society in 'forms of appearance' or understanding. Certain dogmas about the necessary determination of the cultural superstructure by the economic base of production in society were reformulated in varying ways following the New Left's rereadings of Marx's own writings. Louis Althusser asserted the relative autonomy of ideological practices through what he named 'Ideological State Apparatuses'. His theory of ISAs - schools, media, unions, the family, churches – showed how ruling classes in developed societies exercise domination not only through repression and coercion, but also through ideological hailing. Although ISAs are ultimately determined by economic relations, in their own operations, they, in turn, become determinant upon the form and outcome of the latter.*[19] *Ideology became a key term for the social history of art because in this newly theorised sense of its productive role in the relations of class – and hence power and social domination – it was also subject to the contradictions of capitalism. Artistic practices would be part of the ideological, not as an expressive reflex of the society producing the art; rather, artistic practices were to be thought ideological because they critically renegotiated or, at times, confirmed these contradictions in unpredictable but historically explicable ways. In addition, there was a renewed interest in an early twentieth-century Marxist, Antonio Gramsci, whose key contribution to this debate was the concept of hegemony. Ruling classes not only dominate by threat of force, but by acquiring the means to exert social authority; ruling classes try to lead and then so to saturate the accepted forms of understanding with their partial interests, that these come to stand for an inevitable common sense. Hegemony defines reality, containing oppositions, creating, a 'selective tradition'.*[20] *The term might appropriately describe art history.*[21]

Our emphasis here on the importance of Marxism, with its address to social relations, production, ideology, hegemony and class is tactical as well as historical. During the 1970s, what was becoming possible as a critical intervention in art history was the result of a larger conjunction which involved a moment of vigorous debate at the intersection of theories of culture, of the sign, of the subject, and of power. It became possible to conjugate some of the new 'structural Marxism' with other structuralisms in cultural anthropology, semiology, psychoanalysis. These led both to a more complex understanding of historical Marxist theory as a resource for cultural analysis and to a critical engagement with the theories of culture that addressed areas left un-theorised or undertheorised in Marxism: issues of subjectivity, sexuality and language.[22] *Such strange bedfellows as Marxism and psychoanalysis were to prove crucial in adjusting social*

histories of art to questions of gender, sexuality and race.

The cognate area of film studies also developed in new directions in this period. A structural and ideological analysis of cinema was theoretically advanced and then institutionalised through the agency of the new editorial board of **Screen** *magazine between 1971 and 1982 and the study weekends organised by its publishing parent, the Society for Education in Film and Television.*[23] *Ben Brewster was a link between* **Screen** *and New Left Books which provided translations of and critical commentaries on Marxist work from the Frankfurt school to Althusser.*[24] *Instead of being primarily concerned to interpret the 'content' of art or media in relation to its economic conditions, this kind of Marxist analysis focused on the cinema as an ideological apparatus. Economic investment and social or political history could be non-hierarchically articulated with looking at how the cinematic machine produced meaning and pleasure through its address to – the phrase was 'interpellation' of – spectator/consumers. The pages of* **Screen** *brought into circulation, in a cultural community not exclusively interested in film, a range of theoretical resources and debates from earlier moments of Marxism in the radical cultural arena of the newly established Soviet Union in the 1920s and also in the writings by Bertholt Brecht from the Weimar period in Germany in the 1920s-30s. It mixed them with what was on offer as a result of contemporary French intellectual currents around 1968: semiotics, structuralism, and eventually Lacanian and feminist psychoanalysis. As a result of its interest in Freud and Jacques Lacan, which became marked after 1975,* **Screen** *became a major vehicle for the formulation of a highly influential area of specifically feminist cultural theory, criticism and practice.*

Cultural studies – a critical break away from both sociology and English literature studies – emerged as an academic force in the 1970s. The Centre for Contemporary Cultural Studies had been founded at the University of Birmingham in 1964. Under the directorship of Stuart Hall between 1968 and 1979, and especially after 1972, when the first issue of **Working Papers in Cultural Studies** *appeared, the Centre produced some major texts, several of which concerned the systematic rereading of founding texts of Marx such as the* **Grundrisse***. The Centre's members also produced contemporary revisions of Marxism associated specifically with the 'structuralist Marxist' Althusser and renewed interest in the work of Antonio Gramsci. Members of the Centre also put into circulation readings of Foucault, Jacques Derrida and Julia Kristeva.*[25]

The focus of the Birmingham Centre for Contemporary Cultural Studies was a contest over the meanings of the term 'culture'. If studies in film offered new ways for art historians to theorise the production of visual representation, borrowing from cinema notions of apparatus, sign, and spectator, cultural studies was to provide another resource by retheorising cultural practices as part of the complex of social, economic and ideological relations of domination and resistance. Art history, like English literature studies, in so far as both worked within a form of Clark's **Civilisation***, identified Culture, capital C, with the great and the beautiful, the best achievements of Western humanity (male, white, middle class, straight, and so forth). Drawing on social*

anthropology and the New Left tradition associated with the work of Raymond Williams, known as 'culture and society',[26] cultural studies was reframing the study of culture(s), lower case, so that we could begin to deal with the cultures as lived social practice, and lived, therefore, as the site of both domination and resistance. Because of its attention to issues of power in contemporary and historical societies, the publications from the Centre for Contemporary Cultural Studies specifically put the conjunctions and specificities of class, race and gender on the agenda for people working on all aspects of culture and its systems of representation.

These two further instances of interventions in the 1972-82 moment produced a field of alliances and overlapping interests that took the concrete form of common participation in reading groups, conferences, publications and other events. None the less, the component elements of this 'field of alliances' did not melt into one another. Each had a specific job to do. While looking outside art history for resources to expand the horizons of debate within it, only those with an interest in 'puzzling out what is going in pictures' would actually mount such an intervention in the institutions and texts of what still could be specified without mystification as 'art'. Art was to be understood as the effect of all the statements made about it, all the practices that claimed objects as art, rather than the mystical expression of creativity. The social history of art was enriched from its conversations with this broad intellectual-political community. But it retained, and still retains, a specific focus, a particular set of interests, a defined range of problematics. The common ground of shared political and theoretical concerns elaborate a support network and a conversational community while each area relates the theoretical challenge back to its own priorities.

The journal **Block**, associated with the interestingly named Department of Related Studies at what was then Middlesex Polytechnic (now Middlesex University), first appeared in 1979. **Block** is witness to the kinds of exchange which this conjunction produced. In his review of the early years of the magazine, Jon Bird argues that there were two paradigms in operation in its pages. One emphasised art as a social and material practice. It worked to produce closely argued case studies of modern art as the product of specific modes of commodification within the uneven developments of capitalism. This work specifically complements and extends some of the essays printed in this volume, sharing that sense of the need to produce concrete historical studies of the hegemonic moments. Another 'theoretical input' focused on 'work around representation as a structure and process of ideology producing subject positions'.[27]

Feminist writings on art in general and feminist interventions in the visual arts in particular were a key element of these combined projects as published in **Block**. As a journal it represented a different site for the production of this discourse from **Art History**, which was much more clearly identified with a professional body and in competition with other 'academic journals'. **Block**, while also highly scholarly, was made in the mould of its moment, to create a forum for the programmatic development of critical, social and feminist histories of art, design, and media. Each issue reflected the

emergent coalition of interests that was significantly expanding the histories of art into analyses of institutions, discourses and regimes of representation. Its pages also revealed diversification within the project, different allegiances and permitted conflicts. The magazine consolidated a conversational community which was taking on both traditional art history and shaping new histories, in art, design, film, media studies, as well as providing a forum for theoretical debates about procedures and methods for these emerging theoretical, critical and historiographic projects .

We are not writing the history of the social history of art 1972-82 in all its complexity. We are chronicling. Being nostalgic. Reminiscing. We have no need to recall all the anthologies and bibliographies that were published with titles like *Marxism and Art*, or all the excellent art history that was published in *Art Forum* and elsewhere, or all the various conjunctions of Marxism and art practice, Marxism and cultural studies, Marxism and film studies, Marxism and history, Marxism and literary studies, Marxism and philosophy, Marxism and education, geography, law, etc., etc., etc., or all the art-society-history workshops, groups, meetings, conferences, publications and exhibitions that contributed to its vividness and political urgency. And we are aware that we have made no mention of what was happening in France and Germany. There is a research project here for someone. All we are doing is setting a beginning and ending for the larger moment of our collaboration. Which brings us to a discussion of 1982, *The New Criterion* and the 'New Art History'.

It was in September 1982 that Hilton Kramer devoted his editorial in the first issue of *The New Criterion* to an extended attack on a decade or more of social art history and criticism.[28] Kramer, self-appointed militant in the defence of 'critical standards' and the pursuit of 'critical disinterestedness', took us to task for substituting 'political fantasies for the writing of art history' and railed against 'Les Données Bretonnantes: La Prairie de Représentation' for its 'manifest and malevolent misrepresentation of art, of history, of scholarship, and of the institutions that have been created in democratic societies to preserve their integrity'. John Berger was another person taken to task. So was Dore Ashton. And Lucy Lippard. And so, also, was T. J. Clark. We were in good company. Despite its anti-intellectualism, paranoid style and plain wrong-headedness, Kramer's editorial could usefully be read as what might have been the first history of the conjunction of Marxism and art history in what he referred to as 'the aftermath of the insidious assault on the mind that was one of the most repulsive features of the radical movement of the Sixties'. Like beginnings, aftermaths are only recognised when they have passed-by, when their effects have been felt or registered. By the time Kramer sat down to type his first piece for *The New Criterion* the effects of a revitalised and redescribed social history of art had been registered for some time. In so far as his essay was a history it was also an obituary – not for a kind of art history (that is still under construction) but for a moment (that was the necessary condition of that moment's emergence). It also indicated the presence of something new and, as Kramer recognised, specious that was a way of doing art history which was motivated partly by a predisposition in some persons 'to dissociate themselves from the capitalist society in which they live' and

partly by being vulnerable 'to pressure exerted by the special political intensities of the left'. But mostly, it was motivated by 'fashion', 'sheer trendiness' and the tendency 'to conform to whatever views seem at the moment to be "in"'. Kramer had been keeping an eye on the progress of left art history and criticism for several years before the appearance of *The New Criterion*. However, it was not until he became editor of *The New Criterion* that he acquired an effective institutionalised basis from which to disseminate his opinions and the opinions of like-minded persons. It was at that moment, coincidentally, that some of the effects of the social history of art also became recognised as thoroughly institutionalised.

We want to make an important point here about that troublesome notion of incorporation. It was fashionable for a while to talk of art history being in crisis. With hindsight, our suggestion of the social history of art as the function of a historical moment makes us rethink that idea. For dominant institutions are always managing the very opposition their selectivity provokes. It is as important to define the readjustments dominant discourses make to assimilate or defuse a challenge as it is to understand the places they came from. By 1982 we can begin to track a change, not necessarily in the project of the social history of art itself, which is still very much on the agenda of certain people's practice, but in the conditions in which it operated. It is not inevitable that any critical practice will be incorporated or that it will retain a critical effectivity. It all depends on the politics of the theories and the practices they inform. From the present vantage point, we need to apply the perspective of the social history of art to its own historical situation.

The social history of art is a historically created practice within the field institutionalised by the mid-twentieth century as art history – defined by museums, universities, professional organisations, publishers, dealers. The social history of art operates in an environment shaped by international capitalism and its ideological apparatuses. That field is also shaped by the discontinuities of history. The intellectual vigour of Marxist contributions to the plurality of art histories in the 1930s was rerouted through the responses to the rise of Fascism that led to the forming of the broad alliances of the popular fronts. It was finally frozen out in the paranoid years following the instigation of the Cold War. The revitalisation in the 1970s of that interrupted project by revisions of Marxism and by the new politics around gender, sexuality and race represent a major challenge to the hegemony of the selective tradition art history had become by the 1960s. The legacy of Cold War art history, in which formalism marginalised so many other forms of art historical analysis in addition to an overtly social history of art, and the re-emergence of those excluded discourses to challenge a narrowed formalist dogmatism, are not to be understood simply through notions of inevitable incorporation or utopian hopes for radical change. The Gramscian model of civil society perpetually engaged in negotiation to shift alliances and alter power groupings provides an alternative view of such problems. Gramsci would invite us to think in terms of constant tension, contradiction, resistance and adjustment, that does

produce changes but only those that are systematically fought and argued for. There will be no inevitable alteration in art history. It is not a matter of novelty, fashion or style: there is a field of contested meanings that themselves engage profound structures and relations of power. In the early 1970s, Linda Nochlin raised the flag of feminism to call for a paradigm shift in art history as if enlargement and liberalisation would be welcomed. By the 1980s and certainly by the 1990s, there are many more than one paradigm in operation, even within sub-groupings such as feminist, or social or critical histories of art. There is even greater resistance, sometimes masked as well as wilful misunderstanding. Thus there is a great deal of mistaking 'theory' for what was being fought for under the rubric of the social history of art. Theory – capital letter and singular – occludes the difficult task of thinking about history, while working in the present, and knowing that both activities are socially determined with all the limits and possibilities of that dynamic but contradictory process.

O. K. Werckmeister pointed out in his presentation to the Marxist Caucus in 1976 that 'if art history based wholly or in part on Marxist theory is to be pursued today, it will be within a capitalist society which shows no sign of being actively changed in a direction envisaged by Marxist political theory'. What happened to *Rooted in the Soil: A Van Gogh Primer* hinted at how even proto-Marxist histories work in and are inevitably co-opted by the institutions of capitalism with their celebration of individualism and their repression of labour. You're out there running just to be on the run.

1982 was the year that brought the naming of the 'New Art History', the title – albeit with a question mark appended – of a conference, organised by Jon Bird, held that year at Middlesex Polytechnic, London. The 'New Art History', without a question mark, is, to all intents and purposes, the art history of Kramer's dedicated followers of fashion who have learned a bit of the lingo so that they can package what they have to say in a way that betokens current art historical and intellectual up-to-dateness and yet remains acceptable to university curriculum development, to museums and art galleries, and to the publishing and educational industries. What is good about it is not new. And what is new about it is not good. It lacks the ideology critique that breaks the historical illusion of art. It is just more 'compensatory history' of the kind Kurt Forster described in 1972.

*The 'New Art History?' conference, as one would expect given its institutional siting at Middlesex Polytechnic, the home of **Block**, intended to make this epithet 'new' the object of critical debate – to ensure that while major transformations were certainly taking place in the practice of art histories, they were not uncritically incorporated into a new media category that would entirely erase their critical or political purpose in contesting the field of knowledge about art and culture in general. Some of the speakers specifically stressed the long and interconnected genealogies of both the social and the modernist histories of art in the course of the uneven and cataclysmic history of the twentieth century precisely in order to refute the commodification process which*

'newness' inevitably signified. From the audience, a younger generation of art historians, coming to scholarly maturity in the presence of social and other critical histories of art, **Screen**-inspired cinema analysis, and cultural studies, were already enabled to challenge and provoke further debate. They were not buying into novelty, but revealing another way the moment 1972-82 was passing into the institution as a real possibility for critical engagement with the problems of 'doing and, following Nicholas Green, **not** doing art history'. We are thinking here of his important extension of the project in his book **The Spectacle of Nature** (Manchester University Press, 1990). Green criticised the continuing focus of even the social history of art on canonical masters, let alone mistresses, and he shifted the angle of vision much more dramatically through Foucault's work on discourse and power to stress the discursive and institutional production of art as one of its many effects. He radically displaced all remnants of what Antal had called 'the most deep-rooted nineteenth century belief, inherited from romanticism, of the incalculable nature of genius in art'.[29]

Writing in an anthology called **The New Art History**, published in 1986, Adrian Rifkin called 'the new art history' 'an anxious stratagem to market a faded product in a new package' and predicted how it would be used to 'cut up into discretely separate portions' what had been in fact a complex conversation, dialogue, series of alliances, and simply a massive expansion of the possibilities and intellectual resources for studying and thus trying to know the complexities of materially determined cultural practices.[30] It is for this reason that it was possible for one of us to be part of this project, the social history of art, while also writing books and articles that had a strongly feminist intention.[31] It is only the market, and the institution, be it the publishing house or the association conference, that needs to have one discrete stream for feminist art history and another for Marxism and yet another for post-structuralist, or Derridean, or Foucauldian, or psychoanalytical art histories or 'approaches to' art history. Within individuals, these many streams could at different times converge, mutually sustain and nourish or critically contend. The social history of art and its cognates is a project not a package; a way of working on problems thrown up by historical materials, not an approach or a programme.

There was thus a specificity to the project on which we collaborated in the 1970s-80s. Yet it appeared then, as it does now, not to have been able to deal with all that could and should be dealt with. It has sometimes been easier to be a Marxist feminist art historian than to be a feminist Marxist art historian. On the one hand, certain absences from the following texts do suggest a conflict between feminism and the priorities of a Marxist social history of art. On the other, both were products of this moment when it felt as if the existing paradigms for the study of the history of art were being shifted by many forces, by different voices, by various interests. Certainly questions of women artists' position in the either Paris in the nineteenth century or in the mid-1950s New York art communities, or questions about the silence of major critics and art historians on their work, and debates about the possible ways of reading the implicit gender

systems operative in both the avant-garde moments were part of our discussions and resulted in publications produced in the same moment but not included here for they were not part of this particular collaboration.

The direct confrontation between a feminist agenda and one shaped only by the social history of art takes place in one essay in this collection, published here for the first time. It documents the particular struggles with conjugating Marxism and feminism in a critical reading of one moment of modernism. It has taken a long time to devise ways to analyse the artistic practices of women painters in the 1950s while not disjoining them from the mixed and complex context in which they functioned and intervened. The essay is published here to refute the divisiveness of the **soi-disant** 'new art history', yet it is a kind of epilogue because it revisits the temporal and symbolic space we call the 'moment of the social history of art' from the territories of other politics, and other theories: feminism and psychoanalysis. The putting of these different projects into one paper signals its author's refusal to relinquish the problems posed through the social history of art, even if some of the provisional solutions are developed from beyond its historical or theoretical imagination. The paper, written in 1995, indicates that the projects which variously informed the moment of our social history of art remain both a topic to be revisited and a resource to be critically rephrased in an often discontinuous but historically related series of interventions.

By 1982, there were many possibilities on offer and debates within the social and critical histories of art as well as continuing contests between both and the institutionalised form of a dominant discourse. What was to come in the later 1980s is more obviously 'theory driven' than the moment which preceded it, which, in our view, was committed to a problematic continuously shaped by the difficult relations between what we call art and history. In such a historical, albeit historical materialist view of the project, questions of agency, of the social as opposed to the psychic subject, of the lived life as opposed to the mythic biography or 'legend of the artist' in the terms of Kris and Kurz, remain issues. Certainly not resolved, they can still incite us to further theoretical questioning and historical puzzling. Our book concludes therefore with two essays which deal chronologically with our two key moments – the avant-garde moments of the 1880s in Paris and that of the 1930s/50s in New York. That material is traversed by questions around the status of the historical producer, the artist and the function of the author, the effect of both her/his texts and lived life, career, publicity, art historical afterlife. There is a critical balance to be maintained. There are very real gains in the historical analysis of culture achieved by a generalised reconstruction of given categories of thought and practice. But if the means we have explored to aid us in the formulation of a critical project become the ends alone, we will simply have furnished the bourgeois academy with another alibi, another evasion, another displacement of material social relations and their complex articulation in and by representations.

* * *

The collaborations collected here were contributions to a particular moment. Now, they gain another moment. We hope they still communicate something of the sense and purpose that determined them and that they have maintained their use-value as theory and critical history. You might think of them as still trying to kick-against-the-pricks of the painless and reverential story of 'civilisation'. If nothing else, the essays brought together here as *Avant-gardes and Partisans Reviewed* will serve as a collection of documents ready to be transformed into monuments for an, as yet, unwritten archaeology of the social history of art.

Fred Orton
Griselda Pollock
University of Leeds, 1994

Notes

1. Michel Foucault, 'What is an Author?', originally published in *Bulletin de la Société Française de Philosophie*, vol. LXIV, no. 3, 1969, pp. 73-104; reprinted translated from Michel Foucault, *Language, Counter – Memory, Practice*, Attica: Cornell Press and Oxford: Basil Blackwell, 1977 in *Screen*, vol. 20, no. 1, 1979, pp. 13-35.

2. See G. Pollock, 'Vision, Voice and Power' in *Vision and Difference: Feminism, Femininity and Histories of Art*, London: Routledge, 1988, pp. 18-49 for a discussion of the mystifying use of conjunctions in avoiding the complexities of social conditions and artistic practice.

3. Karl Marx, ' Introduction', *Grundrisse*, trans. Martin Nicolaus, Harmondsworth: Penguin Books, 1973, p. 100.

4. Jean Paul Sartre, ' Flaubert's Class Consciousness', *Modern Occasions*, vol. 1, no. 3, 1971, pp. 379-89, 587-601.

5. Arnold Hauser's four volumes of *Social History of Art* were published by Routledge and Kegan Paul in 1951, the year he began teaching at Leeds. He retired in 1957 and went to Brandeis University, Waltham, Massachusetts. For an interesting account of Hauser at Leeds see Tom Steele, 'Arnold Hauser in England: Sociology in a Cold Climate', forthcoming in David Wallace and Jerry Zaslove, *Arnold Hauser and the Social History of Art, Modernism and Modernity*, Vancouver, 1996.

6. Kenneth Clark, *Civilisation*, BBC TV 1969, London: BBC and John Murray, 1969; John Berger, *Ways of Seeing*, BBC TV, Harmondsworth: Penguin Books, 1972.

7. Walter Benjamin, 'The Work of Art in the Age of Mechanical Reproduction', *Illuminations*, ed. Hannah Arendt, London: Fontana, 1973, pp. 219-54.

8. See *Art-Language*, vol. 4, no. 3, October 1978.

9. Michael Baxandall, *Painting and Experience in Fifteenth Century Italy*, Oxford: Oxford University Press, 1972.

10. Kurt Forster, 'Critical History of Art, or a Transfiguration of Values?', *New Literary History*, vol. 3, no. 3, 1972, pp. 459-70.

11. Elizabeth C. Baker and Thomas B. Hess, *Art and Sexual Politics*, New York: MacMillan, 1973. It had originally appeared as an issue of *Art News* in 1971. Linda Nochlin's essay was a shortened version of her paper in *Woman in Sexist Society: Studies in Power and Powerlessness*, ed. Vivian Gornick and Barbara K. Moran, New York: Basic Books, 1971.

12. Linda Nochlin, 'Gustave Courbet: A Study in Style and Society', PhD, New York University, 1963.

13. Linda Nochlin, 'Starting from Scratch', *Women's Art*, no. 61, 1994, pp. 6-11, reprinted in *The Power of Feminist Art: Emergence, Impact and Triumph of the American Feminist Art Movement*, ed. Norma Broude and Mary Garrard, London and New York: Thames and Hudson, 1994 provides her own account of this transition.

14. Thomas B. Hess and Linda Nochlin, *Woman as Sex Object, Art News Annual*, vol. XXXVIII, New York: Newsweek, Inc., 1972.

15. T. J. Clark, *Image of the People*, and *The Absolute Bourgeois*, London: Thames and Hudson, 1973.

16. Nicos Hadjinicolaou, *Histoire de l'Art et Lutte des Classes*, Paris: Librairie Francis Maspero, 1973; *Art History and Class Struggle*, trans. Louise Asmal, London: Pluto Press, 1978.

17. Pierre Macherey, *A Theory of Literary Production*, trans. G. Wall, London: Routledge and Kegan Paul, 1978.

18. Antony Bryant, 'The New Left in Britain 1956-1968', PhD, University of London, 1980.

19. Louis Althusser, 'Ideology and Ideological State Apparatuses (Notes Towards an Investigation)' in *Lenin and Philosophy and Other Essays*, trans. Ben Brewster, London: New Left Books, 1971, pp. 121-73. Although Engels makes it clear – for example, in his letters to J. Bloch, 21-22 September, 1890, C. Schmidt, 27 October, 1890, and F. Mehring, 14 July, 1893 – that he and Marx thought that the political, juridical, philosophical, theological, etc., were possessed of thought that was produced independent of the 'economic movement', the idea of 'relative autonomy' derives mainly from the work of Louis Althusser. Note also that from the beginnings of their conception of history, Marx and Engels understood that the base and superstructure were in a reciprocal determining relationship, see, for example, *The German Ideology* (1845-1846), Students Edition, ed. C. J. Arthur, London: Lawrence & Wishart, 1974, p. 58 where they attend to 'the reciprocal action of these various sides [material production, civil society, state, religion, philosophy, ethics, etc., etc.] on one another'. An excellent analysis of the relation between base and superstructure is to be found in Raymond Williams's 'Base and Superstructure in Marxist Theory' in *Problems in Materialism*, London: Verso Books, 1981.

20. See Stuart Hall, 'Culture, The Media and the "Ideological Effect"', in *Mass Communication and Society*, ed. James Curran *et al.*, London: Edward Arnold, 1977, pp. 332-6 for useful discussion of the contributions of Althusser and Gramsci to cultural analysis. The phrase 'selective tradition' is from Williams, 'Base and Superstructure', and extensively discussed in his *Marxism and Literature*, Oxford: Basil Blackwell, 1977.

21. This is discussed in Griselda Pollock, *Differencing the Canon: Feminist Desire and the Writings of Art's Histories*, London: Routledge, forthcoming 1996.

22. A key text proposing this was Rosalind Coward and John Ellis, *Language and Materialism*, London: Routledge and Kegan Paul, 1977. For an extended critical review of *Language and Materialism*'s mixture of structuralism, psychoanalysis and Marxism, see Jonathan Rée, 'Marxist Modes', *Radical Philosophy*, vol. 23, Winter 1979, pp. 2-11.

23. In his critical study of the journal Anthony Easthope frames 'The Trajectory of *Screen*', between the years 1971 and 1979: 'For nearly ten years the film magazine *Screen* was the most important theoretical journal concerned with aesthetic discourse in Britain'. See 'The Trajectory of *Screen* 1971-79' in *The Politics of Theory*, ed. Francis Barker *et al.*, Colchester: University of Essex, 1983, pp. 121-33. The editorial board included Stephen Heath, Paul Willemen, Colin McCabe, Peter Wollen, Ben Brewster, Christine Gledhill.

24. See note 19.

25. For an example see Steve Burniston and Chris Weedon, 'Ideology, Subjectivity and the Artistic Text' in *On Ideology. Working Papers in Cultural Studies*, no. 10, Birmingham: Centre for Contemporary Cultural Studies, 1977, and Rosalind Coward, 'Class, "Culture" and the Social Formation', *Screen*, vol. 18, no. 1, 1977, pp. 75-106.

26. Raymond Williams, *Culture and Society 1780-1950*, Harmondsworth: Penguin Books, 1958.

27. Jon Bird, 'On Newness, Art & History: Reviewing *Block 1979-85*' in *The New Art History*, ed. A. L. Rees and Frances Borzello, London: Camden Press, 1986, p. 37.

28. Hilton Kramer, 'A Note on *The New Criterion*', September 1982, pp. 1-5.

29. F. Antal, 'Remarks on the Method of Art History' in *Essays in Classicism and Romanticism*, London: Routledge and Kegan Paul, 1966, p. 189.

30. Adrian Rifkin, 'Art Histories', in *The New Art History*, p. 158

31. For instance, Rozsika Parker and Griselda Pollock, *Old Mistresses, Women Art & Ideology*, London: Routledge and Kegan Paul, 1981; it was written in 1977-8 and is now published by Pandora Books.

rooted

IN THE
earth:

A VAN GOGH PRIMER

FRED ORTON &
GRISELDA POLLOCK

Five and thirty years ago the glory had not yet departed from the old coach roads... The passenger on the box could see that this was the district of protuberant optimists, sure that old England was the best of all possible countries... the district of clean little market-towns without manufactures, of fat livings, an aristocratic clergy, and low poor-rates. But as the day wore on the scene would change: the land would begin to be blackened with coal-pits, the rattle of handlooms to be heard in hamlets and villages. Here were powerful men walking queerly with knees bent outward from squatting in the mine, going home to throw themselves down in their blackened flannel and sleep through the daylight... here were the pale, eager faces of handloom-weavers, men and women, haggard from sitting up late at night to finish the week's work, hardly begun till the Wednesday. Everywhere the cottages and the small children were dirty, for the languid mothers gave their strength to the loom... The gables of the Dissenting chapels now made a visible sign of religion, and of a meeting-place to counterbalance the ale-house, even in the hamlets... The breath of the manufacturing town, which made a cloudy day and a red gloom by night on the horizon, diffuses itself over all the surrounding country, filling the air with eager unrest. Here was a population not convinced that old England was as good as possible.
George Eliot, *Felix Holt* (1866), Part I, Ch. I (Read by Van Gogh, 1878)

Chapter 1

Rooted in the Earth:
A Van Gogh Primer*

FRED ORTON AND GRISELDA POLLOCK

The drama of his life did not embellish but obscure the value of his work.
Max Liebermann

There is certainly an affinity between a person and his work, but it is not easy to define what this affinity is, and on that question many judge quite wrongly.
Vincent van Gogh

Born on 30 March 1853, Vincent van Gogh died on 29 July 1890 from self-inflicted gunshot wounds. He was subject to psychomotor epilepsy, a neurophysiological disorder which began to affect him after 1886. During the brief periods of sporadic attacks, he experienced changes of perceptions, moods and states of mind. This condition did not substantially affect what or how he painted.

Van Gogh left home at the age of sixteen to be apprenticed to Goupil & Co., an art dealing firm in The Hague. In 1880 he decided to become an artist after a decade of experiment with a variety of careers not only in art dealing (1869-76) but also in teaching (1876), bookselling (1877), studying theology and evangelising (1877-9).

When, in 1869, Van Gogh quit Groot-Zundert in North Brabant, the full effect of the Industrial Revolution had yet to be felt in Holland. The change of sensibility, however, which this economic and social upheaval had demanded of writers and artists in the more advanced industrialised countries, England and France, was already familiar to

*This is the original title for the book. See discussion in Introduction: Memories Still to Come...

him by the time he decided to become an artist through his intense reading of books of nineteenth-century novelists like George Eliot, Charles Dickens and Emile Zola. His reading was complemented by an equally passionate admiration for the painters of seventeenth-century Holland and the modern French and Dutch painters of peasants and landscapes whose work was infused with a romantic nostalgia for a timeless, rural past. He was probably also acquainted with Dutch criticisms of the commercial and colonial aspects of a modern society in the influential anarchist novel, *Max Havelaar* (1865) by Multatuli.

In the spring or early summer of 1880, Van Gogh wrote to thank his brother, Theo, for a gift of fifty francs, the first of what were to become regular payments that enabled him to commence and thereafter pursue his work as an artist. This letter (Letter 133), which broke a long silence and period of estrangement between the brothers, includes a lengthy exposition of Van Gogh's situation at this turning-point in the story of his life. A careful analysis of the text provides the keys to his future concerns and practice as an artist. It reveals his uncompromising determination and the conscious and deliberate way he would manipulate his younger brother in the fulfilment of his ambitions.

Van Gogh's letters require careful, critical reading. Useful as they may be as documentation, they should not be regarded as spontaneous outpourings or unselfconscious reflections. They are carefully considered pieces of creative writing that constitute a discourse on modern art and the role of the artist in modern society. Van Gogh saw his correspondence as a necessary adjunct or supplement to his paintings and drawings. The letters are his deliberate contribution to modern literature. Through them he prepared and tailored a picture of himself and a view of his art which has survived, more or less intact, through the complicity of his brother, whose role in this characteristically modernist strategy of self-justification and documentation should not be underestimated.

Letter 133, one of the most important letters to have to survived, exemplifies the character of Van Gogh and the structures of his thought and presentation. It is, moreover, the letter in which he announces his decision to become an artist. Characteristically, he never states this decision directly. We have to map out the structures of thought in order to discover just what is being articulated.

The letter begins:

> I am writing you with some reluctance, not having done so in such a long time, for many reasons. To a certain degree you have become a stranger to me, and I have become the same to you, more than you think; perhaps it would be better for us not to continue in this way. Probably I would not have written you even now if I were not under the obligation and necessity of doing so if you yourself had not given me cause.

And concludes:

> For the present I shake hands with you, thanking you again for the help you have
> given me. If you wish to write me one of these days, my address is c/o Ch.
> Decrucq, Rue de Pavillon 3, Cuesmes, near Mons. And you know a letter from
> you will do me good.

Begrudgingly, Van Gogh apologised for the long silence, which might have continued but for his obligation to thank Theo for the gift of fifty francs. His unstated purpose in the letter was, however, the need to win Theo's indulgence and to ensure the continuation of his financial and moral support. In order to re-establish their relationship, it was necessary to explain his self-imposed isolation. The main text of the letter treats the key themes of alienation and *rapport*, moral approval and financial need. It begins and ends in the same vein, establishing the basis of reconciliation. Van Gogh's tone is by turns ingratiating and threatening, aggressive and persuasive, apologetic and demanding. At the end, Van Gogh thanks Theo for the help he has given and anticipates its regular continuation.

By way of persuasion, Van Gogh gives an account of his present circumstances, isolated not only from his brother but estranged from his family and alienated from his bourgeois background. After his appointment as an evangelist to the miners of the Borinage had been terminated by the Belgian Committee for Evangelisation, he had wandered through the Borinage district homeless, unemployed and in search of a new purpose in life. He represents this period by way of an ornithological analogy.

> As moulting time – when they change their feathers – is for birds, so adversity or
> misfortune is the difficult time for us human beings. One can stay in it – in that
> time of moulting – one can also emerge renewed...

Van Gogh thus reassures Theo that no drastic change or deterioration has occurred. Rather, he is engaged in a natural, cyclical process from which he will emerge renewed, superficially different perhaps, but essentially unchanged. The analogy also carries a philosophical connotation derived from his acquaintance – gained through reading Taine's *History of English Literature* (1863) – with the ideas of the influential Victorian philosopher, Thomas Carlyle, who inveighed against the moral deadness of his age, its hypocritical judgements of people and moral questions, its complacent acceptance of prosperity for the very few and commercial success as man's supreme goal. In *Sartor Resartus* (1837), Carlyle's critique is framed in terms of an extended metaphor, the philosophy of clothes. Social conventions and customs are seen as the mere coverings, which conceal, if not obscure, the inner spiritual truths. Van Gogh adopts this extended metaphor in accounting for his loss of an established position in society.

> One of the reasons why I am unemployed now, why I have been unemployed for years, is simply that I have different ideas from the gentlemen who give the places to men who think as they do. It is not merely a question of dress, which they have hypocritically reproached me with; it is a much more serious question, I assure you.

He then directs a vehement attack on those blinkered churchmen and tyrannical art-world academicians who maintain outward conventions and established institutions against all new ideas and fresh aspirations. In doing so, he asserts his allegiance to alternative, independent and radical groups. The sentence, 'I must tell you that with evangelists it is the same as with artists', intimates a new direction in his thinking.

Van Gogh is aware that to those with a vested interest in maintaining the present social system and its institutions, his ideas and behaviour appear eccentric, foolish, alarming. In one passage he conveys the great gulf of misunderstanding that exists between how the world regards him and how he truly is, while subtly displacing responsibility for his situation on to others.

> A caged bird in the spring knows quite well that he might serve some end; he is well aware that there is something for him to do, but he cannot do it. What is it? He does not quite remember. Then some vague ideas occur to him, and he says to himself, 'The others build their nests and lay their eggs and bring up their little ones;' and he knocks his head against the bars of the cage. But the cage remains, and the bird is maddened by anguish.
>
> 'Look at that lazy animal,' says another bird in passing, 'he seems to be living at ease.'
>
> Yes, the prisoner lives, he does not die; there are no outward signs of what passes within him – his health is good, he is more or less gay when the sun shines. But then the season of migration comes, and attacks of melancholia – 'But he has everything he wants,' say the children that tend him in his cage. He looks through the bars at the overcast sky where a thunderstorm is gathering, and inwardly he rebels against his fate. 'I am caged, I am caged, and you tell me I do not want anything, fools! You think I have everything I need! Oh! I beseech you liberty, that I may be a bird like other birds!'

Later, he defines the cage as the prison of prejudice, misunderstanding, fatal ignorance, distrust, false shame, and poverty. Liberation will come with the re-establishment of trust, sympathy and brotherly love. Both Theo's money and renewed belief in him are therefore posed as the solution to his present predicament.

Van Gogh presents himself as someone who is misunderstood and unrecognised. Despite a change in his external appearance and lifestyle, his inner self has remained constant. That self is, admittedly, unconventional, foolish, outspoken, but above all Van Gogh sees himself as a man dominated by intense drives and enthusiasms.

I am a man of passions, capable of and subject to doing more or less foolish
things, which I happen to repent more or less, afterwards. Now and then I speak
and act too hastily, when it would have been better to wait patiently. I think
other people sometimes make mistakes. Well, this being the case, what's to be
done? Must I consider myself a dangerous man, incapable of anything? I don't
think so. But the problem is to try every means to put those selfsame passions to
good use. For instance, to name one of my passions, I have a more or less
irresistible passion for books, and I continually want to instruct myself, to study
if you like, just as much as I want to eat my bread. *You* certainly will be able to
understand this. When I was in other surroundings, in the surroundings of
pictures and works of art, you know how I had a violent passion for them,
reaching the highest pitch of enthusiasm. And I am not sorry about it, for even
now, *far from that land, I am often homesick for the land of pictures.*

Here Van Gogh juxtaposes his real isolation from his family and society to a desire
for another kind of environment, a home, to which he can properly belong, a true centre
of affection, where he can find rest, refuge and satisfaction. He identifies this spiritual
home with the 'land of pictures', the medium through which he can find his place in
society again. To this end, the 'thorough study of pictures and the love of books is a
sacred as the love of Rembrandt'. The one complements the other. Moreover, he believes
that literary style and language can be compared to an artist's brushwork 'quivering
with fever and emotion'. Thus, 'one must learn to read just as one must learn to see and
learn to live'. The interrelation of word and image revealed subsequently in Van Gogh's
own practice is announced in this letter, and the future directions and preoccupations of
his work are suggested by the affinities he finds between the artists and writers who he
names in it.

Within a few months of writing this to Theo, Van Gogh was busy teaching himself to
draw with the help of contemporary copy books and reproductions. From the outset his
works reveal a definite character derived from his studied copying of engravings after
paintings and the wood engravings published in illustrated papers. One of the early
pictures, *Miners Going to Work* (F831), borrows a motif and style from *Going to Work*,
1850-1 (Glasgow City Art Gallery) by Jean François Millet (1814-75). These resources
are appropriated to his own observations of the Borinage miners and to his responses to
the peculiar landscape of the coalfield with its shrivelled blackthorn hedges, bowed and
bent miners dwarfed by the mine workings, and mountains of coal and slag. Van Gogh
brings all these elements together, representing with black lines on white paper what
George Eliot had described in her verbal picture of the contrast of the old rural and
modern industrial worlds in *Felix Holt*. To this he adds his own symbolism. Not only
had he earlier compared blackthorn bushes against a snowy ground to 'black characters
on white paper – like the pages of the Gospel' (Letter 127), but he had seen the miners
– the men who walk in darkness – as symbolic of the whole message of the Gospel,
whose foundations provide 'the light that rises in darkness' (Letter 126).

Fig. 1

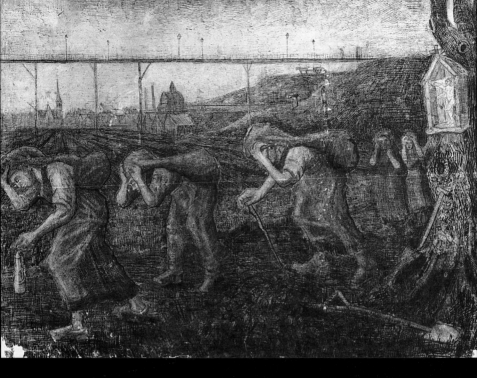

...there are many things which one must believe and love. There is something of *Rembrandt* in Shakespeare, and of Correggio in *Michelet*, and of *Delacroix* in Victor Hugo; and then there is something of Rembrandt in the Gospel, or something of the Gospel in Rembrandt – whichever, it comes to the same thing if only one understands it properly, without misinterpreting it and considering the equivalence of the comparisons, which do not pretend to lessen the merits of the original personalities. And in Bunyan there is something of *Maris* or of *Millet*, and in Beecher Stowe there is something of Ary Scheffer. (Italics added)

A drawing, titled by the artist in English *'Bearers of the Burden'* (fig. 1, F832), completed seven months later in April 1881, after Van Gogh had moved to Brussels in search of more intense instruction, bears witness to the increasing technical accomplishment and the weight of meaning that he intended his pictures to convey through the deliberate positioning of highly significant elements. It shows several women miners returning home carrying sacks of coal that they have gleaned from the slag heaps. However, they are bent double not under the weight of the coal but under a metaphysical burden. They stagger in slow procession across a sombre landscape, which itself is marked by the outward, visible signs of the powerful institutions which spiritually and materially determine the miners' existence. These figures, whose dark tones are scarcely distinguishable from those of the blackened landscape, merge into the ground. In the lighter background, two churches break the skyline, one Catholic and one Protestant, each segregated from the other by the vertical supports of the mine's viaduct, and dominating the huddle of the miners' dwellings. Although the churches aspire upwards, they are enclosed, as Van Gogh has represented the scene, within the structure of the viaduct, a sign of the otherwise absent mine and its underground world that also seems to dominate the figures in the foreground. Three women lead the procession across the picture, past a gnarled tree trunk, on which hangs a Calvary. In this way the material, temporal world is juxtaposed to the spiritual. The agony of the Christ is the symbolic equivalent of the miners' own passion; its presence changes how we see the daily return from work. Van Gogh shows the miners indifferent to Christ's agony, passing unheeded that which is offered them by institutionalised religion.

After a brief stay in Brussels, where he had gone after quitting the Borinage, Van Gogh returned to Brabant, and there he concentrated on making drawings of agricultural workers. The most important of these was *The Sower* (F862). Van Gogh's enthusiasm for the sower as a 'type' derived partly from his admiration for Millet's famous image, a reproduction of which he had copied repeatedly in 1880-1, and partly from the biblical connotations of the Parable of the Sower. The figure of the sower became a symbol of his artistic and political credo: the need to live in harmony with nature's cycles, to be rooted in the earth, to work from nature and celebrate its wholesomeness and fertility. Moreover, representing the sower satisfied his need to create an entirely modern imagery, secular and free from all conventions, which was none the less imbued with a displaced, almost religious emotion. This early study is an example of Van Gogh's desire to find a style and technique appropriate to his commitment to modern realism. The angularity, the awkward stiffness, the rough texture, and the old work-worn face refuse all prettification or picturesqueness. However sublime the idea that lies behind the subject, the drawing signifies actual work.

Throughout Van Gogh's practice, a fascination with the working figure vies with his feeling for landscape, the earth on and in which the peasant labours. The two were closely linked in his imagination, and he often drew or spoke about the one in terms of the other.

Today I have been working on old drawings from Etten, because in the fields I saw the pollard willows in the same leafless condition... Sometimes I have such a longing to do landscape... and in all nature, for instance in trees, I see expression and soul, so to speak. A row of pollard willows sometimes resembles a procession of almshouse men. Young corn has something inexpressibly pure and tender about it... The trodden grass at the roadside looks tired and dusty like the people of the slums. A few days when it had been snowing, I saw a group of Savoy cabbages standing frozen and benumbed, and it reminded me of a group of women in their thin petticoats and old shawls which I had seen standing in a little hot-water-and-coal shop early in the morning. (Letter 242, November 1882)

In December 1881 Van Gogh settled in The Hague, the major urban centre of modern Dutch art. He had become acquainted with the leading artists – Anton Mauve (1838-88), Jacob Maris (1837-99) and Josef Israëls (1824-1911) – and the work of the Hague School during his time at Goupil & Co., the school's main dealers. This move from country to city, from solitary work to a more gregarious life in an avant-garde artistic milieu, begins a pattern of periodic relocation that was to be repeated throughout his life. He moves from The Hague to Drenthe, and from Drenthe to Nuenen, from Nuenen to Antwerp, from Antwerp to Paris, from there to Arles and St Rémy, and finally from St Rémy to Auvers via Paris. In The Hague he anticipated the companionship of like-minded artists, but his uncompromising personality and eccentric, anti-bourgeois behaviour soon cut him off from the respectable members of this group. He fraternised, however, with younger artists Th. de Bock, H. J. Van der Weele, and especially G. H. Breitner (1857-1923) with whom he set out on sketching trips, scouring the poorer quarters of the city for motifs like soup kitchens, third-class waiting rooms, prostitutes, aged poor, and inmates or 'orphanmen' of the almshouses (F962). Breitner and Van Gogh shared an interest in modern French realist novels, in particular those by Zola and the de Goncourt brothers. The latter had encouraged artists to depict the lives of ordinary people and the poorer inhabitants of the new growing cities.

Shortly after arriving in The Hague, Van Gogh started to collect engravings from English and French illustrated magazines, some of which he knew from the time he had spent in England during the 1870s. He was particularly interested in the work of Frank Holl, Hubert Herkomer and Luke Fildes, whose drawings he admired because they aroused sympathy for the poor, the old and the outcast. It became his ambition to work as an illustrator producing drawings not only of the people but for the people. To this end he explored graphic techniques, notably new forms of lithography. His desire to produce a popular art resolved into a scheme for a series of drawings and lithographs of types of the people aimed at a very different public from that of the English magazines.

No result of my work could please me better than that the ordinary working people would hang such prints in their room or workshop. (Letter 245)

The most complex and intriguing work of The Hague period is the drawing and lithograph titled *Sorrow* (fig. 2, F929a). It is one of the most remarkable images of a naked woman in European art. Although there are precedents in Northern art for the use of the naked female body to express pathos rather than available sexuality, here the woman is pregnant and the pathos derives from her despairing posture and the suggestion that she has been abandoned. Note the inscriptions on the drawing – not only the English title but also the quotation from the French philosopher, Jules Michelet: 'How can it be that there is on earth a woman alone and abandoned?' The model was a pregnant prostitute whom Van Gogh had found on the streets and taken into his home under the effect of Michelet's impassioned appeal in his books on Love and Woman for the rescue of modern woman from the dangers in which nineteenth-century society placed her. Van Gogh has radically changed a simple, though unusual, nude study into a many-layered comment on prostitution and love, themes that had engaged so many nineteenth-century thinkers, novelists and artists. The treatment is emphatic, linear, harsh; the figure is situated outside, at a roadside, next to some thorn bushes. Yet the despair and pathos of the image of woman vie with another quite optimistic meaning, once the significant elements of this drawing – fertility, blossoms, nature – are placed in the context of Van Gogh's personal symbolism. From a study of his letters we can see that here he is doing two things; he is making an analogy between two 'outsiders', the pregnant prostitute and the artist, and he is also constructing an allegory on the nature of creative work.

The image of the reader was for Van Gogh a quintessentially modern subject. In his art he aspired to equal the achievements of contemporary literature. His letters are full of admiring references to portrayals of readers by artists as diverse as Ernest Meissonier (1815-90), Puvis de Chavannes (1824-98) and especially Rembrandt (1606-69), in whose use of light and dark Van Gogh recognised a means of conveying pictorially the illumination that books offered to modern man. In a highly finished drawing (fig. 4, F897) made at Etten in 1881 Van Gogh places his reader in a setting typical of the Hague School painter Josef Israëls, who repeatedly pictured the motif of an old peasant man or woman at the fireside. This drawing tries to represent the intimacy of the home and express the conviction stated in Letter 133 that 'One must learn to read, just as one must learn to see and learn to live'.

Throughout his career, Van Gogh repeatedly insisted on the validity and necessity of a complete understanding and application of the laws of perspective. To this end he designed his own variations on a traditional mechanical aid known to Leonardo (1452-1582) and Dürer (1471-1528) and used in Holland in the nineteenth century, the perspective frame (fig. 6, Letter 223). He relied on this contraption until June 1888, but he could never submit himself entirely to the discipline that its use demanded. This accounts for the deviations from linear perspective which came to characterise his work and which have given rise to numerous fanciful or psychologistic interpretations. Despite these interpretations, the divergences from consistent geometric space must be

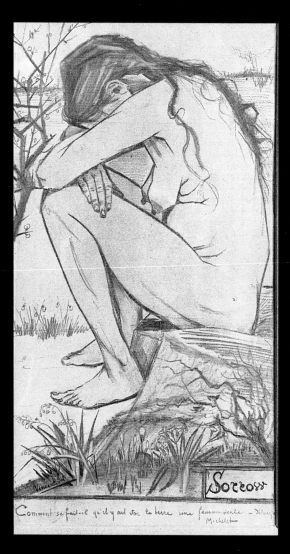

Fig. 2

So you see that I am in a rage of work, though for the moment it does not produce very brilliant results. But I hope these thorns will bear their white blossoms in due time, and that this apparently sterile struggle is no other than the labour of childbirth. First the pain and then the joy.

(Letter 136, 1880)

The whore in question has more of my sympathy than my compassion. Being a creature exiled, outcast from society, like you and me who are artists, she is certainly our friend and sister.

(Letter to Bernard 14, 1888)

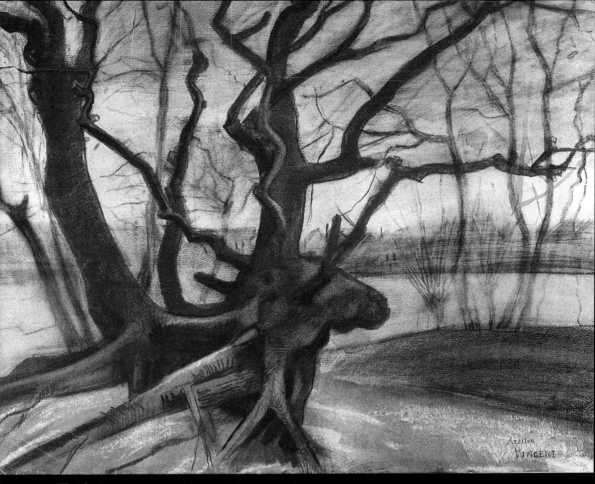

Fig. 3

The other, 'The Roots' shows some tree roots on sandy ground.
Now I tried to put the same sentiment into the landscape as into the figure: the
convulsive, passionate clinging to the earth, and yet being half torn up by the
storm. I wanted to express something of that struggle for life in that pale slender
woman's figure as well as in the black, gnarled and knotty roots.
(Letter 195, 1882)

For myself I learn much from Father Michelet. Be sure you read *L'Amour et La
Femme*... The men and women who stand at the head of modern civilisation – for
instance Michelet and Beecher Stowe, Carlyle and George Eliot and so many others
– they call to you...'Oh, man, wherever you are, with a heart in your bosom, help
us to found something real, eternal true... Let your profession be a modern one and
create in your wife a free modern soul, deliver her from the terrible prejudices that
enchain her.'
(Letter 160, 1881)

attributed to a contradiction of which Van Gogh was at times fully aware. A dialectic was at work between his desire to be traditional in his depiction of space and to present a coherent view of the world unified by a single viewpoint, and the impossibility, at that date, of imposing an artificial unity on the representation of a world that he increasingly realised or sensed to be an interrelated totality in constant flux. The drawing of a view of the backyards and outskirts of The Hague (fig. 7, F930), completed to fulfil a commission from his uncle, evidences the pencil guide-lines of the rectangular perspective frame he had just had made and used. As one of the first drawings made with the help of the frame it shows what could be achieved if the frame's guide-lines were followed more or less rigorously. Even here, however, it is clear that the whole picture has been seen from various points of view. The landscape speeds into the distance while the foreground expands and dips towards the spectator.

Van Gogh's limited interest in or desire to study oil painting began to change in the summer of 1882 when he discovered to his great surprise, through some studies he did in oil out of doors, that he had a natural feeling for colour. Choosing a motif from the most famous Hague School enterprise, H. W. Mesdag's *Panorama* (1881) – a huge circular view of the fishing village of Scheveningen – he set up his perspective frame in the dunes and produced a small painting known as *Beach at Scheveningen in Stormy Weather* (F4). In this picture the returning fishing smacks, the womenfolk, and the waiting horses are subordinate to the dramatic effect of the scudding clouds and the stormy sea rendered in bold strokes and thick paint. The canvas captures the experience of being on the scene rather than merely observing it. Sand is embedded in the paint surface, witness to the storm in which it was painted. The handling of paint and colour, though crude at times, already indicates Van Gogh's later use of painted texture and varied surface to express the world of nature's violence and movement.

A sustained interest in oil painting did not, however, take off until September 1883 when Van Gogh abandoned the city and moved to Drenthe, a desolate province in the northern Netherlands where vast moors and peat bogs stretch for miles under huge skies, intersected by canals and dotted with low-walled huts built into the peat itself and covered with mossy roofs. Although he was only in Drenthe between September and December 1883, these few months are arguably the most formative of his whole career. The letters and pictures produced in Drenthe adumbrate the major themes of his subsequent work, articulate his conception of the artist and indicate his allegiance to nineteenth-century Dutch anarchist thought. A decisive shift away from the art of the contemporary Hague School to new models is also evident in these months. References abound in his letters and pictures to images from an earlier age, from the mid-nineteenth-century community of artists in the French village of Barbizon as well as from the painters of an older Holland, the seventeenth-century forerunners of landscape painting.

A sketch (fig. 8, Letter 330) from a Drenthe letter, in which he described the province as miles and miles of 'Georges Michels' (1763-1843), 'Théodore Rousseaus' (1812-67),

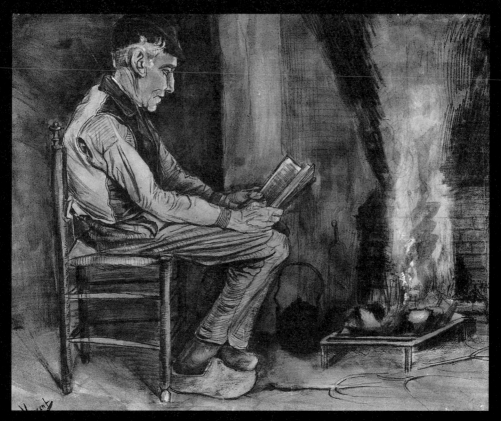

Fig. 4

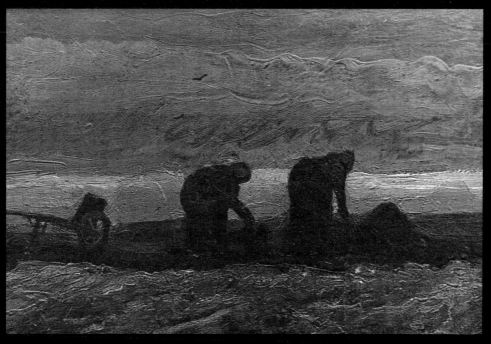

Fig.5

'Jan Van Goyens' (1596-1656) and 'Philips de Konincks' (1619-88), presents us with subjects that will recur in his work through to his last days at Auvers – the cottage, the peasant in the fields, fascination with that sign of Dutchness, the drawbridge, the theme of twilight and night scenes, his conviction of man's relation to the earth, and his analogy between painting and music (fig. 5, F39).

In December 1883 Van Gogh returned to Brabant, to Nuenen, the village of his father's new pastorship where he remained until November 1885. In the Nuenen period, Van Gogh's long-standing admiration for Jean François Millet as both the *peasant* painter and *painter* of peasants, flourished into a virtual identification with the artist, his life and subject matter. He wrote to Theo in 1885, 'When I call myself a peasant painter, it is a real fact' (Letter 400). The rural population of Nuenen included a large number of weavers still using traditional handlooms in their cottages although factories were already threatening the traditional rural-domestic economy the weavers represented. In 1884 Van Gogh repeatedly drew and painted an image made symbolic for him by his reading of George Eliot (fig. 9, F30).

The intensity of his identification with the Catholic Brabant peasant is akin to his involvement with the miners of the Borinage. From the weavers Van Gogh moved on to concentrate on the agricultural workers. His continual drawing and painting of these peasants culminated in his first major subject composition in oil, titled *The Potato Eaters*, completed in April 1885 (fig. 10, F82).

Reworking his concern with light in darkness, *The Potato Eaters* shows a family in a darkened interior illuminated by a centrally placed, old-fashioned hanging-lamp. The peasants have just begun their daily meal of potatoes and coffee.

> I have tried to emphasise that those people eating their potatoes in the lamplight,
> have dug the earth with those very hands they put into the dish and so it speaks
> of manual labour and how they have honestly earned their food. (Letter 404)

The colour and the atmospheric effect was intended to make the painting a 'real peasant picture'. The peasants are painted the colour of a dusty, unpeeled potato and the whole scene was meant to exude an odour of bacon and smoke. Van Gogh wanted to assault all the spectator's senses. To ensure the depth of colour, and remind the viewer of the warm glow of the lamp he suggested that the picture be placed in a golden frame.

According to Van Gogh, *The Potato Eaters* was a picture that came from the heart of peasant life. It was intended to celebrate the peasants' closeness to the earth, a timeless daily ritual, and the honesty of manual work, however small its rewards in material terms. Such a scene was none the less very common amongst Hague School painters, especially Josef Israëls, whose portrayals of peasants' mealtimes emphasised bourgeois concerns with the virtues of home and the family. However, Van Gogh's *Potato Eaters* goes far beyond that genre's bourgeois realism. The peculiar arrangement of the figures in space effects a tension, a powerful sense of unease. The subject, as Van Gogh has

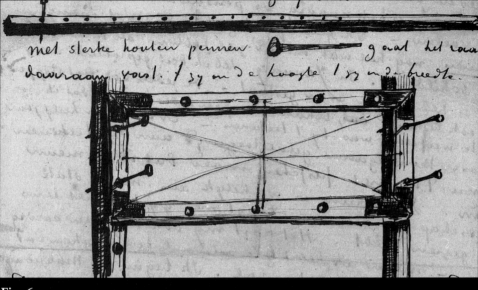

met sterke houten pennen ⬤━━━━━ gaat het raa

daarraam vast. 1 sy en de hoogte 1 sy en de breedte.

Fig. 6

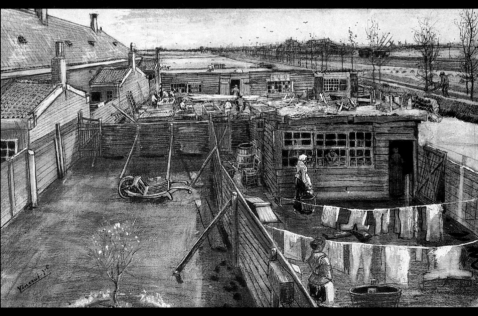

Fig. 7

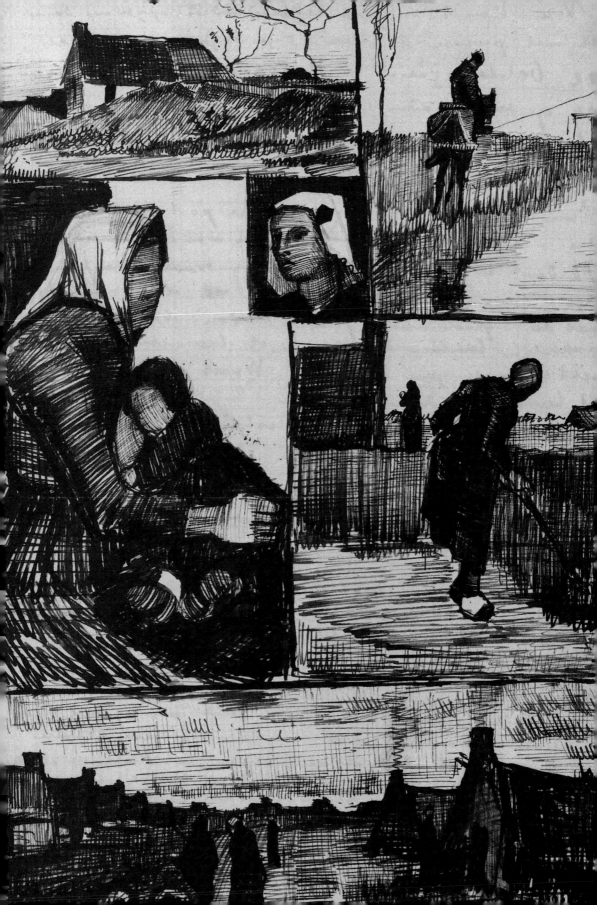

Opp. Fig. 8

A cottage made only of sods and turfs and sticks... I cannot express how their outside looks in the twilight, or just after sunset, more directly than by reminding you of a certain picture by Jules Dupré [1811-89]... two cottages, their moss covered roofs standing out very deep in tone against a hazy, dusky evening sky. That's the way it is here. Inside these cottages, dark as a cave, it is very beautiful. (Letter 324)

In the evening this moor often shows effects which the English call and 'quaint'. Fantastic silhouettes of the Don Quixote-like mills or curious giants of drawbridges stand out against the vibrating evening sky. In the evening such a village, with the reflections of lighted windows in the water or in the mud puddles, sometimes looks extremely friendly. (Letter 330)

But in order to grow, one must be rooted in the earth. So I tell you, take root in the soil of Drenthe – you will germinate there – don't wither on the sidewalk. You will say there are plants that grow in the city – that may be, but you are corn, and your place is in the cornfield. (Letter 336)

Suppose someone should put the question to you, would you like to become a painter if you could suddenly be transferred to the period of forty years ago, when things were the way they were when Corot [1796-1875] etc. were young, and if at the same time you were not alone, but had a companion? The reason I ask you this is that I am feeling exactly as if I had been transferred to the above mentioned period in this country where progress has got no further than stagecoach and barge and where everything is more untouched than I have seen in any other place.

You have seen Drenthe – from the train, in a hurry, long ago – but if you come to the most remote back country of Drenthe, it will make quite a different impression on you, you will feel just as if you lived in the time of Van Goyen, Ruysdael, Michel, in short, in what perhaps one hardly feels even *in the present* Barbizon. This is the important thing, I think, for in such natural surroundings, things can be aroused in a heart, things which would otherwise never have been awakened. I mean something of that free cheerful spirit of former times... (Letter 337)

reconceived it, incorporates a message, taken from Millet, to the effect that modern artists should use themes from peasant life to represent old religious feelings in secular terms. Van Gogh saw that Millet did not paint the figure of Christ but His doctrine, and especially the biblical injunction to earn one's bread by the sweat of one's brow. One can even cite a more directly religious source in the obviously intended reference to a painting long beloved by Van Gogh, Rembrandt's *Supper at Emmaus* (Paris, Louvre). However, Van Gogh's image, stripped of all religious iconography, save for the crucifix on the wall, synthesises these different sources – Israëls, Millet and Rembrandt – and effects a transformation of the genre of peasant painting to produce a modern religious painting. As with the *'Bearers of the Burden'* (fig. 1), the religious connotations are unconventional, and, indeed, the ultimate source for its complex of meanings lies entirely outside the Bible or any religious tract. Once again, it is Carlyle's *Sartor Resartus* that provides a key to the contradictory messages of this particular image of poverty, faith, and dignity. In the final chapters of that essay, Carlyle schematically divides unsettled modern society into the two conflicting classes: the conventional, superficial Dandies and the Poor Slaves. We quote from his description of the latter class next to *The Potato Eaters* (fig. 10).

In answer to the severe criticism of his figure style in the *Potato Eaters* made by a fellow Dutch artist, Anthon Van Rappard (1858-92), Van Gogh produced some of the finest drawings he ever did. They were intended to justify invoking the name of Millet in relation to his own work and many use that artist's most typical motifs. However, their impact is entirely different. There is a studied crudeness or roughness in the draughtsmanship and an exaggerated bulkiness in the figures as they bend towards the earth (F1215, F1255, F1270, F1269).

A long-standing point of contention between Van Gogh and Van Rappard concerned the importance of correct technique. Van Gogh constantly searched for a style to fit his subjects, to find appropriate marks and media, pictorial equivalents to represent a sense of the substantial presence and the material life of his subjects. This necessity may account for the variety of techniques and changes of style that occur in his work over a decade – a diversity of appearances produced in response to an underlying thematic unity, namely the need to assert a specific and increasingly anachronistic view of the necessary relations between man and the earth.

Within a few months of this total commitment to peasant life as the core of modern art, we witness the beginnings of an apparent change of emphasis. Feeling a renewed need to get closer to *the* centre of *avant-garde* art and be among artists and pictures, Van Gogh left the country and moved to Antwerp, a city and a necessary place of preparation prior to his ultimate destination, Paris. His notion of modernity was shifting and this reorientation was illustrated in a still-life (fig. 11, F117) made just before he left Nuenen in October 1885. The opened pages of the Bible are juxtaposed to the bright yellow covers of a modern French novel, Zola's *Joie de Vivre*. It has been argued that this painting proposes the literature of modern reality in place of the old religion of the

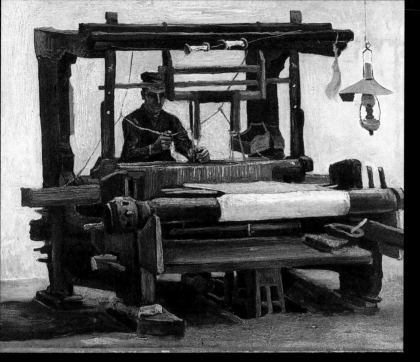

Fig. 9

But what I wanted to express by it was this: 'When that monstrous black thing of grimed oak with all those sticks is seen in sharp contrast to the greyish atmosphere in which it stands, then there in the centre sits a black ape or goblin or spook that clatters with those sticks from early morning to late at night.' And I indicated that spot by putting in some sort of apparition of weaver...
(Letter to Van Rappard 44, April 1884)

Another thing I saw on that excursion was the villages of weavers. The miners and weavers still constitute a race apart from other labourers... I should be happy if one day I could draw them so that those unknown or little known types could be brought before the people. The man from the depth of the abyss – *de profundis* – that is the miner; the other with his dreamy air, somewhat absent-minded, the somnambulist, that is the weaver. (Letter 135, September 1880)

In the days when the spinnng-wheels hummed busily in the farmhouses... there might be seen in districts far away among the lanes, or deep in the bosom of the hills, certain pallid, undersized men, who, by the side of the brawny country folk looked like the remnants of a disinherited race.
(George Eliot, *Silas Marner -The Weaver of Raveloe* (1861), Book, I, Ch, I)

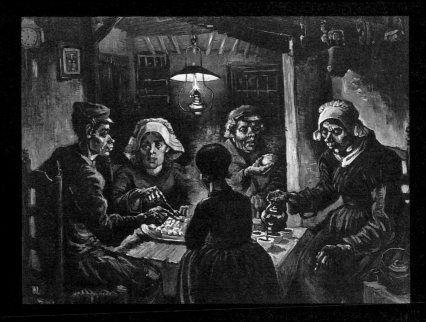

Fig. 10

One might fancy them worshippers of Hertha, or the Earth: for they dig and affectionately work continually in her bosom; or else shut up in private Oratories, meditate and manipulate the substances derived from her...

In respect of diet, they also have their observances. All Poor Slaves are Rhizophagous [root eaters]... Their universal sustenance is the root named potato, cooked by fire alone.

Thomas Carlyle, *Sartor Resartus*, Book III, Ch. X

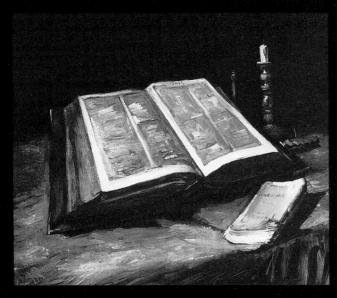

Fig. 11

Bible. However, the choice of Zola's most profoundly pessimistic novel out of those he could have chosen from amongst the many he had read by that author, and the decision to open the Bible at Isaiah 53 – 'he was a man of sorrows and acquainted with grief' – suggests less a virulent opposition than a transposition and so makes the picture a manifesto of his commitment to contemporary forms of literature and art.

The pictures that Van Gogh produced in Antwerp (November 1885 to February 1886) were not painted in the same manner as those he had executed in rural Nuenen. His relationship with the Belgian port and its inhabitants (and their relationship with the world) was different. In Antwerp Van Gogh made the transition from peasant painter to city painter, haunting the café-concerts, the dance halls, the docks and public squares. He was helped in this by an attentive analysis of the paintings of Frans Hals (1580/5-1666) that suggested certain ways in which he could adapt his colouration and technique to a different type of environment, a different type of person, and above all, a different sense of life – new, shifting, transient and rootless. In *Head of a Woman* (F206), of December 1885, the solidity of his heavy Nuenen handling was replaced by a shorter, more nervous touch, and the dominant tonality of earth colours that symbolically linked the peasant to the soil was replaced by a more luminous palette based on complementary colours.

It was in Antwerp that Van Gogh first mentioned owning Japanese prints. He probably purchased them on his arrival in the city which had been host to the Exposition Universelle since May 1885, at which Japan had been well represented. Japanese goods were readily and cheaply available in the port's shops and bazaars. But why did Van Gogh buy them? In the latter months of 1885 he had read de Goncourt's novel *Chérie* (1884), in the preface to which the author had claimed that he and his brother had been responsible for the three most important aesthetic movements of the nineteenth century: *la recherche du vrai en littérature, la résurrection de l'art du XVIIIième siècle, la victoire du Japonisme*. It was under this influence that Van Gogh decorated his studio with Japanese prints. From another work by the de Goncourts he quoted their slogan 'Japonaiserie Forever', borrowing it to substantiate his comparison of the Antwerp quays with scenes he saw in the Japanese prints. Having already embraced the search for modern reality and discussed the revival of eighteenth-century art, he now espoused an interest in the third movement, *Japonisme*. In doing so, he tried to make clear to Theo that he was a truly modern artist, someone well-prepared to take his place in the artistic milieu of Paris.

In March 1886 Van Gogh arrived unexpectedly in Paris, where, for two years, he attempted to come to terms with modern French art. The scene that confronted him in the avant-garde community there was one of great change and bitter division between different sects, each jostling for pre-eminence in the space created by the decline of the now discredited Impressionism. 1886 witnessed the last group show of the Impressionists, from which Claude Monet (1846-1926) and Auguste Renoir (1814-1919) were significantly absent, as well as the announcement of a new movement,

dubbed Neo-impressionism, at the second exhibition of the Indépendants. At this exhibition Georges Seurat's (1859-91) *Un Dimanche d'Été à l'Ile de la Grande Jatte* (1886, fig. 30) took pride of place as a manifesto of a new rigorous, scientific procedure and an interest in a very different aspect of the urban scene than that depicted by what Camille Pissarro (1831-1903), a convert to the new style, called disparagingly 'the romantic impressionists', out of keeping with 'the spirit of the times'. The Symbolist movement declared itself with the publication of the writer Jean Moréas's *Manifesto of Symbolism*, while new musical attitudes developed under the influence of concerts of Wagner's music. With the foundation of the *Revue Wagnerienne* poets and artists began to explore the music of this composer as a model for a new kind of art.

In his two years in Paris Van Gogh took note of the current trends and experimented briefly with their different procedures for painting out of doors, for creating greater luminosity, and for organising a picture surface more systematically. At times some of his suburban or industrial motifs bear comparison with Impressionist or Neo-impressionist modes. But it is also clear that he could not fully endorse what he learned about French art or situate himself in its conflict-riven avant-garde community. For these reasons, one can detect very little change in his work from the late Antwerp pictures for the first nine months of his stay, during which he improved his figure drawing with studies of plaster casts and the nude at the fashionable studio of Fernand Cormon, studied Delacroix's paintings for hints about a colour theory he had already discovered while in Nuenen and, in a style derived from a little-known Provençal artist, Adolphe Monticelli (1824-86), painted a mass of flower studies in order to consolidate his concern for brilliant colour. A brief engagement with Impressionism occurs in the winter of 1886-7, but his access to its principles came second-hand through other expatriate students, notably through John Russell (1858-1931), an Australian painter who had worked with Monet in Brittany. It was not until well into 1887 that Van Gogh met Pissarro (1831-1903) and Paul Signac (1863-1935), advocates of Neo-impressionism, and began to work with a young artist Emile Bernard (1868-1941), whose disaffection from existing movements was leading him in a very different direction.

Van Gogh tried to take his place in this sophisticated urban milieu. One self-portrait (F295) shows him spruce in his city suit, collar and tie, and dashing felt hat; his health restored, his teeth attended to, and his beard neatly trimmed. But later in 1887 he rejected this bourgeois dress, donned a workman's blue jacket and hobnailed boots. Perhaps the shoes pictured in *Boots* (fig. 12, F333) belonged to Van Gogh. In which case, we should see and understand the painting as an indirect self-portrait.

In short, we may presume that Van Gogh's need to come to Paris was not based on any clear idea of what he wanted from it. He took a year and a half to realise that he did not want what it had to offer. By the time he quit Paris he had been enriched by his acquaintance with certain people, artists like Russell, Bernard, Paul Gauguin (1848-1903) and art dealers like Père Tanguy (fig. 13, F363), and he had been affected by his

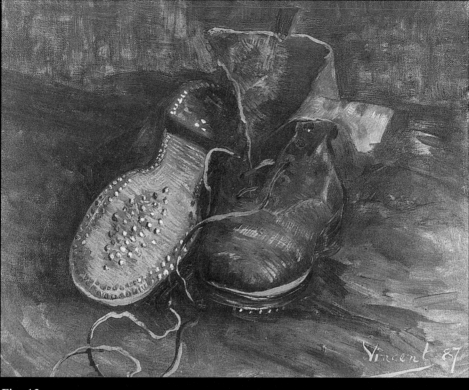

Fig. 12

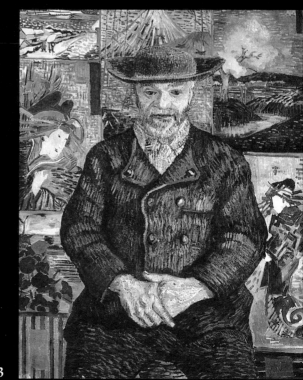

Fig. 13

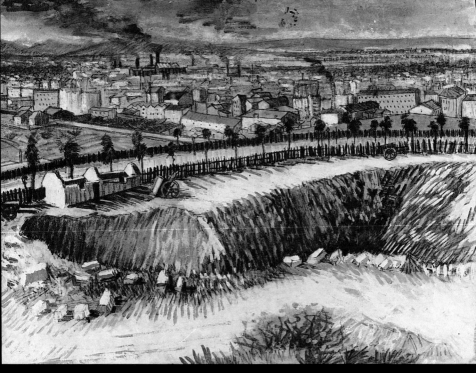

Fig. 14

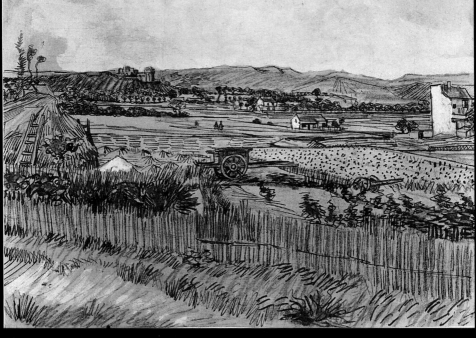

Fig. 15

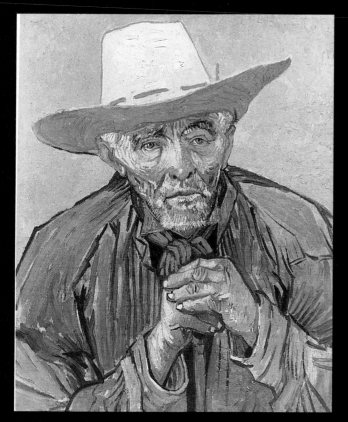

Fig. 16

Par le crépuscule et le hâle
Le paysan deux fois bruni.
(Quoted Letter 406, May 1885)

I imagine the man I have to paint, terrible in the furnace of the heat of
harvest-time, as surrounded by the whole Midi. (Letter 520, August 1888)

We've read *La Terre* [Zola, 1887] and *Germinal* [1884] and if we are
painting a peasant, we want to show that in the end, what we
have read has come very near to being part of us. (Letter 520, August 1888)

Ah! I have another figure all the same which is the absolute continuation of heads I
did in Holland. I showed them to you one day with a picture from that period: *The
Potato Eaters*. I wish I could show you this one.
(Letter to Bernard 15, August 1888)

encounter with certain new ideas. In the last analysis, however, his time in Paris served, more than anything, to validate the convictions about art that he had brought with him. In a letter written a few months after his arrival in the South of France, whither he had gone in February 1888, he wrote to Theo:

> It is only that what I learned in Paris is leaving me, and I am returning to the ideas I had in the country before I knew the Impressionists. And I should not be surprised if the Impressionists soon find fault with my way of working, for it has been fertilised by Delacroix's ideas rather than by theirs. Because instead of trying to reproduce exactly what I have before my eyes, I use colour more arbitrarily, in order to express myself more forcibly. (Letter 520; *Van Gogh uses the term 'Impressionist' to refer to all contemporary French artists*)

In a sense, the most important questions raised by the Paris period are why did he leave and go south, and what did he mean by the 'arbitrary' use of colour? A discussion of Van Gogh's uneven interest in Japanese prints in the Paris years provides some answers to these questions. Despite the popularity of Japanese prints in Paris, there is no evidence that the interest he had shown in them while at Antwerp was sustained during his first year in the French capital. It was probably his friend Russell who drew his attention to them and explained how important they had been to the Impressionists and how significant they were for a thorough understanding of modern art. Van Gogh began to buy Japanese prints systematically and in March 1887 exhibited his collection at the Café Tambourin. Yet no direct debt to them is evidenced in his work even in the first half of that year. His reawakened interest in the prints and a growing awareness of their potential, if still obscure, relevance to his art, coincided with a period of personal crisis – difficulties with Theo, and the collapse of a love-affair. There is evidence to suggest that in the summer of 1887 he experienced some kind of breakdown.

Van Gogh's serious interest in the Japanese prints can be dated to late summer 1887 through December when he made a series of direct copies and included copies of others in the background of at least one portrait (fig. 13). It would seem that the rich, saturated colour and textured surfaces of a certain kind of print offered his solutions to the pictorial problems he had been grappling with since 1885 in his study of Hals, Delacroix and Monticelli. He began to produce paintings in which his brushwork was systematically organised and the colour achieved a greater freedom and boldness. It is of much greater importance, however, that in his state of personal crisis and sense of alienation from both Paris and its artists, Van Gogh began to see the 'Japan' represented in the prints as a depiction of a beautiful, sun-filled, harmonious world. This world offered him the imaginary solace that, as early as 1880 in an earlier period of crisis, he had projected on to 'the land of pictures'. But the difference in 1887 was that he had come to believe that the renovation or renaissance of modern art would only take place away from the city which he regarded as a symbolic of a decadent and diseased society. His search for a world of harmonious relations in which 'man' belonged happily to a

fruitful, natural world found confirmation in his conception of the 'Japan' represented in prints. Although there is almost no direct appropriation of the prints' typical devices of line, flat colour and oriental perspective, the example provided by them gave him the confidence to use colour more brilliantly and arbitrarily.

The portrait of his friend, the colour merchant and art dealer, Julien Tanguy (fig. 13 F363), completed late 1887 to early 1888, has all the force of a manifesto. Despite the inclusion of painted copies of identifiable prints as a screen against which to set Tanguy, any distinctive features taken from the prints are conspicuous by their absence. It is precisely the total absence of line, the bounding black contour, the graphic marks used to vary the surface of printed colour, as well as alteration of perspective that reveal the crucial difference between Van Gogh's mature style and that of his French contemporaries who had taken a great deal from the Japanese prints. He was not interested in appropriating their unusual compositional devices or in drawing on Japan as a source of exotic props. So why are these prints placed behind Père Tanguy?

Precisely because they are treated in an entirely painterly fashion, attention is drawn to what they depict and not to their stylistic character. Interesting oppositions are set up by Van Gogh's selection of prints – between seasons, winter on the left and spring on the right, and between people and landscape, by the pair of figure subjects that are placed below them. The lowest level offers a decorative panel and a small study of flowers against a landscape. These, in fact, adumbrate the motifs that Van Gogh pursued after he left Paris for the South of France and which he justified by arguing that the future of modern art lay in the portrait and in establishing the place of 'man' in relation to nature. The figure of Tanguy is placed centrally and monumentally in this pictorial world. A relationship is established between the idealised landscapes and people, and this man, in his rough, workman's clothes, admired by Van Gogh as a representative of a new world. Tanguy was a republican in his politics, a supporter of avant-garde art and a fellow fighter in the struggle against a commercialised and dehumanised society. The whole composition is unified by systematic patterning of brushwork which describes the various textures. It evidences Van Gogh's complete confidence in his art and his command of the necessary means of realisation.

In a watercolour made in 1887 known as *Outskirts of Paris near Montmartre* (fig. 14, F1410), Van Gogh represents a view over Clichy, across the smoking industrial suburbs of Paris dominated by chimneys, to a distant view of the hills. The picture shows the point where the city meets the country. In the foreground, a still-countrified lane marks the frontier. A hand cart has been left beside an abandoned quarry from where some of the stones used for building the new Paris must have been taken. Just such a cart would give its name to a painting and several related drawings that Van Gogh painted in his first productive summer in Provençe, whither he moved in February 1888.

In 1884, while still in Nuenen, Van Gogh had expressed a desire to paint a series of the seasons in complementary colour pairs (Letter 372). In the first six months in Arles he partly fulfilled that ambition with *Harvest at La Crau (The Blue Cart)* (F412), a

painting in rich oranges and blues connoting summer. From the moment he arrived in the South, Van Gogh repeatedly stressed to his correspondents how he felt that he had arrived in his 'Japan' but this panoramic landscape bespeaks another place – Holland. However, it was an equally idealised 'Holland', seen through the paintings of the seventeenth-century Dutch landscape artists: Ruysdael, de Koninck and Hobbema – names that recur throughout the letters of this period with regard to the landscape he is seeing and picturing. The painting of the Crau was an important work. Van Gogh made drawings in preparation for it (fig. 15, F1484) and drawings after it to send to friends. The differences between the oil and the drawing are significant. In the finished oil, the scale of the view is greater, the landscape more panoramic. He has multiplied the figures to help punctuate the more extended space. They are also made more active – travelling, reaping, building haystacks – at once dwarfed by the landscape and integrated into the world they inhabit and work.

The fiery furnace of the Midi that Van Gogh evokes by the saturated red background of the portrait of Escalier (fig. 16, F444) finds a very different form of representation in a drawing of the town of Arles seen from the wheatfields (fig. 17, F1492), where an expanding vocabulary of graphic marks has been used. The whole surface of the paper is filled with a variety of marks, which describe form, evoke colour, and activate the sky. From this date on in Van Gogh's drawings, space appears to become almost a material substance. Like Paul Cézanne, Van Gogh rejected the opposition of form versus void and with it the notion that space is empty. He seems to have sensed what Georges Braque (1882-1963) was later to call a 'manual', 'tactile' space. In Van Gogh's works, solid and space have equal force and, at the same time, by the same process of pen marks on paper the figures are made inseparable from their environment.

The scene Van Gogh has depicted focuses on the meeting point of city and country. The perspective, looking up to a chimneyed skyline, gives a different view of that frontier from that visible in the Paris drawing (fig. 14). The spectator is placed directly before an already mown wheatfield, where the peasants, reaping and binding sheaves a short distance away, might recently have been at work. The junction of urban and rural work is the railway line and the train steaming along with its freight and passenger cars not only stands for modern, industrial society, but serves as a sign of the network of connections that the railway established between cities, countrysides and countries.

During his stay in Arles, Van Gogh made the acquaintance of the postal employee, Joseph Roulin and his family, of whom the artist painted a series of portraits in late 1888 (fig. 18, F432; fig. 19, F504; fig. 20, F492). Van Gogh thought of the portrait as the future of modern art, or so he wrote to his sister Wilhelmina. He did not mean the portrait as mere likeness, but as a means of painting a representative type of modern man or woman. In the series of Roulin portraits, Van Gogh affirmed an allegiance to the tradition of portraiture in seventeenth-century Dutch art that he consistently proclaimed in his polemical letters to fellow artist Emile Bernard in the summer of 1888: 'I am just trying to make you see the great simple thing: the painting of humanity, or rather, of a

Fig. 17

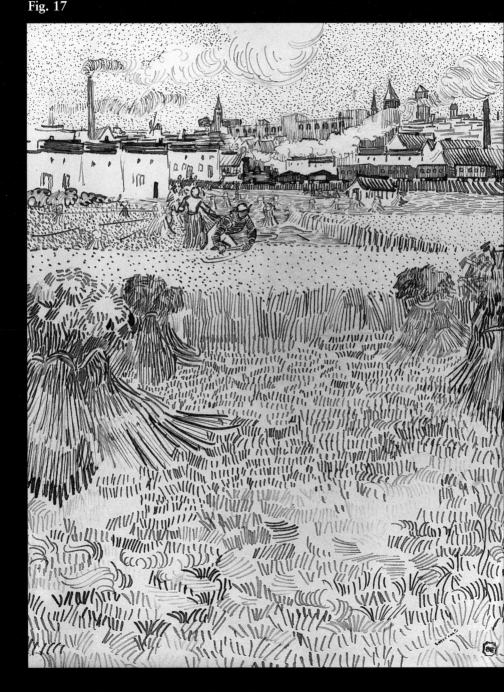

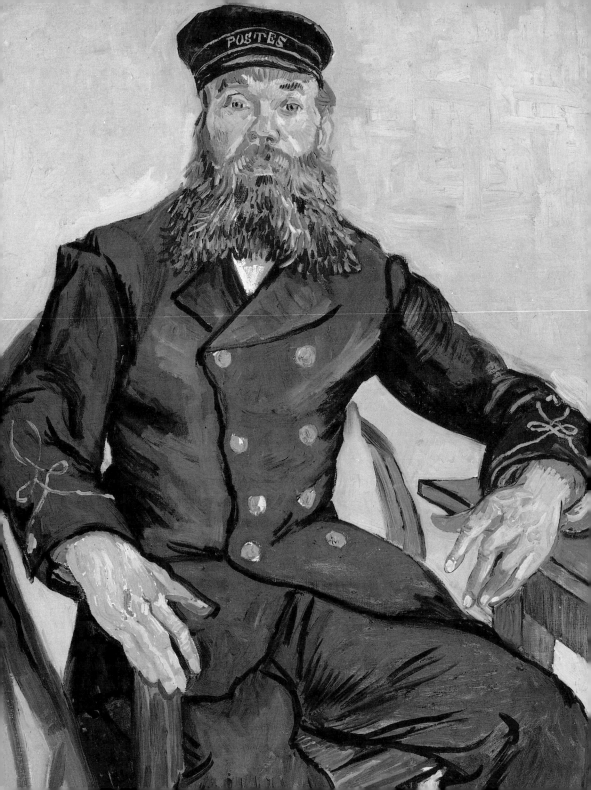

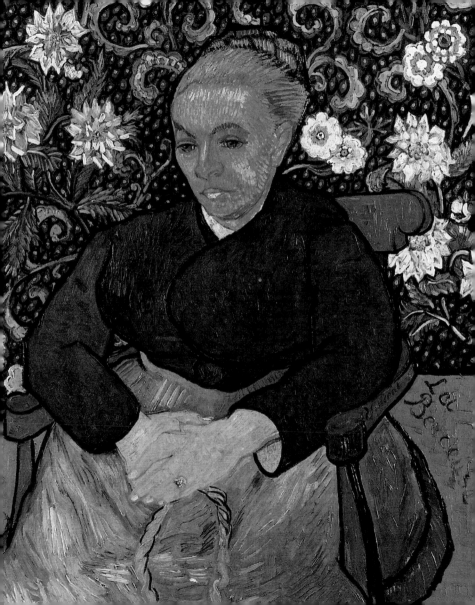

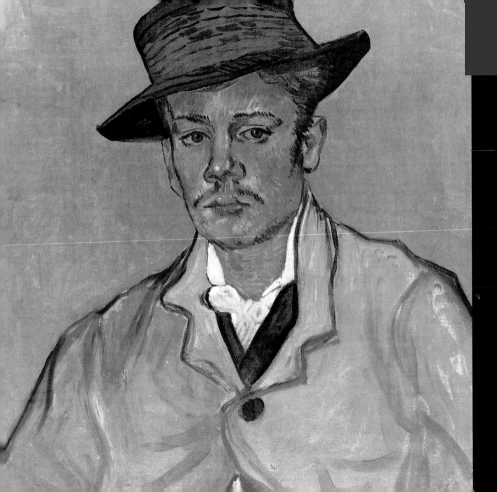

whole republic, by simple means of portraiture' (Letter to Bernard 13, August 1888). The portrait of Armand Roulin (fig. 20) takes its pose, the rakishly angled dark hat, and the painterly handling from a painting by Frans Hals, *The Merry Drinker* (Amsterdam, Rijksmuseum), which Van Gogh attentively studied in October 1885. But the seriousness of the expression and the contemporary dress go beyond direct homage to Frans Hals and attempt to realise Van Gogh's idea of the portrait of a modern man.

> I do not know if I can paint the postman as *I feel him*; this man is like old
> Tanguy [fig. 13] in so far as he is a revolutionary, he is probably considered a
> good republican because he heartily detests the republic which we now enjoy, and
> because he is beginning to doubt and is somewhat disillusioned with the
> republican principle itself. I saw him one day singing the Marseillaise, and I
> thought I was watching '89, not next year, but the one ninety-nine years ago. It
> was from Delacroix, from Daumier, straight from the old Dutchmen.
> (Letter 520, August 1888)

Van Gogh's interest in oppositions of light and dark led to an interest in night scenes, the opposite of brilliant daylight. In Arles, he painted a picture of one of the night haunts of the down and outs and those who worked at night, *The Night Café* (F463, New Haven, Yale University Art Gallery), an alternative name of which in French is *L'Assommoir*, the title of a novel by Emile Zola from the Rougon Macquart series published in 1877. In the uptown *Café Terrace at Night* (F467, Otterlo, Rijksmuseum Kröller-Müller) Van Gogh represented the Café du Forum as a more cheerful locale, using strong yellows and deep prussian blues to convey the way artificial illumination transformed and coloured the night. He contrasts the glare of the gas lights with the softer, less brilliant glow of the stars in the night sky.

The star was a recurring image in Van Gogh's literary and pictorial vocabulary, and, in his letters, he endowed it with heavy Victorian symbolism. The presence of stars in this painting might be taken as benign, their grouping underlining the companionship of seated and strolling couples featured on the streets or on the café terrace.

During the summer of 1888 Van Gogh painted a self-portrait (F476, Cambridge, Fogg Art Museum) to exchange with a group of artists working in Pont Aven, in Brittany, particularly Emile Bernard and Paul Gauguin. Van Gogh had a long-standing plan for a cooperative community of artists and he had convinced himself that this renaissance of art should take place in the South. So he planned a Studio of the South in Arles and he began to pressurise Paul Gauguin to leave Brittany and join him as the Studio's leader in Arles.

Using himself as a model, Van Gogh fashioned an image of the artist as a modern saint. A malachite green background is brushed into radiating, halo-like circles behind his monkishly shaven head and the dark-brown, rough textured jacket contributes to this association. The eyes are made to slant, a feature Van Gogh explained in a letter to Gauguin : 'I have in the first place aimed at the character of a simple bonze worshipping

the eternal Buddha' (Letter 544a, 1888). Yet the worked surface of the painting and the almost sculptural volume of the head have nothing in common with Japanese art, but rather they relate to Van Gogh's conception of the simple, workmanly Japanese artist. The association of Japanese art and the Buddha derives from Van Gogh's reading of a Western view of Japan, namely Pierre Loti's novel *Madame Chrysanthème* (1887).

On 23 October, 1888 Paul Gauguin arrived in Arles, where he stayed a brief two months. Gauguin did not bring any of his paintings with him to Arles and Van Gogh had to rely on Emile Bernard's *Breton Women in a Meadow* (1888), which Gauguin had brought, to acquaint himself with the new work his friends had been doing in Pont Aven. Their use of an emphatic dark line to simplify the form and delineate decorative areas of colour led Van Gogh to experiment with such devices in his own work. Gauguin encouraged him to work from imagination, and free himself from his attachment to nature, to the real, the motif or the person. As his portraits show he was already taking liberties with colour and forms in order to express himself and his view of the world more forcibly than correct observation of externals alone would allow. His Carlylian notion of the world as one vast symbol – or the universe as a great book of hieroglyphs – had already led him beyond descriptive realism, but he remained, as did Carlyle, deeply rooted in reality, however much he felt free in pictorial terms to heighten or exaggerate in order to convey that reality which was embodied in or clothed by external appearances.

The painting of Madame Roulin, *La Berceuse* (fig. 19), begun in December and completed in January 1889, reveals the impact of his discussions with Gauguin. The use of the dark contour line, the decorative background, the unmodulated brilliance of the golden face witness his response to Bernard's and Gauguin's work and their adaptation of the devices of Japanese prints. In May 1889 Van Gogh made a sketch (fig. 21) of how he would like to see the painting hung, as the centre of a triptych flanked by two large canvases of sunflowers. He asked that two copies of *La Berceuse* be sent to Gauguin and Bernard as tokens of friendship. In this sketch, however, he has altered the positioning of the figure, corrected the perspective and extended her skirts to create a more stable and matronly image; by placing her between the sunflowers Van Gogh emphatically positioned this mother figure in his image of nature.

But later, in December, he categorically rejected the 'abstracting' tendencies under which he had originally conceived the painting. He wrote to Bernard:

> As you know, once or twice, while Gauguin was in Arles, I gave myself free rein
> with abstractions, for instance in the *Woman Rocking (La Berceuse)*... and at the
> time abstraction seemed to me a charmed path. But it is bewitched ground, old
> man, and one soon finds oneself up against a wall. (Letter to Bernard 21)

Van Gogh's intentions in *La Berceuse* had always exceeded a mere innovation of style. His numerous discussions of the work in letters to various friends indicate its

importance. These letters also provide keys to the meanings it was meant to carry. Its style, simplified forms and strident colour he compared to popular prints, chromolithographs and Epinal woodcuts. The title, *La Berceuse*, not only means the woman who rocks the cradle, but the song she might sing, the lullaby, 'Whether I really sang a lullaby in colours is something I leave to the critics' (Letter 571a to A. H. Koning). He stressed the analogies not only between his painting and music, but with literature – a Dutch author, Frederick van Eeden's *Little Johannes*, as well as Pierre Loti's novel about the isolated and dangerous life of *Icelandic Fishermen* (1886). Loti described a ship's cabin with its old faience, crudely-made statue of the Virgin in the place of honour as a source of comfort to those far from home. Van Gogh wrote to Theo in January 1889:

> the idea came to me to paint a picture in such a way that sailors, who are at once children and martyrs, seeing it in the cabin of their Icelandic fishing boat would feel the sense of being rocked come over them and remember their own lullabies. (Letter 574)

His suggestion that a picture can be a comfort to remind one of the memories of home links back to one of his earliest references to the emotive power a baby's cradle held for him. In a letter of July 1882 many of Van Gogh's motifs are mentioned and they provide some insight into this painting done far from his home in Holland at a time of great personal stress:

> a small iron cradle with a green cover. I cannot look at this last piece of furniture without emotion, for it is a powerful motion which grips a man when he sits besides the woman he loves with a baby in a cradle near them. And though it was only a hospital where she was lying and where I sat near her, it is always the eternal poetry of the Christmas night with the baby in the stable – as the old Dutch painters saw it, and Millet, and Breton – a light in the darkness, a star in the dark night. (Letter 213)

Van Gogh's need to situate himself both in a specific place or environment and in the world at large was reflected in the consistency with which he painted or drew views from the window of the houses in which he lived. In Arles, however, his home, the Yellow House, had a particular significance. He hoped it would become the home of the Studio of the South, the centre for a collective of artists led by Gauguin who would effect the renovation of modern art. In anticipation of Gauguin's arrival, he decorated his house with the series of orchards, gardens, sunflowers and portraits painted in the summer of 1888. He also advertised his house by painting its exterior and a view of his bedroom (fig. 22, F482). The significance attached to this work is attested to by the fact that the artist sent sketches of it to both Gauguin and Theo, and a year later made two copies, one of which he sent to his sister, with this explanation, 'I wanted to achieve an

effect of simplicity of the sort one finds in *Felix Holt*. After being told this you may quickly understand the picture...' (Letter 15 to Wilhelmina van Gogh). This reference not only suggests that the painting is in some way an oblique self-portrait, but that it is an attempt to represent the kind of modern man that George Eliot portrayed in her novel.

The Artist's Bedroom (fig. 22, F482) is a powerful image. The rich colours and varied textures characterise and charge with emotion the everyday objects the artist uses, the place he lives, sleeps and dreams in, the space he inhabits. How does Van Gogh achieve this effect, an effect of his presence in the room, his knowledge and experience of the objects, and the relation of a man to his environment?

It is produced by abandoning a traditional, linear perspective, which defines the situation of objects, their size and character within the frame while placing the spectator at a distance, outside the picture. The differences between the sketch and the final painting show that Van Gogh wanted to give more than merely visual information. In the painting, he establishes the relations between groups of objects, conveying memories of touch – the texture and weight of the furniture and bedding – the sensations arising from their use, and the relations between the objects as he moved about the room. This accumulation of detail and experiences is built into a space which we can never fully grasp if we remain outside the picture. The painting invites our active participation in the reconstruction of those relationships and the recreation of that lived-in space.

In July 1888, Van Gogh wrote to his brother saying that although two of his most recent drawings, one of the Crau (F1420) and the other of the landscape near Montmajour (fig. 23, F1424), did not look Japanese, they were more so than others. He was not referring to his characteristic drawing technique as being influenced by Japanese prints. While it is true that the various graphic systems which he used in Arles can all be found in the prints, his penmanship is not calligraphic, and the style is definitely non-oriental. In fact, the complex pattern of lines and dots can be found in drawings and prints of Western artists whose work he admired: Rembrandt, Delacroix and Millet. In ascertaining what made the landscape Japanese we should bear in mind that Van Gogh often compared a painting, or a landscape or a scene which he observed with a passage from literature – from a book or article he had read. It seems that in this case he was identifying the motif in the drawing with the Japanese landscape as it had been described by the popular nineteenth-century author Pierre Loti in his novel *Madame Chrysanthème* (fig. 23). Van Gogh had read this novel in June and had immediately fallen under the spell of its narrative, basing his view of Japan as a simple, primitive civilisation largely on this source.

The landscape in this drawing is animated, not only by the graphic systems employed, but by the presence of man moving through the landscape, a man at work ploughing, two figures walking, an old horse-drawn carriage, and the symbol of modern society with its interconnecting system of transport, the railway train. The old and the new are juxtaposed, and we can recall the descriptions of Drenthe, 'where progress had got no

Fig. 21

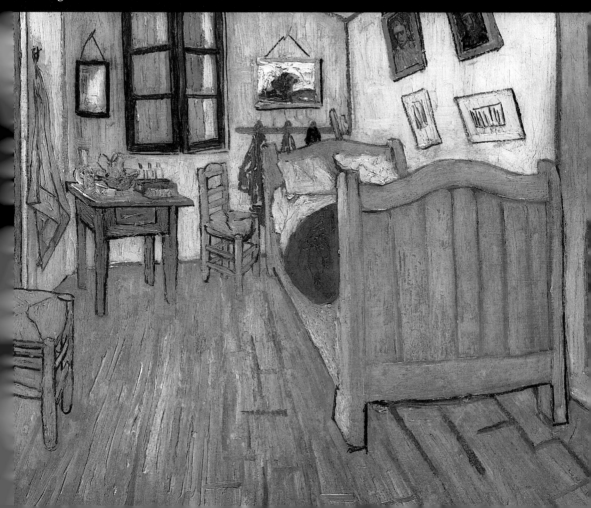

Fig. 22

Fig. 23

Fig. 24

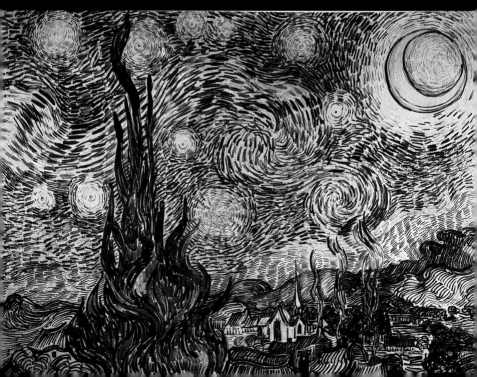

I watched her sleeping... protected by this bright night which had always given me
beautiful thoughts. Around us the stars continued their silent progress gentle like a
great flock of sheep: and for a moment I imagined that one of these stars, the most
lovely and beautiful lost its way and came to rest on my shoulder to sleep...
(Alphonse Daudet, *Letters from my Windmill*, 'The Stars')

'But look up yonder, Rachel! Look above.' Following his eyes, she saw that he
was gazing at a star. 'It ha' shined on me in my pain and trouble down below.
It ha' shined into my mind.'...They carried him very gently along the fields...
It was soon a funeral procession. The star had shown him where to find the
God of the poor; and through humility, and sorrow, and forgiveness he had
gone to his Redeemer's rest.
(Charles Dickens, *Hard Times*, Part III, Ch. 6,
'The Starlight', Read by Van Gogh 1879)

In a symbol there is concealment and yet revelation: here therefore by Silence and
by Speech acting together comes a double significance...Thus in many a painted
Device or Seal-emblem, the commonest Truth stands out to us proclaimed with
quite new emphasis...Then sawest thou that this fair Universe, were it in the
meanest province thereof, is in very deed the star-domed city of God.
(Thomas Carlyle, *Sartor Resartus*)

Over the roof one single star, but a beautiful large, friendly one. And I thought of
you all and of my own past years and of our home. (Letter 67, 1876)

And earnest thoughts within me rise,
When I behold afar
Suspended in the evening skies,
The shield of that red star.

O fear not in a world like this
And thou shalt know ere long,
Know how sublime a thing it is
To suffer and be strong
(Longfellow, *The Light of the Stars* ; Letter 86, 1877)

...But looking at stars always makes me dream, as simply as I dream over the
black dots representing towns and villages on a map. Why, I ask myself, shouldn't
the shiny dots of the sky be as accessible as the black dots on the map of France?
Just as we take a train to reach Tarascon or Rouen, we take death to reach a star.
(Letter 506, 1888)

further than the stage-coach or barge', in order to realise the full significance of this juxtaposition.

In a painting of October 1888 *The Tarascon Coaches* (New York Private Collection), we find an analogous process at work. Under the influence of a literary description in Alphonse Daudet's provençal novel, *Tartarin de Tarascon* (1872), Van Gogh painted some old-fashioned diligences. In describing this work to Theo, he cryptically reminded his brother of a certain passage in the novel – the bitter complaint of an old Tarascon coach against its replacement by the new railway train.

During the troubled but productive year Van Gogh spent in the sanatorium of Saint Paul-de-Mausole at St Rémy in Provence (May 1889 to May 1890), his revitalised interest in Millet and Rembrandt and his desire to return to the north both geographically and aesthetically displaced his identification of Provence with Japan. Early intimations of returning memories of the north are announced in a painting done from imagination under Gauguin's influence in November 1888, *Memory of the Garden at Etten* (Leningrad, Hermitage); they developed into a richly resonant pictorial conception in *Starry Night* (New York, Museum of Modern Art; for the drawing of this composition see fig. 24, F1540).

Apart from mentioning that he had painted a starry night, Van Gogh gave no explanation of the meaning of the picture other than that it was neither romantic nor religious, but based on Delacroix's colour and spontaneous drawing, in order to express the 'purer nature of the countryside compared with the suburbs and cabarets of Paris' (Letter 595). However it was more than this. In fact, it was one of his most important statements and he was extremely upset that no one understood the meanings signified by the scene and its components; they were not only recurrent motifs throughout Van Gogh's own *oeuvre*, but common symbols in so much nineteenth-century literature and thought – a Brabant church, peasant cottages, smoking chimneys, lighted windows, the provençal cypress, the crescent moon, the stars and planets. Images like these can be found in Eliot, Dickens, Zola, Daudet, Longfellow, Whitman, and Carlyle. Many possible layers of meaning are built up in *Starry Night* around memories of places and events, poems and novels Van Gogh had read, prints and paintings he had seen. Here we can suggest a few of the notions, neglected by previous studies, that provide a point of departure.

In St Rémy Van Gogh experimented with a more subdued and subtle northern colouration at the same time as he reworked in rich oil, copies of works by northern artists he had always loved and admired, notably Millet and Rembrandt. Moreover he copied his own, earlier work. A drawing (fig. 25 F1588), reminiscent of *The Potato Eaters*, belongs to a series of drawings of peasants like those done in Nuenen in 1885, and a painting (fig. 26, F675) is in fact directly taken from the page of sketches he had sent to Theo from Drenthe in autumn in 1883 (fig. 8). Once again when personal crisis intensified the need for a secure place in a known, familiar world, these works give expression to the deeply rooted notion of a 'homeland in pictures'.

Van Gogh had entered hospital in St Rémy in May 1889 as a voluntary patient, in order to be able to work undisturbed and receive the appropriate care during the sporadic attacks of his psychomotor epilepsy. This condition is not uncommon and it is thought that it results from slight injuries to the temporal lobes of the brain incurred during birth. It is characterised by short attacks during which the patient suffers intensification and distortion of perceptions and emotional states. This is followed by a period of lethargy, lasting a few days or weeks, and finally complete recovery for prolonged periods. It would seem that Van Gogh was aware of the nature of the condition; he even anticipated the precise times of attacks, during some of which he managed to finish the picture he was working on, for instance *The Quarry* (Amsterdam National Museum Van Gogh). Understandably he took great interest in this disease, and in September 1889 he reported to Theo that he had read an article in *Le Figaro* about the nervous illness of the Russian author, Dostoevsky, who, we now know, also suffered from psychomotor epilepsy. Indeed, his novel *The Idiot* (1868) contains superb and lengthy accounts of what happened during an attack – brilliance of colour, intensification of visual sensations as this following passage shows:

> That there was, indeed, beauty and harmony in those abnormal moments, that they really contained the highest synthesis of life, he could not doubt, nor even admit the possibility of doubt. He felt that they were not analogous to the fantastic and unreal dreams due to intoxication by hashish, opium or wine. Of that he could judge, when the attack was over. These instants were characterized – to define it in a word – by an intense quickening of the sense of personality.
> Dostoevsky, *The Idiot*, Part II, Ch.V

At the time of writing about the article, Van Gogh felt himself fully in control. He wrote 'my brain is working in an orderly fashion and I feel perfectly normal' (Letter 604). Concurrently he was painting several portraits – of the head attendant, the attendant's wife and two of himself. The *Self-portrait* of September 1889 (Paris, Museé du Louvre) employs the gentler colours that characterise much of the St Rémy work and the textured brushwork and suggestive patterned background that he frequently used to add particular meanings to a portrait. In the self-portrait, the solid, calm figure gazes out from a background of swirling rhythms that consciously incorporate the heightened sense of movement that may have been more apparent during the moments preceding an attack. Thus in a period of complete lucidity, he, like the writer Dostoevsky, recollects in quietude some of those intensified experiences of self to which his condition temporarily gave rise.

During his year at St Rémy Van Gogh made many oil copies of reproductions of works by other artists. Copies done thus in his maturity served to establish both his debts and his achievements. Perhaps the most important copy he painted is his transcription of Rembrandt's famous etching, *The Raising of Lazarus* (fig. 27, F677). In it, line and colour work together to signify the renewal of life and its source.

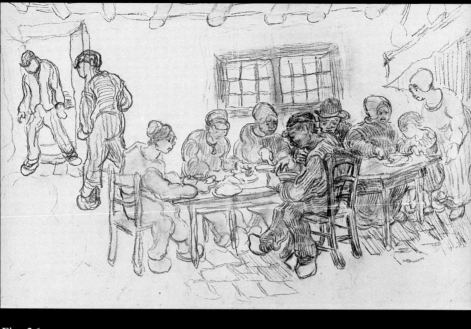

Fig. 25

Fig. 26

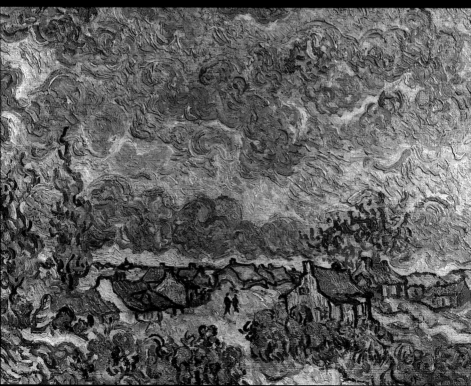

Significantly, Van Gogh omitted the figure of Christ, from whom, in the print, that new life emanates, signified by the light that radiates from his person to dispel the darkness of the tomb. The sun replaces the figure of Christ in Van Gogh's painting. His notion of modern art was founded in the primary significance of colour. In reworking a black and white etching by the master of chiaroscuro, Van Gogh asserts the modernism of colour by the eminence he gives to the natural source of light and colour, the sun, whose light is literally and materially dispersed throughout the painting by the fact that its colour, its pigment, is mixed with every other colour on the canvas. Thus he states his modernism, which both acknowledges his roots and establishes the nature of the modern transformation. He simultaneously pays homage to Rembrandt and lays claim to his succession to this older Dutch master – a notion that intriguingly fulfils a statement made by the de Goncourt brothers in their Journal:

> The future of modern art, will it not lie in the combination of Gavarni [an
> illustrator] and Rembrandt, the reality of man and his costume transfigured by
> the magic of shadows and light, by the sun, a poetry of colours that will fall from
> the hand of a painter? (12 November 1862)

But the transformation in his copies is still partial, in one sense the iconographic reference is still recognisably biblical. In one of the major motifs in the St Rémy work, the olive groves, he attempted a more radical transformation, which avoided traditional iconography and was based entirely on landscape motifs. The series of olive groves with their saddened and sombre colours and struggling forms are addressed both to the real (the olive, the typical tree of the south), and to the symbolic (the historical groves near Jerusalem, in the Garden of Gethsemane which become the signifiers of that religious story). Once again the figure of Jesus is absented, but the religious meanings are not obscure. Van Gogh explained his way of working to Bernard:

> one can try to give an impression of anguish without aiming straight at the
> historic Garden of Gethsemane... it is not necessary to portray the characters of
> the Sermon on the Mount in order to produce a consoling and gentle motif. Oh!
> Undoubtedly it is wise and proper to be moved by the Bible, but modern reality
> has got such a hold on us that, even when we attempt to reconstruct the ancient
> days in our thoughts abstractly, the minor events of our lives tear us away from
> our meditations and our own adventures thrust us back into our personal
> sensations – joy, boredom, suffering, anger or a smile.
> (Letter to Bernard 21, December 1889)

In May 1890 Van Gogh moved north, passing through Paris for a few days to visit Theo and meet his wife and small son, and his namesake, Vincent (born January 1890), before going to the village of Auvers-sur-Oise. Auvers, lying in a beautiful plain twenty miles north-east of Paris, had long associations with painters: Cézanne and Pissarro had

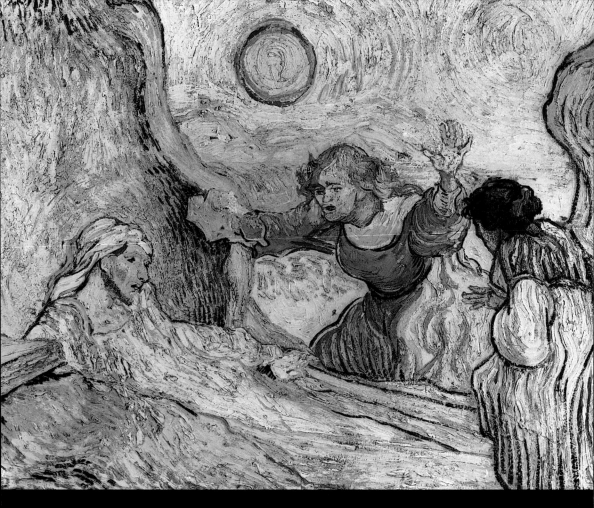

Fig. 27

worked there and it was through the latter's agency that Van Gogh's move had been arranged.

His letters from Auvers to his family in Holland re-established his personal and artistic roots in the north. To his mother he wrote:

> For the present I am feeling much calmer than last year and really the restlessness in my head has greatly quieted down. In fact, I always believed that seeing the surroundings of the old days would have this effect. (Letter 650)

But Auvers was not the surroundings of the old days; he had never been there before. However, a letter to his sister Wilhelmina reveals how he was characteristically identifying the plains, cottages and villages of Auvers with the country and people of Drenthe and Brabant. Indeed the parallels extend to comparable states of mind; his letters and pictures reiterate his preoccupations with feelings of loneliness and nature's comfort, isolation and the need for a community of people, integrated with nature. In Auvers we witness a coming together of themes and motifs that had dominated him since the beginning of his artistic career. The remarkable large *oeuvre* produced in sixty-six working days at Auvers contains studies of cottages, views of panoramic, Michel-like plains as reminiscent of the Crau at Arles as of the peatfields of Drenthe, studies of peasants and portraits. Some works of landscape are touchingly empty but none the less draw the spectator into their wide embrace; others are busy with peasants at work; and one or two juxtapose the peasant to a building, home or, at times, the church. In his letters he compares this motif to studies done in Nuenen, but they also recall some of his earliest works, from the Borinage (fig. 1). But this continuity of themes is carried into a fuller resolution of a pictorial vocabulary appropriate to the realisation of those themes in both line and colour, which are brought closer together then ever before.

The drawing, *Old Vineyard with Peasant Woman* (fig. 28 F1624), is a reworking of a long-standing motif, the peasants, their dwellings, the land they work in and on, combined with the intensity Van Gogh attributed to trees and their forms from the period in St Rémy. But the marks on the paper and the rhythm of lines do not delineate independent objects, separated in space. They draw all forms of life and objects into an indivisible unity; they construct an interrelated totality through flowing lines that convey movement and substance, growth and, most importantly, claim the figure as part of the continuous with this totality.

In Auvers, Van Gogh was nominally under the care of the homeopath Dr Gachet whose portrait Van Gogh painted as a continuation of his attempt to make this genre, like landscape, meaningful on several levels (F753). To his sister Van Gogh repeatedly wrote about his ambitions for the portrait.

What impassions me most – much, much more than all the rest of my métier – is the portrait, the modern portrait. I seek it in colour and surely I am not the only one to seek it in this direction... I should like to paint portraits that would appear after a century to the people then living as apparitions. (Letter to Wilhelmina 22)

I have painted a portrait of Dr. Gachet with the heart-broken expression of our time. (Letter 643)

I painted a portrait of Dr. Gachet with an expression of melancholy, which would seem like a grimace to many who saw the canvas. And yet it is necessary to paint like this, for otherwise one could not get an idea of the extent to which, in comparison with the calmness of the old portraits, there is expression in our modern heads, and passion, like a waiting for something, a development. Sad, yet gentle, but clear and intelligent. This is how we ought to make many portraits. (Letter to Wilhelmina 23, June 1890)

Van Gogh painted the characteristically broad plains of the local wheatfields above the village of Auvers on a new canvas size, using the double square to achieve the effect of spaciousness and distance. Of a sketch he sent in a letter to his brother of the painting *Plain at Auvers*, painted in late June 1890 (fig. 29, F775), Van Gogh wrote recalling his reliance on Dutch prototypes and those of the French painter Georges Michel (1763-1843) when he had once before tried to come to terms with a vast and expansive landscape in Drenthe:

the horizontal landscape with fields, like one of Michel's, but then the colour is soft green, yellow and green blue. (Letter 646)

Many people have been inclined to use these landscape paintings as testaments to Van Gogh's frame of mind. But his letters suggest rather that these panoramas and their associated portraits, painted on the same but inverted double-square canvas, represented a more utopian project.

The concerns expressed in these letters and the evolution of his pictorial language in the Auvers period not only reaffirm the recurrence of key themes and devices in Van Gogh's endeavours as an artist but establish his particular place in late nineteenth-century and early twentieth-century art. He can be compared with the other great Post-Impressionist, Paul Cézanne (1839-1906), in whose work we see a similar attempt to respond to the change in sensibility, to realise a pictorial equivalent for a world in constant flux, a totality which demanded transformation of the role of colour, the movement and meanings of line, and the conventions for the depiction of space.

After his death, Van Gogh's work was appropriated by writers and artists whose own

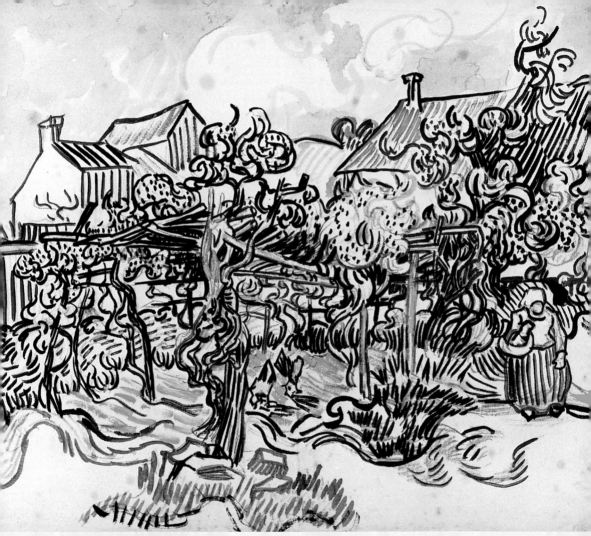

aesthetic and political allegiances as symbolists or expressionists have obscured the character of his art. But some French artists, working in the first decade of the twentieth century at 'the moment of Cubism', saw in Van Gogh something else, something which they recognised as a vital and meaningful contribution to the revolution in artistic practice which the new century demanded. Amongst these artists, one of the most perceptive was the young André Derain (1880-1954), who realised the affinities in the work of Van Gogh and Cézanne. In 1902 he wrote to his colleague, Maurice Vlaminck (1876-1958):

> Soon it will be one year since we saw the work of Van Gogh and his memory haunts me permanently. More and more I see his true meaning. Cézanne also has great power... Van Gogh offers not so much a total cohesion as a unity of spirit.

And a year later, in 1903, Derain elaborated:

> I consider that no difference exists between a tree which is located, lives and dies – and a man – and that equally, the thoughts and despairs of man undergo a parallel development to the tremulous movement of a leaf; their existence is solely conditioned by their environment.

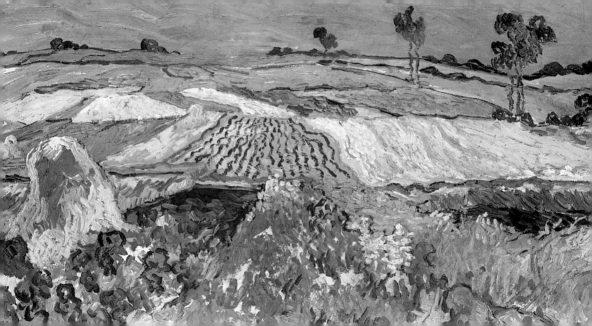

Les Données Bretonnantes:

La Prairie de Représentation*

FRED ORTON AND GRISELDA POLLOCK

The term 'Post-Impressionism' floats in the clouds of the Academe above Portman Square and Central Park, over the Thames and Hudson rivers. It is a signifier in a camouflaging rhetoric of modernist art history that will not name those concrete historical and social relations, those structures and conditions of art practice which determine and mediate the complex and opaque representations made by some of the painters working in Europe between the mid-1880s and the early years of this century. 'Post-Impressionism' has no foundation in history and no pertinence to, or explanatory value for, that historical moment it is used to possess.[1] This is admitted in the catalogue to the exhibition of *Post-Impressionism: Cross-Currents in European Painting*, which was held at the Royal Academy of Arts, London, 1979-80. Nevertheless, its reassertion as the title to the exhibition and its use in the catalogue essays expose its specifiable and significant function within this rhetoric. The use of the designation 'Post-Impressionism' is part of a strategy to classify and contain diverse and complex practices, and to blanket over difficulties and differences, within the 'hospitable galleries' of Burlington House and in the pages of the catalogue.[2]

In Alan Bowness's introductory essay both the purpose of the project and its attendant confusions and inevitable contradictions assert themselves with astonishing insistence. They leak out of the text despite the effort of his urbane and apparently seamless prose to contain them, to conjure them away. Bowness is at pains to explain that 'Post-Impressionism' was an unhappy neologism. It was a 'somewhat negative label', 'the vaguest and most noncommittal' name which Roger Fry could think of in 1910 and

* This paper was prepared as a contribution to the symposium on Post-Impressionism which was to have been held at the Royal Academy in March 1980. The symposium was cancelled.

which John Rewald chose to revive in the mid-1950s.[3]

'Post-Impressionism' was derived from a number of particular texts as part of an endeavour to lay hold of the art produced in the period *posterior* to another *lumpen* category, 'Impressionism'.[4] As a chronological description the term designates something after and its use reveals the underlying assumption that sequence is of itself a significant factor in historical process. The history we are offered is that of a developmental, unilinear progression, an illusion of continuity. It is implicit in the essays wherein the term was first used in 1910 and 1912 that it was meant to indicate a reaction against that which preceded it, a reaction which instantly fragmented into various competing and disparate alternatives. However, the reactions against 'Impressionism' which serve as the point of defining difference do not, and cannot, constitute a unified category. Indeed, as Fry, Rewald and Bowness are forced to admit, 'the unity of an artistic movement is quite simply lacking'.[5] In the absence of any common ground but with some vague notion of an unsubstantiable reaction against an imaginary entity – 'Impressionism' – we are offered merely the spectacle of diverging stylistic and aesthetic tendencies which are held together by the celebration of individualism and genius. But why is 'Post-Impressionism' still retrieved so categorically when both its vagueness as a label and the impossibility of making the works it is used to categorise coalesce into a movement or style are freely admitted? Why is it once again provided with art historical currency as the frame within which we are allowed to contemplate a chaotic array of late nineteenth-century paintings?

The will to conjure up a movement, to produce an art historically coherent entity is all pervasive. In Bowness's essay there is a passage which, in the printing, chances to fall directly opposite the paragraphs in which he admits the purely negative value of the term 'Post-Impressionism'; it is a passage of supreme confidence: 'Post-Impressionism kept its position as the most challenging form of modern art from its heyday in the late 1880s and very early 1890s until c. 1905'.[6] Our doubts are dispelled, certainty restored as the words summon up in black and white a solid artistic entity complete with a position, a heyday, and what seems to constitute a definition, a particular phase in the continuous development of modern art. No sense here, then, that art is a word which describes a discontinuum of practices and that our own sense of art and the artist is contingent, partial and historically formed. The clues to what is being manoeuvred in Bowness's text come thick and fast in the remainder of this paragraph as the four Great Artists are named as Van Gogh, Gauguin, Seurat, and Cézanne, whose deaths or withdrawals from Paris created a vacuum within the vanguard from which 'nobody in France was able to go forward into radically new kinds of art until 1905'![7] The crucial link which reveals the purpose of his project lies in the passage which refers us to the work of Rewald 'that great historian of modern art... to whom we are all so indebted, decided many years ago to follow his definitive history of Impressionism with a study of Post-Impressionism'.[8]

Rewald's book *Post-Impressionism from Van Gogh to Gauguin* revivified

the term and over twenty years after its publication informs the conception of the present exhibition and the organisation and contents of the catalogue. Yet one cannot evidence, let alone examine, a so-called 'crisis in Impressionism' in the 1880s – as the exhibition claims to do – by hanging works of the four geniuses of the Fry-Rewald-Bowness pantheon amidst a mass of other paintings which are said to constitute 'a fuller context of European painting at the time'.[9] Nor can it be achieved by, as Rewald disingenuously claimed to be doing, letting the pictures and documents speak for themselves, by evacuating the difficulties and concealing the absence of any sound historical work on the painting of the period.[10]

Those of us who are neither indebted to Rewald nor convinced of the possibility or desirability of writing definitive histories do, however, believe that it is important to note the historical specificity of the reassertion of 'Post-Impressionism' in Rewald's view of history, the date of the book's publication (1956), the institution which published it (Museum of Modern Art, New York), and the *dramatis personae* acknowledged as Trustees of the Museum of Modern Art (1950s hegemonists, power élitists and upper-class Americans with interests in shaping foreign policy). Rewald's *The History of Impressionism* (New York, 1946) and *Post-Impressionism* must be recognised for what they are, symptoms of, and contributions to, the construction of a history of art from the mid-nineteenth century to the present which was conceived by that Cold War warrior and ideologue Alfred H. Barr Jr., Director of the Museum of Modern Art. Rewald's conception of the history of art fits snugly into Barr's grand design, modernism, into that creation of an autonomous linear development which obfuscates the changing conditions of production in art practices and the real social relations in which they are embedded in favour of those abstractions: style and genius.[11]

This is not the place to begin the deconstruction of modernism as one of the corner-stones of American cultural imperialism. Suffice it to signal its roots in modern bourgeois ideologies of history, in the struggle to appropriate history for the current ruling interests and its pervasiveness within the practice of art history in Great Britain. In his work on *The Historical Novel* Georg Lukács pointed to the emergence in the nineteenth century of a number of distinctly regressing conceptions of history in the wake of the bourgeois revolutions of 1848. One of the tendencies on Lukác's map is that which attempts to 'modernise history', to disguise the specific differences and distinguishing features of past epochs by assimilating all history to the present and re-presenting the past in the image of the present, and reframing it according to current ideological conceptions of society.

> Since history, to an ever increasing extent, is no longer conceived as the
> prehistory of the present, or, if it is, then in a superficial unilinear, evolutionary
> way, the endeavours of the earlier period to grasp the stages of the historical
> process in their real individuality, as they really were objectively, lose their living
> interest. Where it is not the 'uniqueness' of earlier events that is presented, history

is modernised. This means that the historian proceeds from the belief that the fundamental structure of the past is economically and ideologically the same as that of the present.[12]

There is a passage in the Introduction to Rewald's *Post-Impressionism from Van Gogh to Gauguin* in which he describes his historical method:

> It was no small problem to attempt a historical reconstruction which would put in every person, every work, every action, every utterance in its proper place in that big jigsaw puzzle which Verhaeren so aptly likened to a kaleidoscope. To do so required the simplification of many complicated aspects and the unearthing of a mass of little known or forgotten evidence to fill the gaps, to establish the connections between seemingly unrelated factors, to supply minute details while never losing sight of the whole... to recreate the flowing movement, that incessant forward thrust which alone can convey the vitality of a moment of the past.[13]

What Rewald offers us, however, is not just a reconstruction: any historical practice inevitably reworks the past left deposit in the present. Rewald speaks of a recreation. The chaotic evidence is reframed, relocated, simplified or added to in order to produce a coherent, unified and comforting image of the organic forward movement of the art of the past where everything finds its proper, allotted place. 'Post-Impressionism', hinging on Van Gogh, Gauguin and Seurat, emerges from Rewald's study as an episode in a known story. Verhaeren's meaningful metaphor of a changing, overlapping multiplicity, a kaleidoscope, is subtly transposed into a static framed picture, a completed jigsaw puzzle, which, neatly fitting together, supplants the complexity of historical processes in their real individuality.

In Rewald's imaginative narrations (histories or studies of movements and individuals) and in the essays in the Royal Academy catalogue and in the structure of the exhibition, the specificity of the history of artistic production and representation in the late nineteenth century is mystified and appropriated for that heroic fiction, the unilinear evolution, modernism. The conditions of production of the paintings and the difficult problems of what any one of them might mean are ignored. The precise historical processes in which and against which these representations were made are refused and excluded.

How can we go about reclaiming these works for history? What kind of practices do we, as historians of art practices, need to engage with in order to produce history instead of myth, knowledge instead of cliché and tautology? How can we be sure that our mental appropriations of the world correspond with the real social processes? We have to acknowledge that the world exists outside our representations or appropriations and therefore we need a self-critical methodology for gaining access to the knowledge of its processes. If we begin with the acknowledged precondition for our analysis – in this instance, a range of art practices in a historical moment in the late nineteenth century –

we have only an abstract conception of the whole. We have to move from the abstract whole examining the layers and levels of the multiple determinations towards thinner abstractions, simpler concepts. Though reality is complex and cannot be explained in simple terms, it is, however, necessary to the mental procedures of analysis to begin with them. They are not the goal. We have to retrace our analysis to a more concrete representation of the whole no longer seen as a chaotic abstraction but as a rich totality of many determinations and relations: not as a static unity but as a series of relations and practices within the constant movement of history.

There was a collective loss of confidence amongst those who had first exhibited together in 1874 at 35 Boulevard des Capucines and a more general crisis in the practices of the self-confessed Parisian vanguard in the mid-1880s. However, it was not because, as Fry imagined, many artists found 'Impressionism' too naturalistic,[14] or, as Bowness asserts, because 'experience rather than appearance [whatever that could mean] became *the* reason for art'.[15] Such accounts, if they merit the term, are unsatisfactory because they explain nothing or because, at best, they are predicated upon a single explanation. The simplistic model of cause and effect renders the category of art labelled 'Post-Impressionism' both over-precise and over-inclusive. It is over-precise in so far as it offers aesthetic or formalist reasons alone for the changes in painting in this period and excludes a vast amount of relevant materials and determinations. And it is over-inclusive because it extinguishes the crucial distinctions which differentiate the practices and paintings which might constitute a category but cause it to be radically questioned.

Initially, one has to recognise that by the mid-1880s the artists who had participated in the 1874 exhibition could no longer sustain their contradictory acceptance and evasion of the modern urban environment or their invention of a particular space for representation within it. Their problem was symptomatic of a more extensive crisis. It was a crisis of representation within the transformed and transforming conditions of artistic practice which was manifested in questions about what to paint, how to paint, whom to paint for, and – as important – where to paint. This crisis raised problems of how to engage with or disengage from the increasing social confusion and incoherence, the insistence of new relations and forces of class, while at the same time having to confront disintegrating fixities in the practice of art.

The traditions of art, the heritage of grammars and syntaxes of painting, conceptual and practical orthodoxies, were simultaneously undermined, questioned, exposed, displaced, retrieved and reworked. Artists and critics alike tried to force out of the dissolving certainties new conventions for the production or avoidance of meaning, elaborations of supporting critical and theoretical discourses, new systems of exhibition, new publics, and above all new spaces and new subjects for art, new sites for artists to occupy. We are studying an intricate network of visual and textual discourses and representations in specifiable and changing historical conditions rather than the mythologies of magical creativity and mythic genius.

Painting is a practice of representation and through its changing systems and codes men and women produce images of, ideas about, and positions on the world they inhabit.[16] It is a material practice in history, in ideology. Paintings are not mere illusions about the world but determined and produced allusions to it. Art history must acknowledge these complexities and work on these real social processes, significations and their interactions and relations. Art history which is also a practice of representation must provide complex accounts.

The exhibition and its catalogue are conceived of as contributions to the study of 'Post-Impressionism' and we are asked to approach them as serious and significant additions to the existing state of understanding. According to Hugh Casson the 'catalogue will not be only be a fitting record of this exhibition but a significant addition [not to the history of art] but to the literature of the art of this period'.[17] But where is the new work on which this significant addition is based? Isn't it really just a reified lump of Enlightenment? The appearance of accumulating knowledge is by and large only an appearance. The focus on what constitutes that which is designated 'Post-Impressionism' is not, and never has been, sharp enough – at least, not since the late 1880s. Some theory would go a long way as it did then, some awareness of the fact that there are problems, a greater awareness of what those problems are, and an indication of the general shape the answer or answers we should be able to offer might take. Instead we are offered a paradigm of disinformation, concealment, art historical clichés, and little bits of contextual background which are never allowed to transform what we are seeing. The real difficulties and complexities of the practice of art in the period attended to are there for all to see and they cannot be elided. Revamping Fry and Rewald and forcing this art back into the mould of a celebratory art history of great individuals, styles, influences and their dissemination across national frontiers will not do the job. It is not that we have to dispel questions of style, influence and dissemination from our discourse but they cannot be allowed to structure it. That kind of academic orthodoxy and incoherence amounts to a massive negation which absents and renders unimaginable basic questions about why these pictures look as they do.

The exhibition is not simply a collection of paintings, it is a spectacle. An exhibition as a spectacle is a social relation among the people mediated by the paintings on display. The paintings are hung in such a way that superficial comparisons can be made while troubling difficulties and unexpected correspondences can be elided. This spectacle is both the project and the result of the existing mode of production and its dominant art history.[18] The works are intended to be contemplated within false representations which foreclose on the networks of meanings and the real conditions in which they were reproduced. Van Gogh and Jacob Meyer de Haan, for example, have been evacuated from the Netherlands to France where their importance for the exhibition lies. Gauguin, the focus of the so-called 'School of Pont Aven', is virtually absented from Brittany.[19] Where is there any question of reconstructing the works in their historical specificity? What were they made for? Whom were they made for? To do what kind of job? What

do they mean? Do they achieve meaning? How were they understood by their producers, their first viewers, their first public?

At the Royal Academy paintings are dispossessed of their status as works in and over the histories of which they were a part, from which they were produced. Any consideration of their status as history, as historical representations, and their positions within that complex of social and representational practices we call ideology is completely ignored or avoided. We have to engage with the problems of representation within ideology, conditions of life, the work accomplished by art.

Consider this:

> The Large and Small South Rooms are an interlude in the exhibition. They
> present paintings on a single theme, the French province of Brittany. Brittany had
> been popular with the artists since the 1860s and between 1880 and 1910
> painters came to find distinctive qualities in it – the harshness and ruggedness of
> the landscape, the costumes and the primitive customs of its people and their
> piety.[20]

And this:

> Brittany's barren intractable coast echoed the hardship and danger facing its
> inhabitants.[21]

And this:

> There was a further aspect of Brittany which appealed to some artists. Springing
> from its geographical remoteness from Paris, its harsh climate and poor soil, and
> its social and economic backwardness, Brittany was also a region marked by
> extreme poverty, intense piety, residual paganism and a fatalism brought on by
> the bitter struggle for survival.[22]

Brittany is hereby separated from the exhibition's predominant categories and presented as a place of work which attracted artists because of qualities such as remoteness, harshness, poverty, primitiveness and piety.

Paul Gauguin referred to the character of Brittany – other than to comment on how low the cost of living was – two or three times in his letters. In March 1888 he wrote to Emile Schuffenecker, 'I love Brittany; I find there the savage, the primitive. When my clogs resound on the granite soil, I hear the muffled, dull powerful tone which I seek in my painting.'[23] Unfortunately he does not say just what it was that he found savage and primitive about Brittany. Later in that same year he wrote to Vincent van Gogh mentioning the effect of 'rustic and *superstitious* simplicity' which he had achieved in the figures in a picture he was working on.[24] Once again he chooses not to elucidate this remark or offer any clue as to what caused that effect. These unclear and problematic

references have contributed to the myth presented above and elsewhere; used without explication they have acted, and still act, as prime motivators in the machinery of art history.

Brittany occupies a genuinely problematic place in late nineteenth-century painting, and in attempting to understand what it was, and why and how it was represented by artists as diverse as Gauguin and André Dauchez or Emile Bernard and Pascal Dagnan-Bouveret, we have to confront the issues raised above. Yet Brittany is presented to us as an interlude in the exhibition and given a different status to the sections based on individual artists, styles and national groups. It would seem that the orthodoxies of art history break down before the questions posed by Brittany and its painters. John House and Mary Anne Stevens attempt to secure difficult issues in a few mystifying sentences. Their problems arise from confusions about representations of Brittany and what is represented – the geographical and social character of a French province at a particular date. These are neither identical issues nor are their relations merely reflective. The effect of this lack of rigour and recognition of social specifity, complexity and ideology, is to make Brittany and the pictures of it romantically mysterious.

There is little which is unknowable about Brittany in the nineteenth century but it cannot be understood if it is conceived as a unity of fixed attributes. In place of the historical realities of process, constant movements, changing forces and determinations, bourgeois art history imagines a securable entity with a static, self-evident identity in it. In 'The Literature of Art'[25] there is little or no acknowledgement of Brittany as a real place with a history. It is assumed as a given site of, and result of, artistic imagination. The point of departure for work on Brittany, on the artists who went there and made representations of it, must be a methodological clarity which will enable us to unpack the relations and movements which constitute our mental appropriation of it.

Let us begin with the obvious. Brittany was a region of France which for specifiable but differing reasons became the object of attention for non-Bretons, a place to visit, and a fit subject for Fine Art. Where will we find those Brittanys, the meanings produced through and for Brittany in representations within the historical processes from which those representations were made? We can get to know it by a little basic historical research but we also have to work over the representations made of it in a variety of discourses. In order to approach any single painting of Brittany we have to analyse a range of materials, networks of discourse which constitute both the conditions of representation in and against which that work was produced and the conditions of its legibility in the circuits of production and exchange of meaning in their historical specificity. In order to contribute to the study of certain paintings made by Gauguin and Bernard around Pont Aven and Le Pouldu in 1888 we have to unpack the history of Brittany and the history of representations of Brittany and the conditions of a single location within both.

By way of offering background information about why Brittany attracted such a variety of artists from 1795 to the late nineteenth century, Stevens quotes a statement by

Armand Séguin. And by quoting Séguin she is able to expand her discussion of Gauguin's and Bernard's stylistic developments made at Pont Aven in the late 1880s. Séguin, a Breton-born artist who painted in the province in the 1890s and met Gauguin in 1894, suggested that the 'simplification of the image achieved by Gauguin and Bernard was assisted... by the sharply coloured field patterns of the Breton landscape'.[26] What Séguin's remark indicates as much as it does the influence that motif had on style, is the exploited fertility of the land around Pont Aven, fields under cultivation, a well-developed system of agriculture, a man-made landscape. There is no evidence in what Séguin said, or in Gauguin's and Bernard's representations of the Breton landscape, of harshness of climate, the poorness of soil, or even the social and economic backwardness which Stevens regards as qualities which appealed to these artists and drew them to Brittany. Indeed in most nineteenth-century descriptions of the area around Pont Aven those qualities are noticeable by their absence. In the guide-books Pont Aven is usually singled out for a recommended visit because it is pretty and picturesque not because it has a harsh climate and is socially and economically deprived.[27]

So where does the idea of Brittany as a harsh, rugged, barren and backward place come from? Stevens quotes Odilon Redon who seems to substantiate a picture of Brittany as something of the kind. In his journal entry for 3 July 1876, Redon recorded his strange and subjective responses. He called the province a 'sorrowful land weighed down by sombre colours'.[28] But was he referring to the same place, at the same time as Séguin? He was not. Redon was recalling his impressions at Quimper in 1876 and Séguin was describing the area around Pont Aven in the late 1880s and early 1890s. Redon's comment is neither specific to the place nor the date at which Gauguin and Bernard were working. We can derive something useful from these two sources by locating the differences of historical geography contained within them. To do this we have to consult another text from a discursive framework other than artistic practice and tourism which expands our understanding of what Redon and Séguin were unknowingly recording. In the late 1780s an English agriculturist, Arthur Young, made three journeys through France noting as objectively as he could what he saw as he passed through the countryside. The accounts of his trips, made on the eve of the Revolution and just after, were published in 1792. He summed up the region between Quimper and Quimperlé in three words 'wastes – wastes – wastes ...The same sombre country to Lorient.'[29] It seems that little had changed between then and the time of Redon's visit. However, in the Introduction written for the 1889 reprint of Young's book Betham-Edwards pointed out the extent to which Young's observations of Brittany were no longer valid.

> Here [Brittany and Anjou] ... advance has been so rapid within our own time that the traveller revisiting these provinces find his notes of ten or fifteen years ago utterly at fault.

'*Landes – landes – landes* [wastes, wastes, wastes], a country possessing nothing but privilege and poverty', such is the verdict passed by the Suffolk squire on Brittany in 1788. The privileges were swept away with a stroke of the pen twelve months later; the poverty, though an evil not summarily dealt with, had given way to a happier state of things. Of no French province can the economist now write more hopefully.[30]

Betham-Edwards then goes on to discuss the various improvements in Breton agriculture and the concomitant improvements in social conditions. It is clear from this that in the late 1870s and 1880s Brittany was undergoing rapid economic developments. Not only had the region around Quimper and Quimperlé probably changed considerably but maybe it even looked like something like Séguin's albeit brief description of the landscape around Pont Aven. The comments of Redon and Séguin, Young and Betham-Edwards cannot in themselves be used as proofs or illustrations. They have a historical specificity which has to be understood. In so far as they reveal the mesh of representations and that which is represented in and against the real historical conditions, they can function as useful materials for our enquiry.

In the nineteenth century Brittany was caught up in the economic revolution which transformed both urban and rural society. As Eric Hobsbawm states in his study of the latter half of the last century, *The Age of Capital 1848-1875*:

> What a growing part of agriculture all over the world had in common was subjection to the industrial world economy. Its demand multiplied the commercial market for agricultural products – mostly foodstuffs and the raw materials of the textile industry, as well as some industrial crops of lesser importance – both domestically, through the rapid growth of cities, and internationally.[31]

Despite regional variations agriculture and the social orders based on it were dramatically changed by the consolidation of a world-wide capitalist mode of production. Brittany was one of the regions which was extensively and, in terms of productivity and relative prosperity, progressively affected by the economic and social developments. In his study *France 1849-1945: Ambition and Love*, Theodore Zeldin compares the changes in Brittany and the Garonne in the latter half of the nineteeth century to illustrate the effects of the agricultural revolution in France. Whereas in 1848 the Garonne was one of the richest regions, Brittany was one of the poorest. By the turn of the century Brittany had become one of the most profitable and productive regions.[32] One of the factors in this change was the reclamation of waste lands, *les landes*. Between 1840 and 1880 400,000 hectares of waste land came under cultivation, a programme which increased the area of agricultural land by one-third and led to a rise in the production of milk and meat on the pasture land and wine and vegetables from the new arable land.[33] The population increased rapidly; already by 1876 some cantons in Brittany were amongst the most densely populated in France.[34] Transport systems

expanded not only with the building of railways but also with major road-building projects (the granite soil offering useful materials for the macadam).[35] By 1900 Brittany had three times more railway than the Garonne and five-sixths more roadways.[36] The areas which witnessed these changes most rapidly and effectively were the coastal regions, especially in the south, so that by 1880 one could speak of a *ceinture dorée*, a golden belt, around Brittany.[37]

The intensive exploitation of the fertile soils of South Brittany brought it into the world market. Production was for profit on the capitalist market. Potatoes, for instance, were one of Brittany's miracle crops and were produced for export as well as for domestic consumption. In 1881, Kathleen MacQuoid, a visitor to the region, recorded her impressions in her book *Through Brittany* and made special mention of the potato crop at Pont Aven which was exported to England: 'the sending off of them is a remarkable sight'.[38]

The changing methods of farming led not only to more intensive capitalisation and consequent profitability for the tenant farmers but also to the dispossession of smaller landowners and the full proletarianisation of the landless labourers who then became available for labour-intensive activities, such as harvesting, or work in the factories in the neighbouring towns. Some mechanisation of farming also occurred. MacQuoid mentions her visit to a farm at Pont Aven where there was a horse-powered threshing machine which she obviously deemed a sight worth seeing.[39] Pont Aven was a rich, fertile and productive place. Several guide-books quote a saying about it, 'Pont Aven, ville de renom: quinze moulins, quatorze maisons'.[40] The fact that fifty-two markets and twelve fairs were held a year is sometimes noted also.[41]

At the same time that the lands along the southern coast were brought under increased cultivation and worked within the market economy, the sea was also intensively farmed. With the development of industrial capitalism the distinction between agriculture and industry, the modes and relations of production and exchange, were increasingly extinguished. Similarly, the sites of work, rural and urban or agricultural and industrial, often overlapped. Concarneau, a town with 5,000 inhabitants, seventeen kilometres from Pont Aven, was a centre of one of Brittany's flourishing industries, the sardine and tuna fisheries and factories. At least 1,200 boats operated out of the harbour there, and in 1877, even before the impact of the agricultural revolution had been felt, approximately 13,000 people were already employed in the processes of boiling, salting, canning, and bottling huge quantities of fish.[42] A large number of the employees in the fish-processing plants, not all of whom were residents of the town, must have been drawn from the neighbouring countryside. The majority were women displaced from agriculture possibly because of the introduction of the scythe or the extinction of rural domestic industries such as weaving or spinning; their numbers increased in the 1880s.

Another harvest from the sea was seaweed. A. S. Hartrick, who shows little understanding of what he saw, describes the way in which it was collected at Le Pouldu.

> Imagine a country of gigantic sand dunes... peopled by a savage looking race who seemed to do nothing but search for driftwood, or to collect sea weed, with strange sledges drawn by shaggy ponies; and with women in black dresses, who wore the great black 'coif' (like a *huge* black sun-bonnet). [43]

The collection of the different seaweeds - *goémon épave, goémon de dérive* and *goémon d'échonage* – was sufficiently important to the French economy to be strictly controlled by the law. Anyone could collect driftweed – *goémon épave* – but special permission had to be obtained for the other two kinds of seaweed, and it was only given to those persons whose land adjoined the beach or to maritime municipalities. In the spring and summer four women aided by a man and a panniered ass were able to collect as much as six to eight tons of driftweed in the course of a six-hour day.[44] Gauguin's *Seaweed Gatherers* (1889, Esson, Folkwang Museum) and Dauchez's *The Seaweed Burners* (c. 1898, Museé de Moulins, Dépot de l'Etat) both represent the collection of seaweed on the *ceinture dorée*.

By the seventeenth century it was standard agricultural practice to use the nitrogen-rich seaweed as a natural manure to grow crops, especially early vegetables.[45] By the nineteenth century it was also a cash crop. Kelp, the ash which results from burning seaweed, was sold to industry. Kelp was first produced for the soda necessary for the manufacture of glass until the importation of Barilla soda after c. 1810 saw a decline in its production for this use. In 1812 it was found to contain iodine and this revived the kelp industry which thrived until 1874 when Chile began to export great quantities of cheap iodine. The production of kelp in Europe reached a very low level and in some places ceased. In Brittany, however, it continued. Dauchez's picture depicts the process well enough. The seaweed was collected, roughly sorted, and then burnt in shallow pits. The sides of the pit were built up roughly with stone from the beach and in some places the trench was divided into compartments. Each compartment was packed tightly with small pieces of dried algal mass and set alight, and then more seaweed was added slowly and continously. It was Brittany's favourable climate which ensured the survival and development of the kelp industry in France because the ovens could be kept in action until the end of September. The ash obtained was dispatched to factories for the production of iodine. In France kelp-making was concentrated on the coasts of Morbihan and Finistère and the manufacture of iodine was carried out at six centres: Le Couquet, Cherbourg, Montsarac, Portsall, Quartrevents, and nearest to Le Pouldu, Pont L'Abbé. In 1953 iodine was still being produced in Brittany from seaweed gathered on the Breton coast.[46]

Seaweed gathering for manure and the production of kelp for iodine cannot be accurately described as 'one of the manifestations of Breton primitivism'.[47] Nor should it be claimed – even though it obviously appealed to certain artists as a picturesque motif – as representing 'the backward state of Breton agriculture compared with the rest of France'.[48] As we have seen, the state of Breton farming was anything but backward. Also,

it is ridiculous to talk as House does, in terms of Brittany's 'barren, intractable coasts', an opinion which could have been almost based on the spurious evidence provided by Claude Monet's seascapes. Monet spent the summer and the fall of 1886 in Brittany but the reality of the place does not appear in his pictures. Just as he did in Argenteuil so in Brittany, he turned his back on what was awkward in the modern world, turned away from Landscape to the pure sensations of Nature and the process of painting.[49]

Monet, like Gauguin, Bernard, Dauchez *et al.* was a tourist, and to become a place for tourists to visit Brittany had to be accessible and hospitable. It was. As so many guide-books with titles such as *Ramble Into Brittany* suggest, Brittany had been accessible before the 1880s; before the spread of railways, the creation of road and other facilities of communication made travel both easy and comfortable.[50] By that decade tourism had become a major source of income within the Breton economy. It was at that time that conscious and concerted efforts were made to exploit the natural features of such places as Concarneau, Le Pouldu or La Baule so that they could become *station-balénaires*, sea-bathing resorts. Tourism is a complex social activity. Changing economic factors make certain places the object of investigation, experience, travel, and, in the nineteenth century, the site of a search for a new kind of leisure, the summer holiday. *The Narrative of a Walking Tour Through Brittany* by J. M. Jephson, published in 1859, is an instructive document which is introduced to its readers thus:

> The season is approaching when those who have been bearing their part for the last six months in the exhausting contest of busy British life, will have to determine where to spend their summer holiday... Brittany – in its easy accessibility, in the beauty of its natural scenery, in its historical and poetic associations, in the abundance of its Celtic and medieval remains, in its quaint traditional manners and picturesque costumes – possesses unrivalled attractions for the jaded Englishman whose time and means are limited, and who yet pants to escape for a while from the dingy brick walls, dark offices, briefs, ledgers, turnpike roads, or Mrs. Grundy.[51]

To the urban bourgeois and petty bourgeois – English and French alike – considering a summer holiday, Brittany offered an escape to something different. It provided a variety of experiences, embracing a whole catalogue of historical threads from picturesque travel to romantic regionalism, consolidated and packaged, which town dwellers could purchase for their summer leisure and pleasure activity. Some of Jephson's particular comments are interesting. After describing the festivities of a village wedding, he pauses to reflect that some people will call these traditional customs barbarous or puerile but then comments that he doubts 'the wisdom of stripping all social events of everything that appeals to the imagination'.[52] Inherent in that comment is the bourgeois traveller's problem of how to understand and to respond to the customs of a culture other than his own. Though he can recognise some loss of meaning in his own customs – hence the implicit reference to the control, order and reticence of social

formalities which are characteristic of the bourgeois – he can have but little comprehension of the meanings within the culture he is visiting.

Within the discourses and practices of tourism not only the natural and the man-made landscapes are of interest to the traveller. The indigenous population also provides a spectacle for the visitor to consume according to his or her point of view. In the later nineteenth century the people and their rituals and customs were made available to the visitors as part of the experience of Brittany, and the Bretons were not unwilling to put themselves and their way of life on show. In particular, the Pardons and fêtes, and especially the costumes worn at them, were integral features of the province's tourist attraction, features which were open to misreading and misunderstanding, seen as they were against the experiences of the mode of life and custom of the town.

Here is another, more historically specific level at which we have to locate the spectacle of Breton costume. For many visitors in the nineteenth century, Breton costumes were regarded as quaint and picturesque, and perceived as signs of the tradition and the archaic character of Breton culture. In fact, the costumes were neither traditional nor archaic, and such misconceptions as there were about their Celtic origins were the result of ill-informed enthusiasts of Celtomania who were part of a burgeoning Breton nationalist movement. The idea that a Breton dress was as old as the Celtic remains of ancient Armorica was widely promoted, but, as R. Y. Creston has remarked:

> Certainly these different theories did not only influence the imagination of the
> tourist with a weakness for the picturesque who comes to Brittany with the aim
> of finding there something new and strange: a people whose customs and
> costumes belong to another age.[53]

In his book *Les Costumes de Populations Bretonnes* Creston provides a history of nineteenth-century Breton costume. Until the French Revolution, the dress of Breton peasants, though different from that worn by peasants in other regions, was a class costume. It signified the wearer's place in the social hierarchy of a still semi-feudal system. It was only with the abolition of the sumptuary laws at the French Revolution, the ending of control over the use of materials, colours and kind of dress which each class could use, that the distinctive and varied costumes of the nineteenth-century Brittany began to develop.[54] It was as a result of the removal of these rigid restrictions that the variation between the regions and within individual regions were elaborated. Skirt, bodice and *coiffe*, the main elements of female dress, were subject to minute differentiation which came to signify the wearer's clan or locality. For instance, by the late nineteenth century there were as many as 1,200 different kinds of *coiffe* in Brittany, each of which was subject to further variations according to commune.[55]

Furthermore, as a result of the new transport and trade systems, materials such as embroidered cloth and lace became available in Brittany. New decorative fabrics were accessible to Bretons to enhance, elaborate, and vary their personal and local costume.

These were available to those who could afford to buy embellishing haberdashery or expensive cloth in order to display their wealth and rising social status.

Costume is a social signifying system; it has social meanings. In Brittany costume came to signify region, locality, class, wealth and material status within a *nouveau-riche* peasantry. It was worn by them for display on public occasions; it served both to individualise the wearer and to make his or her place within a part of society recognisable, to separate and to unify. However, what it signified to Bretons within a changing social order was not necessarily understood by non-Bretons for whom it seems to have signified Bretonness in general. It was therefore a site of representation of social and economic change and a site of misrepresentation. In the discourses of the non-Bretons, visitors from the town, the signs of dress were appropriated to signify difference, strangeness, otherness. The specific social practices of a rural place and its population were perceived from the urban point of view.

If, as Creston emphasises, the flowering of Breton popular culture in costume was predicated on the emergence of a more leisured and prosperous section of the peasantry – even though this may not have been explicitly recognised or articulated at the time – it is probable that part of the appeal of Brittany for the tourists was precisely that there was a relatively leisured, wealthy, socially acceptable peasantry which was not too strange, not too other. The urban tourist was unlikely to be confronted by Millet's *Man With a Hoe* (1960-2, USA Private Collection) in Brittany in the 1880s.

The sophisticated system of costume signified a social order no matter how distinct from that of the urban bourgeoisie. That is to say that while travelling in Brittany the distinctive costume would ensure that the visitor would know to whom he or she was speaking, and know who were the Bretons he or she had come to see as distinct from the other inhabitants who may have lived and worked there but were not part of the same tourist experience. Tourism structures what is seen, marks it out, and locates it. It also absents and excludes, and preconditions how things are seen. Activities and events, rituals and customs, sites and peoples are rendered intelligible as signs of Bretonness within the discursive and ideological frames of reference from visitors from the town. Tourism can be understood therefore at two related levels. It is part of the economy of Brittany and a product of the new social and ideological structures that joined town and country, metropolis and region, from which were produced a range of representations.

In 1850 Adolphe Blanqui, a Parisian economist, wrote a report on the conditions in rural France after the 1848 revolution.

> The fact that today is most worthy of *our* attention, and which stands out in the most striking way, is the difference in condition and well being which distinguishes the inhabitants of the town from those of the countryside. One would think that one was seeing two different peoples, living though on the same soil, lives so distinctive that they seem foreigners to each other, even though they are united by links of the most domineering centralisation that ever existed.[56]

Investigations of this kind – as varied in their forms and purposes as they were numerous – were the product of a particular consciousness of the effects of the decisive changes in the social structures of France in the nineteenth century. They registered a growing concern over the differences between town and country which were perceived from the urban point of view. The differences were posed in terms of relative levels of economic and social development for which the standard of judgement was the level and form attained by the town, especially Paris, which was the centre of that centralisation, the locus of civilisation and urbanity. These differences, however, also belong on another axis of difference. At one end of this axis was the increasing similarity of life in the towns of which Paris was the paradigm, and, at the other end, was the continuing diversity of the regions, each distinct from each other and from the metropolis.

The urban point of view brought forth distinct ideological meanings from this recognition of difference. Theodore Zeldin points to at least three ways in which the inhabitants of the countryside were viewed by town dwellers and metropolitans. Firstly, they classified the peasants as savages or barbarians – a view which was as common in the writings of some of those who had recently ceased to be peasants and had come to the city as it was in the work of the aristocrat Honoré de Balzac. Zeldin writes that 'People risen from their [peasant] ranks often attacked the peasants most vigorously, seeing education and peasantry as extreme opposites representing respectively civilisation and barbarism.'[57] Difference is being constructed around lifestyle and, above all, class positions. For another group, the Catholic Revivalists, the peasants and rural society were seen as better than the town dwellers and town life. They projected on to rural society a romanticised view of conservatism, piety and respect for a hierarchical social order based on the pillars of traditional society of pre-capitalist epochs, the Church and the land. Another representation of the countryside grew out of Napoleon III's call for a study of the French folklore in 1853. Individuals such as Frédéric Mistral in Provence or bodies such as the Celtic Revivalists in Brittany – as well as many other diverse groups – began to study and document regional customs and cultures. This kind of interest was contradictory. It was based in part on an attention to regional difference and diversity, popular cultures and French history, but it was equally motivated by a sense of the threatened extinction and disappearance of such regional customs and cultures in the wake of the same transformation which was producing the dominance of the town, making it different from and generating a concern about the rural world outside its own increasing uniformity.

All these view points, though they have different forms and work from different ideologies, perceived the world from an urban point of view which was based on the recognition of change and awareness of difference. With this understanding we can locate the prevailing use of such notions as remote, savage, primitive, rustic, simple, or attributions of superstitiousness or fatalistic piety with reference to the peasant population of nineteenth-century France. Their meanings are produced, as are all meanings, within relations of difference. Remote, for instance, could mean a number of

things, the physical inaccessibility of a farm far away from the tracks, roads and railways, or the difficulty of the comprehension of *patois* or a totally different foreign language. All of these levels of differentiation or distance are predicated upon a point, a centre, a given cultural norm, from which something is being seen as removed or distant. Remote means far from civilisation. Thus, remoteness in distance metonymically signifies its opposite, the centre of civilisation according to the dominant social forces which in nineteenth-century France meant Paris. According to Littré's *Dictionnaire de la Langue Française* (1899) *primitif* means at an early stage. The word *sauvage*, other than referring to wild beasts and communities of hunters, means little populated or solitary. *Rustique* describes the way of life in the country as opposed to that of the town. Even *superstitieux* or *superstitieuse* operate on a relative axis. According to the dogma of the Church establishment, superstition means a kind of religious veneration based on ignorance or fear, by which one is led to perform false duties or place one's faith in ineffectual things. *Simplicité* can mean the opposite of complex, but Littré also lists several other usages: with regard to liturgy it refers to the basic, unadorned rituals or offices; with reference to people, it signifies the quality of those who seek neither pomp, affectation, studied elegance, refinement or style. Finally, to underline the social base of such distinctions, Littré also defines simplicity as 'character or innocence, without malice or dissimilation', as such it implicitly opposes the complex, calculated and *blasé* attitudes of urban social relations.

Brittany represented as remote, savage, primitive, rustic, superstitious or simple signifies, within specific historical conditions, a nexus of town and country, uneven developments, regional variations and centralisation, the history of the dominance of the town and its bourgeois social forms and norms. But by the 1880s Brittany was not geographically remote from Paris. Linguistically only limited parts of the interior of the province remained non-French speaking – the growth in the number of schools built during the Third Republic and military service had ensured that. So why was Brittany presented as it was? Who was representing it that way? And whose Brittany do we confront in those representations? When we encounter terms such as savage, primitive, rustic or superstitious in the letters of Gauguin we cannot take them at face value or assume them to be a truth about Brittany, an objective statement of fact, and let them speak as if in explanation of the paintings. We have to recognise them as part of the ideological baggage carried by artistic tourists whose meaning has to be determined within historical conditions from and against which they were produced – conditions of change, relations of difference, and the social and cultural dominance of an urban bourgeoisie.

Gauguin and Bernard went to Brittany from the town, from Paris. As importantly, they went as part of the artistic vanguard which had emerged in the capital. In 1888-9 they lived well beyond the edge of the metropolis, but what they produced there was determined by, and addressed to, the vanguard. The eighth and last 'Impressionist' exhibition, the *Exposition Internationale*, and the *Salon des Indépendants*, all held in

1886, brought into sharp focus the loss of faith amongst the 'Impressionists' and evidenced the beginnings of the attempt to produce what Verhaeren called 'a new art'.[58]

Three years later, in his review of the Café Volpini exhibition, where work produced by Gauguin and Bernard during their stays in Brittany was shown, Félix Fénéon noted some of the shifts which had taken place in the practice of art.

> The means of the *tachistes* [Impressionists] so appropriate for representing *visions disparaissantes*, were, around 1886, abandoned by many painters preoccupied with an art of synthesis and premeditation.[59]

The 'Impressionists' had been faced with a new type of landscape, man-made, difficult and complicated, invaded by capital and class. They knew it well enough; they were part of it. Yet they had evaded it in their pictures. What the 'Impressionists' produced were contrived, expurgated representations of it. How, after all, T. J. Clark has asked, was one to paint the emerging landscape in the later nineteenth century?

> The actual relations of nature and men were so elusive, so destructive, so chaotic and formless that they were, in a word, unrepresentable. Unless, that is, you devised a way of painting that was to treat *anything* as mere phenomena, mere optical fact, merely material for painting.[60]

For a moment in the mid-1880s, Monet, Pissarro and Renoir passed through a moment of doubt about the whole business. In the end, their practices could not be sustained as they were. Only Paul Cézanne, in Aix, realised that that doubt could be made to premise the production of paintings. Fénéon described the moves made after 1886 towards greater premeditation and synthesis. Something was being introduced into vanguard practices to replace phenomenalism – that standing in front of Nature, looking, juxtaposing those broken touches of colour on the canvas, standing back again, hoping that in the process of painting an adequate visual equivalent had been made which was in some way a record of a sensation which had already disappeared. The way in which Fénéon suggests that Gauguin and Bernard reacted was by abandoning what Cézanne was determined to maintain, optical fact – *visions disparaissantes* – as the material for paintings.

In his review Fénéon also proposes another crucial difference between the work of the *tachistes* and the new tendencies.

> In as much as M. Seurat, M. Signac, M. Pissarro, M. Dubois-Pillet realised their conception of this art in pictures where episodes were abolished in a general orchestration subject to the codes of optical physics and where the personality of the author remains hidden like that of Flaubert in his novels, so M. Gauguin works towards an analogous end but by different means. For him reality is but a pretext for distanced creations.[61]

The changes to which Fénéon refers are visible. The paintings of Seurat and Gauguin do not look like those of Monet and Renoir. It is not obvious, however, what those changes meant nor how they came about. Fénéon points to the ways some artists in the late 1880s redefined their practices and developed new techniques. The position of the artist in relation to that which s/he represented became obscured, hidden. The 'Impressionists' had lived and worked in the sites they represented; they depicted themselves, their families and friends in those spaces. Their involvement in their motifs was part of their subject matter but they could only deal with that subject matter phenomenonologically. Seurat's relation to his motif was different, less immediately involved. Instead of painting on the motif, Seurat visited it, studied it, noted what comprised it, and then returned to his studio to work with those materials. In the studio he worked dispassionately; he applied science. Fénéon sees Seurat's and Gauguin's work as evidencing their apartness from the world they represent.

The emergence of several related but distinct alternatives to the work of the 'Impressionists' suggests that a change had taken place within the social relations of the Parisian vanguard. Towards the end of the nineteenth century it became competitive to an extent not known before as artists and critics contended for positions of importance and leadership within it: Seurat made such a manoeuvre in 1886 when he exhibited his large painting of *A Sunday Afternoon on the Island of the Grande Jatte* (fig. 30) at the eighth 'Impressionist' Exhibition and the second *Salon des Indépendants*. The picture represents a scene of metropolitan pleasure. It is not Argenteuil or Le Grenouillère but one of Paris's fast-growing industrial suburbs, Asnières. By 1884-6 – when the picture was painted – they were not so different. This is not Nature. And it is not an evasion. It is a representation of the kind of a crowd that gathered on an island in the Seine on a Sunday afternoon. It is part of the urban landscape, an aspect of public life in the capital. By the mid-1880s the composition of that social gathering was no longer exclusively bourgeois but socially mixed and confusing. Mass production and distribution of bourgeois fashion blurred the lines of class which dress helped signify. Maybe that is Seurat's subject: the confusions and contradictions of social relations and encounters that were part of the Grande Jatte at that time.

The *Grande Jatte* was so successful both as a painting and as a gesture that it helped close the Parisian landscape as a subject for vanguard painting. Even Seurat, once he had laid claim to it, moved on to other sites: the artist's studio, a *café-concert*, a circus, a *boudoir*, the Eiffel Tower – each in their turn came under his scrutiny. There was no alternative for the vanguard to seeing Paris as Seurat revealed it both because of what he showed and because of the way the mode of representation redefined what was represented.

The provinces had always been available to Parisian painters. The 'Impressionists' had made trips away from the capital. In 1870-1 some of them had fled in the advance of another type of vanguard but that was by definition an evacuation. Most often their outings were respites from everyday life in town. The trips which many painters made

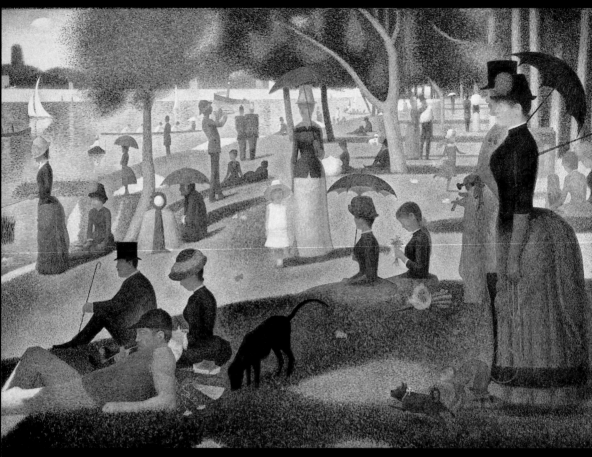

Fig. 30. Georges Seurat, *A Sunday Afternoon on the Isle de la Grande Jatte*, 1884-6. Oil on canvas, 207.5 x 308 cm. Helen Birch Bartlett Memorial Collection. Photograph © 1996, The Art Institution of Chicago. All Rights Reserved

Fig. 31

Fig. 32

away from Paris to Brittany and Provence in the late 1880s were not primarily motivated by the *bon bourgeois* yen for a week or two of the simple life in the country or at the coast. Of course, this was part of it, but by 1886 something had changed. The metropolis was no longer available to them as the main subject matter for vanguard painting. Ambitious artists were directed by necessity to find new spaces to occupy, new areas of representation. Once the *banlieue* had been possible and negotiable but this was no longer the case, and the regions became viable, novel.

Seurat was the figure of authority and centrality in the vanguard, and the *Grande Jatte* was the painting every vanguard artist – no matter where s/he was working – had to come to terms with. The *Grande Jatte* demanded a reaction and art which remained ignorant of what had been achieved by it, looked it. Vanguard painters had to situate their practice in relation to Seurat's current preoccupations; they had to develop along similar lines, take up the issues raised, or challenge his dominance. Van Gogh, in Arles, away from the 'hotbed of ideas' – as he called Paris – acknowledged Seurat's importance. He explored the Frenchman's subject matter without adopting his technique. He even wondered whether his own work was worthy of being exhibited with Seurat's.[62]

Bernard was also preoccupied with Seurat and for a brief moment in 1888 seems to have grasped some of the import and importance of the *Grande Jatte*. He approached Seurat on his own terrain when he produced two watercolour drawings of people relaxing on the banks of a river (fig. 31). Their derivation from the *Grande Jatte* is obvious; and one is actually titled *Idyll at Asnières*. These watercolours certainly explore the same aspect of Parisian life but they are marked apart from Seurat's representation of it by Bernard's almost contemptuous, caricaturing viewpoint. However, these two drawings – they are almost jokes as the ironic title makes clear – were only Bernard's initial, awkward response to Seurat's territory.

Bernard spent several months of 1888 in Brittany, first at the northern seaside resort of St Brieuc, near Dinard, and then in the south at Pont Aven. It was there that he painted *Breton Women in a Meadow* (fig. 32) and re-established contact with Gauguin. Gauguin was so impressed with Bernard's painting that he took it with him when he went to Arles. Van Gogh also recognised it as something special, made a copy of it in watercolour, and discussed it in his letters.

> I have seen a Sunday afternoon in Brittany by him [Bernard], some Breton
> peasant women, children, peasants, dogs walk about in a very green meadow, the
> costumes are black and red and the coiffes are white. But in this crowd there are
> two ladies, one in red and the other in bottle green, who make it a very modern
> thing.[63]

That passage from a letter Van Gogh wrote to his sister Wilhelmina gives several clues to the meanings Bernard's picture held for contemporary artists. There is a passing – and inaccurate – reference to the coloration of the painting. Van Gogh may have been thinking of Seurat's use of complementary colours but he is probably expressing his own

ideas on colour in modern art practice. He also makes a distinction between peasant women (*paysannes*) and ladies (*dames*), between the women dressed in Breton costumes and those dressed in town fashions (and equipped with parasols) which recalls the confusion of *classement social* in Seurat's *Grande Jatte*.[64] Most significantly, Van Gogh refers to Bernard's painting as 'a Sunday afternoon in Brittany'. Maybe Bernard or Gauguin told him what the subject matter was. Maybe not. It matters little whether it shows a Sunday afternoon in Brittany or – as Bernard variously claimed – a *fête*, or an episode in a Pardon. Bernard's preoccupation with the *Grande Jatte* was clear enough. *Breton Women in a Meadow* was a Breton motif which, though not identical, was most equivalent to that landscape that Seurat represented in the *Grande Jatte*, complex and contradictory, not metropolitan but none the less modern, as Van Gogh realised. It is a representation of what has been called, with reference to Seurat's *Grande Jatte*, the dialectic of pleasure in its bourgeois form: the dialectic of constraint and spontaneity, of ease and unease, pleasure and *ennui*, of awkwardness and informality, of nature and artifice, of the unspoilt spot and the ruined resort, of fashion and recreation.[65] Bernard manages to represent most of this but so did Dagnan-Bouveret in *Breton Women at a Pardon* (fig. 33). The vanguard was quite happy to share Brittany with salon painters. They also shared urban preoccupations about Brittany's difference from the town. Both Bernard and Dagnan-Bouveret approached the province from a metropolitan point of view. Once there, they reacted to what they encountered in different ways. Without doubt Dagnan-Bouveret saw Brittany as a source of picturesque rural motifs, aspects of the country to be painted and then put on show at the Salon. Scenes from rural life were one of his specialities, scenes such as a vaccination day in a French village or a Breton Pardon. Brittany, for Dagnan-Bouveret and his audience, provided genre scenes of a different order from those of the town. Brittany was different. Of course, Bernard was an artistic tourist just as Dagnan-Bouveret was. As we have seen, part of the reason for the colonisation of Brittany by the vanguard was that it was easily accessible and provided something different or novel, an alternative field of representation to Paris. However, the scene Bernard represented in *Breton Women in a Meadow*, although rural genre in character, was similar in some aspects to urban life.

By the 1880s it was difficult to sustain the illusion of Brittany's radical difference and particular, historic character. The clear demarcations between town and country, and between one region and another were being eroded. In the 1880s the poet Jean Ajalbert visited Brittany. He has been called an 'Impressionist' poet; his poems deal with those areas of Paris in which the 'Impressionist' painters have lived and worked but he represented with heavy irony the shoddy, adulterated *banlieue* of Clichy St Ouen, St Denis and their leisure spots such as the Grande Jatte on a Sunday with the 'population at play' (*populations en liesse*). From *Paris banlieue – Sur Le Vif* (the title of a series of urban poems), Ajalbert moved to *Les Provinces*, poems produced after a trip to Brittany. What he found there did not accord with his anticipated image of Brittany: the home of a proud, strange race, with a valiant history and a mysterious past, of Celtic remains,

dolmens and menhirs. The dream of an ancient, traditionalist, religious population was fractured and disrupted. The tone of this poem for instance is bitter, disgusted and saddened. But it represents the contradictions of modern Brittany, however much it betrays the preconceptions and prejudices of the poet. An older mythic Brittany is imagined as a foil to the irksome familiarity of its present.

> At each turn of the road they used to plant a cross;
> They crossed themselves when a flash of lightening broke the clouds,
> And tradition, which was still strong amongst them,
> Made them devoted to kings and priests.

> Long ago, they vanquished more than one army of the English;
> Their boats went out to find a distant world;
> And often, waiting on the cliffs, for their uncertain return,
> Young girls wore out their eyes with watching.

> Those sailors are now servants or waiters in hotels
> For bathers, who each summer, come in droves;
> The strand is filled with bathing huts.

> The churches have few flowers on their alters now;
> And making use of crosses to build walls around their land,
> The Bretons write thereon: GAME PRESERVE. [66]

A contemporary reviewer of Ajalbert's poems, Robert Bernier, writing in *La Revue Moderne* in 1886 drew out the implications of the poet's mocking image of a Brittany, invaded by 'this pseudo civilisation... this progress which tends to turn the whole of our native land into one hideous *banlieue*, more ugly and more tedious than the *banlieue* of Paris'.[67]

In Breton Women in a Meadow (fig. 32), Bernard depicts the rural bourgeoisie, the *nouveau-riche* peasantry, and they are not so very different from the mixed crowd of metropolitans who congregated every Sunday on the Island of the Grande Jatte. Bernard must have travelled through Brittany with notions in common with Dagnan-Bouveret, with expectations similar to those of Ajalbert's. They travelled to what was considered to be a social system different from that to which they were accustomed, to a province which, it was thought, retained much of a character of a bygone civilisation. But what Bernard, the vanguard artist, painted in *Breton Women in a Meadow* was a set of social relations very similar to those he knew in the capital. On a Sunday afternoon there was an equivalence between that meadow in Pont Aven and the Isle de la Grande Jatte in Paris. And therein lies at least one level of immediate contradiction in Bernard's picture. He went to Brittany to find difference and novelty, difference from Paris and novelty as

an artist. What he encountered there was not remote, strange or backward, but in many ways modern. How, therefore, could he signify the difference and similarity, the anticipated archaism and the pressing modernity? How could he engage with and evade the real contradictions of the social and economic developments in Brittany which made that space viable and intelligible for vanguard art practice?

We can be sure that Dagnan-Bouveret did not see the real Bretons at the Pardon which provided him with his motif as in any way engaging in similar forms of fashion and recreation to those he knew in Paris. Nevertheless, he did illustrate *classement social* and aspects of social development. He represented the scene confidently, sure of his own position as a Parisian artist in relation to his motif. His work operates within the parameters of Salon naturalism, where what the painting was, what it could represent, and how it could represent, were established in terms of known protocols and procedures. *Breton Women at a Pardon* (fig. 33) is comfortable in the recognisable manner a Salon picture was meant to be. Class is there but in an anecdotal way, part of an episode from a narrative of life in the country. Such contradictions as there were in the social development of Brittany could be contained in the mode of production of the picture. It is intelligible because the clues of gesture, character, narrative space, and the relations between the parts are clear, untroubling for metropolitan art lovers. There is nothing assertive or problematic about the way it is painted, nothing that jolts one out of complacency before it, nothing that makes what is represented puzzling or uncomfortable. As this passage from a review of the Salon of 1889 suggests, Dagnan-Bouveret's picture was well received because its subject seemed natural, self-evident.

> He [Dagnan-Bouveret] set but little store on the beauties which belong to form. His pictures do not portray much artifice in their arrangement, nor his figures much selection in their contours. It is in colour and in their bath of luminous air that they excel... In all his work... there is the same sincerity of passion, the same simplicity in the expression of personal ideas. In... Bretons au Pardon, he shows in an increasing degree the interest in physiognomy... There is nothing finer in the whole Salon than these varied faces, each with its own history of hard work, with its own proclamation of faith, and its own hope in the future.[68]

What Dagnan-Bouveret represents is reassuringly known or knowable because it is reassuringly fabricated.

The assertion of facture was an important part of the strategy of the vanguard. It had always been so. Seurat presented himself as a technician. He claimed objectivity with his quasi-scientific procedures. And his seemingly mechanical application of the paint posed as impersonality. That objectivity and impersonality signified a distance from what he represented. The mode of facture helped distance the spectator from that which was represented. Bernard had to deal with Seurat as much in terms of technique as subject matter. He had found a rural equivalent for the *Grande Jatte* but he had to assert his independence from Seurat technically.

Fig. 33

Fig. 34

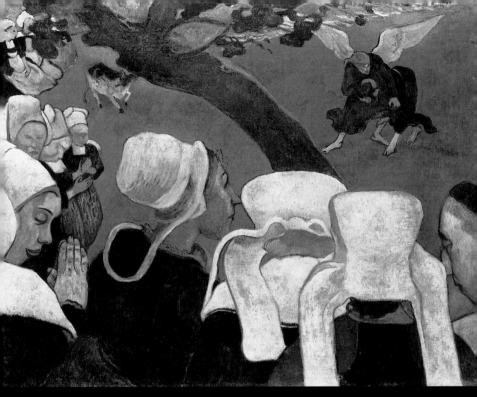

Fig. 35

Fig. 36

Breton Women in a Meadow (fig. 32) is an amalgam of independent groups of figures each in her own area on the canvas. The emphatic outlines seem primarily an aesthetic contrivance, part of a decorative scheme rather than a means of signifying spatial and social relations. Each object has been flattened, made two dimensional, and depth has been suppressed. There is a lack of coherence, a lack of synchronisation between the different parts of the picture. It is a strange painting which holds our attention by its lack of detail and its unreadable space. We are made to see it at once from above, from below, and from our own levels. When Van Gogh copied it he tried to give his model some logical consistency. He changed the intervals between the forms and gave the spectator a positioned space in relation to what it represented. He tried to retrieve a narrative space.

Bernard has dispensed with the obvious clues of physiognomy, gesture and space. It is difficult to understand what is taking place and what the people are doing. But it is not without significance. *Breton Women in a Meadow* represents the recognisable *nouveau-riche* peasantry behaving in a similar manner to the urban bourgeois: strolling, conversing, displaying themselves and their wealth in a public place. Most of the people are dressed in regional costume which, as we have seen, was a sign of class and social development. It signified contemporary Brittany, but it also marked it apart. The Breton costume was a modern form of dress which, at that time, was still evolving, but the urban population saw it as archaic, mediaeval. Bernard also included two ladies dressed in town fashions and a young girl in a knee-length dress. Could these be visitors, tourists? The ladies do not mix with the peasants but the girl seems to have made some contact with a peasant in costume who could be someone of her own age. Maybe they are friends. It is possible that the ladies are *Bretonnes* too. Town fashions – not just haberdashery – had become available in the province and it was not unusual for young women to forsake regional costume on special occasions. Henry Blackburn noticed this. Here is his part of a description of a *ronde* he saw danced at Plougastel in 1880. The line illustration is by Randolph Caldecott (fig. 34).

> There was one figure dressed in the latest fashion of Quimper, who was looked
> upon with doubtful admiration by the other dancers, but who will serve to
> remind us that the distinctive costume, even in these out-of-the-way places, is a
> flickering flame, and that in a few years such scenes will have lost their
> character.[69]

In Bernard's painting the town fashions point to the adulteration of the Breton scene. The unspoilt spot was fast becoming the ruined resort, less rural and more urban in its appearance and manners.

Van Gogh saw these differences of dress in *Breton Women in a Meadow* as signifying a class difference and suggested that this made the picture modern. The ladies are quotations from Seurat's *Grande Jatte*. Van Gogh realised this; as far as he was concerned that was part of the meaning of the picture. As an iconic quotation – and

there is at least one other in the painting – it activated a variety of meanings that vanguard artists and critics would have understood.[70] Even now, they signify not only a particular work by another artist, but what the painting represented, a specific, confusing, modern social space. Maybe Bernard is trying to make the complexity of his motif clear. He might not have been as certain as Van Gogh was that the difference in dress signified a difference of class. It could also have signified a difference within a class. So how, if at all, did Bernard's *Breton Women in a Meadow* produce the effect of *classement social* and modernity? Could it be the way that Bernard painted the people in Breton costume? They are not so obviously recognisable as quotations from contemporary French painting but they do refer us to other materials upon which Bernard was drawing. Bernard was an eclectic. He borrowed devices from gothic stained glass windows, mediaeval textiles, enamel work and Japanese prints in order to represent Brittany. What does it mean to paint the two women who are derived from the *Grande Jatte* as if they are figures in a stained glass window? What does it mean to paint Breton men and women in a manner derived from Japanese prints? What does it mean to medievalise and orientalise Brittany? Does it signify, for example, primitiveness, savageness, or simplicity of the region and the people? Or does the use of such stylistic devices assert the modernity of the artist, his vanguardness? And why did Bernard paint in a deliberately naive, almost awkward way so that the tracking movements of the brush are clearly evident? At the time he and Gauguin were talking of *faire de la peinture d'enfant*. Why? It was better than painting like *décadents*.[71] In what way was painting like a child appropriate for representing *Breton Women in a Meadow*?

The questions multiply. But there are no easy or self-evident answers to them. There is nothing in the picture's complex appearance which affords us the luxury of certainty with regard to its meanings. The longer we spend looking at it, studying it, the more references to the real social developments of Brittany which rendered the space possible for vanguard painters to represent become occluded. They – like Bernard – are distanced beneath the assertion of style and the connotations inculcated by the incongruity of the means and materials used. The way an artist represents a scene transforms that which is represented. The mode of representation used for *Breton Women in a Meadow* could not contain the contradictions in the subject matter or in the position of the artist.

In September 1888 Gauguin painted a picture of Breton women in a meadow which has since become known as *Vision After the Sermon* (fig. 35). Many ink-wells have been emptied by the literati of art establishing the priority of Bernard's *Breton Women in a Meadow* and the stylistic influence which it had on Gauguin's painting. Undoubtedly Gauguin's picture was a response to what Bernard had painted. It was part of vanguard practice to surpass a chosen model or accepted position. Bernard had to go beyond Seurat, and Gauguin had to transcend Bernard. To do that Gauguin had to address the subject matter of Bernard's picture and how that representation was made.

Gauguin's *Vision After the Sermon* (fig. 35) has been appropriated by modernist art history as 'the turning point of his entire oeuvre',[72] 'the epitome of his new style'.[73] To

give it such a status is wrong. *Vision After the Sermon* is an exceptional painting which stands apart from the main tendencies in Gauguin's work in 1888 and has little relationship to anything painted after it. To try to fit it neatly and assuredly within terms of a personal or stylistic development is to resort to the false security which belief in the cult of the artist and the myth of creativity provides. It negates questions about the conditions of artistic production and the strategies of vanguard practice, about the complexity of Brittany and representations made of it in the 1880s.

Vision After the Sermon is a particular representation produced in Brittany, in a particular way, to do a specific job. In September 1888 Gauguin described it in a letter to Van Gogh as *un tableau réligieux*.[74] Was Gauguin responding to the debates about the nature of religious painting which Van Gogh and Bernard were pursuing in their correspondence with each other?[75] There is some evidence that Gauguin was intrigued and amused by Van Gogh's evangelical fervour.[76] Did Gauguin's interest in posing as a religious painter stem from his infatuation with Bernard's sister, Madeleine, who was a devout Catholic? Or was the picture a response to the local Pardon? MacQuoid regarded the Pardon held at Pont Aven in September as one of the best in lower Brittany, 'the wrestling and dancing there have quite a reputation of their own'.[77] Wrestling matches were a feature of the day's activities, part of the pleasure of the Pardon, part of the attractions and various entertainments which began, according to MacQuoid, after high mass.

> Next we went to the wrestling. The people form a great ring. The judges, consisting of the *maire* and the chief of the townspeople, stand in the midst, and make a point of hiding the performance as much as possible from the lookers on...[78]

Was *Vision After the Sermon* in some way a response to this obscured wrestling match?

We can indicate a variety of possibilities to assist us to locate Gauguin's posture as a religious painter or a painter of a specific custom associated with Breton religious practice. But is *Vision After the Sermon* a religious painting? It is not an illustration of people or scenes from a religious text. It is a picture which includes an episode from the Bible as if imagined by a number of Bretons as a reaction to a sermon they have heard. Does it inspire religious devotion, faith, or promote an understanding of religious dogmas? How could it? What would be its meaning if that was the case? Is its subject religious experience? Gauguin stated that he had attempted to produce an effect not of piety – goodness, virtue, reverence, or veneration – but rustic and superstitious simplicity. How could *un tableau réligieux* have as its content superstitiousness – an ignorant, irrational belief in supernatural forces? Littré cites a passage from Pascal wherein superstition is contrasted with piety: piety destroys superstition. Did Gauguin consider superstition synonymous with Christian piety? In 1889 he wrote to Van Gogh

that the Breton costumes were influenced by the superstitions of Catholicism.[79] Perhaps he was aware of, and responding to, the non-Catholic practices associated with the Pardons which took place locally.[80] But did he see the wrestling at Pont Aven in that way?

Vision After the Sermon is not a religious painting. Is it a genre scene? The habit of resting in a meadow close to the church was a common feature of social behaviour at a Pardon. A. Le Braz in *The Land of Pardons* provides this description:

> Only toward the evening, when Vespers are over, do the festivities begin. And what simple pleasures they are; how innocent, how primitive! The good folk flock together in the shade of the walnut trees, on the green sward, beneath the spreading elms. And there, under the eyes of the girls, seated demurely on the surrounding slopes, the youths challenge one another to wrestle, to race, to jump...[81]

This is like the motif Dagnan-Bouveret – and perhaps Bernard – depicted. Maybe it was also Gauguin's starting point. However, if that was the case and Gauguin did base *Vision After the Sermon* on this secular aspect of a Pardon, then the imagined biblical wrestling match works to dispossess the scene of connotations of pleasure, leisure, fashion, recreation, and commerce (fig. 36).[82] Perhaps this refusal of the specific contemporaneity is the point of the work. Gauguin's representation avoids the space which Bernard had claimed with all its awkwardness and contradictions for his vanguard.

The only reference – and it is oblique – to modern Brittany is that sign of Bretonness, costume. A year later Gauguin was of the opinion that the Breton peasants had a mediaeval air and that they showed no sign of thinking for a moment that Paris existed or that they were in 1889. Probably he held the same belief in 1888. In *Vision After the Sermon* Breton costume is deprived of any significance with regard to the social development of Brittany at the time that Gauguin worked there.

It was not until the autumn of 1889 when a different critical and artistic situation had emerged in Paris that Gauguin took up some of the issues that he had raised in *Vision After the Sermon*. However, in *Yellow Christ* (1889, Buffalo Albright-Knox Art Gallery) and *Green Calvary* (1889, Brussels Musées Royaux des Beaux Arts de Belgique) his strategies were entirely different. In these pictures the peasants are not visionaries and the religious connotations are made obvious by the use of the crucifix from the Chapel at Trémalo and the calvary at Nizon. There are also references to the exploited, inhabited landscape around the Pont Aven and Le Pouldu and to the people who lived and worked there; rich and poor peasants, a shepherdess, a seaweed gatherer, pleasure and religion in a rural society and landscape.

In modernist art history's ideological retreat into stylistic accounts and theories of personal artistic 'expression' and 'experience', *Vision After the Sermon* has been used to safeguard certain fictions about Gauguin and Brittany. The terms in which Gauguin

described the effects he thought that he had achieved in figures in this painting are one of the two fragile threads with which certain notions or *données* of Bretonness have been constructed and sustained. In fact, Mary Anne Stevens manages to use both of them with reference to *Vision After the Sermon, Yellow Christ* and *Green Calvary* in one sentence:

> [Gauguin] sought to capture the 'dull, muted, powerful note' of his clogs ringing out on the granite soil, as well as 'the rustic and superstitious piety' [*sic*] of the Breton peasants which he expressed in *Vision After The Sermon* and the two calvary paintings of 1889, the *Yellow Christ*... and the *Breton Calvary*...[83]

These phrases – used as if their meanings are transparent – and the verb 'expressed' reproduce a comforting and unproblematic picture of the artist and what he painted. They render redundant, if not unthinkable, any discussion of the historical conditions and structures of representation which determined and mediated the nature of Gauguin's contact – such as it was – with a real historical Brittany and its classed populations. In the 'Literature of Art' these complex social realities are absented, and modernist art history is built upon and structured by that evasion.

Notes

1. The French artists in the exhibition did not think of themselves, or ever call themselves, 'Post-Impressionists', and, in an admittedly very enlarged and revised sense, 'Impressionists'. See for instance Van Gogh, *Complete Letters*, New York and London, 1958, LT 473, LT 539 and the exhibition of works by Gauguin and Bernard at the Café des Arts in Paris in 1889 held by the 'Groupe Impressioniste et Synthétism'.

2. *Post-Impressionism: Cross-Currents in European Painting*, Royal Academy of Arts Catalogue, London, 1979, A. Bowness, 'Introduction', p. 11 (hereinafter referred to as *R.A. Post-Impressionism*, 1979).

3. *R.A. Post-Impressionism*, 1979, Roger Fry quoted by A. Bowness, p. 10 and n. 1, p. 12.

4. R. Fry and D. McCarthy, *Manet and the Post-Impressionists*, London, Grafton Galleries, 8 November 1910-15 January 1911, pp. 7-13, and R. Fry, *Second Post-Impressionist Exhibition*, London, Grafton Galleries, 5 October-31 December 1912, pp. 7-8.

5. *R.A. Post-Impressionism*, 1979, A. Bowness, p. 11.

6. Ibid., p. 11.

7. Ibid., p. 11.

8. Ibid., p. 11.

9. Ibid., p. 11.

10. 'This has been my guiding principle; I have effaced myself wherever possible so as to let the artists and all the other possible sources speak for themselves.' J. Rewald, *Post-Impressionism from Van Gogh to Gauguin* (1956, New York Museum of Modern Art) revised edition, London, 1978. 'Introduction to the first edition', p. 9.

11. We are currently preparing a historical study of Alfred J. Barr and the role of the Museum of Modern Art in the construction of modernism. Note added 1995: this work appeared in an Open University programme in the series Modern Art and Modernism in 1983.

12. G. Lukács, *The Historical Novel* (1954), trans. S and H. Mitchell (1962), London, 1976, p. 209.

13. Rewald, op. cit., pp. 7-8.

14. R. Fry and D. McCarthy, op. cit., p. 7.

15. *R.A. Post-Impressionism*, 1979, A. Bowness, p. 11.

16. We use the terms 'Practice' and 'Representation'. By practice we mean any process of transformation of a given raw material into a determinate product, a transformation effected by social labour, using definite means of production. What above all characterises human social life is mental and practical work in and on the conditions of life. Society is a

combination of relations of transformation, modes and production of life, modes of appropriation of the world for knowledge and transformation of it. In a variety of structured models we make representations of our conditions of life in order to make sense of them, situate ourselves in relation to them in determinate and determinable ways. Basically, representation means articulating 'x' in terms of 'y', representing the processes and forces of social relations in systems of language and other signifying systems. Both signs and their referents, 'x' and 'y', are complexities which refuse to be simplified in the process. Representation means that our access to the knowledge of the world, societies or their histories, is mediated by the modes and systems of signification available to us, by the constraints and productive possibilities of socially determined signifying systems imbedded in socially determined practices and institutions – the practices of ideology. Neither reality nor history speaks for itself; neither is simple, self-evident nor transparent.

17. *R.A. Post-Impressionism*, 1979, H. Casson 'Foreword', p. 7.

18. We are referring to the extension of the capitalist mode of production into such diversions as exhibitions, the making into commodities of whole areas of social practices, free-time – the colonisation of everyday life. See G. Debord, *La Société du Spectacle*, Paris, 1967.

19. *Post-Impressionism, Royal Academy of Arts*, 1979-80, Exhibition Gallery Guide 'South Rooms: Brittany'. Pictures by Gauguin painted in Brittany were included in the exhibition (cat. nos. 81, 82, of 1886, 84, 85, of 1888, 87, 88, of 1889), but only *Breton Shepherdess* (1886, Laing Art Gallery, Newcastle-upon-Tyne) and one supposedly Breton scene, *Christmas Night*, (cat. no. 92) painted in 1896, probably in Tahiti, were hung in the 'South Rooms: Brittany'.

20. Ibid., no pagination.

21. *R.A. Post-Impressionism*, 1979, J. House, 'The Legacy of Impressionism in France', p. 15.

22. Ibid., M. A. Stevens, 'Innovation and Consolidation in French Painting', p. 22

23. 'J'aime la Bretagne: j'y trouve le sauvage, le primitif. Quand mes sabots résonnant sur le sol de granit, j'entends le ton sourd, mat et puissant que je cherche en peinture.' P. Gauguin to E. Schuffenecker (February 1888). M. Malingue (ed.), *Lettres à sa Femme et ses Amis*, Paris, 1946, p. 322.

24. 'simplicité, rustique et superstitieuse'. P. Gauguin to Vincent van Gogh (September 1988). *Oeuvres Ecrites de Gauguin et Van Gogh: Collections du Musée National Vincent Van Gogh*, Amsterdam, Institut Néerlandais, Paris, 1975, cat. no. G9, p. 22.

25. The phrase 'The Literature of Art' is the heading of the review section of the *Burlington Magazine*. For fuller discussion of this see G. Pollock, 'Artists, Media and Mythologies', *Screen*, vol. 21, no. 2, 1980.

26. *R.A. Post-Impressionism*, 1979, M. A. Stevens (p. 22) thus paraphrased A. Séguin, 'Paul Gauguin', *L'Occident*, March 1903, p. 166.

27. See for instance K. MacQuoid, *Through Brittany*, London, 1881, 'indescribable charm of this sequestered little place' (p. 250) and 'The most delightful excursion to be made from Quimperlé to Pont Aven ... most picturesque' (p. 250); J. Chesney, *A Ramble Round France*, London, 1885, 'one of the best known and prettiest Breton villages in Pont Aven' (p. 65); P. Joanne, *Bretagne*, Paris, 1892, 'Pont Aven est pittoresquement situé sur la rivière' (p. 335); A. J. C. Hare, *North Western France*, London, 1895, 'Pont Aven ... a very pretty spot' (p. 374).

28. O. Redon, *A Soi-même* (1922), Paris, 1961, p. 49, 'Triste pays accablé sous des couleurs sombres...'. It is interesting to contrast this representation with that of an English tourist's perception of the nearby region around Cornouaille in 1859 – 'The general appearance of the countryside is picturesque and pleasing. The Black Mountains, which I passed, were not as their name would seem to import, very sombre, while the farms were well cultivated, the cornfields large and the meadows significantly irrigated.' J. M. Jephson, *The Narrative of a Walking Tour Through Brittany*, London, 1889.

29. A. Young, *Travels during the years 1787, 1788, 1789 and 1790, undertaken more particularly with a view to ascertaining the Cultivation, Wealth, Resources, and National Prosperity of the Kingdom of France*, Bury St Edmunds, 1792, quoted from M. Betham-Edwards (ed.), *Young's Travels in France*, London, 1913, p. 128, first published in this edition in Bohn's Standard Library, London, 1889.

30. M. Betham-Edwards, op. cit., 'Introduction', p. xii.

31. E. J. Hobsbawm, *The Age of Capital 1848-1945* (1975), London, 1977, p. 206.

32. T. Zeldin, *France 1848-1945, Ambition and Love* (1973), Oxford, 1979, pp. 176-8.

33. M. Betham-Edwards, op. cit., p. xiv and T. Zeldin, op. cit., p. 177.

34. J. Delumeau, *Histoire de Bretagne*, Toulouse, 1969, pp. 464-5.

35. J. M. Jephson op. cit., p. 153.

36. T. Zeldin op. cit., pp. 177-8.

37. J. Delumeau, op. cit., p. 421.

38. K. MacQuoid, op. cit., p. 251.

39. Ibid., p. 252.

40. Ibid., p. 250 and P. Joanne, op. cit., p. 335.

41. A. J. C.Hare, op. cit., p. 374.

42. See J. Murray, *A Handbook for Travellers in France*, London, 1877, p. 164; K. MacQuoid, op. cit., p. 357; C. Black, *North France*, Edinburgh, 1885, p. 290; K. Baedecker, *Northern France*, London and Leipzig, 1889, p. 236

43. A. S. Hartrick, *A Painter's Pilgrimage Through Fifty Years*, Cambridge, 1939, p. 30.

44. V. J. Chapman, *Seaweeds and Their Uses*, London, 1950, pp. 73-4.

45. L. Newton *Seaweed Utilisation*, London, 1951, p. 46.

46. Chapman, op. cit., passim, pp. 24-34, Newton, op. cit., passim, pp. 58-68.

47. *R.A. Post-Impressionism*, 1979, M. A. Stevens catalogue entry no. 59, p. 63.

48. Ibid., pp. 62-3.

49. Why, when Gauguin is hardly included in the Brittany section and Bernard's *Breton Women in a Meadow* is excluded, is Monet introduced there? C. Monet, *The Rocks of Belle-Isle* (1886, Museé de St-Denis Reims) and *Storm on Belle-Isle* (1886, New York Private Collection) were exhibited at the Royal Academy in the 'South Rooms: Brittany'. In the catalogue entry for *Storm on Belle-Isle* (no. 138) J. House writes, 'The qualities which Monet found in the Breton coastline are similar to those which attracted his contemporaries, in paintings (cf. nos. 51 [C. Cottet, *Evening Light: The Port of Camaret*, 1893] and 149 [H. Moret, *Waiting for The Fishermen*, Brittany, 1894]) and in books like Pierre Loti's hugely popular *Pêcheur d'Islande* (1886)', p. 98. This is incorrect. Monet did not attend to any 'qualities' of the inhabited and cultivated Breton coast, its social and economic reality which is at least alluded to in both the paintings by Cottet and Moret. Loti's novel is an account, however romanticised, of maritime labour. It is, moreover, about the fishing community of the north coast of Brittany.

50. C. Musgrave *A Ramble Into Brittany*, London, 1870. See also J. M. Jephson, *The Narrative of a Walking Tour Through Brittany*, London, 1859 and J. Murray, *Ramble About France*, London, 1878.

51. J. M. Jephson, op. cit., Preface p. iii and pp. v-vii.

52. Ibid., p. 61

53. R. Y. Creston, *Les Costumes de Populations Bretonnes*, Rennes, 1953, vol. I, p. 15. 'Ces diverses théories, c'est certain, n'ont pas seulment influencé l'imagination du touriste en mal de pittoresque qui vient en Bretagne dans le but d'y trouver quelque chose de nouveau et d'étrange: un peuple dont les costumes et les costumes sont d'un autre age.'

54. Ibid., vol. I, passim, pp. 17-26.

55. Ibid., vol. II, La Cornouaille p. 13.

56. A. Blanqui, 'Tableau des Populations rurales de la France en 1850', *Journal des Economistes*, vol. 28, 1851, p. 9, translated in T. Zeldin, op. cit., p. 131.

57. T. Zeldin, op. cit., p. 132.

58. E. Verhaeren, 'Le Salon des Indépendants', *La Nation*, reprinted in *L'Art Moderne*, 5 April 1891, translated in J. Rewald, op. cit., p. 7, 'There is no longer any single school ... all these tendencies make me think of moving and kaleidoscope geometric patterns ... which all nonetheless revolve within that same circle, that of *the new art*' (author's italics).

59. F. Fénéon, 'L'Exposition Volpini', *La Cravache*, 6 July 1889, reprinted in Félix Fénéon, *Au-delà de L'Impressionisme*, ed. F. Cachin, Paris, 1966, p. 109, 'Les moyens des tachistes, si propres à figurer des visions disparaissantes, furent, vers 1886, abandonnés par plusieurs peintures soucieux d'un art de synthèse et de préméditation.'

60. T. J. Clark, 'The Edge of the City', unpublished paper, pp. 16-17. When writing this piece we were privy to working manuscripts which were published as *The Painting of Modern Life: Paris in the Art of Manet and his Followers*, London and New York, 1984.

61. F. Fénéon, op. cit., pp. 109-10, 'Tandis que M. Seurat, M. Signac, M. Pissarro, M. Dubois-Pillet réalisaient leur conception de cet art et des tableaux où les épisodes s'abolissent dans une orchestration générale docile au code de la physique optique et où la personnalité de l'auteur reste latente comme celle d'un Flaubert dans ses livres, M. Paul Gauguin tâchait vers un but analogue, mais par d'autres pratiques. La réalité ne lui fut qu'un prétexte à créations lointaines...'.

62. See *The Complete Letters of Vincent van Gogh*, New York and London, 1958, LT 500, LT 539.

63. Ibid., LW 16, 'J'ai vu de lui un après-midi de dimanche en Bretagne, des paysannes bretonnes, des enfants, des chiens, des paysans, préambulent dans un prairie très verte, les costumes sont noirs et rouges, les coiffes, blanches. Mais il y a dans cette foule aussi deux dames, l'une en rouge, l'autre en vert bouteille qui en font une chose bien moderne.' See also LB 21.

64. J. Christophe, 'Chronique - Rue Lafitte no. 1', *Journal des Artistes*, 13 June 1886.

65. T. J. Clark op. cit., p. 16.

66. Authors' translation.

A chaque coin de route, ils plantaient une croix;
Ils se signaient, lorsqu'un éclair fend la nuè,
Et la tradition, chez eux continuée
Fait qu'ils aiment toujours les prêtres et les rois.

Ils vainquirent, jadis, plus d'une armée anglaise;
Leurs barques s'en allaient vers un monde lointain;
Et souvent, à guetter leur retour uncertain
Des filles fatiguaient leurs yeux, sur la falaise.

Les matelots sont devenues garçons d'hotel
Des baigneurs qui, l'été se succèdent sans trève;
Des cabins de bains ont poussé sur la grève.

Les églises ont moins de fleurs sur leur autel;
Et se servant des croix, dont leur terre est bordée,
Les bretons ont écrit dessus: CHASSE GARDEE.

67. R. Bernier, 'Un Poète Impressioniste Jean Ajalbert', *La Revue Moderne*, 20 January 1886, p. 13, 'cette pseudo-civilisation ... de ce progrès qui tend à faire de toute notre patrie une hideuse banlieue, plus laide et plus ennuyeuse que la banlieue de Paris'.

68. W. Armstrong, 'Current Art – The Salon', *Magazine of Art*, 1889, p. 418.

69. H. Blackburn, *Artistic Travel A Thousand Miles Towards The Sun*, London, 1895, p. 99. This edition collected together a series of shorter publications by Blackburn. The chapter on Brittany was first published as *Breton Folk*, 1880, accompanied by full page illustrations by R. Caldecott.

70. In *R.A. Post-Impressionism*, 1979, M. A. Stevens (p. 41) regards the two dogs as indebted to Hokusai, a specific reference to the stylistic importance for Bernard of Japanese prints. Undoubtedly the standing dog is a quotation from G. Courbet's *Burial at Ornans* (1849-50 – acquired by the Louvre amongst much publicity in 1881), another complex representation of the rural bourgeoisie.

71. Vincent van Gogh, op. cit., LT 527. For a useful introductory discussion of this point see E. van Uitert, 'Van Gogh and Gauguin in Competition', *Simiolus*, vol. 9, no. 3, 1977, pp. 162-3.

72. A. Bowness, *Gauguin*, London, 1971, p. 8.

73. J. Rewald, op. cit., p. 181.

74. P. Gauguin to Vincent van Gogh (September 1888), *Oeuvres*, 1975 (see note 24), p. 22. In a letter of October 1888 to Theo van Gogh, Gauguin referred to the paintings as 'le tableau d'Église', perhaps because of his offer of the work to the priest at Pont Aven (see also P. Gauguin to E. Schuffenecker, October 1888, LXXI, in M. Malingue, op. cit., p. 140, 'J'ai fait pour une église un tableau'). In a Carnet, dated by M. Bodelson to 1889-90, the painting is listed under two titles, on p. 72 as 'L'Apparition' and on the following page as 'Vision de Sermon' with the number, 7, and the price, 1,000. The date of this Carnet suggests that these notes refer to the exhibition of the work at Les XX in Brussels in 1889 for which Gauguin tried out a number of titles. It was only in 1891, in an article by Albert Aurier, that the painting was designated as a biblical subject – 'la lutte biblique' and entitled 'La Lutte de Jacob avec l'Ange'. A. Aurier, 'Le Symbolisme en Peinture Paul Gauguin', *Mercure de France*, 9 February 1891, reprinted in A. Aurier, *Oeuvres Posthumes*, Paris, 1893, p. 207. In that year, however, in a letter to de Monfried, Gauguin qualified his own, earlier description and called the painting 'un tableaux quasi-réligieux', *Lettres à de Monfried*, Paris, 1950, vol. II, p. 52. The painting thus only gradually acquired a specific title, verbal clues as to how the picture might be read, as it entered the public domain of exhibition and critical discourse. The designations of the painting contemporary with its execution in 1888 are not specific; they vary according to the correspondent addressed. By 1891 Gauguin had himself modified what he said in his letter to Van Gogh. The phrase in that letter does not provide secure evidence of the picture's purpose or meanings.

75. Vincent van Gogh, op. cit., LB8 and LB12. For a fuller discussion of the Van Gogh-Bernard debates about a modern form of religious paintings see G. Pollock, 'Van Gogh and Dutch Art: Van Gogh's Notion of the Modern', PhD, London

University, 1980, forthcoming as *The Case Against Van Gogh: The Cities and Countries of Modernism*, London, 1997.

76. References to God in letters to E. Schuffenecker of August and September 1888 (M. Malingue, op. cit., LXVII, p. 134 and Appendix p. 322) must be interpreted as heavily ironical: Gauguin's sarcastic reactions to Bernard's and Van Gogh's religious theorising. Such aesthetic theory as these letters do contain is a mere restatement of ideas previously articulated without invoking God at all.

77. MacQuoid op. cit., p. 260.

78. Ibid., p. 261.

79. P. Gauguin to Vincent van Gogh (1889/90), *Oeuvres*, 1975 (see note 24), exhibition no. G. 32, 'les costumes sont aussi prèsque symbolique influencés par les superstitions du Catholicisme'.

80. There were many un-canonical practices associated with the local Pardons, the lighting of bonfires – the 'feu de St Jean'; bathing babies in a magical fountain at St Leger, sticking pins in the figurine of a saint at Poulguen (MacQuoid, op. cit., pp. 262-3). It would be wrong to define these as examples of residual paganism. The will to do so was the product of the folkloric Celtic revival of the Movement Bretagne that emerged in the second half of the nineteenth century (see R. Y. Creston, op. cit., p. 13). Moreover E. Weber's extensive study of the French peasantry in the nineteenth century offers evidence of the widespread incidence of such practices throughout France. He documents many non-religious customs associated with festivals and holidays which, like the bonfires of St Jean, served a more practical agricultural purpose – the ashes were used as a fertilizer. See E. Weber, *Peasants Into Frenchmen*, London, 1977, 'The Way of All Feasts', pp. 377-98.

81. A. Le Braz, *The Land of Pardons*, London, 1906, p. xix. The book was originally written and published in French in 1894. It was translated in 1906 by F. M. Gostylyng for which edition Le Braz added a new chapter.

82. A. Le Braz, op. cit., pp. 260-1 also records the entertainment and strongmen. Amusements, refreshments and the sale of other commodities were often part of the events at a Pardon.

83. *R.A. Post-Impressionism*, 1979, M. A. Stevens, p. 22.

Reactions to Renoir
Keep Changing

FRED ORTON

In an essay published in 1970 titled 'The Work of Art as Object', Richard Wollheim sought to characterise what he saw as the dominant theory at work in modern art.[1] This required that he identify the concepts which seem to determine modern art practice, because 'when we act we act under concepts'. The theory Wollheim identifies values a conceptual and practical insistence on the physicality of the work of art: as regards painting, it emphasises or insists that attention is drawn to the surface, and that that surface is used in such a way as to identify itself as the surface of a painting. People acquire concepts of art, or of painting, and these will be operative in the consideration of any painting: what is crucial is that when the spectator looks at a surface as the surface of a painting he or she must look at that whose surface it is as a painting; and for the spectator to be able to look at the thing whose surface it is as a painting there must necessarily be some conception of how the surface should look. What the dominant theory or description of art does is clarify how such procedures are operative.

The account which Wollheim gives of the conceptual and practical hierarchy of modern art is one compatible with the findings of so-called Modernist art criticism and history. That's to say, it's compatible with the criticism of Fry and Bell *pace* Denis *pace* Serusier *pace* Gauguin and so on, with Greenberg's and Fried's, and with the historiography of A. H. Barr Jnr., John Rewald, Robert Rosenblum, William Rubin, John Elderfield, Lawrence Gowing, *et al*. There's nothing surprising about this: Modernist criticism and history, as the dominant critical and historical discourse, is determined by and works with and under the dominant theory.

The dominant theory functions paradigmatically. This is what makes it possible for me to identify that community of specialists, that particular community of interests. It's

not my community, but it is Wollheim's, and his delineation of its dominant theory is correct.

Modernist art criticism and history is also, paradigmatically, a discourse of professional judgements, of evaluations. It sorts out some works as more authentically modern than others and does so by reference to the dominant theory and to the value it places, knowingly or unknowingly, on the insistence on and use of the surface of a painting to insist on its surfaceness as the surface of a painting. This is 'the notorious fact of flatness' – the vivid literal flatness which was recovered at regular intervals by painters after Courbet – which may have involved suggesting forms on the surface, most certainly imposing unity across it: flatness, in play as a conceptual and practical fact of painting. And when Modernist critics and historians approach Renoir's production as valued in the Modernist canon, they are, quite frankly, bewildered. Or to put it another way, when the Modernist critic or historian looks at the pictures in *Renoir* at the Hayward Gallery he is faced with a dilemma because how the surface of a painting by Renoir appears is not how it should look according to the system of concepts and values with which Renoir's status is supposed to be assured. How then does the Modernist viewer celebrate that surface, value it? Indeed, how is the Modernist going to talk about it? How, if you like, is he or she to act under a concept which does not seem to apply or does not seem to have played a crucial role in the determination of the valued painting-to-be-valued and stay in business?

Modernist criticism and history has found Renoir's production problematic. We might say that of all the Artists we read about in the History of Impressionism it's Renoir who causes the Modernist most problems in terms of the value to be placed on his paintings and hence the value of those paintings, and of Renoir, to Modernism.

When I mentioned to one of my students what I thought I might be contributing to this symposium she just couldn't understand why I was bothering to engage with Modernism one more time. The point is it's unavoidable, either as Modernism as the kind of criticism and history I've been talking about up to now which is directly connected through Greenberg and Fry to nineteenth-century French art and theory, or as 'modernism' as a more general category of criticism and history of modern art, a loose configuration of discourses which shares a few basic emphases with Modernism (like 'flatness', autonomy, aesthetic judgement, intuition, quality, and a certain notion of progress). Both Modernism and 'modernism' misrepresent the possible cognitive and historical meanings of art and how and why works of art are produced and consumed in particular circumstances. The need is to replace them with another discourse, a second-order discourse which will have the capacity to become the new first-order discourse and not just inhabit the same managerial space as an alternative coexistent with it. One requirement of this second-order discourse is that it should be capable of including the first (i.e. describing what it describes and explaining what it explains) but that it should also furnish an explanation of how (and perhaps why) the explaining is done. The Social History of Art as a project of historical materialism can be considered

as the second-order discourse on Modernist and 'modernist' art history and criticism and the functions they are assigned in capitalist institutions.[2]

The trajectory of this talk was sparked off not by seeing *Renoir* at the Hayward Gallery or by reading *Renoir* the catalogue but by hearing John House's first-order lecture which accompanied them, 'Renoir and the Earthly Paradise',[3] which he also gave at Leeds. House struggled to apply the evaluative paradigm of Modernism to Renoir's work as a 'modernist' concerned to value it. He explained that Renoir the exhibition, his catalogue essay 'Renoir's World' and the lecture were 'revisionist'. However, there was nothing Marxist-Leninist about them. He meant 'revisionist' in the sense that the 1981 Pisarro exhibition and catalogue – which followed the same route: Hayward Gallery, London; Grand Palais, Paris; Museum of Fine Arts, Boston – had been 'revisionist'.[4] *Renoir* in 1985 could be claimed to be 'revisionist' because it responded to the recognised 'inadequacies of the narrow, a-historical concept that had formerly annexed the nineteenth century to a certain formalist vision of the destiny of twentieth century modernism'; because it seemed to recognise some of the complexities of development within French art and the avant-garde; and because it was 'more responsibly historical, less deformed by hindsight and more intent on searching for significant connections between the visual arts and the broader structures of social and intellectual life of the time'. This isn't House's description of 'revisionism' but it's one that I'm sure he wouldn't disagree with – at least not seriously.[5] The 'revisionist' *Renoir* in 1985 claimed to be examining the full extent of Renoir's achievement, his contribution to Impressionism and his relationship with the European traditions of landscape and figure painting; it was also about making sense of the diversity of his styles and subject matter, and with negotiating the fact that so much of his production was done for the money; and rectifying the lack of serious and consistent critical and historical attention accorded him. No matter how thorough House's 'revisionist approach' was intended to be, it was nevertheless determined to leave the traditional hierarchies of quality in nineteenth-century French painting intact. *Renoir* as inherited value would not be upset. In other words, this 'revisionist' *Renoir* exhibition, the catalogue and the related symposia are concerned with emphasising familiar secure stock and with instating or revitalising less familiar or less secure stock. Here the reproduction of value under the guise of revisionist re-assessment of it stands as the History of Art.

At Leeds, House's 'revisionism' was accompanied by a prefatory explanation or apologia for his involvement in the project, an international exercise in art-historical co-operation sponsored by the American multi-national IBM corporation. One got the impression that House thought that IBM's support and help was necessary, but that it wasn't necessarily 'a good thing'. However, IBM's patronage and the 'revision' of *Renoir* were linked for better or worse. These were House's observations, not mine. Of their kind they're typical. This kind of talk about the sponsorship of spectacular art shows by multi-national corporations has become part and parcel of a certain kind of Social

History of Art. It was interesting to see House using it as part of his presentation and I want to pursue his mention of IBM a bit further. House seemed to be doing no less and certainly no more than Deborah Cherry and Griselda Pollock had done in their review of *The Pre-Raphaelites* and *The Pre-Raphaelite Papers* which he might well have had in mind at Leeds, of course. According to Cherry and Pollock, rightly I think, what was being celebrated then was 'the rising status of the works in academic practice with a full-scale curatorial and art-historical ratification'. They pointed out that the exhibition part of that celebration was

> sponsored by a large, multi-national corporation, Pearson, which is not only the parent company for a range of industrial and investment enterprises but is involved in cultural production through the communications and leisure industries it owns... Pearson is not only exemplifying the practice of legitimating corporate capital by cultural patronage. Financing exhibitions is part and parcel of its daily practices in leisure industries which not only sell commodities, such as the exhibition, the catalogue, the collection of essays, the posters, postcards, and even plates made by Royal Doulton commemorating the exhibition. They also sell meanings.[6]

This formulation now seems a bit inelegant, and some puzzling about its inelegance tells us something about the nature of the Renoir exhibition, the catalogue, House's lecture, my paper, the symposia, etc. Cherry and Pollock are concerned with what multi-national corporations do with culture, but while this is undoubtedly a legitimate concern it tends in its focus on distributive finance to direct attention away from the producers of the exhibition and the catalogue, the producers of the meanings. Furthermore, it seems to me – and this might be a bad reading – to imply that the meanings Pearson sells are somehow its meanings or are *of* it rather than *of* curatorial and art-historical practices. Think of it like this with reference to Renoir: IBM sponsored the exhibition and its catalogue but the meanings produced therein were produced by House, Gowing, Anne Distel, the Arts Council of Great Britain, etc., and it's those meanings which IBM patronises and which might or might not become what the owners of IBM and their employees think of Renoir and his paintings. How then can one conceptualise say Gowing's Modernist and House's 'modernist' place with regard to the production, distribution and exchange of *Renoir* in 1985? I would want to talk about Gowing and House as part of professional management – one of the many and various classes that may be distinguished by their particular relations to the means of production and their political interests and organisations, but which monopoly and multi-national capitalism makes over into the '*bourgeoisie*'.

Professional management burgeoned under capitalism as ownership of the means of production became more and more passive while the 'technical' knowledge – the knowledge referred to and deferred to – of the managerial class enabled it to gain more and more power. A subset of professional management is cultural management which

got going in the nineteenth century with the development of a considered state policy on the arts, in Britain with such figures as Charles Eastlake, President of the Royal Academy, Secretary of the Royal Fine Arts Commission and first Director of the National Gallery (which at that moment bought contemporary British art), and Henry Cole who helped set up the Victoria and Albert Museum and managed the government's design and design education policy. In France, Vivant Denon, General Director of the Paris museums under Napoleon, and in Germany Gustav Waagen, first Director of the Royal Picture Gallery in Berlin (who visited England in 1835 to tour and document its many collections of art treasures, gave evidence before a Royal Commission on Art and Design, and returned throughout the 1850s to advise on State intervention in the arts), can be considered as early cultural managers. They were involved in organising museums and to some extent in art education; they wrote extensively about old and modern art and played leading roles in perpetuating dominant beliefs about what art was and what was to be valued as 'great' art. As intellectuals they also generated values and ideas which were not simply a response to the interests of their patrons and employers. These precedents aside, however, it seems that cultural management really took off in the United States *c.* 1900-30 where one of the first sites of the *consolidation* and *internationalisation* of its power was the Museum of Modern Art, New York. Here the necessity to distinguish between those business-liberal multi-national-capitalists who own the museum and professional cultural managers becomes evident. The Rockefellers may own the museum but who runs it? Some of those who run MoMA may come from the same class as the owners but many of them don't, and didn't: A. H. Barr Jr., for example, the museum's first director; or René d'Harnoncourt his successor; or Porter McCray the director of the important International Program in the 1950s. This class, because of its professional skills, its cosmopolitanism and education, its distributive talents, gained control of the ratification and legitimation of culture. Its ideology is the ideology of professionalism: the organisation of art into production, distribution and consumption. In a sense it manages careers, including its own as self-management. Latter-day Situationists might say that this class manages the spectacle of culture or spectacular consumption.

Cultural management realised quite early that there was a valuation to be made of art as situation free, as free from 'particularistic' or 'localistic' or 'regionalistic' contingencies. The more internationally manageable and distributable art could become then the more powerful it, management, could become as well. This class gained power because it had technical superiority, and, indeed, with its stressed (rather than actual) independence or autonomy from business and political interests and with its professed disinterestedness of aesthetic and historical judgement, it also seemed to have moral superiority. Part of its practice is to devalue any meanings other than those which can be explained and valued in terms of what it saw in its realisation that the production of modern art could be regarded as rule oriented, for example, to and by a dominant theory, rather than causally produced by complex, unpredictable, historically and

culturally specific external forces. It valued 'flatness' (as a meaning ripped apart from its manufacture) and transformed it into a valued product (independent of the consciousness and will of the producers) amenable to distribution on a grand scale. However, if management wants to distribute it has to control quality. Quality control = distribution power. Cultural management is concerned with the kind and quality of cultural production, distribution, and consumption. It controls and distributes culture and produces an apology for it as the thought of non-thought, the official forgetting of historical practice. It tears art from its particularity and makes it a diversity of information newness for quantifiable spectacle consumers.[7]

All of us here are part of this class: we're all managers of culture. Not all of us are official forgetters but we still get caught up in the dominant systems of control and distribution no matter how far away our Archimedian point is located. The bits of cultural management I'm talking about are the ways the managerial apologies for the spectacle of the London-Paris-Boston *Renoir* in 1985 deal with the currency of Renoir's paintings from the late 1880s on. It's these paintings which provoke the Modernist and 'modernist' dilemma, and within them it's the 'nude' that is the most problematic.

As someone interested in Modernism I'm familiar with Greenberg's criticism. In 1950 he wrote an essay on Renoir – in *Art and Culture* it's significantly sandwiched between 'The Later Monet' and 'Cézanne' – the first sentence of which provides the title of this paper: 'My reactions to Renoir keep changing'. One day Greenberg found Renoir 'almost powerful, another day almost weak; one moment brilliant, the next merely flashy; one day quite firm, another day soft'.[8] He thought that part of what caused these contradictory reactions might be the way Renoir handled value contrasts and the un-Impressionist variety of his subject matter. Renoir didn't quite fit into Impressionism: he was more successful with the single figure, the still life, the flower piece than landscape. Greenberg discussed Renoir's use of the 'picturesque', all that was 'viable, transmittable without risk, in the ingredients of proven art', and how it brought him relatively early financial success as well as contributing 'to the genuine felicity of more than a few of his pre-1900 pictures'. It enriched 'the Impressionist slice of nature, unmanipulated by "human interest" and uniform in emphasis from edge to edge of the canvas'. Before he gave up the 'picturesque' toward the end it gave Renoir's art 'a sweeter but also a crisper unity'. Without it:

> his lushness might have spilled over into a suffocating kind of decorativeness,
> given that he had even less appetite in the beginning for sculptural definition than
> Monet and was never quite sure of himself in articulating an illusion of really
> deep space. Always, after the middle 1870s, he tended to half-identify broad
> planes with the picture plane itself and to deal with them in terms of color
> texture rather than spatial function, dissolving large surfaces into dappled,
> swirling iridescences. But he would preserve enough of the motif's actuality to
> keep the eye from questioning the picture as representation of three-dimensional

forms; here the picturesque, with its manipulation of the motif in terms of anecdotal interest and set patterns of design, could serve to firm up the whole and impose coherence. The result often verged on prettiness, but it is perhaps the most valid prettiness ever seen in modernist art.

In the last decades of his life Renoir won through to a new handling of three-dimensional form. He achieved this in two ways: by throwing the entire emphasis of his color on warmth – his adherence to a bas-relief organization of the picture, in which solid forms were lined up on a single frontal, therefore advancing, plane (as in Titian), permitted him to do this with plausibility – and by modeling throughout with white highlights and correspondingly light and translucent coppery reds and silvery greys. It is above all to this high-keyed, aerated modeling that Renoir owes the triumphs of his later nudes, portraits and figure compositions. Paradoxically, it was by dint of becoming more sculptural, having at last tried his hand at actual sculpture, that he joined the Venetians and Rubens on the heights of painterly painting. But wherever he went into deeper space, the outcome still remained doubtful.[9]

Greenberg likes the 'later nudes', the portraits and figure compositions: he refers to them as 'triumphs' but in the end, because of them, he's still uncertain... about Renoir's quality:

Perhaps we are still too close to Renoir fully to appreciate his uniqueness. The current notion of what constitutes paint quality and highly finished painting derives very largely from his art, which in its own time was reproached, like that of other Impressionists, for crudeness of *facture* and lack of finish; and this notion is a compromising one. At the same time, his method of high-keyed modelling has become a staple of academic modernism.[10]

How then to value Renoir? That's still the problem for art history and criticism in 1985.

It's plain to me that the concepts that helped determine the dominant theory or description of Modernist painting and which determine Renoir's paintings of the late 1860s through the mid-1880s do not – unfortunately for the Modernist – reappear as sufficiently or regularly regulative in his work c. 1886-1919. The conceptual importance of the dominant theory's technical features and concerns don't seem to have determined his paintings as much as they do some others', Monet's or Cézanne's for example. This occasions a kind of crisis of evaluation. The concepts of the dominant description cannot be used in the dominant critical and historical discourse except with an unease and a doubt about quality. But the dominant discourse is constrained to use the dominant theory even when it doesn't fit.

The putative evolution of Modernist painting according to the dominant theory has

been characterised as the gradual 'victory' of *surface* over *subject*. For a painter, like Renoir, in whose practice this contrast was raised as a real issue – as an antinomy – it seems that all decisions which had to be taken when making a painting could at some point be indexed to be one or other of these concerns: *vivid surface* or *vivid subject*.[11]

Clearly vivid surface and vivid subject aren't always seen as antinomic in practice. I'm sure they weren't for Monet or Cézanne, or Braque for example – that, I would suggest, is what makes their stock in Modernism secure. Neither surface nor subject predominates: there's a kind of tension (which gets misrepresented in cultural management's assertion of surfaceness and 'flatness' over the meaning of the represented subject). In Renoir's production one finds surface and subject held in tension from *La Grenouillère* (1869, National Museum, Stockholm) until the latter, rather than the former, is emphasised in *The Bathers* (1887, Philadelphia Museum of Art). And when subject is asserted in this manifesto-like painting it is one which is almost impossible to celebrate under the dominant theory.

The 'nude' is a difficult subject for an artist wanting to achieve with the dominant theory of modern art. The problem is one of how to reconcile the vivid emphatic subject and its vivid emphatic plasticity with the conceptual and practical insistence that the surface of the painting be used to insist on its surfaceness as the surface of a painting. How does the 'nude' suffer under this description? It's discredited, even disintegrated. With Renoir painting to the telos of the dominant theory, the 'nude' almost disappears (*Study*, known as *Nude in the Sunlight* of 1875 – Musée d'Orsay, Paris), or else the dominant theory is jettisoned (the *Bathers* of 1887, 1892-5, and 1918-19; the reclining nudes of 1905-7; and the *Judgement of Paris* of 1908 and 1913-14). It's very difficult for Modernist criticism and history to value these post-1887 'nudes', especially when they're placed against the valued achievements of Modernist painting contemporaneous with them, for example Picasso's *Demoiselles d'Avignon* (1907); Braque's *Big Nude* (1907); Matisse's *Blue Nude* and *Le Luxe* (1907)... or *Bathers by a River* (completed in 1916); and Duchamp's *Nude Descending a Staircase* (1912)... or *The Bride Stripped Bare by her Bachelors, Even* (*The Large Glass*, 1915-23). That was 'Modern Art' between 1900 and 1919. However it could be represented, the 'nude' was not plausible as a mimesis of a sensuous body. It became instead the site of a genre struggle for survival under Modernism.[12] How does management go about valuing Renoir's problematic production next to that body of paintings? The answer is, of course, that it doesn't. The cultural managers ignore that complication and assess Renoir as an artist by staying with Renoir's paintings. By acting in response to an unacknowledged necessity – the necessity of the dominant tendency – House, for example, blocks all possibility of representing Renoir's practice as possibly open to different (and maybe contradictory) determinations. 'Modernist' art history is never explicit about the organising concepts it inherits from Modernist art criticism (perhaps because it actually believes that reading Greenberg would be seen as naughty).

In his lecture at Leeds, House, developing his catalogue essay, created a Renoir-

Author-Artist for the paintings who was then posited as the source of their meaning and value. According to House, Renoir found it increasingly difficult to live and paint in Paris and so moved to the Riviera where he created an imaginary Earthly Paradise which became his subject matter. In constructing Renoir in this way House was able to remove the paintings from a history of production and social relations and represent them as the expression of the creative personality of the Renoir-Author-Artist. This is a novel variant on the usual Renoir as a Great Artist theme. House's approach was typical: it's the way cultural management has come to handle artistic individualism; it's monographic, catalogue-raisonnéish; its purpose is to establish an expressive totality and give a comforting coherence to a practice-production which was, and is, best understood as discontinuous and awkward. Admittedly there's nothing particularly Modernist about this strategy but it has become part of 'modernist' art history's idealisation of the modern artist whereby a rational and coherent career is produced and indexed to progressive formal changes in the artist's work. Under the false coherence of this Renoir-Author-Artist, management can create and even isolate a non-disruptive sub-set of the category Renoir: 'Late Renoir' or a 'Renoir of the Earthly Paradise'.

In his essay 'Renoir's Sentiment and Sense' Gowing, like House, creates a Renoir-Author-Artist.[13] This Renoir is also a Great Painter, but one who makes his own kind of sense, one who relied on what was innate; his practice – Gowing says 'self-management' – was impeccably natural and effortless, etc., etc. Gowing's job is distinct from House's. He validates *Renoir* in 1985 by just masturlocating in public. 'Renoir's Sentiment and Sense' strikes me as Modernist in as much as it's anchored in Bloomsburyan formalism and purpled with a Bloomsburyan mixture of intuitionism and emotivism. For the most part all he's doing is uttering value judgements which are nothing but expressions of his preference, of his attitudes, or of his feelings. Gowing's essay is less concerned with explanation and producing knowledge than with getting the reader to accept what he says and how he says it and to use his evaluative expressions about Renoir and the paintings as if they were governed by objective critical and historical criteria – which they aren't. It's difficult to isolate a fragment to give you a flavour of (the pleasure of?) the text. Let this suffice; he begins by out Belling Bell; the 'idea of painting' dictates not only material practice but also the conditions of existence:

> The idea of painting as a quite physical indulgence dictated the philosophy and the coherent strategy of life that were entirely his own. It was itself a kind of originality, and it was entirely conscious; questioned about it Renoir would answer with an unaffected and unforced coarseness. He was neither modest nor boastful about the phallic role in which he imagined his brush. An artist's brush had hardly ever been so completely an organ of physical pleasure and so little of anything else as it was in Renoir's hand. Its sensate tip, an inseparable part of him, seemed positively to please itself. In the forms it caressed it awakened the life of feeling and it led them not to climactic fulfillment but to prolonged and undemanding play without any particular reserve or restraint – or commitment.

If the brush defines and records, it is for pleasure, and the shapes it makes, quivering in their pearly veil, discover satisfaction and completeness. One feels the surface of his paint itself as living skin: Renoir's aesthetic was wholly physical and sensuous, and it was unclouded. In essence his art had no other matter; human identity and character were seen entirely in terms of it. His ethos was ideal for an art that must express physical things in physical terms, and there was no great part in it for theory or thought or reflection, nor perhaps at root even for generosity, open-hearted though he was. His love distributed its favours at random, decorating the visible scene with its capricious indifference. The fruits of his sentiment are abundant in every sense voluminous: few, I think, look at them unmoved.[14]

Much of this is false, most of it is highly contentious, but it is exemplary of the magisterial silliness which the dominant theory can induce in perceptive and intelligent persons.

There are certainly more ways available to the 'modernist' critic or historian of negotiating the problem of assessing *Renoir* in 1985 than those I've mentioned but I want to discuss just one more, a recent strategy which Adrian Rifkin indicated in a graduate seminar he gave at Leeds. Rifkin pointed out how a so-called 'social history of art' had, since the publication of T. J. Clark's *Image of the People* in 1973, become one of the 'official' discourses of the history of art. As the Social History of Art – never a discrete area of study – developed in the 1970s it represented a *relation* with the dominant New York University or Portman Square model, although it emerged from within the institutional space of this model. With the massive expansion of art history as a professional discipline in the 1970s and 1980s the professional field expanded and the Social History of Art became part of this process. To the extent that it did not challenge the *site* of art history or its objects, the Social History of Art became part of the dominant discourse allowing for its renewal and expansion. It became a tool appropriated by 'modernist' critics and historians who had realised that 'any art practice implies a theory of the subject, a theory of history, and a theory of the sign',[15] or who had noted the six substantive issues to be addressed as listed by Simon Watney in his critique of the Open University's *Modern Art and Modernism*,[16] or who had learned a bit of *Language and Materialism*, acquired some New Accents, and read Janet Wolff's synthetic *The Social Production of Art* and thought that that was all there was to it. The 'social history of art' has become part of what cultural management uses to meet challenges to the canon made by the Social History of Art or by its own failure to carry on practice as normal with and under the dominant theory. This false or 'affected' 'social history of art' turns up every so often. Rifkin pointed out how it could be evidenced in *Block* as Terry Smith's essay on Frida Kahlo where the use of Lacan signals biography, etc., Foucault signals health, etc., and Marx signals industry, etc., but where the basic structure of the art-historical narrative remains that of the Institute.[17] At Leeds it turned up more discreetly absorbed and urbanely disarmed, in House's 'revisionist' 'Renoir and

the Earthly Paradise'.

Let us retrieve House's use of IBM's sponsorship of *Renoir*. You can't puzzle the nature of that kind of patronage without a theory of multi-national capitalism and of the way the dissemination of culture must be located within it as one of the forms of connections, interdependences and interrelations which aid but also obscure the global production and exchange relations which characterise capitalism in its latest phase. In the 1930s IBM's slogan was 'World Peace Through World Trade'.

House also talked about class – or rather, he didn't talk about class, that's my point. He talked about the *bourgeoisie* and with reference, for example, to *The Apple Seller* (*c.* 1890, the Cleveland Museum of Art) about a commercial transaction between a peasant woman and a bourgeoise and her children. In his catalogue note he points out how 'the pyramidal arrangement which encompasses all four figures draws them into a single harmonious ensemble'. I'd say that here House was raising the problem of representing class and even, maybe, of the Renoir family's relation to the *classe ouvrière* and the *bourgeoisie*. It doesn't really matter if the seated woman isn't Mme Renoir and the children aren't Pierre and nephew Edmond Jr.; Renoir, it seems to me, is painting himself, Aline and the kids into the *bourgeoisie*. You can't get anywhere puzzling *The Apple Seller* constrained by the closures inherent in the dominant discourse which restrict explanation of the meaning of the picture to a description of the formal and technical possession of the surface: the subject as language-object, composition, brushwork, colours and value contrasts. *The Apple Seller* has to be seen as an ideological representation of changing social relations and developing circumstances (that arrangement and technical use of the surface, as it were, harmonising and concealing those relations and differences, beliefs and values... making them seem 'natural') and as *of* Renoir as a producer working for specific audiences and publics.

I also want to flag House's discussion of the metropolis. It would be wrong to claim that this interest in late nineteenth-century Paris and in representations of it had been appropriated from the Social History of Art. Since Meyer Schapiro's work in the 1930s both 'modernist' and materialist art historians have been interested in Parisian civilisation of the Third Republic. Maybe there is something appropriated from recent work in the Social History of Art on metropolitan Paris as a place to paint, a place to paint in and a place, in the mid-1880s, to leave.[18] But I wouldn't want to emphasise that claim too strongly. It is more to the point to say that if the 'modernist' does not see the various pictures of Haussmann's Paris and of life in it as representations of the contradictions and uncertainties of nineteenth-century capitalism then he or she must be seeing them superficially. House seems to see them in that way, as representations of contradictions. I've noticed that 'modernist' critics and historians have recently taken to using '*contradiction*' in their vocabulary. They've learned a bit of the lingo so they can package what they have to say in a way that betokens current art-historical fashion and intellectual up-to-dateness and yet remain acceptable to the multi-national gallery, publishing, and university systems. House uses '*contradiction*' to describe Renoir's

paintings and his reactions to them. However, it has to remain a relatively meaningless usage uninformed as it is by the basic structural contradiction of capitalism identified by Marx. It's a matter of reading the founding texts; and that might mean giving up a fear of the texts in question.

Penultimately, I want to argue with House's use of what one can call 'presences and absences' – another part of the Social History of Art. House showed how Renoir left out of his paintings of Cagnes certain aspects of the process of urbanisation there. He also never painted the villa he had built at Les Collettes, preferring instead to paint the farmhouse in the grounds. So what? Monet, one of the best train spotters in the History of Impressionism, never, as far as I know, painted the railway which ran beside his lily ponds (quite a busy line – I would have thought – between 1914-18). What does one make of this kind of thing? It's got to go to more than a compare and contrast exercise: compare art with the reality it claims to picture or conjure away. What art? What reality? For the historian these are problems of how to work through the links between the historically and culturally specific representations, the partly autonomous determinations of 'technique', and the totality Marx called 'social practices'. Here, again, we're back with the founding texts.

Finally, I want to mention House's use of feminist work in the Social History of Art on representations of women. As I argued earlier, it's difficult for the 'modernist' cultural manager to value the 'nude' as genre – at least as Renoir works with it – in terms of the dominant theory of modern art. Discussion on the way the surface of the painting has been used to insist on its surfaceness as the surface of the painting closes down on talk about what is there described by and in paint on the surface: a naked male or more often a naked female. One of the achievements of feminism has been to make talking convincingly about the 'nude' even harder. Over the last ten years or so the genre and its attendant conversation have gained a new political import. House managed to talk about the 'nude' and circumvent the issues of cultural politics, class, gender, subjectivity etc., etc., by playing on feministic metaphors – for example woman as the bearer of the look displayed for the male gaze – while keeping his idea of 'Renoir's nudes' securely within the parameters of the traditional masculine discourse on art.

To sum up: the Social History of Art has become available for appropriation by the 'modernist' critic and historian who finds it difficult to value the art he's got to value with the concepts he works with and under when the concepts don't appear in the art and so can't appear convincingly in his discourse. So what does he do? He diversifies by bringing in some terms of reference from the discourse which can talk about the art in question because it works with and under different concepts. This ends up at best as a liberal or permissive pluralism of approaches, or a 'revisionism' uncertain about what to make of its own limited achievements,[19] or a 'social history of art' ignorant of and inconsiderate of why, how, by and for whom the Social, History, and Art are constructed.

When I rehearsed some of the points I've been making with that student I mentioned

earlier she said, 'O.K., but in the end all cultural management has to do is bring the bits and pieces into the spectacle. It doesn't have to talk. All it has to do is put the paintings on the wall of the Hayward, pretend they speak for themselves, construct their own rhetoric. That is a valuation. Anyway I still don't understand why you're talking about Modernism, assessment, quality. It's not how we see the paintings.' She's right, of course. We don't, but the dominant discourse, Modernism or 'modernism', does. And reactions to Renoir will keep changing, and cultural management will hold the canon for a while longer. Eventually, however, it's got to give. Eventually we'll be rid of the illusion of culture, and we'll all act under different concepts.

My thanks to John House for inviting me to contribute a paper to the Arts Council sponsored Renoir symposium, Courtauld Institute of Art, London, 29 March 1985, and to Charles Harrison, Alex Potts and Adrian Rifkin whose conversation helped produce that contribution and this amended and extended version of it.

Notes

1. Richard Wollheim, 'The Work of Art as Object', *Studio International*, vol. 180, no. 128, December 1970; revised version in Wollheim's *On Art and the Mind*, Harvard University Press, 1973, pp. 112-29.

2. The idea of a second-order discourse is derived from work in *Art & Language*. See Michael Baldwin, Charles Harrison, Mel Ramsden, 'Art History, Art Criticism and Explanation', *Art History*, vol. 4, no. 4, December 1981, pp. 450-53 and the later elaboration in 'Manet's Olympia and Contradictions (A propos of T. J. Clark's and Peter Wollen's recent articles)' in *Block*, vol. 5, 1981, pp. 34-43.

3. *Renoir*, catalogue by John House and Anne Distel, with essays by John House, Anne Distel and Lawrence Gowing, London: Arts Council of Great Britain, 1985.

4. *Pissarro*, catalogue with essays by John Rewald, Richard Brettell, Françoise Cachin *et al.*, London: Arts Council of Great Britain, 1981.

5. These fragments are taken from Kirk Varnedoe, 'Revisionism Revisited', *Art Journal*, Fall/Winter 1980, p. 348. Despite the mention of T. J. Clark's (pre-Harvard) work, this is a wholly conservative account of a trend in contemporary scholarship. Varnedoe has in mind the art history of Robert Rosenblum, Pierre Rosenberg, Robert Herbert, John House, Mary Anne Stevens, *et al.*

6. Deborah Cherry and Griselda Pollock, 'Patriarchal Power and the Pre-Raphaelites', *Art History*, vol. 7, no. 4, December 1984, p. 481.

7. Management of the art world has been a topic of conversation within Art & Language in recent years. See, for example, 'A Cultural Drama: The Artist's Studio', *Art & Language*, Los Angeles Institute of Contemporary Art, 1983, pp. 10-11:

> Mel Ramsden [...] In order to enter Art & Language work you have to cease to be a managerial person, an administrative person, and you cannot, in a sense, consume it and stay secure in your consumption. In order to talk about it in any detail you have to participate or enter into its discursivity. And this has been a perennial problem, and it's proper that it should be. If you look for the reviews of Art & Language you will find that there really haven't been any. Art & Language has always made the relationship between the eternal assumptions of the work and the internal participation of the work very problematic. We continue to try to reproduce this. We continue to address and attack the managers of the art world. Mike Baldwin: you make it sound as if somehow there are these 'baddies' – the administators and managers of the art world – and then there's us 'goodies'. The point is that we live in a culture of management. The post-Nietzschean culture is a barbaric one. It has no workable aesthetic except a managerial one. The managers are not just people who happen to wear suits or sell art. They happen to be in charge, but it is our culture which puts them in charge. It is in virtue not of some non-natural quality supervening over management and managers. When we discuss management we suggest that the culture is characteristically managerial.

I am greatly indebted to Mel Ramsden for introducing me to 'cultural management' in some notes of his critical reading of my work-in-progress on the Museum of Modern Art, New York, and to Alex Potts for indicating its nineteenth-century precedents.

8. Clement Greenberg, 'Renoir', *Art and Culture-Critical Essays*, Boston: Beacon Press, 1961, pp. 46-9. Greenberg's reaction is entirely typical of the perpetual oscillation induced when a paradigm confronts an object which refuses to conform to its categories.

9. Ibid., pp. 47-8.

10. Ibid., pp. 48-9.

11. For an extended discussion of vivid surface and vivid subject see Charles Harrison and Fred Orton, 'Jasper Johns: "Meaning what you see" ', *Art History*, vol. 7, no. 1, March 1984, pp. 78-101.

12. In mind here were Lisa Tickner's notes on 'Modernizing the Nude: Survival, Revival' in 'Allen Jones in Retrospect. A Serpentine Review', *Block*, vol. 1, 1979, pp. 34-40.

13. *Renoir*, op. cit., pp. 30-5.

14. Ibid., p. 32.

15. Margaret Iversen, 'The Avant-Guardian Angels', *Art History*, vol. 6, no. 4, December 1983, p. 497.

16. Simon Watney, 'Modernist Studies: The Class of '83', *Art History*, vol. 7, no. 1, March 1984, p. 109.

17. Terry Smith, 'From the Margins: Modernity and the Case of Frida Kahlo', *Block*, vol. 8, 1983, pp. 11-23.

18. For example, Fred Orton and Griselda Pollock, 'Les Données Bretonnantes: La Prairie de Représentation', *Art History*, vol. 3, no. 3, September 1980, pp. 314-44. Ch. 2 in this volume.

19. See Varnedoe, op. cit., p. 349:

> Increasingly impressive government and corporate funding and generous museum publicity cannot obscure the fact that our recipes are inadequate to the proliferation of new ingredients; in significant ways, interested tolerance becomes a mask for our uncertainty about what to make of it all. Apparent incoherency, the breakdown of rigid order, and the proliferation of diversity are characteristics, perhaps the characteristics, of the development of nineteenth-century art. This does not mean that an honest and responsible art history of the period need itself be characterized by the same features. Levelling alone is an inadequate replacement for a false exclusivity. It is stimulating to see new images, and it is certainly pleasurable to understand and enjoy more than a few Olympian artists. But a worthwhile revisionism should eventually portend more than simply a plethora of new information, new pictures, and lesser doctoral theses.

This strikes me as a lament for 'revisionism's' appearance of accumulating information and of not knowing how to make it cognitively productive – or of avoiding doing so.

Chapter 4

Van Gogh and Holland:
Nationalism and Modernism

GRISELDA POLLOCK

Vincent Van Gogh was indubitably Dutch. He was born in the village of Groot Zundert, Noord Brabant on 30 March 1853 to the family of Theodorus Van Gogh and Anna Carbentus-Van Gogh. As a result he had Dutch citizenship in terms of legal status. But in what ways could 'Dutchness' in these terms inflect or determine what Van Gogh the artist produced? Cultural nationality was a relatively belated construct. It was indeed to become one of the defining modes of nineteenth-century art history, which classified the cultures of the Europe's past in terms of national schools. These patterns informed the arrangements in newly founded art museums, and were publicised in such magazines as the *Gazette des Beaux Arts*, initiated by Charles Blanc in 1859, who also undertook to edit a massive publication titled *Histoire des Peintres de Toutes les Ecoles* (1849-73). He personally wrote the volume on *L'Ecole Hollandaise* (Paris, 1861). Hegelian ideas of art as emanation of a national spirit and Hippolyte Taine's positivist notions of 'race, milieu et moment' informed nascent art history's cultural nationalism.[1] Nations, either very recently formed or still in the process of being established as political entities, such as Italy, the Netherlands, France, Germany, became the organising principle through which to understand the cultural production of long-established geographical communities connected, sometimes very tenuously, by subtle cultural phenomena such as custom, religious affiliation, and language. Obviously the larger states like France had achieved the appearance of national identity under the rule of its absolutist monarchs since the seventeenth century, but the country itself remained fractured by regional, religious, economic and linguistic differences which were hardly eroded until the later nineteenth century.[2]

At the very moment, however, at which these historical narratives of national schools

were being widely promulgated as the basis for art history, the impulse of modernism was beginning to undermine cultural particularism and prepare the way for cultural internationalism. Modernism is the cultural phenomenon of the economic processes of modernisation – industrialisation and urbanisation associated with the global assault of capitalism. Capitalism is theoretically indifferent to national boundaries. None the less, in its actual, uneven historical development, it has been shaped within national forma-tions, been fostered or delayed by different kinds of state, been aided or defeated by existing class systems, flourished with or been starved by local economic resources. The world capitalist system has been, therefore, differentiated into national capitals. But national frontiers have been less decisive than the complex conjunctions of social, polit-ical, geographical, cultural, and traditional forces which dominated within the power blocs of nations conceived of as complex entities, simultaneously economic, political, and cultural. Much ink has been expended by economic and social historians in analys-ing the quite different impact of industrial capitalism in Belgium and the Netherlands, neighbouring territories which only became separate nations in the 1830s. Why did what we now know as Belgium industrialise as rapidly and successfully whereas the Provinces to the North seemed resistant and only belatedly in the period after 1850, and especially after 1870, began to undergo that radical transformation of economic processes and social relations?[3] The answer is not my job; but the question alone makes the point.

Modernism was and is a transnational phenomenon – or at least it tended to efface local particularism in pursuit of ways to deal with its topic and resource, modernity. Modernity can be understood in part as the very process by which local differences were erased and a general culture began to colonise and homogenise the world brought into varieties of contact through colonisation, trade, commerce, political power and tourism.

In the narratives typical of modernist art history, the Netherlands have their mod-ernist moment with figures such as Mondriaan and the De Stijl movement.[4] These are clearly legible in terms of transnational modernism which is defined by a set of core con-cerns inflected by local, but, more typically, purely individual differences. In her impor-tant article attempting to break open the modernist straitjacket in which De Stijl has been trapped, Jane Beckett argued that the emergence of Dutch modernism must be sit-uated in the context of a series of discourses through which the Netherlands was being constructed as an industrial nation.[5] Modernisation restructured the Dutch economy, remaking its cities so that there, too, people experienced what had been the decisive for-mation which had made Paris from the 1850s to the 1880s what Walter Benjamin called 'the capital of the nineteenth century'.[6] Berlin was to undergo the process in the early twentieth century and with that change in the city, we witness a development of a mod-ernist avant-garde as well.[7] While Amsterdam was to become the modern city within Dutch modernism in the last years of the nineteenth century, it was in The Hague that Van Gogh attempted, unsuccessfully, to fabricate a self-consciously modern practice based on the processes of modernisation evident in the expanding and changing economic

geography of this traditional capital city.[8]

Van Gogh is both paradigmatic and exceptional as a case study through which to examine the contradictory forces of modernism and nationalism. While Mondriaan functions as both an artist with clear Dutch connections, to the Hague School for instance, and as a canonical modernist master who ended up in New York as a part of the international transfer of modernism,[9] Van Gogh seems, however, an aberration in the story of modernism. For a long time, his Dutch origins were effectively suppressed. Classified in innumerable slide collections and exhibitions as a French artist, his career was neatly divided by one author into a backward-looking apprenticeship in a provincial backwater, followed by an explosive moment of maturity when he entered the mainstream of modernism by moving to France.[10] The same narrative informs the texts of John Rewald, the author of one of the most used textbooks on the history of Post-Impressionism, *Post-Impressionism: From Van Gogh to Gauguin* (New York: Museum of Modern Art, 1956).

In 1980 I organised an exhibition at the Rijksmuseum Vincent van Gogh titled *Vincent van Gogh in zijn Hollandse Jaren: Kijk op stad en land door Van Gogh en zijn tijdgenoten 1870-90*. Its major purpose was to exhibit Van Gogh's work in the context of contemporary Dutch painting and its exploration of the antimonies of city and country. These were topical concerns in all European painting, but they were inflected in quite specific ways in Dutch art, ways which Van Gogh tried to assimilate, and, in failing to do so, dramatically subverted. Inadvertently this show was but the beginning of a series of massive exhibitions devoted to the work of Van Gogh held in Amsterdam and Toronto *(Vincent Van Gogh and the Birth of Cloisonism* 1981), Paris *(Van Gogh à Paris* 1987) and, of course, New York *(Van Gogh in Arles* 1984 and *Van Gogh in St Rémy and Auvers* 1987) in the last decade. Within this exceptional clutch of shows, four exhibitions have been devoted to the work of the period 1886-90, namely Paris and after, while my show, covering Van Gogh and contemporary Dutch art in five important years, 1880-5, was but one small local event with no international circulation and a catalogue left in the international obscurity of the Dutch language. (None of the other catalogues were published in Dutch.) This exhibition received no corporate sponsorship.

Big yellow and blue pictures are more easy on the eye than Van Gogh's black and white drawings and sombre representations of rural emiseration. In the twentieth century, France is a more popular tourist experience than the Netherlands – a reversal of the nineteenth century. More viewers it would seem can relate to the Langlois Bridge (*The Langlois Bridge with Women Washing*, F397, March 1888, Otterlo Rijksmuseum Kröller-Müller) than to its genuine Dutch prototype at Nieuw Amsterdam in Drenthe (*The Drawbridge at Nieuw Amsterdam*, F1908, November 1883, Groningen, Groningen, Museum).

The radically uneven attention paid to the work of Van Gogh produced when he lived on French soil and what he made when living in the Netherlands provides some direct evidence of the difficulty of accommodating Van Gogh's Dutchness to his position in

modernist narratives and in the consumption of modern art.

I am not a Hegelian trying to discern the intrinsically Dutch character of Van Gogh's *oeuvre*. I do not believe in national identity as a matter of race, genes or even environment. Yet we must take into account the historical and social effect of discourses, practices and customs within which people are formed as social subjects in histories not of their own choosing. The term, subject, is typically used now to refer to a psychological construction of subjectivity, but we are also socially formed subjects, and become, in all senses of the word, the culturally specific subjects of our diversified societies. Bearers of and actors in a culture, we are also subjected to it and subject to its authorities. In this sense, it is argued, we are the subjects of ideology which creates identities which we live out contradictorily. For these identities and the values and beliefs associated with them are always part of the processes of social power and domination, what Antonio Gramsci defined as 'hegemony'. Raymond Williams has carefully stressed the distinctions between traditional notions of ideology and the more expanded concept of hegemony. Culture can then be grasped as part of a continuing process of domination and subordination, of pressures and limits, that go beyond the articulation of ideas and beliefs to saturate the whole living process. Williams writes of hegemony saturating 'the whole substance of lived identities and relationships, to such a depth that the pressures and limits of what can ultimately be seen as a specific economic, political and cultural system seem to most of us the pressures and limits of simple experience and common sense'.[11] Williams's theorisations of hegemony permit us to grasp a social and cultural system as a complex of determinations and relations rather than as a geographical or racial entity, or a mere extension of some political arrangement. He also insists that a culture is an active process, with its dominant features and elements constantly under pressure from emergent forces it may or may not be able to incorporate without being radically transformed. These include traditional, residual as well as newly emerging elements. Powerful as an organiser of hegemony is tradition itself, which Williams identifies as much more than the sedimented past. Instead he defines it as an actively constructed, selective and present-shaping version of a past 'powerfully operative in the process of social and cultural definition and identification'.[12] Thus, while there is no transhistorical Dutch character to which we can refer Van Gogh, or his works, we can use Williams's formulations to argue for a specific configuration of factors within which Van Gogh was shaped, socially and ideologically as a citizen, and to go on to specify his cultural particularity within that formation which constituted the conditions for his interventions in artistic practice. In my doctoral dissertation, 'Van Gogh and Dutch Art: A Study of Van Gogh's Notions of the Modern' (London University, 1980), the exhibition in Amsterdam which I curated in 1980, and recent articles on Van Gogh's Dutch period, I have been trying to avoid modernist indifference to cultural specificity while also escaping from idealist notions of national essences and identities.[13] Such a project involves relocating the relationships between Van Gogh's work, contemporary nineteenth century representations of Dutch art of the seventeenth century and the formation of modernism.

Van Gogh was born in Brabant, and educated there. But from early adulthood he travelled. Van Gogh worked in The Hague (1869-73), London (1873-5), Paris (1875), Ramsgate/ London (1876-7), Dordrecht (1877), Amsterdam (1877-8), Brussels (1878) Wasmes (1878), Brussels, (1880-1), Etten (1881), The Hague (1881-3), Drenthe (1883), Nuenen, (1883-5), Antwerp (1885-6), Paris (1886-8), Arles (1888-9), St Rémy (1889-90), Auvers (1890). At one point he called himself a cosmopolitan, a fair enough claim for someone who spoke several languages and read history, poetry, literature in Dutch, German, French and English and lived in four European capitals. It was not, however, money and status, the typical necessities for the cosmopolitan, which made Van Gogh a European; it was his access to its culture. In his collected letters, there is a recurring theme of a homeland of art. This homeland was culled from his reading, collecting of images, and erosion of the boundaries between the fictionally constructed or artistically fashioned land or cityscape and actual locations. London for Van Gogh was the London of Charles Dickens's novels and his Paris was a confection of Victor Hugo and Emile Zola. Van Gogh's culture was a modern form of *bricolage* and it shows. Thus Van Gogh's access to European culture of the nineteenth century was quite different from the aristocratic patrimony of the eighteenth-century gentlemen who made the Grand Tour. Van Gogh's connection to those he called the 'leaders of the nineteenth century' (Eliot, Carlyle, Dickens, Millet, Corot, etc., LT 307, 429, LW 307) was a direct product of modernisation: the international distribution of culture through books, prints, magazines, photographs.

Commodity capitalism expanded the publishing industry. It led to international distribution of cheaper books and, as importantly, engravings, prints, and photographic reproductions. Van Gogh intimately knew collections of art he had never visited and drew from paintings he had never seen. He claimed a place in a lineage of artists fabricated from art history books, magazines and cheap prints he collected. Employed, moreover, by Goupil's, an art dealing firm which had branches in Paris, London, Brussels, The Hague, and eventually New York, Van Gogh was a participant in that very process. The 'Van Gogh' of the Complete Letters is both symptom and effect of the expanded systems of communication and new media, international systems of distribution facilitated by new rail networks and steam boats, telegraph communication, international exhibitions celebrating colonial power and commerce.

Writing on 15 October 1881, to the Dutch artist Anton van Rappard, whom he had met in Brussels, the artist Van Gogh made the following programmatic statement:

> Therefore speaking only from an artistic point of view, I tell you that in my
> opinion, you as a Dutchman will feel most at home in a Dutch intellectual
> climate [hollandsche opvatting], and will get more satisfaction by working after
> the character of this country than by specialising in the nude... The more we
> know of what is happening abroad, the better, but we must never forget that we
> have our roots in Dutch soil. (LR 2)

At first sight, this might read as a statement of nationalist retreat. Ignore what is happening outside the Netherlands (France in particular) and concentrate not only on existing in a specifically Dutch cultural context, but on representing the very land itself, Dutch landscapes and Dutch people. The letter is enunciating an artistic strategy, but it rests upon a complex logic.

There is a double movement, a dual viewpoint. On the surface, the letter presents itself as a statement of rejection and withdrawal. To retreat, a person must have the option of having that which is being rejected and withdrawn from. The meaning, therefore, depends on a series of oppositions: national/non or international; specific/general; metropolitan/local. The international or rather the non-national language of art was still that of classicism, signified here by the reference to the nude (life class, history painting, erotic art). Academic theory, basing itself on Raphael and the later Italian Renaissance, proposed a general standard of perfection and aspiration which set the agenda for the artist and her/his public in terms of execution, content, ambition and forms of appraisal. Against a non-specific but general programme for art, the academy and the nude (the abstract and synthesised ideal body), this letter sets up the specific and the local: Dutch places and people. The writer/artist has already tried to inhabit that general space of art, but the rejection of it is represented as a kind of return by which can be regained something which has a more authentic and genuine use value for the artist. This is a source of inspiration founded in memory and bathed in nostalgia.

Raymond Williams has pointed out in his important study of *The Country and the City* that nineteenth-century literature offers many examples of a correlation between images of the countryside and memories of childhood, especially in writings by authors who personally experienced the transition from agrarian to urban society so characteristic of European modernisation.[14] The metaphor of rootedness plays on both having grown up in the country and on continuing to be nourished by it. The metaphor occurs often in writings by Van Gogh. From Drenthe in 1883, he wrote to his brother about becoming an artist in the countryside and he exhorted him not to wither on the side walk, but to germinate in the soil (LT 336). Later in Auvers, in 1890, being rooted in the countryside functioned as an alibi for landscape paintings such as *Crows over the Wheatfields* (early July 1890, Amsterdam Rijksmuseum Vincent van Gogh, LT 649).

As importantly, the terms of this letter imply an awareness that Dutch subjects have a currency as a resource for artists in the general marketplace of art. Yet the very notion of Dutch soil depends upon the valuation of specific Dutchness which can only be understood by its relation to the non-Dutch, and thus to the outsiders for whom some specific set of signs signify Dutchness. This is, of course, the discourse of tourism.[15]

Tourism establishes a picture of otherness for a metropolitan gaze. The difference that tourist discourse establishes, depends upon and results from a process of differentiation taking place from a perspective which has to be outside what the tourist looks at and consumes so that the tourist can be made to want to visit, look and consume that which is different from the familiar. Tourism thus establishes specific representations of that

which its discourses and practices select and mythologise. Dutch landscape and its farming communities became subject to tourist inscription at two levels during the nineteenth century. There is much evidence of actual tourism through guide-books and holidays. G. H. Boughton's *Sketching Rambles in Holland with illustrations by the author and Edwin Abbey* (New York, 1885) is a typical crossover in which artists holiday by travelling and sketching and thus produce an illustrated guide-book, already coding the countryside and the population for artistic viewing. Representations of contemporary Dutch landscape were also circulated by artists of the Hague School in quite new ways in the later nineteenth century. Indeed it can be argued that they contributed to a redefinition of what 'Holland' signified. As late as the mid-nineteenth century, guide-books encouraged the visitor to the Netherlands to visit a series of cities and towns which were remarkable for their architecture and quaint features such as canals and drawbridges. They were indices to the historical moment in which a national identity had been established in the early seventeenth century. In the very period of a new wave of urbanisation and economic modernisation, Holland became for the non-Dutch synonymous with the countryside, a quiet agricultural backwater which resisted the impact of modernisation and industrialisation – the very forces which seemed to erode the local and traditional character of the Netherlands' more advanced neighbours from whose populations tourists to Holland were drawn.

The cult of cultural nationalism in historical and art historical narrative, to which I referred at the beginning of this paper, has important correspondences in the patterns of tourism in the nineteenth century in which urban metropolitan bourgeois sought out so-called remote and unspoilt places where the past could still be held onto through the cultivation of the *folklorique* and the picturesque. Dutch fisherfolk shared with Breton weavers, Dutch peat diggers with Tahitian mango-harvesters, the attraction of being perceived by certain Europeans as difference, the past, the non-modern. They became signifiers in an urban discourse seeking to found an understanding of the modern by inventing its opposite. In place of change, images of a traditional countryside signified stability and timelessness. As against the pressures of modernising homogeneity, less advanced regions were treasured for their local diversities and particularities. A few months before writing the letter cited above to Van Rappard, Van Gogh, in a letter to his parents dated February 1881, listed the collection of costumes such as miners' grey trousers, fishermen's oilskins and sou'westers, peasant smocks which he would like to acquire. He also told them that he was toying with going to Blankenberghe, Scheveningen or Katwijk to work. These were the well-known tourist villages to the readers of Baedecker's and Murray's guides for travellers. Scheveningen was well connected by rail with the Rhine lands and Paris.

Van Gogh calculated well. Such images of this Holland of poor fisherfolk and rural peasants in their humble cottages and barns were to make Josef Israëls a rich man. It has been calculated that large watercolours by this Hague School artist would sell for 9,000 guilders in the 1890s, the equivalent to the price of a substantial bourgeois villa in a

smart suburb. The painters of the Hague School were, with the French painters associated with the village of Barbizon, massively popular with the industrial bourgeois collectors of France, England and North America.[16] In addition, artists from other countries came to paint this agricultural tourist view of the Netherlands: Monet en route to England in 1870[17] and, most consistently, the German painter Max Liebermann.[18] The image of Holland signified by fresh-faced women in white caps and clogs, windmills and dykes persisted well into the twentieth century and is still residually present at Schipol's gift shops where I can buy clogged and white-capped Dutch dolls for another generation.

In his subsequent art work based on Dutch subjects, Van Gogh, however, went wrong. He failed to understand that the pleasures offered by a mythologised Holland depended on managing the internal opposition which structured it. Acknowledgement of the modern was peacefully disavowed by the carefully calculated rhetoric of a misty landscape populated by pacific peasants and munching sheep (for instance, Anton Mauve's *The Return of the Flock*, Philadelphia Museum of Art; or Josef Israëls's *Midday meal in a Cottage at Karlshaven*, 1885, Dordrecht, Dordrechts Museum). In analysing the conditions of existence of Van Gogh's major painting of Dutch rural life, *The Potato Eaters* (fig.10, 1885 Amsterdam, Rijskmuseum Vincent van Gogh), I have argued that the painting failed because it did not achieve the necessary degree of mythologisation. It failed to suppress 'history' and translate it into the carefully considered colour codes and compositional schemes which alone made such scenes available for artistic representation and touristic consumption. Van Gogh produced this multi-figure composition of Nuenen poor at their dish of potatoes as a modern, history painting. The traditional conventions of academic art, typically reserved for representation of the general and the ideal, were to be coopted to figure the specific and local, and to register pressure of history. In immediate and contemporary terms this meant representing the factors of time and change on the land and its workers. *The Potato Eaters* did not picture traditional peasants, but showed the inhabitants of Nuenen as a now emiserated rural proletariat.

Based on detailed first-hand study in the cottage of Cornelia de Groot in the village of Nuenen, the painting was none the less riven with contradictory impulses which can be listed as nostalgia for a passing rural world, anger at the effects of modernisation, fantasies of a simple life conceived by a bourgeois all the more intensely captivated by his class and gender in the alienation from bourgeois society's sexual and sartorial mores expressed through a fantasy identification with a life of brutal poverty misrecognised as 'simple peasant life'. The pressure to make this image of rural life register the network of conflicting desires and beliefs produced a work that indelibly registered the modern and was, therefore, for its first viewers, literally unspeakable.[19] With the radical failure of this painting, Van Gogh abandoned the project for a modern art based on rural Dutch life and went back to the city, leaving the Netherlands to live first in Belgium and then France.

The project of the next five years (1886-90) was still motivated by the need to shape

a programme for making a modern art, and to belong to that self-conscious artistic community which was shaping up in Paris, the avant-garde. But it is my contention that the strategies formulated under this impulse were founded on a disavowal of history and of the modern. This withdrawal was made possible precisely through the currency of art history's emergent cultural nationalism.

Van Gogh not only became a tourist in France, both in Paris and more so in Provence. But he became a tourist in time. In the summer of 1888, he outlined a programme for modern art in letters to the Parisian artist, Emile Bernard, based with Paul Gauguin in the tourist village of Pont Aven in Brittany. The terms for this modern art Van Gogh outlined were a confection composed from his reading of the new art historians, writers such as Charles Blanc (author of books on the Dutch seventeenth-century school and on Rembrandt) and Eugène Fromentin, (author of *Maîtres d'Autrefois*, 1876, the journal of a trip to the Netherlands and round its museums, and a Tainean study of the national character of Dutch art expressed through the portrait and landscape). The most important resources were, however, the writings of Théophile Thoré (who published under the pseudonym Willem Bürger), the republican critic who was to have such an impact on the writing of art history of Dutch seventeenth-century art. Thoré's special significance, to nineteenth-century artists, lay in the persuasive ways he argued that a model for modern art could be found in the very features which defined the distinctive, local character of Dutch seventeenth-century art, embodied in the *oeuvres* of Rembrandt, enjoying a major revision of reputation, Hals, reclaimed from the Flemish school and disgrace as a mere painter of low life, Ruysdael, the epitome of the home-loving romantic landscape painter, and Vermeer, virtually reconstituted by Thoré's research.[20]

Thoré 'nationalised' the hitherto transnational, academic, or classical tradition. Displacing it from its status as the general and absolute standard, he made it merely local. Classical art (Raphael was its paradigm) was presented as Italian, southern, Mediterranean, and Catholic. Taine's categories of 'race, milieu, et moment' and Hegel were used to qualify the eighteenth-century North/South, spiritual/rational, mystical/material set of polarities in specific relation to national entities. A Dutch nation and a Dutch culture had emerged in the seventeenth century from the struggle against a Catholic empire, a monarchy, an aristocracy and the weight of tradition. In contrast to the Italianate tendency to use the abstract and the symbolic, the Dutch made an equally significant and specifically democratic, hence modern, art by portraying the specific individual or the local landscape.

Thoré's prime example was Rembrandt's painting of *The Anatomy Lesson* (1632, The Hague, The Mauritshuis). According to Thoré, Rembrandt represented the idea of science not by emblem or allegory, but by a portrait of a scientist: 'It is simply the substitution of Man himself for all hieroglyphs, logogryphs and enigmas.'[21] By means of the specific and the individual, Dutch art could be read as a model for a modern, democratic art, relevant as the cultural paradigm for the struggles of contemporary European

nations for a social and thus modern democracy.

I now want to identify another, double movement. What looked at first sight as the opposite to modernist transnationalism, namely art history's cultural nationalism, functions now as the very articulation of a kind of modernist programme. For Thoré the issues of culture were simultaneously political. He was a bourgeois republican whose art history was produced while in exile from Napoleon III's Second Empire. Van Gogh's appropriation of Thoré's critical discourse to formulate his modernist programme inscribes a Dutch grasp on Thoré's French and also nationalist republicanism. Within a Dutch context, Van Gogh's attachment to the 'democracy' of the Dutch patriciate bourgeoisie of the seventeenth century could be read as a reactionary and conservative position, significantly different from republicanism in French political configurations. (Republicanism was often associated with promotion of *laisser-faire* capitalism, while Van Gogh's ideological position was romantically anti-capitalist and opposed to social democracy's qualified support for capitalism.)

The critical *bricolage* of which Van Gogh's later work was composed, made it a combination of several forms of tourism – geographical, historical, temporal and finally aesthetic. The latter was largely the effect of art history whose publishing formed the basis for his extensive *'musée imaginaire'*.[22] The modernism he forged was one in which the modernity, the historical process, momentarily engaged with while living in Holland, was banished and the world he invented was one composed entirely from art. The midwife for this reactionary modernism was ironically the cultural nationalism of emergent nineteenth-century art history.

He could legitimate a retreat from the social crises and contradictions of the modern world by coming perilously close to copying the work of seventeenth-century Dutch art, Rembrandt and Hals in particular (and later nineteenth-century French painters such as Millet and Michel). Evacuating the present, the sources Van Gogh used enabled him to raid the past in the name of progress towards an imaginary future. The discourse of progress so characteristic of avant-garde culture could as easily signal retreat to pasts fabricated and circulated in the present by art historical publications shaping their selective and soon to be hegemonic versions of 'tradition'.

By the early twentieth century, with the conquest of European culture by modernism, Van Gogh's Dutchness matters very little. Van Gogh is represented as the paradigm modern artist precisely because he seemed so totally rootless, alienated, dislocated and individual. These reference points of modernist discourse are, none the less, touristic. They are premised upon intense individualism and an aesthetic, and later purely formal, frame of reference.[23] Relocating Van Gogh as a Dutch artist, or rather, re-engaging with what it might mean to talk about the specifically Dutch determinants on the formation of his practice, is therefore not an act of cultural nationalism. It is precisely its opposite. It involves insisting once again upon the historical and the culturally particular to undo the effacement of history which has been the effect of both modernism and art history in general.

Notes

1. G. F. Hegel, 'Vorlesungen über die Aesthetik' (1835), in *Samtliche Werke*, Stuttgart: Fr. Fromans Verlag, 1949-61, vol. XIV, pp. 121-4, and H. Taine, *Philosophie de l'Art*, Paris, 1865

2. See E. Weber, *Peasants into Frenchmen: The Modernization of Rural France 1870-1914*, London, 1977.

3. J. A. de Jonge, *De Industrialisatie in Nederland tussen 1850-1914*, Amsterdam: Scheltema and Holkema NV, 1968; J. Mokyr, *Industrialization in the Low Countries 1800-1850*, New Haven, 1976; J. Mokyr, 'Capital, Labour and the Delay in Industrial Revolution in the Netherlands', *Economisch en Sociaal Historisch Jaarboek*, vol. 38, 1975, pp. 280-99; R. T. Griffiths, *Industrial Retardation in the Netherlands 1830-1850*, The Hague: Martinus Nijhoff, 1979.

4. J. Beckett, 'Discoursing on Dutch Modernism', *Oxford Art Journal*, vol. 6, no 2, 1983.

5. Ibid., p. 69.

6. W. Benjamin, *Charles Baudelaire: a Lyric Poet in the Era of High Capitalism*, London: Verso Books, 1973; the essay 'Paris – the Capital of the Nineteenth Century' first appeared in Schriften, 2 vols, Suhrkamp Verlag, 1955. See also D. Harvey, *Consciousness and Urban Experience*, Oxford: Basil Blackwell, 1985, and T. J. Clark, *The Painting of Modern Life Paris in the Art of Manet and his Followers*, London: Thames and Hudson, 1984.

7. D. Frisby, *Fragments of Modernity: Theories of Modernity in the Writings of Simmel, Kracauer and Benjamin*, Massachusetts: M I T Press, 1986; D. Frisby, *George Simmel*, London: Routledge, 1984.

8. G. Pollock, 'Stark Encounters: Modern Life and Urban Work in Van Gogh's Drawings of The Hague 1881-1883', *Art History*, vol. 6, no. 3, 1983, pp. 330-57.

9. See the exhibition *Mondriaan and the Hague School* organised by the Gemeente Museum, The Hague for an Arts Council Tour of Britain, 1980, and the many paintings of this early years of Mondriaan's career which are a direct reprise of the vocabulary of Hague School versions of Dutch landscape, for instance, *Trees Beside Water*, c. 1907, The Hague, Gemeente Museum, and *Windmill*, c. 1903-5, Slijper, Gemeente Museum.

10. A. Bowness, *Vincent Van Gogh London*, London: Arts Council, 1968, p. 57. Attention had been paid to the Dutch period by W. Vanbeselaere, *De Hollandse Periode in het Werk Vincent van Gogh*, Amsterdam and Antwerp, 1937 (an analytical catalogue of this period), by Marc Tralbaut, *Vincent van Gogh in Drenthe*, Assen, 1959 (a documentary study of these three months) and in his many other publications. A. Boime, 'A Source for Van Gogh's 'Potato Eaters', *Gazette des Beaux Arts*, 1966 per. 6, vol. 67, was one of the first texts to see Van Gogh's work in relation to his Dutch contemporaries, an issue which was the main theme of the study by G. Pollock, 'Vincent van Gogh and the Hague School', London University, Courtauld Institute, M.A. Thesis, 1972. A. Murray, 'Strange and Subtle Perspective, Van Gogh, The Hague School and the Dutch Landscape Tradition', *Art History*, vol. 3, no. 4, 1980, explored the use of space in Van Gogh's work in relation to the nineteenth and seventeenth-century traditions. This handful of texts needs to be contrasted with the massive number of publications on Van Gogh's relations to French art and later modernisms.

11. R. Williams, 'Hegemony' in *Marxism and Literature*, Oxford University Press, 1977, p. 110.

12. Ibid., p.115.

13. G. Pollock, 'Stark Encounters...' op. cit.; G. Pollock, 'Labour – Modern and Rural: The Contradictions of Representing Handloom Weavers in Brabant in 1884', *Australian Journal of Art*, vol. VI, 1987, pp. 25-44; G. Pollock, 'Van Gogh and the Poor Slaves: Images of Rural Labour as Modern Art', *Art History*, vol. 11, no. 3, 1988, pp. 408-32.

14. R. Williams, *The Country and the City*, London: Paladin Books, 1973, p. 357.

15. D. MacCannel, *The Tourist A New Theory of the Leisure Class*, London: Macmillan, 1976.

16. C. Dumas, 'Art Dealers and Collectors' in *The Hague School Dutch Masters of the Nineteenth Century*, ed. R. de Leeuw, J. Sillevis, C. Dumas, London: Weidenfeld and Nicholson, 1983 and see also R. A. M. Stevenson 'Sir John Day's Pictures', *Art Journal*, 1893, E. G. Halton, 'The Collection of Mr Alexander Young: the Modern Dutch Pictures', *The Studio*, vol. xxxix, no. 166, 1907.

17. See exhibition catalogue *Monet in Holland*, Amsterdam, Rijksmuseum Vincent van Gogh, 1986.

18. See *Max Liebermann en Holland*, Gemeente Museum, The Hague, 1980 and also H. Kraan, 'The Vogue for Holland' in *The Hague School*, op. cit.

19. Fuller discussion of these points can be found in my article 'Van Gogh and the Poor Slaves', op. cit.

20. See F. Jowell, *Thoré-Bürger and the Art of the Past*, New York, 1977; ' Thoré-Bürger and the revival of Frans Hals',

Art Bulletin, vol. LVI, no. 1, 1974. T. Thoré/ W. Bürger, 'Frans Hals', *Gazette des Beaux Arts*, 1868, xxiv; 'Van der Meer de Delft', *Gazette des Beaux Arts*, 1966, xxi. Fuller explanation of the impact of the critical revival of seventeenth-century Dutch art on Van Gogh's 1888 project can be found in my thesis, 'Van Gogh and Dutch Art', London University, 1980, Chapters 5-8.

21. T. Thoré/ W. Bürger, *Les Musées de la Hollande*, Paris, 1858, vol. I, p. 203.

22. In my PhD thesis I provide an analysis of the all-important letter LT 133 in which is formulated the guiding trope of Van Gogh's conception of art as a 'homeland of pictures'. See op. cit., Ch. 1; and a version of that reading in Ch. 1 of this volume.

23. On the readings of Van Gogh's work produced in Europe in the early modernist period see C. Zemel, *The Formation of a Legend, Van Gogh Criticism 1890-1920*, Ann Arbor, Michigan: UMI Research Press, 1980.

Chapter 5

Cloisonism?*

FRED ORTON AND GRISELDA POLLOCK

What we're reviewing is the book of an exhibition – not the exhibition. In scope and curatorial strategy *Vincent van Gogh and the Birth of Cloisonism* was smaller than *De David à Delacroix* (Paris, Grand Palais, 1974), *Post-Impressionism: Cross Currents in European Painting* (London, Royal Academy of Arts, 1979-80) and *The Realist Tradition: French Painting and Drawing 1830-1900* (Ohio, Cleveland Museum of Art, 1980-1), but that shouldn't obscure the fact that it was qualitatively the same kind of mind-boggling, arbitrary, and spurious stock-taking of some nineteenth-century paintings. More of everything – even when there's less of it on show – will not suffice. Like Willard, we can't see any method.

Evidently Bogomila Welsh-Ovcharov's aim was to explore the relationship of Van Gogh to the birth of 'Cloisonism', to the tendencies of 'Synthetism' and 'Symbolism', and his influence on Gauguin and Bernard. This is an area which Welsh-Ovcharov has been researching for over ten years. It's a pity then that she gives so little away (or is it a case of making a little go a long way?). It's to the point that discussion – such as there is any – of Van Gogh's relationship to 'Cloisonism', 'Synthetism' and 'Symbolism' and his influence on Gauguin and Bernard is fragmented, littered through the texts and footnotes, elided. In short, the book's content neither meets the claim of the title nor the author's aim. The most substantial part of the book is the introductory essay 'From Cloisonism to Symbolism'. It provides the overview, and it's here that one would expect the major points to be made, the arguments raised and the conclusions reached for the proofs which the pictures and the notes to the pictures will provide. This introduction serves as the major resource for our review.

**Vincent van Gogh and the Birth of Cloisonism* (Toronto, Art Gallery of Ontario) by Bogomila Welsh-Ovcharov, Toronto, 1981.

'From... to...'

Modernist art history is constructed of two fetishes, Author or Artist and Chronology. It dare not give them up. It dare not get involved with 'real active men [and women] as they are conditioned by a definite development of their productive forces and of the intercourse corresponding to these...'.[1] Therefore, sources and materials are required only as and when they can be invoked by a context – for example, the introductory essay, pictures in an exhibition. They are not expounded, or set forth in detail, interpreted or used in any meaningful way.

Sources and materials (in the case of *Vincent van Gogh and the Birth of Cloisonism*, the texts by Dujardin, Fénéon, Aurier *et al.*, and the paintings and drawings) can and should serve the historian in two ways. They can be interrogated and searched for what they meant, for how they were understood by the writer or maker, what meanings they had for the patron, the first readers or viewers and so on. The texts and paintings are fit for exegesis in texts. Or the historian can take the texts and paintings as resources, points of departure in the formulation of and dealing with a particular problem or set of issues. Both mean that the historian arranges his or her work in the knowledge that there are questions to be asked about the conditions of artistic production. The sources and materials function as springboards to new knowledge. As we have pointed out elsewhere, the mere appearance of accumulating knowledge – by rearranging the order in which you discuss the material or elaborating the conventional wisdom – is by and large only appearance. Nothing new is really on offer. For the modernist historian all that matters is the immanent process of art seeming to develop out of itself naturally. All he or she has to do is chart the move 'From... to...' with the emphasis on the Author or Artist and the (Discrete) Object (of Desire). The latter is not dealt with in terms of what it signified, or is of, not in terms of what it meant or was a response to or was caused by. Hence the importance of Chronology and Biographical Data (see e.g. pp. 90-5) which are substituted for History.

'...to... 'Cloisonism'...?'

Another modernist strategy is definition. You trace a word back to its first usage and claim to have articulated its meaning.

> Because the question of defining French Symbolist painting within the broader context of European Post-Impressionism so necessarily depends upon a sound understanding of how the term originated and was defined, this question will be addressed in the present catalogue introduction. In contrast, the discussions accompanying specific works of art are intended, in their cumulative effect, to trace the development during the late 1880s of both individual artists and the group as an interacting whole.[2]

'Cloisonné' had by the 1880s an agreed usage. 'Cloisonism' is, however, more

problematic. In Littré's *Dictionnaire de la Langue Française* (1889) no such word exists but we find 'cloison', partition of apartments, a membrane that separates cavities in the body, a decorative keyhole; 'cloisonné', divided into compartments; 'cloisonnage', a term from architecture for the separation of rooms. Applied to enamel or its derivatives in stained glass 'cloisonné' describes a way of holding sections in place or dividing up a surface into areas which segregate colours or bind many areas of colours into a single surface. In no sense does the term in its classic usage indicate contours or bounding lines.

What would 'cloisonné' mean when applied to a kind of painting? This is largely a question of what Edouard Dujardin hoped to signify when he used it and the neologies, 'Cloisonism', in an essay on Louis Anquetin 'Aux XX et aux Indépendants: Le Cloisonisme?' in the 1 March 1888 issue of the journal he edited, *La Revue Indépendante*. Dujardin says that Anquetin has given up working in an Impressionist or Pointillist manner and has hit on a rather novel and special way of painting 'à tons plats et lisses', i.e. in even or regular and smooth tones. This signals his rejection of agitated brushwork and impasto, modulation or vibrance. Dujardin is not talking about flat tones or flat colours – in the catalogue essay these two are used interchangeably. He is talking about a different kind of surface from that with Impressionist facture or divisionist dots. By way of example Dujardin refers the reader to two paintings, *The Mower at Noon: Summer* (August 1887, Paris, Coll. Velluz) and *Avenue de Clichy: Five O'Clock in the Evening* (November-December 1887, Hartford, Connecticut, Wadsworth Atheneum).

> At first glance, these works give the impression of decorative painting; an outer line, a violent and fixed coloration, recalling inevitably popular imagery and Japonism; then beneath the general hieratic character of the drawing and of the colour one perceives a truth of sensation [une vérité sensationelle] disentangling itself from the impetuosity of romanticism; above all, little by little, it is the intentional, the reasoned, the intellectual and systematic construction that requires analysis.[3]

This statement functioned, made sense, in a specific context, a bitter and highly competitive atmosphere of debate between the romantic Impressionists with their impetuous brushwork and seemingly unsystematic surfaces, and the new claims for rationalised picture-making applying science and premeditation, creating vibrant fields of colour by patterns of dots which none the less unified the surface. The word 'sensation' and its derivatives were crucial and particular (remember Cézanne?). Dujardin is manoeuvring a place for Anquetin's speciality – a new kind of decorative painting – within the discursive framework of Paris avant-gardists and their allies in Brussels.

Welsh-Ovcharov only latches on to allusions to popular and Japanese prints, links them with Anquetin and thus conjures up a 'broader category of decorative painting'. She misses the new moves Dujardin is making. By dint of slight carelessness in the

translation, this broader category is then defined by the presence of black outlines and flat colours. Though she is not wrong to see a connection between Japanese prints, *Images d'Epinal* and what Anquetin was trying out, noting it is not enough; we need to know what these materials offered Anquetin in that context. However, once seen, these elements come to overstructure her way of seeing. She looks for outlines and flat colours and unusual viewpoints and thus discerns the constant 'influence' of Japanese prints – as if objects can have a direct effect on another object without the mediation of human will or consciousness. This leads to some peculiar sightings and slippery prose. Discussing Gauguin's paintings of 1886-7, she writes:

> However, in his finished paintings, Gauguin's Japanist-Cloisonist tendencies remained clothed in still basically naturalist colour schemes and Impressionist brush techniques, even while his figure style (see cat. nos. 45 and 46) is clearly tending towards flattened volumes and well defined contour outlines. Gauguin was perhaps not yet ready to be called a cloisonist nor to call himself a Synthetist in public, but his art was nonetheless moving in a Japanist direction.

Dujardin's pictorial system was something substantial. He continues:

> The point of departure is a symbolic conception of art. In painting as well as in literature, the representation of nature is a chimera. The ideal in the representation of nature (whether or not viewed through a temperament) is trompe l'oeil. And, in a trompe l'oeil picture, why do not figures move about, hear sounds etc?... the system of representation of nature leads logically to considering theatre the supreme form of art. On the contrary, the aim of painting and literature is to give the sensation of things; according to the special means of painting and literature. What ought to be expressed is not the image but the character of things. Therefore why retrace the thousands of insignificant details the eye perceives? One should select the essential trait and reproduce it – or, even better, produce it. An outline is sufficient to represent a face. Scorning photography, the painter will set out to retain, with the smallest number of characteristic lines and colours, the intimate reality, the essence of the object he selects. Primitive art and folklore are symbolic in this fashion... And so is Japanese art.[4]

This is neither a manifesto for 'Symbolism' nor a linking of that 'ism' with 'Cloisonism' as Welsh-Ovcharov claims. Dujardin is explaining that the premises of Anquetin's work are symbolic as opposed to naturalist. If the logic of imitation leads one to Theatre, one can only deduce that the aim of painting – which will always fall short of full illusion of life – must be somewhat different. It aims to give the sensation of the object; it is after all a sensual medium. Yet there must be something identical between a picture and that which it represents or depicts to enable the one to be a picture of the other. Presumably *The Mower* and *Avenue de Clichy* were vivid for Anquetin and Dujardin: maybe the essence of the former was yellowness and of the latter blueness. But

the artist must manage to picture the essential character with the means and materials appropriate to his or her chosen practice, which, for the painter, meant with the least number of 'characteristic' lines and colours.

In Dujardin's system lines signify that which is permanent and colour that which is transitory. Line describes form and colour 'defines atmosphere, fixes a general colour sensation'[5]. The former encloses the latter and the latter determines the former. It's a tautology but it makes a point. It is a union; unification of the surface was the name of the game. The colour is not just and flat and fixed, but it's unitary. It is 'something like painting by compartments, analogous to cloisonné, and his technique consists of a kind of cloisonism...'.[6] The important thing here is not the sources, Japanese prints, mediaeval art, stained glass windows, but the artist's project and then the appropriateness of the sources as resources. For Dujardin painting is an intellectual pursuit based on the analysis of the practice of painting and Nature. The result is decorative painting: the lines and colours lock together as a pattern on a two-dimensional surface, as in stained glass or a cloisonné enamel. There's no synaesthesia about this 'Cloisonism', no imitation, no seeing nature through a temperament, no romanticism, no pseudo-scientificity. What Dujardin does is identify the expendable conventions of painting and make an appeal for an art to be made which is concerned with its own means and materials. Dujardin would have made a good modernist: essentialistic, reductionist, purist. Welsh-Ovcharov glimpses this but doesn't recognise it for what it is: 'the anti-naturalist bias of this succinct statement of art theory is as manifest as the proto-abstract canon which it advocates'. Where is there any notion of abstraction even intimated in a statement that art is based on sensation and the reproduction of essential traits of things? You cannot have both a symbolic conception of art and an abstract canon. The former is all about expressing something by revealing things as they 'ideally' are; the latter refusing Nature as the point of departure, substituting an independent schema consistent within its own art form. This slippage from anti-naturalist to proto-abstractionist is typical modernist chronology-making, stringing together befores and laters with a touch of anticipation in order to make possible neat, linear diagrams of the sequence of 'movements'. It has nothing to do with History. The questions to be asked are why was it that Dujardin was articulating this in 1888; what caused him to argue for it; why was cloisonné work in all its forms now a suitable resource material along with Cézanne (whom we must not forget – Bernard didn't in his 'Notes...')?[7]

The times they were a-changing. Artists were seeing new things in Japanese prints. In the 1860s Japanese prints had seemed to offer a pictorial equivalent for the chaos of metropolitan Paris at that time; their modernity and strangeness was somehow equatable with a new experience of a new Paris. By the late 1880s they offered something else. They were seen as providing clues as to how a picture's surface could be flattened and integrated and simplified. Also, in the traditional arts of stained glass and ceramics a revival was occurring and attracting attention from painters, as did the popular *IX Exposition de L'Union Centrale des Arts Décoratifs* in August 1887.[8] They

were exciting, up-to-the-minute, *l'art moderne*; modern, not ancient, resources for artists in pursuit of that most modern phenomenon, avant-garde status. However, even if one accepts that this was one of those occasions when the arts were being hunted back to their mediums and there isolated and defined, that still leaves the question of why Anquetin and Dujardin thought 'Cloisonism' something worthwhile to chase after. Hunting after line and colour, what meaning did it have? What did it signify about the condition of the avant-garde? It was clearly modern, maybe even artisanal, matter of fact. Where does this go to? Nowhere in *Vincent van Gogh and the Birth of Cloisonism*.

And where does Van Gogh – Welsh-Ovcharov's Centre Point – fit into this? By the spring of 1887 Van Gogh was one of a group of artists who had situated themselves and their practices in relation to Seurat. Seurat's was the paradigmatic avant-garde art, the painting everyone had to watch. His work was the achievement whose status the 'Impressionists of the Petit Boulevard' were all sure of and had to become independent of or transcend. We can be sure that this structured their discourse to a great extent, and Van Gogh's conversation was part of that discourse. Maybe he even encouraged Anquetin and Bernard to consider Japanese prints as resources. He also put his art dealing and entrepreneurial skills to use. And he knew Anquetin's *The Mower* and *Avenue de Clichy*. But can we claim any more for him? Was Anquetin's style 'a product... of experiments in pictorial form evolved in close collaboration with such fellow artists as Bernard, Vincent [*sic*] and Lautrec' as Welsh-Ovcharov maintains? Conversation is one thing, collaboration is another. We'd do well to remember that although Van Gogh was around at the conception and birth of *The Mower* and *Avenue de Clichy* he was out of town when they were baptised. If the collaboration was that close, that effective, surely he would have understood what Dujardin meant by 'Cloisonism' (even if he got the information second-hand); to him Seurat was still, in July 1888, the leader of the 'new tendency' and Bernard had gone further than Anquetin in the Japanese manner.[9] Not that Van Gogh was alone among the 'Impressionists of the Petit Boulevard' and the artists and critics who were acquainted with them in the way he received Dujardin's 'cloisonist' claims for Anquetin's two paintings. Apart from Fénéon and Geoffroy they either ignored 'Cloisonism' or misunderstood it, deliberately or otherwise. From what information Welsh-Ovcharov gives it seems that the term never did catch on – except among modernist art historians who've found it a useful peg on which to hang their Designated Artist or Special Period.

'...to Synthetism...'

'As with Cloisonism, the term Synthetism was first used as the label for an art movement in reference to a major exhibition event. In this case it was *L'Exposition de peintures du groupe impressionniste et synthétiste* held in the *Café des Arts* operated by a certain M. Volpini and located on the Champ-de-Mars, the grounds of the Universal Exposition of 1889.' It seems that it's not known who came up with the term. The critic Jules Antoine in his review of the show '*Impressionnistes et synthétistes*' (*Art et Critique*, 1, 9

November 1889) identified Anquetin and to a lesser extent Bernard as 'Synthetists' while Gauguin was an 'Impressionist'. Moreover, Antoine thought that Anquetin's *The Mower* and *Avenue de Clichy* were the most synthetic paintings in the exhibition, paintings which Bernard would classify as either 'synthetist' (*'Notes...'*, 1903) or 'cloisonist' (1932).[10] Were the terms almost synonymous? Albert Aurier's explanation of the synthesis involved in the works of Anquetin, Bernard and Gauguin in his discussion of the show in *'Concurrence'* (*Le Moderniste*, 1, 27 June 1889) is really just a précis of Dujardin's *'Le Cloisonisme'*:

> In most of the works shown, and especially in those of Gauguin, Bernard,
> Anquetin etc, I seem to have noticed a marked tendency towards a synthesis of
> drawing, composition, and colour, as well as an effort to simplify these means of
> expression which appears very interesting to me at this particular moment when
> empty prowess and cheap tricks are the rule.

Despite Aurier's exemplary clarity Welsh-Ovcharov still asserts that 'Synthetism' was never adequately explained in print at the time. Then what about Fénéon, fellow editor with Dujardin at *La Revue Indépendante*? He reviewed the Volpini show and offered another perceptive exposition of what was at issue.

> The means of the impressionists [*tachistes*] so suitable for representing fugitive
> visual perceptions were, around 1886, abandoned by several painters interested in
> an art of synthesis and premeditation. While MM. Seurat, Signac, Pissarro,
> Dubois-Pillet realised their conception of this art in painting where episodes were
> abolished in a general orchestration following the codes of optical physics and
> where the personality of the author remained hidden like that of Flaubert in his
> books, M. Gauguin struggled towards an analogous goal but by different means.
> Reality was only a pretext for distanced creations; he reorganised the materials
> which she provided, disdained trompe l'oeil of atmosphere, stiffened the lines,
> restricted their numbers, and hieratised them, and in each of the spacious districts
> which formed their interlacing, a rich and heavy colour is sadly proud.[11]

Fénéon restates the shift from the aesthetic of Impressionism where means corresponded to the transitoriness and instability of what was being represented, to a more synthetic (i.e. ordered and systematised) way of making pictures. The term, of course, is of the Academy. It refers to the necessity of artistic transformation of nature after careful study into a composition – a synonym for *synthèse* in French. For Fénéon, Anquetin was still vacillating. His works evidenced a contradiction between the precision of his facture and the evanescence of the visual events which were still his subject matter. He admitted the possibility of a formal exchange between Gauguin and Anquetin but in no other way. Anquetin's work, however learned and decorative, lacked 'sensation' – feeling, sentiment.

It's always too easy to indicate varying, even competing definitions, call them confusing and then pretend they tell us nothing. The term synthesis was quite obviously circulating widely amongst artists and critics in Paris from *c.* 1886. But it was not a thing, 'Synthetism'; it was a set of practices which were seen to be attempts at making paintings differently from Impressionism. It was neither a style, nor an iconography – both of which Welsh-Ovcharov tries on – and it's not something that we will see simply if we juxtapose Anquetin's *Mower* and Van Gogh's *The Mowers; Arles in the Background* (F545, Paris, Musée Rodin, June-July 1888). Anquetin works with a close viewpoint observing a single man harvesting; his damaged picture now reveals its shrinking skin of yellow, painted over a delicate tracing of figure and building in the attempt to achieve an intense and unifying tone. Van Gogh's is a panoramic painting with a surface clearly divided up by a variety of kinds of brushmark, held together by perspective and the very busy-ness of such a surface. There might have been a coincidence in the project, but none in the execution at any level. Their placement side by side – for the very first time – as in both exhibition and catalogue merely obscures all the complexity of their relation within the development of a new project for painting and reduces the matter to the banalities of the visible.

'...and on to... symbolism'

The final sections introduce us to Albert Aurier whose articles on Van Gogh and Gauguin in *Le Mercure de France* in 1890 and 1891 seem to have provided Welsh-Ovcharov with her point of departure.[12] 'It has been his classification, brilliant in its simplicity, yet flawed in terms of historical sequence which has prevailed until the recent past and which the present study seeks to modify.' What classification is this? Aurier called Bernard, Gauguin, Serusier, Denis and other Nabis 'Symbolists' but he did not include Toulouse-Lautrec, Anquetin or Van Gogh. Does she mean therefore that we should call the latter 'Symbolists'? We thought the project was to identify the birth and development of 'Cloisonism'. But they have all got so muddled up as 'Cloisonist-Japanist-Synthetist-Symbolist' that it seems we are required to dismiss anyone who makes distinctions as historically flawed.

'One can surmise that Gauguin was more than mildly surprised that it was Vincent [*sic*] and not himself whose art Albert Aurier chose to celebrate in the very first issue of his new Symbolist journal, *Le Mercure de France*.' This is just wrong. Aurier wrote about Van Gogh in a series called 'Les Isolés'; the other painters so described were Eugene Carrière, Jean-Paul Henner and Henri de Groux. Aurier made the point that Van Gogh's relationship to the concerns of the Paris avant-garde was at best oblique.

Welsh-Ovcharov is correct to point out that the Aurier essay is more insightful than it's usually given credit for; but she misses most of its insights herself. The main point is that Aurier tries openly to contend with the complexity of Van Gogh's positions, the diverse traditions within which he had to be accommodated all at the same time. And that was probably more typical of the period than the clear-cut year by year evolution

that Welsh-Ovcharov hoped, but failed, to discover. For Aurier Van Gogh was at once a Realist and a Symbolist. By Realist he meant a Naturalist; he attends lovingly to appearances of things and this attachment to the tangible world is signalled by impetuous and vibrant manner of drawing and painting. But Van Gogh could also be called a symbolist – 'prèsque toujours symboliste' – because he makes his palpable forms signify, have meanings beyond that of mere sensual existence. Aurier is obliged to qualify symbolist. He distinguished between a mystical symbolism characteristic of the Italian primitives who sought to dematerialise their visions and an idealist-symbolism of those who endeavour to materialise their ideas in intensely sensual and material forms. They try to render ideas tangible in the physical materiality of the medium or by means of representing tangible objects in that medium express the ruling Idea that informs the whole material world. According to this theory – a mishmash of German Idealist philosophies – the material world is full of significance which art seeks to extract and express via appropriate pictorial forms. All he is saying is that art can express something; it is more than a recording device, and also more than a formal exercise. There was nothing very new about this dressed up restatement of Academic theory. Indeed, in the later article (1891) Aurier had to make up a new word *'Idéeistes'* precisely in order to separate his 'Symbolist' artists from Idealists – practitioners of a debilitated academic formalism.[13] The two poles, naturalism and symbolism – with a multitude of neologisms between – function within the overlapping fields of artistic theory and practice in the 1880s and 1890s of which Aurier's texts were particular and important articulations. They could lead us to ask what was there in Van Gogh's texts and paintings which invited Aurier's readings? In what ways were Van Gogh's practices and statements symptoms of the confused theoretical terrain of avant-garde culture in the 1880s which offered unexpected points of intersection between a motley collection of aspiring artists and writers out to make a space for themselves?

Notes

1. Karl Marx and Friedrich Engels, *The German Ideology*, Students Edition, London: Lawrence & Wishart, 1974, p. 47.

2. F. Orton and G. Pollock, 'Les Données Bretonnantes: La Prairie de Représentation', *Art History*, vol. 3, no. 3, 1980, pp. 318-19 (Chapter 2 in this volume).

3. Authors' translation. Edouard Dujardin, 'Aux XX et aux Indépendants: Le Cloisonisme', *La Revue Indépendante*, 1 March 1888, pp. 489ff. See comparable translations in J. Rewald, *Post-Impressionism From Van Gogh to Gauguin* [1956], New York: Museum of Modern Art, 1978, p. 176, and S. Loevgren, *The Genesis of Modernism* [1959], Bloomington Indiana: Indiana University Press, 1971, pp. 131-2. Curiously Loevgren's important study of this period is absent from Welsh-Ovcharov's bibliography.

4. Dujardin, op. cit.

5. Ibid.

6. Ibid.

7. E. Bernard 'Notes sur l'école dite de "Pont-Aven"', *Mercure de France*, vol. XII, 1903, p. 676.

8. See P. LeFort, 'L'Union Centrale des Arts Décoratifs, Neuvième Exposition', *Gazette des Beaux-Arts*, November 1887. This revitalisation of certain applied and decorative arts and the interest which fine artists showed in them was not confined to France. C. Monkhouse, 'Pictures in Enamel', *Magazine of Art*, London 1887, pp. 222-6 gives some insight into this. According to Monkhouse 'It was comparatively but the other day that the art of cloisonné enamel on porcelain was discovered by the Japanese, and the patent which secures to Messrs. Simpson the right of producing enamel pictures

in sections (i.e. decorative panels, altar pieces – size was no limitation) is dated but three years ago'. See also J. Starkie Gardner, 'On the Decorative Uses of Enamel', *Transactions of the National Association for the Advancement of Art and Its Application to Industry*, Edinburgh Meeting 1889, London, 1890, pp. 212-20. Starkie Gardner's paper was one of several which were given on a variety of up-to-the-minute topics including that read by W. R. Richmond on 'French Impressionism and Its Influence on English Art' (pp. 98-109). Richmond maintained that 'The Impressionists are indeed falling, even if they have not already fallen, into mannerism as fatal to progress as the most pedantic Academy could teach'. The demise of Impressionism and the interest the 'Impressionists of the Petit Boulevard' showed in the applied and decorative arts were, of course, not unrelated.

9. Vincent van Gogh, *The Complete Letters of Vincent van Gogh*, London, 1959, LT 500.

10. E. Bernard, *'Notes'*, 1903, and 'Louis Anquetin: artiste-peintre', *Mercure de France*, November 1932, pp. 594-5.

11. F. Fénéon, 'L'Exposition Volpini', *La Cravache*, 6 July 1889, reprinted in F. Fénéon, *Art de l'Impressionisme*, ed. F. Cachin, Paris, 1966, pp. 109-20.

12. A. Aurier, 'Les Isolés: Vincent van Gogh', *Mercure de France*, vol. 1, no. 1, 1890, pp. 24-9, and A. Aurier, 'Le Symbolisme en Peinture – Paul Gauguin', *Mercure de France*, vol. 2, no. 2, March 1891, reprinted in *Oeuvres Posthumes*, ed. R. de Gourment, Paris, 1893, pp. 205-19.

13. Aurier, op. cit., 1891, p. 212.

Don't Take the Pissarro:
But Take the Monet and Run!

or Memoirs of a Not So Dutiful Daughter*

GRISELDA POLLOCK

One of the rare pleasures of my current academic employment is to hover in the office of this journal's reviews editor and browse through the books, pristine and glossy, which accumulate there. The expensively produced art book has a distinct appeal even to the most 'anaesthetic' of art historians.[1] Costly, heavy in weight though less often in scholarship and intellectual meat, the sophisticated techniques of colour reproduction within and without promise a particular brand of visual pleasure. We know we should all see the originals, and nowadays there is an annual feast of megashows giving us direct access to paintings in remote or private collections. Tim Hilton in the *Guardian Weekly* (16.9.90) called *Monet in the 90s* (London Royal Academy, 1990) the 'show that will not be repeated in our life-time'. But such exhibition viewing only serves to remind us of our merely spectatorial relations to other people's property. The art book, often these days the permanent monument to these displays of private or corporate wealth, offers the pleasure of vicarious proximities and indirect possession of art which, through luscious colour replication and the frequency of details, is brought close to us and into our own homes for the most delicious moments of private contemplation. That is, of course, if you can afford to buy the books. Art history is, without doubt, a financially crippling profession. So the reviews editor's shelf becomes a favoured spot for dreams, which sometimes come true. The price is a job of reading and appraising.

I admit it straight away. I am a junkie for the publications of Yale University Press,

* Richard Brettell, *Pissarro and Pontoise: The Painter in the Landscape*, Yale University Press, 1990.
Paul Hayes, Tucker, *Monet in the 90s :The Series Paintings*, Yale University Press, 1990.

especially their modern art list. Their books are quite superb: loads of colour, endless details, and often substantive and intelligent texts. These are the books we want, which we will quickly put down on next year's reading lists, seeing perhaps a new seminar topic in competing interpretations, or comparative approaches, modernist, revisionist, social-historical, feminist and so forth. But after the delectation and anticipation of such pedagogic novelties, come sterner questions.

There's a politics in art publishing. Editors establish their lists in ways which associate their press's name with selected tendencies, theoretical interests, or just certain styles and schools of art history. It is personally discouraging and a waste of time to submit the 'wrong' kind of manuscript to particular publishing houses, for it will be politely refused with suggestions for where such an 'approach' or 'perspective' might be more favourably treated. This leads to certain marked political differences in the publication of art history, whose debates and conflicts could be currently mapped by a chart of publishing houses. These differences, however, have important repercussions on the style of presentation of ideas and thus on the authority of the views published in varying kinds of books.

All serious art historical scholarship requires expensive colour illustration, but only certain kinds of texts get it, through the bigger university or commercial presses. Intellectually challenging texts on 'visual representation' are required to stand on the value of their text, aided by sometimes reasonable, often awful, black and white reproductions.[2] Colour is costly and it makes for an expensive book. The capital outlays can only be recouped by the dual markets that can be tapped at the price. Libraries must buy the latest monograph on Monet or Pissarro, which, if attractively produced, will also serve to attract the coffee table book purchaser. Another marketing strategy which we have seen developing over the last two decades is the amalgamation of the book and the exhibition catalogue, which began with extended essays threatening to overwhelm the function of equally extended catalogue entries on the exhibited paintings. Now we can go to an exhibition, and buy the monograph in which the scholarship on which the exhibition's theme is founded is fully rehearsed in book form. The book is what can be bought to represent the experience had at the exhibition, but with the difference: the pleasure of the book offsets the alienation of the exhibition and the transitory nature of our access via other people's personal property to the work itself.

Paul Tucker's book on *Monet in the 90s* is an example. Its publication coincided with the exhibition at the Royal Academy in London of the series paintings made by Monet in the 1890s. The book cannot be reviewed apart from the context of its production, the exhibition, because I am sure that the sheer cost of the book in photography and reproduction fees alone would have made most publishers blanch. The exhibition, *Monet's Series*, came to us packaged by the current myth of art – money. We used to be drawn to artists by the tragedy of their life stories, or the heroism of their struggle. Now, in our post-modern times, it seems, the public is simply fascinated by the price tag. Previews and reviews of the show stressed the sheer expense of the project, in Paul

Tucker's globe trotting to locate all the works, in the transport and insurance costs. Sponsorship for the exhibition from Digital Corporation came to a mere $1.4 million. Net receipts were in the region of $3 million. It was, at its London showing, the event that was set to save its financially troubled host, the Royal Academy. Ticketing and admission were arranged along lines reminiscent of the systems pioneered to deal with Van Gogh mania. The correlation between Monet and money, which was the leitmotif of the daily reports and reviews of the exhibition, indicate that 'Van Gogh' is not unique. His aura has spread now to the art of this period, to French modernism, whose actual prices at the auction house have been falling. No longer does the artist need to have been unsuccessful or suffering. Indeed, as we have seen with Van Gogh in 1990, a sanitised version of an artist dedicated to his craft is what the big money markets now need to underwrite their investments of obscene surpluses. Both Monet and Pissarro are being redefined in these texts as serious men of their craft, neither overly swayed by market demands in the case of Tucker's version of Monet, nor tainted with anti-capitalist politics in the case of Brettell's cool and very modernist Pissarro.

It is impossible to review these texts as just two more, bigger, better and more lushly produced chapters in the modernist story of modern art. Their arguments, which I will address in due course, are different and indicate movements against the Rewald paradigm of the History of Impressionism. Whatever the intentions and integrities of their authors or editors, these books exist in the mutual imbrication of money and art which is the modern condition of art history – for us all. Where do most of our royalties go, but in paying for the right to reproduce the property of collectors and institutions? The more critical the text, the less likely it is to become either textbook or coffee table adornment, or even the vicarious object of desire to exhibition visitors; and thus the less likely it is to sustain the kind of publication values and reproduction fees which confer on it not blue chip status as a commodity, but as a set of authorised ideas and knowledges – a valorised public story, as Donna Haraway would call it.

A certain brand of art history wraps itself then in the seductive forms which titillate our commodity fetishism – lodging its meanings into the economy of our professional desires, keeping its place as the authorised version. Other histories of art precariously insinuate themselves in smaller format, colourless volumes from worthy but not art history presses, or have to colonise their non-academic and blatantly commercial ventures with the inevitable loss of academic prestige. Who publishes feminist art historians? Those already with critical theory, cultural studies or women's studies lists. Only belatedly has Thames and Hudson set up a women and art list, though its contribution is increasingly substantial.

Yale University Press is one of the leaders of this field of expensive, regarded and scholarly publication. Its books figure large in defining the hegemonic definitions of Impressionism. Its authors have a warm relation to the editors, whose faith and confidence and encouragement are regularly acknowledged. They also have a warm relation to each other. Glancing through the opening pages of the books under review, I

found a network of admired teachers and grateful students. Paul Tucker and Richard Brettell were co-graduate students at Yale University. Both acknowledge their debt to Anne Coffin Hanson and Robert L. Herbert. The latter's major text *Impressionism: Paris, Leisure and Society* (YUP, 1988) acknowledges among many debts both Anne Coffin Hanson and Paul Tucker.

This network may usefully be considered, respectfully, through Donna Haraway's concept of the 'patriline'. A feminist historian of science, Haraway traced the theoretical and professional descent in the field of primatology in her essay 'The Contest for Primate Nature: Daughters of Man-the-Hunter in the Field, 1960-1980'.[3] Sherwood Washburn, 'the visible father in the primate order' (p. 179), made a decisive contribution to the framing of the questions and the methodological procedures of primate study that has shaped several generations of primatologists in the United States. Washburn established what should be the object of investigation in this new area of study, allowing his graduate students then to diversify and corroborate his fundamental thesis about the meaning of primate social groups being visible through male activities. Haraway traces the work of his graduate students and then theirs. Many have been women, and through their scrupulous development of Washburn's framework and observational techniques, some of the women in the field shifted the endemically patriarchal story told by Washburn and his male offspring. Haraway stresses that this is not a question of the gender of the women versus the men who followed Washburn's 'man-the-hunter' hypothesis. Rather she emphasises the potential in the framework itself for fostering independent enquiry and topic formation, individual initiative, within empowering methods of rigorous yet innovative research.

> Washburn students were not members of a particularly authoritarian laboratory; they chose their own topics. They also opposed Washburn in several ways and worked independently of his ideas and support. But several report the sense in retrospect that the intellectual excitement of a new synthesis... and Washburn's nurturance of students' choices and opportunities (as well as indifference to other choices) suggest the existence of a more explicit plan.[4]

The Yale patriline involves many more people than Robert Herbert, and it is also a matriline, through Anne Coffin Hanson. But it is clear that, since the 1960s, Robert Herbert has been developing a series of moves which would produce a substantive shift *vis-à-vis* the Museum of Modern Art's hegemonic story of modern art.[5] In the preface to *Impressionism* (1988) he writes that the origins of the book go back to lectures at Yale in the early 1960s. Further researched in Paris in 1972, then given as the Slade Lectures at Oxford during 1978, these ideas about the relation of Impressionism to the society and leisure practices of Paris in the 1860-80s involved historical research and socially oriented cultural analysis of what the paintings meant in contrast to the emphatically formalist stories about paintings of light and flat colour.

One might sense a historical coincidence here. The late 1960s and early 1970s are

also significant dates in the revival of a Marxist social history of art, which first took on Courbet (where Herbert has been reappraising Courbet's mid-century contemporary rejected from modernism's canon, Millet) and moved on to consider 'Paris in the Art of Manet and his Followers'. From the current vantage point of the 1990s, we can see the appearance first of T. J. Clark's book *The Painting of Modern Life* (1984) with that subtitle, and then Herbert's long-awaited *Impressionism* (1988) as indicators of a more profound opposition in modernist studies for all that both appeared to have a common opponent in MoMA's overly narrow definition of modernism. Herbert's liberal social history of art, the product of liberalisation in the post-McCarthyite era, was prepared to entertain historically specific iconographic analysis of paintings of modern urban leisure. The Clark line, forged in the Paris which produced the intellectual formations known through the code '1968', demanded a more systematic understanding of the ideological *work* of art practice – a matter as much of postures, attitudes and curated identities amongst the art world, as of the paintings themselves; a matter as much of the how the painting 'worked' its socially loaded and coded resources as as a text, as what these texts were in relation to historically specific configurations of economic processes and social relations.[6]

Tucker and Brettell, members of Yale's postgraduate community, studying with Herbert, would have chosen dissertation topics before this further complication of the field of competing versions of the social history of art had become fully apparent with Clark's move to the United States in 1979 and the publication of his new work on Manet and the Impressionist moment. Their choices reflect a necessary strategy of deference to their teachers. Both work in a liberal social history of French painting. But they must also find a space for their own professional singularity and difference. Hanson is a Manet specialist and Herbert's book favours the city, while both Tucker and Brettell work on landscape painters. Then there is the question of sibling rivalry, which is articulated of necessity by the late-comer Richard Brettell. *Pissarro at Pontoise* is Brettell's Yale University dissertation-become-book and it vies therefore with Tucker's dissertation-become-YUP-book, *Monet at Argenteuil*, published in 1982:

> Paul Tucker, whose now famous study *Monet at Argenteuil* was written
> somewhat later than the bulk of this text, is a more subtle and patient student of
> the relationships between real and painted landscapes. Yet, even in his brilliant
> book, the reader comes away with the feeling that landscape paintings are what
> they represent, and that, if we learn enough about their apparent subjects, we
> shall be able to understand them. Perhaps because Pissarro was a maddeningly
> complex artist – more so than Monet – Tucker's methods do not work very well
> when dealing with Pissarro and Pontoise, and for that reason, the two books will
> be independent pendants, whose texts will often appear to contradict each other.[7]

But in the interim, Brettell would have had time to read T. J. Clark's book with its chapter on Monet at Argenteuil, to which no direct reference is made in his Pissarro

study. Tucker has read it, and his new book indicates certain assimilations to this alien patriline, in the insistence on the notion of Monet's campaigns in art. Clark's analysis emphasised the strategic element in modernist art-making, and carefully structured the balance between historical material and the conditions of production of pictures of Argenteuil (or Paris, for that matter) and the equally historical and material processes of painterly representation which makes his book the product of a more theoretical, or conceptual patriline which could include Meyer Schapiro and Clement Greenberg as co-sponsors. Brettell has also learnt this from Clark, it seems, or let us say his book reads Pissarro at Pontoise with care for the failures of vision, the revealing selectivity of the painter *vis-à-vis* the available sites, what he notes in his Chapter 2, 'Pissarro's Pontoise: Omissions and Admissions'. Yet there is no evidence that either author sees the other social histories of art as relevant to his own writing. It simply falls below even the threshold of their footnotes and bibliography.

It is a genuine indictment that can be levelled, that books like these can be published with such protected and authorised ignorance of the discipline to which they belong, that they can marginalise, by verbose omission, anything that would make what they are doing problematic and difficult. The feminist and Marxist patrilines of art history do not ignore their work; yet they feel free to ignore ours.

Brettell definitely, and Tucker implicitly, would claim that their books offer new stories. Brettell's conclusion openly contests accepted views of Impressionism, in part because the conventional story places Monet at the centre and turns Pissarro into a *retardataire* painter who missed the modernist boat by favouring peasants and rural scenes over urban and suburban locations, by producing heavily worked and carefully constructed landscapes without any interest in the gestural, the ephemeral or the rapidly passing sensation.

> It is possible to turn the tables and create a definition of Impressionism with Pissarro at the centre. This definition would view the period as a struggle between traditional values of the landscape aesthetics and the realities of modern life and landscape. In such a vein, Monet's art would seem narrow in its acceptance only of the bourgeois world. Monet's style, to follow this logic, would lack the experimental quality and the struggling attempts to unite past and present, sensation and construction, so evident in Pissarro's style throughout the 1870s.[8]

It is obvious that Pissarro is the more complex and historically interesting artist, but Brettell does his best to undermine his own advantage by the Pissarro that his text progressively invents. It is a pity that T. J. Clark's loving assessment of Pissarro's difficult project is only available on its annual programming on British television as part of the Open University's *Modern Art and Modernism* course. Clark locates Pissarro firmly in the Impressionist project defined as a decision to adopt a bolder approach to seeing itself, a practice 'committed to registering the actual, vivid look of a landscape, and

doing it directly, building a likeness out of touches and smears of raw colour'. The picture which emerged from this process is 'not easy'; it is the opposite of straightforward, a unity only just achieved, a precarious unity, 'a fragile achievement on the painter's part'.

This assessment is based on a reading of Pissarro's painting, *Climbing Path at L'Hermitage* (1875), a painting which is then argued to be untypical of the artist who 'lost faith in the notions of landscape upon which this practice depended'. Not nature, but the countryside was Pissarro's project, a concept in part inherited from an earlier generation of painters who felt some confidence in using for their painterly harmonies, structures of intelligible relations between man and nature that a pastoral or arable economy made available. Pissarro's representations of a worked land, therefore, involved some unemphatic, but conceptually determining, presence of those who worked the land as the linchpin of why the effects called 'nature' – ploughed and planted fields, blossoming orchards, cultivated plots, gathered wood – were there to be painted as a set of visual experiences.

In direct contrast to the understated representations of the working figure within a visually apprehended environment of agriculture and weather, painted in the 1870s, Clark discusses a painting of 1886, *The Applepickers*, in which 'the fact of work is not assumed but pictured'. Pissarro remakes himself as a figurative painter, setting himself technical problems he is not always able to resolve. Why the change? Clark's answer is matter of fact and unemotional: politics. Pissarro confronted the contradictions of the social world, known by the fashionable euphemism, modernity, and he addressed its conflicts with a degree of painful self-consciousness. It is this struggle between the necessity as bourgeois and painter (an important distinction) to paint the fact and problem of work as both social relations and index of social life, and the appalling difficulties of doing so, that makes Pissarro's retain its critical interest for Clark. It also encourages him to recommend that Pissarro's more fashionable contemporaries – the late Monet for instance – be allowed to fall into benign neglect.[9]

Brettell's insight about Pissarro's potential significance, however, is too radical for his own taste, and his reversal of the Monet-Pissarro axis in Impressionist studies is rejected as a mere rhetorical device: 'Both critical methods are, of course, wrong.' The issue of Pissarro's project is displaced onto a catalogue of tasks to be undertaken if we are to arrive at an understanding of this complex movement, Impressionism. Brettell concedes that there have been 'certain historiographical advances'. But what he chooses to note are a rum lot. Sam Hunter, Phoebe Pool, Theodore Reff (largely on Degas) are the names he cites. What I wonder lies behind the unreferenced statement: 'The sociology of the movement is now well understood owing to recent revisionist art history.'[10] It is clear that for Brettell, feminist work on this topic does not even rate a mention, and serious debates about the relations between 'modernity' and modernism are merely noted obliquely in this laconic dismissal of such arguments as not art history, but sociology.

The problem is that the conflicts, discords, and debates are not only those of the

1870s, but they belong to the 1970s, in which decade this book was being formulated, and to the 1980s, when substantive publications competed over the understanding of French culture of the Second Empire and Third Republic, and finally to the 1990s, when books like Brettell's could be launched with their costly and expensive perfume of 'proper' art history to cloak their lack of intellectual engagement with the issues that define both historical and cultural analysis.

Reading these two books is, therefore, in itself a complicated historical and strategic processes for they cross refer and yet aim to be radically different. They indicate the institutional, theoretical and political alignment from which writing is produced, and art history is shaped. Yet I am still puzzled as to how to engage with the review process at the level of the texts themselves and the precise arguments. I clearly belong to a another patriline, established negatively by disgruntled graduates of the Courtauld Institute in the late 1960s and early 1970s, who, for a moment, formed a nucleus at the University of Leeds, of a Marxist Social History of Art. I feel closer to Donna Haraway's key agents, for I am a *daughter* of Man-the-Modernist, caught up in the struggle for 'artistic nature'.[11] What was it in that moment of theoretical and methodological self-examination in the 1960s-70s that made possible, from within this powerfully patriarchal formation, a Marxist-feminist analysis which set itself adrift from both its fathers and brothers, while yet remaining recognisably caught up in the Francophilia that Nicholas Green argued located Impressionist studies in the heart of British (and American) bourgeois tourism and taste. In those days (the later nineteenth century when the Havermeyers were buying, or the early twentieth when MoMA's trustees had Rewald buy for them), you could bring back the pictures of Monet and Pissarro as the mementos of the trip to the Ile de France. Now insured for many millions, these pictures become the precious properties of which we buy via YUP the technologically reproduced simulacrum.

Zygmunt Bauman has written of the dramatic shift in the role and function of the intellectual from legislator to interpreter.[12] No doubt the major art historical figures in museums and universities earlier this century were legislators of taste and knowledge and what they said and did had explicit connections with their nations' policies in shaping and, more formally, legislating the social conditions of their contemporaries. Their laws of modernism, however, have since been challenged. Many of us no longer want a part of such 'establishments'. Art historians, however, increasingly find themselves, *de facto*, merely members of radically different political and intellectual communities within the overall cultural formation, interpreting the oft times opposing interests and conflicting knowledges from one to another.

Yet this analysis is not itself quite accurate. For while I am keen to read Brettell and Tucker and will no doubt be influenced in substantive ways by the careful scholarship of their reassembled series (Tucker reconstructs each of Monet's ten series), or minutely calibrated phases (Pissarro's work in Pontoise is broken down by Brettell into four periods and three sub-moments or interludes), I find no reciprocal recognition of the

other communities of knowledge in their texts. There is no sense of the debates which have riven the representation of modernism's moments and major instigators. The Yale patriline allows internal dissent sufficient to establish the individuality of its inheritors and developers, but it is immune to self-criticism resulting from awareness of a more radical challenge than it is prepared to mount. There is simply no admission of the politics of knowledge; the texts of Tucker and Brettell are structured by their own – ideological – omissions. In this, more than any other sense, they remain thoroughly modernist writings. Offering newly formulated, definitive readings of works, secured by scrupulous empirical observation of the facts (or what they deem as facts), the paintings, they tell the stories of art through its canonical artists, who are the unproblematic agents of their own narratives.

A lone feminist voice was raised at the art historical event of the year, the Monet symposium for invited participants at the Royal Academy in December 1990. Anthea Callen argued that there were critical ways in which gender was enacted in both technique and its representation in reviews of Monet's work. (In passing, it is significant that Brettell, despite his call for serious analysis of technical questions, has never studied Anthea Callen's important work on the techniques of the Impressionists, accessible to scholars in a University of London doctoral thesis, and in several easily available and well-illustrated publications.) Referencing – footnotes – is also a method of the patriline which endorses other's stories of art quite selectively. In vain does one read these texts for any sense that issues of gender and sexuality are at stake in the persistent gaze of bourgeois men at working women's bodies (I'm thinking here specially of Pissarro's tormented self-consciousness about painting peasants and his non-acknowledgement of the fact he endlessly painted *women* peasants); in the freedom to travel, to rent spaces for work, to work outdoors in the ways which are substantial conditions of Monet's practice, reported in letters to stay at home Alice Hoschede.

But my regret at what is not here will sound mere peevish partisanship, as if I cannot appreciate anything other than what speaks to me, comes out of my own political and theoretical community. In reading these texts, I found myself arguing with the texts, often scribbling major objections or comments. This indicates an engagement with the arguments and the historical interpretations. But what point would a listing of objections serve, except to reveal what is already known, that there is a real difference in the fundamental conceptualisations of what art history is about, and what art-making is, what Pissarro or Monet were up to?

Let's risk it, none the less. Brettell's thesis is in two parts. An unmarked Part One deals with what Pissarro painted. In Chapter One, 'Pontoise: The Landscape Itself', Brettell marshals a range of historical materials, guide-books, local histories, contemporary texts on landscape, France and travel, to establish what Pontoise was like and how its past was seen as more glorious and definitive than its present. Then comes 'Pissarro's Pontoise: Omissions and Admissions', an analytical survey which shows that Pissarro avoided in his choice of motifs those which exposed extremes of wealth or

poverty, piety and tradition, functional landscapes of mill and quarry, and the crowded landscapes of town centre, leisure and whatever elements of urban modernity the undistinguished town of Pontoise offered. An unmodern painter of local modernities of the industrial landscape, Pissarro emerges as an artist of the agricultural landscape and, in particular, of the hamlet of L'Hermitage where Pissarro himself lived. But again Brettell's argument is negative. Against the work of literary analysts who study poets and their love of home or place, the genius loci, he argues:

> Pissarro's home environment was important to him because it was varied and accessible rather than because of any abstract genius loci or of any psychological attachment to it as home. Pissarro's vision of L'Hermitage was, if anything, a structural vision, one more concerned with balance and a deliberate blandness than with any forcefully associationist concepts of landscape.[13]

This quality of detachment from what was there, what could be seen, 'nature' as it is called in ideology, namely the countryside and its social relations of labour and exchange, as well as its classed forms of leisure, is a leitmotif of Brettell's Pissarro. And so is Pissarro's refashioning of what was there for the purposes of art. Now, in a sense, this is to state the obvious. Landscape painting is precisely the artifice of fashioning an order for what it fabricates in the doing as 'nature'. Pissarro's significance is the way in which he tried to make that process obvious, a matter of choice, work and later political conscience. Of course, an artist of Pissarro's community could no longer seriously entertain the myths of art or nature which served Millet and his mostly dreadful legatees. But it took some years of working this out, well into the 1870s. That difference is what 'Pissarro' as the author name for a complex historical strategy signifies and the almost obsessive self-documentation which forms the Pissarro correspondence indicates the kind of critical relation to the past – the need to work a way through its definitions and beyond them. In the 1860s, the would-be modernists forged their space of difference by calculated deference. Manet was the arch-historicist, but the debts to an art historically and musealised past structures the initial projects in the 1860s of most of the artists we now associate with 'the new painting'. That burden is discharged by the 1870s, but not in a way which produced any security for the artists.

Brettell reads as detachment all the signs of Pissarro's critical sense of what it was to be painting what he was at that moment, its ambiguities and difficulties. This allows Brettell to backtrack from Herbert's over-simple revisionism (archive, fact, interpretation), to fetishise Pissarro's 'ambivalence and fundamental indecision' and 'detachment' and move through his treatment of the bourgeoisie and the peasantry (of which these two comments are made) to a legislative analysis of Pissarro's 'Progressions and Regressions'.

Part Two of Brettell's book – a long final chapter – is a reading of Pissarro's work for its progress and triumph over equally forceful *retardataire* tendencies. Citing Theodore Duret's letter (6 December 1873), Brettell argues that Pissarro was influenced to retreat

from competition with Monet and Sisley and to concentrate on what Duret called 'his path of rustic nature'.[14] In contradistinction to Clark's positive reading of Pissarro's attention to the social relations of the landscape he was painting as a move against (what Nicholas Green called) the nature of the bourgeoisie – that privileged, recreative and often proprietorial or touristic contemplation of the not-city as a means of self-identification – Brettell sees Pissarro's interest in the labouring figure in the countryside as a regressive move away from the work of the classic Pontoise period 1872-3.

Green was a rebellious son, writing yet another story which far more radically challenged all the patrilines discussed so far. Nature, landscape painting and the fabrication of the nature artist in nascent, nineteenth-century art history as a paradigmatic class and later political subjectivity, were all formations which he located as discursive constructs of the early nineteenth-century bourgeoisie, and later of the official policies of the Third Republic, whose first decade witnessed the deaths of leading artists of the myth, Millet and Corot, and the strategic coordination of art historical text-making and market massage.[15]

Pissarro saw Monet's series as just such an example of self-curation in the conditions of market production. A letter to his son of 9 April 1891 complains of his disappointment in Monet's submitting to the demand to repeat himself and the 'terrible consequences of success'.[16] Paul Tucker's job is to rescue Monet from this indictment and lend authority to the series initiated in the 1880s as Monet's competitive response to the challenges of Seurat and Neo-impressionism in the later 1880s and to a longer-standing commitment to the *ralliement* of France after the humiliating defeat by the Prussians in 1870.

> On the surface, Pissarro's explanation seems quite reasonable. Everyone could find something to like in pictures that were painted with such 'pretty colours' as Pissarro described them. In addition, who could disparage such scenes of beauty and calm? With nothing disturbing or unrecognizable in them, the paintings encouraged the eye to roam and the mind to expand. But Pissarro's explanations suggest a host of other concerns that these paintings... appear to raise. What kinds of criteria for painting were operating here? What role was Monet assuming? And what really were the viewers seeing in these works? How, therefore, in the end, were the series paintings actually functioning?[17]

Tucker clears Monet of sharing Pissarro's 'socialist' (*sic*) beliefs and argues for a grander scale of ambition in which his individualism (i.e. if you are not a socialist, you are apolitical, not seeing individualism as itself a specific political and ideological class ideology) was put at the service of 'the nation's deep rooted interest in images of her countryside'.[18] Tucker uses the terms France and nation as if they were subjects, agents of history, acting as an entity:

France's interest in la terre was tinged with pride, patriotism and nostalgia… [or later] For as France attempted to redefine her goals, she needed reassurances about national fundamentals. She could take pride in various advances she had made during the period, such as her widely expanded colonial empire or the enormous expansion of her railway lines, but if she looked across her eastern borders to Germany or across the seas to England or America, she found that her competitors were outdistancing her in all areas of production, even in the realm of the arts. Thus images which propagated the wealth and beauty of the countryside, such as Monet's *Grainstacks* did much, however naively, to allay nascent fears about her undesired change in status.[19]

Tucker's suggestion that this series of paintings, and those that followed, mapped an imaginary territory of political fantasy in troubled times seems compelling, except that it's not quite what he thinks he's saying. Monet's *Grainstacks* seem to offer reassurances about the world, associating human life with natural rhythms and seasons. The problem arises in reading off such pleasures from the paintings and supposing that they appealed to 'France'. Tucker uses social history as background information on the anxieties of the bourgeoisie about national and colonial rivalries that would eventually precipitate the debacle of the First World War. He uses such information to a spurious historical credibility or sanitised political value to Monet's gambit in the 1890s. What it adds up to is that the paintings 'reflect their times'. Tucker seems unprepared to entertain the ideas that paintings are symptomatic of the complex and contested construction of what Benedict Anderson has called 'imagined communities', fictions of national unity that disguise and displace the real conflicts and fractures of late nineteenth-century European capitalisms.[20]

The problem is doing art history by formula. Researching the iconography of the regions of France, of poplar trees (the tree of Liberty in 1789), and Rouen's Gothic cathedral leads Tucker to discover the rich cultural and political resonances of images, icons and signs in the intensely politicised culture of nineteenth-century France. Does this mean that Monet's paintings meant what the signs they used signified at the time? Tucker's book has been generally recommended for its superb reconstruction of which pictures Monet painted and exhibited in the series of the series. But his attempt to read Monet as a politically aware artist has been repeatedly challenged. The Herbert/Yale patriline deals in artists, untroubled by questions addressed to authorship and agency from Marxist, structuralist, critical or psychoanalytical theory. Meaning thus is left as an exclusive matter of intention. Prove Monet did not intend this or that and the argument for any reading falls by the wayside. Other 'approaches' allow us to talk of the currency of imageries, suggesting that meaning is a factor of what references circulate in the culture in which texts are produced, distributed, used and consumed. Whatever Monet thought he was doing, which is a critical element of art practice at that date and in those emergent conditions of artistic production, his works once exhibited or sold became public items and encountered social meaning systems. These systems

constitute what Foucault would call discursive formations.

There can be no doubt that the question of France as a nation functioned axiomatically for the political and cultural discourses of the later 1880s. Tucker is right to address its role within Monet's aesthetic fabrication of utopian images of natural, timeless France – especially after the centennial exhibition of 1889, when Monet elected to share a two-person show with Auguste Rodin. But there was no safe idea of *La France*; only the most bitter contest for its identity and political direction as the country swayed from proto-fascist conspiracies with the Boulanger affair 1888-9 to the campaigns of armed urban guerrilla violence against the State in the early 1890s, a moment which also saw the eruption of that most brutal and divisive of political traumas, the so-called Dreyfus Affair. Here the question of the Nation as a matter of culture, social contract, race, or soil fissured the whole society for over a decade.[21] What Tucker reads under the positive rubric of historical nationalism was for others the sound of a devastating racism.

In 1882 Ernest Renan delivered a lecture at the Sorbonne under the title: 'What is a nation?' The ambiguities and contradictions of the desire for national identity were evident. As Max Silverman has argued, the text is usually read for a rationalist and contractual theory of nationhood which put race and an ethnic notion of the nation to rest. Yet the imagery of Renan's text is 'deeply infused with essentialism and ideas of tradition and of the spirit'.[22] Renan stated:

> A nation is a soul, a spiritual principle. Two things which in truth are but one,
> constitute this soul or spiritual principle. One lies in the past, one in the present.
> One is the possession in common of a rich legacy of memories; the other is the
> present day consent, the desire to live together, the will to perpetuate the value of
> the heritage that one has received in an undivided form.[23]

While seeming to argue against certain right-wing theories of the nation as defined by race, 'blood and soil', Renan's argument forges national unity out of a daily plebiscite combined with a cult of ancestors. Negotiating a participatory idea of the nation as the product of social cooperation, the argument still fell back on what Martin Thom has shown to be the basis of the Aryan and Germanising politics that became so horrifically explicit in the twentieth century.[24] The tensions between a civic, republican belief in the nation (which was inclusive) and a more racist cult of ancestors (which was exclusive) split France apart with the Dreyfus Affair. Monet's only known political identification was with Zola's pro-Dreyfus stand.

This does not allow a direct reading of his paintings, or his painting practice. It does, however, shape the parameters within which they were produced, leaving us the historians to question more closely the nationalist imperative that invested the soil, the land, the mountains, the regions, the historic monuments and even the trees of France with highly contestable meanings that no painter could escape, and certainly not one who is shown by Tucker to be calculating his 'campaigns' so anxiously with a view to

his market and reputation. Could nature become a sign for the nation, or was its use a way to avoid its complexities if nation could somehow be made synonymous with a neutralised, painterly factuality called nature? Monet's strategies involved the making of a highly recognisable, marketable set of aesthetic formulae that offered in themselves a sufficient and fantastic domain for the individual viewer/buyer to contemplate. Attenuated and abstracted, nature is transformed, and art itself, signified by all the signs of the paint, surface, and brushes, comes to provide a surrogate world of internally created balance and harmony in which the tensions of race, class, gender and nation – the former three literally exploding onto the political scene called the latter at this time – are not only suspended but made unimaginable. Monet's particular version of this modernist trajectory needs spelling out, rather than being vindicated in terms of a simplistic appeal to embarrassingly complacent bourgeois revisionism.

Tucker's attempted address to what was happening in French culture and politics in the 1890s – nation into nature – is preliminary to the weight of the rest of the book. Each chapter touches on the issue before reverting – thankfully perhaps – to the security of art historical description and the accumulation of data, reviews, chronology and corroborating evidence in the style made definitive for this domain of art history by John Rewald. Collation of such material is always valuable but there is not much more to be done with it; it begins to close the topic it alone structures and limits the project.

Change will only come if art historians start taking both art-making and history more seriously. How do the facts, so unselfconsciously narrated by Tucker as background, become foreground for analysis, the substantive basis and indeed process of a painting practice? This is the famous question T. J. Clark posed in 1973, in the essay 'On the Social History of Art'.[25] What are the relations between the densely woven picture surfaces and the minutely calibrated colour scales to exhibition strategies and sites, the selection or critics for catalogue essays, the decisions about motifs, and the public profiles Monet achieved with his subscription to buy *Manet's Olympia* (1863) and present it to the nation?

Not everyone is interested in the answers to such questions. They want the artist and his vision. They want to tell stories about 'artistic nature' – a confirmation more often than not of white masculine identities – and the place to do this best, as Nicholas Green found, is with painters of nature. Brettell and Tucker rerun the competition of the 1890s' avant-gardists, each supporting their own man. Only in reading Pissarro and Monet as related and interacting facets of the contradictory social and cultural moment in which their author-named practices were forged can we grasp the relations between the political, the historical, the textual and the subjective which complexly form the field of social action and cultural practice. Pissarro is, in this book, politically cleaned up, and Brettell makes him a good candidate for a post-modern award for ambiguity and ambivalence. Monet is likewise rescued from another Pissarro's politically motivated slurs, and is redefined as a political good guy, a patriot and nationalist. Clark's abrasive disdain for Monet and sympathetic reading of Pissarro's anguished engagement with

genuine political accountability as a painter in the era of high capitalism can be summonsed to muddy these moneyed waters.

But for all their differences, there remains a fundamental convergence in the way these various patrilines define their project and practice. The names remain the same, the canon is always in place, the monograph is the model, replicating the conditions of marketing, now, as then. By way of complete and revealing contrast, let me cite Tamar Garb's recent book on the complex place of women artists in the art institutions and discourse of late nineteenth-century France. Her study revealed how gender was an intricate part of the competing conceptualisations in France of the nation and of nature in the last two decades of the nineteenth century. Her work does not use background information merely to foreground the individual, authorised man-the-modernist story, but she carefully analyses the determinations upon artistic practice across the dispersed institutional and discursive formations of official *Ecole* and independent *Société*, press and market, which each social fraction of the art world had to negotiate.[26] Such work achieves both a depth of historical analysis and an understanding of the elaborate and many-sided ways in which artistic practice – making, exhibiting, selling, acquiring public significance and meaning – interfaced with, was the site of, resisted and disarmed the always intensely political and social practices which formed the very texture of what we call the historical and study as our object. Its pertinence as a model for all studies arises because such feminist enterprise and theoretically astute analysis pass beyond the patrilines which currently compete for the territory and defend in one form or other the same old man-the-modernist story.

I end by relocating this daughter with others less dutiful and borrow the phrase from Barbara Kruger: *We don't need any more heroes.*

Notes

1. A term inappropriately applied to this reviewer by the late Peter Fuller in one of his many tirades against the contamination of art by structuralist interrogations of its conditions of existence and affect.

2. Thames and Hudson has a serious book list, which is cheaper and less lavishly illustrated. T. J. Clark's books, which will figure in this story, come through that format. Then Manchester University Press has produced some major texts in cultural analysis, Nicholas Green's *The Spectacle of Nature* (1990) is a typical instance.

3. Donna Haraway, 'The Contest for Primate Nature: Daughters of Man-the-Hunter in the Field, 1960-80' in M. Kann (ed.), *The Future of American Democracy*, 1983.

4. Ibid., p. 184.

5. MoMA's version can be located in the writings of A. H. Barr, e.g. *Cubism and Abstract Art*, 1936, and in John Rewald, *History of Impressionism*, 1949.

6. See especially 'On the Social History of Art' in *The Image of the People*, London: Thames and Hudson, 1973.

7. Brettel, op. cit., p. 5.

8. Ibid., p. 203.

9. This discussion is taken from the text of the episode on Pissarro written and spoken by T. J. Clark in the series *Modern Art and Modernism*, produced by the Open University, Milton Keynes, England, 1983.

10. Brettell, p. 203.

11. I am punning here on her work on the women students of Washburn, daughters of Man the Hunter thesis, whose work she names as a struggle for 'primate nature'. Both art history and primatology ultimately are facets of what Foucault named 'the sciences of Man', for their underlying topic of their research in of course a political interpretation of what constitutes human social order represented and legitimated as human nature.

12. Zygmunt Bauman, *Legislators and Interpreters, On Modernity, Post-modernity and Intellectuals,* Cambridge: Polity Press, 1987.

13. Brettell, p. 117.

14. Ibid., p. 165.

15. The entire argument was proposed in Nicholas Green's PhD thesis, 'The Nature of the Bourgeoisie', 1986, under Adrian Rifkin's and my supervision at Portsmouth Polytechnic and it was posthumously published as *The Spectacle of Nature, Landscape and Bourgeois Culture in Nineteenth Century France,* Manchester University Press, 1900, and in articles in *Block, Art History* and the *Oxford Art Journal.*

16. Cited Tucker, p. 107.

17. Tucker, p. 107; the explanation referred to was that the success of Monet's 1889 exhibition at Petit's gallery was unsurprising given the fact that the paintings breathe contentment and are so pretty, p. 109.

18. Ibid., p. 110.

19. Ibid., pp. 111-12.

20. Benedict Anderson, *Imagined Communities: Reflections on the Origins and Spread of Nationalism,* London: Verso Books, 1983.

21 See Norman L. Kleeblatt, *The Dreyfus Affair: Art, Truth and Justice,* New York: The Jewish Museum and California University Press, 1987.

22. Max Silverman, *Immigration, Race and Nation in Modern France,* London: Routledge, 1991 (cited from the manuscript edition).

23. Ernest Renan, 'What is a Nation' [1882] reprinted in translation by Martin Thom in Homi Bhabha, *Nation and Narration,* London: Routledge, 1990, p. 19.

24. Martin Thom, 'Tribes within Nations: the Ancient Germans and the History of Modern France', in H. Bhabha, op. cit., pp. 22-3; I am grateful to Max Silverman for his references and advice on this section.

25. T. J. Clark, 'On the Social History of Art' in *Image of the People,* New York and London, 1973.

26. Tamar Garb, *Sisters of the Brush: Women's Artistic Culture in Late Nineteenth Century Paris,* London and New Haven: Yale University Press, 1994. Note that although this book is a Yale publication, it has no colour reproduction at all.

Avant-Gardes
and Partisans Reviewed

FRED ORTON AND GRISELDA POLLOCK

An *avant-garde* does not simply emerge 'readymade' from virgin soil to be attributed *à la mode*. It is actively formed and it fulfils a particular function. It is the product of self-consciousness on the part of those who identify themselves as, and with, a special social and artistic grouping within the *intelligentsia* at a specific historical conjuncture. It is not a process inherent in the evolution of art in modern times: it is not the motor of spiritual renovation and artistic innovation; and it is more than an ideological concept, one part of a complex pattern of imagery and belief. An *avant-garde* is a concrete cultural phenomenon that is realised in terms of identifiable (though never predetermined) practices and representations through which it constitutes for itself a relationship to, and a distance from, the overall cultural patterns of the time. Moreover, its construction and the definition of its function result from a broader discursive formation that provides the terms of reference by which artists can see themselves in this illusory but effective mode of difference, and by which others can validate what they are producing as somehow fulfilling an *avant-garde's* function.

The term *avant-garde* had a short provenance in the language and literature of art. It was not until the twentieth century that its military or naval meaning (the foremost division or detachment of an advancing force) or the political usage (an élite party to lead the masses) was appropriated by art criticism. Modernist art history has evacuated the term's historical meanings, using it to signify an idea about the way in which art develops and artists function in relation to society. *Avant-garde* is now a catch-all label to celebrate most twentieth-century art and artists. 'Avant-gardism' has become the pervasive, dominant ideology of artistic production and scholarship.[1] It instates and reproduces the appearance of a succession of styles and movement often in competition

and each one seemingly unique and different in its turn. And like all ideologies, 'avant-gardism' has its own structures of closure and disclosure, its own way of allowing certain perceptions and rendering others impossible. The illusion of constant change and innovation disguises a more profound level of consistency, a consistency of meaning for the *avant-garde* that results from the concrete history of real practices and postures which were first designated as a cultural *avant-garde* in Paris in the 1850s-1870s. Furthermore, the same illusion of continuity also serves to mask the problematic moments of genuine rupture and transformation within that real history.

The defining parameters of art recognised as modern were adumbrated in the practices and procedures of art-making in Paris in the 1850s-1870s. Art, it was claimed, should have no aim but itself: art should use its own techniques to bring itself into question. This set of artistic practices and aesthetic ideology can be rightly characterised as *avant-garde*. But the *avant-garde* means more than this. *Avant-garde* must also signify, as it did in its inception in the second half of the nineteenth century, a range of social postures and strategies for artists by which they could differentiate themselves from current social and cultural structures while also intervening in them. To be of the *avant-garde* was to participate in complex and contradictory tactics of involvement with, and evasion of, immediate forms of metropolitan social and economic life. That transitionary period of engagement and disengagement can be called the *avant-garde* moment.

In this century there has been only one other, successful *avant-garde* moment when the *avant-garde* and the definition of appropriate vanguard practices had to be, and was, revivified and rearticulated. This occurred in New York and in the late 1930s and early 1940s when a new discursive framework was established that enabled some of the artists and intellectuals who gathered there to construct an identity for themselves that was simultaneously an opposition to, and an extension of, available American and European traditions. It provided them with a consciousness of a role and a function through which they could engage with, and disengage from, the current social turmoil and ideological crisis. What concerns us here as historians of modern American art is the failure of art history to recognise this formation. Most historians of American art since the Second World War make no distinction between the influences – artistic or otherwise – on the development of Abstract Expressionism as a style of painting, and those decisive forces which shaped the consciousness of the artists and apologists involved in its production and ratification. Until these forces are mapped we shall not understand what it was that allowed those artists and intellectuals to regard themselves as an *avant-garde* and to be recognised as such in America and eventually in Europe.

In the celebratory histories of the American phase in the history of modern art the term *avant-garde* or vanguard is taken for granted. The opening sentences of Irving Sandler's introduction to his book on *The New York School: The Painters and Sculptures of the Fifties* are paradigmatic.

From 1947 to 1951, more than a dozen Abstract Expressionists achieved 'breakthroughs' to independent styles. During the following years, these painters, the first generation of the New York School, received growing recognition nationally and globally to the extent that American vanguard art came to be considered the primary source of creative ideas and energies in the world, and a few masters, notably Pollock, de Kooning, and Rothko, were elevated to art history's pantheon.[2]

Here Sandler rehearses now familiar clichés about the growth and subsequent 'triumph' of Abstract Expressionism whereby the work of certain artists is represented as the School of New York and inserted into the history of art as the successor to the School of Paris. The phrase 'American vanguard art', slipped in without explanation or qualification, serves merely as a descriptive label for an art produced in New York in the 1940s and promulgated throughout the world during the period of the Cold War. *Avant-garde* is synonymous with Abstract Expressionism. It signifies merely the novelty of appearances in a style of painting. Sandler's conception of artistic production is a simple, three-fold process. First, there is the creation of a new style in art. Thereafter, critical acclaim at home and abroad recognises the advancedness of those styles. Finally, those advances are situated in the history of art as a school with certain masters.

Sandler's art historical method is common enough. It is intentionalist and formalist, a history of style which is based on notions of individualism and multiple discovery. It manifests all the symptoms of '*avant-gardism*' in its inability to account for the *avant-garde*. In Sandler's history the *avant-garde* becomes commonplace, matter of fact, eternal rather than something specific or disputable. It is not surprising, therefore, that his major full-length study of New York painting *c.* 1942-52, *Abstract Expressionism: The Triumph of American Painting* (New York, 1970)[3] fails to identify the twentieth-century *avant-garde* moment, and does not consider how the *avant-garde* was formed and what it was formed for. Sandler's narrative of 'broader attributes of [this] process of stylistic change'[4] conceals the fact that a section of the New York intelligentsia was intensely preoccupied with the *avant-garde* in the late 1930s and early 1940s. No mention is made of the intervention which one member of that group, Clement Greenberg, made at that time in *avant-garde* theory and American intellectual – and, importantly with regard to Abstract Expressionism – artistic strategies. Greenberg has to be accounted for. Yet he is virtually absent from Sandler's discussion of the 1930s and he is misrepresented in the chapter wherein Sandler describes how 'A New Vanguard Emerges' in the early 1940s.[5] In this chapter Sandler mentions the fact that several like-minded artists became better acquainted with one another after 1943 and exhibited together. He provides a survey of critics' reviews of these shows and their various attempts to find a title for this new style of painting. While Sandler cannot ignore Greenberg's role as an art critic in this decade, he treats him exclusively as an exhibition reviewer, responding to paintings and mediating between artistic innovation and the public. None the less, Sandler intuits a critical relationship between Greenberg and the

term *avant-garde*. In fact, Sandler only uses the term *avant-garde* or vanguard – below the title, that is, – with reference to Greenberg's criticism or in quotations from it. Greenberg is never acknowledged as having been part of the *avant-garde*, and his contribution to its formation in writings which were published prior to the appearance of Abstract Expressionism as a recognisable style is ignored. 'Avant-Garde and Kitsch' (1939), Greenberg's major article on the *avant-garde* is neither referred to in Sandler's text nor cited in his bibliography.[6] Sandler draws his notion of *avant-garde* from Greenberg's essay 'Towards a Newer Laocoon' which was published in 1940.[7] It is an important text but it is not about the *avant-garde*. 'Towards a Newer Laocoon' is a defence of a certain kind of abstract painting made with reference to Greenberg's history of the *avant-garde*. Sandler quotes one passage in which the term *avant-garde* is used only adjectivally and with reference to certain formal strategies and preoccupations which, however symptomatic of *avant-garde* painting they are, do not define the *avant-garde*.

> The history of avant-garde painting is that of a progressive surrender to the resistance of its medium; which resistance consists chiefly in the flat picture plane's denial of efforts to 'hole through' it for realistic perspective space... Painting abandons chiaroscuro and shaded modelling... Primary colours replace tones and tonality.[8]

Sandler's distortion of Greenberg's ideas and position is furthered by attributing to the 1940s arguments which were not fully articulated until the 1950s. He maintains that 'Greenberg exhorted artists to rid art of expendable conventions, of borrowing from other arts, in order to arrive at progressively purer stages, each of which was avant-garde in its time.'[9] He assumes that *avant-garde* is merely a label which Greenberg applies to stages in the successive 'purification' of art. Sandler's account is a common but serious misconception of Greenberg's theory of the *avant-garde*. He fails to grasp the nature of Greenberg's intervention or to realise that his argument concerning the *avant-garde* was historically specific, a product of its moment and conditioned by it. Sandler can neither reconstitute the historical ineligibility of Greenberg's discourse on the *avant-garde* nor tell us what is special about it.

Greenberg's first essay on the *avant-garde*, 'Avant-Garde and Kitsch', was published in *Partisan Review* in the Fall of 1939.[10] The article – an essay not on painting or sculpture but on culture – was Greenberg's considered contribution to a debate about the role and nature of revolutionary literature and art which was undertaken in this magazine between 1936 and 1940. *Partisan Review* was a literary magazine which had been founded in 1934 by William Phillips and Philip Rahv. The intention was for the magazine to publish the best writings of the New York John Reed Clubs,[11] to publish creative and critical literature from the viewpoint of the revolutionary working class. From the outset, however, the editors thought that it was wrong to make literature the vehicle for currently expedient political ideas. Literature should not just promote class struggle. Literary history had to be preserved even if it was largely the history of

bourgeois authors writing for a bourgeois audience. As far as Philips and Rahv were concerned, a literary theory derived form Marxism was an intellectual tool to be used to understand and preserve the best literature of the past while creating the basis for a new culture.

In July 1935 the Seventh World Congress of the Third Communist International defined the new Soviet policy of the Popular Front, an attempt to unite a broad spectrum of intellectuals in a common campaign against fascism which would, moreover, more favourably dispose non-aligned Marxists and liberals towards the Soviet Union. The John Reed Clubs were one of the first casualties of this redefinition of Soviet policy with its move away from revolutionary class struggle. They were disbanded and replaced by the League of American Writers, an organisation that was formed to provide the necessary framework to accommodate sympathetic individuals and a more flexible approach to literature.[12] Most of the little radical magazines who relied on the John Reed Clubs for literary and financial support were forced to cease publication. *Partisan Review* was critical of the Popular Front and remained committed to a revolutionary new literature. It managed to continue publication without becoming affiliated to the League but toward the end of 1936 it, too, folded. In December 1937 *Partisan Review* resumed publication, but with a different orientation.

To *Partisan Review* the 'death' of proletarian literature left the problem of the modern writer and intellectual with no adequate solution. How could revolutionary writers forge a new sensibility out of a reconciliation of Marxist ideology with formal or artistic experimentation? The events of 1935 (Popular Front) and 1936 (Stalin's purge of independent intellectuals and political enemies, the Moscow Trials) cast fundamental doubts on the integrity of Soviet Communism. It seemed imperative to recognise and resist the degeneration of the Communist movement which had been responsible for the misdirection of revolutionary culture towards the policy of the Popular Front. This process is most evident in the magazine's reassertion of the theoretical purity of Marxism by a temporary identification with Trotskyism – a form of Marxism which appealed to the editors' highly intellectualised radicalism and clarified their objection to Communism. When *Partisan Review* resumed publication it did so independent and critical of the Communist movement. There were four new editors. Phillips and Rahv were joined by G. L. K Morris (the painter and member of American Abstract Artists) who provided much of the financing of the magazine until 1943 but had little to do with literary or political issues, and Fred Dupee (formerly an editor of *New Masses*), Mary McCarthy (the novelist and poet), and Dwight MacDonald (who had been on the staff of *Fortune*), who were all sympathetic towards Trotskyism. It was MacDonald who in late 1937 wrote to Trotsky – in exile in Mexico – on behalf of the editors outlining the policy of the magazine and requesting a contribution to a symposium on the theme 'What is Alive and What is Dead in Marxism?'. Trotsky replied refusing: he thought the symposium seemed extremely pretentious and confused; the majority of the writers whom the editors had invited had shown a complete incapacity for theoretical thinking

– some of them were political corpses. He doubted the strength of the *Partisan Review*'s conviction to rid itself of Stalinist influence. Towards the end of his letter, dated 20 January 1938, Trotsky wrote:

> A world war is approaching. The inner political struggles in all countries tend to become transformed into civil war. Currents of the highest tension are active in all fields of culture and ideology. You evidently wish to create a small culture monastery, guarding itself from the outside world by scepticism, agnosticism and respectability. Such an endeavour does not open up any kind of perspective.[13]

In other words in the current state of world affairs it was not sufficient to withdraw into political scepticism and idly debate about the condition of Marxism. Trotsky insisted that the imperative and inescapable events of revolutionary significance which were affecting all spheres of culture and ideology demanded engagement from those involved in these areas to *act* with a breadth of view and develop a truly revolutionary perspective for their work.

However, another, later request to Trotsky met with a positive response. His doubts about *Partisan Review* eased, he expanded his arguments in a letter dated 18 June 1938 which was published in August under the title 'Art and Politics'.[14] Much of 'Art and Politics' is devoted to an attack on the conception of art's function and the bureaucratic constraints on artistic practice in Stalinist Russia. Trotsky also addressed American artists for whom the immediate crisis of capitalism and the imminence of war, which might either produce or foreclose the potential for revolution, were pressing realities. Trotsky offered some ideas on the revolutionary role which artists and their art could play. He wrote:

> The decline of bourgeois society means an intolerable exacerbation of social contradictions, which are transformed, inevitably into personal contradictions, calling forth an ever more burning need for a liberating art. Furthermore, a declining capitalism already finds itself completely incapable of offering the minimum conditions for the development of tendencies in art which correspond, however little, to our epoch... Art, which is the most complex part of culture, the most sensitive and at the same time the least protected, suffers most from the decay and decline of bourgeois society.

> To find a solution to this impasse through art itself is impossible. It is a crisis which concerns all cultures, beginning at its economic base and ending in the highest spheres of ideology. Art can neither escape this crisis not partition itself off. Art cannot save itself... unless present day society is able to rebuild itself. This task is essentially revolutionary in character. For these reasons the function of art in our epoch is determined by its relation to the revolution.[15]

Here history had set a trap for the artist. Trotsky gave the October Revolution as an example. The October Revolution gave a magnificent impetus to all kinds of Soviet art. After the Revolution, however, a massive bureaucracy was formed which stifled artistic creation. According to Trotsky, art was basically a function of the nerves and demanded complete sincerity. This genuine art was impossible in Soviet Russia where art – official art – was based on lies, deceits and subservience.

For Trotsky, art, culture and politics needed a new perspective without which humanity would not develop. But, he maintained, this new perspective should not begin with, or be addressed to, a mass base. A progressive idea only found its masses in the last stage. Trotsky maintained that all great movements had begun as 'splinters' of older movements. Protestantism, for example, had been a splinter of Catholicism and the group of Marx and Engels had come into being as a splinter of the Hegelian left. Movements in art occurred in the same way, and the more daring the pioneers showed in their ideas and actions, the more bitterly they opposed themselves to the established authority which rested on a conservative mass base.

Trotsky regarded it as vital that art should remain independent of any authority other than its own rules and principles.

> Art, like science, not only does not seek orders, but by its very essence cannot
> tolerate them. Artistic creation has its own laws – even when it consciously serves
> as a social movement. Truly intellectual creation is incompatible with lies,
> hypocrisy and the spirit of conformity. Art can become a strong ally of the
> revolution only in so far as it remains faithful to itself.[16]

This view, which Trotsky has first put forward in *Literature and Revolution*[17] – wherein he had argued that a work of art should in the first place be judged by its own law, that is the law of art[18] – was restated in the 'Manifesto: Towards a Free Revolutionary Art' that appeared in *Partisan Review*, Fall 1938.[19] The 'Manifesto' was published under the signatures of André Breton and Diego Rivera but is generally agreed that the text is substantially Trotsky's. Here it was pointed out that certain conditions were required if art was to play a revolutionary role. Foremost among these was the need for a complete opposition to any restriction on artistic creation. The imagination had to escape from all constraint. However, the practice of art had to be undertaken in concert with political practice.

> It should be clear by now that in defending freedom of thought we have no
> intention of justifying political indifference, and that it is far from our wish to
> revive a so-called 'pure' art which generally serves the extremely impure ends of
> reaction. No, our conception of the role is too high to refuse it in an influence on
> the fate of society. We believe that the supreme task of our epoch is to take part
> actively and consciously in the preparation of the revolution. But the artist cannot
> serve the struggle for freedom unless he subjectively assimilates its social content,

unless he feels in his very nerves its meaning and drama and freely seeks to give his own inner world incarnation in his art.[20]

In February 1939 *Partisan Review* published an enthusiastic letter from Trotsky which was written in support of the 'Manifesto'.[21] Trotsky explicitly located the demand for artistic freedom in relation to Stalinist corruption: 'The struggle for the revolutionary ideas of art must begin once again with the struggle for artistic truth.'[22] In relation to the current world crisis, reaction and cultural decline 'truly independent creation cannot but be revolutionary by its very nature, for it cannot but seek an outlet from intolerable social suffocation'.[23]

Thus Trotsky proposed a particular and historical relationship between art and bourgeois society in its state of aggravated contradictions and of art to social authority in general. Art requires a social base. Currently it depends upon bourgeois society. At the same time it plays a liberating role in relation to it. Art cannot escape the present crisis or save itself. Art will wither if society withers. It is historically tied to those forces which will rebuild society – revolution. Art has to be considered in a dialectical relationship to historical forces and social forms, autonomous in pursuing its role but not independent of the society which sustains it.

Art is the force through which humanity advances. It liberates by contributing progressive ideas and new perspectives on the world. But artistic progress cannot be prescribed in advance: it is not subject to bureaucratic contract or mass opinion. Art is therefore presented as kind of 'advanced guard' on the level of culture and consciousness. In order to fulfil its function art must be free from external constraints. It may be dependent but it serves only by pursuing its own trajectory – specifically, not arbitrarily. Art's participation in revolution will not be accomplished by subservience to political bureaucracy, to fabricating and supporting party lines, but by its concern for its own human integrity.

During 1939 *Partisan Review* became increasingly concerned about conditions in Europe. In addition to the need to take a political stance opposing fascism and the imminent war, *Partisan Review* discussed the fate of Western culture under this dual threat. The unsigned editorial, 'The Crisis in France', Winter 1939, described the special significance which Paris had as the 'eye' of modern European civilisation.[24] For a century the history of Paris had been the history of European politics, art and literature. It was there that 'the expression of the best integrated culture in modern times, the *avant-garde... in art and literature' was born and survived.[25] Now that was threatened. The eye of the Western culture was dimming. If France went fascist, as it seemed likely under the Daladier government,[26] the West could say goodbye to culture in all seriousness for a long time to come.

In the editorial of the Spring 1939 issue of the *Partisan Review* titled 'War and Intellectuals: Act Two', Dwight MacDonald appealed to intellectuals to resist the drive towards a second war.[27] Spuriously presented as a crusade for democracy, the war was,

in fact, a war in the interests of the capitalist ruling class and itself a product of capitalism. MacDonald insisted that support for the war under the banner of opposition to fascism abroad meant 'political and cultural submission to the ruling class at home'.[28] He restated the opposition to the Stalinist policy of a united front against European fascism. American intellectuals seemed to have forgotten that there was a genuine alternative to capitalism and its wars – social revolution.

> The great objection to the war programme of individuals is not so much that it
> will get us into the war - the bourgeoisie will decide that question for
> themselves... but that is diverting from our main task: to work with the masses
> for socialism, which alone can save our civilisation.[29]

Intellectuals who support the war claim to be concerned with the future of civilisations; they think themselves to be on the side of the people. In effect, they are aligning themselves with the bourgeoisie, with capitalism, in supporting the war, in identifying the enemy as foreign fascism. According to MacDonald this paradox results from the 'peculiar relationship of the intelligentsia to the class struggle'.[30] By virtue of their not having a direct economic interest in one side or another they can pose as 'disinterested', free from class loyalties, addressing themselves to 'society in general'. However, like the small bourgeoisie from which most intellectuals come, the intelligentsia does adopt class alignments. In times of severe capitalist crisis they may side with the workers but more often they follow the big bourgeoisie – which is now leading them into war. In this virulently anti-war piece, MacDonald calls on American intellectuals to ally themselves with socialism to defend civilisation and to reoccupy their position which involves the 'privilege – and duty – of criticising ruling class values'.[31]

The role and place of intellectuals, the intelligentsia, was taken up by Philip Rahv in his editorial 'Twilight of the Thirties' in the next issue of *Partisan Review*, Summer 1939.[32] Rahv's article opens with an attack on certain ideas put forward by intellectuals who want to defend literature and the human values of culture by supporting the war. Rahv reviews the fate of literature and its relation to politics in the preceding decade. Literature – as opposes to the mere production of books – is already being 'liquidated' as much in so-called democratic countries as in totalitarian states. Writers seem to be voluntarily and enthusiastically submitting themselves to a coarsening and shrinking of the cultural market symptomatic of an exhausted civilisation. Rahv argues that there are lessons to be learned from the relationship of politics to literature, especially in the abuse of talent and which results when writers serve party machines and fellow party lines. Politics *qua* politics is neither good nor bad for literature which is none the less subject to general processes of social determination. Literature cannot escape the influence of its society, its history. At the present time politics is shaping its destiny. This impact can be seen in the prevalence of a reactionary *Zeitgeist* which reflects the two great catastrophes of the epoch, the victory of fascism and the defeat of the Bolshevik

Revolution. In America Rahv sees symptoms of this decline in the emergence of a new gentility in literature, a cowardly and hypocritical pandering to official public opinion, a patriotic regionalism celebrating America's bourgeois history. In pointing to the ebb of creative energy and rapid decline in standards, Rahv identifies an absence:

> This is the one period in many decades which is not being enlivened by the feats and excesses of that attractive artistic animal known as 'the younger generation'. With very few exceptions, the younger writers of today, instead of defying, instead of going beyond, are in fact imitating and falling behind their elders. There still are remnants, but no *avant-garde* movement to speak of exists any longer... Everywhere the academicians, the time-servers, the experts in accommodation, the vulgarizers and the big money adepts are ruling the literary roost... For more than one hundred years literature... was in the throes of a constant inner revolution, was in the arena of uninterrupted rebellions and counter rebellions, was incessantly renewing itself both in substance and in form. But at present it seems as if this magnificent process is drawing to a close.[33]

To speak of modern literature, Rahv argues, is to speak of a particular kind of social group created by the drastic division of labour which prevails under capitalism, namely the intelligentsia. Modern literature belongs to the intelligentsia who – restricted to the realm of technical and spiritual culture – make their living by preserving the old, and by producing new forms of consciousness. But what is the relation of this group to classed society? Rahv maintains that Marxist criticism in discussing the social base of literature had always laid too much stress on such polarised terms as 'bourgeois' and 'proletarian'. Literature was not linked to either of these classes directly: it was associated with, or dissociated from, the life of society as a whole as well as from the different classes because it gave expression to the given bias, moods, ideas of the intellectuals who produced it. This concept of the intelligentsia's social place and sense of independence, which had been developed initially by Trotsky with reference to the nineteenth-century Russian Symbolists, is expanded by Rahv. Rahv sees the claim for self-determination by the intelligentsia as a broader and characteristic phenomenon. The intelligentsia has operated with and within this ideology. Self-determination, however, remains an illusion. The intelligentsia is materially and politically dependent on society and its classes, but the illusion of self-determination has enabled it to act and think independently of both masses and ruling strata and to produce moral and aesthetic values which oppose and criticise the bourgeois spirit. Thus Rahv proposes that the most typically literary tendencies have become articulate because of the supportive social framework provided by the relative detachment of intellectuals from a society basically hostile and indifferent to human or creative – i.e. non-commercial – values.

Modern artists have been criticised by socially minded critics of the right and left for their introversion and privacy, their aesthetic mysticism, their tendency to the obscure and morbid. Without these qualities – which are not derived from limitless self-

confidence but from group ethos, the self-imposed isolation of a cultivated minority · the modern artist could not have survived in bourgeois society. It is this isolation, ideologically translated into various doctrines – Rahv gives the theory of 'art for art's sake' as an example – which prevented the art object being drawn entirely into the web of commodity relations. The modern artist preferred alienation from society to alienation from herself or himself.

The effect of the crisis of the 1930s has been to undermine this. Weakened, the capitalist system withdrew the privilege of limited self-determination which it had previously allowed the intelligentsia. It could not afford an independent or even a semi-independent class of intellectuals, and the intelligentsia could no longer make light of or disregard political beliefs or actions. It was drawn back into alliances with the ruling class. But which class was the ruling class – the decrepit bourgeoisie or the contending proletariat? The question momentarily posed by the events of 1917 had been elided by Stalinism with its political prescriptions for literature, and Rahv asks:

> In view of what has happened, is it not clear that the older tradition [of individualism in modern literature] was a thousand times more 'progressive' – if that is to be our criterion – was infinitely more disinterested, infinitely more sensitive to the actual conditions of human existence, than the shallow political writing of our latter days?[34]

Rahv doubted whether a new *avant-garde* movement 'in the proper historical sense of the term' could be founded in the pre-war situation, but he was not prepared to write an obituary.[35] This is hardly surprising. At its reappearance *Partisan Review* was conceived as a kind of 'international' of intellectuals who were devoted not to writing off the *avant-garde*, but to redefining it, preserving it and reproducing it. The editors, including Rahv, believed that cultural change could only be initiated by an international community of intellectuals and that the cultural epicentre – the *avant-garde* – of that community would be the Trotskyist intellectuals whose best work was being published in *Partisan Review*.

Partisan Review's discussion of the *avant-garde* was continued and developed in the next issue by Clement Greenberg in his essay 'Avant-Garde and Kitsch'. Greenberg had become associated with the magazine towards the end of 1938. He had contributed a review of a new translation of Bertolt Brecht's *A Penny for the Poor* to the Winter edition of 1939.[36] However, 'Avant-Garde and Kitsch' was his first major piece of writing. It is strategically complex both in terms of why it was written and what it argued. On one level, it can be read as a contribution to the discourse within *Partisan Review* on art and revolution and cultural change, and on another level, it can be seen as an attempt by a young writer to situate himself, or have himself accepted within, the Marxist intelligentsia of New York. 'Avant-Garde and Kitsch' was both a discussion of the nature and function of the *avant-garde* and the author's means of access to it. It was his way of claiming space within an *avant-garde* at that formative moment. Greenberg

was successful on both counts. In 1940 *Partisan Review* published another extended essay by him entitled 'Towards a Newer Laocoon' which, with 'Avant-Garde and Kitsch', provides the premises of his subsequent art writing, his apology for Abstract Expressionism and after. In 1941 he also became editor of the magazine. He was brought onto the board by MacDonald – with whom he agreed on most important political and cultural issues – and stayed until 1943.[37] In the same year that he became editor of *Partisan Review* he also became the first critic of *The Nation*, a position of considerable influence which he held throughout the decade.[38] Within a very short period, then, Greenberg moved from the relative obscurity of his job in the customs service in the Port of New York, spare time writer and painter, and sometime attender at Hans Hoffman's School, to occupy a central position within the radical and intellectual movement and cultural intelligentsia.[39]

'Avant-Garde and Kitsch' was written for the specific historical context of the debates in *Partisan Review*. In 1939 it had tactical implications. However, it was able to transcend that immediate context. Although 'Avant-Garde and Kitsch' accords with *Partisan Review*'s Trotskyism it does not proselytise a self-evident Trotskyist position. At that time Greenberg thought that it was 'necessary to quote Marx word for word' not Trotsky.[40] Greenberg's address was to the diversity amongst the young New York and East Coast left intellectuals and to the much larger body of liberals and radicals of various shades of opinion who made up the readership of the magazine.[41] After the war its status and credibility changed. In the 1940s and 1950s America's anti-Communism made the work of those intellectuals and institutions which had been, like Greenberg and *Partisan Review*, anti-Stalinist and against Communism before the war acceptable and important. Greenberg and his work could be, and were, mobilised for other projects. 'Avant-Garde and Kitsch', in particular, gained a currency and accessibility beyond that afforded it at the *avant-garde* moment.[42] Moreover, Greenberg offered something novel in his discussion of the *avant-garde*. He considered not only what it was but also what it was not. In this respect his essay addressed a problem raised in *Partisan Review* in February 1939 by Dwight MacDonald in an article on 'Soviet Society and its Cinema'.[43] MacDonald had raised the problem of mass taste. Why should the Russian masses like the Hollywood kind of film? And why should they prefer Russian academic painting to the work of Cézanne or Picasso? Why was the Museum of Western Art always empty and the Tretyakov always crowded? To what extent was the expression of popular taste in Russia spontaneous or stimulated and conditioned by official policy? Greenberg argued that it was not simply a question of choice between new and old (as Kurt London had done in his *Seven Soviet Arts*) or of 'conditioning' by the State (as MacDonald maintained).[44] It was a choice between 'the bad up to date old and the genuinely new'.[45] Greenberg gave as evidence the information provided by MacDonald that in 1925 at the height of the great period of the Soviet cinema, when the *avant-garde* was actively encouraged, the popular success was Douglas Fairbanks in Raoul Walsh's *The Thief of Baghdad*, and not Sergei Eisenstein's *Battleship Potemkin*.

There was a choice between *kitsch* and the *avant-garde*. The masses chose *kitsch* and they chose it irrespective of where they were, whether in backward Russia or the advanced West. 'Conditioning' could not explain the potency of *kitsch* or the lack of interest in the *avant-garde*.

In his introductory remarks to 'Avant-Garde and Kitsch' Greenberg observes that one and the same civilisation has produced two very different things, *avant-garde* and *kitsch*, which are both on the order of culture, and are ostensibly both parts of the same culture and products of the same society. It is his intention to distinguish and describe these coexistent forms and provide a historical account of their emergence. It seems quite likely that 'civilisation' refers to the general condition or social order of a particular society and that 'culture' is the work and practices of intellectual and artistic activity. Greenberg may well have had in mind Trotsky's definition of culture as the organic sum of knowledge and capacity which characterises an entire society, or at least its ruling class: culture embraces and penetrates all fields of human work and unifies them into a system, and individual achievements rise above this level and elevate it gradually.[46]

The article operates on two axes. It provides a particular historical perspective on Western bourgeois culture since the mid-nineteenth century, and critically, it addresses the contemporary condition of that culture. The correlation of the two is established at the outset. At the beginning of Section 1 on the *avant-garde* Greenberg offers some general statements about the fate of culture in a society which in crisis 'becomes less and less able, in the course of its development, to justify the inevitability of its particular forms'.[47] In the face of the resultant doubts and loss of communicative consensus between artists and their audience, culture comes to a kind of standstill, Alexandrianism. This constitutes an academicism in which controversy is avoided and creativity declines into virtuosity, repetition, or variation of established themes and modes. Greenberg says that 'It is among the hopeful signs in the midst of the decay of our present society that we – some of us – have been unwilling to accept this last phase for our own culture.'[48] Greenberg then offers the first definition of '*avant-garde*'. 'In seeking to go beyond Alexandrianism, a part of Western bourgeois society has produced something unheard of heretofore: avant-garde culture.'[49] *Avant-garde* culture is produced in Western bourgeois society as a means of resisting or overcoming the stagnation of culture - it is the force which 'keeps culture *moving*'.[50]

Greenberg provides a profile of the *avant-garde* not as an idea or as an artistic development. The *avant-garde* is a special socio-artistic intellectual *agency* through which culture can be advanced. Greenberg's characterisation implies a particular relationship between the artists who constitute the *avant-garde* and society which has a need of such a special cultural instrument. Greenberg also writes of *avant-garde* culture. This was produced at a historical moment *c.* 1850 in and against a network of particular ideological, social and economic conditions. Thus *avant-garde* refers to a novel *form* of culture produced in bourgeois society in the mid-nineteenth century and a novel *force* which advances and keeps culture at a high level.

At its inception the *avant-garde* was identical with the settlers of Bohemia, a place apart from bourgeois society. Circulating within this space were revolutionary ideas, anti-bourgeois ideas which enabled the *avant-garde* to identify itself as different from the bourgeoisie and to challenge it. This notion for Bohemia indicates that the *avant-garde* was formed by an ideological and social separation from bourgeois society. As soon as that primary detachment had been made, the *avant-garde* differentiated itself still further. It repudiated the revolutionary political ideas through which it had initially derived its consciousness of difference and distance. 'The revolution was left inside society, as part of that welter of ideological struggle which art and poetry find so unpropitious as soon as it begins to involve those "precious", axiomatic beliefs upon which culture thus far has had to rest.'[51]

The *avant-garde* withdrew from both bourgeois and anti-bourgeois politics in order to keep culture alive and developing independent of extraneous directives from external masters. This does not imply a non-political position or political indifference but a necessary distance, a distinct function which the *avant-garde* accomplished by disengagement. The *avant-garde* was formed by that from which it became separated. Politics gave it consciousness and courage but culture has its own spheres of activity and processes which are distinct from those of politics. Although the revolutionary impetus provided notions of change and progress, and the impulse to move forwards and reject stasis, the form of cultural revolution was not to be dictated by it.

The aim of the *avant-garde* was to preserve, direct and advance culture, but this could not be achieved by arbitrary experimentation. The *avant-garde* functions by defining and pursuing the proper concerns of art. 'Art for art's sake' was one result of this impetus: subject matter or content were dissolved completely into form so that to all intents and purposes the processes and disciplines of art became the subject matter of art. Abstract or non-representational art followed on from this.

> In turning his attention away from the subject matter or common experience, the poet or artist turns it in upon the medium of his own craft. The non-represent-ational or 'abstract', if is to have aesthetic validity, cannot be arbitrary and accidental but must stem from obedience to some worthy constraint or original.[52]

Literature or art no longer imitated the experimental world. Attention was turned upon the processes by which the imitation of that world had hitherto been produced. Art now referred to and investigated that which defined it in its particularity, its own disciplines and traditional practices.

> Picasso, Braque, Mondriaan, Miró, Kandinsky, Brancusi, even Klee, Matisse and Cézanne, derive their chief inspiration from the medium they work in. The excitement of their art seems to lie most of all in its pure preoccupation with the invention and arrangement of spaces, surfaces, shapes, colours, etc., to the exclusion of whatever is not necessarily implicated in these factors.[53]

The *avant-garde's* methods are fully justified because they are the only means by which to keep culture progressing, to create the genuinely new, and to maintain high standards in literature and art. However, 'art for art's sake' – *the avant-garde's* specialisation of itself - is a necessity which is not without its disadvantages. Many of those who traditionally supported and appreciated ambitious literature and art have been alienated because of the difficulty which the *avant-garde's* preoccupation with art's own means and materials presents. Culture in the process of development has never been a mass phenomenon. The *avant-garde* was never *economically* independent of bourgeois society but was tied to a fraction of its ruling class by an 'umbilical cord of gold'.[54] Now, *avant-garde* culture has begun to estrange some of that cultural élite on whose support it depended. The existence of the *avant-garde* is currently threatened by the erosion of its limited and inevitably select social and economic base; this undermines its confidence and courage and tempts it into academicism.

There is also another threat to culture. Greenberg calls this *kitsch*, which is the popular, commercial art or literature that appeared at the same time as the *avant-garde*. 'Kitsch is a product of the industrial revolution which urbanised the masses of Western Europe and America and established what is called universal literacy.'[55] *Kitsch* is a commodity produced to satisfy urban populations that have become dislocated from traditional rural folk cultures and now enjoy leisure sufficient to be bored. The masses need entertainment and diversion. *Kitsch*, which is mechanical, formulaeistic and profitable, provides it. *Kitsch* offers vicarious experience and faked sensations. It does not demand of its audience the hard work which is required for the enjoyment of high culture.

The signal difference between *avant-garde culture* and *kitsch* lies in imitation. With an *avant-garde* painting – Greenberg gives a painting by Picasso as an example – the spectator must react to an impression left by plastic or formal qualities. The ultimate sympathetic values, however, are derived at a second remove: they are the result of reflection upon that immediate impression and must be projected into the painting by the spectator as part of a reaction to the formal qualities. This second level of response is called the '"reflected" effect'.[56] With *kitsch*, the '"reflected" effect' is already included, available to, or for, the spectator's easy enjoyment and passive consumption. *Kitsch* is ersatz culture; it uses the debased and academicised simulacra of the mature cultural tradition as a reservoir for its tricks and stratagems. It provides a short cut to what is inevitably difficult and demanding in living culture, in art and literature of a high order.

As a mass-produced commodity of Western industrialism *kitsch* has been exported to the whole world. It is a cultural form for the masses. *Kitsch* has been adopted as the official culture of totalitarian régimes in Nazi Germany and Soviet Russia where it is used to win the political support of the masses.

> The encouragement of kitsch is merely another of the inexpensive ways in which totalitarian régimes seek to ingratiate themselves with their subjects... the main

trouble with avant-garde art and literature, from the point of view of Fascists and Stalinists, is not that they are too critical, but that they are too 'innocent', that it is too difficult to inject effective propaganda into them, that kitsch is more pliable to this end. Kitsch keeps a dictator in closer contact with the 'soul' of the people. Should the official culture be one superior to the general mass-level, there would be a danger of isolation.[57]

Kitsch, the cultural rearguard, has become a tool of political reaction. 'Avant-Garde and Kitsch' is a manifesto for the *avant-garde* in which Greenberg plays off a description of the reasons for the historical formation of these two cultural products against the circumstances of culture and society in 1939. The *avant-garde* was originally a product of bourgeois society, but, in decline, capitalism is threatened by whatever of quality and progressiveness it is still capable of producing. Accordingly, in the current crisis of capitalism, the dialectic by which the *avant-garde* was formed in and against bourgeois society as a product of it and challenge to it, is resolved in a different manner. Now, Greenberg argues, the *avant-garde* must look to revolutionary politics, to socialism, not only for a new culture but for the preservation of living culture, of itself. The *avant-garde* can, in this way, be aligned with revolution.

In 'Avant-Garde and Kitsch', Greenberg drew a map of the forces and relations of cultural production in Western bourgeois society since the mid-nineteenth centre in order to describe the constellation of those forces and relations in his present. Like Rahv, Greenberg could not point to the existence of an active *avant-garde* but he did indicate the necessity for it and describe how it might be formed.

'Towards a Newer Laocoon' which was published in July-August 1940 is in many ways the corollary to the arguments advanced in 'Avant-Garde and Kitsch'. In it Greenberg takes up issues which were summarily treated in the earlier piece such as imitation, the importance of the medium, and the historical significance of Cubism with reference to *avant-garde* painting. 'Towards a Newer Laocoon' is not an account of the *avant-garde per se.* Its point of departure is Greenberg's need to explain what he regards as the present supremacy of abstract purism. The necessities of that task lead him to provide an historical sketch of the concerns and procedures characteristic of the *avant-garde* in painting and sculpture from the 1850s to the early twentieth century. The essay is an application of certain general theses put forward in 1939 to a particular artistic trend in contemporary painting. 'Towards a Newer Laocoon' also serves as an elaboration of Greenberg's idea of the historical *avant-garde* and provides a more detailed definition of its purposes and procedures.

The article is presented primarily as a defence of abstract purism, abstract and non-objective painting, which rejects literature as a model for the plastic arts and therefore eschews overt subject matter. The purists had been dismissed as merely symptomatic of a cultist attitude towards art. Greenberg justifies their dogmatism and intransigence because these represent an extreme concern for the fate of art and a desire to conserve painting's identity. However, Greenberg argues that the claims made for abstract purism

by its supporters and practitioners can be questioned on the grounds that they are unhistorical. He writes:

> It is quite easy to show that abstract art like every other cultural phenomenon reflects the social and other circumstances of the age in which its creators live, and that there is nothing inside art itself, disconnected from history, which compels it to go in one direction or another. But it is not so easy to reject the purist's assertion that the best of contemporary plastic art is abstract.[58]

Greenberg proposes a historical answer to the problem of the present supremacy of abstract purism. It can be seen as 'the terminus of a salutary reaction against the mistakes of painting and sculpture in the past several centuries' which resulted from a confusion, a tendency for the arts to imitate each other and their respective effects.[59]

The preliminary historical and theoretical background is sketched in the first Section.

> There can be, I believe, such a thing as a dominant art form; this was what literature had become in Europe by the seventeenth century... Now, when it happens that a single art is given the dominant role, it becomes the prototype of all art: the others try to shed their proper characters and imitate its effects.[60]

Literature dominated the arts from the seventeenth century onwards. The pictorial arts had fallen into decline producing trivial forms of interior decoration for the royal and aristocratic courts on whose patronage they relied. The creative and rising social class, the mercantile bourgeoisie, turned its energy and support towards literature. In the shadow of literature's vitality and social pre-eminence, the other arts distorted their own natures in imitation not merely of literature but also of its effects. Painters and sculptors were tempted to conceal the characters of their respective mediums and thus they obscured the identities of their art forms. Visual artists had attained such technical facility and virtuosity that they could annihilate the mediums they worked in favour of illusion. They could achieve not only illusionism but the effects attained in other arts, and they were especially tempted to become the stooges of literature, sacrificing the medium to literary subject matter and to the creation of poetic effects in the interpretation of the subject matter.

In Section II of the article, Greenberg begins to map the artistic and social geography of culture in the nineteenth century with a discussion of the legacy of Romanticism. 'The Romantic Revival or Revolution seemed at first to offer some hope for painting, but by the time it departed the scene, the confusion of the arts had become worse.'[61] The Romantic Revolution coincided with the triumph of the bourgeoisie and as a result a fresh current of creative energy was released into every field. In the visual arts frivolous literary subject matter was replaced by more sincere and powerful themes which necessitated new and bolder pictorial means. Temporarily the medium was brought back into the limelight but the exploration of it soon deteriorated into virtuosity. Talent was

perverted in the service of realistic imitation. Romantic theory with its emphasis on the direct communication of feeling between artist and audience and the celebration of the artist's personality further eroded any sense of the craft and discipline peculiar to each art by virtue of its medium. Poetry was held to be the highest art, and with it, communication was established as the paradigm for all the arts. The legacy of Romanticism was a novel cultural phenomenon, academicism, a stasis in which talented artists serviced bourgeois society with an art of realistic illusion required by sentimental or sensational literature.

Here Greenberg situates the formation of *avant-garde* culture, the successor to and negation of Romanticism, a product of bourgeois society but also a challenge to it. In Section III he writes:

> Romanticism was the last great tendency flowing directly from bourgeois society that was able to inspire and stimulate the profoundly responsible artist - the artist conscious of certain inflexible obligations to the standards of his craft. By 1848 Romanticism has exhausted itself. After that the impulse, although indeed it had to originate in bourgeois society, could only come in the guise of a denial of that society, as a turning away from it. It was not to be an about-face towards a new society, but emigration to a Bohemia which was to be art's sanctuary from capitalism.[62]

In its Bohemian retreat the *avant-garde* strives to find 'adequate cultural forms for the expression' of bourgeois society.[63] This it does without succumbing to the ideological divisions within that society, its class conflicts and political struggles. The *avant-garde* also demands that the arts should be recognised as their own justification and not as vehicles of politics or servants of society. The major concern of the *avant-garde* is the preservation of art, and its exclusive responsibility is to the values of art. The *avant-garde* attempts to liberate painting and sculpture from ideas through which they are affected by current political struggles. It also tries to escape from the domination of literature, from the idea of art as communication, from subject matter in general, and from the concomitant disregard for the medium.

In an important aside Greenberg makes a distinction between subject matter and content. All art has content – it is neither empty nor meaningless - but subject matter is something extraneous which the artist has in mind whilst working. Content is a result, an effect of the work of art. Subject matter is a prior programme for it, something to be communicated to which the medium must be subservient. In place of subject matter, the *avant-garde* strives to emphasise form, and to insist on each art as an independent vocation, as a craft and a discipline, as something which deserves respect for itself not as a servant of social or literary communication.

In the subsequent paragraphs of this third section of 'Towards a Newer Laocoon' and in the whole of Section IV Greenberg's focus narrows to the internal history of *avant-garde* painting. He discusses the project of the *avant-garde* since the mid-nineteenth

century and identifies two variants in it. The first variant is represented by Courbet - 'the first real *avant-garde* painter'[64] – Manet, and the Impressionists who stressed sensations as the basis for painting and who, with materialist objectivity, attempted to emphasise the medium of their craft. In their work one can detect moves towards a greater sense of flatness, a tendency towards all-overness, and an insistence on plastic qualities. They also negotiated the problem of subject matter. Courbet challenged official bourgeois art and parodied it by representing prosaic contemporary life in place of literary subject matter. Manet used subject matter but with such insolent indifference that this directed attention to the medium. And the Impressionists sought to emulate the detachment of science, and simultaneously investigated the essence of visual experience and the essence of painting. Within this first variant of *avant-garde* practice the redemption of painting was accomplished by the erosion of subject matter through parody, indifference, detachment, or the inversion of the relative status of subject matter and medium. It also demonstrated the materialist emphasis on medium, visual experience and effect in painting.

The second variant of the *avant-garde* was also preoccupied with medium but investigated it for its expressive resources. It intended to express not ideas but sensations, the 'irreducible elements of experience'.[65] This tendency held several dangers, one of which was to tempt painting back into imitation. In this case it was not emulation of literature and its effects which was the danger but rather the emulation of music and to a lesser extent poetry. Remote from the possibility of imitation and absorbed in the physical qualities of its medium which was capable of great suggestiveness, music became the cynosure for all the arts. Music was, or seemed to be, the art of immediate sensation. It was only when music was considered as a method to be emulated rather than as an art to be imitated that the *avant-garde* made a breakthrough and came to recognise music's significance as an art of pure abstract form. Music can operate abstractly, without imitation or preconceived subject matter. It functions by appealing to those sensations proper to its medium and through which it can be suggestive, can have content. The *avant-garde* in painting, learning from music, had to pursue the particular identity of the medium of painting. Painting had to attend to its own pure form; it had to identify the sensations by which its medium appealed and by which it was to be known and responded to as a distinct art. Its emphasis, therefore, was found to be on the physical, the 'sensory'. Music had appealed to the *avant-garde* because, in opposition to literature which was concerned with the communication of conceptual messages, it was pure, sensuous, abstract. In order to liberate painting once again from the imitation of effects, it was necessary for the *avant-garde* to realise that music was not (or need not be) the only pure, sensuous, and abstract art form.

In Section V of 'Towards a Newer Laocoon', Greenberg discusses *avant-garde* practice since the 1890s and establishes a trajectory towards abstract purism which was the essay's point of departure.

Guiding themselves, whether consciously or unconsciously, by a notion of purity derived from the example of music, the avant-garde arts have in the last fifty years achieved a purity and a radical de-limitation of their fields of activity for which there is no previous example in the history of culture... Purity in art consists in the acceptance, willing acceptance of the limitations of the medium of the specific art.[66]

According to Greenberg there has been a historical process taking place by which the confusion between several arts has been increasingly clarified. Each art has been defined in its particularity in terms of the discipline which its medium imposes on it and the effects that medium produces. It is the *avant-garde* which functions to preserve the specific identity of each art. In the visual arts the medium is physical: it produces visual sensations and such emotion as it conveys may be called, in the words of Valéry, an emotion of 'plastic sight'. But there is yet one more distinction to be made within the plastic arts. Painting must be differentiated from sculpture. Greenberg maintains that much of the history of the *avant-garde* in painting hangs upon the programme of excluding the sculptural and other related means of realistic imitation from painting. Chiaroscuro and modelling are abandoned. Line no longer delineates shape, contour or volume; it is treated as colour. Space and depth or fictive three-dimensional illusion are reduced as the planes become flattened, pressed together to meet on the real plane of the canvas surface. These moves constituted a decisive surrender to the problems and character of the medium particular to painting.

The most crucial of these is the flatness of the picture plane which had, since the Renaissance, been consistently evaded by attempts to create the illusion of realistic space and the illusion of three-dimensional objects located in that space. The destruction of this pictorial space and with it the object 'was accomplished by means of the travesty that was cubism'.[67] Cubism represents the culmination of *avant-garde* moves to date and represents a decisive break with the past. But painting was not fully brought to abstraction by the Cubists. That was accomplished by subsequent artists, by the Germans, by the Dutch, and by the English and the Americans. Paris, hitherto the home of *avant-garde culture,* is not the centre of abstract art. Abstract art has now emigrated to London, and Paris is now the home of a regressive tendency in the arts towards literature and subject matter. This reaction, Surrealism, has to be omitted from Greenberg's notion of the *avant-garde*. It is here that his strategy becomes clear. Greenberg uses the phrase the 'development of Modern painting',[68] which is a collective term for art produced within the various strands of the historical *avant-garde* in painting. But not all modern painting is *avant-garde* – modern painting and the *avant-garde* are not synonymous. In this penultimate section of the essay, Greenberg identifies what, within the category of modern art practices, is still, in 1940, of the *avant-garde* and capable of advancing culture.

In the concluding part of 'Towards a Newer Laocoon', Section VI, Greenberg clearly states that he has 'offered no other explanation for the present superiority of abstract

art than its historical justification'.[69] He is adamant that abstract art is a justifiable product of the *avant-garde*'s necessary procedures for identifying and preserving the specific identity of painting as an art. There can be both *avant-garde* and reactionary tendencies in the arts; which is which is determined by the history of the *avant-garde* and the present condition of each art with regard to its traditions and conventions. Abstraction is only one of several contemporary tendencies in modern art. It is historically the most significant and potentially the vanguard of *avant-garde* culture in painting. The final paragraph begins:

> It suffices to say that there is nothing in the nature of abstract art which compels it to be so. The imperative comes from history, from the age in conjunction with a particular moment reached in a particular tradition of art.[70]

In 'Avant-Garde and Kitsch' Greenberg appealed to history, especially to a historical moment in the mid-nineteenth century in order to identify a comparable moment and recognise a parallel need for a special agency, the *avant-garde*. In 'Towards a Newer Laocoon' he traces the internal history of the art produced by that *avant-garde*. Greenberg not only contributes to the reconstruction of an *avant-garde* consciousness, a need for the force, but he also specifies the form of *avant-garde* culture in painting. The two essays, in conjunction, point to a new moment, a rupture, and indicate a consistency that enables Greenberg to identify the course in painting which the *avant-garde* might take.

The polemic of 'Towards a Newer Laocoon' is directed at contemporary critics and artists who, favouring a return to the imitation of nature in art, oppose and repudiate abstraction. Greenberg was addressing a specific constituency in the cultural intelligentsia, the practitioners and apologists of visual art. His essay represents a strategic manoeuvre within the coterie of *Partisan Review*'s editors and readership. The debates in the magazine had hitherto been pursued either in general cultural terms or with exclusive reference to literature and cinema. In 'Towards a Newer Laocoon' Greenberg was attempting to define a special place for himself within the artistic community and to reconstruct an *avant-garde* position for painting.

Greenberg reminisced about the late 1930s in New York in an article published in 1957, 'New York Painting Only Yesterday'.[71] He wrote:

> Abstract art was the main issue among the artists I knew then; radical politics was on many people's minds but for them Social Realism was as dead as the American Scene.[72]

When this was republished in 1961 in the edition of his selected writings, *Art and Culture*, a parenthesis was added in which Greenberg made an oblique but crucial reference to the political climate and debates on art, revolution and the *avant-garde* in *Partisan Review* between 1937 and 1940.

(Though that is not all, by far, that there was to politics in art in those years; some day it will have to be told how 'anti-Stalinism', which started out more or less as 'Trotskyism', turned into art for art's sake, and thereby cleared the way, heroically, for what has to come.)[73]

On to a Trotskyist claim for a special freedom for art, and for art as a form of cognition of the world and as a necessary precondition for the building of a new consciousness, Greenberg mapped one of the strategies of the historic *avant-garde,* 'art for art's sake', the steeping of painting in its own cause. In this transaction the momentary specificity of Trotsky's revolutionary perspective and Marxist vocabulary – some might say Trotsky's millenarianism – was erased. Opposition to prescribed subjects or functions for art – anti-Stalinism – was matched by a claim for the relative autonomy of artistic practices. This was then overlaid by the concept of a cultural *avant-garde* which, of necessity, fulfilled its social purposes at a distance from party politics and political organisation. Greenberg's participation in, and manoeuvres upon, that ideological terrain had the effect of clearing a space. He contributed to that moment by offering a special sense of a group identity for some painters and by defining a function for a specific kind of painting.

Notes

1. N. Hadjinicolaou, 'Sur l'idéologie de l'avant-gardisme', *Histoire et Critique d'Art*, vol. 2, 1976, pp. 49-76.

2. I. Sandler, *The New York School: The Painters and Sculptors of the Fifties*, New York, 1978, p. ix.

3. Republished in paperback as *The Triumph of American Painting: A History of Abstract Expressionsim*, New York, 1976.

4. I. Sandler, *Abstract Expressionism: The Triumph of American Painting*, New York, 1970, p. 1.

5. Sandler, op. cit. (1970), Ch. 6, pp. 78-89. In Chapter 1, 'The Great Depression', pp. 5-28, Sandler discusses New York art and artists in the late 1930s. He quotes form Greenberg's later writings, using them only as a document or a source of information, pp. 20, 23, 24. Greenberg is not discussed as a participant or formative figure in the intellectual and cultural milieu.

6. C. Greenberg, 'Avant-Garde and Kitsch', *Partisan Review*, vol. VI, no. 6, Fall 1939, pp. 34-49. Hereafter noted as A-G & K.

7. C. Greenberg 'Towards a Newer Laocoon', *Partisan Review*, vol. VII, no. 4, July-August 1940, pp. 296-310. Hereafter noted as TANL.

8. Sandler, op. cit. (1970), p. 84; TANL, p. 307.

9. Sandler, op. cit. (1970), p. 84.

10. See note 6.

11. The John Reed Clubs were founded in 1929 in memory of the American literary Bolshevik John Reed. For information on the Clubs see J. B. Gilbert, *Writers and Partisans: A History of Literary Radicalism in America*, New York, 1968, pp. 91-2, 108-9; and D. Aaron, *Writers on the Left*, Oxford and New York, 1977, pp. 221-30, 271-3, 280-3.

12. On the League of American Writers see Gilbert, op. cit., pp. 134, 138-49; and Aaron, op. cit., pp. 238-4.

13. Leon Trotsky, 'Letter to Dwight MacDonald', 20 January 1938, republished in *Leon Trotsky on Literature and Art*, ed. P. N. Siegel, New York, 1970, p. 103.

14. Leon Trotsky, 'Art and Politics', *Partisan Review*, vol. V, no. 3, August-September 1938, pp. 3-10.

15. Ibid., pp. 3-4.

16. Ibid., p. 10.

17. Leon Trotsky, *Literature and Revolution*, 1923, first translated into English by Rose Strunsky and published in 1925.

18. Leon Trotsky, 'The Social Roots and Social Function of Literature' in *Literature and Revolution* (1923) reprinted in *Leon Trotsky on Literature and Art*, ed. P. N. Siegel, p. 37.

19. André Breton and Diego Rivera, 'Manifesto: Towards A Free Revolutionary Art' (translated by Dwight MacDonald), *Partisan Review*, vol.VI , no. 1, Fall 1938, pp. 49-53.

20. Ibid., pp. 51-2.

21. 'Leon Trotsky to André Breton', 22 December 1938, *Partisan Review*, vol. VI, no. 2, Winter 1939, pp. 126-7.

22. Ibid., p. 127.

23. Ibid.

24. 'This Quarter - The Crisis in France', *Partisan Review*, vol. IV, no. 2, Winter 1939, pp. 3-4.

25. Ibid., p. 3.

26. S. Niall, 'Paris Letter Christmas Day 1938', *Partisan Review*, vol. VI, no. 2, Winter 1939, pp. 103-7. For instance, Niall wrote (pp. 103-4):

> A spectre is haunting France – not, alas the spectre of communism but that of internal fascism and external war... for politically conscious artists are already sufficiently distressed by the conviction that Daladier bears a more sinister resemblance to one Henrich Bruning than to Napoleon Bonaparte he apparently fancies himself to be, without having a quiet art weekly suddenly burst into reactionary howls against artistic progress which are unnervingly reminiscent of that 'Anti-Kultur-Bolshewismus' movement which, similarly born in 1932 Berlin, grew like a rank weed till, with Hitler's accession to power, it finally succeeded in entirely strangling German culture.

27. D[wight] M[acDonald], 'This Quarter - War and the Intellectuals: Act Two' *Partisan Review*, vol. VI, no. 3, Spring 1939, pp. 3-20.

28. Ibid., p. 10.

29. Ibid.

30. Ibid., p. 19.

31. Ibid., p. 10

32. P. Rahv, 'This Quarter - Twilight of the Thirties', *Partisan Review*, vol. VI, no. 4, Summer 1939, pp. 3-15.

33. Ibid., p. 5.

34. Ibid., p. 14.

35. Ibid.: 'I do not believe that a new avant-garde movement, in the proper historical sense of the term, can be formed in this pre-war situation. For obituaries, however, the time is not yet; despite multiple pressures a literary minority can still maintain its identity.'

36. C. Greenberg, 'The Beggar's Opera - After Marx' (a review of A Penny for the Poor by Bertolt Brecht, translated by D. Versey and C. Isherwood), *Partisan Review*, vol. VI , no. 2, Winter 1939, pp. 120-2.

37. On Greenberg and *Partisan Review*, see Gilbert, op. cit., pp. 244-5. Also see C. Greenberg and D. MacDonald, 'Ten Propositions on the War', *Partisan Review*, vol. VIII, no. 4, July-August 1941, pp. 271-8.

38. D. Ashton, *The Life and Times of the New York School*, New York, 1972, p. 158.

39. On Greenberg's use of Hoffman's teaching see Greenberg, A-G & K, p. 49, note 2: 'I owe this formulation to a remark made by Hans Hoffman, the art teacher, in one of his lectures. From the point of view of this formulation surrealism in plastic art is a reactionary tendency which is attempting to "restore" outside subject-matter.' See also C. Greenberg, 'Art', *The Nation*, vol. 160, no. 16, 1945, p. 469, wherein he states that he owed 'more to the initial illumination received from Hoffman's lectures ttha to any other source.'

40. Greenberg, A-G & K, p. 49.

41. See Gilbert op. cit., pp. 195-7 for discussion of the results of a questionnaire sent out to subscribers and readers in 1941: 35 per cent were found to live in New York and 50 per cent were spread over the East Coast. 'But in general the magazine was directed to the radical intellectual community of New York' (p. 197). See also L. Fielder, *'Partisan Review – Phoenix or Dodo? – The Life History of America's Most Influential Cultural Magazine'*, *Perspectives*, vol. 15, Spring 1956, p. 84.

42. The essay was reprinted in *The Partisan Reader*, ed. W. Phillips and P. Rahv, New York, 1946, pp. 378-92 and also as the opening essay in the edition of selected writings by C. Greenberg, *Art and Culture: Critical Essays*, Boston, 1961, pp. 3-21.

43. D. MacDonald, 'Soviet Society and its Cinema', *Partisan Review*, vol. VI , no. 2, Winter 1939, pp. 80-95.

44. Greenberg, A-G & K, pp. 41-2.

45. Ibid., p. 42.

46. Leon Trotsky, 'Literature and Revolution' (1923) in *Leon Trotsky on Literature and Art*, ed. P. N. Siegel, p. 54.

47. Greenberg A-G & K, p. 34.

48. Ibid., p. 35.

49. Ibid.

50. Ibid., p. 37.

51. Ibid.

52. Ibid., p. 37.

53. Ibid.

54. Ibid., p. 38. The notion stems from a text by Joseph Freeman, Proletarian Literature in the United States, New York, 1935, p. 20.

55. Ibid., p. 39.

56. Ibid., p. 44.

57. Ibid., p. 47.

58. Greenberg, TANL, p. 296.

59. Ibid.

60. Ibid., p. 297.

61. Ibid., p. 299.

62. Ibid., p. 300.

63. Ibid., p. 301.

64. Ibid., p. 302.

65. Ibid., p. 303.

66. Ibid., p. 305.

67. Ibid., p. 308.

68. Ibid., p. 309.

69. Ibid., p. 310.

70. Ibid.

71. C. Greenberg, 'New York Painting Only Yesterday', *Art News*, vol. 56, no. 4, Summer 1957, pp. 58-9, 84-6.

72. Ibid., p. 58.

73. Reprinted as 'The Late Thirties in New York' in *Art and Culture: Critical Essays*, 1961, p. 230.

Jackson Pollock, Painting and the Myth of Photography*

FRED ORTON AND GRISELDA POLLOCK

On 11 November 1957 Porter A. McCray, Director of the International Programme of the Museum of Modern Art, New York, wrote to Bryan Robertson, Director of the Whitechapel Art Gallery in London. McCray was arranging a European tour of the Jackson Pollock retrospective which at that moment constituted a major section of the United States representation of the San Paulo Biennale. He hoped that Robertson would be able to arrange a showing of the Pollock exhibition in late October the following year. McCray made it clear that the European shows would be larger than that which the Museum of Modern Art had devoted to Pollock in 1956 (the year he died) and that there would be at least thirty-four paintings and twenty-nine watercolours and drawings, many of which would not have been seen before. After the information about the likely contents of the exhibition, he gave details about the installation, transportation and costs; the catalogue and publicity material which the Whitechapel Art Gallery could use; and finally:

> We can supply an excellent documentary film on Jackson Pollock which shows
> him at work and provides a background for the understanding of his work. It is a
> 16mm film in colour, and runs for about 10 minutes. We hope that arrangements
> could be made either to have showings of the film at your museum or at some
> other appropriate location periodically throughout the time that the exhibition is
> on view.[1]

Pollock Painting, photographs by Hans Namuth, edited by Barbara Rose, New York: Agrinde, 1980.
L'Atelier de Jackson Pollock, photographs by Hans Namuth, Paris: Macula/Pierre Brochet, 1978.
Jackson Pollock (Paris: Centre Georges Pompidou, Musée National d'Art Moderne), Paris, 1982.

The substance of McCray's letter ends, 'I feel the exhibition would arouse great interest in London and would do much to stimulate understanding of advanced tendencies in contemporary American painting'.[2] Robertson replied enthusiastically accepting the Museum of Modern Art's offer of the retrospective (how could he refuse?) and arrangements went ahead. Although the exhibition travelled through Europe by train 'the excellent documentary' or 'the Pollock film', as it is usually referred to in the correspondence between the Museum of Modern Art and the Whitechapel Art Gallery, seems to have travelled as part of McCray's personal baggage. We do not know if the film was shown at the Whitechapel Art Gallery during the exhibition, but Robertson certainly showed it, under the auspices of the Museum of Modern Art, when he gave a lecture on Pollock to a largely specially invited audience that assembled at the Arts Council, 4 St James' Square, on 20 November 1958.

'The Pollock film' was the film of Pollock painting that Hans Namuth and Paul Falkenberg made with commentary by the artist and music by Morton Feldman which had its first showing on 14 June 1951 at the Museum of Modern Art. It accompanied the Pollock retrospective in 1967 at the Museum of Modern Art and, more recently, it formed an integral part of the retrospective at the Centre Georges Pompidou, Musée d'Art Moderne in Paris – an exhibition which gave pride-of-place to the works of 1947-51, 'les drippings', a place which was largely constituted for them by 'the Pollock film'. At the Centre Georges Pompidou, entrance to the exhibition was through a darkened gallery which despite the documentation on display there and in the side rooms was really a cinema with one programme: the only feature being 'the Pollock film' projected on to a wall-sized screen. The film held its audience captive. Whether one likes this kind of museum display or not one has to agree that it has an effect beyond temporary captivation. Consider these fragments from two reviews of the installation at the Centre Georges Pompidou. Francis Frascina wrote:

> Most people sit on the floor watching the film over a couple of times... There is
> no warning or contextualisation of the film as a bit of theatre. The shots of
> Pollock's house, of the restless intent artist in the open air, of his paint splattered
> boots, of the contrived painting on glass, etc., accompanied by a droning
> soundtrack tends to mythologise the man before seeing the exhibited work.[3]

And Simon Wilson wrote:

> Entrance to the exhibition is through a lobby in which is continuously projected
> on to an entire wall Hans Namuth's film of Pollock at work. Off each side of this
> lobby small documentary sections of photographic material and works by artists
> considered influences or precursors... The visitor thus approaches Pollock's own
> work armed with both a vivid image of the man and his methods and with some
> sense of relationship to the past.[4]

One person's fiction is another's vivid image of a man and his methods; one person's bit of a theatre is another's documentation. And it is this problem which is brought to the fore in a recent collection of some of Namuth's black and white photographs of Pollock and stills from his film published by Agrinde, New York, as *Pollock Painting*.

Pollock Painting contains a memoir on 'Photographing Pollock' by Namuth; various statements by Pollock from 1944, 1947 and 1952; one interview with him and two others with Lee Krasner; some notes on the production of 'the Pollock film' by Paul Falkenberg; an essay by Francis V. O'Connor on 'the Photographs of Jackson Pollock as Art Historical Documentation'; another by Rosalind Krauss on 'Reading Photographs as Texts'; an essay by the editor, Barbara Rose, on 'Namuth's Photographs and the Pollock Myth' and her Introduction to the whole *mélange*: 'Jackson Pollock: The Artist as Culture Hero'.

Before we go on to review these contributions, it has to be said that the book is a mess. It looks quite promising but it is unpaginated and badly proofed – footnotes and text are misplaced or missing and at least one photograph is printed in reverse, and so on. The photographs are neither identified as to subject matter nor dated. Though Namuth's photographs are claimed to provide a unique documentary record of the artist in action, the selection and the layout is spurious and wilfully confusing. The central section of the book comprises 'The Photographs' which seem to document Pollock at work painting *Autumn Rhythm* (New York Metropolitan Museum of Art). This section is bracketed by two studio shots. The first photograph is taken at floor level and shows an array of open paint cans in the foreground and in the background, leaning against the wall, two completed paintings, *Lavender Mist No. 1 1950* (Washington, National Gallery of Art) in front of *One No. 31* (New York, Museum of Modern Art). This has to be a photograph of the studio taken after the particular session in which several of the following pictures were taken because some of them show Pollock painting *One No. 31* and not *Autumn Rhythm* as the arrangement implies to be the case. Pollock's eccentricity in numbering his paintings does not excuse the confusing layout of these photographs which have been mixed and matched according to the necessities of the design and the construction of the spurious narrative. The final bracketing photograph of this section shows the paint cans again and a pair of paint-splattered boots (the artist has completed his work) which Pollock seems not to have worn while working on *Autumn Rhythm* or *One No. 31* but did wear for the outdoor sequences in the film.

Pollock Painting is an extended version of a previously published book titled *L'Atelier de Jackson Pollock* published in 1978 as a supplement to the French magazine *Macula*. The *Macula* publication is much better – for the most part it is paginated, the layout sequence is different, there are more photographs, some of which are identified and dated, and it is more likely to retain the square format and integrity of the 2 1/4 x 2 1/4 inch negatives which were produced by the Rolleiflex camera which Namuth used to photograph Pollock at work. A comparison shows that in the Agrinde publication the photographs have been severely cropped and what we see in any individual photograph

is usually an enlarged detail. For instance, the sequence of photographs of Pollock painting begins with a photograph of the artist pulling out canvas from a huge roll. The effect of the cropping here is to bring Pollock closer to the spectator, to make a kind of portrait study out of what was originally a view of the artist in his studio space – on the wall behind him a finished canvas, *No. 32* (Düsseldorf Kunstsammlung, Norheim Westfalen), and stretching out in front of him an empty one. Both the Centre Georges Pompidou catalogue and the *Macula* book reproduce in correct ratio several works of Pollock starting work on *Autumn Rhythm* – including the one we have just mentioned. These photographs are arranged linearly and sequentially so that the process can be clearly understood. Pollock starts at what is recognisably the lower right-hand corner and moves to his left along the canvas, occasionally stepping on to it. Opposed to this kind of unspectacular presentation, the Agrinde book opts for a montage of three of these photographs cropped to create the impression not that the artist was moving along the canvas but that the camera was moving in towards him. Namuth states that he took most of the still photographs on the floor. Sometimes he stood on a stool (or maybe on some stepladders) or held the camera above his head but usually he stayed in one place while Pollock, working, moved nearer to him. Namuth did not move about a great deal, and it was often necessary to photograph Pollock from a distance, when he was painting *Autumn Rhythm* for example, nine to eighteen feet. This produced square format photographs which evidence the relationship of Namuth to Pollock (somewhat distanced physically and mentally), of Pollock to his canvas, canvas to the studio floor and to the work on the walls etc. The enlarged details which are the Agrinde publication's versions of Namuth's photographs draw out of them the facets that have been most attributed to them since the 1950s, Pollock's speed about the canvas, the disposition of his body, the movement from the hips, the expansive sweeping movements of the hand, the choreographer and the dancer. But this kind of representation of the artist as Action Man is achieved by editing the photographs, by cutting out large sections of the painting on which he is at work, by decontextualising, isolating him from what he is doing, where and why. Krauss and Rose complain about this. They think that Namuth puts too much emphasis on Pollock the actor to the detriment of revelations about his work. But is this the case? The *Macula* book seems to preserve the Rolleiflex ratio and keeps the original photographs integral so that often a considerable expanse of canvas is shown. Admittedly, a canvas moves in and out of focus but the photograph is none the less informative for that. The Agrinde book, however, treats Namuth's photographs with disrespect, and suppresses much that they represent. So whose Namuth's photographs are Krauss and Rose writing about? Has anyone tried to reconstruct the sequence in which the photographs of *Autumn Rhythm*, for example, were taken so that we could trace some useful knowledge about how Pollock worked. Until this basic work is done – and one can imagine the result might look a bit like Muybridge's photographs of figures in action – any discussion of the status of Namuth's photographs of documentation or evidence is rather dubious.

Namuth's essay 'Photographing Pollock', dated 17 November 1979, is really just an extended version of two texts which were first published in the 1950s.⁵ Namuth first met Pollock in July 1950 at the opening of an exhibition of local abstract painters at the Guild Hall, East Hampton in which Pollock was participating. He introduced himself as a student of Alexey Brodovitch and a photographer for *Harpers Bazaar*, and asked if he could take photographs of Pollock at work. Pollock agreed, and in the summer and early fall of that year Namuth visited the artist's studio and made at least 500 photographs, one black and white movie, and with Paul Falkenberg's help, one colour movie, 'the Pollock film'. Namuth tells us that the first photo-session lasted about thirty minutes; he used two cameras and took about sixty photographs. A problem with one of the cameras led to a loss of picture sharpness in some of the photographs and Namuth did not show these to Pollock. He says that it was only years later that he realised how interesting those photographs were. That is odd, because in the subsequent series of photographs it would seem as if Namuth reproduced those accidental effects or continued to work with the defective camera. He had to use slow shutter speeds of 1/25th and 1/50th. But the special effect of blurred focus where the head of a white covered paint brush or stick describes an arc of passage through the air or Pollock's facial expression seen unfixed, mobile, become components of the codes which constituted Namuth's representation of Pollock. These codes function to signify that combination of physical activity and mental concentration which make Namuth's Pollock distinct, and maybe most useful for mobilisation for the Pollock myth. In October 1950 Namuth showed his Pollock photographs to Edward Steichen, Director of the Photography Department at the Museum of Modern Art. Steichen was not particularly impressed with them and advised Namuth to take less photographs of Pollock working and concentrate on portraits, studies of the man's everyday life and moods. Namuth took this advice and produced a series of quite different photographs of Pollock in front of his studio, on the grass, or in his car. A selection of these, arranged to construct another narrative, illustrate his memoir. First, Pollock and his wife Lee Krasner and their dog are seen in front of a barn (you have to know *'his story'* to know that this is the studio). It looks like a farmstead, and establishes connotations of the American countryside and the WASP farming communities of Pollock's youth. Then Pollock and James Brooks are seen outdoors engaged in earnest discussion about how to make an *objet trouvé* sculpture out of a sun and sea bleached branch, a pebble and the skeleton of a fish (the artist can collaborate with friends – queer thing Surrealism?). Moving closer, the next photograph has Pollock staring straight out at the camera; he is seated on a window sill beside a large, empty ornate picture frame (the death of easel painting? the end of tradition? etc., etc.,). Next we see Pollock in a dark T-shirt and jeans, some distance from his studio, posed as if in deep thought (select an adjective or adjectives from the following: melancholic; dejected; discontented; resentful; anxious; worried; unhappy; doomed...). The photographic narrative ends as does Namuth's essay with Pollock at the wheel of his Model A Ford (again you have to know *'his story'*.

'They say it's art killed Pollock – As if that could be. In fact he missed a bend and drove his Ford into a tree.').[6]

According to Namuth, Krasner told him after the first photo-session that until then she had been the only person to watch Pollock painting. However, while Namuth may have been the first to photograph Pollock painting *'les drippings'*, he was not the only person to have photographed him at work. Arnold Newman had photographed him in 1949 for *Life* magazine working on small paintings laid out on the floor, and there are several photographs of him at work on ceramic pieces in Mrs Larkin's studio in the winter of 1949-50. In fact, Namuth was not the only person to photograph Pollock painting *'les drippings'*. Some time between his first visit and the session which recorded the production of *Autumn Rhythm* Rudolph Burckhardt went to the studio and photographed Pollock at work on *No. 32* (which can be seen in the background of many of Namuth's photographs in *Pollock Painting*). Interestingly, Burckhardt chose a different point of view to Namuth. He photographed Pollock from above. He probably leant out over the hayloft – a vantage point which Namuth only used for some segments of his first, black and white, movie. The Burckhardt photographs were used very effectively in 1958 to illustrate Allan Kaprow's article 'The Legacy of Jackson Pollock' (*Art News*, October 1958) wherein Kaprow argues for a Pollock who destroyed painting, created environments, and left artists in the position to become 'preoccupied with and even dazzled by the space and objects of our everyday life, either our bodies, clothes, room, or if need be, the vastness of Forty-Second Street...'.[7] Burckhardt's photographs enhance Kaprow's manifesto by virtue of their point of view, whereby the space and geography of Pollock's studio is completely suppressed and Pollock is put into his pictures by being seen as if on top of the canvas.[8]

Reference to the photographs of Pollock at work by Burckhardt, Newman and Lawrence Larkin introduce yet another important qualification that can be made with reference to Namuth's work. Pollock was well documented in the 1940s. There are also photographs by Martha Holmes (who was part of the *Life* team in 1949), by Herbert Matter who in 1948 completed a movie on Alexander Calder and considered making one of Pollock, and also by the sculptor Wilfred Zogbaum.[9] There were, therefore, several Pollocks on offer by 1950 and Namuth's contribution needs to be scrutinised carefully and not seen as innocent reportage, but as representation, a particular kind of constructed image of Pollock and *'les drippings'*. Each photograph has to be recognised as an actively manufactured rendering of Pollock painting produced from available cultural resources. The signal difference between his photographs and all the others – with the possible exception of Burckhardt – is that by taking so many photographs of Pollock in what turned out to be a summer of highly significant production, Namuth's photographs had a status which came to be over-determined by the other evolving critical and institutional discourses in the 1950s that would claim and ratify the artist and *'les drippings'*.

The most unusual of Namuth's are those where Pollock is seen not only blurred but

made more indistinct by a fall of light. A sunbeam from a window or possibly a crack or gap in the fabric of the studio distorts the value contrast and flattens the development of field, dissolving features and figure ground relationships. In his essay on 'The Photographs of Jackson Pollock as Art Historical Documentation', Francis V. O'Connor selects one of these 'informative images' as 'Namuth's masterpiece'. 'The sun's glare and his own momentum cast his face into an uncanny resemblance to that of Charles Baudelaire, as abstracted by Raymond Duchamp-Villon in his 1911 bronze of the poet-critic.' O'Connor wants to say something about Pollock's relation to artistic and natural processes and the matching of the inner and outer worlds. The photograph is his point of reference:

> Thus this powerful photograph, by means of the alchemy of light, identifies Pollock and his extraordinary technique with one of his truly kindred predecessors. It leaves us to contemplate those *correspondences* of fact, fate and chance which transcend lenses, chemistry, history and scholarship to reaffirm the unity at the root of all authentic art.

It is a pity that O'Connor's essay ends in this ludicrous rhapsody because it begins promisingly with the realisation that the status of Namuth's photographs as documents or data is not problematic. He writes:

> What a photograph says in itself and what others say about it produces a subtle triangulation between *1)* the physical record of what light etched at a given moment on a given chemical emulsion, *2)* the meaning of that data relevant to an art historian's inevitably selective and usually subjective purpose, and *3)* the role of the image as cultural 'icon'.

Here O'Connor's initial assertion that a photograph says something in (or of) itself runs straight up against his next observation that the production of meaning is contingent on the spectator's (in this case, the art historian's) interests – and one might add competence. The point being that a photograph – like any other cultural product – does not speak in, of, or for itself. The idea of the photograph as some kind of truth to refer to has to be questioned. It is a record of what light etched on to the emulsion at a given moment but whatever it was that was etched there, in this case Pollock painting, and by whom, in this case Namuth, was contingent on Pollock's interests and competence as a painter painting and Namuth's interests and competence as a photographer at work first in the artist's studio and then in the dark room. Once the photographs had been printed, claims by Namuth *et al.* about what they document, reveal, show, express, or signify are claims of a different order. Most images, and photographs in particular, rely on some kind of verbalisation to instigate or prevent the diffusion of meaning. But neither Namuth's photographs of Pollock nor the claims made for them are truths. A photograph only seems to speak for itself: 'this-is-what-happened-

and-how-when-Pollock-painted-*Autumn-Rhythm*'. It does not. It mediates historical actuality. When O'Connor talks of the way an image functions as a 'cultural "icon"' he means that certain of the produced meanings for the photographs become universal. The 'cultural "icon"' seems to be a special kind of representation which is honoured as worthy of special attention; it's even more than a portrait; it represents not only a historical actuality but it signifies a type of historical actuality, *the* Abstract Expressionist painter, *the* kind of Artist the Abstract Expressionist, and how that kind of painter works. This is, after all, the strength of 'the Pollock film' as McCray saw it.

Even the film could not function without a commentary. People had to be told, Falkenberg tells us in his essay, 'Notes on the Genesis of an Art Film', 'what to see... and what to think', and they had to be told by Pollock so that his gestures and voice remained 'authentic', real actual genuine. The commentary composed and spoken by the artist confers the status of truth on Namuth's and Falkenberg's representation of him as a certain kind of artist. It anchored particular meanings in the film and set up certain resonances: the artist's relation with nature, with the seasons, with the outdoors, with the American frontier, rugged individualism, etc. which would be claimed as truths from a knowledge of Pollock's biography and deferred to as proofs to document that biography. What happens in this process is that biographical details and photographic representations combine to construct a mythic subject seemingly of and for the work; a mythic subject that is posited as the meaning of the work.

Using a Rolleiflex, which is not a single-lens reflex camera, Namuth could not pose Pollock for his photographs. He could, however, establish in his viewfinder a particular space – or arena – where Pollock would be working. Aiming his camera across the expanse of his canvas, he took pictures of Pollock as he moved into and across a kind of stage-set, i.e. the flattened, framed space visible through the Rolleiflex's viewfinder. Such practicalities invite questions about the origin of the representation of the artist-in-action or as an actor. How was this conception arrived at? Was it contingent on the pragmatics of being there whilst Pollock worked, and the limitations imposed on photographic representation by the kind of camera that Namuth was using and the geography of the studio – limitations which resulted in the decentering of the artist as psychological subject and the resituating of him as actor? Or had Namuth some notion of Pollock as action painter in mind before he set up his camera, and if so, from what sets of discourses did he derive that idea? If the former was the case, then Namuth more or less invented the image of artist as action painter and made it available for utilisation by the burgeoning discourses on Pollock in the 1950s, particularly that of Harold Rosenberg. If the latter was the case, then we need to know what those discourses were. In her essay, 'Namuth's Photographs and the Pollock Myth', Rose confuses this issue and states in her opening remarks about Rosenberg's article 'The American Action Painters' (*Art News*, December 1952):

> In retrospect I realise that Rosenberg was not talking about painting at all; he was describing Namuth's photographs of Pollock. All the metaphors were decipherable from the photographs: Pollock attacking his canvas spread out on the floor in front of him like a boxing ring or bull fighting arena, with the paintbrush extended aggressively, in the manner of banderillas...

She fails to recognise that meanings proliferate. Who is reading the pictures matters. Yet for Rose associations of boxing and bullfighting inhere in Namuth's prints. The conception of Pollock as an action painter and of Abstract Expressionism in terms of drama transcending pure painting are normally attributed to Rosenberg. Rose blames him for the manufacture of a 'cultural myth', an 'action hero'. According to her, however, Rosenberg was only describing Namuth's photographs. So is Namuth responsible for the myth, or perhaps Rose believes that photographs wilfully misrepresent of their own accord? The precise manoeuvres within and against the powerful critical and institutional practices which were functional in New York around 1950 that shaped Rosenberg's text and made it intelligible – and, of course, might have helped shape Namuth's conception of Pollock – are ignored, and what we are given once again is that old art historical chestnut, 'influence'.

Rose claims that by the late 1950s Namuth's film and photographs were so well known that the critics grew mute in the face of them. They provided an alternative to dealing with the difficulty of Pollock's work. Even Clement Greenberg had little to say. (Perhaps he thought he had said enough by the time the *Partisan Review* published '"American-Type" Painting' in the Spring of 1955. We are certain he had lots of worthwhile observations on Pollock painting to point out to Helen Frankenthaler. And we doubt that his critical silence was due to his difficulty in writing about the artist.) Evidently critical mutism lasted until the time of the Museum of Modern Art retrospective in 1967 when Greenberg made a 'last attempt to come to terms with the artist he considered "in a class by himself"', and Don Judd blasted the state of Pollock criticism but offered only monosyllabic admiration as an alternative. Rose writes that 'Judd spread a literalist interpretation of Pollock but the origin of the attitude that Pollock signalled the end of painting is actually in an essay by Allan Kaprow "The Legacy of Jackson Pollock"'. However, Kaprow also got Pollock wrong because he paid too much attention to Namuth's film and photographs rather than the actual paintings. Rose tells us, 'What Kaprow saw and I suspect he saw it in Namuth's photographs and not in Pollock's deliberately controlled paintings, was the liberating possibility of acting out – catharsis through art.' 'Acting out' has wholly different connotations from either the notions of action painter or of the artist-as-actor. Its psychological connotations bear no relation to the historical conditions of art practice in New York in 1958 that prompted Kaprow's calculated intervention in which he drew the outline of a novel position from material produced by several critical discourses on offer, including those of Greenberg and John Cage as well as Rosenberg.

Abstracting Namuth's photographs as much as Kaprow's or Rosenberg's polemics from history, Rose concludes that 'Namuth's photographs played a far greater role than anyone has understood in determining the course of recent art history.' Photographs cannot, of their own volition, however, become available, be widely used, or be more intelligible than anything else. (Rose condemns Namuth's photographs for the *kitsch*-like quality of being too easy and too accessible.) Someone has to use them and anchor a certain range of meanings for them. The letter discussed at the beginning of the review tells us that the Museum of Modern Art, New York was circulating Namuth's images of Pollock. The curatorial strategies of the Whitechapel Art Gallery in 1958 and the Centre Georges Pompidou in 1982 are a further two reminders of institutional promotion and ratification.

The title of Rosalind Krauss's 'Reading Photographs as Texts' – in the *Macula* publication its title is 'Emblèmes ou lexies: le texte photographique' – offers some hope that the existence of a body of photographic rhetoric will become evidenced, acknowledged and discussed. The idea of the photograph as a text operative in terms of the *emblèmes* or *lexies* raises the issue of art, or the photograph, and language. Krauss is using the terms in a somewhat specialist manner derived from the vocabulary of semiology. 'Reading Photographs as Texts' implies that Krauss's essay offers a reconstruction of Namuth's photographs as a particular arrangement of signs interpreted through a knowledge of the various discourses they are of or engage with. Such a reading is potentially very useful. Unfortunately, Krauss doesn't provide it or even approach the problem with a semiological attitude. What semiology there is is developed from Jean Clay's essay 'Hans Namuth: Critique d'Art', which was published in *Macula*, no. 2, 1977. According to Krauss, Clay argued that Namuth's photographs have consistently been misread, looked at as documentation and for their 'narrative content'. Viewers have thus ignored the way in which they were coded, the way in which meaning is 'built into them by means of a camera angle, framing or the control of values through exposure and printing'. Krauss summarises what Clay says in this way:

> In the field of Namuth's photographs, Pollock is always sandwiched in between large stretches of canvas, some on the wall, some on the floor, on which the black and white skeins of line form and active, engulfing pattern which repeats itself in the linear drips and splatters of paint which appear on the floor of the studio as well. The photographs, then, recreate the space of all-over pattern in which the human figure can barely exist, or in which its relationship to gravity, to a solid foundation is made equivocal at best. The space of the studio is subsumed by another, more active, more dazzling space: a concatenation of flat, decorative surfaces which form a collage of flat planes held together not by the original circumstances of the room's floor and walls, but by the optical circumstances of the photographic field's independent planarity.

In other words, Namuth's photographs, for Clay and Krauss, both signify the

immediate circumstances of the conditions of production of Pollock's pictures and recreate the effect of any one of them, and they are more than documentation, 'they are an interpretation of the meaning of the work'. Well, let's not quibble with that. Hereafter the analysis moves on through the bizarre to the dubious.

> Namuth's photographs do not merely document the fact that Pollock worked on the floor. They often recapitulate that peculiar angle of vision that was the artist's own... Namuth photographed Pollock frequently from above... I am linking Namuth's work to a specific photographic tradition... aerial photography...

Aerial photography supresses the three dimensional or sculptural quality of the real world and pictures taken from great heights looking down make us work to read their flattened out schemes confronting us 'with "reality" turned into a text' and this makes us conscious of artifice or fabrication – i.e. cleanses the photograph of its indexical relation to the real. However, standing on a chair or going up to the hay loft are, it strikes us, traditionally or otherwise, qualitatively and substantially different from going up in a dirigible or an aeroplane – even if, and the point is arguable, both photographic views afford 'striking spatial ambiguities and the sense of drifting fields'. Anyway, the aerial viewpoint was not as Krauss claims 'the enabling point of view for all the photographs of this series'. Of the 34 photographs of Pollock painting *Autumn Rhythm* and *One No. 31* only ten views are taken from above Pollock, the rest are taken at his eye level or from a point of view below as a 'worm's eye' or 'impact splatter's' view point. Is she in fact thinking of Burckhardt's overhead views of Pollock? If so then much of her argument about Namuth falls flat. Barbara Rose is also intrigued by Namuth's point of view, particularly the viewpoint used to film the painting on glass, *No. 29, 1950* (Ontario, National Gallery of Canada). According to Namuth, he wanted to show the artist at work with his face in full view, and the idea to film from beneath a horizontal plane of glass was a solution to the problem of how to do this. As we have seen, Namuth was interested in the view from the point of paint impact, the canvas, where he could represent Pollock's mobility and expressivity. What he could not do from that point of view was depict the artist full face or the artist concentrating on, thinking about his work, and show him working. We doubt Rose's idea that this segment of the film was suggested by 3D movies which she claims were popular at the time. The first 3D movie *Bwana Devil* did not go on general release until 1952. Duchamp's *Large Glass* which Rose also cites seems a more likely precedent – if artistic precedent is needed for what was by Namuth's account a solution to a specific photographic problem sensitive to but not necessarily a 'natural development of... the problems raised by the poured paintings'.

Krauss's textual analysis [*sic*] constitutes the latter part of her essay. In the opening section she points out that part of Namuth's achievement was to depict another artist at work. Such images like Manet's painting of Monet at work, or Monet's painting of

Renoir at work, or Gauguin's painting of Van Gogh painting sunflowers, or K. X. Roussel's photographs of Cézanne at work near Aix-en-Provence are not, as Krauss believes, uncommon, they might also alert us to the historical conditions under which such representations become current, the identity of the artist, the status of method and facture. Namuth's images belong in a specific frame of altering significations, critical parameters for work, art and facture. In the 1950s art criticism, art history and journalism needed photographs of Pollock painting. He had been taken up by the media at the end of the 1940s and undoubtedly Namuth's documentation met a demand which became firmly established in the early 1950s. Pollock was already – even if according to *Life* magazine, questionably – America's greatest living painter and good copy, and he knew it. As Krauss points out, Pollock realised the importance of his work and the way it was made, and that's why he allowed Namuth to photograph him. Pollock correctly assumed that this was an important moment in his own career and the history of art, and he knew very well the advantages of having it recorded. However, what was recorded is still not clear.

Notes

1. Porter A. McCray to Bryan Robertson, 11 November 1957, Archives of the Whitechapel Art Gallery, London.

2. Ibid.

3. Francis Frascina, 'Jackson Pollock in Paris', *Art Monthly*, April 1982, p. 9.

4. Simon Wilson, 'Jackson Pollock at the Beaubourg', *Burlington Magazine*, May 1982, p. 316.

5. Hans Namuth, 'Jackson Pollock', *Portfolio. The Annual of the Graphic Arts*, Cincinnati, 1951; a statement written for the American Society of Magazine Photographers' Picture Annual, 1956; and a text used eight years later to accompany the promotion of a Jigsaw Puzzle of *Convergence No. 10, 1952*, Buffalo, Albright-Knox Art Gallery.

6. From 'A Portrait of V. I. Lenin in the Style of Jackson Pollock I & II' by the Red Crayola and Art & Language in *Kangaroo*, Rough Trade 19, 1981.

7. Allan Kaprow, 'The Legacy of Jackson Pollock', *Art News*, October 1958, p. 56.

8. Ibid., p. 24, and particularly p. 25. See also *Jackson Pollock*, Paris: Centre Georges Pompidou, Musée National d'Arte Moderne, 1982, p. 353. It is interesting to note that in this catalogue a photograph of Pollock at work on *No. 32* is used to introduce the reproductions of 'Les Chefs d'oeuvre de Pollock', p. 97.

9. For photographs by Martha Holmes see *Jackson Pollock*, Centre Georges Pompidou, p. 273, and by Wilfred Zogbaum, op. cit., p. 269. In addition there is a section (pp. 349-54) entitled 'Images de Jackson Pollock' which includes photographs by Newman, Burckhardt, and Michael Vaccaro.

Chapter 9

Action, Revolution and Painting

FRED ORTON

A raised arm has many meanings.
Convictions falter with desire; the arm remains.
Harold Rosenberg, *The Men on the Wall*

There was a time, in the late 1950s and early 1960s, when explainers of Abstract Expressionism valued Harold Rosenberg's writings and took them into account. After that, he was increasingly marginalised, overlooked, or uncited. One reason for this was the increasing, and what came to be almost exclusive, attention that was given to the writings of Clement Greenberg. This is not to say that the focus was misdirected, for Greenberg is a necessary if insufficient text. Critical art history needs him, but if it is not to rehearse its histories of Abstract Expressionism exclusively with reference to his ideas of the triumph of a depoliticised art practice, apolitical painting and art for art's sake, Greenberg's cannot be taken as the only story. This is precisely where Rosenberg takes on importance. Rosenberg's writings on art and culture provide us with another necessary but insufficient corpus producing a knowledge of Abstract Expressionism. Many of the Abstract Expressionists – most of the Irascibles and others – regarded their work as having a social and political content which Rosenberg, as close as anyone to the studio talk and closer than more or less anyone to its politics, was committed to explaining. This he did consistently and more vividly than any other explainer of Abstract Expressionism – not as an apologist or as an opponent but as someone keeping his preoccupations up to date and well oiled.

One of the aims of this essay is to bring Rosenberg in from the margins he is so often made to occupy, and to begin writing against the grain of those bits of conventional wisdom that represent his ideas as naive, romantic, quasi-philosophical, theatrical, and as reconciling an avant-garde ideology with the ideology of post-war liberalism. It sets

out to situate Rosenberg with respect to the changes in New York leftism in the 1930s and 1940s, and then to use his writings on drama and the proletariat, which focus on issues of action and agency, as relevant to understanding his characterisation of action painting in the 1952 essay, 'The American Action Painters' – one of the first published attempts to endow Abstract Expressionism with meaning.[1] My concern is to offer a political reading of this essay to replace the lazy existentialist-humanist reading that has become paradigmatic.

Part of the significance of 'The American Action Painters' has to be located in the way Rosenberg shows that the political impasse which many on the left currently regard as uniquely 'post-modern' was already inscribed within the modernism which emerged in the United States circa 1940, and that this sense of impasse was international and not narrowly American. Action painting, for Rosenberg, was painting about the possibility of a radical change that had not happened in the 1930s and 1940s – far from it – and could not happen in the 1950s. It was a possibility that neither he nor his 'American Action Painters' could afford to abandon. No more can we.

The politics of action painting were determined by the failure of the proletarian revolution and its continuing regeneration within the dialectical dynamism of capitalism, with acting out the possibility of radically transforming the situation, while forever failing to do so. It will become clear as this essay proceeds that the negation of the negation played out in action painting could never produce the redefinition of identity that would negate the negative identity given to the proletariat in capitalism. The action painters could not succeed in culture where the proletariat had failed in politics. Action painting could not compensate at the symbolic level for the fact that the political action which would redefine the proletariat did not, at that moment, seem to be available to it as a class. Instead, action painting was caught up in the failure of the proletariat, but the action painters glimpsed that that failure was not total.

In this reading of Rosenberg's 'The American Action Painters', the action painter was not a middle-class artist playing with symbolic or surrogate revolutionary gestures, acting out, in art, a drama of political agency and identity that no social class is able to do. Action painting was not revolutionary gesturing. It was painting concerned with the dialectical possibility of a revolution whose outlines can neither be defined nor denied.

I

 who thrust his fist into cities
 arriving by many ways
 watching the pavements, the factory yards,
 the cops on beat
 walked out on the platform
 raised his right arm, showing the fist clenched
 'comrades, I bring news'

came back then skies and silhouettes,
facing the bay, of sailors
who no longer take the sea
because of strikes, pay-cuts and class-unity

'comrades, I bring news'

of the resistance of farmers
in Oneida county on a road
near a small white cottage
looking like a Xmas card,
4 shot, the road was blocked
glass to blow their tires

there was one guy we grabbed
some bastard of a business man
learning to play State Trooper
one of the boys tackled him neat as he ran

Behold my American images get it straight
a montage of old residences bridges shops freights
Xmas, the millions walking up and down
the tables where applications are received
the arguments that will yet get down to something
in the center of this a union-hall
and on the platform he
with right arm crooked, fist clenched
'comrades, I bring news'

That poem by Rosenberg appeared in the *Partisan Review* for January-February 1935.[2] Titled 'The Front', it refers to the life circumstances of millions of Americans around Christmas 1934, some five months into the sixth year of the Great Depression: to capitalism in crisis, mass unemployment and applications for benefit, strikes, organised labour and class unity, and the class struggle in town and country. At the centre is a union hall, and out on to its platform walks someone who raises his right arm, fist clenched, and addresses the assembly: 'comrades, I bring news'. I cannot describe the specific circumstances of the poem's making or limit the excess of meaning available for its strikes, pay cuts, and so on, nor extend the particularity of that event in Oneida County. What can be said – leaving aside a discussion of its structure and the momentum of its syntax – is that Rosenberg's poem, dedicated by its title to the United Front, was meant to participate in winning the workers' support for revolutionary organisations and for an agreement on action of some kind – insurrection, if not revolution.

Aged twenty-eight when he wrote 'The Front', Rosenberg had already earned himself something of a reputation as a poet and intellectual. *The Symposium*, edited by James Burnham and Philip Wheelwright and described as a journal of philosophical discussion, had published several of his essays, including, in 1932, the seminal 'Character Change and the Drama'.[3] He had also edited with H. R. Hays an 'experimental quarterly' called *The New Act*.[4] Harriet Moore's *Poetry: A Magazine of Verse*, which published all kinds of verse, conventional and innovative, had regularly printed his poetry and commissioned book reviews from him, and would continue to do so throughout the 1930s and 1940s.[5]

In 1936 he was considered, by William Phillips and Philip Rahv, to be one of the poets who had achieved 'the much desired integration of the poet's conception with the leading ideas of the time'. This 'desired integration' was achieved by way of an awareness that the necessary revolt was aesthetic as well as social, and that as such it was 'a revolt within the tradition of poetry rather than against it'.[6]

'The Men on the Wall', published a year earlier in 1934, may well be one of Rosenberg's first poems to make reference to the historical and social circumstances of its writing.[7] It uses some stereotypical metaphors of state, worker and capitalist power:

[...] a sword
in the hand of the arm
flowers from a sleeve of gold brocade

[...] and that arm's fist,
whose khaki cuff is stained with grease,
is yours, and clasps the hammer of your resolve.
And whose contending tendons flex with threat
against the background factories and glass?

[...] the wind still affirms
the faces of ruminants with folded arms,
the men below, divining peace before their doors,
the azure casings of whose blood are torn
by no quick haemorrhage of indissoluble event;
whose ecstasy, despair and rage
are hidden escapades that lift no arms.[8]

But at the end of the poem, the men on the wall stay there, 'entranced somnambulists', on the night shift. It is a poem which seems more symptomatic than critical of the moment that inscribes it, a social poem with a tendency to leave its workers working and only half-awake. By the end of the year when Rosenberg wrote 'The Front', that tendency had changed, or been clarified; the workers were unemployed, less dreamy, and politicised.

'The Front' is a socialist poem, and as the editors of *Partisan Review*, the year-old journal of the John Reed Club of New York, were keen to point out, it was the first poem that Rosenberg had published in a 'proletarian magazine'.[9] The John Reed Club was founded in 1929, the year the Great Depression began and the year when Stalin's first Five Year Plan was adopted. Initiated by and affiliated to the International Union of Revolutionary Writers, the Club was, from the outset, influenced by the Proletcult movement, led by members of the Communist Party, and dedicated to the belief that art was a weapon in informing, educating and radicalising the worker. It had branches in most large cities and many of them published their own periodical of literature and art, the best known being that of the New York branch, *Partisan Review*.[10]

The Rosenberg of 'The Front' is a Marxist and probably a fellow traveller of the C.P.U.S.A., a poet and critic committed to the artist's capacity to participate in the class struggle.[11] But he was short-lived. The authorial 'I' which 'The Front' and *Partisan Review* had inaugurated was put in the position of having to manoeuvre itself when, in July-August 1935, the Seventh Congress of the Comintern promoted the 'broadest united front [...] the establishment of a unity front with social democratic and reformist organisations... with mass national liberation, religious-democratic and pacifist organisations, and their adherents [...] for the struggle against war and its fascist instigators'.[12] Unlike the United Front this 'Popular Front' was not a strategy of class struggle, but of class co-operation. One almost immediate result of the Popular Front was that the Proletcult movement was abandoned.

The Popular Front had been written on the wall for some time. The writing was there, for example, in January 1935 in the call put out by the National Committee of the John Reed Club, under instructions from the C.P.U.S.A., for an American Writers' Congress to undertake an 'exposition of all phases of a writer's participation in the struggle against war, the preservation of civil liberties, and the destruction of fascist tendencies everywhere'.[13]

The American Writers' Congress met at the end of April and Rosenberg reported its proceedings in the July issue of *Poetry*.[14] He was obviously impressed by the representative of a group of Pennsylvania miners who were prepared to print and circulate 10,000 copies of any poem that they could recite or sing together and by an appeal on behalf of 300 workers' theatres for works to perform.[15] He thought that here 'it became possible to see how poetry might step forth from the little magazines [...] and walk once more upon the stage and street'.[16] How, in other words, art might achieve a valid constituency and a valid agency. However, it was clear to him that, faced with the dangers to society of fascism and war, the writer was forced to play his part not in revolution, but in society's effort to protect its peace, freedom, and progress.[17] The questions were: what was the role of the writer in the social movement, and what was the best mode of performance?[18] The answers were provided by Earl Browder in his opening address: one could not be converted automatically into a literary genius just by calling oneself 'Marxist'; revolutionary art could succeed only 'through achieving

superiority as art, not through politics'; 'the socially conscious writer need not engage in organisational activity at the expense of writing'. The attitude of his party was: 'better a good writer than a bad organizer'.[19] Browder's party was the C.P.U.S.A. Indeed, he was its General Secretary and national spokesman, a familiar figure on a wide variety of platforms.

After quoting Browder, Rosenberg made a point of mentioning Waldo Frank who 'also attacked "leftism"' and who 'would not capitulate easily to dogma, outside control'.[20] Frank, an editor of the C.P. Journal *New Masses*, would go on to represent the League of American Writers, the organisation that came out of the American Writers' Congress at the Popular Frontist First International Congress of Writers for the Defense of Culture which met at Paris in June. Rosenberg, the revolutionary poet and critic writing in the liberal-democratic *Poetry*, pointed out, reassuringly, and following Browder's line, that though 'the Congress turned its face left, it donned no red uniform'.[21]

Later that year Rosenberg became active in Popular Front art politics and art theory through his involvement with *Art Front*. *Art Front* was the official publication of the Artists Union, the militant trade union that had emerged from the Unemployed Artists Group set up by the John Reed Club of New York in 1933 and which, in 1935, came to represent the interests of the artists employed on the Federal Art Projects. *Art Front*'s political orientation was, of course, never in doubt. It was dominated by the Communist Party, committed to art as propaganda, and to guiding its members in their role as revolutionary artists. However, it was always prepared to debate whether the art they were to produce should be social realist or modernist, expressionist, surrealist, abstractionist, etc. – there was, after all, no Party-line on art at the time, even in the Soviet Union. In a sense, *Art Front* was the New York communist and left art community's public conversation about art and politics. Moreover, it was at that time the only periodical in the United Stated which was primarily concerned with art and politics. At the end of 1935, the editors signified *Art Front*'s sympathetic attitude to modernist art by bringing on to the board Joseph Solman, Max Spivak and the assistant who had been assigned to him by the W.P.A., Harold Rosenberg.[22]

Rosenberg's 'beginnings' as a practising art critic can be located in the work he produced for *Art Front*:[23] a translation of Fernand Léger's Museum of Modern Art lecture 'The New Realism';[24] reviews of the Museum of Modern Art's *Van Gogh* and *Cubism and Abstract Art* shows;[25] several book reviews, including one of Salvador Dali's *Conquest of the Irrational*;[26] and a review of an exhibition of William Gropper's paintings at the A.C.A. gallery in which he stated that 'the revolutionary painter, far from being a grim specialist of a world seen in contracted focus, is precisely the major discoverer of new pictorial possibilities as well as of new uses for the old [...] by his easy and graceful mastery of the materials of social struggle, by his presentation of it, as it were, *from the inside*, without strain, [the revolutionary painter] carried forward the possibility of technical discovery in revolutionary art'.[27]

Recent art history has produced several versions of how the American left was affected by the Russian-French Non-Aggression Pact of 1935 and the inception of the Popular Front, by the three show trials in Moscow of August 1936, January 1937 and March 1938 of prominent intellectuals and party leaders and activists (including, in his absence, Leon Trotsky), by the signing of the Russian-German Non-Aggression Pact in August 1939 and the collapse of the Popular Front.[28] Large numbers of intellectuals who began the decade in support of the Communist Party lost faith at certain points – abruptly, reluctantly, with such disillusion that they could not be reconciled to it. As we have seen, Rosenberg's support for the Party survived the shift from the United Front to the Popular Front. It also survived the Moscow Trials of 1936 and 1937 but was abandoned before the signing of the Russian-German Pact in 1939.[29] The moment of the move away, early or late, is important as an indicator of the intensity of his commitment to and subsequent disillusion with the Party line and Soviet communism.

For Marxists like Rosenberg, who were disillusioned with the Communist Party but who remained committed to Marxist politics and the revolutionary function of the artist and intellectual, one place to go was to the personality and writings of Trotsky – not to the Trotsky of the Civil War and the Red Army, but to the outlawed peripatetic Trotsky of the 1930s, analysing fascism and Stalinism and still committed to keeping a radical Marxist project going.

For Trotsky, theorist and exile in Mexico, revolution and art became in certain respects alike as forms of human activity. As he made clear in his letter of 1 June 1938 to the founding conference on the Fourth International, they were inseparable and he approached both in the same way.

> I have always forced myself to depict the sufferings, the hopes and struggles of the working classes because that is how I approach life, and therefore art, which is an inseparable part of it. The present unresolved crisis of capitalism carries with it a crisis of all human culture, including art [...]
>
> Only a new upsurge of the revolutionary movement can enrich art with new perspectives and possibilities. The Fourth International obviously cannot take on the task of directing art [...] give orders or prescribe methods. Such an attitude towards art could only enter the skulls of Moscow bureaucrats drunk with omnipotence. Art and science do not find their fundamental nature through patrons; art, by its very existence, rejects them [...] Poets, artists, sculptors, musicians will themselves find their paths and methods, if the revolutionary movement of the masses dissipates the clouds of skepticism and pessimism which darken humanity's horizon today...[30]

Trotsky wrote another letter two weeks later, this time to the editors of *Partisan Review*, who published it in the August-September issue under the title 'Art and Politics'.[31] This expanded what he'd written to the Fourth International. 'Art and Politics' got Trotsky inside the still Marxist but by then anti-Stalinist *Partisan Review*.

He reappeared in the next issue when the journal made its relationship with him more secure by publishing the Manifesto of his International Federation of Revolutionary Writers and Artists.[32]

Rosenberg reconnected with *Partisan Review* at just this moment, when it was beginning to identify with Trotskyism. He re-entered it in the Winter issue with a long critical discussion of Thomas Mann's idealistic, anti-radical anti-fascism.[33] To the Summer issue he contributed replies to a questionnaire-symposium on 'The Situation in American Writing',[34] and a commentary on Arthur Rosenberg's *Democracy and Socialism*: 'By his sly shift in historical meanings', this author converted the 'principle of "permanent revolution" into that of coalition governments and the Popular Front'.[35] He also signed the statement issued by the Trotskyist League of Cultural Freedom and Socialism with its demand: 'COMPLETE FREEDOM FOR ART AND SCIENCE. NO DICTATION BY PARTY OR GOVERNMENT.'[36] A year later, in December 1940, the journal published his essay, thoroughly Trotskyist in its art and politics, on the fall of Paris.[37]

The foregoing describes part of the historical matrix which produced 'Harold Rosenberg'. It serves its purpose by enabling a reading of 'The American Action Painters' as a text situated in and inscribed by a particular Marxist tradition, by the mutation and modification of New York Marxism related to the C.P.U.S.A., by the setbacks of the late 1930s, and by the espousal of international Trotskyism with its notion of agency and of the freedom of art. Rosenberg's Marxist 'beginnings' were in the early and mid-1930s, in the art and politics of the Great Depression and the New Deal, the union movement, public protests, federal agencies, resistance and strikes, the United Front and Popular Front. The encounter with Marxism and Marxist politics was significantly different for him, and for many of his comrades, than it was for those persons who began with Marx around 1939, disenchanted with Russia and the C.P.

The 'Harold Rosenberg' I've produced from 'The Front' and a little bit of history and biography was not the kind of critic of art and culture who in the late 1930s and early 1940s quoted Marx word for word to get noticed by New York's left intelligentsia only to jettison that Marxism once it had served its purpose. In the 1950s, he was scathing about those persons of the 'turning generation' who adapted to 'Couch Liberalism'.[38] There was, it seems to me, nothing superficial or opportunistic about his Marxism; and his commitment to it was long-lasting.

II

Another clenched fist, a 'rapping of the soldier's fist', begins 'The Fall of Paris' where it announces the German army's entry into the city on 14 June 1940. In this essay Rosenberg was not particularly interested in the demise of Paris as the French capital. It was more important to him as 'the laboratory of the twentieth century': the place that had drawn artists from all over Europe and America and which had become the site of their collective practice producing new ways of seeing and representing. Rosenberg, like

Trotsky, thought that the continuity of culture mattered, even through revolutions and periods of social upheaval; but with the fall of Paris that continuity had been terminated. As far as Rosenberg was concerned, the cultural laboratory had not been working very effectively for ten years or so, but 'the rapping of the soldier's fist' announced its closure (TN, 209).

Rosenberg considered that twentieth-century Paris was to the intellectual what America had been in the nineteenth to the pioneer. It was, he thought, a place where no one class was able to impose its purpose and representations on artistic creation, and where individual nationalities and cultures were blended; and yet where what was alive in various national cultures might be discovered. What Paris stood for was thus the opposite of individualism and nationalism in culture because in it and through it the art of every individual and nation was increased. It was, in effect, the International of culture. At the end of the 1930s and the beginning of the 1940s, with civil war in Europe, and when cultural production was being directed by state bureaucracies in the United States and the Soviet Union, what had been achieved by Paris provided evidence for him that cultural internationalism was possible as a creative communion which could sweep across boundaries (TN, 209-210).

Rosenberg's Paris was a material place with a particular physiognomy and a lot of ideology. It was the French capital at a certain moment, say 1907-29, and the artists who gathered there. It was also the style which was produced there: 'the Paris style', 'the Paris Modern', 'Modernism' or 'the Modern' (TN, 210-211). However, Rosenberg realised that the Internationalism of Paris was not 'the actual getting together of the peoples of different countries'. And he also realised that the Modern 'was an inverted mental image... with all the transitoriness and freedom from necessity of imagined things. A dream living-in-the-present and a dream world citizenship – resting not upon a real triumph, but upon a willingness to go as far as was necessary into nothingness in order to shake off what was dead in the real. A negation of the negative' (TN, 212-213).

This negation was not the practice of merely saying 'no'. It was not a practice of pure negativity. Following Marx and Engels following Hegel, Rosenberg took the 'negation of the negative' as an immanent dialectical moment of development, 'becoming', mediation and transition. The negation of the negation is a dynamic for change.[39]

Rosenberg saw the Modern as 'the style of today' – 'the contemporary as beginning in 1789' (TN, 214) – and by reference to it as 'a negation of the negative' he pointed to its critical, resistive and emancipatory potential in the development of an advanced, liberating, revolutionary consciousness. Paris had been central to it as the site of the International of culture but not to the modern as a temporality because 'the social, economic and cultural workings which define the modern epoch are active everywhere' (TN, 215).

And just as the International of culture had a capital, Paris, so in the 1920s the political International – the Third International – had a capital, Moscow. 'It is a tragic irony of our epoch,' writes Rosenberg, 'that those world centres were not brought

together until the signing of the Franco-Soviet pact in 1935 when both were already dead. Then the two cadavers of hope embraced farcically, with mutual suspicion and under the mutually exclusive provincial slogans: DEFENSE OF THE USSR and FRANCE FOR FRENCHMEN' (TN, 215).

And what happened to the modern formulae perfected by Paris and Moscow and discarded with the Russian-French Non-Aggression Pact and the inauguration of the Popular Front? They were taken over by Germany and adapted to its particular aims. 'In that country politics became a "pure (i.e., inhuman)" art, independent of everything but the laws of its medium... Against this advanced technique, which in itself has nothing to do with revolutionary change, the Paris of the Popular Front compromise was helpless' (TN, 218). The demise of the Modern was inseparable from revolutionary defeat and the defeat of the revolutionary idea, i.e., from the rise of Stalinism and fascism and the rehegemonisation of nationalism and individualism, and the working class's loss of political independence. The fall of Paris merely made it definitive.

Despite this, 'The Fall of Paris' manages to end optimistically. Against the fascist modernist mysticism 'dreaming of an absolute power to rearrange life according to any pattern of its choice', Rosenberg glimpsed the possibility of 'other forms of contemporary consciousness, another Modernism' (TN, 220). But he found it impossible to predict where the centre of this new phase of the Modern would be located.

III

By the late 1940s-early 1950s, it had become possible for Rosenberg to identify the new International of culture – if not the International of politics – and to discuss the significance of the movement or style produced by it. He does this in 'The American Action Painters' which was published in the issue of *Art News* for December 1952. Like 'The Front' and 'The Fall of Paris', 'The American Action Painters' begins with a gesture; epigrammatically with a fragment from Wallace Stevens: '"*J'ai fait des gestes blancs parmi les solitudes.*" APPOLLINAIRE "The American will is easily satisfied in its efforts to realise itself in knowing itself." WALLACE STEVENS.'

One thing which needs to be immediately established is what it is that Rosenberg thought was 'American' about 'American action painting'. He was obviously trying to write something about a kind of collective identity, but there is nothing nationalistic, patriotic or chauvinistic about his use of 'American' or his idea of what kind of person the 'American' action painter might be. 'American' has to be understood as meaning a king of ethnic diversity and cosmopolitanism.[40] You only have to read his 1959 essay, 'Tenth Street: A Geography of Modern Art', to see how clearly the material and ideological space of the American action painters was, in Rosenberg's scheme of things, related to the International of culture he'd described nineteen years before in 'The Fall of Paris'.[41] Here, in this essay, 'the new American "abstract" art' is the kind of painting made around 10th Street, New York, by displaced persons, immigrants, the sons and

daughters of immigrants, and by Americans who have 'moved' there (DP, 102) maybe for reasons similar to those of the artists, writers, etc., who travelled from all over the world to Paris and produced the Modern.

In 'The American Action Painters' the artist is figuratively and literally a pioneer and an immigrant. And just as the earlier International of culture was determined partly by the physical character of its place of production and by the qualifying and the blending of nationalities and class positions which was possible there, so 'Tenth Street' was determined not only by its geography – Rosenberg writes that it 'has not even the picturesqueness of a slum' (DP, 103), it is 'devoid of local colour', it's a 'neutral zone' (DP, 104) – but also by the unfixing and mixing of nationalities, races, classes, and ideologies which happened there (DP, 106). In 1940 Rosenberg had described the Paris 'International' as a 'No-Place'; in 1959 he described the area around 10th Street as a 'no-environment' (DP, 104), it was all places and none of them.[42]

As the new site of cultural internationalism, 'Tenth Street' transcended the internationalism of the moribund Paris 'International' of the 1930s. Its 'ethnic openness' – its 'Americanness' – went beyond the 1930s fighting talk of 'internationalism' (DP, 104). And its 'American' action painting went beyond the dogma of 1930s 'modernism' (DP, 104). I will consider this double 'going beyond' later, but for the moment I want to stay with Rosenberg's notion of 'American' and 'Americanness' and consider how it relates to his thinking about identity and action. One of Rosenberg's most interesting considerations of 'Americanness' occurs in his 1949 essay 'The Pathos of the Proletariat'.[43] This was the second of two essays on class and class struggle – the first was 'The Resurrected Romans' of 1948[44] – which he wrote at a time when he was concerned with 'the drama of modern history as conceived by Marx, a drama in which individual identity and action are replaced by collective actions formed out of historical processes and myths' (AA, 206), Both essays, but particularly 'The Pathos of the Proletariat', are significantly inscribed by what he had written in 1932 in 'Character Change and the Drama'. We need to look into 'Character Change and the Drama' before we consider 'Americanness' in 'The Pathos of the Proletariat' and start rereading 'The American Action Painters' because it's in this early essay that he develops most fully those ideas on the making of an 'identity' and the relation of this to individuality which are so central to his politics.

What Rosenberg wrote in 'Character Change and the Drama' was informed as much by his studies in law school as by his interest in the theatre and the mechanics of tragedy.[45] Legal definitions were important for his argument. He explained that the law totally defines an individual by his 'overt acts', by what he did in particular circumstances. The law does not recognise 'personality', a person with a biography, a life pictured as fully and precisely as possible. It is only interested in a person's actions, an 'identity' to which its judgements are applied (TN, 138). Rosenberg goes on to argue that in *Hamlet* the Prince is transformed from a 'personality' (a thoroughly naturalistic, psycho-biographical character) into a dramatic 'identity' (a character relevant to and

able to perform the role required by the plot in which he is located) (TN, 146-149).

Hamlet has all the qualities required for action; what he lacks is the identity structure which would fit him to be a character in the drama, a oneness with the role originating in and responding to the laws of his dramatic world. The change occurs when he acquires a certainty with regard to his feelings, and when his capacity for action is no longer the expression of his 'personality' but accords with the dramatic rules of the situation in which he finds himself. He breaks with one character and *'becomes'* another: 'This is I, Hamlet the Dane.' From that moment, 'his action hustles the play to its tragic close and the apparently accidental character of his revenge serves to emphasise that he is controlled at the end not by the conflicting intentions of a self but by the impulsions of the plot. Transformed from the image of a personality into that of a dramatic identity, he has found at last his place in the play' (TN, 149).

Here, in Rosenberg's legalistic thinking about character change in *Hamlet*, we find a key for understanding his reading not only of Marx on class and class struggle, but also of the American action painters and American action painting. This paragraph near the end of 'Character Change and the Drama' is crucial:

> Individuals are conceived as identities in systems whose subject matter is action and the judgment of actions. In this realm the multiple incidents in the life of an individual may be synthesised, by the choice of the individual himself or by the decision of others, into a scheme that pivots on a single fact central to the individual's existence and which, controlling his behaviour and deciding his fate, becomes his visible definition. Here unity of the 'plot' becomes one with unity of being and through the fixity of identity change becomes synonymous with revolution. (TN, 152)[46]

Fifteen years later, in 'The Pathos of the Proletariat', the identity change which becomes synonymous with revolution is that made by the 'hero of Marx's drama of history' whose 'action is to resolve the tragic conflict and introduce the quiet order of desired happenings' (AA, 14). The hero was not to be an individual but a particular kind of collective identity, a social class: the proletariat (AA, 15). But for an American radical like Rosenberg, four or five years after the First World War, the social revolution seemed unlikely: capitalism was secure; its internationalisation well advanced; Soviet communism was discredited. The revolutionary processes of capitalism had not genuinely illuminated the worker about himself nor united him with other workers. Existence had not yet determined a revolutionary consciousness. Instead it had determined a revolutionary politics and propaganda, a collective 'I' defined and confirmed by the Party and its bureaucracy (AA, 47). But unlike many Marxists, Rosenberg was not claiming or complaining that the proletariat had not lived up to its appointed form of consciousness or had failed in the role imagined and written for it. Rather, the problem of the agency of revolutionary change which had previously been thought of in terms of the individual had now become a central preoccupation, and one

which he puzzled in terms of class. The question which concerned him in 'The Pathos of the Proletariat' was how the proletariat's character and consciousness might be transformed into a revolutionary consciousness and identity.

The proletariat had been on stage since the industrial and bourgeois revolutions, but if it had only the social character and function assigned to it by the process of production, what did it mean to speak of it as revolutionary? (AA, 17-18). Rosenberg finds answers, or partial answers, to this question in Marx's *The Class Struggles in France*, *The Civil War in France*, and especially in *The Eighteenth Brumaire of Louis Bonaparte*. In these 'historical-literary' writings, the class transcends its given form and its economic function and 'expresses its collective personality and acts with an intelligence and spirit peculiar to itself' (AA, 19). It is apparent to Rosenberg that, in these texts, 'the essence of class definition consisted for Marx in this active character-shaping spirit' (AA, 19). He finds this implicit in the statement: 'The working class is revolutionary or it is nothing.' In terms of 'Character Change and the Drama', the class would be defined 'by the coherence of its acts and with the fact in which they terminated'. Without this 'identity' or 'character' the proletariat would merely be a 'personification' (AA, 21), and as a personification it would be nothing. Since Rosenberg believes that dialectically and by definition the proletariat must be more than a personification, that its existence presupposes a revolutionary consciousness and will, and that its own direct decisions and acts – and not decisions or actions taken on its behalf – must be the basis of any change considered to be socialist, he argues that the self-consciousness which converts it from 'social character' to 'character' or historical actor is an aspect of revolution and of revolutionary practice (AA, 22). The proletariat must come to consciousness through its own action, its own response to the structural contradictions of capitalism. 'Both class awareness and class identity rise out of class action' (AA, 22).

To the question of how the proletariat's 'social character' might be transformed, Rosenberg finds an answer in that part of *The Eighteenth Brumaire* where Marx writes that the proletarian revolution will be characterised by its total abandonment of the past:

> The social revolution cannot draw its poetry from the past but only from the future. It cannot begin with itself before it has stripped off all superstitions in regard to the past. Earlier revolutions required world-historical recollections in order to drug themselves concerning their own content; the revolution of the nineteenth century must let the dead bury the dead. There the phrase went beyond the content; here content goes beyond the phrase. (AA, 23)

Whereas the bourgeois revolutions had been performed in costumes borrowed from the past, with ghosts of dead heroes presiding over events – like the ghost of Hamlet's father – the social revolution has to be without recourse to myth, and must be clear concerning its content. The proletariat, called into existence by the bourgeoisie and a

product of modern industry, is without a past. Its revolution 'is to owe nothing to that repertory of forms out of which history has supplied earlier revolutions with the subjective means for meeting their situation' (AA, 23). Pastless, the proletariat must begin its revolution, become one with the drama of history, with a profound asceticisation of mind of imagination realising itself for what it is, the personification of wage labour (AA, 23).

In other words, there will come a moment when the proletariat, as the first condition of historical action, must surrender its given character and function under capitalism. It will then act to fulfil its historical role, develop a form of revolutionary consciousness and 'identity', and come to exist at the level of political struggle.

Rosenberg regarded the pastlessness of the proletariat as the key to its 'character' and its revolutionary role. Here, in 'The Pathos of the Proletariat', he developed the idea that the proletariat and the American are 'similar' or analogous with regard to their pastlessness and their capacity for action. As an immigrant, or the descendant of immigrants, the American is regarded as detached or estranged from his or her origins – the culture, traditions, places, things, even the human relations of Europe – and this constitutes a kind of pastlessness; 'the American exists without the time dimension' (AA, 27).[47] Also, he does not meditate, he acts; and his 'self-consciousness arises through the "practical movement"' (AA, 28). 'For the American action is but a natural response [Rosenberg makes it sound like a species characteristic] to need or desire (whether his action can satisfy that need is another question)' (AA, 31).

This *'similarity'* might seem a bit flim-flam now but it would have seemed less so in the 1940s when Lenin's and Trotsky's views on American agriculture and industry were more part of left conventional wisdom than they are today.[48] That's to say, the assimilation of the values attaching to 'American' with those attaching to proletarian in 1949 worked because of the job it was doing and the context in which it was uttered.

> Many of the attributes of the proletariat as the potential embodiment of the spirit
> of the modern are, inescapably, attributes of the American,[49] unquestionably the
> best available model of the new-fangled; from Marx to Lenin to Trotsky,
> American practices have been cited to illustrate qualities needed under socialism.
> (AA, 29)

However, the American is no revolutionary: 'his history has been one of setting limits to his revolutionising' (AA, 30).

But how does the simile work? What is it supposed to illustrate with reference to the proletariat's character change and the drama of history?

Speaking half-figuratively,[50] to become a human being the proletarian must *'Americanize'* himself, that is, overcome the void of his past by making a new self through his actions (AA, 32).[51]

IV

It should be clear from the foregoing that Rosenberg's idea of 'action' – that 'American-action' – came out of the very particular way he read Marx's writings. As far as his thinking about 'action' in 'action-painting' is concerned, I doubt that he found much use for what he wanted to write in Hans Namuth's photographs of Jackson Pollock painting which appeared in the *Art News* for May 1951.[52] Some persons think they were important for him, but the point is that he did not need to see – or see photographs of – any of the artists at work – Pollock or Willem de Kooning or Barnett Newman – to write what he *saw* their painting as or *as of*.[53] On the other hand, I can see why, in 1947, some passages in Richard Huelsenbeck's 'En Avant Dada' caught his eye amongst the proofs of Robert Motherwell's Dada anthology.[54] In one passage, which he and Motherwell included in *Possibilities*, you can read: 'The Dadaist should be a man who has fully understood that one is entitled to have ideas only if one can transform them into life – the completely active type, who lives only through action, because it holds the possibility of achieving knowledge.'[55] That seems compatible with how he read Marx. Motherwell has said that Rosenberg's notion of 'action' derives from Huelsenbeck.[56] There was more to it than that, indeed more to it than I have written here. But then, beginnings are always overdetermined.

We can now start reading 'The American Action Painters' and answer the question posed about action painting in its first section: 'Modern Art? Or an Art of the Modern?' For Rosenberg, writing in 1952, Modern Art is painting which has caught up with, or is catching up with, what was produced by the 'School of Paris', the academic, moribund Modern of the late 1920s-30s. It is painting secure in the knowledge of what art is, practising its immediate past, enabled and supported by a stable structure. This Modern Art is what has to be negated in and by any radical art practice: an Art of the Modern will be that negation (TN, 23-24).

But Modern Art is not only painting. As Rosenberg points out, the category could also include architecture, furniture, household appliances, advertising 'mobiles', a three-thousand year old mask from the South Pacific, even a piece of wood found on a park bench (TN, 35-36). Modern Art has nothing to do with style, with when it was produced, why, by whom, for whom, etc., and more or less everything to do with the social power and pedagogy of those persons who designate it as 'psychologically', aesthetically or ideologically relevant to our epoch' (TN, 36). It is a 'revolution of taste' conducted by those persons who value it and contested by those who do not. Responses to it represent 'claims to social leadership' (TN, 36). Rosenberg was alluding to that aspect of the struggle for leadership within the ruling class which, during the Cold War, was fought with claims about Modern Art. On one side, there was that fraction (the internationalist-multinationalist 'business liberals') which valued it, collected it and made it available to the public in those bits of the cultural apparatus owned and controlled by it – the Museum of Modern Art, New York, was a prime site – and for whom Modern Art had 'a supreme Value [...] the Value of the New' (TN, 37). On the other side there

was that fraction (the isolationist-nationalist 'practical conservatives') which regarded Modern Art as un-American, subversive, 'snobbish, Red, immoral, etc.' (TN, 36), and whose views were represented publicly by the likes of Congressman George A. Dondero. Rosenberg, who understood how Modernism – or those aspects of Modern Art which were synonymous with his Art of the Modern – put the politics of both class fractions at risk,[57] regarded this struggle, restricted to 'weapons of taste' and at the same time addressed to the masses, as a 'comedy of revolution' (TN, 36), i.e., a farce.

The professional enlighteners of Modern Art use action painting in their struggle and for their pedagogic and profit-making purposes (TN, 37), but they do not understand it. Their judgement is a matter of taste, of identifying 'resemblances of surface', and of perpetuating beliefs about what is to be valued as 'modish' (TN, 38). So they failed to grasp 'the new creative principle' which set action painting apart from twentieth-century picture making (TN, 39). Rosenberg's action painting has nothing to do with taste or with 'the all too clearly rationalised' 'previous mode of production or modern masterpieces' (TN, 24). It was a different kind of practice to that of the earlier abstractionists of the International culture or, as it was called in 'The American Action Painters', the Great Vanguard (TN, 24). The Modern, or the Great Vanguard, was historically and culturally specific to Paris, 1907-29. Action painting was historically and culturally specific to an art community associated with 10th Street, New York, 1945-52. It was that community's response in relation to the unevenness of history and to what Rosenberg regarded as a break in the Modern. Not surprisingly – nor illogically according to his order of things – Rosenberg's action painters regarded the style of the Great Vanguard as dead or as something to be transcended. Though it is possible to see a cutaneous similarity between their work and previous abstract painting, the two kinds of painting are crucially different with regard to their functions. Rosenberg said that what the action painter produces 'has separated from' the Great Vanguard and from what the taste bureaucracies and formalism have designated Modern Art because it is determined by and produced with an awareness of a new function for painting (TN, 24). Rosenberg's use of 'the Modern' remained consistent since 'The Fall of Paris' and continued to mean – as it did in 'The Pathos of the Proletariat', where he talked about 'the spirit of the modern' (AA, 29) – the style of the progressive consciousness of the epoch. Action Painting then, is not Modern Art but an Art of the Modern.

Rosenberg points out that most of the artists he has in mind were over forty years old when they became action painters. Before then, many of them had been '"Marxists" (W.P.A. unions, artists' congresses) [...] trying to paint Society. Others had been trying to paint Art (Cubism, Post-Impressionism)'. It amounted to the same thing. They had been trying to paint the Modern. By 1940 both the Society and the Art Modern were dead. 'The Fall of Paris' had written their obituaries. It is in this double demise, not in 'the war and the decline of radicalism in America', that Rosenberg locates the beginnings of action painting. 'At its center the movement was away from, rather than towards. The Great Works of the Past and the Good Life of the Future became equally nil' (TN, 30).

It was at this moment of 'grand crisis' (TN, 30) when the two Moderns of Art and Society became nothing, and were recognised as having failed, that it became possible to make an Art of the Modern again. However, the ideas, beliefs, theories, practices, materials, and methods of Art and Society which survived were useless to those artists who were concerned to deal with the crisis and work it out in practice. 'Value – political, aesthetic, moral' had to be rejected.[58] But this rejection did not, as it had done with Dada and Surrealism after the First World War, take the form of condemnation of defiance. This time the reaction was, not surprisingly, 'diffident' (TN, 30), distrustful of Society and uncertain about 'Art', 'creation', 'creativity', 'individuality' and the 'identity' of the artist.

In coming to nothing the two Moderns provided artists with a major resource for any vanguard practice: *nothingness*. With the idea of nothingness and with severely reduced material equipment the action painter 'decided to paint... just TO PAINT' (TN, 30). There was no intention 'to reproduce, re-design, analyse or "express" an object, actual or imagined. What was to go on the canvas was not a picture but an event. The painter no longer approached his easel with an image in his mind; he went up to it with material in his hand to do something to that other piece of material in front of him' (TN, 25). The image that was produced by 'staining' the canvas or by 'spontaneously putting forms into motion upon it' (TN, 25) was the indexical – and occasionally the iconic - mark or trace of those actions.[59] Initially that was all there was to it. But then the painter began to take stock of the way the surface was marked, started to attend to the 'act of painting', to what might be learned about painting and art and about himself as an artist: 'What matters always is the revelation contained in the act' (TN, 26-27). Action painting is, in Rosenberg's account of it, painting at the point of formation, when everything has to be redone; it is Ur-painting at the moment of thematisation; but it is not yet, and may never become, painting as art.[60]

We are now near to understanding this new painting which Rosenberg regards 'as an act that is inseparable from the biography of the artist', that is 'a "moment" in the adulterated mixture of his life', that is 'of the same metaphysical substance as the artist's existence', and that has 'broken down every distinction between art and life' (TN, 27-28). But we will not understand it if we see it as Modern Art, i.e. in relation 'to the works of the past, rightness of colour, texture, balance, etc.', or as expressing or representing some aspect of the artist's existence, for example, his 'sexual preferences or debilities' (TN, 29). Taking the hint from the reference to 'the critic who goes on judging' (TN, 28) (and recalling what he had written previously in 'Character Change and the Drama' about the way the law defines a person by his acts), it seems clear that Rosenberg understands action painting as a given sequence of acts which enable a judgement by the painter and the critic, a judgement which is an inseparable part of recognising the painter's 'identity'. 'The law is not a recogniser of persons; its judgements are applied at the end of a series of acts.'[61] With regard to individuals the law thus creates a fiction, that of a person who is identified by the coherence of his acts

with a fact in which they have terminated (the crime or the contract), and by nothing else. The judgement is the resolution of these acts. The law visualises the individual as a kind of actor with a role whom the court has located in the situational system of the legal code' (TN, 136).

In understanding an action painting or the 'act-painting' as an act which is 'inseparable from the biography of the artist', Rosenberg doesn't see it as a mere attribute of or clue to the painter's 'psychology, philosophy, history, mythology, hero worship' (TN, 28). Nor, if the action painter is to be understood in terms of the commonly ascertainable elements of his acts – his action paintings – should he ever be made to be more than he could have possibly performed. 'In contrast with the person who is recognised by the continuity of his being, we may designate the character defined by the coherence of his acts as an "identity"' (TN, 136). This, if we follow Rosenberg, is how we are to understand the action painter: as an 'identity'. The action painter's activity is intended to define his 'identity' at a moment of 'grand crisis':

> With the American, heir of the pioneer and the immigrant, the foundering of Art
> and Society was not experienced as a loss. On the contrary, the end of Art
> marked the beginning [...] of an optimism regarding himself as an artist [...] On
> the one hand, a desperate recognition of moral and intellectual exhaustion; on the
> other, the exhilaration of an adventure over depths in which he might find
> reflected the true image of his identity... Guided by visual and somatic memories
> of paintings he had seen or made – memories which he did his best to keep from
> intruding into his consciousness – he gesticulated upon the canvas and watched
> for what each novelty would declare him and his art to be. (TN, 31)

Aware that their ideological and material conditions were thoroughly immiserated and freed from, or wanting to be free from, past ideas and beliefs, the action painters acted according to their historical circumstances and entirely in their own interests. The 'saving moment' occurred 'when the painter first felt himself released from Value – myth of past self-recognition' and 'attempted to initiate a new moment' in which he would 'realise his total personality – myth of future self-recognition' (TN, 31). It was here that the painter's character change became, like Hamlet's or like the '*Americanized*' proletariat, synonymous with revolution. This is Rosenberg on revolutionary action in 'The Pathos of the Proletariat'.

> For the worker action is but a possibility, the anguishing possibility of
> transforming himself into an individual. Hemmed in on the bare, functional stage
> of industrial production, altogether '*there*', without past or vision of paradise, he
> is, except for this possibility of acting, a mere prop, a thing that personifies.
> Speaking half-figuratively, to become a human being the proletarian must
> '*Americanize*' himself, that is, overcome the void of his past by making a new self
> through his actions.

Yet all the relations of capitalist society forbid the working class to act except as a tool. Hence its free act must be a revolutionary act, one that must subdue 'all existing conditions' and can set itself no limits. The proletarian victim of the Modern cannot enter the historical drama as an actor without becoming its hero. In 'the indefinite prodigiousness of their aims', as Marx described them in *The Eighteenth Brumaire*, the workers signify that with them revolution is a need of the spirit, a means of redemption. Before Marx's internal pioneer opens a frontier without end (AA, 31-32).

This is what he wrote, or rewrote, in the 'American Action Painters':

> The revolution against the given, in the self and the world, which since Hegel has provided European vanguard art with theories of a New Reality, has re-entered America in the form of personal revolts. Art as action rests on the enormous assumption that the artist accepts as real only that which he is in the process of creating. 'Except the soul has divested itself of the love of created things...' The artist works in a condition of open possibility, risking, to follow Kierkegaard, the anguish of the esthetic, which accompanies possibility lacking in reality. To maintain the force to refrain from settling anything, he must exercise in himself a constant No. (TN, 32)

The action painter can only produce effectively if he is in relation to the dominant culture as a proletarian, an alienated proletarian, a proletarian within a class. Action is the prerequisite of class 'identity'. For the proletariat, which is held in an alienated, exploited fixed-relation, any free act, any action made spontaneously and without recourse to myths of the past or to a Utopian future, will be, by definition, revolutionary and will begin the revolution in permanence. Action is also the prerequisite of the vanguard painter's 'identity'. In the crisis period of 1940 and after, the painter could either remain inactive and continue to paint Art and Society, or he could rid himself of all considerations except those demanded by his historical situation, directly encountered, and... just PAINT. He could produce Modern Art or an Art of the Modern, make art or 'original work demonstrating what art is about to become' (TN, 24).

As I read them, 'The Pathos of the Proletariat' and 'The American Action Painters' are the essays of a Marxist who *refused* to be forced into a pessimism which would be quite alien to the Marxist tradition.[62] The Harold Rosenberg who wrote 'The Front' was still here, residually, in these essays of the late 1940s and 1950s. The proletariat still had the potential for revolution: '*So long as the category exists*, the possibility cannot be excluded that it will recognise itself as a separate human community and revolutionise everything by asserting its needs and its traditionless interests' (AA, 56-57). And the American action painters provided evidence that there was still some potential for personal revolt and for insurrection. For Rosenberg, 'good' action painting left 'no doubt concerning its reality as an action and its relation to a transforming process in the artist' (TN, 33). Weak or 'easy' action painting lacked 'the dialectical tension of a genuine act, associated with risk and will' (TN, 34). The painter seemed to be able to

act out an 'identity' – 'Dramas Of As If' (TN, 27) – which the proletariat, at that moment, could not.

Maybe the action painter's action was always, at some level, a failure – unless, as seems unlikely, it was part of a 'revolution' whose outlines were not perceptible in political terms, but whose potential could only be denied at the cost of an entire loss of self.

Rosenberg was able to remain optimistic because his analyses incorporated the dialectic. When it appeared, the dialectical method, which combines the negativity of man's social experience with the need for change, introduced an essential, confident movement into his writing. Remember: the Paris Modern represented 'a dream living-in-the-present and a dream world citizenship – resting not upon a real triumph, but upon a willingness to go as far as was necessary into nothingness in order to shake off what was dead in the real. A negation of the negative.' For Rosenberg, that was what the work of American action painters was. If action painting had any meaning, it was about revolutionary political agency arising from the contradictions of capitalism, the reality of which could not be totally excluded if the prospect of radical change was to be kept open... sometime... somewhere... Action painting was the sign that the possibility of revolution was not totally closed down, that the dynamic of revolution was still there.[63] Action painting was that, or it was nothing.

'I am nothing and I should be everything.'
Karl Marx, *Critique of Hegel's Philosophy of Right: Introduction* (1844)

Notes

1. Harold Rosenberg, 'The American Action Painters', *Art News*, vol. 51, no. 8, December 1952, pp. 22-3, 48-50, reprinted in *The Tradition of the New*, 1982, pp. 23-39.
Note these abbreviations used throughout:
 AA = Harold Rosenberg, *Act and the Actor, Making the Self* (N.Y.: World Publishing Co., 1970, The University of Chicago, 1983).
 DP = Harold Rosenberg, *Discovering the Present/Three Decades in Art, Culture, and Politics* (Chicago: The University of Chicago, 1973, Phoenix Edition, 1976).
 TN = Harold Rosenberg, *The Tradition of the New* (N.Y.: Horizon Press, 1959, The University of Chicago, Phoenix Edition, 1982)
2. Harold Rosenberg, 'The Front', *Partisan Review*, vol. 11, no. 6, January-February 1935, p. 74.
3. Harold Rosenberg, "Character Change and the Drama", *The Symposium*, vol. III, no. 3, July 1932, pp. 348-69, reprinted in *The Tradition of the New*, 1982, pp. 135-53. See also his other work for *The Symposium*: 'Myth and Poem', vol. II, no. 2, April 1931, pp. 179-91; a review of William Empson's *Seven Types of Ambiguity*, vol. II, no. 3, July 1931, pp. 412-18; a review of Kenneth Burke's *Counter Statement* and Montgomery Belgion's *The Human Parrot and Other Essays*, vol. III, no. 1, January 1932, pp. 116-18; and a review of Jules Romains's *Men of Good Will*, vol. IV, no. 4, October 1933, pp. 511-14.
4. Rosenberg and Hays published three issues of *The New Act*, Number One, January 1933, Number Two, June 1933, and Number Three, April 1934. *Poetry, a Magazine of Verse*, vol. 45, no. 6, March 1935, p. 357, referred to it as an 'experimental quarterly'. *The New Act* published articles by René Daumal, Paul van Ostayen, Henry Bamford Parkes, George Plekhanov, Ezra Pound, Samuel Putman, and Parker Tyler. For Rosenberg's contributions see 'Note on Class Conflict and Literature', *The New Act*, Number One, January 1933, pp. 3-10, and 'Sanity, Individuality and Poetry', *The New Act*, Number Two, June 1933, pp. 59-75, two essays in which he developed the ideas on class conflict and individuality that he had first written in 'Character Change and the Drama', 1932.
5. Rosenberg's contributions are indexed in *Thirty Years of Poetry: A Magazine of Verse. Index to Volumes 1-60, October*

1912-September 1942 (inclusive) and Index to *Fifty Years of Poetry, A Magazine of Verse*, Volumes 1-100, 1912-1962 (N.Y.: AMS Reprint Company, 1963).

6. William Phillips and Philip Rahv, 'Private Experience and Public Philosophy', *Poetry*, vol. 48, no. 2, May 1936, p. 104.

7. Harold Rosenberg, 'The Men on the Wall', *Poetry*, vol. 44, no. 1, April 1934, pp. 3-4.

8. Ibid.

9. 'Contributors', *Partisan Review*, vol. II, no. 6, January-February 1935, p. 2.

10. On the John Reed Club and *Partisan Review* see Daniel Aaron, *Writers and Partisans: A History of Literary Radicalism in America* (N.Y.: Wily, 1968); Richard H. Pells, *Radical Visions and American Dreams: Culture and Social Thought in the Depression Years* (Wesleyan University Press, 1973); Alan Wald, 'Revolutionary Intellectuals: Partisan Review in the 1930s', *Occident*, n.s. viii, Spring 1974, pp. 118-33; Eric Homberger, *American Writers and Radical Politics, 1900-1939: Equivocal Commitments* (N.Y.: St. Martin's Press, 1986).

11. Considering the secrecy which continues to surround membership and which was deliberately fostered by the C.P., it's very difficult to know who was and who was not a member of the C.P.U.S.A. and there are conflicting reports. It seems that being a member demanded a kind of discipline that most writers and artists would not be able to accept. One has to remember that the C.P.U.S.A. was partly committed to democratic centralism and to the strategic use of writers and artists. Because it could not accommodate any criticism from members at local levels of organisation, it would not accept into its ranks any really independent figures, and they, in turn, would not accept its dictates. My guess is that Harold Rosenberg was a fellow-traveller.

12. 'The Coming Writers' Congress', *Partisan Review*, vol. II, no. 6, January-February 1935, pp. 94-6, see p. 95. The Congress, it was announced, would also 'develop the possibilities for wider distribution of revolutionary books and the improvement of the revolutionary press, as well as relations between revolutionary writers and bourgeois publishers and editors'. It was clear from this that when the Congress met at the end of April it was to be less concerned with revolution than with establishing good relations with the literary bourgeoisie and with fighting fascism.

13. Jane (Tabrisky) Degras, *The Communist International 1919-1943: Documents Vol. 3* (London and New York: Oxford University Press, 1965), p. 375, quoted in Duncan Halas, *The Comintern* (London: Bookmarks, 1985), p. 143, an excellent discussion of the Comintern's revolutionary period.

14. Harold Rosenberg, 'The American Writers Congress', *Poetry*, vol. 46, no. 4, July 1935, pp. 222-7.

15. Ibid., p. 226.

16. Ibid., pp. 226-7.

17. Ibid., p. 225.

18. Ibid.

19. Ibid.

20. Ibid.

21. Rosenberg is using Browder's speech to the Congress which was intended to reassure the non-communist writers that the C.P. had no intention of putting them into 'uniforms'. This mention of 'uniforms' was clearly a reference to Max Eastman's *Artists in Uniform* (N.Y., 1934).

22. Here I've relied on Gerald M. Monroe's essay 'Art Front' in *Archives of American Art Journal*, vol. 13, no. 3, 1973 pp. 13-19. The editorial board's shift towards modernism was made partly as a result of pressure which had been brought to bear by some modernist members of the Union – Solman, Ilya Bolotowsky, Balcomb Greene, Mark Rothkowitz, Byron Browne, George McNeil, and others – and partly because the Popular Front made it necessary to open up the editorial board to modernism. The move did not go uncontested. Rosenberg's place was secured at the expense of Solman's and Spivak's and several others, and then only on the advice of a visiting official of the French Communist Party who sat in on a crucial board meeting.

23. Rosenberg's first piece for *Art Front* was a report on an Artists Union demonstration outside the C.A.A. on 15 August 1935, at which 83 W.P.A. artists and art teachers were arrested, see 'Artists Increase their Understanding of Public Buildings', *Art Front*, November 1935, pp. 3, 6.

24. Harold Rosenberg, translator, Fernand Léger, 'The New Realism', *Art Front*, December 1935, p. 10.

25. Harold Rosenberg, 'Peasants and Pure Art', January 1936, pp. 5-6, and 'Cubism and Abstract Art', *Art Front*, June 1936, p. 15.

26. Harold Rosenberg, 'Book Reviews', *Art Front*, March 1936, pp. 13-14, see p. 14.

27. Harold Rosenberg, 'The Wit of William Gropper', *Art Front*, March 1936, pp. 7-8.

28. The most complete and still the best account can be found in the rich detail of Chapter One 'New York, 1935-1941: The De-Marxization of the Intelligentsia' in Serge Guilbaut's *How New York Stole the Idea of Modern Art: Abstract*

Expressionism, Freedom, and the Cold War (The University of Chicago Press, 1983).

29. In 1937 Rosenberg published several things in *New Masses*, the cultural magazine of the C.P.U.S.A. which always affirmed the validity of the Moscow Trials and the Communist line. 'Portrait of a Predicament', his very hostile review – in the context of *New Masses* it couldn't have been anything but hostile – of William Saroyan's *3 Times 3* appeared in the same issue as 'The Moscow Trials: An Editorial', *New Masses*, 9 February 1937, see p. 24. Other writings are: 'What We May Demand', *New Masses*, 23 March 1937, pp. 17-18, an article on literature and major political writings (i.e. 'But the least we may demand from literature is that it equal the best political and historical writings of our time in the consciousness of its own subject matter. Only thus can it probe the wound of humanity which the act of thinking and of political combination is part of the effort to cure [...] no poem or novel of the past few years can equal as a literary expression of modern human consciousness the Communist Manifesto or Marx's Eighteenth Brumaire.'); 'Aesthetic Assault', a review of Jules Romains's *The Boys in the Back Room*, *New Masses*, 30 March 1937, p. 25; and 'The Melancholy Railings', a poem, *New Masses*, 20 July 1937, p. 20. However, he did not publish in *New Masses* after July 1937, and he did not put his name to 'The Moscow Trials: A Statement by American Progressives' endorsing the trials, *New Masses*, 3 May 1938, p. 19. This break with *New Masses* helps date his move away from the C.P.

30. Leon Trotsky, *Writings of Leon Trotsky* (1937-8) (N.Y.: Pathfinder Press, 1970), pp. 351-2.

31. Leon Trotsky, 'Art and Politics', *Partisan Review*, vol. V, no. 3, August-September 1938, pp. 3-10.

32. See André Breton and Diego Rivera, 'Manifesto: Towards a Free Revolutionary Art', *Partisan Review*, vol. VI, no. 1, Fall 1938, pp. 49-53. It is generally agreed that this text is substantially Trotsky's.

33. Harold Rosenberg, 'Myth and History', *Partisan Review*, vol. VI, no. 2, Winter 1939, pp. 19-39.

34. 'The Situation in American Writing', *Partisan Review*, vol. VI, no. 4, Summer 1939, see pp. 47-9.

35. Harold Rosenberg, 'Marx and "The People"', *Partisan Review*, vol. VI, no. 4, Summer 1939, pp. 21-5, see p. 124.

36. 'Statement of the L.C.F.S.', *Partisan Review*, vol. VI, no. 4, Summer 1939, pp. 125-7, see p. 127. He also signed the League's Manifesto 'War Is The Issue!', in the next issue of *Partisan Review*, vol. VI, no. 5, Fall 1939, pp. 125-7. See Rosenberg on the L.C.F.S. in 'Couch Liberalism and the Guilty Past', *Dissent; a Quarterly of Socialist Opinion*, vol. II, Autumn 1955, pp. 317ff., reprinted in *The Tradition of the New*, 1982, pp. 238-9.

37. Harold Rosenberg, 'On the Fall of Paris', *Partisan Review*, vol. VII, no. 6, December 1940, pp. 440-8 reprinted under the title 'The Fall of Paris' in *The Tradition of the New* (1982), pp. 209-20.

38. See Harold Rosenberg, 'Couch Liberalism and the Guilty Past' (1955), TN, 221-40.

39. In the dialectical process of development 'The old quality is negated by its opposite [...] thus constituting the first negation. However, the superseded quality does not remain in its original form but, by another process of negation, develops into the next stage, the negation of the negation. Marx, Engels and other classical Marxist philosophers developed the concept from Hegel, but gave it a materialist content and stressed its dynamic aspect of development. However, as Engels and Lenin insisted, neither negation nor the negation of the negation in dialectics amounts to the total denial or rejection of the old. Thus socialism is basically a negation of capitalism, yet the former also embodies the best elements of the latter' (J. Wilczynski, *Encyclopaedic Dictionary of Marxism, Socialism and Communism* (Berlin and New York: De Gruyter, 1981), p. 382).

In 'The Pathos of the Proletariat', AA, 35, Rosenberg quotes this fragment from *Capital* with reference to the Hegelian dialectic as summarised by Marx: 'it includes in its comprehension an affirmative recognition of the existing state of things, at the same time also, the recognition of the negation of that state, of its inevitable breaking up'. For the classic formulation of the negation of the negation see Karl Marx, *Capital I*, trans. Ben Fowkes (Harmondsworth and London: Penguin/New Left Review, 1976), p. 929: 'The capitalist mode of appropriation, the result of the capitalist mode of production, produces capitalist private property. This is the first negation of individual private property, as founded on the labour of the proprietor. But capitalist production begets, with the inexorability of a law of Nature, its own negation. It is the negation of the negation. This does not re-establish private property for the producer, but gives him individual property based on co-operation and the possession in common of the land and the means of production.'

The negation of the negation cannot, however, produce a self-sustaining positivity. Accordingly the positive value of the social revolution must be constituted through successive stages of development and transition. The social revolution prevents the dialectical movement coming to an end; the proletariat will continually remake society and itself.

Slavoj Zizek, *The Sublime Object of Ideology* (London: Verso, 1989), pp. 176-7, provides this useful gloss on the negation of the negation and identity (which is also helpful with regard to reading what Rosenberg writes, TN, 32, about the American action painters' 'revolution against the given, in the self and in the world'): 'This is also, in a nutshell, the logic of the "negation of the negation": this double, self-referential negation does not entail any kind of return to positive

identity, any kind of abolition, or cancellation of the disruptive force of negativity, of reducing it to a passing moment in the self-mediating process of identity; in the "negation of the negation", the negativity preserves all its disruptive power, the whole point is just that we come to experience how this negative, disruptive power, menacing our identity is simultaneously a positive condition of it. The "negation of the negation" does not in any way abolish the antagonism, it consists only in the experience of the fact that this immanent limit which is preventing me from achieving my full identity with myself simultaneously enables me to achieve a minimum of positive consistency, however mutilated it is.

'This, then, is the "negation of the negation": not a kind of "super-seding" of negativity but the experience of the fact that the negativity as such has a positive function, enables and structures our positive consistency. In simple negation, there is still the pre-given positive identity which is being negated, the movement of negativity is still conceived as the limitation of some pre-given positivity: while in the "negation of the negation", negativity is in a way prior to what is being negated, it is a negative movement which opens the very place where every positive identity can be situated.'

40. See David A. Hollinger, 'Ethnic Diversity, Cosmopolitanism and the Emergence of the American Liberal Intelligentsia', *American Quarterly*, vol. XXVII, no. 2, May 1975, pp. 133-51, especially with reference to Rosenberg pp. 146-7: 'Although it would be an exaggeration to say that New York took the place of Paris as the cultural capital, the temporary ascendancy of Hitler in Europe suddenly transformed America, as Kazin put it in [*On Native Grounds*] 1942, into "a repository of Western Culture" in a world overrun by its enemies. This impression was not simply a general one; it had the specific reinforcement of the new intellectual migration. However parochial and nativist American society remained in the 1930s and early 1940s, it at least managed to accept a number of prominent political dissenters and non-Aryan physicists, philosophers, and psychoanalysts driven out of Central Europe. The presence in America of spirits like Thomas Mann, Jacques Maritain, and Albert Einstein, noted Kazin, intensified one's pride in trying to create here "a new cosmopolitan culture". Values once associated with Europe, especially Paris, now had no physical, geographical, social foundation more solid than that provided by the United States. Suddenly America did not seem so outrageously provincial. This is the context in which we must see the legendary patriotism of the intelligentsia in the Cold War era.

'With varying degrees of certainty and enthusiasm, the intelligentsia of the 1940s and 1950s believed that the United States had become a viable, if imperfect embodiment of the cosmopolitan ideal. This "nationalism" triumphed only when it was felt to be distinct from the sensibility of the same name that had been so firmly rejected by the likes of Bourne, Cohen, and Rosenberg [in 'On the Fall of Paris']. The superiority of America to the Soviet Union was partially described in terms of the greater freedom and diversity that seemed to characterise American society. One needs neither to quarrel with nor to affirm the appropriateness for this assessment to understand that much of its persuasiveness derived from the actual social circumstances of the intelligentsia at the time: its members had come out of their various "exiles" – expatriation, the Diaspora, displacement from contemporary Europe – to find not simply "America", but to find each other. Feeling, in each other's presence, that cosmopolitanism was substantially a fact, they could not only choose sides in the Cold War, but could even show selective appreciation for American provincialism. The life depicted in [James Agee's and Walker Evans'] *Let Us Now Praise Famous Men* was in no way a threat and could be drawn upon as a source of insight, in accordance with the cosmopolitan ideal. The same could be felt about even Brooklyn or the Lower East Side: [Alfred Kazin's] *A Walker in the City* could scarcely have been written until its author was utterly secure not simply as an American but as a cosmopolitan.'

41. Harold Rosenberg, 'Tenth Street: A Geography of Modern Art', *Art News Annual*, vol. XXVIII, 1959, pp. 120-37, 184, 186, 190, 192 reprinted with slight modifications in *Discovering the Present: Three Decades in Art, Culture and Politics* (1973), pp. 100-9.

42. See DP, 104, 'Identical with rotting side streets in Chicago, Detroit, and Boston, Tenth Street is differentiated only by its encampment of artists. Here de Kooning's conception of "no environment" for the figures of his Women has been realised to the maximum with regard to himself.' According to Thomas B. Hess, *Willem de Kooning* (N.Y.: The Museum of Modern Art, 1968), pp. 78-9, the idea of 'no environment' was developed by de Kooning while he worked on *Woman I* (1950-2) to refer to 'the American urban scene and its lack of specificity ... Everything has its own character, but its character has nothing to do with any particular place'. Rosenberg in *Willem de Kooning* (N.Y.: Abrams, 1973), p. 15, refers to de Kooning arriving 'at his concept of "no style"' as an aspect of 'the act of painting': 'Transient and imperfect as an episode in daily life, the act of painting achieves its form outside the patterning of style. It cuts across the history of art modes and appropriates to painting whatever images it attracts into its orbit. "No Style" painting is neither dependent upon forms of the past nor indifferent to them. It is transformal. ...' Given that in 'The Fall of Paris', 1940, Rosenberg had discussed the Paris Modern as a 'No-Time' and the Paris 'International' as a 'No-Place' it seems likely that de Kooning shared, and shared with other persons in their bit of the New York avant-garde artistic community, with John Cage, for example. As Richard Shiff points out in 'Performing an Appearance: On the Surface of Abstract Expressionism', *Abstract*

Expressionism, The Critical Developments, edited by Michael Auping (Harry N. Abrams Inc. in association with the Albright-Knox Art Gallery, 1987), p. 121: n. 77, 'The concept "no style", indicating both emptiness and plenitude, might also be related to the teachings of Zen' – as, indeed, it was for Cage.

Here it is worth recalling part of the statement which Cage wrote to accompany Robert Rauschenberg's *White Paintings* (1951) when they were exhibited at the Stable Gallery in September 1953:

> To Whom:
> No subject
> No image
> No taste
> No object
> No beauty
> No message
> No talent
> No technique (no why)
> No idea
> No intention
> No art
> No feeling
> No black
> No white (no and)

After careful consideration, I have come to the conclusion that there is nothing in these paintings that could not be changed, that they can be seen in any light and are not destroyed by the action of shadows.

Maybe – its possible – Rosenberg had Rauschenberg's *White Paintings* in mind when he wrote in 'The American Action Painters', TN, 26: 'The new American painting is not "pure" art, since the extrusion of the object was not for the sake of the esthetic. The apples weren't brushed off the table in order to make room for perfect relations of space and color. They had to go so that nothing would get in the way of the act of painting. In this gesturing with materials the esthetic, too, has been subordinated. Form, color, composition, drawing, are auxiliaries, any on of which – or practically all, has been attempted logically, with, unpainted canvases – can be dispensed with.'

43. Harold Rosenberg, 'The Pathos of the Proletariat', *The Kenyon Review*, vol. XI, no. 4, Autumn 1949, pp. 595-629, reprinted in *Act and the Actor* (1983), pp. 2-57.

44. Harold Rosenberg, 'The Resurrected Romans', *The Kenyon Review*, vol. X, no. 4, Autumn 1948, pp. 602-20, reprinted in *The Tradition of the New* (1982), pp. 154-77.

45. Born in New York City in 1906, Rosenberg attended City College, 1923-4, Brooklyn Law School and graduated with a law degree from St Lawrence University in 1927.

46. Rosenberg is here rewriting that bit of Marx's third thesis on Feuerbach which goes: 'The coincidence of the changing of circumstances and of human activity or self-changing can be achieved and rationally understood only as a revolutionary practice.' By 1933 the political reading would have become unavoidable.

47. Rosenberg has a note here: '* One effect of American indignation is to play down the difference in spiritual form of a nation with a past of immigration, pioneering and democratic revolts. The official American view is that America has culture, too; in other words, an inheritance like any other country. Yet American writers and artists know through experience that they cannot hope to define themselves as individuals so long as they follow European models in respect to the past, even a past of their own. Moi, je suis barbare, defiantly declared a character in one of Dostoyevsky's stories. It would be a gain for American consciousness if it, too, boldly accepted its predicament as a nation (aging) of "new men".'

48. On the place the United States held in Lenin's thinking, see *Lenin on the United States: Selected Writings by V.I. Lenin* (N.Y.: International Publishers, 1970). Trotsky's most extended discussion of the economy – and politics – of U.S. monopoly capitalism is to be found in the introduction to his book *The Living Thoughts of Karl Marx* (Philadelphia, 1939) which was published separately as *Marxism in the United States* (N.Y.: Workers Party Publications, 1947).

49. Rosenberg has a note here '*In comparing the American and the proletariat we are thinking of them, of course, not as categories, where they overlap (since many Americans are wage workers), but as collective entities or types – the first actual, the second hypothetical.'

50. Rosenberg has a note here: '* Only "half" figuratively, since becoming Americans has been the actual salvation chosen by millions of workingmen from older nations. With the proletariat there is more to the impulse to become an American than the desire for economic opportunity, flight from oppression, etc. Primarily, it is a will to enter a world where the past

no longer dominates, and where therefore that creature of the present, the workingman, can merge himself into the human whole. Thus proletarians immigrate to America in a different spirit from middle-class people or peasants, who from the moment they enter "American time" experience it as something disconcerting and even immoral, and whose nostalgia for their homelands and customs is often communicated from one generation to the next. But America's thin time crust, that seems so desolate to immigrants from other classes, is precisely what satisfies the proletariat and has provided so many workers with the energy to become leaders of industry. Becoming an American is a kind of revolution for foreign proletarians, though it is a magical revolution rather than a revolutionary act. It alters the workingman's consciousness of himself; like a religious conversion it supplies him with a new identity. But this change does not extinguish his previous situation as a character in the capitalist drama; he is still in the realm of economic personifications. As an American, too, a social-economic role will be assigned to him: worker, farmer, capitalist. The elimination of these abstract types continues to call for a transformation of the historical "plot".'

51. James P. Cannon, 'Trotsky on the United States', *Internationalist Socialist Review*, Fall 1960, reprinted in *Leon Trotsky: The Man and His Work* (N.Y.: Merit Publishers, 1969), pp. 87-8, quotes this fragment from Trotsky's 'Europe and America', 1926, which is useful with regard to what I'm arguing here: 'In this "revolutionary Marxist critique of Americanism ... we do not all mean thereby to condemn Americanism, lock, stock, and barrel. We do not mean that we abjure to learn from Americans and Americanism whatever one can and should learn from them. We lack the technique of the Americans and their labor proficiency ... to have Bolshevism shod in the American way – there is our task! ... If we can get shod with mathematics, technology, if we Americanise our frail socialist industry, then we can with tenfold confidence say that the future is completely and decisively working in our favor. Americanised Bolshevism will crush and conquer imperialist Americanism".'

52. Robert Goodnough, 'Pollock paints a picture', photographs by Hans Namuth, *Art News*, vol. 50, no. 3, May 1951, pp. 38-41, 60-1.

53. See what Rosenberg wrote in his review of Bryan Robertson's *Jackson Pollock* (N.Y.: Abrams, 1961), with regard to Pollock or something Pollock may have said to him, 'The Search for Jackson Pollock', *Art News*, vol. 59, no. 10, February 1961, pp. 59-60: 'according to Robertson... "During a conversation in 1949 with Harold Rosenberg, Pollock talked of the supremacy of *the act of painting* as in itself a source of magic. An observer with extreme intelligence, Rosenberg immediately coined the new phrase: action painting" (Robertson's italics). The aim of this statement is obviously, to present Pollock as the originator of Action Painting in theory and in practice, if not in name ... The statement is, of course, entirely false, and whoever informed Mr. Robertson that this conversation took place knew it was false. Pollock never spoke to Rosenberg about the "act of painting", of its "supremacy" (to what?) or of any "source of magic" in it. This can easily be demonstrated. The concept of Action Painting was first presented in the December 1952 *Art News*, so that if the conversation described by Robertson had taken place in 1949 Rosenberg did not produce the phrase "immediately" but waited three years. It may have required that much time for him to penetrate the depths of Pollock's observation, but in that case one would be justified in questioning his "extreme intelligence". On the other hand, Rosenberg had published writings on the subject of action as constitutive of identity as far back as 1932; in 1948, a year before the alleged tip-off, he further elaborated the topic in an essay in *The Kenyon Review* entitled "The Resurrected Romans", which may have had something to do with "magic" but nothing to do with Pollock or with painting. A conversation between Pollock and Rosenberg did occur in 1952, immediately preceding the composition of 'The American Action Painters' but in this talk Pollock said nothing about action. He spoke of identifying himself with a tree, a mode of self-stimulation not unknown in the tradition of which we have been speaking and more relevant to the paintings for which he is famous. He also attacked a fellow artist for working from sketches, which in Pollock's opinion, made the artist "Renaissance" and backward (this point was reported in the "Action Painters" essay, though without mentioning names). In the last years, Robertson informs us, Pollock liked to refer to the canvas he was working on as "the arena" – this term was garnered from "The American Action Painters", which says: "At a certain point the canvas began to appear to one American painter after another as an arena in which to act." Apparently, Pollock, or someone presently speaking for him, wished to acquire this thought for himself exclusively, although Rosenberg told Pollock, in the presence of a witness, that the article was not "about" him, even if he had played a part in it ...'

Despite this, the idea that Pollock was somehow the model for 'action painting' or provided Rosenberg with the idea, or that Namuth's photographs of Pollock at work did, persists. See, for example, the letters exchanged between Rosenberg and William Rubin in *Artforum*, April 1967, pp. 6-7 and, especially, May 1967, p. 4, correspondence concerning Rubin's 'Jackson Pollock and the Modern Tradition, Part I', *Artforum*, February 1967, pp. 14-22. See also Barbara Rose, 'Hans Namuth's Photographs and the Jackson Pollock Myth: Part One: Media Impact and the Failure of Criticism', *Arts Magazine*, vol. 53, no. 7, March 1979, pp. 112-19, especially pp. 112-13; and more recently Deborah Solomon, *Jackson*

Pollock: A Biography (N.Y.: Simon and Schuster, 1987), p. 210, Ellen G. Landau, *Jackson Pollock* (N.Y.: Abrams, 1989), pp. 85-6, and Steven Nifeh and Gregory White Smith, *Jackson Pollock, An American Saga* (N.Y.: Clarkson N. Potter, 1989), pp. 703-7.

54. 'An Interview with Robert Motherwell', *Artforum*, vol. IV, September 1965, p. 37: 'At that time, I was editing "Dada" proofs of Huelsenbeck's which ultimately appeared in the Dada anthology [*The Dada Painters and Poets: An Anthology*, edited by Robert Motherwell (N.Y.: Wittenborn, Schultz, Inc., 1951), pp. 22-48.] as 'En Avant Dada' ... Harold came across the passage in proofs in which Hulsenbeck violently attacks literary esthetes, and says that literature should be action, should be made with a gun in the hand, etc.'

55. *Possibilities*, No. 1, Winter 1947-8, pp. 41-3. *The Dada Painters and Poets: an Anthology*, 1951, p. 28.

56. 'An Interview with Robert Motherwell', *Artforum*, vol. IV, September 1965, p. 37.

57. On the internationalist 'business-liberals' and the old guard, 'America First', isolationists as fractions of the U.S. ruling class, see the books of G. William Domhoff, for example, *Who Rules America?* (Englewood Cliffs, N.J.: Prentice Hall, 1967), and *The Powers That Be: Processes of Ruling Class Domination in America* (N.Y.: Random House, 1978). In 'Revolution and the Idea of Beauty', *Encounter*, vol. I, no. 3, December 1953, pp. 65-8 (reprinted and revised as 'Revolution and the Concept of Beauty' in *The Tradition of the New* (1982), pp. 74-83) Rosenberg discusses the use made of Modern Art by the likes of Representative George A. Dondero (Michigan) and Alfred H. Barr Jr., in 'Is Modern Art Communistic?', *New York Times Magazine*, 14 December 1952, pp. 22-3, 28-30; here's an example from the *Encounter* version, pp. 65-6: 'You can take it from a philosophical anarchist, Herbert Read, who writes in his The Philosophy of Modern Art : "The modern movement in the arts which began to reveal to itself in the first decade of the century was fundamentally revolutionary ... When I characterise this movement as fundamentally revolutionary, I attach a literal meaning to these well-worn words."

'The New York Times, which hesitates to give the embarrassing label of revolutionary to things now hanging in respectable American homes and museums, recently printed an article demonstrating that abstract and expressionist art was banned in Nazi Germany and is outlawed in the U.S.S.R. If the Nazis and Communists have disapproved of the modernist mode, how can it be radical? But this way of defending modern art is surely a bit sly. The antagonism to modern art of Fascists or Communists does not exonerate it of subversiveness. It could even, perhaps, show just the opposite: that modern art is so subversive it is looked upon as a danger even by "revolutionary" régimes. (Another possible interpretation is that the hostility, which was not evident in the early years of Fascism and Bolshevism, is proof that these movements in time stopped being revolutionary.)

'It would seem that what one can say is that modern art is revolutionary, but that this revolution is neither Communist nor Fascist. [...]

'It is important therefore to try to remove the confusions inherent in the notion of revolutionary art, even if that were possible. It is necessary, however, to expose the fact that there is a confusion, especially now that the adulteration of art with politics (and of politics with art) has ceased to be innocent. Today, everyone ought to be aware that revolution in art and revolution in politics are not the same thing, and may even contradict one another. But this awareness is kept under cover for professional reasons. What takes its place is sophisticated impure play upon the ambiguities of the revolutionary position, radical painters being palmed off as respectable (as in the *New York Times* article), philistine work screaming that it is changing the world. The result is an atmosphere of mauvaise conscience, or, more simply, of dupery and semi-dupery. Today, the poison of bad conscience about revolution is the specific malady of art.'

58. Which is not to say that there is not a political, aesthetic and moral purport to action painting as 'painting in the medium of difficulties'. See the note provided by Rosenberg, *The Tradition of the New* (McGraw Hill paperback, 1965), and the subsequent reprints, TN, 33-34: 'As other art movements of our time have extracted from painting the element of structure or the element of tone and elevated it into their essence, Action Painting has extracted the element of decision inherent in all art in that the work is not finished at its beginning but has to be carried forward by an accumulation of "right" gestures. In a word, action painting is the abstraction of the moral element in art; its mark is moral tension in detachment from moral or aesthetic certainties; and it judges itself morally in declaring that picture to be worthless which is not the incorporation of a genuine struggle, one which could at any point have been lost.'

59. For an interesting discussion of the indexical and iconical in Abstract Expressionism, see Richard Shiff, 'Performing an Appearance: On the Surface of Abstract Expressionism', *Abstract Expressionism, The Critical Developments* (1987), pp. 94-123.

60. See Richard Wollheim's account of Ur-painting in *Painting as an Art* (Princeton University Press, 1987), pp. 19-25, p. 359, n. 9.

61. Rosenberg has a note here, '* Razkolnikov, for example, in Crime and Punishment sought judgment so that his act

would be completed and he could take on a new existence.'

62. Here I had in mind something of what Alasdair MacIntyre writes in his conclusion to *After Virtue, A Study in Moral Theory* (University of Notre Dame Press, 1981), pp. 243-4: 'Here I was of course speaking of Marxists at their best in, say Yugoslavia or Italy; the barbarous despotism of the collective Tsardom which reigns in Moscow can be taken to be as irrelevant to the question of the moral substance of Marxism as the life of the Borgia pope was to that of the moral substance of Christianity. None the less Marxism has recommended itself precisely as a guide to practice, as a politics of a peculiarly illuminating kind. Yet it is just here that it has been of singularly little help for some time now. Trotsky, in the very last few years of his life, facing the question of whether the Soviet Union was in any sense a socialist country, also faced implicitly the question of whether the categories of Marxism could illuminate the future. He himself made everything turn on the outcome of a set of hypothetical predictions about possible future events in the Soviet Union, predictions which were tested only after Trotsky's death. The answer that they returned was clear: Trotsky's own premises entailed that the Soviet Union was not socialist and that the theory which was to have illuminated the path to human liberation had in fact led into darkness.

'Marxist socialism is at its core deeply optimistic. For however thorough-going its criticism of capitalist and bourgeois institutions may be, it is committed to asserting that within the society constituted by those institutions, all the human and material preconditions of advanced capitalism is what so many Marxists agree that it is, whence are these resources for the future to be derived? [...]

'A Marxist who took Trotsky's last writings with great seriousness would be forced into a pessimism quite alien to the Marxist tradition, and in becoming a pessimist he would in an important way have ceased to be a Marxist. For he would now see no tolerable alternative set of political and economic structures which could be brought into place to replace the structures of advanced capitalism. This conclusion agrees of course with my own. For I too not only take it that Marxism is exhausted as a political tradition, a claim borne out by the almost indefinitely numerous and conflicting range of political allegiances which now carry Marxist banners – this does not at all imply that Marxism is not still one of the richest sources of ideas about modern society – but I believe that this exhaustion in shared by every other political tradition within our culture.'

63. N.B. Harold Rosenberg and Robert Motherwell, 'Possibilities', *Possibilities*, no. 1, Winter 1947-8, p. 1: 'If one is to continue to paint or write as the political trap seems to close upon him He must perhaps have the extremist faith in sheer possibility.'

Chapter 10

Footnote One:
The Idea of the Cold War

FRED ORTON

This paper is nothing more than a footnote to be added to the histories of Abstract Expressionism's belonging to a Cold War polity.[1] The very idea of the Cold War is a problem. If we want to consider questions like 'What were the circumstances in which a national bourgeoisie, in pride of its victory, came to want something as odd and exotic as an avant-garde of its own?' and 'To what extent was the meeting of class and art practice in New York in the later 1940s more than just contingent?' – the kinds of questions asked of Abstract Expressionism by the Social History of Art – we would be well advised to consider what sets of ideas and beliefs are mobilised when we appropriate the idea of the Cold War as a resource with which to ask our questions and research and write our answers.[2]

The idea of the Cold War is of limited use for understanding U.S. foreign and domestic policy at the beginnings of the post-war world, which is to say that it is of limited use for understanding Abstract Expressionism's place and function in – what has been referred to as – 'the world fiction called America'[3] between 1946 and 1956 or thereabouts. The idea of the Cold War has the form of an irreconcilable conflict between two different social systems: the U.S.A. and the Soviet Union; the Free World and the Communist Bloc; democracy versus red fascist[4] or socialist totalitarianism. The Cold War is a constraining notion, a closure, which conditions us not to probe deeper the real determinations of foreign and domestic policy, and the violence and conflict which were an integral part of them. At some level – the level of language, of procedure, of presuppositions about world making – Abstract Expressionism belonged to these determinations, was part of their effected violence and conflict.

Revisionist historians have shown that U.S. foreign policy in the early post-war

period was determined not so much by the fear or the threat of the Soviet Union as by a concern that the U.S. would retreat to the isolationism, nationalism, and economic depression of the 1930s.[5] When the U.S. emerged from the Second World War as the strongest military and economic nation on the globe, it did so with policy-makers who were confident of their ability to reconstruct the world according to objectives which they had identified before it entered the war. Between 1939 and 1941 they had come to the conclusion that the war was going to end with the U.S. in a position of global domination.[6] The question was: 'How do we organise the world?' Essential to that planned for new world organisation was the conviction that there should be no fundamental changes, no redistribution of income and power, no modification of the basic structures of and within the U.S. It was the world that had to be reconstructed, not the U.S., changed so that a certain kind of business – a certain kind of national bourgeoisie – could operate and profit without restriction wherever it needed to. What was required was a world of politically reliable, stable, conservative and subservient capitalist nations and free access to their markets and raw materials. In geographical terms the minimum necessary 'Grand Area' – as it was referred to – included the entire Western Hemisphere, the British Empire and the Commonwealth, the Far East, China and Japan.

However, neither Congress nor Joe Public were likely to endorse or pay for such an expansionist and interventionist foreign policy unless they could be persuaded that the war was not yet fought and won. They were persuaded of this in 1947 when Britain's withdrawal of financial and military aid to Greece presented President Truman and his advisers with an opportunity they could not afford to miss. The Truman Administration realised that here was the basis for consolidating U.S. power in the Middle East and for mobilising Congressional and public support for an expansionist foreign policy. Initially the problem was articulated as a need to prevent Greece going Left. The U.S. were committed to intervene to prevent the defeat of the fascist government there. In a larger context, however, the problem of the British withdrawal was regarded as a crisis in the world economy and a test of the U.S. ability to cope with it. The Soviet Union was not an originator of these conditions nor was it a protagonist in Greece. Stalin was well aware that Greece was an area central to U.S. power. The Russians had no role to play there.

On 12 March 1947 President Truman went before a joint session of Congress and delivered his 'Doctrine'. Truman appealed for financial and military aid for Greece, a country devastated by the Germans and threatened still further by Communist-led terrorist attacks along its borders with Albania, Bulgaria, and Yugoslavia. He conceded that the Greek government was not perfect, but maintained that it needed the support of the U.S. if Greece was to become a self-supporting democracy and survive as a free nation. He also argued that Greece's neighbour Turkey needed U.S. aid so that it could continue the 'modernisation' of its national integrity which was essential for preserving order in the Middle East. Truman asserted that if Greece fell to the Communists the

effect on Turkey would be immediate and serious. Confusion and disorder would spread through the Middle East and the effect of this would be far reaching for the West. This being the case, Truman continued, it had to be U.S. policy to support free peoples everywhere and at any time to maintain their free institutions and national sovereignty against aggressive movements whether armed minorities within a country or external pressures that sought to impose their totalitarian regimes. Poland, Rumania, and Bulgaria were given as examples. Finally, Truman requested that Congress appropriate $400 millions for aid and stressed that though he did not intend to send troops to the Middle East there was a need for military and civilian personnel to be sent to help administer and offer advice. He got everything he asked for.[7]

The importance of the Truman Doctrine to U.S. foreign policy cannot be overestimated. With it the U.S. replaced Britain as the economic and strategic power in the Middle East, and more than that. For the purposes of this paper the most important thing about it – and Noam Chomsky pointed this out in a lecture he gave at the Polytechnic of Central London in 1981 – is what a 'marvellous device' the Cold War was 'for mobilising the domestic population in support of the aggressive and interventionalist policies of America's ruling class under the threat of a super power enemy'.[8] The rhetoric of the Truman Doctrine and the idea of the Cold War obfuscates the fact that ruling class interest was the main determination of the move which the U.S. made from traditional expansionism to imperialism after the Second World War. Chomsky's mention of 'America's ruling class' was, for me, his talk's moment of blindness and insight. Insight because it so clearly tied an idea of class to the Truman Doctrine. Blindness because Chomsky gave little indication of what, or who, 'America's ruling class' was. It was too bloc-like; it needed fractionalising; and those fractions had to be understood as functioning in allegiance with other class fractions; and all those fractions had to be understood as engaged in a struggle – class struggle – in and through which they would achieve political and cultural representation.

In several books published between 1967 and 1979, G. W. Domhoff was at pains to describe and document the existence in the U.S. of a national social upper class of businessmen and their descendants that came into existence in the late nineteenth century as owners of the means of production that was held together by such institutions as stock ownership, trust funds, intermarriages, private schools, exclusive clubs and resorts.[9] It makes up less than one per cent of the population and owns or controls – or did so until quite recently – not only the major corporations and banks, etc., which dominate the U.S. economy, but also the foundations and universities, the largest of the mass media, major policy-making and opinion-forming organisations, the executive branch of government, the regulating agencies, the federal judiciary, the military, the C.I.A., and the F.B.I. To all extents and purposes Domhoff's object of study was the processes of ruling class domination within the U.S. As far as I am aware, however, he never made it clear – though he provided the evidence for doing so – that at any moment in its history the class which controls the State and the cultural apparatus is but one

fraction of that social upper class he so fully documented. He knows the class is fractionalised but he does not realise the importance of this for answering the kinds of questions he is interested in asking – questions like 'Who Rules America?' or 'Who are The Powers That Be at any historically specific moment?'

Not surprisingly – inevitably – the fractions are based on antagonisms, the most important of which are clashes between different business interests or different kinds of capital. To make this point Domhoff uses an observation of C. Wright Mills:

> In the higher circles of business and its associations, there has long been a
> tension, for example, between the 'old guard' of practical conservatives and the
> 'business liberals', or sophisticated conservatives. What the 'old guard' represents
> is the outlook, if not always the intelligent interests, of the more narrow
> economic concerns. What the 'business liberals' represent is the outlook and
> interests of the newer propertied class as a whole. They are 'sophisticated'
> because they are more flexible in adjusting to such political facts of life as the
> New Deal and big labour, because they have taken over and used the dominant
> liberal rhetoric for their own purposes, and because they have, in general,
> attempted to get on top of, or even slightly ahead of, the trend of these
> developments rather than to fight it as the practical conservatives are wont to
> do.[10]

I have my quibbles with this and they are obvious enough. But it is a useful observation.

The 'old guard' are the nationally oriented businessmen whose associations are the National Association of Manufacturers, the Chamber of Commerce of the United States, the American Enterprise Institute, and the American Security Council, and generally they are right-wing Republicans. The 'old guard' tends towards 'America First' isolationism, the flag propped up by guns, self-sufficiency in terms of production and consumption, circulation and exchange, and expansion but only in the Western Hemisphere. The 'business liberals' are internationalists, committed to an 'Open Door' policy. Primarily East Coasters, their main concern is with making money and keeping it on a grand scale through investment and trade that covers the world. They operate through their own policy-making institutions such as the Council on Foreign Relations, the Council on Economic Development, the Business Advisory Council, the Democratic Party and the moderate wing of the Republican Party. The key fractional conflict between the 'old guard' and the 'business liberals' was articulated over foreign policy, between nationalism and internationalism.

The image of the U.S. during the period from the end of the First World War to its entry into the Second World War is one of isolationism. It begins, I suppose, when Congress, vetoing an overtly activist foreign policy, rejected unqualified membership of the League of Nations and, thereafter, moved further into isolationism and nationalism when the Depression hit in 1929. It is possible to exaggerate this, but the clear contrast

with the period following the outbreak of the War in 1939 points to a difference between those who held State power in the 1920s and 1930s and those who came to hold that power at the end of the 1930s and to exercise it in the 1940s. Before the War it was held by the 'old guard' nationalists. After the War it was held by those who needed to get their finance capital out and about in the world and by those who had most to gain by avoiding crises in their expanding industries by an expansionist and interventionist foreign policy, the 'business liberal' internationalists.[11]

The 'business liberals' struggled for ruling class power during the 1920s and 1930s but it was not until they gained control over foreign policy formulation and implementation between 1939 and 1941 (the moment can be dated very accurately) that they achieved that power. In a sense the Truman Doctrine marked the consolidation of the 'business liberals' achieving power at home (in the modern period foreign policy determines domestic policy) and inaugurated the implementation of its aims abroad. Truman may have spoken his tenets in the name of the American people but his Doctrine was delivered very much on behalf of that fraction – the ruling fraction – of the national bourgeoisie whose political and economic interests he and his administration represented. And having achieved their desired power the 'business liberals' then had to defend it and struggle to retain it at home and abroad.

The class struggle between the ruling 'business liberals' and the 'old guard' was most publicly carried on in the private institutions of the cultural apparatus. Here, the State Power, legal and political, controlled by the 'business liberals' could be effectively used against it by the 'old guard'.

Louis Althusser, philosophising about ideology and the State, got this much right when he wrote that:

> No class can hold State power over a long period without at the same time
> exercising its hegemony over and in the State Ideological Apparatuses... This last
> comment puts us in a position to understand that the Ideological State
> Apparatuses may be not only the *stake*, but also the *site* of class struggle, and
> often of bitter forms of class struggle.[12]

This, I suggest, is how we should understand the various attacks made on modernist art between 1946 and 1956. They have to be seen as an aspect of the class fractional struggle within that bit of the U.S. national bourgeoisie which owned the means of production, as incidents fought out using the rhetoric of the Cold War: the 'business liberal' internationalists being, as it were, *for* modernist art; the 'old guard' nationalists being, as it were, *against* it.

The first site of this particular struggle seems to have been the exhibition of seventy-nine paintings which the State Department purchased to tour Europe and Latin America in 1947, *Advancing American Art*.[13] This exhibition included work by Walt Kuhn, John Marin, Max Weber, William Gropper, Ben Zion, Ben Shahn, Stuart Davis, Yasuo Kuniyoshi, Adolph Gottlieb, William Baziotes, and Jack Levine. It was attacked in the

pages of the *New York Journal-American* and the other seventeen daily papers owned by the 'old guard' nationalist Randolph Hearst. *The New York Journal-American* referred to it as a 'Red Art Show', and pointed to 'left-wing painters' like Davis, Gropper, and Zion and others who were said to be members of Communist-front organisations.[14] The show was made up of the work of a 'lunatic fringe' and concentrated 'with biased frenzy' on what was 'incomprehensible, ugly, or absurd'.[15] It was also attacked by various groups like the National Academy of Design, Allied Artists, the Salgamundi Club, the Society of Illustrators, and the American Artists Professional League. The criticism of the American Artists Professional League was typical: 'the exhibition devalued all that was noble in art, was one sided, and was influenced by radical European trends not indigenous to our soil'.[16]

The State Department, under scrutiny from Congressional appropriation committees and worried about the future of the Office of Information and Cultural Affairs, capitulated, cancelled the exhibition, and recalled it from abroad. What happened with *Advancing American Art* seems to have set the pattern, strategy and language used in subsequent struggles with and against modern art. Later, after the United States Information Agency had been formed and had started sending art abroad in the 1950s, criticism that modern art was un-American, Communistic, and lunatic was usual. Of course, some of the exhibitors were or had been members of the Party, were Jewish, or had oriental names, but anti-Communism, anti-Semitism and racism characterised both fractions of the national ruling bourgeoisie and the various fractions of the proletariat. The real issue obscured by this was which class fraction of the national bourgeoisie was going to advance the idea of American modern art abroad and at home.

The leading spokesman of the 'old guard', nationalist position on modern art was Congressman George Dondero, the Republican representative for Michigan's 17th Congressional District.[17] Dondero entered Congress in 1932 opposed to Roosevelt's domestic and foreign policy. Under Truman he developed into an outspoken anti-Communist. He seems to have become interested in art during the struggles over *Advancing American Art* in 1947-8. In 1953, after the Republican victories, he was appointed Chairman of the House Committee on Public Works. He retired in 1956. The kind of social history of art which makes its case with Dondero usually does so with reference to only four speeches, all made in the House of Representatives in 1949, followed up by a sometimes quoted interview reported in *Harper's Magazine* (this was an unfriendly interview in an important 'business liberal' owned magazine; it is, of course, a Harper & Row publication).[18] The speech of 16 August 1949 is favoured, the one that has in it the passage that goes like this:

> All these isms are of foreign origin, and truly should have no place in American art. While not all are media of social or political protest, all are instruments and weapons of destruction. [...] Cubism aims to destroy by designed disorder. Futurism aims to destroy by the machine myth. [...] Dadaism aims to destroy by

> ridicule. Expressionism aims to destroy by aping the primitive and insane. [...]
> Abstraction aims to destroy by the creation of brainstorms. Surrealism aims to
> destroy by the denial of reason [...][19]

Dondero knew his modernism. The 'isms' and the chronology he used were surely appropriated from the art historical tradition mapped by the museum which was one of his major targets, the Museum of Modern Art, New York. But, if I am right, this attack went beyond the museum to those who owned it and whose interests in culture it represented; a hint is there in a reference – it comes near the beginning of the speech – to 'those who are now in the big money, and who want to remain in the big money', who are *confusing* 'the legitimate artist', *disarming* 'the arousing academician', and *fooling* 'the public'.[20] 'Those who are now in the big money'? These persons are surely not the artists or the museum directors and curators.

In 1950 the directors of the MoMA, N.Y., the Institute of Contemporary Art (previously the Museum of Modern Art), Boston, and the Whitney Museum of American Art, N.Y., put out a joint response to Dondero's attack.

> We ... reject the assumption that art which is esthetically an innovation must
> somehow be socially or politically subversive, and therefore unAmerican. We
> deplore the reckless and ignorant use of political or moral terms in attacking
> modern art. We recall that the Nazis ... and ... the Soviets suppressed modern art
> ... and that Nazi officials insisted and Soviet officials still insist upon a hackneyed
> realism saturated with nationalistic propaganda.[21]

In December 1952, *The New York Times Magazine* published 'Is Modern Art Communistic?' by Alfred H. Barr Jr., Director of Collections at the MoMA, N.Y. This was a delayed and rather weak response to attacks on modern art in New York and Los Angeles in 1951 and to a speech made by Dondero in the House in 1952. Barr concludes:

> It is obvious that those who equate modern art with totalitarianism are ignorant
> of the facts ... Those who assert or imply that modern art is a subversive
> instrument of the Kremlin are guilty of fantastic falsehood.[22]

For many persons Dondero's speeches offered appealing slogans. His constituency extended far beyond Michigan's 17th District. Disregarding consideration of who that constituency was – though it has been hinted at – Dondero's attack on modernism and Communism, as with Joseph McCarthy's broader attack, masked the real issue being contested which was the struggle for class power between the nationalists and the internationalists.[23] Dondero's attack on modernism must be seen as but an aspect of this broader struggle. What he was doing was attacking the fraction whose systems of beliefs, values, images and techniques of representation – whose ideologies – were

represented in the cultural apparatus by modernist art and by the claims that were made for it by, for example, Alfred H. Barr Jr.

I want to look at one more struggle in the cultural apparatus and how it can be understood as having been determined by the class struggle on which I have been insisting. It is another favourite example of the Social History of Art that is concerned with this period. In 1956 an exhibition organised by the magazine *Sports Illustrated* titled *Sport in Art* was sponsored by the United States Information Agency to tour the U.S. and thereafter to travel to Australia during the Olympic Games which were being held there.[24] The show was assembled by the American Federation of Arts, and one of its destinations was the Dallas Museum of Art, Dallas, Texas. The Dallas Museum had been criticised locally for over-emphasising 'all phases of futuristic, modernistic, and non-objective [art] ... [and for] promoting the work of artists with known communist affiliation to the neglect of ... many orthodox artists, some of them Texans, whose patriotism... has never been questioned'.[25] The terms are familiar enough. Four months before *Sport in Art* arrived in Texas some of the exhibited works had been attacked on the grounds that they were by artists accused of having been aligned with 'the Communist-Socialist international group of subversives'.[26] These works were Ben Shahn's drawing of a baseball game, Yasuo Kuniyoshi's skating scene, another skating scene by Leon Kroll, and a painting of a fisherman by William Zorach. The museum's trustees defended the show but failed to mollify the criticism of the Dallas County Patriotic Council, a group made up of sixteen organisations including the Dallas posts of the American Legion and the Veterans of Foreign Wars. The exhibition went on show. The Patriotic Council had to be content with picketing outside and inside. Evidently persons were allowed to stand beside the pictures in question to warn the public that these were works by 'Reds'.

Sport in Art was a 'business liberal' affair. *Sports Illustrated*, the magazine which instigated it 'to cultivate the periphery of [its] field through publicity', was a Time Inc. publication owned by Henry Luce and backed by many well-known members of the Eastern side of the 'business liberal' fraction, including representatives of Morgan and Rockefeller interest groups. Luce's wife, Clare Booth, was not only U.S. ambassador to Italy but also a trustee of the MoMA, N.Y. The Dallas Museum's trustees were led by Stanley Marcus, an important Texas 'business liberal', head of the big store Niemans-Marcus – which co-sponsored *Sport in Art* at the museum – and soon to become a member of the International Council at the MoMA, N.Y. It is a relatively straightforward matter, then, to identify those who were responsible for *Sport in Art* with a particular fraction of the ruling class. It is not so easy to do this with those who, in Dallas, protested against it.[28] As a group, they cannot be obviously and directly linked, as I linked those persons who protested *Advancing American Art*, to a key individual member of the nationalist isolationist fraction. It would be useful to know who owned the *Dallas Morning News* which closely followed the controversy (and may have effected it). At this stage, I would like to eliminate Harold Lafayette Hunt from my

enquiries. A footnote in Jane de Hart Matthews's essay 'Art and Politics in Cold War America' directs us to him via an article in *Art News*.[29] I do not need Hunt to make the case, but he would be detail to make it with because he was a very important Texas new-monied nationalist, an oil millionaire who financed McCarthy, and no friend of the 'business liberal' internationalists.[30]

The activities of the Communism in Art Committee of the Dallas Patriotic Council reverberated across the federation to Washington and forced the USIA to back out of sending *Sport in Art* abroad. *The New York Times* reported the decision on 21 June: 'The agency declined to comment today on the reasons for its stand on art matters ... The problem has been extremely troubling for officials of the USIA, including Theodore Streibert, its Director.' *Sport in Art* was Streibert's third problem with 'subversive art' in 1956. Objections had been raised about an exhibition put together from U.S. university and college collections which was to travel abroad, because it contained a picture by Picasso who was a member of the French Communist Party. The Picasso problem had been solved but another plan to send abroad 100 twentieth-century American paintings to Europe had to be dropped because the American Federation of Arts who put the package together refused to allow the artists to be vetted for their political beliefs, or to remove works by ten 'social hazards'.[31] Almost immediately Streibert appeared before a Senate Foreign Relations Sub-Committee chaired by Senator J. William Fulbright (another member of the International Council at the MoMA, N.Y.) to explain the cancellations. Streibert stated that the USIA had 'a policy against the use of paintings by politically suspect artists in its foreign art shows' but refused to comment on reports 'that the cancellations were made because of charges of pro-Communism against some of the artists represented'. After the hearing Fulbright commented that he thought that art should be judged 'on its merits'; that he was not clear how the USIA could test the loyalty of artists; that 'looking into their political beliefs' was 'really an impossible task'; and that unless the agency changed its policy 'it should not try to send any more exhibitions overseas'.[32] The USIA did not change its policy; and it did not send any exhibitions of modern art overseas for quite a while. That job was taken over by the International Council at the MoMA, N.Y.,[33] that is to say by the institution which by the mid-1950s was recognised as the international centre of collecting, exhibiting and disseminating knowledge of modernist art owned, as all social historians of art know, by the Rockefellers and Whitneys, key members of the United States ruling class at that moment.

In this 1946-56 Cold War the Abstract Expressionists are conspicuous not by their presence but by their absence. They are not absent presences. *They were absent.* Those artists who figured in the cancelled *Advancing American Art* were not Abstract Expressionists, or were not yet Abstract Expressionists. Were there any Abstract Expressionists, Action Painters, 'American-Type' Painters, or New American Painters in 1946? And none of those shown in *Sport in Art* ten years later were Abstract Expressionists either. That is hardly surprising. The Abstract Expressionists were not

interested in representing or expressing sport in art. Well, maybe de Kooning's *Woman and Bicycle* of 1952-3 could have been included; but the point is that it was not.

Dondero was not interested in Abstract Expressionism or the Abstract Expressionists. And Jackson Pollock was beyond paying the slightest attention when, in 1959, Congressman Francis Walter claimed that he was one of 34 of the 67 artists in a USIA exhibition of that year who had 'affiliations with Communist causes'.[34]

Sure, Abstract Expressionism belonged to the MoMA, N.Y., to its collections and to the tradition it helped establish as the history of modern art. The MoMA, N.Y., got onto it very quickly. And it always included Abstract Expressionism when it sent its selections of the best of contemporary American art to the São Paulo and Venice Biennales of the 1940s and 1950s, although it never sent Abstract Expressionism abroad unchaperoned until the posthumous *Jackson Pollock* retrospective of 1956. But it did this sending as a private institution not accountable to Congress in the way the Office of Information and Cultural Affairs or the USIA were. And this was the way the 'business liberals' preferred it. And it was the MoMA, N.Y., that sent *The New American Painting* abroad to tour Europe in 1958, and brought it home as the *Triumph of American Painting*, as the most up to the moment movement in its international history of modern art.[35] Maybe we can talk of Abstract Expressionism's belonging to the Cold War at this point, but only, I suggest, if we pose the problem of its belonging in terms of how the MoMA, N.Y., created a tradition for modern art and situated Abstract Expressionism within that tradition at the moment when the fraction of the U.S. ruling class which owned the museum made its move to win and secure hegemony in a world market more or less of its own devising. It is not my intention to consider this here.

Of course, the Abstract Expressionists knew about the Cold War and its effects. 'Marvellous device' it may have been, but its effects were real enough. What did David Caute tell us?[36] Some 9,500 federal civil servants were dismissed; 15,000 federal civil servants resigned while under investigation; 3,800 seamen were fired; 600 teachers were dismissed; over 300 persons were blacklisted in movies, television and radio; 500 state and municipal employees were dismissed; and some 500 people were arrested for deportation because of their political convictions. The number of scientists and university teachers who lost their jobs ran into hundreds. And then, in case we forget, there were the executions of Julius and Ethel Rosenberg. Beside that the suppression and coercion of artists, the censoring of murals, and the cancellation of art exhibitions might seem small beer.

Art News regularly commented on these matters in its editorials. But, somehow, the Abstract Expressionists were beyond all this. What they did was peripheral to it; and at the periphery they were to become central to the modernist tradition which was always an international tradition in art. As the self-professed avant-garde they situated themselves *in* their paintings and *in* their practice beyond the class struggle. Whichever story you prefer – Rosenberg's or Greenberg's[37] – it is a narrative of non-involvement in the class struggle. But ideologically removed from it, they were, nevertheless, related to

it by – to appropriate a phrase of Greenberg's from 'Avant-Garde and Kitsch' – the umbilical cord of gold that attached them to the ruling class fraction of the national bourgeoisie and helped sustain their basic needs and their desires either 'just **TO PAINT**' or to develop 'the history of avant-garde painting [which] is that of a progressive surrender to the resistance of its medium'.

Whichever story you think their collective art practice best illustrates and whatever their paintings looked like, both the artists and their paintings were put to use by those persons and institutions that appropriated them: the 'business liberals' who desired a modernised American art on the international model established by Europe. And those future uses or future contexts must have been imagined by the Abstract Expressionists and must have determined, to some extent, how and even what they painted. In other words, one determination of Abstract Expressionism must have been an imagined use or misuse of it by the 'business liberals' in their struggle for power at home and abroad. After all, the Abstract Expressionists were not political simpletons; many of them were or had been 'Marxists', had been members of Works Progress Administration unions and artists' congresses. They knew who bought their art and took it travelling.

Notes

1. On Advancing American Art see William Hauptman, 'The Suppression of Art in the McCarthy Decade', *Artforum*, vol. 12, October 1973, pp. 48-52; Jane de Hart Matthews, 'Art and Politics in Cold War America', *American Historical Review*, vol. 81, October 1976, pp. 762-87; and especially Taylor D. Littleton and Maltby Sykes, *Advancing American Art: Painting, Politics, and Cultural Confrontation at Mid-Century*, Tuscaloosa and London: The University of Alabama Press, 1989 (introduction by Leon F. Litwack).
This is the text of my paper 'Abstract Expressionism: Weapon of the Cold Taste War' presented at the Tate Gallery, Liverpool during the showing of an exhibition titled *Myth Making: Abstract Expressionist Painting from the United States*, 10 March 1992-10 January 1993. It has been only slightly modified for inclusion in this collection and is really published as work-in-progress.
2. See T. J. Clark, 'In Defence of Abstract Expressionism', unpublished paper, *XXVIII International Congress of the History of Art*, Berlin, 1992, for some of the kinds of questions still most worth asking of Abstract Expressionist paintings.
3. Ibid.
4. For 'red fascism' see Les K. Adler and Thomas G. Peterson, 'Red Fascism: The Merger of Nazi Germany and Soviet Russia in the American Image of Totalitarianism, 1930s-1950s', *American Historical Review*, vol. 75, April 1977, pp. 1046-64.
5. The literature on the Cold War is enormous. To my mind the basic books are still Gabriel Kolko, *The Roots of American Foreign Policy*, Boston: Beacon Press, 1969 and Joyce Kolko and Gabriel Kolko, *The Limits of Power: the World and United States Foreign Policy, 1945-1954*, New York: Harper & Row, 1972. For a very interesting essay-length discussion see Mick Cox 'The Cold War as a System', *Critique 17: A Journal of Socialist Theory*, 1986, pp. 17-82.
6. See the rich detail in Lawrence H. Shoup and William Minter, *Imperial Brains Trust*, New York and London: Monthly Review Press, 1977, an extended study of the work of the Council on Foreign Relations and United States foreign policy.
7. See J. Kolko and G. Kolko, *The Limits of Power*, Chapter 12, 'The 1947 Crisis: The Truman Doctrine and American Globalism'. See also Lawrence H. Shoup and William Minter, *Imperial Brains Trust*, Chapter 4, 'Shaping a New World Order: The Council's Blueprint for World Hegemony, 1939-1975'.
8. An edited and shortened transcript of Noam Chomsky's talk was published as 'The cold war is a device by which superpowers control their own domains. That is why it will continue' in the *Guardian*, 15 June 1981, p. 7.
9. Domhoff's books include: *Who Rules America?*, Englewood Cliffs, N.J.: Prentice Hall, 1967; *The Higher Circles*, N.Y.: Random House, 1970; *Fat Cats and Democrats*, Englewood Cliffs, N.J.: Prentice Hall, 1972; *The Bohemian Grove and Other Retreats*, N.Y.: Harper and Row, 1974; and *The Powers That Be: Processes of Ruling Class Domination in America*, N.Y.: Random House, 1978. *Who Rules America?* and *The Powers That Be* proved the most useful for thinking

about the character of the United States ruling class. In *Who Rules America?* Domhoff presented evidence for the existence, in the United States, of a 'social upper class' of rich businessmen and their descendants. His aim was to develop the work of E. Digby Baltzell, C. Wright Mills, Paul Sweezy, and R. Dahl to show that the 'national upper social class' was a 'governing class'. The weakness of this work is, as Domhoff indicates, that it is 'beholden to no theory about the dynamics of history or the structure of society'. Nevertheless, his definition of a 'governing class' as a 'social class which owns a disproportionate amount of the country's yearly income, and contributes a disproportionate number of its members to the controlling institutions and key decision making groups in the country' is compatible with a Marxist definition of capitalism's ruling class as the social class that owns the means of production, exercises state power and controls all aspects of social life. In *The Powers That Be* Domhoff referred to his seminal work as providing 'a description of the sociological structure of the ruling class', 'the clearly demarcated social class which has "power" over the government (state apparatus) and the underlying population in a given nation (state)'. However, Domhoff does not make it clear that at any particular moment the United States ruling class is but one fraction of the national socio-economic class of possessors that he so fully documents.

10. C. Wright Mills, *The Power Elite*, New York: Oxford University Press, 1956, p. 122, quoted in Domhoff *Who Rules America?*, pp. 28-9.

11. See Lawrence H. Shoup and William Minter, *Imperial Brains Trust*, Chapter 1, 'A Brief History of the Council' for the role of the Council on Foreign Relations in this move to power.

12. Louis Althusser, 'Ideology and Ideological State Apparatuses: Notes Towards an Investigation' (1971) in *Lenin and Philosophy and other Essays*, London: New Left Books, 1971, pp. 39-40.

13. On *Advancing American Art* see William Hauptman, 'The Suppression of Art in the McCarthy Decade'; Jane de Hart Matthews, 'Art and Politics in Cold War America'; and D. Taylor Littleton and Maltby Sykes, *Advancing American Art: Painting, Politics and Cultural Confrontation at Mid Century*.

14. See Littlejohn and Sykes, p. 26.

15. Ibid., p. 27.

16. Open letter to Secretary of State James F. Byrnes published in *Art Digest*, vol. 21, 1946, pp. 32-3, quoted in Matthews, 'Art and Politics in Cold War America', p. 777; and in Littleton and Sykes, *Advancing American Art*, p. 29.

17. On George Dondero see Donald Drew Egbert, *Socialism and American Art in the Light of European Utopianism, Marxism and Anarchism*, Princeton, N.J.: Princeton University Press, 1967, p. 125 and pp. 132-3; William Hauptman, 'The Suppression of Art in the McCarthy Decade', pp. 48-9; and Jane de Hart Matthews, 'Art and Politics in Cold War America', pp. 772-3, 775-6.

18. For lists of Dondero's speeches see Egbert, p. 125, note 238; and Matthews, p. 773, note 43. See also Emily Genauer, 'Still Life with Red Herring', *Harpers Magazine*, no. 199, 1949, p. 89. The two most important speeches of 1949 – 'Communists Manoeuvre to Control Art in the United States' and 'Modern Art Shackled to Communism' – are reprinted in Charles Harrison and Paul Wood (eds.), *Art in Theory 1900-1990: An Anthology of Changing Ideas*, Oxford: Blackwell, 1992, pp. 654-8.

19. See Dondero's speech 'Modern Art Shackled to Communism', United States House of Representatives, 16 August, 1949 in Harrison and Wood, *Art in Theory 1900-1990*, p. 657.

20. See Dondero's speech 'Modern Art Shackled to Communism'. Harrison and Wood omit this paragraph which can be found in Hershel B. Chipp, *Theories of Modern Art: A Source Book by Artists and Critics*, University of California Press, 1968, p. 496.

21. See Donald Drew Egbert, *Socialism and American Art*, p. 125, note 238.

22. See Alfred H. Barr Jr., 'Is Modern Art Communistic?', *New York Sunday Times Magazine*, 14 December 1952, pp. 22-3, 28-30.

23. G. W. Domhoff, *Who Rules America?*, p. 75-6, citing Hobart Rowan, *The Free Enterprisers*, New York: Putnam, 1964 p. 77, points out that 'The incident which triggered McCarthy's censure … was his high handed treatment of yet another member of the power elite [that is to say, the 'business liberal' power elite], corporate leader Robert T. Stevens of Andover, Yale, J.P. Stevens & Company, General Electric, and Morgan Guaranty Trust [who] was serving as a Secretary of the Army when embarrassed by McCarthy on nationwide television: "During the May 1954 meeting at Homestead, Stevens flew down from Washington for a weekend reprieve from his televised torture. A special delegation of Business Advisory Council officials made it a point to journey from the hotel to the mountaintop airport to greet Stevens. He was escorted into the lobby like a conquering hero. Then, publicly, one member of the BAC after another roasted the Eisenhower Administration for its McCarthy-appeasement policy. The BAC's attitude gave the Administration some courage and shortly thereafter former senator Ralph Flanders (a Republican and BAC member) introduced a Senate resolution calling for censure."'

24. On *Sport in Art* see Donald Drew Egbert, *Socialism and American Art*, p. 134; William Hauptman, 'The Suppression of Art in the McCarthy Decade', pp. 50-1; Eva Cockcroft, 'Abstract Expressionism, Weapon of the Cold War', *Artforum*, June 1974, pp. 40-1; and Jane de Hart Matthews, 'Art and Politics in Cold War America', pp. 769-70.

25. Resolution of the Public Affairs Luncheon Club, 15 March 1955, quoted in part by Hauptman, p. 50.

26. See Egbert, p. 134.

27. See Matthews, p. 770.

28. Matthews gives some names including that of Alvin Owsley – also noted by Hauptman – who 'had begun compiling his own directory in 1921, which, with names from the annual reports of the House Un-American Activities Committee and congressional speeches, constituted a formidable list of "subversives" against which local citizens could check the names of writers, composers, actors, and artists that appeared in local newspapers and museum catalogs'. Matthews also notes Colonel John Mayo, B.I.F. McCain – also a Legionnaire and past President of the Dallas Chamber of Commerce – and Riveau Basset, a local resident and traditional artist.

29. See Matthews, pp. 768-9.

30. For the moment H. L. Hunt must remain a circumstantial representative of the class fraction that owned some of the means of production in Dallas which was known to be opposed to the 'business liberal' internationalists. In 1953 *Look* magazine in its feature 'The Ring Around McCarthy' named him as one of the three Texan oil millionaires who were backing McCarthy. As founder of 'Facts Forum', an ultra-conservative radio and television station programme with hundreds of local outlets, he used McCarthy as a featured speaker, and distributed copies of *McCarthyism: The Fight for America* to interested listeners. He also published the *American National Research Report* which named Communist and Communist-front organisations and described their activities. Glimpses of H. L. Hunt can be had in Richard M. Fried, *Men Against McCarthy*, New York: Columbia University Press, 1976, p. 277; David M. Oshinsky, *A Conspiracy So Immense: The World of Joe McCarthy*, London and New York: The Free Press, 1983, pp. 301, 302-3; and Thomas C. Reeves, *Freedom and the Foundation: The Fund for the Republic in the Era of McCarthyism*, New York: Alfred A. Knopff, 1969, p. 64.

31. The cancellations were reported by Anthony Lewis in an item headed 'Red Issue Blocks Europe Art Tour. U.S. Information Unit Fears 10 Painters in Show May Be Pro-Communist. Action Called A Fiasco', *New York Times*, 21 June 21 1956, p. 33.

32. See 'Exhibits Ban Works Of Accused Artists', *New York Times*, 28 June 1956, p. 21.

33. See the report by Stuart Preston, 'To Help Our Art. Council Will Circulate Exhibitions Abroad', *New York Times*, 30 December 1956, X, p. 15, which announced the foundation of 'The International Council at the Museum of Modern Art' which planned to take over the museum's international programme in July 1957. Its purpose was summed up by its President Mrs John D. Rockefeller III in this way: 'Our plans call for financing a program, response to which clearly demonstrates the need not only for its continuation but also for its expansion. Despite the valuable activities being carried out by the United States Government, and through it other private and public organisations receiving Government grants, we feel that in accordance with American traditions a large share in the initiative for patronage of the arts and for sending exhibitions abroad should be the responsibility of privately sponsored organisations.' Preston pointed out that 'No longer simply a museum activity, the Council, whose first aim is fund raising, will endeavour to make its contribution a thoroughly national one and to employ the talents of specialists the country wide. Some of the immediate projects which the Council is taking over financially are United States participation in three major international art exhibitions and a show of modern painting to travel in Europe.' See also the *New York Times*, 16 December 1956, p. 53, and 28 December, p. 20.

34. See David Craven, '*Myth-Making in the McCarthy Period*', *Myth-Making: Abstract Expressionist Painting from the United States*, Tate Gallery, Liverpool, 1992, p. 7, p. 42, note 4. Craven does not point out that Pollock had been dead for three years and that, rather than 'late', the attack was somewhat belated.

35. It is often overlooked that it was Alfred H. Barr Jr., and not Irving Sandler, who first wrote about Abstract Expressionism as the 'triumph' of American painting. Note the last paragraph of his 'Introduction' to the catalogue of *The New American Painting* organised by the International Program of the Museum of Modern Art, New York under the auspices of the International Council at the Museum of Modern Art, New York 1958-9: 'To have written a few words of introduction to this exhibition is an honour for an American who has watched with deep excitement and pride the development of the artists here represented, their long struggle – with themselves even more than their public – and their present triumph.'

36. See David Caute, *The Great Fear: The Anti-Communist Purge Under Truman and Eisenhower*, London: Secker and Warburg, 1978.

37. See Harold Rosenberg, 'The American Action Painters', *Art News*, vol. 51, no. 8, December, 1952, pp. 22-3, 48-50, reprinted in Harold Rosenberg (1982) *The Tradition of the New*, The University of Chicago: Phoenix Edition, 1982, pp. 23-39; and Clement Greenberg, ' "American-Type" Painting', *Partisan Review*, vol. XXII, 1955, pp. 179-96, reprinted in *Art and Culture: Critical Essays*, Boston: Beacon Press, 1961, pp. 208-29.

illing
MEN
and
dyin
WOM

**Woman's Touch in the
Cold Zone of American
Painting in the 1950s**

A Short Book in

Fig. 38
Lee Krasner, *Prophecy*, 1956.
Oil on cotton duck, 147.3 x 86.3cm.
Courtesy, Robert Miller Gallery
ARS, NY and DACS, London 1996

Fig. 39
Lee Krasner, *Sun Woman I*, 19
Oil on canvas, 247 x 178.4cm.
New York, Collection Placido /
ARS, NY and DACS, London 1996

Chapter 11

Killing Men and Dying Women

A Woman's Touch in the Cold Zone of
American Painting in the 1950s

A SHORT BOOK IN TEN CHAPTERS

GRISELDA POLLOCK

1. Some Word Play
or Gentlemen Prefer Blondes, They Say

2. The Year is 1953

3. Hot Lady in a Cold Zone

4. The Most Famous Living American Artist

5. Looking For Difference
or What Greenberg Did Not Say

6. Is the Gesture Male?
Disappearing the Mother into Symbol Or Capturing Her Absence in Space

7. Is the Artist Hysterical?

8. Massacred Women Don't Make Me Laugh

9. Inside Marilyn Monroe

10. Dancing Space
Lee Krasner – From Prophecy to Sun Woman

Preface

In 1956 the American painter Lee Krasner, an abstract painter since the 1930s, was unnerved when she produced a semi-figurative painting called *Prophecy* (fig. 38). The vast monstrosity that is Picasso's *Demoiselles d'Avignon* (1907, New York, Museum of Modern Art) out of de Kooning's *Woman* (fig. 56) has one eye, a displaced, but still red mouth. A sightless eye, incised by the end of the brush, as if in negative, hovers in the upper right-hand blackness that challenges and frames the ghastly pinkness of the hybrid forms.

> The image was there, and I had to let it out. I felt it at the time. Prophecy was fraught with foreboding. When I saw it, I was aware it was a frightening image.[1]

On 12 July 1956, Lee Krasner departed for a trip to Europe and a break from the worsening relations between herself and her husband, the painter Jackson Pollock. He had shared her unease about the painting, advising her to paint out the incised eye. She left *Prophecy*, however, on the easel, unchanged. Within a month she received a phone call informing her that Jackson Pollock had been killed in a car crash on 11 August. She returned to the States, the artist's executor and sole heir, responsible for the management of the estate of the 'most famous living American painter'. In the next eighteen months, Krasner's own work became the site of an important struggle for her own continuing artistic identity as Lee Krasner, now that, in her husband's permanent absence, she was, if not more than ever, captured and erased by her role as 'Mrs Jackson Pollock' – or rather, 'the widow of Jackson Pollock'.[2]

On her return to the U.S., Lee Krasner had to deal with *Prophecy*, 'I had to confront myself with this painting, again, and I went through a rough period in that confrontation'.[3] Out of this unexpected turn in her own work, Lee Krasner eventually produced a series of paintings, one of which, *Sun Woman I* (fig. 39), is the object of this

analysis here. How did Lee Krasner get to this painting? What are we seeing? The answer I shall propose is this: she got there by taking on the powerful artists whose avant-garde gambits and rivalry determined her corner of the contemporary art world: Pollock and de Kooning. So what's new?

In 'feminist interventions in art's histories', we have to confront the problem of how to 'see' what artists who are women produce. Their works come to us already 'framed' by existing art historical discourses that define the meaning of the period and practices within which the artists worked. Such frames can make the work perfectly invisible, and worse, illegible except as something lacking in relation to what the dominant discourse produces as the canon. Art historical discourse already inscribes its own privileging of the masculine in art as the norm, leaving us feminists to fit the women in, against the grain of what has been validated as the centre of the artistic moment. It is my contention that the artists who are women work across a doubled field. As ambitious painters shaped by the formation we call the avant-garde, they must negotiate the conditions of their own intervention just like any other. They must evolve their own gambits in the complex play of 'reference, deference, and difference'.[4] The resources from which they will inevitably draw to do so will include dimensions of social, cultural, psychic and even corporeal experience that is unacknowledged by a phallocentric culture. Such experience is not gendered in essence, but our minds, memories and bodily sensations are marked by the process that, in shaping our subjectivty, demands its submission to an always-already and yet constantly renegotiated law of sexual difference. How can this be spoken of without letting an interest in the difference – call it femininity – radically undermine our concern with the making of art? Why would femininity undermine the status of the art produced in dialogue with psychic or corporeal specificity? Because the very definition and cultural canonisation of what is art is itself shaped within the discursive production and perpetuation of current, phallocratic regimes of sexual difference. Art defined in contemporary discourse and its institutions is both an instance of the production of sexual difference, and a representation that serves its ideological perpetuation. Art history's stories of art are structurally sexist.

This paper is a lengthy footnote to this major feminist problem, probing the necessary relations between a woman who is an artist, her cultural moment and the discursive terms available for historical analysis and interpretation. In the 1950s, such a confrontation was framed through as rigid a sexual division and ideological polarisation of gender as we have seen since the mid-nineteenth century creation of the doctrine of separate spheres. The war against fascism and the post-war settlement under American hegemony, which produced the Cold War against so-called Red fascism, interrupted the historical struggle for a modernisation of sexual difference that had been the major impetus of the early twentiety century: what we can call the generation of 1928.[5] It was not until the revolt of the generation of 1968 that a revitalised feminist movement repoliticised this suspended question of gender that high modernist culture had disavowed and placed under cultural censorship while establishing an extreme return to

bourgeois notions of a totally segregated masculinity and femininity.

In the first decades of the twentieth century, modernism had offered some relief for modernising women from the nineteenth-century ideologies of sexual difference that had completely saturated woman as the sex: women's minds, bodies, emotions, and social status were determined for them by the culture's definition of women by the functions and dysfunctions of their sexual organs. Modernism seemed to offer women a fiction in which universals and absolutes could be pursued in freedom from the messy business of gender relations and this prisonhouse of sex. Women artists and writers embraced modernism as a liberation from the tyrannies of gender stereotypes, wanting to share in this chance, for instance, just to be an artist, not confined to being a woman artist, and to make art, not to be judged for making feminine art. Stalking their ambitions, however, was always the dread of being once again discovered to be a woman, to be classified as a 'woman artist' which really means no artist at all. The profound and impossible antagonism between the terms woman and artist, still unchanged within modernism even if publicly disavowed in the name of transcendent truths, played their disfiguring games in the 1940s, and especially the 1950s, in the United States in ways which did not, however, prevent two generations of artists who were women from sharing in the ambitious enterprise that was American abstract and gestural painting in those decades.

To do so they had to take a considerable risk. They had to stay near enough to the action to be part of it and grasp what was on offer. They had to make a space within which to make a difference, to make their own particular difference, which resulted from the whole complex of who each one of them was, while endlessly dodging the curatorial sniffing out of what would be deadly to their desires for recognition, the contaminating signs of a disqualifying 'femininity'. In this 'short book', I want to take the reader on a journey through the ideological thickets of the avant-garde moment as it played out in the 1950s in order to be able to 'see' one or two paintings by one artist, Lee Krasner. That journey will involve finding ways to understand how artists like her deeply admired their contemporaries as much as they fiercely competed with them. Rivalry, competition, envy, those transformations of what Melanie Klein took to be our most archaic emotions, can function critically to drive and sustain creative practices. Rather than collaborating with our culture's continuing ghettoisation of artists who are women as 'women artists', so absolutely different that they cannot belong, except in their own special compartment, as the others of the 1950s that liberal conscience obliges us now sometimes to mention in passing, at least, I want to mess with the historical moment of Abstract Expressionism by coming at it from a feminist perspective, and taking as my focal point some paintings by Lee Krasner. About them, in the end, I will have not have much to say. For I hope by then, they will start to look different, to become visible within a feminist vision, open to a different kind of debate. The idea is to create a different frame that acknowledges the play of difference so as to suggest how an artist like Lee Krasner dealt with the necessary, and inevitable, confrontation with the

powerful artistic figures who dominated the field in which she also wanted to be an acknowledged artistic presence. Did she do it by 'killing men'? Perhaps, for she certainly was not a 'dying woman'.

1
SOME WORD PLAY OR...
Gentlemen Prefer Blondes, They Say

Well, there you have it! At last the feminist is out in her true colours. *Killing men.* That's what you've always suspected about feminists: manhaters the lot of them! But with a little help from a French philosopher, Jacques Derrida, I invite you to reconsider what you are seeing when I write: *Killing Men and Dying Women.*

Killing men – this could imply someone is killing men: men are the object of homicidal attack. On the other hand, killing could be an adjective, qualifying the character of men, making them the active subject of violence: men who kill. Killing men are soldiers for instance, warriors in a cold war perhaps.

A similar undecidability nestles in the second phrase of the title: *dying women.* When spoken, it is a little exemplar of what Derrida called 'différance'. Dying could be heard to suggest that women are meeting their death. Women d-i-e. It could also refer to women changing the colour of something. Women d-y-e.

In the 1950s, what women dyed was their hair. And there was only one colour that signified dyeing because we all know that *Gentlemen Prefer Blondes.* In her cultural critique and autobiographical reflection on 'Blondes', Teresa Podlesney writes:

> Gentlemen prefer Blondes, but only if their roots don't show. I am determined to make mine visible.[6]

My project here is to track a moment in American culture of the 1950s – which was paradigmatic of modern culture internationally – when dying women met killing men and dying men had to be killed – metaphorically, in paint. It's a bit more of the story of the Cold War and its cultural politics. It features questions of gender and sexual difference, and deals with making a difference. One of the key actors is Marilyn Monroe, made stellar by Twentieth Century Fox's release in July 1953 of the film of Anita Loos's novella and Broadway play, *Gentlemen Prefer Blondes* (fig. 40). In the role of 'dumb blonde' gold-digger, Lorelei, Marilyn Monroe condensed a history of woman as image in the cinema within that decade's cinematic myth of femininity.[7] The other key character is the painter, Jackson Pollock – almost himself a method actor and, as a result

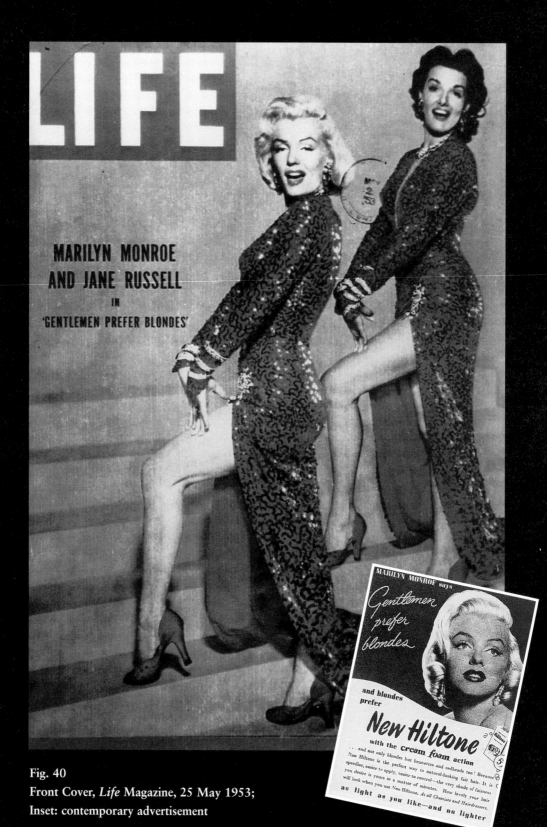

Fig. 40
Front Cover, *Life* Magazine, 25 May 1953;
Inset: contemporary advertisement

of some spectacular publicity and photography, the high art version of the masculinity Marlon Brando in his wildest role would project on screen.[8] Jackson Pollock was cast as symbol of modern, American masculinity.[9] Podlesney asks:

> Does the blonde, characterised as mere image, mere hair colour, make possible the emergence of the "real" man, the sensitive man of the 1950s. Because one half the screen is so obviously and transparently constructed, the other half, reflected, can be seen as "real", not constructed, "natural".[10]

The Actors' Studio – to which of course Marilyn Monroe went to in her desire to be recognised as a serious actor – set about naturalising the cultural image of the male. Julie Burchill writes:

> Masculinism started with the Method. The Method Actor looked at the Sex Doll and thought her empty and unworthy: he turned to the mirror and the other man.[11]

They look so different: Jackson and Marilyn (figs 41 & 42). Crude as such a juxtaposition is, it underlines the fact that the 1950s was a decade of extreme gender polarisation when the post-war American state attempted to put the genie back in the bottle by making all the Rosie the Riveters of the war years go home, bake brownies and live the suburban dream that Betty Friedan would expose in 1963 as a nightmare, the problem with no name: *the feminine mystique.*[12]

Yet, at another level, Marilyn and Jackson, icons of America in the 1950s, are disturbingly convergent. Both died unnecessary and tragic deaths: Jackson Pollock on 11 August 1956 at the age of 44 and Marilyn Monroe at the age of 36 on 4 August 1962. Both deaths created the absence of the subject in history that paradoxically made them the object of commercialising and academic myth. Both deaths have fuelled a fascination with a mythic identity that sudden mortality augmented.

Killing is what the culture does; dying is the fate of those who symbolise it. Yet I want to show the roots. I want to read an underside. I want to get inside the surface of the image where myth inserts itself. I want to destabilise these mythic images of masculinity and femininity in 1950s America. For this was also the moment of remarkable creative participation by a number of women in the legendary period of America's accession to cultural domination of modernism, when, as Serge Guilbaut has argued, New York stole the avant-garde.[13] How could you be a woman and an artist caught between the twin myths of gender and art embodied by the images of Monroe and Pollock? What account of female creativity could we salvage either from the heroic narratives of *The Triumph of American Painting*[14] or from the anti-mythical exposé of 'Abstract Expressionism as Weapon of the Cold War'?[15] What has gender to do with the cold war, the gesture, the flatness of the canvas?

First of all, many artist-women survived the decade, its art politics and its gender

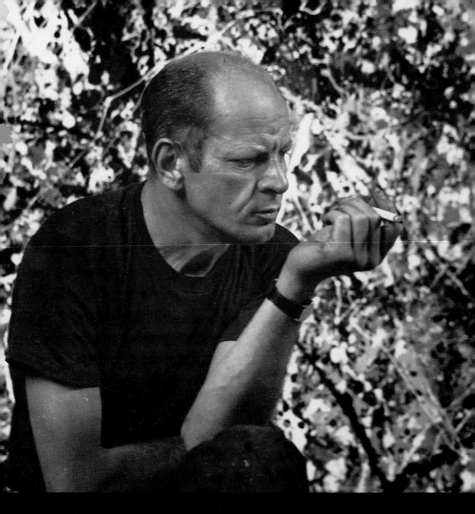

Fig. 41
Hans Namuth, *Jackson Pollock*, 1950.
Krasner House and Study Center,
East Hampton, N.Y.
© Estate of Hans Namuth Pollock

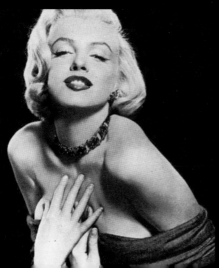

Fig. 42
Marilyn Monroe. Publicity Still, early 1950s

politics. Neither dyed nor dying. Lee Krasner lived into creative old age; born 1908, she died in 1984 at the age of 76. Helen Frankenthaler, born 1928, is still alive and working, as is Grace Hartigan, born 1922. Elaine de Kooning (1928-1989), Joan Mitchell (1926-1992), Louise Nevelson (1900-1988), Alma Thomas (1891-1978), lived into old age - but not really into history, canonisation, or myth (fig. 43). While we celebrate with unabashed adulation the modern masters such as Picasso or de Kooning who survived into untimely old age, there is no comparable discourse that accords such venerated status to the long-lived artist who is a woman. Until the re-emergence of the women's movement, these painters scandalously received but passing notice.[16] Such artists are but witnesses to, and survivors of, the contradictions between three none the less related terms: modernity, femininity and representation. As Nichola Bird asks in her recent project: what icons and images do women artists negotiate when they are *Dressed to Paint?* (fig. 44).[17]

Did they make it by killing men rather than becoming dying women? Is creativity a necessarily sadistic, even murderous activity? This is not, however, a feminist, manhating thought. I derive it from two thoroughly canonised modernists: Clement Greenberg and Georges Bataille.

In his 1940 essay, 'Towards a Newer Laocoon', in which he justified the logic of advanced art's relentless drive towards abstraction, Clement Greenberg rewrote the history of modern art with its current endpoint as predestined outcome. Assessing the nineteenth-century strategies which created modernism, Greenberg claimed that Manet had made the decisive break that would liberate painting from subject matter and literary dependence by attacking the subject matter painting inherited from its sister arts on its own terrain. In his transitional paintings of the 1860s, Greenberg saw Manet including the traditional subjects of Western art – the nude, historical or literary themes – but, according to Greenberg, Manet *exterminated* them, then and there, on the canvas.[18] Manet is posed as a modernist because he took on the freight of tradition that burdened his practice and killed it stone dead.

The idea of artistic advance through destruction, however, precedes Greenberg's formalist application of it. It emerges as a theme in the surrealist Georges Bataille's writings on art. In 1930 Bataille cited approvingly Dadaist Tristan Tzara who observed that Miró, in a moment of rapid reorientation of his work through the use of collage, was aiming to *kill* painting by its own means, a notion already in circulation through Maurice Raynal's quotation of Miró saying 'I want to murder painting'.[19] Bataille's assertion that modern picture-making arrives when *decomposition* replaces composition – 'an intelligible totality' – came to fruition in the book he published on Manet in 1955.[20] Comparing Manet's strategy in paintings such as *Olympia* (1863-5, Paris, Musée d'Orsay) and *The Execution of Maximilian* (1868, Mannheim, Kunsthalle), both of which 'refer' to a text – that of Baudelaire's poetry in the former case, and to a journalistic report in the latter – Bataille wrote: 'In both cases the picture obliterates the text, and what the picture signifies is not the text, but the obliteration of that text.'[21]

Bataille reads the history of modern art for these key moments of cancellation. Attempts to interpret modernist painting by seeking a source, a meaning, a psychological centre for a picture are thus misguided. Destruction and the libidinal, sadistic impulses that drive it, become the key terms for Bataille's history of modernist art that traces its trajectory, mixing the erotic and the sadistic, from Goya and Delacroix through Manet's critical annihilation to Moreau and Surrealism. (In 1955, and later in her long career, Lee Krasner would make a major move by her own murderous use of collage.)

Rather that reading modernist art as a formalist search for the flatness of the canvas, an interpretation now overfamiliar to us through cheap jibes at Greenbergian formulae, Georges Bataille works from Malraux's definition of the modern in painting as that which refuses – effaces – all values foreign to painting.[22] A certain indifference, or silence, may result but this is not a positively created value, such as flatness was for Greenberg, that is being identified to replace what has been 'murdered'. As part of this same logic, Bataille defines the role of surface in a painting differently from what we are accustomed to see through formalist criticism. The surface of the painting can be imagined as a kind of lid, which conceals its deadly freight, like a tombtone in a graveyard covers up a corpse. Attracting us and yet obscuring the view, the lid could also lead down a thread of association to Pandora's box, the image in Greek myth that evokes a box with both a dangerous content and a dangerously beautiful surface, the box being both the woman Pandora, and her invisible but mortifying sexuality. The myth of Pandora is a critical one for my text. The phallocentric version conjugates danger and death with any form of interiority linking both to Woman's body while rendering feminine curiosity about feminine sexual interiority a deadly mistake. Box, tomb, sex, these terms together with the painted surface create a chain of fantastic signifiers that circle around a feminine Other, sliding onto death, with secrets that mortify, and an imaginary feminine body on the edge of both abjection and ecstacy.[23]

In a recent paper that aims to interrupt the fetishistic and voyeuristic logic of the phallocentric culture encoded in the myth of Pandora's box, Laura Mulvey has reclaimed the twin image of the dangerous beauty of woman as both a treacherous surface and a deadly, death-dealing interior.[24] Displacing these equally negative images, she reformulates the tale to produce an aesthetics of feminine curiosity, a desire to know about the feminine interior or rather about the interiority, subjectivity and sexuality of the feminine – as yet hardly knowable under the phallic regime of meanings which attribute to Woman only a negative dimension. She uses this feminist revision of the myth to imagine both a feminist pleasure in knowledge and the possibilities of feminist aesthetic practices – both of which I want to enroll to aid this project.

The blonde cinema star, Marilyn Monroe, can stand as a modern incarnation of the masculine Pandoran fantasy – a glittering, artificial surface. So fabricated an image functioned as a representational obstacle for women, who as artists, might have needed to break through that excessive and fetishistically fabricated carapace called femininity to explore for themselves the kind of interiority – physical and psychic – that was

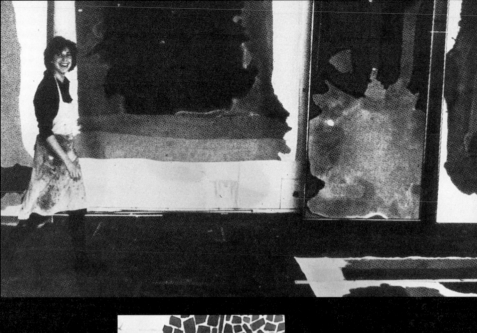

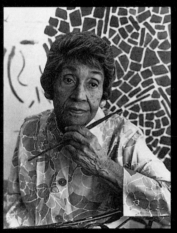

Fig. 43
Women Artists of the 1950s:
top, Helen Frankenthaler;
left, Alma Thomas;
lower left, Louise Nevelson;
lower right, Lee Krasner

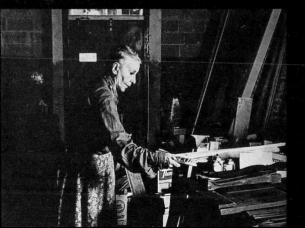

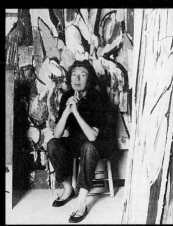

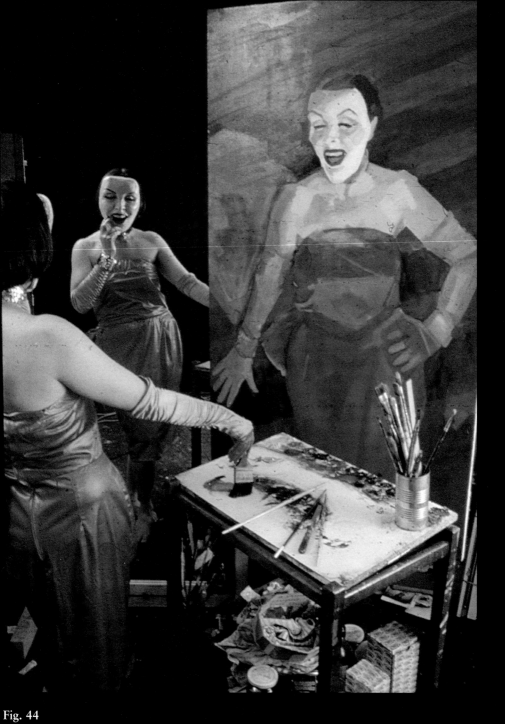

Fig. 44
Nichola Bird *Dressed to Paint*, working proof, 1993.
Leeds, Collection of the Artist

imagined as the possibility of the post-Surrealist abstract painting but which was mythically represented only by the tragic hero – exclusively in the masculine – of a Promethean quest: Jackson Pollock.

But, I shall suggest, women, as artists engaged, pandorically, in a strategy of feminine curiosity, and located at the heart of the modernising enterprise in painting, may have had to 'kill' to gain access to it.

2

THE YEAR IS 1953

> It was in 1953-4 that Monroe became indistinguishable from her image – so much so that whatever she might do she would never seem out of character. Her bombshell performance in *Niagara*, and the back to back release of *How to* and *Gentlemen* made her the nation's number one box office attraction for 1953-4.[25]

Consider this series of conjunctions:[26]

– The first issue of *Playboy* magazine featuring Marilyn Monroe on the cover appeared in December 1953. She was also featured inside as both the first centre-fold and the first ever sweetheart of the month. Accompanied by one of the famous nude calendar shots, the text calls her 'natural sex personified' and 'blonde all over', while remarking that 'She's as famous as Dwight Eisenhower and Dick Tracy, and she and Dr. Kinsey have so monopolised sex this year, some people in high places are investigating to make certain no anti-trust laws have been bent or broken.'[27]

– The first English translation of Simone de Beauvoir's 1948 *The Second Sex* was published in 1953. The book opens thus:

> One is not born, but rather becomes a woman. No biological, psychological or economic fate determines the figure that the human female presents in society; it is civilisation as a whole which produces this creature, intermediate between male and eunuch, which is described as feminine.[28]

– In 1953 Twentieth Century Fox released back-to-back two films starring Marilyn Monroe, *Gentlemen Prefer Blondes* (July) and *How to Marry a Millionaire* (December). They rapidly established Marilyn Monroe as the hottest and blondest star in Hollywood. From then on her every move, marriage, film, illness and affair was chronicled and photographed in the popular press. In 1953, she was voted the year's most popular actress and earned for her studio more money than any previous female

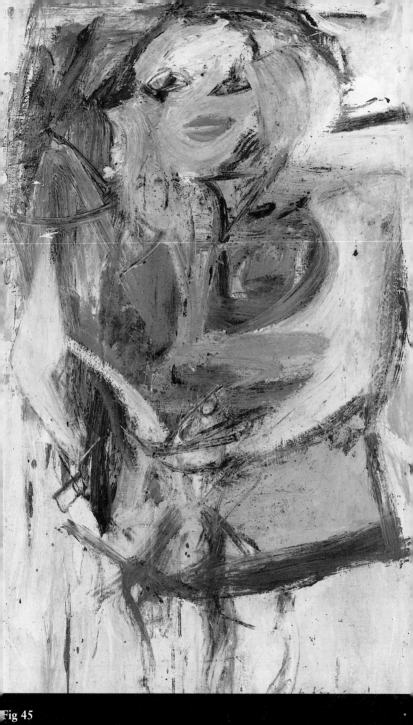

Willem de Kooning, *Marilyn Monroe*, 1954. Oil on canvas, 125 x 75 cm.
Purchase College, State University of New York. The Neuberger Museum of Ar

star. Donald Spoto writes: 'The role of Lorelei fixed Marilyn Monroe in the world's consciousness as the exaggeratedly seductive blonde: all body; no thought; little feeling; all whispery high voice and no sensibility.'[29]

– In July 1953 Dr A. C. Kinsey and his team produced his report on the *Sexual Behaviour in the Human Female*. It appeared the same month as *Gentlemen Prefer Blondes* was released. Religious and civic leaders – like *Playboy* magazine – linked Monroe and Kinsey in their attacks. Kinsey's report sold 250,000 copies with its revelation that over 50 per cent of women were not virgins at marriage, over 50 per cent had at least one homosexual relationship or experience, 25 per cent had extramarital affairs, and that the clitoris was the site of female sexual pleasure – itself a major shock of the report: women enjoyed sex.

– And finally Willem de Kooning's *Marilyn Monroe* (fig. 45). A strange, even wan epigraph to a series of extraordinarily striking and vicious paintings called *Woman* (fig. 56) that had been occupying the painter since 1948 in his filial battle with the domination of Picasso.[30] Eve Arnold quotes de Kooning: 'They seem vociferous and ferocious. I think it had to do with the idea of the idol, the oracle and above all the hilariousness of it.' Red lips float in a noseless face beneath kohl-lined eyes atopped with a crop of yellow blond hair. The same yellow across the lower torso reflects the *Playboy* jibe: blonde all over. Between these two areas of yellow, the breasts are red, rhyming with the mouth. These clashing colours create a sublimated and yet virulent representation of the female sexual body that is shockingly at odds with the sanitised mixture of sensuality and sweetness that has characterised all but *Playboy*'s writing on Marilyn Monroe.[31]

3

HOT LADY IN A COLD ZONE

Shortly after gracing the cover of the initial issue of *Playboy*, Marilyn Monroe was again in the headlines because of her marriage to all-time famous baseball star Joe DiMaggio. In a blaze of publicity, they honeymooned in Japan. Monroe was invited to perform for the troops now guarding the frontiers of the Free World against the Red Peril in Korea, the first major military front opened up in the so-called Cold War. The war itself was over. A truce had been signed in the summer of 1953. To entertain the troops remaining on guard on the border, Monroe agreed to put together a show based on her numbers from her 1953 box office hits. She did ten performances on four days between 16 and 20 February 1954 (fig. 46).

In freezing sub-zero temperatures, scantily dressed in clinging lavender dress and

shoes that barely deserve the name, she sang 'Bye, Bye Baby' and 'Diamonds are a Girl's Best Friend' to a hooting, laughing and applauding male audience who had in fact never seen the films from which the songs came. But Monroe was already the pin-up of the American troops, extensively photographed, reproduced in magazines and calendars. A MASH team had voted her 'the girl we would most like to examine'.[32] On the final show of the tour, the troops rioted. The Army launched an investigation into Monroe's activities in a Cold War zone, while a disaffected reporter for the *New York Times* referred to the concurrent hearings on the Army by leading Cold War zealot, Senator Joe McCarthy, bemoaning the exposure of such weakness of morale in the overexcited and 'feminine' way the soldiers responded to Monroe – the reporter compared them to bobby-soxers – as fuel for his domestic investigation as well as for America's 'enemies': 'their conduct must have delighted the Communists and all who hope for signs of degradation and decline in the United States'.[33]

Marilyn Monroe sent to galvanise the troops – with what? She was an American. But how she was 'American' in that political climate was based on her vanilla ice-cream whiteness, for as Richard Dyer has argued: 'the ultimate embodiment of the desirable woman' is not only the white woman, 'but the blonde, the most unambiguously white you can get... Blondeness, especially platinum (peroxide) blondness is the ultimate sign of whiteness.'[34] The blonde is 'racially unambiguous'.[35] Monroe was also on offer because of sex: 'The Hollywood blonde body is the limit and promise constructed by the discourses of white phallo-supremacy.'[36] But where sex and race intersect, the blonde plays a role in the recirculation of the white lady/dark lady opposition, itself mapped onto oppositions of light/dark, good/evil, chaste/sexual: '...the blonde woman comes to represent not only the most desired of women but also the most womanly [read: chaste] of women'.[37] This in turn hinges upon a contradiction. In *The Sadeian Woman*, Angela Carter argues that the 1950s blonde embodied in figures like Marilyn Monroe contained a Sadeian paradox. Because a woman's success in Hollywood was first and foremost about sex, but a woman's success in America was first and foremost about virtue, a tension arose in the 1950s that produced 'The Good Bad Girl, the blonde buxom, sorority of Saint Justine, whose most unfortunate martyr was Marilyn Monroe'.[38] Carter sees in Marilyn a physical fragility which is the conscious disguise of masochism: perhaps too dependent on later knowledge of the life, or rather the death of Monroe, this reading, none the less, makes us attend to the violence involved in putting a half-clad woman out in freezing weather to be ogled by sex-starved killing men: soldiers. Monroe contracted pneumonia from the trip. A complex web of racial and sexual politics within the classic narratives of gender – men look while women watch themselves being looked at - was enacted when the Hottest Lady touched the Coldest Zone.

She was on offer to the killing men as a sex symbol. What does that mean?
She is a symbol of sex. She is not a symbol of her sex, and certainly not of her

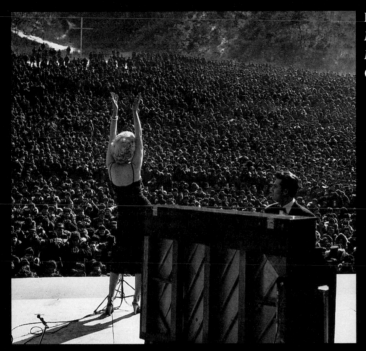

Fig. 46
*Marilyn Monroe in
Korea*, 1954.
Corbis-Bettmann/UPI

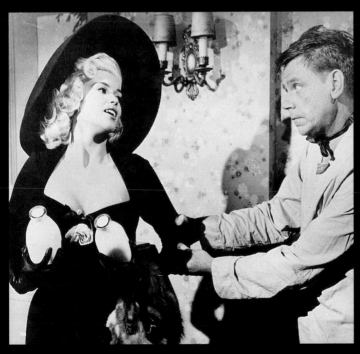

Fig. 47
Still from *The Girl
Can't Help It*, 1959.
Dir. Frank Tashlin.
Twentieth Century
Fox

sexuality. As Luce Irigaray has argued, in patriarchal society, there is only one sex of which anyone can be a symbol. There is only one sex and its other, i.e that which is not the one. That one sex is masculine. Indeed the very idea of sex is established in the gesture that produces the masculine. In this phallic economy woman is a displaced sign of his/this sex. Representation of the sexual in this hom(m)o-sexual logic involves the deformation and transformation of the woman's body as a commodity that circulates in a masculine economy of exchange that is secured psychically by the translation of the feminine body as a fetish for the phallus - the one signifier that is also the signifier of the one (sex).[39] Reworked through codes of dress, hair, make-up, and nowadays body sculpting through exercise and dieting, woman's body as image, however, signifies masculine anxiety about a possible difference that is deferred through the psychic defence of fetishistic scopophilia: covering up the danger of feminine otherness so that, remade as image, 'she' presents a perfect and reassuring surface. The beautiful mask is, however, double-edged. While allaying the fear that difference inspires, it also marks the very spot. It merely veils what remains menacingly hidden: displacing and yet intensifying the threat of what is concealed beneath that glossy packaging. Pandora's box suggests the oscillating movement between surface and interior, between masculine subject and that which, as its other, can never cease to provoke his anxiety and reworking. As Jacqueline Rose states:

> We know that women are meant to look perfect, presenting a seamless image to the world so that man, in his confrontation with difference, can avoid any apprehension of lack. The position of woman in fantasy depends, therefore, upon a particular economy of vision.[40]

The images of Marilyn Monroe being refashioned from a pretty brunette factory worker into the peroxide blonde sex symbol during the 1950s are so familiar and so much part of the cultural sign systems that signify America in the 1950s – and feed a pervasive nostalgia for that moment – that perhaps we no longer see the violence implied in the manufacture of that beautiful image that Warhol aesthetically canonised in his pantheon of modern fame and death and that, in his paintings of *Woman* (figs 45 & 56), de Kooning radically eviscerated and exploded. Trained to keep her red lips lowered over her teeth so that her smile would not be too gummy, and her eyelids perpetually drooping, Monroe worked hard cosmetically to perfect the mask that would promise some ineffable pleasure from its riant loveliness.[41] The artifice of this modern-day *Coppelia* becomes more vividly outlined in the attempted reproduction of the fabrication by the other blondes of the 1950s. In 1959 Frank Tashlin made a parody of 1950s gender politics of the image, a movie-cartoon starring a simulacrum of Marilyn Monroe: Jayne Mansfield. Mansfield played with her role as sex symbol with knowing irony, exposing the extremity of this artificially manufactured sexual automaton called the blonde sex symbol while the script brings out the utter contradiction in which

Angela Carter saw a modern version of Justine: woman as the sex symbol and woman as domestic servant. In a famous scene set to the music of *The Girl Can't Help It*, Mansfield, strapped into a figure exaggerating black suit, visits the down-and-out talent promoter her rich boyfriend has hired to make her a star. While he recovers from an alcoholic haze, she dons apron and cooks the perfect breakfast while saying that she does not want a career but longs to be a wife, and a mother – 'while everyone keeps on taking me for a sex symbol'. Tashlin's visual joke of the busty Mansfield clutching two bottles of milk in front of her uplifted breasts, plays off the Justine/Sade that Angela Carter identified within the Monroe legend itself (fig. 47).

4

THE MOST FAMOUS LIVING AMERICAN ARTIST

Why did they not think to send the most famous living American artist to Korea to galvanise the troops? In August 1949 *Life* magazine ran an article on Jackson Pollock under the headline 'Is he the greatest living painter in the United States?' featuring a photograph by Arnold Newman of the artist in paint-splattered denims with a cigarette dangling from his lips, standing in front of *Summertime* (fig. 48).[42] Willem de Kooning commented when he saw the article: 'Look at him standing there, he looks like some guy who works at a service station pumping gas.' Budd Hopkins is reported as saying:

> 'He had everything. He was the great American painter. If you conceive of such a person, first of all, he had to be a real American, not a transplanted European. And he should have big Macho American virtues - he should be rough and tumble American – taciturn ideally – and if he is a cowboy so much the better. Certainly not an Easterner, not someone who went to Harvard. He shouldn't be influenced by the Europeans so much as he should be influenced by our own – the Mexicans, the American Indians and so on. He should come out of native soil – a man who comes up with his own thing. And he should be allowed the great American vice, the Hemingway vice, of being a drunk. It's no wonder that he had a popular *Life* magazine success, because he was so American and unique, and quirky and he had this great American face. Everything about him was right.'[43]

Pollock also appeared in film and photography. Hans Namuth photographed Jackson Pollock at work during the summer of 1950 and then began two films, with Paul Falkenberg, past associate of German directors G. W. Pabst and Fritz Lang, in the fall of 1950, first in black and white of Jackson Pollock painting in his cold barn at the Springs, East Hampton, and then in colour including some famous outdoor shots (fig.

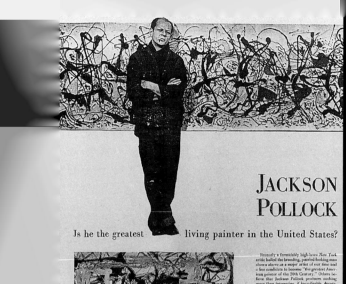

JACKSON POLLOCK

Is he the greatest ———→ living painter in the United States?

Recently a formidably high-brow New York critic hailed this brooding, puzzled-looking man shown above as a major artist of our time and a fine candidate to become "the greatest American painter of the 20th Century." Others believe that Jackson Pollock produces nothing more than interesting, if inexplicable, decorations. Still others condemn his pictures as degenerate and find them as unpalatable as yesterday's macaroni. Even so, Pollock, at the age of 37, has burst forth as the shining new phenomenon of American art.

Pollock was virtually unknown in 1944. Now his paintings hang in five U.S. museums and 40 private collections. Exhibiting in New York last winter, he sold 12 out of 18 pictures. Moreover his work has stirred up a fuss in Italy, and this autumn he is slated for a one-man show in avant-garde Paris, where he is fast becoming the most talked-of and controversial U.S. painter. He has also won a following among his own neighbors in the village of Springs, N.Y., who amuse themselves by trying to decide what his paintings are about. His grocer bought one which he identifies for bewildered visiting salesmen as an aerial view of Siberia. For Pollock's own explanation of why he paints as he does, turn the page.

"NUMBER TWELVE" reveals Pollock's liking for aluminum paint, which he applies freely straight out of the can. He feels that by using it with ordinary oil paint he gets an exciting textural contrast.

Fig. 48
'Jackson Pollock: Is he the greatest living painter in the United States?'
Life Magazine, 8 August 1949

Fig. 49
Jackson Pollock at work from 'Abstract Expressionists'
Life Magazine, 9 November 1959 still sequence from Hans Namuth and Paul Falkenberg *Jackson Pollock*, 1951

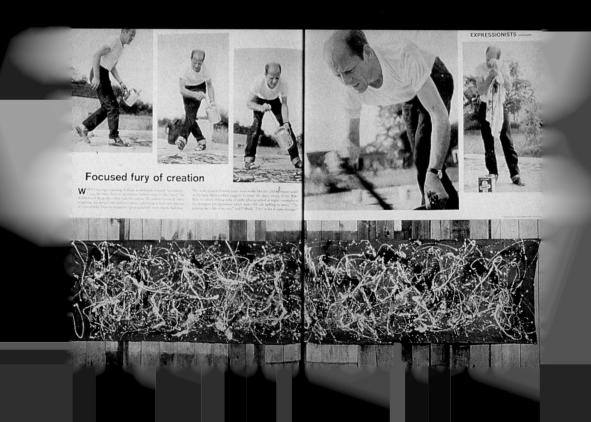

EXPRESSIONISTS continued

Focused fury of creation

When beginning a painting, Pollock worked with focused fury laying his bare floors of his outdoor symbol atop for his "tool," he tickled and flung the colors onto the canvas. He stared from all sides, weighting the design with balanced paint, collecting it with occasional occasional colored dots. Then he stopped to "get acquainted" with whatever had then.

The work of each finished hours over works like this the 23d of mural noted on his bare Spring which happens to trace the story swing of the Milky Way to which strong webs of traffic photographed at night—examples of the designed interpretations which make this art baffling to many. "I'm painting like a life of its own," said Pollock. "I try to let it come through."

49).[44] The film was premiered at the Museum of Modern Art in June 1951 and at a festival in Woodstock in August of the same year. It was not well received. These images failed to present the expected iconography of the artist. Yet both films and photographs offer us a crucial kind of access to the problem of sexual difference and painting precisely in that failure to coincide with the prevailing representation of the modern artist.

As photo documentaries Namuths photographs locate Pollock's performance in a totally different space from that of Marilyn's (fig. 50). It is the unheated but interior space of the studio at the Springs, East Hampton, Long Island, a seemingly private place where the artist works alone with his materials. Despite the contemporary critical failure of Namuth's images of Pollock at work, they can be placed – if deviantly – in a significant genealogy of modern art. Indeed they figure in a critical relation to one of its key imageries: art represented reflexively by the image of the painter at work. The artist in the studio became a major trope of early twentieth-century vanguardism.[45] This iconography confirmed the artist as symbol of art as surely as Monroe was made through cinema still and pin-up into a symbol of sex.

In her identification of the politics of the representation of the artist in the studio in early twentieth-century modernist painting, Carol Duncan further revealed an insistent masculinisation of modern art at the level of its actual practices, its key representations and painterly strategies, and its symbolic self-representation. The artist in the studio, she argued, figured bourgeois fantasies of masculine freedom through the vicarious access offered by such images to the unlicensed sexuality of the artist painting the violently exposed and animalised female nude. Usually the artist man is clothed, while the model, prototypically a woman, is naked, often supine, in some gracelessly uncomfortable position. In rare cases, such as Matisse's *The Painter in His Studio* (1917, Paris, Centre Pompidou), the masculine nudity of the upright artist at work signifies something different from the saturated sexuality of the female nude. Apollonian intelligence and creativity are confirmed by what is on the easel in front of the seated painter, namely his abstracting and formally decorative recreation of the brute material of the faceless female model in the corner of his studio. Such painting is a palimpsest of three orders which define Western art-making in the modern era. The combination produces a sexual hiercharchy which is paradigmatic of a whole tradition of painting figured by this juxtaposition of two bodies in space – the painter's body (art) and the feminine body (its other: nature). One stands for the very act of creation, the other a mass in a chain that moves from materiality or nature to art without subjective contribution.[46]

Hans Namuth's photographs of Jackson Pollock – perhaps as a result of these images the most famous sign of 'body of the painter' of the modernist century – frames the producing body and his activity not as the studio, a social space of encounter between culture (the artist and his work) and its resource (nature/woman/other) but as the canvas from which that other has been banished. The unframed and uncut canvas lies on the floor receiving the flurry of his gestures that mark and record the artist's presence to

declare, however, a Dionysian rather than an Apollonian masculine creativity. The sexual hierarchy pictured in Matisse's prototypical modernist image is not visualised in Namuth's images. But the legacy is surely there in the potency and activity of the masculine body now directly mastering the canvas, that has subsumed into its uncharted space the once necessary feminine object, the sign of painting's referent to that from which art is made because art is other to it. The artist patterns the canvas's displacing and condensed surface with his signature, overlaying lid, screen, mirror with his painted, or dripped, even for some, urinated inscriptions as he dances around its immense inviting but also threatening expanse.[47] I am not suggesting something so crude as the canvas now equals woman. Rather I want to open up the possibility that the structural relations between artist – world – art involved a mediating term for which the nude female model had stood in symbolic explorations of the act of making art in the early modernist moment. This structure is both a product of and the condition for a historically particular ordering of sexual difference articulated through this symbolic site: the studio.[48] While abstract painting of the kind Pollock's work seems to signify banishes that middle term, to leave us with both a practice and a representation of that practice that sets up a dyadic reflexivity between painter and painting, I want to mark the point of disappearance of the body of the woman, and suggest the lingering trace of that necessary feminine other projected now, as one of many dimensions and associations, onto the space of inscription – the canvas as both mirror in which the artist will inscribe his mark and as a screen which might veil that disappeared, historic term. Thus instead of the painting registering the process of artistic transformation of something in the world, a referent of a different order, the canvas becomes the support for marks that immediately make it the other to that marking, involving it both formally and psychically in a dialectic with the painted trace. The canvas as the field of action, the support of paint, the surface for inscription as much as for the inevitable projection of fantasy, can thus play a variety of roles in this art of worldly renunciation. I am merely wanting to introduce into its multiple registers traces of the other (historically coded as feminine and figured through the female body) that had been structural to the self-conception of the virility of modernist art, and that, paradoxically, becomes all the less mastered by disappearing into the infinite otherness of the unrolled sheet/space of the unprimed canvas.

For women painters the modernist genealogy of the artist in the studio posed a conundrum in both its figurative and sublimated, abstract form. Women also desired to make such art. They longed to be the laboring creative body in the discrete space of the studio and to make their mark on the canvas. The desire stems from, and will inevitably trace somehow, what it means to exist within the experiential parameters of a feminine body that the polarity – body of the painter (art) and feminine body (nature) – I have indicated cannot accommodate without a third term: the *creative woman's* body. Thus this ideological field is triangulated: the painter's body - the creative act; the feminine body – the mediating sign of art's other (figured or deferred); and the contestation of

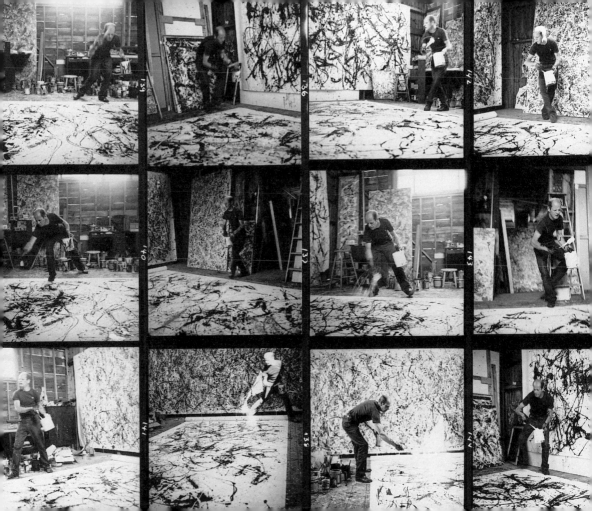

their asymmetrical duet through the emergent discourses and practices of what the women's struggle in art has been about – 'the creative woman's body'. The project to realise such a third term in the 1950s would play itself out across a historically produced cultural field that was bisected and overdetermined by another dissymmetry: the sex symbol and the symbol of the artist standing in and for opposing domains in culture. By the 1950s, things have changed. Woman is symbol of Sex – and that not her own. Woman is definitively not nature: the blonde bombshell is as artificial, as fabricated and thus as fetishised as one can get. She stands at the polar opposite of that which was inversely elevated as the real, the true, the authentic, the creative – the disciplines and intensities of autogenetic modern artistic masculinity.[49]

Between, therefore, these two incommensurate icons of the 1950s, Marilyn Monroe and Jackson Pollock, structural binaries were reified: high art and popular culture, painting and cinema, art and commodity, authenticity and artifice, masculinity and femininity. Between their opposition which was also a structural complementarity, painting – as opposed to dying – women were caught in dilemmas and riddles posed by the gender polarities of that culture which were inevitably but the form of these many divisions. Part of the current feminist project is to dismantle the falsely dividing walls that segregate areas of social practice so that we can track what Foucault called the discursive regularities that constitute the formations of gender, class and race between high and low, élite and mass, because they all end up meeting in *Life* – the magazine that is. What I am looking for are signs of the discourse and negotiated practices constitutive of a historical regime of sexual difference so that I can begin to answer the question: what would it be to be a woman painter caught in the inevitable web between these two representational scenes and systems that produced such diametrically

MoMA and their owners and backers, the Rockefellers and Whitneys, of cynically using the artists' work in their Cold War programmes to convince the free world of the legitimate claims of American cultural and hence political leadership. Whatever the metaphorics of interpretation which have evolved to locate this kind of work in its social and historical context, and whichever school of thought we look to, be that formalist art history or the social history of art, the issue of gender and the Cold War is never raised in dealing with the culture produced in the 1950s. Sealed off from its popular other, painting has been insulated so that a false universalism that is, in fact, unacknowledged masculinism, has remained unquestioned. If we jump forward to the 1980s, the politics of sexual difference in the 1950s escapes the ideological freezer of the Cold War to be retrospectively revealed in the discourse of the daughters revolting against this painting. Both Cindy Sherman and Barbara Kruger resource their practice from not just the imagery but the very feel and sensibility of the sexual politics of the 1950s which is so vivid in its popular cultural forms: Barbara Kruger referencing not only in her imagery, but in the graphic design and red on black and white colour system, *Life* Magazine, while Cindy Sherman explores with both pathos and discomforting ambivalence, the uncanniness of the femininities of her mother's generation in the fifties.

But none of the imaginary femininities created from Cindy Sherman's wardrobe and make-up box rediscover an image of female creativity. Relentlessly cinematic, her *Untitleds* confirm Laura Mulvey's analysis of woman as the very sign of cinema, and cinema as the full articulation of woman as spectacle, fetish and commodity. All surface, all artifice and all dangerous mystery.[51] Where is there any evidence of women artists' sustained contribution and diverse challenges to the problematics of high modernism in that crucial decade of the 1950s? How in the era of diverted speech and repressed reference did gender signify in the Cold Zone of Hot Painting?

5

LOOKING FOR DIFFERENCE OR...

What Greenberg did Not Say

My alternative title for this paper was *What Greenberg Did Not Say*. Clement Greenberg did not say anything much about women artists. This is pretty devastating, given his significance as one of the most articulate critics of the American moment of modernism. Helen Frankenthaler gets a passing mention in an article about Morris Louis and Ken Noland.[52] Lee Krasner gets a put down in another, Georgia O'Keefe is viciously reviewed, Hedda Sterne is called 'a piece of femininity' and 'nothing more than a delicate sensibility', and the sculptor Anne Truitt gets an article of reasonable length

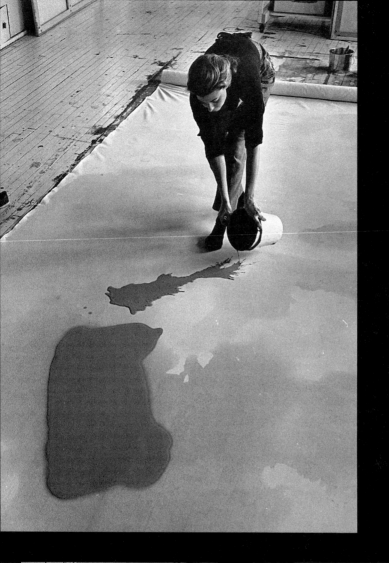

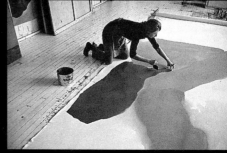

Fig. 51
Ernst Haas, *Helen Frankenthaler in her Studio*, 1969

in *Vogue* which, however, concludes: 'She remains less known than she should be as a radical innovator. She certainly does not "belong". But then how could a housewife with three small children, living in Washington belong? How could such a person fit the role of pioneer of far-our art?'[53]

At the beginning of my teaching career at the University of Leeds, I collaborated on a range of projects for a social history of art with my colleague Fred Orton. This volume is witness to the outcome of that work. We also jointly taught a course called *Readings in American Culture and Society in the 1950s*. But it never seemed possible for me to integrate into this programme the feminist work I was simultaneously doing with another collaborator, Rozsika Parker, which appeared in 1981 as *Old Mistresses*.[54] That is, feminist and social histories of art ran in parallel lines that seemed to allow of no convergence. On our course, I introduced sessions on Helen Frankenthaler and Louise Nevelson; but these were one-off events, the set aside time to talk of Women in the New York School. Of course, the very idea of special sessions marked off the women artists from the main trajectory of the course, of the histories, debates that Fred Orton and I were so scrupulously tracking through the critical writings and exhibitions that shaped the institutional accreditation of so-called Abstract Expressionism. A sub-set, a special interest, women artists were made simply symbols of sex: i.e. of that sexual otherness that holds no meaning except of its lack *vis-à-vis* what really mattered.

In our concurrent search to develop a feminist analysis of the relations between subjectivity, art and sexual difference, Rozsika Parker and I had turned to the Hans Namuth photographs of Pollock painting in 1950. We juxtaposed a series of photographs by Ernst Haas of Helen Frankenthaler at work in 1969 (fig. 51). I am fascinated by photography and the way it can function as more than document or evidence. The photograph is a trace of something which would otherwise exist entirely beyond our knowledge because it remained beyond the visible. The photographs of Pollock and Frankenthaler at work do appear to provide some mundane information about how these painters actually produced their paintings. That itself is historically significant. The painter had been the focus of representation before. But the process of painting itself had not, and this was even more significant now that the process was itself the topic as well as the resource of the practice. But that is not all we are seeing. There is much more made visible in these photoperformances than what we think we are seeing.

Rozsika Parker and I used the juxtaposition to ask some heretical, feminist questions: What is the difference that these images may allow us to see being inscribed? Do Pollock's slashing and throwing of paint, his gyrations around a supine canvas, enact a macho assault upon an imaginary feminine body? Are the traces of paint on canvas the residues of a psychic performance? Is this *écriture/peinture masculine* at its most vivid?[55] How then could we read Helen Frankenthaler's pouring, pushing, smoothing gestures as she stood in the canvas, or knelt near its edge as a surface continuous with her space and her body's large spreading and delicate shaping movements. Is this a feminine modality inviting us to invent metaphors that might link female bodily experience to fluidity in

order to account for the sensuousness and lusciousness of her effects?[56]

When we use the term 'feminine' in this context, it is important to distinguish it from the pejorative term of abuse employed by contemporary critics to discount the art of women – 'the feminine stereotype'. Yet we can reclaim its negativity and suggest a productive excavation of the relations between psychoanalytic hypotheses about the otherness of the other – the feminine as negation of phallocentricism – and cultural conventions of the 1950s that manufactured an excess of feminine masquerade. To raise the spectre of the feminine in talking of a painter who is a woman is to tangle with a complex historical legacy that she must disavow and we must theoretically question. It is a conundrum we cannot avoid as historians or as feminists. The term 'feminine' signifies nothing in and of itself. It marks the place of the recalcitrant issue of sexual difference and the riddles of how we, named women, live it and create within its unsettled and contradictory formations.

Precisely because the Namuth and Haas photographs abandon the formal iconography of artistic portraiture for the mundane record of painting as activity/action, do these gestures of labouring, painting bodies register some profoundly different way of being in the body and of being a *differentiated*, psychically imagined corporality in that actual, as well as symbolic, or fantasmatic space – the canvas/studio – the products of which a viewer will, later, read according to prevailing cultural signs of gendered sexuality? Are sexual politics right there in the most formal, and even technical, processes of high modernist painting? Are they historically raised to a level of transparency by the very dedicated abstractness of such painting processes?

We require terms in which to think about difference and thus to be able to see it, to read it. The danger is that because, within phallocentrism, there is only one sex, the only difference allowed is negative: that what is not the one, is not. It signifies simply the lack of what is positively endorsed. The term feminine is often abused to signal simply that negative difference. Therefore, Helen Frankenthaler's work will read only relationally to Pollock as 'after Pollock', 'sub Pollock', 'less good' than Pollock. Accustomed culturally to read art purely and simply through the significations of the masculine, anything that betrays signs of difference offers nothing but that lack of what is expected. Or, the positive reading is made which sees only an artist who made a breakthrough after Pollock, serving as the necessary artistic intermediary between the Pollock and Morris Louis and Kenneth Noland. What is wanting in our culture are the terms by which to specify what the difference of women might be, the terms with which to imagine what the otherness of women is, *other* than being *other* to men. Yet this difference is not categorical. The trick will be to find ways to see the *differencing* of/by the feminine as a result of both the intensity of the artist's engagement with the central problematics of this art historical moment called Abstract Expressionism and the possibilities it offered for something in excess of it, that we might invoke as a dimension of the specificities of the feminine.

The accepted art historical account would place Helen Frankenthaler as a second

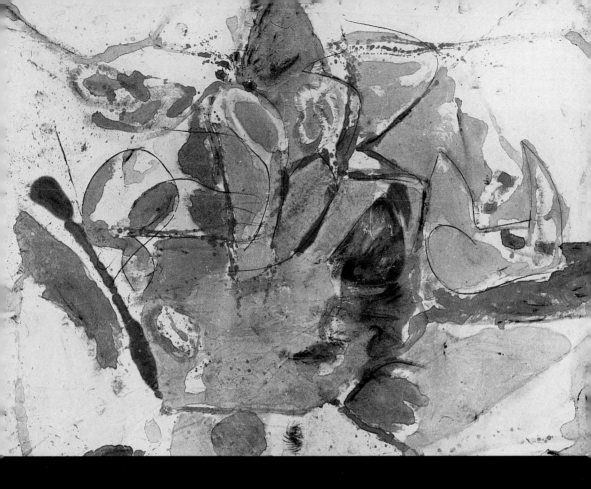

Fig. 52
Helen Frankenthaler, *Mountains and Sea*, 1952.
Oil on canvas, 216.5cm x 282.5cm. Collection of the Artist: on extended loan to
Washington, National Gallery of Art © Helen Frankenthaler

generation Abstract Expressionist who first saw Pollock at his 1951 Betty Parsons show and was then was directed by Clement Greenberg to Pollock's studio at the Springs, East Hampton in 1952. She found the encounter 'a clinching point of departure' from her current involvement with Cubism and de Kooning:

> I felt I could stretch more in the Pollock framework. I found that in Pollock I also responded to a certain Surreal element... You could become a de Kooning disciple or satellite or mirror, but you could depart from Pollock.[57]

The artist spent the summer of 1952 painting in Nova Scotia and came back to New York to produce the enormous canvas *Mountains and Sea* (fig. 52). Helen Frankenthaler has said in a very Hoffmanesque statement: 'I know the landscape was in my arms as I did it.'[58] The connection with landscape has prompted a critical obsession with lyrical or pastoral references in the work of Frankenthaler. There is an important art historical case to be made for the gambit of landscape as a means of shifting abstract painting's relation to the historical legacies that had to be purified as part of the continuing job of modernisation. Displacing that debate for the moment, I would like to stress the place of the body signalled by the artist's revealing comment. This phrase suggests that the body mediates between the experience of being in space and the process of painting from that memory of being in space, between resource and outcome, which is, however, not representation and not even reference. The painting body accomplishes this role as if it were itself both the instrument of the psyche and of the painter – replacing the brush or stick that replicates the look or feel of something in the world, called landscape. Something different must occur if the painter who paints with such a body is, in fact, a woman artist, painting from (or to find) 'the creative woman's body'.

This is not to drag in an essential idea about what that body is. As Julia Kristeva has insisted: woman is not. Woman is not in the order of *being*.[59] My statement presumes nothing at the level of content, having no truck with the expressive fallacy. Yet, as feminists, concerned to pose the repressed question of what the sexual difference might be outside of a phallocentric, monosexual regime, we must allow a space of possibility for the specificity of the feminine as both effect and arrangement of drives, impulses, locations, pleasures, repressions, fantasies and so forth.[60] The difference arises between the binary notion of opposites – man/woman – and the deconstructing move that allows itself to imagine a differentiating difference that is marked by the politics of the feminine. Ironically, in the very spaces of the highest of modernist painting, from which had been evacuated the signs and symbols of the continuing legacy of nineteenth-century culture's invidious definition of the human subject in violently polarised genders, and in the name of an abstract universalism: 'serious art or ambitious painting', there emerged the possibility of experimentation with a practice open to that *différance*. By this I mean the deferral and destabilisation of monosex and the exploration through the work of the painter's body of sexual specificities unimagined and unsignifiable in the existing

semiotic and political order. Thus the very abstraction and formalism of the Greenbergian view of the purified practice of modernist painting as completely 'steeped in its own cause' – the phrase is Mallarmé's from 1876 – paradoxically opens up the space of painting to the process of sexual difference in every gesture, relation and effect.[61]

Barbara Rose has pointed out that the use of the stain and soak technique that Frankenthaler evolved in response to what she saw in Pollock's work as a point of creative departure, using unprimed cotton duck, was not entirely without precedent in the history of *à la prima* painting. Frankenthaler's significance lies in much more than inventing a painting technique: 'For the first time in the history of art, the painterly was completely dissociated from the loaded brush' – or stick for that matter.[62] This displacement of the phallic brush is almost too obviously suggestive. Equally Frankenthaler used thinned paints which almost mimicked watercolour washes, and she rejected the strident colours of the Fauvist tradition as well as the monochromes of both Pollock's current work, and before him, the still influential Cubist palette. These moves allowed her to resolve some of the tensions between pictorial space created by any marking of the canvas and absolute fidelity to the two-dimensionality of the canvas support which were, according to Greenberg's formulations at the time, the cutting edge of advanced post-Cubist painting. Through staining colour onto unprimed cotton duck, the artist effectively made surface and image, support and space literally one, allowing the optical ambiguities of colour itself to create their immaterial 'push and pull' which was so critical to the tension that such painting strove to create, and then contain, by its own logic, in lieu of the coherence created by traditional composition or the armature of drawing. 'Decomposition' – Bataille's favoured move – undermines composition, while there is a new aesthetic order to be achieved by the very negation of its traditional forms. It could be, and probably should have been argued, that much of Greenberg's later writing on the 1950s, including the famous 'American-Type Painting' essay, and his move to authorise colour field painting, depends critically upon what Frankenthaler's 1952 breakthrough had opened up.[63] But it was a gesture of which he could never fully speak. Its meaning lay not in her 'sex' as a 'woman artist', but in the shifting of alignments within the practice towards a feminine semiotic dimension of which we, the feminist generation of post-1968, can now tentatively begin to speak, because we now have the means to theorise and politicise the complex we name sexual difference.

Like Pollock, Frankenthaler seized the key modernist assertion that process was all: the very mode of making the painting could itself become not the means of signification, but the signification itself. As such, it would, however, have no meaning, i.e. no fixed symbolic equivalent. Associations, fleeting glimpses of possible forms, suggestions, prompts for parodic and humorous titles, yes, but the paintings did not aim to let what was on the canvas stand as a signifier for what was not. As other art historians before me have recently argued around Pollock's work, this project was also an assault on the

centrality of metaphor that had so long constituted the basis of signification in Western painting.[64]

Identification of painting as both process and project could lead, however, to different effects. To conflate act and art could collapse the painter into the painting, thus making the subject, the producer, merely a part of his/her own object. Formalist, and later semiotic, readings of art tend in this author-decentring direction, reading painting as text. On the other hand, this same confusion of artist and practice could make the painting, the object, signify only the painter, the subject. Mary Kelly argues that such reification of the painter and fetishisation of the author characterises mainstream modernist criticism in its collaboration with the marketing and exhibiting strategies of the capitalist culture industry. Modernist criticism treats painting as the support for the gesture that creates and guarantees the artistic subject. Painting becomes the site of a signature – the overall marking and making as much as the final verbal flourish of a name – that confirms the artist's subjecthood as the symbolic commodity on the art market, a process that is assisted by art history's predominantly monographical writing and exhibition practices in artist-centred modes.[65] What are most retrospective exhibitions but another episode of this narrative affirmation of a creative subjectivity through the painted signature of a singular artistic gesture? Authorship dominates scholarship and its constructed function is to predetermine the forms of our cultural consumption.

To go beyond modernist criticism is to defetishise and decommodify the gesture/signature/author complex by returning both to the laboring, producing body and to a subjectivity – in process and on trial – in history, a subjectivity whose psychic and social practice the gesture *indexes* as it works across and within the representational space of its aimless signification. Instead of using painting as a metaphor, a substitution for the artist, rendering 'him' (as this logic demands) the symbol of art, we could explore the practice of painting, in social as well as symbolic space, as a metonymic trace, an index of a socially formed, psychically enacted subjectivity at work, both consciously and unconsciously, upon its own and its culture's materials.

The key to this process in the painting practices under consideration is to think through the possible relations between the *gesture* (not understood as mere formal device or technique, and not just as a way of putting on paint, but as the overall semiotic process of a specific context), the *surface* (not imagined as flat support, but rather as a territory, a field, a mirror, a screen), and the *subject* (not the coherence retrospectively attributed by the name of the author/artist, but a process, divided, heterogeneous, negotiating difference and the radical instabilities of identity).

6

IS THE GESTURE MALE?

Disappearing the Mother into Symbol Or Capturing Her Absence in Space

In her recent feminist research into artistic practice and sexual difference, Hilary Robinson has alerted us to the potential contribution of Luce Irigaray's writings, especially a paper entitled 'Gesture in Psychoanalysis'.[66] Irigaray's provocative essays challenge both feminist and traditional philosophies by the seeming adamance with which the philosopher-analyst asserts the existence of sexual difference. Read one way, her statements appear universalising and absolute. Read philosophically, rather than anatomically, they parody and revise the declarative assurance of Western, phallogocentric philosophy which thinks through absolute oppositions, asserting unargued essences such as Man and Woman. In using her work, I aim to provoke, while wanting to revoke any suggestions of a simplified absolutism: men paint like this and women like that. Irigaray dares to pose such questions in order to expose systematically that what is called the world, art, conventions, society, nature - all terms that parade as neutral generality – are all definitions that stem from a sexually differentiating logic inscribed in the discourses of Western social systems whose effect is to produce and sustain the logic of the One. For those positioned through these terms as the Other to the One, what their difference, by which we must always only gesture at what difference might be, becomes logically unsignifiable. Thus feminists are presented with the impossible challenge of seeking to name feminine difference while they must also theorise it as an inessential, non-ontological effect of the social, psychic and symbolic production of subjectivity.[67]

'Gesture in Psychoanalysis' is an essay which belongs to a series of Irigaray's assaults on the false use of neuter terms in philosophy and in psychoanalysis. In her exploration of gesture as an elaborated meaning system involving both bodies in spaces and intersubjective relations parallelling verbal communication, Irigaray considers difference in the analytical scenario – the recumbent patient, the listening analyst, the gestures that break with social conventions and the relations of signs to language and both to the here and now (that is, lying down in a professional space and talking to someone who does not reply about things that memories and associations prompt). Irigaray asks if sexual difference matters to the way this disarming situation is experienced. Some analysts argue that it can not matter because the analytic scenario returns analysands, male and female, alike to a childlike state. So is the child neuter?

To answer this, Irigaray returns to Freud's famous tale of his grandson, Ernst, playing with toys in the absence of his mother. Freud studied this episode to develop his exposition of his theory of neurotic repetition and the death drive.[68] When his mother leaves him, Little Ernst invents and plays three games. In the first he throws a cotton reel

away and accompanies the gesture with the vocalisation, *o-o-o*. In the second version, he throws the reel but draws it back with a string and now utters a second vocalisation *a-a-a* when the reel is recalled. These sounds are interpreted by Freud and Ernst's mother, Sophie, as the German words *fort* – gone, and *da* – here. Both reel and words are part of the way the little child deals with the separation from the mother and the absence of her body. In a third variation, Ernst kneels before a mirror and makes his image disappear and reappear while expressing now the phrases *bébi ooo* and *bébi aaa*.

Much analytical and theoretical literature has devoted itself to the discussion of these games and the ways in which they dramatise the role of the absence of the maternal body in propelling the child towards the use of symbols: external object-symbols such as the toy cotton reel that stands for the disappearing and reappearing mother as much as for the mastery the child is imaginatively creating for himself in the game, and internal, verbal ones, in which the child masters loss through vocalisations that symbolically keep the mother inside himself by uttering sounds that vibrate in the mouth, shutting the imaginary mother his word evokes behind his teeth. It is these processes of symbolic substitution that will eventually insert him and his ambivalent relations to loss and fantasy mastery into the signifying chain of language and thus of culture.

Irigaray pauses to ask if this story could have been told about a girl. She argues not.

> A girl does not do the same things when her mother goes away. She does not play
> with string and reel that symbolise the mother, because the mother is the same
> sex as she is she cannot have the object status of a reel. The mother is of the same
> subjective identity as she is. [69]

This is a problematic statement for it assumes so early a knowledge of gender identity. But read another way, it is not so strange. For there would be no reason for a child to imagine itself different from its mother. It is the culture which invents the difference, calling it gender, that serves only to create the boy's sense of masculinity as a difference from the mother. The game of *fort-da* is one of the mythic moments of that condensation of absence and loss with a prescience of difference of the boy child from his mother, to cover which what we call masculinity is formed.

So without having to assume that the little girl knows difference and recognises that she is the same as what the phallocentric order constructs as its difference – i.e. the feminine – we can follow Irigaray, who allows femininity to have its particular psychic formation and history. She then asks: what will the girl's reactions be to the separation from the mother? When she misses her mother, Irigaray argues, the little girl throws herself down on the ground in distress. She is lost. She loses the power and the will to live. She neither speaks nor eats; she becomes totally anorexic. Or,

> She plays with a doll, lavishing maternal affection on a quasi-subject, and thus manages to organise a kind of symbolic space; playing with dolls is not simply a game girls are forced to play; it signifies a difference in subjective status in the separation from the mother. For mother and daughter the mother is a subject that cannot be easily reduced to an object, and a doll is not an object in the way that a reel, a toy car, a gun are objects and tools used for symbolization.[70]

A third defence Irigaray outlines is when a little girl 'dances and thus forms a a vital subjective space open to the cosmic maternal world... to the present other'. If she speaks during this play, it will not be the opposing of syllables and phonemes, but something like a litany, or a song, tonally modulated.

Whether these statements stand as descriptions or as attempts to make us attend to the psychic meaning of differences usually ascribed to social conditioning of young children, Irigaray opens up ways of reading for structurally differentiating psychic processes. I want to draw out from this essay Irigaray's attention to space, to rhythm and to movement that symbolically manufactures the experience of both proximity and distance, relation and non-relation, and a borderline between several subjects. Here I am mapping onto Irigaray's hypotheses terms created by the artist and analytic theorist Bracha Lichtenberg Ettinger in her radical challenge to phallocentric logic in psychoanalysis and her theoretical project to expand our idea of the Symbolic to contain more than one signifier for the processes and strata of subjectivity.[71] In lieu of the monolithic One, established by phallic logic, Lichtenberg Ettinger proposes a stratum of archaic experience that comes before the One/Other binary emerges to structure subjectivity in a phallic mode. At this level, there are several part-subjects unknown and unknowable to each other, but in forms of proximity where the inner limit of one is the outer boundary of another. She is using the image of the latest moments of pregnancy in which the fantasising maternal subject and the already sensate infant share not just the physicality of an actual body, but the fantasy-creating space of a perplexing proximity with unknownness. At that borderline, mutually subjectivising effects can occur. This theory, but briefly suggested here, is not a theory exclusively for, or of, women. It concerns the possible signification of this instance of the feminine of which every born person will have traces in their most archaic deposits as a parallel stratum to the subjectivising process presently theorised by psychoanalysis. While it does contain specific psychic and political importance for women, the theory of the matrix is not exclusive to them, any more than the phallus, the primary signifier of subjectivity in a phallocentric organisation of subjectivity, is exclusive to men. The signifiers are effective across the sexes they themselves produce, but they produce differential alignments and possibilities for signifying meanings specific to that difference. A feminine signifier - the matrix – would allow aspects of feminine bodily specificity to filter into the Symbolic, into culture, to allow the relief of signification for those meanings that the phallically dominated Symbolic currently closes off. This specificity is not anatomical or morphological. It concerns the sensorial resources for a fantasy that allows of the 'co-

emergence of the several'. What Irigaray is attempting through her discourse on the much later occurrence of the daughter's other – feminine? – negotiation of loss through the fantasy of 'dancing space', rhythmic sound, non-syntactical utterance can be grasped more definitely through the prism of matrixial theory.

Irigaray insists that because of a relation to an imagined identity that is, none the less, spatially separate – the mother leaves and must be left – a girl does not master separation by the *fort-da* game. 'The daughter has her mother under her skin, secreted in the deep damp intimacy of the body, in the mystery of her relation to gestation, birth and sexuality.'[72] Furthermore, the sexual movement characteristic of the girl is whirling round rather than throwing and pulling objects back as does little Ernst. In trying to reproduce, around and with her, an energetic, circular movement that protects her from abandonment, from attack, depression and loss of self, Irigaray invokes the relation of body to territory in distinction from the mastery of space through the relation of subject to object mediated by syntax and language. Both modes are suggestive for a structural reading of painting – not to produce a reading of men's art versus women's art, but in order to explore different moments and practices which might tend more towards the one than the other, and in doing so open up the possibility of a more productive relation for women artists to this feminine in the space of artistic practice.

These insights need, therefore, to be used carefully. But they are suggestive for reading the artistic moment we call Abstract Expressionism: a form of painting that specifically staged a kind of primal gesturing, an intentionally informal relation between the body of the painter and the things with which the painter works to create a trace of being in that body by its movements in space - both literal and mapped on canvas. If, at a certain level, abstract painting took to its logical conclusion, as Greenberg argued, the fundamentals of the activity – paint, a surface, and, add from Rosenberg, an active, but also *acting* painter – we have the gesture as the articulating sign of that process we call subjectivity.[73] Furthermore, if gesture can be tracked to certain formative moments in the history of the subject – heightened and re-evoked in the Surrealist legacy of 'psychic automatism' which Jackson Pollock and his associates embraced as another method of breaking down the conventions embedded in their practice – and, if the gesture in this formative moment of the subject's history falls along different axes according to the sexually differentiated child's fantasised relation to the mother, then we must begin to speculate on the sexual difference of the traces in the work that is the product of the gesture on the canvas in the studio in that painting practice.

Hans Namuth's photographs make Jackson Pollock appear to dance. Frankenthaler herself stressed his 'choreography.' Photographed from above, Pollock appears like a whirling dervish in the flurry of creative activity as he moves up and down and around the length of his canvas laid out on the floor. But these are ritualised movements that are dictated by the primary activity of throwing the skeins of paint off his stick onto the supine canvas. As B. H. Friedman has unwittingly revealed, Pollock's work conveys more 'insistent and regular rhythms', pulses, that take no little imagination to relate to

masculine sexuality, what T. J. Clark admitted are a 'metaphorics of masculinity'.[74] The shapes of Pollock's canvases reflect this more patterned, syllabic, alternating movement than the squarer or upright rectangular formats characteristic of Helen Frankenthaler's. Pollock's gestures cover over the blankness of the canvas. I am tempted to follow the metaphoric licence typical of Irigaray's writing and heretically propose that the canvas is not just a blank surface awaiting his mark. In psychic fantasy, it is a space, and that evokes the space of the (m)Other.[75] To use the verb to be makes an emphatic statement of what is always in the realm of fantasy and thus the overdetermined site of many possible meanings. Thus the canvas functions as a kind of mirror which, as yet, contains no reflection, signalling either the absence, or the immense self-sufficiency, of the Other in relation to which the subject is always being constituted. This Other is not a person, but culture, language, yet the complex and evolving relation with the mother is both the mediator of this necessary relation to a non-personnified Other, whose purely symbolic place the (Name-of-the-)Father will later support. At the same time, that indifferent Otherness of the blank canvas threatens to overwhelm, if not wipe out, the emerging subject, its unmarked perfection signifiying the absence, even the death of that would-be-subject. Recall Ernst's game of appearing and disappearing in the mirror – a game repeatedly acting out his own feared death and its disavowal. Any painting that results from such a staging of the encounter of artist and canvas as a field, as a territory of the (m)Other, is the product of the risk, experienced in that procedure, that what the painter threw from his stick, was also part of himself, and that, what he covered, was his own absence/non-sense. At the same time, there is the equal possibility that what he covered was the m(O)ther, what he mastered was her absence,[76] and what he distanced was her engulfing presence, separation from which is the necessary condition of the would-be-subject's existence as subject. The passage of both self and (m)Other into object - the painting - and their negotiated differentiation is the product of this psychic formation when, for art historical reasons, the process of painting is made the exclusive preoccupation of the practice. What may be implicit in all painting – from the point of view of this specific interest in psychic deposits in cultural practice – is foregrounded at the moment when 'the law of modernism' exposes the structural basis of painting, 'to be steeped in its own cause', while releasing, through movement in painting, and the extended scale of the gesture made by an entire body, its latent psychic dynamic – loss, death, disavowal.[77] When we confront a painting by Jackson Pollock, we confront the energy of that couvade, that relentless pacing, covering, knotting a surface of his own making and a sealing over the threatening surface of the once blank canvas. Surface becomes lid, the heavily worked covering that overlays the ghost of the corpse in the tomb – a ghost that always threatens to rise up and haunt even the most abstract work with anthropomorphic hallucinations.

I am not suggesting a literal superimposition of cotton reels and strings onto Jackson Pollock's painting practice. But I want to insist upon the aggressivity involved in the process Freud identified when watching his grandson play: it may be said, a little

metaphorically, that in mastering through play and investing objects with the potential to cover over a threatening absence, and to disavow lack in order to prevent oneself dying, one could become, symbolically, a 'killing man'. There may lie some of the violence and the sadism that so-called Abstract Expressionist painting practices liberated; not in the (un)conscious misogyny of individual men whose mothers messed up their heads – as is implied in many of the Pollock or de Kooning biographies. It lies in a structural condition of modern masculinity to which a certain painting practice gave an aesthetic form.[78]

Helen Frankenthaler's practice 'played' in and on that same space – unframed canvas on floor of large studio – but it may be useful to view it through the prism of sexual difference: to allow for the possibility of a differentiating and thus differentiated relation to absence, and the loss of the maternal body. Is her innovation, with stain and soak, with annulling the material distinction between her mark and the canvas's surface by the immersion of the one in the other and the loss of fixed boundaries, the site of an inscription of the feminine dimension of loss and separation? Irigaray has written:

> Woman always speaks *with* the mother, man speaks in her absence. This *with* her obviously takes different shapes and it must seek to place speech *between*, not to remain in an indissociable fusion, with the women woven together. This *with* has to try and become a *with self*. Mother and daughter turn around each other, they go up and down while encircling themselves but they also delineate two entities that they are: in the lips, the hands, the eyes.[79]

Frankenthaler produced paintings that are not tangled skeins, nor webs and veils – that is whatever Morris Lewis took from her and returned to Pollock. With colour and surface oscillating as one and yet other, she created space through the ambiguities of colour saturation and hue. Out of those spaces emerge, often joyously, humorous and jouissant spectres of figures which are, by the artist's retrospective titling, maternally connoted: for instance *Mother Goose Melody* (1959) and *Nude* (1958; fig. 53).

In this painting, Frankenthaler has poured, stained and spread paint in ways that leave much of the central area of the canvas blank. This almost empty space reads, none the less, as a figure, a maternal nude that, with no little humour, exists upon the canvas as if the painter merely allowed her to emerge from the ground into a visibility that, does not, however, detach her from that ground. It is through colour and the ambiguous play between the absence and presence of the painted mark that the painter allowed the 'mother'/Other to be. Not viciously covered, strangled, trapped, or wrenched into or out of shape as we find in the paintings of *Woman* by de Kooning (fig. 56), a reference to a female body has been made visible and yet 'she' is not there. 'She' is not only absent, the effect of where the traces of the artist's gestures have not stained the surface, but 'she' is imaged as absence. 'She' is what is left untouched, the negative space of where the painter has not been gives her an allusive form. We have the painter's marks and the pools of paint and we have a mirage. Signs of the painter and the image she has not

Fig. 53
Helen Frankenthaler,
Nude, 1958.
Oil on canvas,
252.5cm x 95cm.
Collection of the Artist.
© Helen Frankenthaler

painted coexist and co-emerge in an oscillation that draws attention to the fundamental play in painting between its presence as material and medium and its ability to suggest it is the means of delivering into image a phantasm of something in the world or from the imagination.[80] I am tempted to read this form of ambiguity in terms of Irigarayan notions of the feminine as the specific evocation of playing with making a symbolic space in which the (m)Other is not lost and the one does not have to die for the other to be. 'Girls describe a space around themselves rather than displacing a substitute object from one place to another.'[81]

There is a fundamental flaw in this argument as presented. I seem to be setting up the possibility of a painting practice that is not caught up in the logic of *fort-da*. Alison Rowley has suggested that painting cannot but be part of that process of substitution.[82] The very conditions of 'material there/not thereness, the mark/no mark, form/no form of the paint on canvas' places all painting into that 'phallic' on/off field. In a sustained psychoanalytical analysis of this very artistic/theoretical problem of painting, *The Matrixial Gaze*, Bracha Lichtenberg Ettinger examines the varieties of theories that struggle to analyse the implications of *fort-da*: Lyotard and his *figure-matrice*, Fédida's *objeu* (a word play on object (*objet*) and play (*jeu*) in French).[83] These attempts explore the very conditions of meaning and subjectivity in a kind of pulsional scansion of the play of presence and absence. Fédida argues: 'It is perhaps *the mother as repetition* [...] *repetition as the mother!*' and,

> What we call meaning is engendered by the play of absence-presence [...] It is not enough to say that the reel play is the active staging of a repetition passively experienced by the child (Freud leads us to this interpretation): there is no play possible without the rupture (disjunction) introduced here in the repetition and aided by the enacting of this repetition...[...] What's important is the discovery of meaning as absence and the play finds its strength in the creation of the effect of absence's meaning.[84]

This Bracha Lichtenberg Ettinger glosses: 'The absence of the mother is painful by what she leaves behind when she is no longer there, that is a repetition wherein even play is impossible because the *I* finds itself subjected to the mother's active absence...'. Lichtenberg Ettinger intends to explore another possibility for painting as play/work in this domain.[85] In these negotiations of the limits of absence/presence as the condition of meaning Lichtenberg Ettinger sees what she calls 'post-natal offspring of the matrix'.

> The matrixial gaze emerges by a simultaneous reversal of with-in and with-out (and does not represent an eternal inside[86]), by the transgression of borderlinks manifested in the contact with-in/-out an artwork by a transcendence of the sub-ject-object interval *which is not a fusion*, since it is based on an a-priori *shareability in difference*. In the matrixial aesthetic experience, 'relations without

relating' transform the unknown Other into a still unknown partial subject with-
in an encounter. The subject's relations with the Other do not turn it into a
known object, swallowed or fused, rejected or abjected. The *non-I* as a subject
changes me while *I* changes it; all participants are receiving and investing libido
with-in and with-out the joint process of change itself – the metramorphosis –
with-in and with-out their common borderspace... In metramorphosis, the fluidity
of experience puts both partial subjects in a reciprocity without symmetry, in
which both transform and are transformed by one another differently, creating
joint eroticised aerials... creating matrixial desire.[87]

Matrix and its figure, metramorphosis, co-exist with the phallus and its figures,
metaphor and metonymy, and thus such a feminist argument inhibits us from placing
Pollock on one side and Frankenthaler on the other as representatives of masculine and
feminine styles of painting or types of subject. Instead these theorisations allow us to
draw out from paintings the different registers on which they were formed and through
which they form us as we view them. The painting is always a substitution, an already
displaced site of a play that itself is already a metaphor for the process of negotiating
meaning through absence. Yet, it can also be the place for an interference from another
level or stratum of matrixial subjectivity that co-exists with the phallic organisation,
even though phallic culture and its theories of both meaning and the subject have
repressed its recognition. It is a matrixial insight that allows the co-existence of both the
proposition that painting as an activity is ruled by the logic of *fort-da* and one open to
this transgression of the borderlines which intimates this other management of
difference through the joint borderspace where several partial-subjects almost encounter
each other at the spot of the painter's touch at the limits of the visible – even though that
gesture, in a phallic prism, enacts the mark/no mark, on/off logic of the phallic order of
signification and subjectivity.

The theoretical issues around painting and sexual difference do not end here. Indeed
this debate only opens up a necessity to undo the very fixities of gender that have
haunted this essay even while I have been searching for ways of specifying a route for
'the feminine' into painting. I want now to come at the problem from another, though
still psychoanalytical direction.

7

IS THE ARTIST HYSTERICAL?

In her study of semiotic and psychoanalytic contributions to the analysis of painting, Claire Pajaczkowska reminds us why we might need to approach historical painting practices through this kind of theory by citing Roman Jacobson's 1921 critique of art history as gossip:

> Not so long ago, art history and in particular the history of literature was not yet a science, but rather gossip. It obeyed all the laws of gossip; it moved cheerily from one theme to another and the lyrical flood of words on the elegance of the form gave place to anecdotes drawn from the artist's life. Psychological truisms alternated with problems related to the philosophical basis of the work and to problems about the social milieu [...] Gossip does not have a precise terminology [...] Thus art history knew no scientific terminology since it used words from the common everyday parlance without first critically screening them.[88]

I cite this passage at length because I have been so struck when researching painting in the 1950s by the wealth of gossip about the artists, their dealers, their marriages and friends. So immense is the wealth of anecdotal detail – interviews, oral history and plain old-fashioned gossip – that I felt I would sink under the unmanageable weight of all the words that rarely touched on the question of the structure, necessity or affect of painting except in lyrical celebrations of the formal innovations that served to celebrate the greatness of the always male artists. Like Jacobson, I think we need to push art history beyond gossip, and struggle to theorise artistic practices in addition to studying their social and historical conditions of existence.

Pajaczkowska introduces a range of French semiotic and psychoanalytical theories about painting that remain little studied within the English language academic community.[89] The application of semiotics and structuralism to the question of Western painting was initially premised on the model of language and approached painting as akin to a verbal signifying system. While enabling us to discern in figurative painting an organisation of signifieds in something similar to the structure of myth that Lévi-Strauss identified, such a semiotic treatment of painting fails, according to Pajaczkowska, to address the processes and material resources of painting. It also ignores the psychic freight these may not only carry, but which may be the driving force behind their emergence into visibility as not only the resource for, but the topic of, the practice of painting in the mid-twentieth century.

Pajaczkowska, therefore, introduces another thread from psychoanalytic theories of modern painting, notably as proposed by Guy Rosolato and his successor, Julia Kristeva.

In contrast to Freud, who believed that of all the psychic structures, that of neurosis, and particularly hysteria, was relevant to the study of art, Guy Rosolato has argued that art might be better understood through the psychic structure of perversion; and a particular form of it, fetishism. Fetishism is a dynamic psychic process, a fundamental oscillation between knowing and not knowing, between threat and its disavowal, between surface and depth. It works between the two poles of meaning: metaphor, in that the fetish stands for that which is absent, the mother's penis; and metonym, in that erecting a fetish to veil this lack makes the fetish contiguous with the lack so that the fetish always commemorates – indexes – what it metaphorically tries to disavow by substitution. The art work is a fetish that displaces absence while the practice of art as repetition marks its very spot.

What about the pleasures – what Rosolato calls the jubilation and fascination – of art? Rosolato argued that pleasure arises for both artist and spectator in *identification*. Pleasure in art derives from the point at which an art work offers a moment of stabilisation of the relations of the subject to the unconscious and beyond that to the unsignified and unsignifiable body, a realm of non-sense. This links art-making to yet another psychic structure: the formation of the ego in the mirror phase, that Lacan has theorised as a metaphor for the ways in which the infant is drawn into becoming a (potential) subject. Lacan famously argued that a subject-to-be acquires the possibility of an ego through a complex encounter with a plane/surface and an imago on it, in the mirror. In this fiction of the repeated encounter with literal or metaphoric mirrors – the mother's face and gaze, the culture's representations to the child – there are many threads and paradoxes rather than any simple moment of recognition. In the mirror phase there is alienation in so far as the image that the putative subject must embrace as the imaginary container within which to situate an ego – a composed and cohering I – comes from outside, from the place/the space and surface of the Other.[90] Hence there is splitting between the site of the subject and the sight or image that will alone allow the subject to come into being as a fictive boundaried image within which its uncontained drives and sensations will be localised and the possibility of an identity – a difference from the other – will be always precariously stabilised.

The mirror phase involves misrecognition through the idealisation of the imago as more complete and potent than the viewing proto-subject senses itself to be, because it is still radically dependent on others around it and so physically immature. The subject-to-be 'identifies' with that which is other, as a more perfect *ideal* ego, and takes it in as an *identification* around which to build an ego. Finally, because it is other, there is a certain aggressivity towards this image, that can be turned back on the subject, or against the image, predicting a dynamic struggle at this site – or any site or situation that evokes the structuring moment of the mirror phase, such as the screen of cinema or the canvas of the painting.[91]

Another layer of Rosolato's analysis of the structure and pleasure of art is the question of authorship. Every time artists sign a painting, they make a claim to

authorship. In patriarchal culture, this is a claim to paternity, and thus an insertion of the name into the Symbolic Order which operates under the Name of the [Dead] Father. Authorship is the point at which the person painting makes a claim for a stabilisation of a self in the work that can sustain the fiction of an author identity, so as to be acknowledged an artist. Authorship is thus, paradoxically, a reinvention of that law of the Father. For Rosolato, making art is a transformation of rules and representations that up to that point have held authoritative status within the community of culture. But transgression of the rule is itself the law of the father. Freud argued in *Totem and Taboo* that killing the father is the very means by which the law of the Father is installed.[92] In the paradox of patriarchal culture founded on what Freud called 'the common crime', the more you kill the father, the more Symbolic he becomes, the more that killing affirms his authority, or rather, authority and law in the paternal name.

Art history provides a narrative of great men in a succession of male genius. This lineage reaffirms the murderous rivalry of men with their father/artists, and its psychic freight might suggest how and why that narrative has become so tenaciously canonical and impenetrably masculine. Thus we might also read the modernist avant-garde's rule of transgression as a transparent moment of the paradox of phallocentrism in art: the more men kill men, the more powerful their Symbolic, phallocentric order becomes. Avant-gardist transgression is not merely idealist play; and it is certainly not implicitly radical or revolutionary. It conforms to the engine of the Symbolic law which is played out by the Oedipal son over his mother's disappeared body and beneath his ever-resurrected dead Symbolic Father's gaze. In this sense, the difficulty feminist art historians experience when trying to accommodate women's artistic practices within modernism is revealed as a contest with another, structural sexism, embedded in the very notion of vanguardist rivalry and progress.

Let me back-track a bit and see how we could insert a different sexual narrative. According to Rosolato, what provides pleasure in art is the way in which painting allows movement between several points: a) 'the body' – or rather the drives and pulsions of a chaotic corporeality – which is in a state of non-sense, unsignified; and b) the unconscious, where meaning is fashioned through fantasy; and finally, c) the realm of symbolically articulated, culturally recognised thought and communicable meaning. Painting provides specific and intense pleasures precisely because, in its modernist forms, it allows so precisely for play between these registers through its simultaneous operation as both metaphor and metonym. According to Rosolato, its pleasures derive from the movement which carries the work from the realms of bodily non-sense and unconscious fantasy toward systematised meaning. A new, historically and aesthetically particular pleasure arises when that movement is finely balanced between the first two points and does not actually arrive at the final destination of symbolic meaning. There is an anecdote that illustrates this abstract idea in a concrete instance. We are told that after a day's painting, Jackson Pollock would invite Lee Krasner into his studio, asking her to review his day's work and decide: is this a painting? (fig. 54). In a practice that

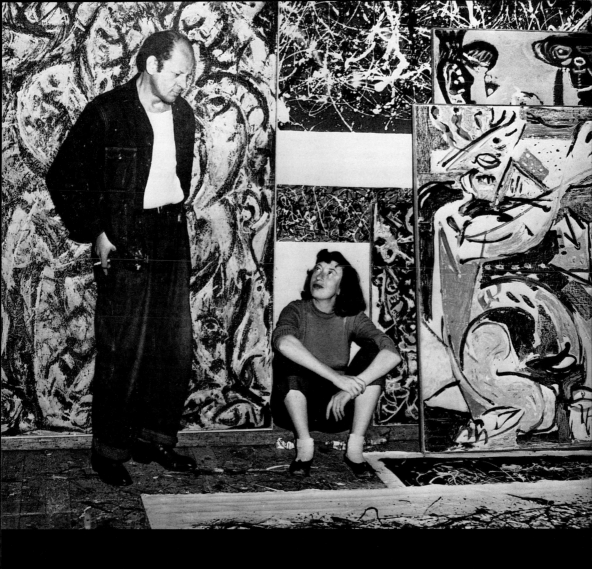

Fig. 54
Lawrence Larkin, *Jackson Pollock and Lee Krasner in Pollock's Studio*, 1949.
Photography by Lawrence Larkin, 1949. Pollock-Krasner Home and Study Center,
East Hampton, N.Y.

specifically aimed to avoid figuration and iconic representation, that tried to dump the load of tradition that tied painting to a metaphoric status with regard to a presumed world to which it can refer, that tried to stay closer to the very gestures and movements, rhythms, pulsions and colours that are painting's *arche* materials, the question is genuine and interesting. It means, does what has happened today on my canvas stabilise at a point that, without becoming metaphoric – this expresses that; this refers to that out there – can provide something to hold an identification and can offer a *jouissant*, jubilant pleasure in the precarious balance it sustains between stability and flux, between the realm of potential sense, inviting interpretations that are deadly to this pleasure, and the domain of non-sense, that is threatening in its potential slide towards the place where the subject disappears.

This movement passes through a range of signifying or rather, to introduce a little prematurely the work of Rosolato's follower, Julia Kristeva, semiotic elements, from traces or marks, to the early patterning of rhythm, on through to pictograms – archaic images – and fuller pictorialisation and finally onto symbolisation. This allows us to theorise the gossip around artists such as Jackson Pollock and Lee Krasner about their ambition to use painting to liberate the unconscious. By this vague invocation, I think, they were trying to find a working method that allowed them to operate in the seemingly more open zones, inhibiting pictorialisation and symbolisation while privileging those elements of the practice that stayed closer to trace and rhythm, calligraphy, and to the drives and the way things are put together in unconscious fantasies. These artists were not painting anything external and did not want their paintings to end up being treated as symbols, as metaphors for the Cold War, fear of nuclear disaster, democratic freedom, machismo or femininity. We could argue that the very process of painting that they invented and practised remained closer to the pole of metonym, that is, of contiguity with the painting body and indexicality to the subject-on-trial,[93] rather than moving towards the level of displacement as metaphor or symbol. So we would seek in vain to say what these paintings mean at the usual level of social or historical interpretation. Their meaning operates at what Rosolato insisted was the non-dialectical oscillation the painters strove to maintain between the metonymic and metaphoric axes characteristic of painting at a structural level. The developed artistic practice for which Pollock was recognised in the early 1950s – the drip paintings of 1948-51 – can be read as a process where painting acted as a filter for deposits from the bodily strata of sensate memories and from the unconscious zone of fantasy. The painter, however, participated in a culturally recognised semiotic system, and designated his vanguardist authorship by being able to recognise at what stage such a painting practice could deliver pleasure by aesthetically or formally stabilising a viewing relation to those bodily and unconscious elements it indexed through its pulsional, rhythmically deposited traces of the subjectivity-in-action. The viewer, including the artist as first viewer, could enjoy a managed identification, not with an image (echoes of the mirror phase), but with the field that constantly opens the relay between metaphoric possibilties of stability and

metonymic traces of the other scene that promises different pleasures. This involves, however, the risk of unravelling subjectivity, so each move towards these pleasures might also need at times to be fetishistically disavowed. Thus the play of *painting* as process might need to be ended with the completion and signing of a painting.

At this point, you, the reader, must endure yet one more turn of the theoretical screw. Painting, especially in the traditions of figurative representation in the West, served as a kind of doubling; a repetition of the mirror phase that is also the transformed mirror in which the act of mirroring is represented and the ego jubilantly finds itself with an identity through which to stabilise itself by seeing a perspectively organised, delineated and anthropomorphic world. But remember the mirror game played by Freud's little grandson Ernst that Freud related to the death drive, to the problem of separation from the mother which haunts us in the drive to return to the state of stasis, inanimate and even dead. The third stage of the game played out between child and mirror was a play with death, not just his mother's through absence, but his own. This game established the separateness of the boy and supplied him with a fantasy of its always dangerous mastery. The forms of the game, however, articulated his expulsion from the mother's space, from her body as both space and limit, by mapping both into an object, a substitute, be it toy or word, modelled, according to Irigaray, on a phallic logic.[94] Being, for a subject construed 'in the masculine', is sustained at the price of that expulsion. Rosolato called art perverse, fetishistic, an insight which indicates the continuing necessity to stall this being-threatening recognition of difference and loss for the child that will be, within the patriarchal order, designated as masculine.

But what of Freud's original suggestion that a different psychic formation, hysteria, offers a model for understanding the artist? Consideration of another possibility might allow a less rigidly masculinist account of art since it is generally agreed that fetishism is not a major feminine perversion. Hysteria, not only connected historically with the feminine, is, in addition, related to questions of life and death, as Elizabeth Bronfen has shown in a recent paper on Cindy Sherman.[95] The hysteric poses the question of subjectivity. The hysteric puts the subject of sexual difference on trial by asking: what am I? Man or Woman? which also questions: Animate or Inanimate? Alive or Dead? Hysteria would be a way for, and a sign of, a kind of fantasmatic bisexuality, or rather, a suspension of the patriarchal law of sex, a momentary refusal of any stabilisation of identity as a sexual identity, a possible place of play and oscillation. For a female hysteric, hysteria is a refusal to be confined within the cipher of the 'feminine' under a patriarchal law; for the masculine subject, however, hysteria allows a recovered identification with the mother from which he, as a 'he', has been expelled as the price of having an imaginary relation of possession to the paternal phallus. Being an artist must involve some fantastic connection with the maternal, creative specificity of the female body. Thus Claire Pajaczkowska concludes: 'If authorship means paternity, "being an artist" is a compromise identity forged by the adult male ego as a way of mediating a fantasy of being a woman and of creating, and "art" is male hysteria

institutionalised and contained within representation.' [96]

Representation as canonical art history has institutionalised is, however, a world orchestrated by psychic desires, traumas and drives of the masculine subject. Made to the measure of masculine fantasy, it has gained hegemonic status. This then determines the very terms within which we are obliged to be creatively male or female. Women artists have been placed not only in an asymmetrical relation to the art world/world in representation because of the current ordering of sexual difference and whatever specificity that might imply, but they are positioned dissymmetrically both to the figurations of femininity within the culture, and to the figurations of artistic identity which hysterically appropriate both parental figures, maternal and paternal. The very theory that enables us to see this, also allows us to break down the ideological fixing of a binary system of sexual identity – art history's hegemonic attachment and neutralising universalisation of masculinity – so that the masculine process in artistic practice looks less fetishistic and is conceived as hysterical, unstable in its relation to a gender position. This move opens up a gap wherein we can glimpse how a subject 'in the feminine' orchestrates her hysteria, her unstable and creatively destabilising relations to both maternal femininity and paternal law into creativity.

At the beginning of this essay, I proposed a very fixed, binary and fetishistic opposition of sex symbol and art symbol: Marilyn and Jackson, movie icon and artist. The suggestion that masculine art is a form of male hysteria, that it might contain a destabilising of the fixity of masculine subjectivity in relation to the maternal in the same move as it inscribes once again the paternal law through avant-gardist rivalry, opens up the unfixity of sexual identity for us to consider the play around women's bodily and fantastic inscriptions in the texts of culture.[97] We thus discover a way to theorise the practices of painting in their historical and stylistic diversity as a kind of staging of the drama of the subject. What is produced is not a style or an object; but a moment of identity, which, in the male canon, has been achieved only through the encounter with and specific negotiation of sexual difference, that is with the constituting symbols of sex in Western culture: the mother and the father. If we relate the canvas, the material resources like colour and the gesture to the framing psychic relations within which identity is shaped – the fantastic figures of the mother and the father – we can ask what is going on within a *feminine* subject-on-trial on this stage. By including Freud's work on art as hysterical, within the larger psychoanalytical framework, it is possible to see the drama of art as the drama of sexual difference through which there will be several possible individual trajectories, indeed in the end, as many as there are artists. Thus we can escape the perennial trap, when discussing the impact of sexual difference, of determining all artists as merely exemplars of its asymmetrically polar terms: Artist/Woman Artist. Being an artist 'in the feminine', working in a practice that opens up historical and aesthetic possibilities of 'inscriptions in and from the feminine', does not reduce Helen Frankenthaler or Lee Krasner to 'being women'. Their work is instead made legible, as it plays on this historical stage when the semiotics of artistic practice

within modernist painting opened up the very questions of identity, pleasure and difference in which the bodily and the psychic traces of the produced but always unravelling subject of sexual difference could reconfigure their relations in and through painting.

Thus instead of leaving unchallenged and unreconstructed the dominant narratives of Abstract Expressionism in order to make a sideways move off the map of serious art history to consider women artists, I hope to have redefined the central playing field. The binary opposition of sex symbol and art symbol is revealed as an ideological fixing of processes, that, in the studios where Abstract Expressionist or American-type painting was being made, may have been far less stable – or at least differently orchestrated. This alone allows us to understand modernist women painters' investment in the protocols of modernist painting; to grasp their embrace of that extraordinary practice which is painting that women like Helen Frankenthaler and Lee Krasner and so many others did, day in day out, for a lifetime. These women of the 1950s were drawn to practices of painting that structurally opened up spaces for the exploration of what had not yet been inscribed through that process – an invitation existing in the synonymity of *énoncé* and *énonciation*, of what is said and the means of saying of it, representation as the process itself.

They practised, however, in an art world that, shaped in the ideological polarities of the moment, was barefacedly misogynist. Curators, gallery owners, critics, other artists created an ambience that was not only masculinist, but virilist and sexist. Part of that culture was imaged through its popular icons, of whom the central sign and symbol was Marilyn Monroe. She was the fetish supreme, all perfected shiny, glossy surface. We need to pierce that carapace both to return her to her body and subjectivity, to get to Lee Krasner, who as a painter was closest to Pollock and was thus – artistically – in mortal danger, and, finally, to get to the maternal body buried in her art that *Prophecy* fearfully presaged and *Sun Woman I* (figs 38 & 39) allusively contacted.

8

MASSACRED WOMEN DON'T MAKE ME LAUGH

In her essay 'A New Type of Intellectual: The Dissident', first published in 1977, Julia Kristeva identified several types of modern dissidence that stand in opposition to the assimilation of the intellectual to the modern establishment of power. The rebel attacks political power. The psychoanalyst wages a contest between death and discourse and finds his archetypal rival in religion. The writer (we might add artist) experiments at the limits of identity, shifting the relations of law and desire by stripping the latter down to

its basic structure: Kristeva calls this rhythm, the conjunction of body and music. But from these three spaces of politics, analysis and art/writing, Woman is absent because she represents a fourth kind of dissidence. 'Woman' does not mean female people in the social sense. 'Woman' is a sign within the ordering of sexual difference that manages the potentialities of humans as corporeal, psycho-symbolic entities within historically shaped, social and semiotic forms. Woman, that is, sexual difference, is a particular moment of historical dissidence because it is as 'woman' that we who are named women encounter as writers, analysts or political rebels the intransigence of a patriarchal ordering of this difference. Because of her specific potentialities in sexuality and through maternity, those under the sign Woman are caught up, according to Kristeva, with what she calls divine law, death and religion in opposition to human law, government, politics, ethics. This results from Woman being in touch with death through her role in life: that is through reproduction. From the point of view of human, patriarchal law, Woman is thus a kind of exile – who, when captured for its social forms, is made either into the demonic image of the witch (*femme fatale*, movie star, name her as you wish) or targeted to for total assimilation to the existing order. We can either join in by trying to be the President, or singing Happy Birthday to the man in a dress so tight she had to be sewn into it (fig. 55). This tension is a result of the lack of a language in which to speak of childbirth, of the specificity of those processes that both provide the structure of particular feminine experience and erase all subjectivity in an encounter with an other than is literally within. Thus Kristeva concludes:

> Under these conditions female 'creation' cannot be taken for granted. It can be said that artistic creation always feeds on an identification, or rivalry with what is presumed to be the mother's *jouissance* (which has nothing agreeable about it). This is why one of the most accurate representations of creation, that is, of artistic practice, is a series of paintings by de Kooning entitled *Women* [sic]: savage, explosive, funny, inaccessible creatures in spite of the fact they have been massacred by the artist. But what if they had been created by a woman? Obviously she would have had to deal with her own mother, and therefore with herself which is a lot less funny.[98]

This comment has fascinated and appalled me for years. It is useful because of the direct link between the kind of feminist theory I have been using and the American painting of the 1950s. My reading of Frankenthaler's joyous and humorous paintings of the 1950s, I hope, belies the idea that women cannot deal with their mothers or themselves pleasurably. But it's the idea of killing men, men killing women in their art being funny that I resolutely cannot handle. De Kooning's paintings stand at the opposite pole to that at which I have tried to situate Pollock's dripped canvases. In the *Woman* series there is less metonomy and more metaphor. There is an image: *Woman* (fig. 56). The paint, however, retains a powerful indexicality to the bodily intensity of the gestures and physical movements of the artist as he produced on canvas this

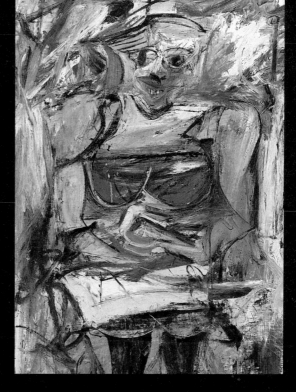

Fig. 56
Willem de Kooning *Woman V*
1952-3. 154.5 x 114.5cm.
Canberra, National Gallery of Art.

monstrous form, with seering, toothy, blood-red smile and stark, staring eyes. The feminist art critic Cindy Nemser had a conversation with the painter Grace Hartigan about these paintings, expressing a straightforward feminist distaste for the violence perceived in de Kooning's interpretation of women. Grace Hartigan disagreed.

> The violence is in the paint. De Kooning's women are very loving. Since imagery became part of my work I became closer to de Kooning than to Pollock. I saw most of those women being created in Bill's studio and we were very good friends. When those first women – those fifties women – were shown I had a big argument wth Jim Fitzsimmons who is the editor of *Art International*. He said they were destructive, that it was hatred, Kali, the blood goddess. He pointed to one painting that had big palette knife strokes slithering across the chest and said 'Look, De Kooning is wounding her with blood'. So I went to Bill and I said, 'Jim Fitzsimmons said you stabbed that woman and that is blood.' Bill said 'Blood? I thought it was rubies.'[99]

Nemser then suggests that there might be unconscious impulses behind an artist's actions, but Grace will have none of it. 'No one is going to convince me that Bill de Kooning does not love women.'[100] I think one could make a case with the paintings either way. Like Picasso, de Kooning clearly loved 'cutting up women', to borrow a phrase from the ever insightful and much lamented Angela Carter. At the same time, to get back to dying women and killing men, I could put forward an argument about men killing the fetish. Laura Mulvey has suggested that Hollywood cinema at its height in the 1950s condensed the fetishism of the commodity and the psychic economy of fetishism into the spectacle signified by the image of woman on screen. Woman as spectacle is all surface, all appearance, but turn the psychic screw of fetishism and this image is all threat. Marilyn Monroe's exceptional appeal lay in the cosmetically and chemically achieved allaying of that threat by the combination of her excessive sexuality with a delectable goodness: like vanilla ice-cream as Norman Mailer put it.[101] She is the funny, inaccessible creature that was massacred by culture. De Kooning's series of *Woman* paintings, which include one named *Marilyn Monroe* (fig. 45), clearly bring together the legacy of Picasso's cut-up women and the iconic objectification of woman in the blood red lips that are the displaced and violated sign of her 'wound'.[102] De Kooning uses Picasso to allow him to cut the female open so that out comes, not vanilla ice-cream, but ruby red blood, her jewels. The ambiguity of these images lies precisely in their oscillation between metonymic and metaphoric figuration of female sexuality on the one hand, and of masculine castration fantasies on the other. In a sense the shock offered by de Kooning's paintings that so polarises opinion about them is that they are so *little* fetishised. They expose the female body. They give it so frankly a sex – yet in so displaced and disavowed a fashion – rubies? blood? They bluntly imagine an interior. Yet they are made from a massively built up density of paint. 'The violence is in the paint.' But the signature, the gesture in the paint, makes such revelations a violent

disrobing. We cannot escape the aptness of Julia Kristeva's notion of a massacre. Killing men/dying women.

9

INSIDE MARILYN MONROE

If Marilyn Monroe was the icon in part behind the series *Woman*, we need to get beyond de Kooning's 'covering exposure'. No woman can look at either the image of Marilyn, or her replicas like Jayne Mansfield, without pain. For all the gloriousness of their dramatic skills and exceptional beauty as women, the torturing of their bodies and the total neglect of their souls – to quote Rossetti – makes for a profound and contradictory anguish as we watch the fetishistic, tied up, distortions that betray the sadistic culture from which Monroe died metaphorically even if her death was but the unfortunate accident of bad medical supervision.[103] Marilyn Monroe said:

> The truth is I've never fooled anyone. I've let men sometimes fool themselves. Men sometimes did not bother to find out who and what I was. Instead they would invent a character for me. I wouldn't argue with them. They were obviously loving someone I wasn't. When they found this out, they would blame me for disillusioning them – and fooling them.[104]

Graham McCann cites this comment in a sociological study that tries to be another kind of biography, one that recognises the author as part of the text and of the problem, while also wanting to allow Marilyn Monroe, the body, a voice. But, unexpectedly, McCann's text also allows Monroe another kind of body, with a specific sexual interiority. McCann chronicles with tenderness Marilyn Monroe's desires and difficulties in having a child. Monroe suffered very badly from an extremely distressing condition called endometriosis.[105] Part of the lining of the womb colonises others parts of the internal organs, and as the hormonal cycle causes this blood-enriched surface to engorge and then be shed, the woman suffers agonising menstrual pain throughout her abdominal region. This condition radically impairs the chances of successful conception and sustained pregnancy. Monroe underwent many abortions. At times she wanted to be pregnant yet she suffered several miscarriages and ectopic pregnancies all of which involved repeated hospitalisation, and mourning.

Miscarriage is a very bland word for the experience of losing a wanted baby in early pregnancy. All the hopes and dreams that are released when a desired pregnancy is discovered grow quite out of proportion to the size of the tiny embryo burrowing its way into the cavities of one's loving yet alien and uncontrollable body. The failure of

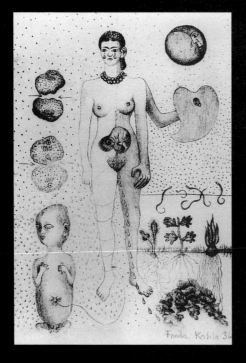

Fig. 57
Frida Kahlo, *Frida and the Miscarriage*,
1932. Lithograph, 31 x 23 cm. Dolores
Olmedo Foundation, Mexico City. Photo
Mary-Anne Martin Fine Arts, New York

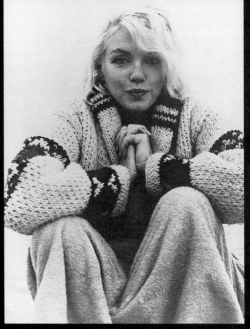

Fig. 58
George Barris, *Marilyn
Monroe*, 1962. This is
called the last photograph
ever taken of Monroe
World Copyright: George
Barris, U.S.A.

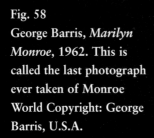

Fig. 59
Lee Krasner in Hans Hofmann's Studio,
early 1940s

one's physiology to sustain a wanted pregnancy unleashes the pain of a disappointment that is experienced by a feminine subject as her failing as a woman. Losing one's potential motherhood replays the very loss of the mother that, through sharing her bodily capacity for childbirth, pregnancy fantasmatically repairs. In miscarriage, against her will, the body destroys the nestling child that the mother-in-hope has already so richly fantasised as her desired and restoring other. Is it a murder of another – a killing woman or a moment of dying as a woman?

Procreative failure and its attendant grief, loss of self and depression are radically ignored in our culture. There are almost no representations of it – apart from some striking paintings and drawings by Frida Kahlo (fig. 57). These exteriorise in fantastic forms elements of a female bodily interior as well as a psychic, or imaginary internal world of objects and images. But Kahlo's images are exceptional. There is a silence as profound amongst women about miscarriage, for it is so fearful a process that it is hardly spoken of for fear of frightening others, turning this culturally endorsed celebration of our function as bearers of new life into a narrative of death, despair and the challenge to female sexual identity. Having lived through three miscarriages to dare to tell the deadly tale, I feel an empathy for this historical icon, Marilyn Monroe, when I read of this other Monroe body, with living, and dying interior. Empathy, whether historically justified or not, breaks through the carapace of the fetishised image to a woman doubled up with menstrual pain that the studios dismissed as malingering and lack of professionalism, to a woman weeping in the hospital bed for yet another child she had lost, for yet another lost chance to repair the loss of her own mother through the mothering of the baby she might have borne.[106] This narrative of her longings and losses brings into focus a different female body from the caricature the costume designers created for her: a woman with knock knees and quite small breasts. It forces into shocking conjunction the body of the sex symbol and the body of the would-be mother, the bleeding, miscarrying site of death and mourning. What would an old Marilyn Monroe have been like (fig. 58)?

> I want to grow old without face-lifts. They take the life out of a face, the charac-
> ter. I want to have the courage to be loyal to the face I've made. Sometimes I
> think it would be easier to avoid old age, to die young, but then you'd never
> complete your life, would you? You'd never wholly know yourself.[107]

While the drunken man killed himself, and the dyed lady was killed by her doctors, 'female creators' (Kristeva) survived a culture that did its best to kill them by denying them any representational support or symbolic acknowledgement. It falls to us to grasp Mulvey's idea of creative curiosity and break open Pandora's box – smashing the fetished artifice of Woman and letting through to the surface of culture's texts our desire to know about femininity – its pleasures, fascinations and, at times, its killing humour.

10
DANCING SPACE

Lee Krasner – From Prophecy to Sun Woman

Bataille's idea of artistic progress through murder finally converges on women painters of the 1950s knowing that they wanted to be part of a project that included the painting of Pollock and de Kooning. These men would have to be dealt with – what they were doing was important, interesting, necessary for anyone who wanted to be part of this ambitious moment. Yet how would an artist who was a woman prevent them from overwhelming the resources from which a woman must create and separate? I suggest that a brief and final view of Lee Krasner's painting will reveal that she was a good *Bataillist*: she took on the others' work and killed it, right there, on her canvas – but with such radically different effects that it has awaited feminism to allow us to read that event as differentiating realignment within that artistic moment and not lack or diversion from it.

We see Lee Krasner here photographed at work in Hans Hofman's studio (fig. 59). She appears as a dedicated student of abstract art, standing in front of her heavily outlined, post-Picasso, de Stijl coloured, abstracted still-life composition, assertive, determined, momentarily interrupted in her work as she turns and looks, without aggression, but with a certain tension or intensity, at the photographer. The picture dates from the early 1940s by which time Krasner had produced a mural for the WPA and had joined the asssociation of Abstract Artists of America. Her paintings in this idiom are very accomplished, intense in colour. They reveal an immense understanding of the various vocabularies of abstract and cubist art on offer in the then still influential School of Paris which was increasingly fertilising New York painting through migration and exile.

Lee Krasner retrospectively described her first encounter with Jackson Pollock in November 1941 in a number of interesting ways. She was impressed, moved, overwhelmed, blasted, stunned, bowled over. Once she said 'she almost died'.[108] *A dying woman meets a killing man?* Some art historians have argued that Krasner was initially uncertain about what to make of Pollock's work. She was herself a much more mature, advanced and thoughtful abstract painter at the time than the student of Thomas Hart Benton just discovering surrealism. But such accounts of the mythic moment when their relationship began serve here to express the excitement of being in contact with what, in part under her influence, would become the dynamic force in American painting by the end of the decade, and for a brief moment. The artist's words also convey the risks entailed in being so close to that fire: one that could move or overwhelm; that could indeed almost kill her as an artist. But only because as an artist, she was what the world would exclusively 'see': a woman. Like Helen Frankenthaler a decade later, Lee Krasner

recognised something in Pollock's practice and project to which she wanted to be close, probably because of her own considerable maturity as an abstract painter, who had worked for the previous decade through the lessons offered by Hofmann on Cubism, John Graham on the non-formal elements of abstract art, and was acquainted with Gorky and Mondriaan. I think we need to be able to imagine what the very fact of the possibility of a relationship with the man meant in terms of an artistic relationship with one of the live wires of contemporary art at a particularly critical moment of realignment. It could be read as a sign of ambition and not submission, as so many biographers of Pollock seek to do. It is the risk that women repeatedly have to take where their artistic intelligence draws them into proximity with a resource that indeed most other artists would eventually have to deal with when, as in the case of Pollock, his work became the key *oeuvre* for ambitious younger artists to figure a way beyond. Even his contemporaries, like Lee Krasner, would both want to know it and yet need to 'kill it' creatively for there to be, not an 'after' Pollock, but a beside, or with 'Pollock' that was 'Krasner', a *with-self*. Neither partnership nor master-pupil, might there not be a matrixial moment of covenant between two painters different in their very proximity where creative rivalry does not entail the death of either one?

The initial proximity, however, nearly did kill 'Krasner', the artist. Despite this we must also find some way to acknowledge her act of artistic recognition which translated into so material a support for the alcoholic Pollock in the years in which he came to produce the remarkable work for which art history hails him. This support meant more than the mundane back-up of domestic chores. No one should underestimate the importance of domestic order, companionship, shared lifestyle and good food, much of which they cultivated themselves, in the relative poverty in which they were obliged to live when they moved out of New York city to the Springs, East Hampton. Lee Krasner also provided the first level of what is called a social representation for the work, the mirror of intelligent criticism in which that artistic personality we call 'Pollock' could gauge the character of his own novel activity as a painter. Just as the mother forms the third look in the mirror phase, the point to which the child looks to confirm that 'he' is both *what* 'he' has seen and *where* what 'he' has looked and been seen from, on the surface of the mirror, and that she is the Other who has seen him, so Lee Krasner's intelligent, artistically advanced eye was there to confirm that what Jackson Pollock saw in his paintings was painting, was art, was good.[109] For her own artistic practice, however, this early encounter with the Pollock of the early 1940s resulted in a stalemate: a total block, a phenomenon that occurs in the artistic biographies of a number of women artists trying to negotiate their specific space in modernist practices within a sexist culture where their sex, their humanity and their artistic identity are so hard to coordinate.[110] The lid of the surface that is the painting remained firmly slammed shut and Lee Krasner worked for several years, laboured rather, only to generate encrusted paintings that looked as dead 'gray slabs'. Her phrase recalls Bataille's image of the surface as a tombstone.

I began feeling the need to break with what I was doing and to approach some-
thing else. It wasn't clear what I was moving into. I went into my own black out
period which lasted two or three years where the canvases would simply build up
until they'd get like stone and it was always a gray mess. The image wouldn't
emerge, but I worked pretty regularly. I was fighting to find I knew not what, but
I could no longer stay with what I had.[111]

In interviews about the period 1946-9, Krasner reported that eventually an image
began to 'break through'. The 'image' is not drawn, figured or applied. It emerges onto
the surface as if from the painting's own depths, coming through from beyond, from an
imaginary interiority that touching that borderline with paint abstractly seems both to
allegorise and enact. These paintings formed a series called *Little Image*. No
reproduction can adequately convey the eventful density and sensuous colour of these
small paintings, roughly about two foot square, made on the floor or a table with paint
of a thick pouring quality (fig. 60). The idea of an image does not imply a figuration,
but rather an ordering of elements that lure the travelling eye to the surface and sustain
its exploratory pleasures over a non-hierarchical surface of oscillating depth and visual
incident. The image's 'breakthrough' suggests a specific topography of the image coming
from behind the surface, a borderline of the visible, a threshold between the emerging
subjectivity of the painter painting and the other, fantasised part-subject with which
painting symbolically plays. Thus the surface functions as a system, a structuration
(Rosolato) which renders it more than the blank site of inscription. It becomes the plane
of a movement or a moment of opening between surface and depth, between image –
the pole of metaphor – and its (re)sources that index rather than articulate or figure
some aspect of the fantasising, painting body, closer to the pole of metonym. In the *Little
Image* paintings, the surfaces are worked but ordered, pictogrammic rather than
pictorial, calligraphic but non-syntactical.

After the success of her first one-person show at Betty Parsons's gallery in 1951 with
work she later destroyed, Krasner began a series of drawings she had been making in a
kind of anxious dialogue with her artist partner, Pollock. But then she cut them up in
disgust. She later did the same to paintings, mostly her own, sometimes his. This violent
massacre of the work, of his presence in it, left shreds of paper or canvas piled on the
floor of her studio in a informal disarray that inspired a move into collage – which
Bataille had praised in Miró as the undoing of painting. Sliced up and sutured, the
resultant works use that murderous device in a Bataillian creativity that also breaks
open the tomb and devastates notions of surface and covering, behind and on top, so
that the elements jostle and realign in a relentless ambiguity that defies any certainty
about the plane and its pictorial space: *The City* (fig. 61). Continuing to work with this
mode of production, collage, into 1955, when she again had a major one-person show
at the Stable Gallery, Lee Krasner processed the possibilities and dangers offered in the
work of many other artists forming the community of her activity (fig. 62).

This all-too-brief survey of some aspects of Krasner's work from the mid-1940s to the

Fig. 60
Lee Krasner *Composition* 1949.
Oil on canvas. 95.5 x 71.1cm
Philadelphia Museum of
Modern Art, Gift of Aaron E.
Norman Fund, Inc.

Fig. 61
Lee Krasner *The City* 1953.
Oil and paper collage on
Masonite, 121.9 x 91.4cm.
Courtesy New York,
Robert Miller Gallery
ARS, NY and DACS, London 1996

mid-1950s serves to underline the radical shock that the emergence in July 1956 of the image in the painting *Prophecy* represents (fig. 38). It was a disaster. She was mortified. Amidst all the other factors bringing this work into being, a long-standing dialogue with de Kooning's work broke through all censorship demanding its own price: life or death. De Kooning was not just the other big name on the current New York scene to be dealt with. He was the painter of *Woman*, one (all?) of whom was *Marilyn Monroe* (fig. 45). For an artist of her, namely his, generation, that dominance inscribed the violent if ambivalent mythemes of masculinity's tortured relation to femininity into the heart of modern American painting. As such, it could not be avoided. Even more so was it inevitable for a painter such as Lee Krasner to take it on in her canvas.

I have been sketching her creative practice to be read according to Bataille's thesis on hybridity and decompostion in modernism, rather than in relation to Greenberg's teleological and all-male law of avant-garde succession and internal purification. Greenberg did see the 1955 Krasner exhibition at the Stable Gallery. In an interview with Bryan Robertson who was arranging Krasner's retrospective at the Whitechapel in 1965, Greenberg claimed that he considered the 1955 show to have been 'a major addition to the American art scene of that era'.[112] But he never said so in print and included no reference to Krasner in his definitive essay '"American-Type" Painting'. By 1965, it was ten years too late for his version of the story, modernism as a formalist evolution and confrontation with Cubism's shallow space was cast in the concrete of museal and academic histories of modernism that had only men in its annals. Bataille's interest in decomposition and destructive reworking permits a way to relate Krasner's knight's moves across the board of New York painting that could allow Pollock, de Kooning, Rothko, Motherwell and the others their necessary contribution to what was interesting in making paintings at this moment while also creating the space for her own decisive reconfiguration of the project of painting.

But *Prophecy* stands outside this model, at this point. Welling up into view are bodies, fleshy and plant-like with sightless eyes dislocatedly on the watch. A series of seventeen works created in the eighteen months after Pollock's sudden death in August 1956 were clearly about Pollock ('Pollocks' of the early 1940s perhaps) and killing him again – reliving the very crux of their relationship as a mythic competition between the sexes, killing men and dying women (fig. 63). The dead man – the dead Father that a canonised Pollock would become for that generation – cannot be killed openly. He must be included in the work and exterminated, there and then on the canvas through the work of undoing painting.

But that deadly other with whom the painter had to struggle was also de Kooning from whom the woman as artist must reclaim her body, the body he has used, the sexuality he has prostituted, the interior he has torn open and covered up with his grandiose gesturing in paint. Sadism must be released and then creatively sublimated to avoid being just another dying woman – to reach what I above named 'the creative woman's body'.

Fig. 62
Lee Krasner, *Milkweed*, 1955.
Oil, paper and canvas on cotton
duck, 209.5 x 146.7cm.
Buffalo, Albright-Knox Art Gallery
ARS, NY and DACS, London 1996

Fig. 63
Lee Krasner, *Birth*, 1956.
Oil on cotton duck, 209.6 x 121.9cm.
Barbara B. Millhouse
ARS, NY and DACS, London 1996

Out of this struggle emerged *Sun Woman I* (1957, fig. 64) – painted a year before Helen Frankenthaler's *Nude* (fig. 53). The explosive ebullience of the centrifugal composition, the lightness of the painted touch with its deep reds and yellows, the repeating circularity of gesture that tempts us to read a face or two, with open, singing? mouths, a breast, a belly, seems a liberated universe away from the clogged surfaces and desultory colours of paintings like *Birth* (fig. 63) that followed *Prophecy*. Not a massacred and funny creature, these clearly gynomorphic forms belie Julia Kristeva's doubts about the possibility of 'female creation'. Kristeva argued that for a woman to paint pictures like de Kooning's, that index the problem and significance of the dissidence of Woman, of sexual difference, the woman as artist would have to deal with her own mother and thus herself as woman. At no point have I assumed that woman is, that is, that Woman is on the plane of being, a given entity. I work with the difficult notion of being both inside and outside a designated social space and semiotic sign shaped by the complex configurations of psyche, fantasy and concept that constitute both a Symbolic order, and a regime that produces sexual difference, and one that is equally disrupted by the excess that the very process of ordering and differentiating generates. Yet I feel more and more compelled to allow that excess as well as that ordering to include a corporeal schema, an image or sensation we might tentatively call bodyliness. Without falling right back into the trap of a founding anatomical basis to the difference of the sexes, I would also want to embrace the possibility that our psychic and symbolising experience of the corporeal – filtered through its psychic representatives and our symbolic signifying systems – will be always marked by bodily specificity. But a particular symbolic order might foreclude certain bodily specificities from representation, forcing them onto the plane of hallucination, the uncanny and apparition. The pulsational rhythms of the masculine experience of sexuality mark a different possibility of what is never just the body's repertoire of sensations and meanings. Bodies are always my body, his body, her body and even that is not simple for hers may be a lesbian body, a black lesbian mother's body, a marked body and so on. With *Sun Woman I* (fig. 64) I have not found the authentic moment of 'women's art'. I have worked towards a possibility of recognising in the space of this painter's actions, gestures, processes, meditations, responses, decisions, desires, ambitions, distress, a moment of what a phallically ordered culture does not allow us to see, let alone name, and finally enjoy: pleasures in the jubilant identification of a difference that the language of even sympathetic formal analysis will kill.

A modest proposal is on offer, after a lenghty theoretical and historical journey to lay in the conditions of this painting's visibility – for me at least. What my working through prompts me to see is a joyous revelation of body schema on a canvas, a surface, incorporating the calligramic signature encountered in the *Little Image* series. The painting leaves evident the traces of the circular movements of the arms that produce the possibility of an image that is a corporeal schema invented for projective identification – a moment of stabilisation that structures the viewer's visual tourism within the

elaborated surface. Then there is the measured play of absence and presence, of paint and canvas, or painting and not painting, of colour and ground. These create what I must call in gratitude to Luce Irigaray *a dancing space*. This is not like the literal dance performed by Pollock around this canvas and mythicised in photosession and film with Hans Namuth. It is a created effect, a produced illusion, made through the play of colour, the energy of line, the ebullient fullness of the central image on the canvas. The viewer perceives the canvas optically but experiences it sympathetically as a dancing space, a play around presence and absence that is pleasurable because it does not index an obsessive repetition of mastery (Pollock) or the need for violence (de Kooning).

My concern in this brief reading is to throw up the possibilities that result from tracking a pathway through several psychoanalytical theories of the subject and of painting. These diversely open doors from one space of culture to another. Hingeing the discourse of sexual difference in popular culture – where it is so visible - to the formalist text of high art – where it is virtually denied – moving from Marilyn to Jackson and back, opens up a space in which to read 'female creation' (Kristeva) that was ecstatic, funny, intellectually intense, artistically acute (Frankenthaler and Krasner). What are the semiotic possibilities and historical conditions of a relation between creativity and femininity? Once posed at the theoretical level through the discourse of psychoanalysis that, at least, allows us to frame such a question, do we need a socio-historical base of practices with which to probe it, let alone answer it? That is what I have been hoping to do. The paradox of feminism's interest in the repressed question of sexual difference addressed to social history of art's apparent indifference to anything but what is framed by dialectical materialism, is played out in a historical archive that was structured by its own, historically formed version of that contradiction. High modernism outlawed questions of the social, that is, all ideological baggage that prevented art from saving itself within a capitalist system. Gender, like class and race, was irrelevant and dangerous to the ambitious pursuit of the self-denying ordinances of modernism. Lee Krasner, like Helen Frankenthaler, and the many women active on this American scene of modernist painting and sculpture, had comparable ambitions and agendas: to push painting down that modernist trajectory and to be a major event within it. To do this, they wanted to be considered just painters, not women. Krasner has been eloquent about just how sexist the actual art community was – the critics who did not review the shows, the dealers who would not buy and exhibit, the curators who did not buy and historicise. Gender was as active in the modernist community as it was in the rest of the conservative, post-war culture of Eisenhower's hegemonising Cold War America. I do not want to make them 'women' in those, impossible terms.

The feminist writer faces the challenge of naming that sexism, while simultaneously unpacking the practices of painters who, as women, were 'disappeared' from their historical moment. This involves creating for their work a visibility in the terms of the

actual historical moment of production. This is not a feminist return to formalism. Rather feminism intervenes in a historical discourse to tease out possibilities already struggled for by those who painted within its orbit. But those painters, like Lee Krasner, worked from a position that opposed the ideological straitjacket of gender. None the less, they engaged with a process in painting that opened their practice up to unsignified dimensions of what must be named and claimed as a sexual difference. Traversing modernist painting, they created a space for access to an alignment of relations of subjectivity that we can theorise as 'the feminine'. Modernist language and feminist desire converge in a moment of shocking necessity. But feminism effects a movement within the paradigm, an internal shifting of its elements.

I certainly want to be part of a project that makes Lee Krasner's work more visible and seriously debated. But the desire is not to integrate 'women artists' within the dominant narrative of art history. As Julia Kristeva has argued in 'Women's Time', this means assimilation to the time of nations, their histories, their phallocentric fantasies. Equally we need to guard against the opposite tendency. Kristeva identifies a second generation of feminism which turns to culture and insists absolutely on women's difference. Cultural experimentation displaces the agitation for political reforms on behalf of women that have formed the basis of the women's social movements since the nineteenth century:

> Essentially interested in the specificity of female psychology and its symbolic real-izations, these women seek to give a language to the intrasubjective and corporeal experiences left mute by culture in the past. Either as artists or writers, they have undertaken a veritable exploration of the *dynamic of signs*, an exploration which relates this tendency, at least at the level of its aspirations, to all major projects of aesthetic and religious upheaval.[113]

It would be an anachronism to place Krasner and her contemporaries in the cultural generation of 1968 and imagine that they could ever conceive their work in terms of such a 'dynamic of signs' – or a *peinture féminine*. They thought about and accounted for their work in the then current, modernist terms. It would, however, be self-defeating not to allow the insights created by this post-1968 generation of psychoanalytically inspired artists and writers to reframe the questions we ask about all artistic practices by women. For there is an excess in the work of the women painters of 1950s that is not legible through the discourses accounting for its production. Hence Greenberg's symptomatic silences. This excess is not Woman, in an essentialising way. But it has something to do with 'the feminine' conceived theoretically and defined via semiotics and feminist readings in psychoanalysis. Equally, it was determined by the actual social coding and cultural representations of gender that I have suggested can be tracked across the major myths of that culture – there in Marilyn on screen and canvas. The social history of art opened up modernist criticism and art history to historical and ideological analysis. But when, in turn, its still indifferent discourse is expanded by the

Fig. 64
Lee Krasner, *Sun Woman I*, 1957.
Oil on canvas, 247 x 178.4cm.
New York, Jason McCoy Inc.
ARS, NY and DACS, London 1996

Fig. 65
Ernst Haas, *Lee Krasner at Work in Her Studio*, 1981.

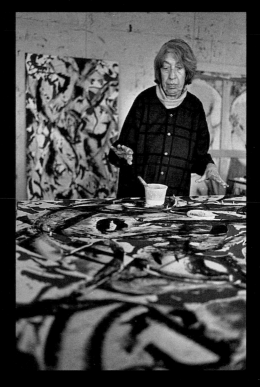

philosophical and theoretical elaborations called feminism, an even playing field is produced on which the image of 'Jackson Pollock', made across the spaces of studios, galleries, art magazines, films, museums, art history books, postcards and jokes can be tracked in the same way as we chart the making of the icon 'Marilyn Monroe'. While identifying the mythic faces, bodies, and styles of a polarised culture of gender, I have also deployed other theories of subjectivity, corporeality and gesture to destabilise the very binary of gender that bourgeois myth tries to naturalise, in order to represent artistic practice as a site of psychic and semiotic negotiation, a drama of the will towards subjective stabilisation through identification and metaphor, and a drama of the drives that play with the pleasures of staying closer to metonym, to a kind of indexicality of the bodily, to the archaic alternations of presence and absence, life and death, upon which the very possibility of embodied subjectivity is predicated. This is what I mean by introducing the concept of sexual difference: a tricky space where both subjectivity and sexuality are precariously produced while always deforming, destabilising, undoing whatever cultures and societies try to do with them.

Yet, even in the remotest reaches of the constantly occurring process of subjectivity, we encounter its framing within the problem of sexual difference. The subject comes into existence in a structure which casts the major players in the drama in both sexed and sexualising roles. Parents figure this difference as both positions and signs: mother and father. The triangular structure of the child confronting this signified difference sets the terms of the infant/child's sacrificial journey to language, sexuality and the illusion of being. Artistic practices of the kind that emerged in studios in New York in the 1940s and that were elaborated in mature statements during the 1950s, historically and aesthetically lifted the lid and opened the pathways to an aesthetic engagement with the elements of that journey. Whether through personal encounters in analysis or therapy, or through popularised notions of the 'working from the unconscious' and automatism inherited from Surrealism or John Graham, the moment of the 1950s cannot be studied without taking the indirect impact of psychoanalysis into account: the artistic practices themselves staged a shifting sense of subjectivity and artistic activity which were historically conditional upon the psychological modernism that was psychoanalysis. Embarrassing as the attempts to read Pollock psychoanalytically may sometimes be, they at least try to breach the censorship of formalism. They remain, however, caught in expressionism, and seek to explain Pollock's paintings by what was apparently on his mind. What I am interested in is not psychological interpretation of the paintings or psycho-biographical readings of the man, or woman. Post-1968 feminist interest in psychoanalysis is of a radically different order. It does not address individuals but reads culture, society, and its institutions through the texts, myths and subjectivities they produce while wanting to resist total anti-humanism by retaining the destabilising concept of the divided subject en procés.[114]

Julia Kristeva advocates, or merely imagines?, a third feminist possibility – one that lies behind some of the complexity of this argument. 'The very dichotomy man/woman

as an opposition between two rival entities may be understood as belonging to *metaphysics*.'[115] The politics and aesthetics of two generations of feminism have remained within that metaphysics of sexual opposition. My title appears to do the same. The alternative is neither utopian bisexuality nor the effacement of difference; it is what Kristeva calls the 'demassification of the problematic of difference'. There are considerable risks involved in this project to retreat from representing the issues of subjectivity and sexuality in anthropomorphic terms: man/woman. In the course of her essay, Kristeva considered the price of contemporary arrangements for women and identifies two possible responses: terrorism or creativity. The terrorist internalises her violation by society to the point where she becomes its 'possessed agent'. Killing and dying in the same gesture. Against the terrorist, Kristeva sets maternity – an ambiguous sign in the contemporary feminist struggle with dominant ideologies of gender but one that must be won back for the complexities it truly represents for women and for culture as a whole. Maternity is fundamentally, for Kristeva, a profound relation with an other that challenges the very notions of identity upon which the patriarchy is founded. The symbolic model of doubled subjectivity and ethical relations to alterity which maternity represents does not require a literal living of motherhood. It can function metaphorically as a paradigm for other relations – social and political as well as other practices – literary and artistic.

Thus Kristeva posits a third generation of feminism which historically and imaginatively incorporates the other two: the campaigns for equal social and political rights and the cultural exploration of feminine specificity. This third *signifying space* allows me to frame this project. For it is that sense of space enabling the co-existence of several quite different positions or elements that mutually inflect each other's meanings that needs to be held onto in both theoretical and art-analytical work. Yes, art history has to learn how to read paintings by Lee Krasner and Helen Frankenthaler as works by painters who were American, Jewish, New Yorker, immigrant or bourgeois women. But no, that women bit does not say it all. The real struggle is for us to be singular in our femininity – to demassify what sexual difference might mean for women from the term that in effect negates its very articulation: Woman. Each artist I am interested in is unique, particular, historical – yet each practice provokes questions about the semiotics of the feminine in culture.

> This process could be summarized as an *interiorization of the founding separa-tion of the socio-symbolic contract*, as an introduction of its cutting edge into the very interior of every identity whether subjective, sexual, ideological, or so forth. This in such a way that the habitual and increasingly explicit attempt to fabricate a scapegoat victim as foundress of a society or counter-society may be replaced by the analysis of the potentialities of *victim/executioner* which characterize each identity, each subject, each sex.[116]

To speak of the feminine is neither to idealise women artists nor to scapegoat them as

victims of a discriminating society. Killing/Dying – art as a play around sadism, creativity, passivity, activity, loss and displacement – these are the thematics that have to be tracked in artistic practices for each practioner who has, in order to be a subject, to negotiate the sacrifices demanded by the socio-symbolic bond. To 'aesthetic practices', such as painting, Kristeva then attributes the possibility of supporting such an adventure. Not only will art stand in opposition to the ever more extensive massifications of hegemonic multinationalism with its totalising use of a false community of language. Aesthetic practices – working on the very semiotic and subjective materials of identity and culture – both bring out the '*singularity* of each person, the multiplicity of every person's possible identifications... *the relativity of his/her symbolic as well as biological existence*, according to the variation of his/her specific symbolic capacities'. Here we confront my theme and Kristeva's defection: 'And the responsibility which all will immediately face of putting fluidity into play against the threats of death which are unavoidable whenever an inside and an outside, a self and an other, one group or another, are constituted.'[117] Killing and Dying/ Men and Women/ surface and depth/ insides and outsides. I have played with these terms – undone their apparent oppositions – in order to confront violence, sadism, aggressivity and creativity; to link making art and not dying even while death is always the stake in art. But at this point in her theory, Kristeva's resolution is undermined by a rapid descent into phallic binaries of self versus other. Irigaray's tentative suggestions that the feminine offers ways to be with the (m)Other while also separate and creative – to dance with death (loss, absence) – take us one stage away from an exclusively phallic model. This is further strengthened by Lichtenberg Ettinger's concept of the matrix: 'a feminine dimension of the symbolic order dealing with asymmetrical, plural, and fragmented subjects composed of the known as well as the not-rejected and not-assimilated unknown, and to unconscious processes of change and transgression in borderlines, limits, and thresholds of *I* and *not-I* emerging in co-existence'.[118]

I aim neither to assimilate Krasner to these theories nor to consolidate one theory through appeals to Krasner's painting. The project is to create a covenant – a kind of productive exchange – between two moments of femininity, modernity and representation. One is a historical moment of artistic practice and gender politics in the 1950s; the other a moment of politico-philosophical revolution and gender politics now. The unfinished business of twentieth-century feminism is the precipitating force that bridges these two moments of women's history and offers ways to allow the feminine visibility through a gesture – in art and in theory.

To end, one more photograph: Lee Krasner at work in 1981 by Ernst Haas (fig. 65). She has been painting, standing up at a large table. She is now thinking about what she has done. She is reading her own work – with her eyes but also with her hands. The gesture is captured in the photograph – but here, the gesture is nothing so literal as the action that made the painting. Her hands describe a kind of imaginary space, prompted as well as indexed by what she has done on the canvas. Those hands, circling above the

canvas as an unconscious bodily response to what the painting is for her at that moment, provide a visual clue, a glimpse beyond the visible sign, beyond the object that is an index, to what this practice offers: much less dramatic than Pollock's elaborate choreography; more detached than Frankenthaler's pouring and stroking. The photograph holds in view the complex sense of gesture in painting – a woman's body in the studio space, creating, thinking, dancing with death.[119]

Notes

1. Lee Krasner quoted in Eleanor Munro, *Originals: American Women Artists*, New York: Simon and Shuster, 1979, p. 116.

2. Anyone working on Lee Krasner is currently indebted to the very important analyses by Anne Wagner of Krasner's negotiation of artistic identity in relation both to her own gender and the constructions of it made by the culture in which she worked. I gratefully acknowledge the importance of her work for this study. See Anne Wagner, 'Lee Krasner as L.K.' *Representations*, vol. 25, 1989, pp. 42-57; reprinted in Norma Broude and Mary Garrard, *The Expanding Discourse*, New York: Harper Colllins, 1992, pp. 425-36. See also Anne Wagner, 'Krasner's Presence, Pollock's Absence' in *Significant Others*, ed. Whitney Chadwick, London and New York: Thames and Hudson, 1993, pp. 223-43. Lee Krasner stated: 'I was put together with the wives... Rosenberg... never acknowledged me as a painter, but as a widow, I was acknowledged' in Wagner, 1993, op. cit., p. 223.

3. Lee Krasner in Cindy Nemser, 'The Indomitable Lee Krasner', *Feminist Art Journal*, vol. 4, 1975, p. 9.

4. The idea is advanced in my *Avant-Garde Gambits: Gender and the Colour of Art History*, London and New York: Thames and Hudson, 1992.

5. I use this date because it marks the emancipation of British women, then granted the vote, and is linked culturally to Virginia Woolf's *Room of One's Own*, to Radclyffe Hall's *Wells of Loneliness*, but it stands for the decade which politically and culturally represents a major moment not just of modernist culture but of the struggle for a 'new woman.' Beyond the false glamour of a slogan this phrase does represent a genuine exploration of modernisation of the conditions of sexuality, sexual identity and was epochal for that attempt to reconstruct the terms of sexual difference. It thus becomes another moment in which we can establish profound historical and philosphical connections between femininity, representation and modernity/modernism.

6. Teresa Podlesney, ' Blondes', *The Hysterical Male: New Feminist Theory*, ed. Arthur and Marilouise Kroker, New York: St. Martin's Press, 1991, p. 70.

7. This argument is based on Laura Mulvey's analysis of the condensation of spectacle and commodity in the cinematic image of woman which forms part of her forthcoming book. Paper delivered at the University of Leeds, 8 March 1995.

8. An article on the Abstract Expressionists which featured Jackson Pollock was entitled 'The Wild Ones,' *Time*, 20 February 1956, p. 75; while Pollock was also posthumously linked with James Dean whose suicide preceded Pollock's own death by just one year.

9. This issue is elaborated by Andrew Perchuk, 'Pollock and Postwar Masculinity' in *The Masculine Masquerade: Masculinity and Representation*, ed. Donald McMahon, Cambridge Massachussetts: MIT Press, 1995, pp. 31-43.

10. Podlesney, op. cit., p. 76.

11. Julie Burchill, *Girls on Film*, New York: Pantheon Books, 1986, p. 175.

12. Betty Friedan, *The Feminine Mystique*, New York: Bantam Books, 1963.

13. Serge Guilbaut, *How New York Stole the Idea of Modern Art: Abstract Expressionism, Freedom and the Cold War*, Chicago and London: The University of Chicago Press, 1983.

14. Irving Sandler, *The Triumph of American Painting*, New York: Praeger, 1970.

15. Eva Cockcroft, 'Abstract Expressionism: Weapon of the Cold War', *Artforum*, vol. 12, June 1974, pp. 39-41.

16. To take Lee Krasner as a case study: her first major one-person retrospective only took place in England in 1965 (Whitechapel Art Gallery, *Lee Krasner : Paintings, Drawings and Collages*). Marcia Tucker curated *Lee Krasner: Large Paintings* at the Whitney Museum of American Art in 1974. Significant interventions were made by the writings and research of Ellen G. Landau, Eleanor Munro, Cindy Nemser and Barbara Rose after 1970. Ellen G. Landau has just published the first complete catalogue of Krasner: *Lee Krasner. A Catalogue Rasionné*, New York: Harry Abrams, 1995.

17. Nichola Bird's project was exhibited in *Absent Bodies/Present Lives*, City Art Gallery, Leeds, 1993. The work is in

the collection of the artist and this particular exploration of artistic identity plays off the images of Jackson Pollock at work by Hans Namuth and those of Marilyn Monroe from *Gentlemen Prefer Blondes*.

18. Clement Greenberg, 'Towards a Newer Laocoon,' *Partisan Review*, vol. VII, no. 4, July-August 1940, pp. 296-310; citation p. 303.

19. Bryony Fer, 'Poussière/peinture: Bataille on Painting,' *Bataille - Writing the Sacred*, ed. Carolyn Bailey Gill, London and New York: Routledge, 1995, p. 155. She is citing Maurice Raynal, *Anthologie de la Peinture en France de 1906 à nos jours*, Paris: Editions Montaigne, 1927, p. 34 and Tristan Tzara, ' Le Papier Collé ou le Proverbe en Peinture,' *Cahiers d'Art*, no. 6, 1931, p. 2. I am indebted to Bryony Fer's essay for this line of the argument.

20. Georges Bataille, *Manet* [1955] Paris: Skira, 1994, p. 28: 'une totalité intelligible'. I am grateful to Adrian Rifkin for introducing me to this text.

21. Ibid., p. 55: 'Dans l'un et l'autre cas, le texte est *effacé* par le tableau. *Et ce que le tableau signifie n'est pas le texte, mais l'effacement*'. Bataille uses other metaphors in this subsequent paragraphs: suppression and pulverisation, to define this destructive liberation of painting concluding of the nude figure in Olympia: 'ce qu'elle est, est "l'horreur sacré" de sa présence - d'une présence dont la simplicité est celle de l'absence.'

22. Ibid., p. 37.

23. Bryony Fer, op. cit., p. 160.

24. Laura Mulvey, 'Pandora's Box: Topographies of the Mask and Curiosity', in Beatriz Colomina (ed.), *Sexuality and Space*, Princeton: Princeton Architectural Press, 1992, pp. 53-72.

25. John Hoberman, 'Korea and a Career', *Art Forum*, vol. 32, no. 5, 1994, p. 11.

26. These events are briefly mentioned in Podlesney, op. cit., p. 75.

27. *Playboy*, vol. 1, no. 1, December 1953, p. 17. 'Marilyn "blonde all over" Monroe is the juiciest morsel to come out of the California hills since the discovery of the navel orange.'

28. Simone de Beauvoir, *The Second Sex*, [1949, Paris: Librairie Gallimard]; London: Four Square Books, 1964, p. 9.

29. Donald Spoto, *Marilyn Monroe: The Biography*, New York: Harper Collins, 1993, p. 231.

30. Eve Arnold suggests that Marilyn Monroe was the image behind the entire series. Eve Arnold, *Marilyn Monroe - An Appreciation,* London: Hamish Hamilton, 1987, p. 12.

31. Antonio Lara, 'Sensualidad e Inocencia: Las peliculas de Marilyn Monroe [Sensuality and Innocence in the Films of Marilyn Monroe]', *Cuadernos del Norte*, vol. 8, pt. 43, 1987, pp. 61-8.

32. Janice Anderson, *Marilyn Monroe: Quote Unquote*, London: Parragon, 1994, p. 42.

33. Quoted in Hoberman, op. cit., p. 11.

34. Richard Dyer, *Heavenly Bodies: Film Stars and Society*, New York: St. Martin's Press, 1986, pp. 42-3.

35. Ibid., p. 44.

36. Podlesney, op. cit., p. 72. This idea is listed as one of the four genealogies of the blonde phenomenon that tie it specifically to a moment of production in the 1950s.

37. Dyer, op. cit., p. 45.

38. Angela Carter, *The Sadeian Woman*, London: Virago Books, 1979, p. 63.

39. Luce Irigaray, 'Women on the Market' and 'Commodities Among Themselves' in *This Sex Which Is Not One*, [1977] trans. Catherine Porter, Cornell University Press, 1985, pp. 170-97.

40. Jaqueline Rose, *Sexuality in the Field of Vision,* London: Verso Books, 1986, p. 232.

41. Eve Arnold, op. cit.: on cosmetic secrets, p. 27; on her management of her mouth to reduce the size of her nose in photographs, p. 11.

42. 'Pollock was virtually unknown in 1944. Now his paintings hang in five U.S. museums and 40 private collections. Exhibiting in New York last winter, he sold 12 out of 18 pictures. Moreover his work has stirred up a fuss in Italy, and this autumn he is slated for a one-man show in avant-garde Paris, where he is fast becoming the most talked-of and controversial U.S. painter.' *Life*, 27, 8 August 1949. On Newman see 'American Artists Photographed by Arnold Newman', *Art in America*, vol. 53, 1965, pp. 106-13.

43. Both quotes from Stephen Naifeh and Gregory White Smith, *Jackson Pollock: An American Saga*, New York: Clarkston N. Potter, 1989, p. 595.

44. For a review of these photographs and the claims made about them see Chapter 8 of this volume.

45. Carol Duncan, 'Virility and Male Domination in Early Twentieth Century Vanguard Art', *Art Forum*, December 1973; reprinted in Carol Duncan, *Aesthetics and Power,* Cambridge: Cambridge University Press, 1993.

46. This is argued more fully in my 'Painting, Feminism and History', in *Destabilising Theory*, ed. Michelle Barrett and Anne Phillips, Cambridge: Polity Press, 1992.

47. Thomas Craven and Thomas Hart Benton in 1950 and 1951 accused Pollock of making these drip paintings by eating the paint and then urinating on the canvas. Naifeh and White Smith, op. cit., p. 631.

48. The major statement of this genealogy is Courbet's *The Studio* (1855, Paris Musée d'Orsay).

49. Andreas Huyssen, 'Mass Culture as Woman: Modernism's Other' in *After the Great Divide: Modernism, Mass Culture and Postmodernism*, London and New York: MacMillan, 1986, pp. 44-64 argues for the historical dialectic between the feminisation of mass culture and the masculinisation of the modernist project defining itself as the discipline of self-authentication through dedication to the textuality of its own practice.

50. Eva Cockcroft, op. cit.

51. For Laura Mulvey's analysis of Cindy Sherman, fetishism, femininity and the Eisenhower decade see 'A Phantasmagoria of the Female Body: The Work of Cindy Sherman', *New Left Review*, no. 188, 1991, pp. 137-50.

52. Clement Greenberg,' Louis and Noland', *Art International*, May 1960, pp. 94-100.

53. Clement Greenberg, 'Changer: Anne Truitt', *Vogue*, May 1968, reprinted in Clement Greenberg, *The Collected Essays and Criticism, Vol. 4 Modernism with a Vengeance 1957-69*, ed. John O'Brien, London: University of Chicago Press, 1993, p. 291. The other references are passim in the four volumes of Greenberg's criticism edited by John O'Brien.

54. Rozsika Parker and Griselda Pollock, *Old Mistresses: Women, Art & Ideology*, London: Pandora Books, 1981; new edition 1995.

55. I am referring of course to the idea of *écriture féminine* proposed by Hélène Cixous to suggest a way that a new form of writing by women might explore the specificities of feminine psychic modalities through drawing on the semiotic resources of the drives and the body's inchoate pleasures. See especially 'The Laugh of the Medusa', trans. Annette Kuhn, *New French Feminisms*, ed. Elaine Marks and Isabelle de Courtivron, Brighton: Harvester Press 1981, pp. 245-64. The phrase *écriture féminine* is translated as 'writing the body'. Nancy Spero has explored the possibilities of this literary project for painting and speaks of *peinture féminine*. See Lisa Tickner and Jon Bird, *Nancy Spero*, London: Institute of Contemporary Art, 1987.

56. This is a serious suggestion deriving from the early positions of Luce Irigaray who argued that the metaphors of culture favour the representation of a masculine psychic and corporeal experience. She searched for others that might catch feminine experience and draw it into cultural representation to which end she argued for touch over sight, and metaphors of fluidity, mucosity and doubling. Luce Irigaray, *Marine Lover of Friedrich Nietsche*, trans. Gillian Gill, New York: Columbia University Press, 1991.

57. Henry Geldzhaler, 'Interview with Helen Frankenthaler', *Artforum*, vol. 4 no. 2, October 1965, p. 37.

58. Ibid.

59. Julia Kristeva, ' La Femme n'est jamais ça,' [Woman can never be defined], interview with *psych & po, Tel Quel*, 1974; reprinted in translation in Marks and Courtivron, op. cit., p. 137.

60. I am drawing here on Michèle Montrelay, 'Inquiry into Femininity', *M/F*, vol. 1, 1978, pp. 83-102.

61. To give an example of the kind of easy imposition of what Rozsika Parker and I named the 'feminine stereotype' against which I am arguing, let me quote: 'It was appropriate that she adopted this particular technique. It is free, lyrical and feminine - very different from the more insistent rhythms of of the best and most typical Pollocks... Indeed as this kind of art is completely involved with the physical act of painting (not only with the fingers, or the hand, or the wrist, or the arm, but with the entire body) we recognize a sexual analogy. Her palette, too, is seductive and feminine, often... dominated by pale muted pinks, blues, yellos and greens; rarely harsh or overpowering.' B. H. Friedman, 'Towards the Total Color Image,' *Art News*, vol. 65, 1966, p. 32.

62. Barbara Rose, *Helen Frankenthaler*, New York: Harry Abrams Inc., 1970, p. 57.

63. Clement Greenberg,'"American-Type" Painting', *Art and Culture*, Boston: Beacon Press, 1961, pp. 208-29; published originally in *Partisan Review*, 1955. 'Louis and Noland', *Art International*, May 1960, pp. 94-100.

64. T. J. Clark, 'Jackson Pollock's Abstraction', *Reconstructing Modernism*, ed. Serge Guilbaut, Cambridge Massachussetts: MIT Press, 1990, p. 229.

65. Mary Kelly, ' Reviewing Modernist Criticism', *Screen*, vol. 22, no. 3, 1981, pp. 41-62.

66. Luce Irigaray, 'Gesture in Psychoanalysis', [1985] in *Sexes and Genealogies*, trans. Gilian C. Gill, New York: Columbia University Press, 1993, pp. 91-104. Hilary Robinson has been researching the contributions of Irigarayan theory to the analysis of painting and sexual difference in a doctorate at the University of Leeds. Papers given University of Leeds, 25 November 1994 and at the Museum of Modern Art Oxford, 12 October 1995.

67. As Paul Hirst and Penny Woolley firmly establish in their study of 'Psychoanalysis and Social Relations' (in *Social Relations and Human Attributes*, London and New York: Tavistock Publications, 1982), according to Freud, there is no

'nature' - 'All organisation of the sexual instincts is psychical and symbolic. "Nature" is a cultural category too. Freud's arguments lead us to recognize that there is no "nature" separate from the psychic and symbolic', p. 160.

68. Sigmund Freud, 'Beyond the Pleasure Principle' [1920] in Sigmund Freud, *On Metapsychology: The Theory of Psychoanalysis*, vol. 11, Penguin Freud Library, Harmondsworth: Penguin Books, 1984, pp. 269-338.

69. Irigaray, op. cit., p. 97. This is a problematic statement because it attributes to the female child an implicit knowledge of an identity in common with the mother at the very point at which separation and loss are only just precipitating the child into a forced sense of is distinctness from the maternal body and world. Obviously all these events hypothesised to explain the trajectory of human entry into language and subjectivity always take place in an already sexually marked world where there is no moment absolutely free of the weight of culturally projected sexual difference. Moreover, we might argue that the girl child has no need to imagine a sameness because the pre-Oedipal child has no means to imagine a difference from the mother; it is the tragedy of the boy child to be obliged to admit its unlikeness. The very ambiguity of this moment is important for the subsequent development of my argument about sexual difference and the act of making art. Beyond that point, however, lies the possibility that a non-Oedipal sense of relations of difference between part-subjects is an element of our most archaic formation, that comes before the structures of psychic life that produce the subject-object, the self-other opposition. See Bracha Lichtenberg Ettinger, 'Matrix and Metramorphosis', *Differences*, vol. 4 no. 3, 1992, pp. 176-210.

70. Irigaray, op. cit., p. 97.

71. Bracha Lichtenberg Ettinger, 'Metramorphic Borderlinks and Matrixial Border Space', *Rethinking Borders*, ed. John Welchman, London: MacMillan, 1993 and *The Matrixial Gaze*, Leeds: Feminist Arts and Histories Network at the University of Leeds, 1996.

72. Irigaray, op. cit., p. 98.

73. See Fred Orton on Rosenberg's concept of action in this volume, Chapter 9.

74. B. H. Friedman, op. cit., p. 32. T. J. Clark, 'Jackson Pollock's Abstraction', in *Reconstructing Modernism*, ed. Serge Guilbaut, Cambridge Masschussets: MIT Press, 1992, p. 229.

75. The term Other is not used anthropologically to refer to a subject different from the viewing or speaking subject. In Lacanian usage the Other is not a subject but that which structures the subject's coming into existence. It is the place of law, language, a position on the grid in relation to which all the various actors in the drama of subjectivity are positioned. At different moments in the process of subject formation, different figures can be assumed to represent the Other for the subject that comes into existence only as an effect of that relation. Feminists intervene to ask how sexual difference is mapped into this other example of neutered language - the Other/the subject. As Lacan argued, the speaking subject, hence the subject, is sexed: the accession to the Symbolic occurs via the Oedipal trauma. The phrase (m)Other is designed by Bracha Lichtenberg Ettinger, and it marks the trace of the maternal - not the actual mother person but the function and moment of the condition of all our existences as gestated, matured bodies and potentially psychic entities that cohabited the maternal body and passed out of it but not beyond its sensate memory trace. The Other is not the mother - but equally the Other is not without the maternal as one of its moments and elements despite what phallocentric culture with its mother-denying, neutral-paternal philosophies try to imply.

76. In the sense that Freud's legend of his grandson narrates this structural process through the events of ordinary childhood occurences of the actual absence of the actual mother. Irigaray notes: 'Woman always speaks *with* the mother, man speaks in her absence.' op. cit., p. 99.

77. 'It seems to be a law of modernism - thus one that applies to almost all art that remains truly alive in our times - that the conventions not essential to the viablity of a medium be discarded as soon as they are recognized.' Clement Greenberg, '"American-Type" Painting', *Art and Culture*, Boston: Beacon Press, 1961, p. 208.

78. I am here coming a little closer to the reading of Pollock's *bassesse* proposed by Rosalind Krauss in *The Optical Unconscious*, Cambridge Massachussetts: MIT Press, 1993. She argues against the sublimated Pollock, desired and produced by art history's privileging of the hung, exhibited paintings over the moment of their production on the floor, being made by a body with a certain violence.

79. Irigaray, op. cit., p. 99.

80. I am indebted to Alison Rowley for this formulation. See her 'On Viewing Three Paintings by Jenny Saville: Rethinking a Feminist Practice of Painting' in *Generations and Geographies in the Visual Arts: Feminist Readings*, ed. Griselda Pollock, London: Routledge, 1996. This whole argument can be taken much further into a theoretical territory around the borderline visibility and the matrixial *objet a;* that is another theorisation of the specificities of the feminine significations of loss. A subsequent paper by Rowley will develop this reading in relation to Frankenthaler's painting.

81. Irigaray, op. cit., p. 99.

82. I am deeply indebted to Alison Rowley for conversations about this paper and this issue in particular.

83. Bracha Lichtenberg Ettinger, *The Matrixial Gaze,* Leeds: Feminist Arts and Histories Network at the University of Leeds, 1995.

84. P. Fédida, *L'Absence*, Paris: Gallimard, 1978, translation by B. Lichtenberg Ettinger, op. cit., 1995, pp. 169, 189, 191.

85. Lichtenberg Ettinger, op. cit., p. 41.

86. Bracha Lichtenberg Ettinger names the symbol the matrix, which is Latin for womb. In the matrix, the womb is raised to the level of symbol and is thus freed from the metaphorics associated with the womb in phallic culture where is it either a deadly interior or an utopian inside. Instead the matrix symbolises a borderline between several part-subjects.

87. Ibid., pp. 43-4.

88. Claire Pajaczkowska, 'Structure and Pleasure', *Block*, no. 9, 1983, p. 5, citing Roman Jakobson, 'On Artistic Realism: Theory of Literature' [1921].

89. Adrian Rifkin has pointed out the different trajectories of the alliance between semiotics, structuralism and psychoanalysis in France where painting became the cultural object systematically theorised and in Anglophone communities where cinema is the focus and thus the paradigm. This has influenced art history through notions of the gaze, the spectator, the mirror, but such theorisations are steadfastly anti-corporeal and take little interest in drives not associated with vision.

90. For some of the complexity of this logic see Jane Gallop, 'Where to Begin?' in her *Reading Lacan*, Ithaca and London: Cornell University Press, 1985. Lacan's text 'The Mirror Stage as formative of the function of the I' is published in English in *Ecrits*, London: Tavistock Publications, 1977, pp. 1-7.

91. Jacques Lacan, 'Aggressivity in Psychoanalysis' in *Ecrits*, op. cit., pp. 8-29. Frederic Jameson, 'Imaginary and Symbolic in Lacan: Marxism, Psychoanalytical Criticism and the Problem of the Subject', *Yale French Studies,* 1977, pp. 55-6, 338-95.

92. Sigmund Freud, *Totem and Taboo* [1919] Harmondsworth: Pelican Books, 1938.

93. This phrase is from Julia Kristeva, who framed the subject as '*en procès*' - reading in English as both 'in process', constantly being formed and undone, and 'on trial', being tested and interrogated. Kelly Oliver comments: 'Her notion of the subject-in-process, however, challenges Lacanian psychoanalysis, with its emphasis on the mirror stage and the Name of the Father as the initiation into subjectivity. For her, subjectivity is a process that begins with the material body before the mirror stage. It is a process that has its beginnings in the maternal function rather than the paternal function. The maternal body is itself a primary model of the subject-in-process; its unity is called into question by the other-within, an other-in-process. In addition to the discourses of psychoanalysis and maternity, poetic language is another discourse that calls the subject into crisis, puts the subject on trial. Undeniable within poetic language, the semiotic element disrupts the unity of the Symbolic and thereby disrupts the unity of the subject of/in language.' Kelly Oliver, *Reading Kristeva*, Bloomington: Indiana University Press, 1993, p. 13.

94. 'The *fort-da* is not their [girls'] move into language. It is too linear, too analogous with the to-and-fro of the penile thrust or its manual equivalent, with the mastery of the other by means of an object. It is too angular also.' Irigaray, op. cit., p. 99.

95. Elizabeth Bronfen, 'The Knotted Subject: Hysteria, Irma and Cindy Sherman' in *Generations and Geographies*, ed. Griselda Pollock, London and New York: Routledge, 1996.

96. Pajaczkowska, op. cit., p. 9; drawing on Guy Rosolato, 'Fonction du père et créations culturelles', *Essais sur le Symbolique*, Paris: Gallimard, 1969, pp. 172-84.

97. A short digression will confirm this. Julia Kristeva used some of Rosolato's insights in her writing on Italian painters of the fifteenth century. She shows the differences between various artists in the ways that they negotiate the structural role of painting which she sees as a 'representation of a psychic relation to the maternal body'. Each biographically distinct male subject has a different narrative of separation from his mother which will inflect the signifying economy he produces. Thus for Kristeva, Leonardo's psychic relation to the maternal body is revealed to be fetishistic; in contrast Bellini uses light and colour to articulate maternal *jouissance*. In her reading of Giotto, Kristeva suggests that we get closer to the prelinguistic instances of what she calls the semiotic, rhythm and colour being the signifying registers that undo the fixity of symbolic meaning to allow a play that runs back to Ernst and the game, to the bodies and the spaces that gestures, sounds and marks began to map out. See Julia Kristeva, *Desire in Language*, ed. Leon Roudiez, New York: Columbia University Press, 1980.

98. Julia Kristeva, 'A New Type of Intellectual: The Dissident', originally published in *Tel Quel*, no. 74, 1977, pp. 3-8;

trans. Séan Hand, in *The Kristeva Reader*, ed. Toril Moi, Oxford: Basil Blackwell, 1986, p. 297.

99. Cindy Nemser, 'Interview with Grace Hartigan', *Art Talk; Conversations with Twelve Women*, New York: Scribner's, 1975, p. 158.

100. Ibid.

101. 'She was our angel, the sweet angel of sex, the sugar of sex that came up from her like a resonance of sound in the clearest grain of a violin.' Norman Mailer, *Marilyn: A Biography,* New York: Grosset and Dunlap, 1973.

102. There is a Man Ray photograph of a woman in black and white, putting on lurid red lipstick, titled *Red Badge of Courage.*

103. Despite all the conspiracy theories about her death, at the moment I am following those who suggest that through the lack of consultation between the various physicians and psychiatrists treating Monroe's insomnia, she accidentally dosed herself with two kinds of sleeping drugs whose swift action brought her within half an hour to the verge of death. Her last desperate phone call - the phone was found in her hand - was too late.

104. Graham McCann, *Marilyn Monroe*, Cambridge: Polity Press, 1988, p. 31.

105. Spoto typically dismisses it as a 'minor but uncomfortable health problem', op. cit., p. 297.

106. Hope Edelman has published an extensive study of the profound psychological effects of 'motherless daughters'. She includes under motherlessness, daughters who are bereaved, abandoned and abused. Monroe was a complex instance of this trauma, which would, I suggest, have overdetermined her own ambivalence about having a child, being a child, being a mother and experiencing repeated intended and unintentional procreative loss. See Hope Edelman, *Motherless Daughters: The Legacy of Loss*, New York: Delta, 1994.

107. McCann, op. cit., p. 80.

108. Francine du Plessix and Cleve Gray, 'Who was Jackson Pollock?', *Art in America*, vol. 55, 1967, p. 49. The various phrases used by Krasner to describe the meeting are compiled in Naifeh and White Smith, op. cit., pp. 392-3.

109. For a corrective view which documents how much of advanced art and its related ideas Krasner revealed to Pollock in these years, see Ellen Landau, 'Lee Krasner's Early Career: Part Two: the 1940's', *Arts Magazine*, vol. 56, 1981, pp. 80-9.

110. I am thinking here of Meret Oppenheim, who left Paris shortly after her immense success with the *Déjeuner en Fourrure* in 1936 and reports suffering a creative block for twelve years. I am also thinking of Nancy Spero, a young artist from Chicago who tried New York in the later 1950s before leaving for Paris. She produced a series of almost black paintings in which vague images were either buried or struggling to emerge - indexing a degree of struggle which echoes what Lee Krasner endured with what she called her gray slab paintings of the mid-1940s.

111. Cindy Nemser, 'Lee Krasner', *Art Talk,* op. cit., pp. 86-7.

112. Ibid., p. 95.

113. Julia Kristeva, 'Women's Time', trans. Alice Jardine and Harry Blake, *The Kristeva Reader*, ed. Toril Moi, op. cit., p. 194.

114. The clearest statement of this calibrated balance is Julia Kristeva, 'The System and the Speaking Subject' [1973] in *The Kristeva Reader*, op. cit., pp. 25-33. She coins the phrase 'semanalysis'.

115. Julia Kristeva, 'Women's Time', op. cit., p. 209.

116. Ibid., p. 210.

117. Ibid.

118. Bracha Lichtenberg Ettinger, 'Matrix and Metramorphosis', *Differences*, vol. 4, no. 3, p. 176.

119. Just as I completed this chapter, I read Claire Pajaczkowska, 'Art as a Symptom of Dying', *New Formations - Psychoanalysis and Culture*, no. 26, 1996, pp. 74-88. Pajaczkowska explores a Kleinian reading of the relations between art and dying that may add a further dimension to the arguments explored in my work.

Chapter 12

Writing on a Text of the Life

J. R. R. CHRISTIE AND FRED ORTON

> The greatness of Rothko's painting lies ultimately, I am quite sure, in its expressive quality, and if we wanted to characterise this quality – it would be a crude characterisation – we would talk of a form of suffering and of sorrow, and somehow barely or fragilely contained. We would talk perhaps of some sentiment akin to that expressed in Shakespeare's *Tempest* – I don't mean expressed in any one character, but in the play itself.
> Richard Wollheim, 'The Work of Art as Object'

It may strike you as odd that Richard Wollheim should have titled an essay which is for the most part concerned with painting, expression and expressive quality, 'The Work of Art as Object'.[1] We guess it was done to fix its purport as a defence, in the late 1960s and early 1970s, of one kind of art exemplified by the paintings of Henri Matisse, Morris Louis and Mark Rothko against the critical and curatorial success of Conceptual Art which, because of its preoccupation with the production of written texts as part of 'the work', was seen as opposed to the idea of 'the work of art as object'.[2] Of course, it wasn't just that, and we'll mention more of what it can be read as later. Suffice it to say that the moment of its historicity and inscription is not without significance. Wollheim, who wrote – and still writes – as representative of a certain community of interests, was concerned with holding on to, if not the canon, the value placed on a kind of canonical painting. And his was a powerful voice. Writing in *Studio International*, which was then the most important international journal of contemporary art published in the U.K., Wollheim spoke with the authority of his institutional position as Grote Professor of Mind and Logic in the University of London, as an academic with an interest in psychology, aesthetics and art, and as author of what was claimed to be 'the best modern book on philosophical aesthetics', *Art and its Objects*, first published in

1968, and in 1970 just out in paperback.

In 'The Work of Art as Object', Wollheim seeks to characterise what he sees as the 'dominant theory' at work in what he calls 'the mainstream of modern art'. Restricted to painting, Wollheim's 'dominant theory' insists on the surface of the painting and on its possession by the artist. To this assertion, Wollheim adds three considerations or qualifications. First, the twentieth-century artist does not just possess the surface in making a painting, for all painters have done that before as well as after 1905. He or she insists on the surface to a degree to which the painter before the twentieth century did not. According to Wollheim the modern painter equates the picture (that which is on the surface) and the physical object (that which is the surface, the ground), and regards the manipulation of paint not as preliminary to making art but as the making of art. The dominant theory makes a predilection for the medium a necessity and temporally re-situates art. Wollheim's second qualification points out that you have to know what a painting is before you can pay attention to its surface as the surface of a painting, and this means for the painter that he or she must specify the surface by working the chosen medium in a characteristic way. Thirdly, although the dominant theory insists on the surface of the painting, or upon the fact that the painting has a surface, it is not enough for the painter to assert the existence of the surface. It must additionally be used, and the way it is used may wholly or partially obscure the fact that it is a surface of a painting.[4]

At this point Wollheim considers three paintings which he regards as masterpieces of twentieth-century art to try to clarify the point he is making. He says that in *La Fenêtre Ouverte* (1913), Matisse uses the surface in two ways: he asserts the ground so closely with the use of the surface (the way the oil paint makes the picture, the window ledge, the window and the view through it), that the spectator accepts the size of the surface as determining the extent of the ground, and that the surface is used in such a way that one avoids seeing the view through the window as filled with solid object – as filled with ground, canvas.[5]

Wollheim's second example is a painting by Morris Louis. He says that with *Alpha Phi* (1961) Louis uses the surface in such a way as to limit the possibility of the viewer seeing the colours, the acrylic painted bits, as volumes (which are three-dimensional) and shapes (which are two-dimensional), so that any potential spatial effect is minimised. The colour is encountered, so he says, in a pure mode, 'as predicated of extended but non-spatial elements'.[6]

Wollheim's final example is Rothko's *Red on Maroon* (1959), one of eight pictures originally painted to fulfil a commission to decorate the Four Seasons Restaurant in the Seagram Building, New York, which came to the Tate Gallery, London, as a gift from Rothko via the American Federation of Arts in 1969-70. Wollheim says that Rothko uses the surface – he makes it, paints it – in such a way that he sees the painting as simultaneously containing an image within it (a ring of flame or shadow) and as itself an image (like a stained-glass window), that is, as forms within a painting and as an

imposed unity across a painting. This use of the surface is, for Wollheim, calculated to produce and preserve an uncertainty which is more than a mere oscillation of perception, more than an op-artistic effect. It is to produce and preserve a formal counterpart for 'the expressive quality' of the painting, which for Wollheim is its value, its 'greatness'. He describes this as 'a form of suffering and of sorrow, and somehow barely or fragilely contained... of some sentiment akin to that expressed in Shakespeare's *Tempest* – I don't mean expressed in any one character, but in the play itself.'[7]

Wollheim is writing many things here, but most of all – and he would not regard this as a misrepresentation – he is uniting two logically distinct notions of expression in art which in *Art and its Objects* he referred to as 'natural expression' and 'correspondence'.[8] To see Rothko's *Red on Maroon* in terms of 'natural expression' is to see it as having been painted by the artist while he was in a certain state of mind, which he may or may not have been aware of, and as bearing unmistakably the marks of that state in the way the surface has been used. To see *Red on Maroon* in terms of 'correspondence' is to regard it as producing a state of mind or feeling in the spectator which seems to match or correspond to what he or she feels when he or she is in that emotional condition. It may also be good for reminding the spectator of that emotional condition or reviving it in him or her. As Wollheim points out in *Art and its Objects*, for an object, like *Red on Maroon*, to be expressive in this sense, it is not necessary that it should originate in the condition it expresses, nor in any claim about its genesis. However, the two notions interact, and it is very difficult to imagine the one without the other. Indeed, what can be called 'the dominant theory of expression in art' conflates the notion of 'natural expression' and 'correspondence'.

When Wollheim says in 'The Work of Art as Object' that in *Red on Maroon* 'Rothko uses the surface in a highly complex way. And I shall only give one hint of how we might think of this. The greatness of Rothko's painting lies ultimately ... in its expressive quality ... a form of suffering and of sorrow ... somehow barely or fragilely contained ...', he is claiming that the effect which the use of the surface produces in him corresponds with what he feels when he feels a kind of suffering and sorrow, and that is what it reminds him of, or revives in him. But what he feels is not just brought by him to *Red on Maroon*. He feels what he feels because the surface he is looking at bears the unmistakable marks of that state on it, in the way it has been used, a use which issued directly and immediately from Rothko's state of mind, an originating condition which Rothko may or may not have been aware of.

Since the 1940s Clement Greenberg has been the most articulate art critic and historian associated with the dominant theory of modern art who has also held to the dominant theory of expression in art. It is more often than not overlooked that Greenberg's theory of art is never as purely formalist as it is claimed to be. These six sentences from his essay '3 New American Painters', published in *Canadian Art* in May-June 1965, are not those of a pure formalist:

> Louis is not interested in veils or stripes as such, but in verticality and colour. Noland is not interested in circles as such, but concentricity and colour. Olitski is not interested in openings and spots as such, but in interlocking and colour. And yet the colour, the verticality, the concentricity, and the interlocking are not there for their own sakes. They are there, first and foremost, for the sake of feeling, and as vehicles of feeling. And if these paintings fail as vehicles and expressions of feeling, they fail entirely. [9]

Here we can look briefly at Greenberg's 'theory of expression' as it is represented in one of the essays which laid down his main preoccupations and commitments in *Partisan Review* in 1939-40, not in 'Avant-Garde and Kitsch', where it is indeed stated, but in 'Towards a Newer Laocoon', where it is stated more clearly, and then look at it as it was iterated in 'Complaints of an Art Critic', in *Artforum* in October 1967.[10] There are several reasons for re-examining Greenberg's theoretical views. Certainly, he deserves better readers than he has had of late, on both the right and left of art criticism and history. He also provides a useful criticism of one aspect of the dominant theory, even as he deploys that theory, as we will shortly show. But further, and more significantly, he can be situated in that community of interests we have gestured at. This community, which would include Michael Fried (footnoted in Wollheim's 'Work of Art as Object'), was one in which the dominant theory of art and expression, and a certain kind of painting, produced by Rothko, Louis, Kenneth Noland, Jules Olitski and Frank Stella, was written into an 'attack', as Fried put it in 'Art and Objecthood' of 1967, on Minimal Art, seen then as symptomatic of the possible demise of the community and its art. Wollheim's 'attack' of 1970 on Conceptual Art unites it with this reaction, three years earlier, against Minimalism. Both moments maintain the expressive quality of art, that is, they vindicate what Greenberg, Fried and Wollheim said about how they felt in front of certain kinds of paintings.[11]

Back in 1940, in 'Towards a Newer Laocoon', Greenberg considered what he saw as the internal history of avant-garde painting. He discussed the project of the avant-garde since the nineteenth century and identified two aspects or variants of its development. The first variant is a restatement of what he had earlier written about the medium: the avant-garde inverted the relative status of subject matter and medium and concentrated on the problems and character of the medium particular to painting.[12] The second project or variant was a tendency to investigate the medium particular to painting for its expressive effects: 'There is a common effort in each of the arts to expand the expressive resources of the medium, not in order to express ideas and notions, but to express with greater immediacy sensations, the irreducible elements of experience.'[13] Here Greenberg is making a distinction between subject matter and content. It had been flagged earlier, almost parenthetically, when he had written 'Ideas came to mean subject matter generally. (Subject matter as distinguished from content: in the sense that every work of art must have content, but that subject matter is something the artist does or does not have in mind when he is actually at work.)'[14]

Twenty-seven years later in 'Complaints of an Art Critic' Greenberg defended himself against the accusations of extreme formalism made by the American art historian Robert Goldwater. He did so by reiterating and clarifying what he had said about 'content' in 1940, and by emphasising that his reputed formalism was first and foremost addressed to the idea of art as expression. He writes:

> the quality of a work of art inheres in its 'content', and vice-versa. Quality is 'content'. You know that a work of art has content because of its effect. The more direct denotation of effect is 'quality'. Why bother to say that a Velasquez has 'more content' than a Salva(d)or [sic] Rosa when you can say more simply, and with directer reference to the experience you are talking about, that the Velasquez is 'better' than the Salva(d)or [sic] Rosa? You cannot say anything truly relevant about the content of either picture, but you can be specific and relevant about the difference of their effect on you. 'Effect' like 'quality' is 'content', and the closer reference to actual experience of the first two terms makes 'content' virtually useless for criticism. To say (as Robert Goldwater does) that Kline's art offers an 'image ... of optimistic struggle of an entirely unsentimental "grace under pressure" ... is to say something that is both indifferent and wanton ...' And if I choose to feel that Kline is pessimistic rather than optimistic, who can say me nay? Where is the evidence on the basis of which Dr. Goldwater and I can argue about that? There is not even the evidence of taste. For you do not have to be able to see painting in order to say that Kline's art shows either optimism or pessimism. I, who am considered an arch-'formalist', used to indulge in that kind of talk about 'content' myself. If I do not do so any longer it is because it came to me, dismayingly, some years ago that I could always assert the opposite of whatever it was I did say about 'content' and not get found out; that I could say almost anything I pleased about 'content' and sound plausible.[15]

We can isolate two things from these fragments from 'Complaints of an Art Critic' and 'Towards a Newer Laocoon'. Greenberg is pointing out that you can say anything you want to say about what you feel a painting expresses and not be corrected, and that for him, as for Wollheim, 'content' or 'effect' or 'expressive quality' (which is in all paintings modern and pre-modern) is to be located neither in the subject matter of the painting nor in the problems of the medium; it is not what the artist intended his or her painting to be about; it is not in the medium used metaphorically, because metaphors are representations. The 'expressive quality' is unintended and carried in the medium as it is used to make the surface.

If ever Wollheim and Greenberg get together to talk about modern painting, to talk about Rothko's *Red on Maroon*, for example, there is much they will agree on: on the insistence on and use of the surface of a painting; that the painting will have an 'effect' or 'content' or 'expressive quality'; and that the 'effect' or 'content' or 'expressive quality' is the painting's value – it is there, and it is good, because they feel it is. But whereas Wollheim will be, as we have seen, prepared to describe as well as measure the

'expressive quality', Greenberg will hold only to its measurability and to its unspecifiability: the experiences he has in front of art are distinct from any other kinds of experience he has and are, in 1967, held to be ineffable. It is this which makes art *Art* for Greenberg, and why he comes to write his expression claims only in terms of comparative worth.

A certain scepticism can now be made manifest, if indeed it is not already clear. This scepticism concerns the heuristic, critical and explanatory value of the belief in artists' abilities to express emotions in their work, that their work possesses 'expressive qualities', 'effects', or 'contents', and that critics, and anyone else, are capable of intelligibly and defensibly voicing their correspondent experience of these qualities. Two texts in particular have helped in prompting and solidifying this particular version of disbelief in the 'expressive quality' of art. They are Hal Foster's 'The Expressive Fallacy',[16] and Art & Language's 'Abstract Expression';[17] these are very different kinds of text but they have something in common.

In 'The Expressive Fallacy', Foster is primarily concerned with German and Abstract Expressionism, but if we take 'expressionist' to mean 'avant-garde' or 'modern', as Greenberg did in 1939, what he says can be read as referring to all modern art, including that which is not explicitly expressionist in its gestural character. Expressionist art, says Foster, is less a historical style than a language. It is, he says, a language which has been designed to look and is claimed to be 'natural', 'immediate': a language whose mode persuades or encourages the viewer to see it as originating in the artist's 'self'; a language which seems neither socially or historically mediated nor rhetorical.[18] In other words Expressionism is a language made to look as if it is not one, as if it has no relations with anything other than the inner state or inner world of the artist whose 'presence' is signalled or expressed in it – not in the subject matter but in and by the traces which are the brushstrokes, etc.; or else, to put it in Wollheim's terms, in the use he or she has made of the surface, which is there but unintentioned. Foster shows that expressionist painting is linguistically coded in at least two ways. Firstly, it is coded in so far as the traces and colours, as distinct from the subject matter, stand metaphorically as representative of the artist's inner self and of his or her inner necessity to express it. And secondly, it is coded as a painting, as a particular kind of representation; the stretched canvas signals a representational paradigm; it is always already a painting or the pretext for one. As Wollheim said in 'The Work of Art as Object', 'in the making of art a concept enters into, and plays a crucial role in, the determination of what is made: or, to put it another way, that when we make a work of art, we make it under a certain description...'.[19]

Foster then points out how:

> Nietzsche... the great philosophic precursor of Expressionism... wrote precisely against such naive notions of self-expression, which derive, as Paul de Man notes, 'from a binary polarity of classical banality in the history of metaphysics: the opposition of subject to object based on the spatial model of an "inside" to an "outside" world' – with the inside privileged as prior. To Nietzsche such 'inner

necessity' is based on a *linguistic* reversal: 'The whole notion of an "inner experience" enters our consciousness only after it has found a language that the individual *understands* – i.e., a translation of a situation into a familiar situation – "to understand," naively put merely means: to be able to express something old and familiar.' This 'translation' precedes, indeed constitutes, any formed expression so that 'between' the self and expression a rhetorical figure intervenes. The adequation of self and expression is thus blocked – by the very sign of expression.[20]

This sign is the calculated use Rothko made of the surface of the painting *Red on Maroon*.

There is no way in which direct, unmediated feeling can be put into, and disinterestedly taken out of, the surface of the painting. Inner experience only enters consciousness when it finds a language; whereof we cannot speak, thereof we must remain silent. If it is not to be passed over in silence, experience must be translated. Between 'self' and 'expression' lies the realm of translation and rhetoric – a visual rhetoric in the case of painting which, when taken up in discourse, is claimed to have in it a content beyond convention, a reality beyond representation, a natural as opposed to a cultural status. Yet, we would claim, there is very little that is natural about, or natural in, Rothko's so-called pure painting, or the experience of it.

Reading 'Abstract Expression' it seems that Art & Language, unlike Foster, think that a painting may have some immaterial/emotional causes of production, as well as material/cognitive causes, which inhere in it as structural features which can be recognised as referring to emotions.[21] However, their discussion points out that if expression is not fallacious, talk about expression in art is carried on at a high level of abstraction.[22]

Like Wollheim, Art & Language attend to 'correspondence', to the idea that *Red on Maroon* makes one feel 'a form of suffering and of sorrow', and to 'natural expression', to the idea that *Red on Maroon* expresses 'a form of suffering and of sorrow', as logically distinct notions or statements which interact in expression theory and in talk about expression in art. But, unlike Wollheim, they are not so prepared to conflate them to make the causal equation that the artist's psyche = the use of the surface = the emotion felt by the viewer, the painting assessed as the causal connection which ensures the isomorphic replication of the inner state from artist to viewer. Indeed, Art & Language argue that it is the job of persons like Wollheim and Greenberg to make sure that a relation holds between 'correspondence' and 'natural expression', by ensuring that statements made about the experience a person has in front of a painting, and about what the painting expresses, are glued together, and the logical distinction thereby papered over.[23] Thus the statement about *Red on Maroon*, making one feel a form of suffering and sorrow, is turned into a statement about *Red on Maroon* expressing a form of suffering and sorrow, which is itself a statement to the effect that a form of suffering and sorrow was consciously or unconsciously there in the creative process which

produced *Red on Maroon*.

It is useful to see critics, historians of art, museum curators and philosophers of art as members of a certain class fraction; a class of cultural managers which, because of its professional skills, cosmopolitanism and education, productive and distributive talents, has become responsible for the legitimation, ratification and validation of our artistic culture. This class gained that authority because it had a kind of technical superiority; and with its professed, rather than actual, natural sensibility and disinterestedness of aesthetic and historical judgement, it seemed also to have a moral superiority. It is from this class that are drawn the persons who, Art & Language point out, establish the expressive meanings for paintings because of the stipulative power we permit them,[24] who fix the reference that the 'expressive quality' of *Red on Maroon* is 'a form of suffering and of sorrow', or whatever.

The acclaimed clothedness of the emperor could be empirically tested and shown to be a misrepresentation of the actual state of affairs. Expression in art and expression claims are of a different order of things. It is inappropriate to ask whether expression in art is true or false because the expressive quality in question cannot be refuted empirically. It also seems inappropriate to point out counter facts, because the dominant theory is so stated that any such facts are impotent. In a sense, it becomes a matter of faith, a belief in the unquestionable nature of expressive effects and the incorrigible nature – this is Greenberg's point – of the consequent feelings of sensitive observers with stipulative power. Art & Language show how any claim about what a painting expresses is designed to function to block enquiry into what causes that painting to be seen as expressing the state of mind claimed for it, and to block enquiry into what causes the critic to make the claim he or she does. With these blocks in place, critical discourse is thereafter restricted to reinforcing prevailing expression claims or to engaging in 'battles' for critical or managerial power fought out over issues of interpretation or translation.[25]

Robert Goldwater's argument with Peter Selz in 1961, reprinted to make the catalogue for the MoMA, New York and Whitechapel Art Gallery, London, Rothko retrospective in 1961, and referred to and partially reprinted in the Tate Gallery's catalogue for its Rothko retrospective in 1987,[26] provides a good example of critics fighting over expression claims, in this instance for the power to write the meaning and 'expressive quality' of Rothko's painting. Selz claimed that generally Rothko's painting made you feel a charge, the atmosphere of just before or after a thunderstorm; his reds expressed a mood of foreboding and death.[27] Goldwater objected to Selz's literariness, and claimed that the general impression was one of gaiety or sadness, aggressiveness or withdrawal, seriousness.[28] Selz made no explicit claims about what the *Red on Maroon* paintings expressed; he said they looked like rims of flames, entrances to tombs, they were Orphic, and like a modern Dance of Death.[29] Goldwater was dismissive of these similarities; he talked of their sombre mood.[30] Neither critic was prepared to be as upfront as Wollheim was ten years later when he claimed the that 'expressive quality'

was 'a form of suffering and of sorrow', maybe because Rothko's interest in less bright and less easily discriminable colours, sustained insistently over the several paintings made for the Four Seasons scheme, was a relatively recent one and, in 1960-1, was only just being taken up in critical discourse.

Art & Language point out in 'Abstract Expression' that our ordinary ways of thinking about expression have the character of being causally grounded, and that because many people's intuitions are satisfied if told that what is meant by saying that a painting expresses a sombre mood or a form of suffering and of sorrow is that a sombre mood or a form of suffering and sorrow played some part in a causal chain or sequence leading to the production of the picture, then that is what is implied or stated in the expression claim.[31] In the case of *Red on Maroon*, what is meant by saying that it expresses a 'sombre mood' or 'a form of suffering and of sorrow' is that Rothko's sombre mood or form of suffering and sorrow was implicated in the use he made of the surface of the painting. The personality of Rothko is very important in the context of seeing *Red on Maroon* as expressing a sombre mood or a form of suffering and sorrow. It becomes a crucial counter for making credible expression claims. Expression claims about the 'meaning', 'content', 'effect' or 'expressive quality' of the surface of a painting which have any chance of sticking must be made implicitly or openly, tacitly or not-so-tacitly, with reference to and by way of not the gloomy, suffering and sorrowful surface, but with reference to and by way of the biography of the artist because, though paintings cannot be caused to be gloomy, suffering and sorrowful, people can.

Discourse making critical and stipulative expression claims is necessarily concerned with a biography of the individual artist – Rothko, for example – or of a group – the Abstract Expressionists, for example. Expression claims which stick emotions to paintings are claims inferred from what critics know or conjecture about the life of the person who made them. To this extent critics deal with the state of the discourse about the artist; and if a life does not exist in discourse, it must be written, because, without it, critics cannot make convincingly any claims as to what a painting is to be seen as expressing. They can only claim that a painting is expressive. One of the jobs that the Tate retrospective did, and it is a job that any retrospective of any artist or group of artists does, was to write the life of Rothko one more time.

...AND 'THE CLOTHES AND BUTTONS OF THE MAN'

While preparing the talk which forms the basis of this article it was interesting to find that the idea of biography had already been raised and problematised with regard to Rothko and Rothko's paintings by the American poet and critic David Antin, in an essay entitled 'Biography'.[32] Antin's focus is, initially, on a series of paintings in tones of black, brown and grey which Rothko made between 1969 and 1970.

> These airless, lightless, nearly colourless paintings... have come to be known as the 'black paintings.' ... Because they were dark paintings and because they were

the last paintings of Rothko's career, there has been a general tendency to connect them with the mood of despair used to explain his suicide. In this sense Robert Goldwater's 1971 essay in *Art in America*, coming just one year after Rothko's death... is typical beyond its elegiac eloquence.

The paintings are seen as constituting a distinct period and style within Rothko's work, a final period characterised by 'starkness and quiet' and by a 'remoteness of a kind never evident in any of his previous work.' To sustain this claim, Goldwater positions the paintings among the other events of Rothko's life – his exhaustion after completion of the murals for the Houston chapel, his aneurism, his summer on the Cape, his work with acrylics on paper... And what he found was a structural discontinuity in the life, beginning with the completion of the chapel paintings, that as he saw it matched the discontinuity he saw in the paintings.

But Goldwater was a sophisticated scholar, who staked his biographical claim with a certain diffidence. Though he would claim that 'the sombreness, the sadness, of these works was evident and shocking,' he went to some lengths of stylistic analysis to argue this. Rothko had painted other very dark paintings before, most notably the mural series for the Seagram Building and the vast sequence for the Houston chapel. To separate the last paintings from the earlier dark ones, Goldwater isolates several features of the last series – that they are flat and opaque and lack the atmospheric depth of even the darkest of the earlier paintings, that they are divided into two registers by a relatively sharp 'horizon line,' and that their representational allusion to landscape or seascape is consistently reinforced by the narrow framing band that surrounds each of the paintings.[33]

Antin is pointing out how Goldwater, to substantiate his claims about what the 'black paintings' of 1969-70 express, refers to the life of Rothko and makes them the penultimate event in a biography indexed to the mood which caused Rothko's suicide, the ultimate biographical event. But Goldwater also refers to the use of the surface that is the 'black paintings' and which is seen as distinct from the surfaces of the Seagram murals (*Red on Maroon*), the Houston Chapel scheme, etc., etc., etc. However, it was not enough to point to more or less obvious visual differences between one series of paintings and another to establish that they were different in expressive quality rather than in degree; they had to be indexed to a biography. Antin develops this train of thought, pointing out that back in 1961 'Max Kozloff had characterised the Seagram murals as "flat, dark and opaque" and had claimed that they ran "counter to the whole meaning" ["content", "effect", "expressive quality" are synonyms for "meaning" here] of Rothko's Museum of Modern Art retrospective exhibition'.[34] For Goldwater they do

not signify a break with the brighter paintings of the 1950s.[35] So what is at stake, Antin says, is not a disagreement between two critics over the discrimination of visual differences among discrete objects, but over the significances they attribute to the differences each of them derives from the biographical narrative progression he constructs for the work.[36] Each critic, each art historian constructs a different biography, a different Rothko.

Concluding his essay, Antin asks whether the 'black paintings' are really so different and final, so connected to the end. He finds at least one purple and black painting made in 1953, and his memory suggests, correctly, that there might be others. The main distinction is, he concludes, in the medium and the use of the surface; the black paintings are in acrylic and insist on the binary division of dark above light. However, though Antin cautions against biographical narrative, he comes out, in the last paragraph of his essay, in favour of it. He writes: 'If we are going to come to terms with these paintings as significant human acts, we are going to have to position them in some kind of narrative sequence between the desire that motivated them, the contingencies they encountered, and the outcomes they achieved, as it is very likely that the artist himself positioned them while he was making them – and no less likely that they were positioning him while making him into the painter who painted them. And since this is a narrative of self, as of the consequences of this self, we have to construct some kind of biography, though it may have to be a more precise, self-conscious, and equivocal biography than we are used to.'[37]

Like Antin, we are cautious about the possibility of biographical narrative and also, like him, loath to abandon it. 'Cautious' may be the wrong word. The particular issues here are that biography has been problematised by a wide range of contemporary critical theory (what is getting called in the U.K. 'superstructuralism'), and the ways in which we might try to situate art history in relation to that, to find the grounds on which to have a dialogue with it, to see if art history can use it and be of use to it. If the rest of this essay evidences a kind of theory crisis, that simply is the price one pays during the negotiation. Thus what follows is not so much a theoretical excursus as specimen musings, possibilities for thinking through a relation to 'superstructuralism' by focusing on biography as a way of returning to comment on Wollheim's notion of the expressive quality of Rothko's painting.

'Superstructuralism' incorporates the whole field of structuralism, including the works of Saussure, Jakobson, Lévi-Strauss, Greimas and the early Barthes. It also incorporates semiotics, Althusserian Marxism, Lacanian psychoanalysis, together with the work of Foucault and Derrida.[38] Attempts either to present or to use this assemblage as one thing have little chance of success. Foucault, for example, resists the whole psychoanalytic apparatus and its account of subjectivity, and he resists equally traditional or more newly fashioned notions of ideology. The Derridian project is in part an attempt to overcome the boundaries set by structuralist linguistics, anthropology and psychoanalysis, and has in turn incurred Foucault's opposition and hostility. To unify all

this, conceptually and methodologically, is a rather profound mistake. If one is keen on maintaining, say, 'difference', a favourite term across this set, then it is as well to recognise its rather obvious activity in one's critical apparatus. Otherwise, one may well be asked, why is so much 'difference' all the same? Methodologically, too, the spurious linkages purveyed by such terms as 'decentred subjects', 'difference', etc., can obscure the utility of particular strategies and texts. The specificities of the texts – their irreducible differences – have to be respected and insisted on. It is only, for example, in attempting to use a meticulously Derridian deconstruction with reference to art history that this particular element of critical theory will reveal any value for art history which it may possess - a value, we would add, that is as yet wholly unclear, because the kind of work which could clarify such value has simply not been undertaken. To the extent that 'superstructuralism' presents itself as one, not several, it simply functions as a blender, something which breaks up then mixes different ingredients together, which homogenises heterogeneity to produce a blandly critical paste.

You can spread this 'superstructuralist' paste on anything you like, but it is particularly suited to certain surfaces, namely texts, or, more globally, 'textuality'. 'Superstructuralism' itself has a further terminological value, in so far as it in turn picks out a space which, with a kind of regretful, backward glance, used to be defined over against the 'base', the forces and relations of production of classical Marxist analysis. 'Superstructuralism', therefore, we can think of as picking out and operating upon that level (for Marx, politics, law, religion, philosophy) which we now generalise to include all aspects of low and high culture, and does so by reconceiving all of these artifacts as kinds of textuality. This superstructural textuality can now be summarily presented in its blended form. We do so with no disparagement for its components, and with contrasting emphases upon that which it purports to abandon – referentiality, historicity, persons.

As paste, critical theory's main commitment is to a concept of language as a process of signification whereby meaning is generated by the differential relations between linguistic signifiers, rather than by any referential capacity which language may possess. This problematisation of the referent (which operates on a sliding scale between saying that the referent is continually deferred or that there is no transcendental signified, to saying that the referent has been abandoned or stolen and referentiality is a myth) is the pivot on which critical theory turns. Certain consequences follow from it. Meaning is only produced textually. There is nothing to the point outside of the text – this is Foucault's inelegant reading of Derrida – so that the distinction between text and context, a work and its surrounding environment is dissolved; it is all one surface, a portion of the intertext. The meanings residing here are mobile, non-unitary and contradictory, because meaning only exists in the particular differential moment of its textual occurrence.

If we add to this view of linguistic function, as critical theory does, a highly rhetoricised notion of language, syntax and grammar, we arrive, again, at a position

where directly literalist and referential aspects of language are infinitely recessive, the indeterminate field of figuration. Here, what historians have thought of as ideas and concepts become figures of speech, metaphors and metonymies. For the role of figuration here is not to fix or redefine meanings in texts, to be used as 'clues' to origins of concepts, to specify analogic sources of concept formation. Exactly the opposite is the case. Figuration is the classic site of unfixing determinate meaning, the deferral or abandonment once again of a referential object for language. Critical theory thereby undoes the object.

At the same time, it undoes the subject. The human subject attains its subjectivity in and through language, and is therefore inevitably subjected, a pronominal shifter subjected to the differential displacement of meaning within the linguistic chain, and divided necessarily in the act of attaining linguistic identity. The human subject appears therefore as incoherent. It is dispersed, divided and decentred by language. In addition, through the operation of specific discursive forms it becomes constituted in modes of subjection, subjected to powers of textual domination, controlled through the power of language to define the nature and limits of modes of being. What we traditionally conceive of as human persons, as verifiable, situational actors in history, in this theoretical framework become signifiers, in technical terms 'proper names'. 'Mark Rothko' is not a name unproblematically denominating a human agent. It is a proper name dangling problematically from a text, say *Red on Maroon* or the Seagram murals or the Houston Chapel scheme, a trial, the Tate Gallery retrospective, or indeed this essay, and it attains a meaning only in association with the text, as a part of the text, at the edge of the text, to be read according to the interests and competences of the reader. As the meaning of the text changes, subjected to different critical readings, so the meanings of the proper name 'Mark Rothko' will also change. Human persons thereby lose any primacy they have traditionally possessed as subjects in history. For intellectual history and history of art an important set of distinctions are elided and inverted. Authors, conceived of as intentional producers and at least partial controllers of meaning as found in their texts (their paintings), are deprived of these author-itative qualities. An author is no longer in any assignable sense outside of the text, standing in any productive or causal relation to it. The author instead, as a textually incorporated proper name, is ineluctably enclosed by textual meanings – art-historical, philosophical, legal, ethical, political, touristic, journalistic, Gentile, Jewish, etc. – the text thereby produces the author, not the author the text. And because the text as language consists of multiple and displaced meanings, so does the author, now no longer a site of coherent and productive identity, but a momentary sequence of symbolic representations.

Contemporary critical theory further dissolves assumptions with which historians routinely work. If, as critical theory proposes, there is only textual surface, the intertext, then the distinction between primary sources and secondary sources, the archive and its selective reworking in historical narrative, disappears. Primary and secondary sources are instead simply successive representational layers. The primary as authoritative (*Red*

on Maroon or what Rothko said about it) in relation to the secondary (what Mrs Rothko and Philip Johnson told Ronald Alley, or what John Fischer, who met Rothko on a transatlantic liner in June 1959, reminisced, in 1970, about what Rothko said about the Seagram commission, or what Bernard Reis and James Brooks, who shared the same studio building, remembered, or what Norman Reid said Rothko said, etc., etc.)[39] no longer holds, because the primary is only a linguistic representation and is, therefore, in principle, no closer to any historical actuality. Just as much as the secondary historical narrative, the primary source is always-already a language object – one more bit of our second-hand world – and is, therefore, lacking in authoritative primacy. It, too, is an interpretation, a representation as dubious and devious as anything any historian, working centuries later, may produce.

If these kinds of routine assumptions go, abandoned as outmoded devotion to the coherent 'liberal-humanist subject', or as archival fetishism, so too do many of the reflexes of disciplinary historical practice. One obvious example may suffice here. Historians often think in originary terms, writing articles and books on the origins of the French Revolution, of the First World War, of Modern Art and Modernism. Historians also teach students to think and write in this way, setting essay and exam questions in a fashion which assumes the idea of the originary as common-sensically intelligible within disciplinary practice. What were the origins of Impressionism, of Cubism, of Abstract Expressionism? Routine questions, perhaps, but indicative of the standard practices we exemplify and inculcate, and without which we might feel a certain professional lack, not to say incompetence. We need origins because we operate under the practical constraint of having to start somewhere. Narratives seem to require beginnings, and thus we specify relevant beginnings for the object of our analysis. We assume that beginnings have some sort of shaping power, and hence some sort of explanatory force. It is difficult, indeed, to envisage ways in which historical practice could conventionally continue without a working assumption of the relevance of origins, so important is it for the framing and construction of the kinds of narrative which historical discipline expects of us. Critical theory, however, subjects origins to the severest scrutiny. It concludes that the originary, however secular the terrain of its application, is a deeply theological notion, enshrining the mythic status of creative agency and the creative moment. Furthermore, the designation of the originary will always be teleologically bound, a slippage of the properties to be explained back to a moment intended to initiate their explanation. This moment, conceived as exclusively originary, is also questioned. It is held to be arbitrarily and conventionally constructed, always preceded by another and potentially relevant origin, and hence subject once more to the familiar scenario of meaning-displacement along the signifying chain.

On these theoretical premises, the conventional practice of history, of history of art, and of biography, become hugely problematic. Indeed, in strict theoretical terms, they become impossible. Consider what is no longer available or accessible: persons as unitary identities; authors as producers of texts; contexts as relevant to texts; sources as

access to lived history; 'beginnings' and 'origins' as explanatory foundation.

Now, the kind of history of art which most interests us, a Marxist history of art, is committed to the recovery of the historicity of the past. But, as indicated, within 'superstructuralism' or contemporary critical theory, historicity as genuinely recoverable and textuality seem to be deeply opposed principles. Critical theory has created heightened possibilities of 'ideological' reading and decoding or recoding, but what it also often seems to disbar is any possible and detailed causal account of the production of the text as specific to a particular kind of person in a particularised social, ideological formation at a particular time, and any genuine analysis of how and why texts get produced as effects of impersonal and personal historical agencies. This is surely serious news for historians, Marxist and non-Marxist alike. If Marx was correct, 'there is only one science: the science of history'. If Derrida is correct, there is only one science, the science of grammatology; and it is not a science, nor is it 'one'. Unless we opt for outright confrontation or simple stand-off, negotiation is enjoined.

Biography has been a genre of historical writing which has promoted, and still does promote, some of the assumptions which need to be remaindered, like over-individualised accounts of artistic creation, and reductive explanations in terms of talent or genius, or incorrigible psychoanalytic interpretations. The social history of art, especially recently, has worked against the monograph.[40] But frequently, and incorrectly, it has regarded biographical narrative as synonymous with, and as expendable as, monographical narrative. In place of the decisively compromised monograph, and the Subject which conventional monographic practice enjoins, we can instead argue for a certain kind of biograph.

It is possible to argue for the ontological priority of persons, and even Derrida has a Rousseau outside-text: it is just that he is not knowable outside-text. And one can envisage a biography which would represent an individual who will contain Whitmanesque 'multitudes' or a Barthes-like 'infinite'. One can simultaneously and non-contradictorily represent an individual in a society, a culture, sub-culture, a country, a mode of production.[41] The project would thus remain one of attaining historicity through the realisation of human agency in the context of large-scale historical causes. Or, to put it somewhat differently, of combining structural and epochal causation and the historicity of the construction of the subject and subjectivity.

It would still remain to nail that multitudinous individual, and to think him or her in the place of biography, but before so doing we can state, bluntly, our own justification of and for biography, and that is that it is unavoidable. This is because humans are irreducibly narratable, narrating beings. Richard Rorty says somewhere that we live in story after story after story.[42] Stories, indeed, are the primary device through which we first begin to apprehend consciously the possible connected meanings of the world. We not only internalise and retain these stories, but the idea of story, too, and we never abandon it. In every historically and culturally specific human head is a scriptwriter and speaker who never stops writing and speaking these historically and culturally specific

stories. If you stopped reading now, for 15 to 30 seconds, that is the voice you would hear, filling the internal silence. It has endless stories at its disposal, genres and sub-genres, plots, digressions, beginnings and ends.

A friend, a mediaevalist, once asked if people thought and lived in generic narratives. It was difficult to conclude they did not. And since persons are historically and culturally specific so must be their narratives and narrative forms. Was it easier to live a Saint's Life in eighth-century Northumbria than it would be now? Very probably. The *Life* was simpler. The knack was, because there was a burgeoning market for sacred commodities and potential sacred commodities, to avoid becoming relics before your appointed time. The scriptwriter and speaker sorts and files narratives for immediate or later use. He or she gets the stories from other lives and what he or she learns of other lives, 'factual' or 'fictional', and, having decided on their relevance, uses them existentially. And in so far as these narratives attain levels of material and ideological necessity, which in our view is largely the case, they in turn create that possibility of existential appropriation. We live, then, biographically: we live a way of living, or – more correctly – we live ways of living; we live plural-bio-graphically.

'I will construct a text', Mark Twain wrote in his *Autobiography*,

> What a wee little part of a person's life are his acts and his words! His real life is led in his head, and it's known to none but himself ... His acts and his words are merely the visible, thin crust of his world, with its scattered snow summits and its vacant wastes of water – and they are so trifling a part of his bulk! A mere skin enveloping it. The mass of him is hidden – it and its volcanic fires that toss and boil, and never rest, night or day. These are his life, and they are not written, and cannot be written. Everyday would make a whole book of eight thousand words – three hundred and sixty-five books a year. Biographies are but the clothes and buttons of the man – the biography of the man himself cannot be written.

Mark Twain's *Autobiography* does not have to be read to know the name 'Mark Twain', know it as the author of *The Adventures of Huckleberry Finn* or *The Adventures of Tom Sawyer* or *The Prince and the Pauper* or *A Connecticut Yankee in King Arthur's Court*, as a name conditioning the circulation and the effects of those texts, attached in discourse in general and in discourses in particular. This much one gets from reading 'Michel Foucault'. Where then does it come from, that quotation validated by 'Mark Twain' to the effect that the biographic subject is unknowable and that the biography is unwritable? In the course of thinking of the comparability of artist's studio and scientist's laboratory, rhetorically, ideologically, perhaps materially, we came across it in David Nye's *The Invented Self: An Antibiography from Documents of Thomas A. Edison*.[43] Nye deals with the problem of how one knows Menlo Park, Edison's laboratory; and his book, as the title makes clear, is an attack on biography as a mode of historical writing. Influenced by contemporary critical theory, he questions historians' assumptions about writing history, about language as an unproblematic medium, about

the status of the narrative forms they use, and about their sources.[44] Historians, he says, 'have become purveyors of myths about the self, about communication, and about the nature of documents'.[45] They endorse the myth that 'individuals are not divided selves who remain essentially unknowable in their endless variations, but, rather, beings whose lives can be recovered'.[46] In Nye's text the individual ceases to exist as this unitary object and becomes a series of meeting points, a pattern of possibilities to be read from all kinds of texts. Not *the* biography, but a book of biographies, not Thomas Alva Edison, but a plurality of Thomas Alva Edisons, the many clothes and buttons of a subject who cannot be written, at least not under monographic assumptions.

A conclusion might go something like this: that there is no such thing as expression in art, only expression claims seemingly attached to a biography written for the artist; but under the impact of contemporary critical theory, the artist becomes unknowable and biography unwritable, thus what we are left with, all that is available for consideration, are expression claims made in virtue of the work of art which is no longer, in any way, a primary source object. This has to be thought about. But then we find we can make a modified, expanded case for biography, and even for the existence of *homo narrans*, who can, like Mark Twain (and yet not like Mark Twain), write the unknowable. And thanks to those aspects of critical theory which give us the pluralised subject we see that the biographies of the artist – biography must be indelibly plural – can be written as a pattern of possibilities.

We want nevertheless, and in addition, to return from the clothes and buttons of the man to the 'expressive quality' which Richard Wollheim claimed for *Red on Maroon* in 1970. At present, we can hold with reference to expression in art that what we must do is understand the production and consumption of meaning, of expression claims like Wollheim's, as social, institutional, differential, dispersed, dynamic and as part of the discourse of power. After all, on whose behalf do we permit cultural management to make the claims it does? And why? Who are the cultural managers? It is not the job of an art historian, critic, philosopher of art, whoever, to stand in front of a painting and say: this means so and so; this expresses such and such. Neither is it the job of cultural managers to compare assorted commentators on a painting and say of the explanations that one of them is right and that the others are wrong, and to imply through that that the painting is inherently what the one who is considered to have explained it correctly said it was. What needs to be excavated and written is the nature of the explanatory systems mobilised by these always-already institutionalised commentators and the conditions under which they, like Wollheim, worked to produce their explanations, their expression claims, their biographies; and why.

Meanings are appropriated, and appropriated differentially. That item of difference has to be made intelligible. Rendering that intelligibility is, according to this closing suggestion, a matter of constructing a discourse of the second order, whose capability would be redoubled in the following way. It would be able to work on the usual territory of critical art history – conventionally, let us say, paintings: their production,

consumption and historically specifiable meanings. Simultaneously, and with much the same apparatus, it would be able to work on the orders of meaning produced and consumed by those interested communities of cultural managers, aesthetic philosophers and the like. The point of being able to do both at once is to be able to provide better accounts than those of Establishment meaning-mongers, while making clear, at one and the same time, the deficiencies of method and explanation with which they persist.

Much the same techniques serve both purposes, for painting and art talk are produced in and at locatable, analysable cultural sites. Paintings are seen, read and written as meaningful, expressive entities within particular institutional contexts: art schools, universities, art journals, art galleries, film and television, etc. What is required, therefore, is analysis of the nature and function of these discursive contexts within which particular meanings and values are assigned. Only with this can we begin to understand the historically and culturally specific production and consumption of meaning, and the effects of that production and consumption.

It is by no means clear that this can be done simply by using 'critical theory', given its lack of analytical systematicity, and given its problematisation, through textuality, of reference, history and persons. What may, however, be done with respect to second-order analysis is to stipulate carefully those elements of critical theory which have potential use-value for such a project. If we then stipulate, for example, a notion of the human subject dispersed, decentred, deconstructed, as possessing analytical use-value for the second order, then we could, for example, still study the historically and culturally specific production, consumption and effects of Wollheim's statement. In so doing we would still be studying the biographical, however problematised, and now in doubled form. Wollheim's statement was made, let us say, at the moment of the demise of high-modernist painting, and was made to give that kind of painting its best and possibly only defence. It was published in December 1970 in *Studio International*, to effect the meaning or 'greatness' or 'expressive quality' of Rothko's painting as 'a form of suffering and of sorrow, and somehow barely or fragilely contained'. This can now be studied by writing a kind of biography for Wollheim, who must, in this biography, have written 'The Work of Art as Object' in September or October at the latest, and in the knowledge of Rothko's suicide in March. At this point, the biographical becomes doubled, and starts to be constituted as a dual narrative circuit, connecting a biographical Wollheim, with a biographical Rothko, painter of a certain surface twenty years before. Doubled and dispersed this terrain may be, but it retains an eliminable biographical dimension. Mark Rothko's discursive inscription was into an imputed biography produced by Wollheim; this inscriptorial imputation now also becomes an element in a biographical fragment of Wollheim which we in turn construct: we join narratives which are of persons, *homo narrans narratur*.

Notes

1. Richard Wollheim's 'The Work of Art as Object', first published in *Studio International*, vol. 180, no. 928, December 1970, pp. 231-5, is a revised version of a lecture given in November at the Gardner Centre for the Arts, University of

Sussex. It is reprinted in *On Art and the Mind*, Harvard University Press, 1973, pp. 112-19 and an edited version is included in Charles Harrison and Fred Orton (eds), *Modernism, Criticism, Realism*, London, 1984, pp. 9-17.

2. In 'The Work of Art as Object', *Studio International*, p. 234, Wollheim refers to 'some of the banal pronouncements characteristic of Conceptual Art' and directs us, for examples, to *Studio International*, vol. 180, no. 924, July/August 1970, which contained a '48 page exhibition' organised by the New York entrepreneur, art gallery owner and publisher Seth Seiglaub. Seiglaub had invited six critics - David Antin, Germano Celant, Michel Claura, Charles Harrison, Lucy R. Lippard and Hans Strelow - to each edit an eight page section of the magazine, and to make it available to the artist or artists that interested him or her. It seems likely that Wollheim had in mind Charles Harrison's section, which included 'works' by Keith Arnatt, Terry Atkinson, David Bainbridge, Michael Baldwin, Harold Hurrel, Victor Burgin and Joseph Kosuth, and maybe Lucy Lippard's section, which consisted of 'works' by Robert Barry, Stephen Kaltenbach, Laurence Weiner, On Kawara, Sol LeWitt and Douglas Huebler. The *Studio International* 'exhibition' was part of a *moment* symptomatised by exhibitions with titles like *When Attitudes Become Form* (ICA, London, 1969), *Idea Structures* (Camden Arts Centre, London, 1970), *Art as Idea from England* (New York Cultural Centre, 1971), all organised by Harrison, by writing about 'the dematerialization of art' - see John Chandler and Lucy Lippard, 'The Dematerialization of Art', *Art International*, February 1968 - and 'post-object art' - see Donald C. Karshan, 'The Seventies: Post-Object Art', *Studio International*, vol. 180, no. 925, September 1970, pp. 69-70 - and by the publication of *Six Years: The Dematerialization of Art*, ed. Lucy Lippard, London, 1971, described on the title page as: 'a cross-reference book of information on some esthetic boundaries... focussed on so-called conceptual or information or idea art with mentions of such vaguely designated areas as minimal, anti-form, systems, earth, or process art occurring now in the Americas, Europe, England, Australia, and Asia (with occasional political overtones)...'.

3. See the endorsement by Anthony Quinton on the back of the Pelican edition of *Art and its Objects*, Harmondsworth, 1970, which concludes that Wollheim 'has never written anything better, nor on this subject, has anyone else'.

4. Wollheim, 'The Work of Art as Object', *Studio International*, 1973, pp. 232-4.

5. Ibid., pp. 234-5.

6. Ibid., p. 235.

7. Ibid., p. 235. *Red on Maroon*, 1959, oil on canvas, 266.7 x 238.8 cm (105 x 94 in), Tate Gallery, T1165, is reproduced in colour on the cover of the catalogue of the inaugural exhibition, *Mark Rothko. The Seagram Mural Project*, Tate Gallery, Liverpool, 28 May 1988-12 February 1989.

8. Wollheim, *Art and its Objects*, 1970, see sections 15-18.

9. Clement Greenberg, '3 New American Painters', *Canadian Art*, May/June 1963, p. 175.

10. Clement Greenberg's 'Avant-Garde and Kitsch' was first published in *Partisan Review*, Autumn 1939, pp. 39-49 and 'Towards a Newer Laocoon' in *Partisan Review*, July-August 1940, pp. 296-310. They are reprinted in *Clement Greenberg. The Collected Essays and Criticism, Vol. 1, Perceptions and Judgements, 1939-44*, ed. John O' Brian, University of Chicago Press, 1986. 'Complaints of an Art Critic' was first published in *Artforum*, vol. 6, no. 2, October 1967, pp. 38-9; an edited version is included in Harrison and Orton (eds), *Modernism, Criticism, Realism*, pp. 3-8.

11. Wollheim refers to Michael Fried's essay in the catalogue for the exhibition *Three American Painters*, Harvard University, Fogg Art Museum, 1965, during his discussion of Louis's painting, see 'The Work of Art as Object', *Studio International*, p. 235. Fried's 'Art and Objecthood' was first published in *Artforum*, June 1967, pp. 12-23; it is reprinted in *Minimal Art: A Critical Anthology*, ed. Gregory Battcock, New York, 1968, pp. 116-47. Fried always acknowledges his debt to and use of Greenberg's writings, see for example in 'Art and Objecthood', *Artforum*, pp. 15,16, 20, 23. Both Wollheim and Fried mention and use Stanley Cavell's essays collected in *Must We Mean What We Say?*, New York, 1969. Wollheim refers to Cavell's discussion of the connections between art, concepts under which art is produced and theories of art, see 'The Work of Art as Object', pp. 232 and 233; and Fried refers to Cavell for 'more on the nature of essence and convention in the modernist arts', see 'Art and Objecthood', p. 23, no. 4 – Cavell is also acknowledged in notes 10 and 19.

Greenberg and Fried figure in Wollheim's recent *Painting as an Art*, London, 1987, the expanded and revised version of his Andrew W. Mellon Lectures in Fine Art, National Gallery of Art, Washington, 1984 - for a discussion of what Wollheim has to say about them in this context, see Michael Baldwin, Mel Ramsden and Charles Harrison, 'Informed Spectators', *Artscribe*, March/April 1988, p. 75.

12. Clement Greenberg, 'Towards a Newer Laocoon', in *Clement Greenberg. The Collected Essays and Criticism*, vol. 1, pp. 28-30.

13. Ibid., p. 30.

14. Ibid., p. 28.

15. Clement Greenberg, 'Complaints of an Art Critic', in Harrison and Orton (eds), *Modernism, Criticism, Realism*, p. 7.

16. Hal Foster, 'The Expressive Fallacy', *Art in America,* January 1983, pp. 80-3, 137.

17. Art & Language, 'Abstract Expression', *Art-Language,* vol. 25, no. 1, October 1982, pp. 1-22; an edited version is included in Harrison and Orton (eds.), *Modernism, Criticism, Realism*, pp. 191-204.

18. Hal Foster, 'The Expressive Fallacy', p. 80.

19. Wollheim, 'The Work of Art as Object', p. 234.

20. Hal Foster, 'The Expressive Fallacy', pp. 80-1.

21. Art & Language, 'Abstract Expression', in Harrison and Orton (eds.), *Modernism, Criticism, Realism*, pp. 197-8.

22. Ibid., pp. 193, 195.

23. Ibid., p. 194.

24. Ibid., pp. 192-6.

25. Ibid., pp. 193-4.

26. *Mark Rothko: A Retrospective Exhibition, Paintings 1945-1960,* Whitechapel Art Gallery, London, 1961, see Peter Selz's 'Mark Rothko', pp. 14-20 and Robert Goldwater's 'Reflections on the Rothko Exhibition', pp. 21-5, reprinted from *Arts,* vol. 35, no. 6, March 1961. Goldwater's essay is included in *Mark Rothko 1903-1970,* Tate Gallery, London, 1987, pp. 32-5.

27. Peter Selz, in *Mark Rothko: A Retrospective Exhibition ...*, pp. 14-20.

28. Robert Goldwater, ibid., pp. 21-5.

29. Selz, ibid., p. 19.

30. Goldwater, ibid., p. 24.

31. Art & Language, 'Abstract Expression', in Harrison and Orton (eds.), *Modernism, Criticism, Realism*, p. 196.

32. David Antin, 'Biography', *Representations,* no. 16, Fall 1986, pp. 42-9.

33. Ibid., p. 42.

34. Ibid., p. 43

35. Ibid., p. 43.

36. Ibid., p. 43-4.

37. Ibid., p. 46.

38. The term 'superstructuralism' is taken fron the title of Richard Harland's *Superstructuralism: the Philosophy of Structuralism and Post-Structuralism,* London: Methuen, 1987.

39. For an account of who said what to whom and when see Ronald Alley, *Catalogue of the Tate Gallery's Collection of Modern Art Other than Works by British Artists,* London, 1981, pp. 658-60.

40. For example, Griselda Pollock, 'Artists, Media, Mythologies: Genius, Madness and Art History', *Screen,* vol. 21, no. 3, 1980, pp. 55-96, and Nicholas Green, 'Stories of Self-Expression: Art History and the Politics of Individualism', *Art History,* vol. 10, no. 4, December 1987, pp. 527-32.

41. R. M. Young, 'The Basic Discipline for a Human Science: Biography', unpublished typescript, n. d., p. 8.

42. Ibid., p. 7.

43. David Nye, *The Invented Self. An Antibiography from Documents of Thomas A. Edison,* Odense University Press, 1983.

44. Ibid., p. 9.

45. Ibid., p. 8.

46. Ibid., p. 8.

Chapter 13

Agency and the Avant-Garde:

Studies in Authorship and History by Way of Van Gogh

GRISELDA POLLOCK

> The image of literature to be found in ordinary culture is tyrannically centred on the author, his person, his tastes, his passions, while criticism still consists for the most part in saying that Baudelaire's work is the failure of Baudelaire the man, Van Gogh's his madness, Tchaikovsky's his vice. The explanation of the work is always sought in the man or woman who produced it, as if it were always in the end, through the more or less transparent allegory of the fiction, the voice of a single person, the author 'confiding' is us.
> Roland Barthes 'The Death of the Author' (1968)[1]

Art history has been represented as a discipline bypassed by the theoretical impulses which have so transformed its closest relatives in film and literary studies.[2] Such indifference has however made it an easy target for varying forms of imperialism from its neighbours, especially from those in literary studies. It would, on the other hand, be foolish to deny the immense stimulation gained from contact with literary structuralism or cinematic semiotics by art historians intent on bringing their lagging discipline into line with major intellectual movements of the twentieth century. As a result of these multiple cross-overs, there is now a common territory upon which specialists in studies of the visual arts confer with literary critics, philosophers, linguists and film analysts. We need only consider the composition of annual conferences of the Association of Art Historians in recent years to recognise the extent of the exchanges between art historians and other disciplines.

Where does this interdisciplinarity actually leave the study of those practices, objects and discourses specific to what used to be known as art history? Are they to be

abandoned to those art historians who have not yet engaged with structuralism and since – thus leaving intact not only the canon of selected objects for study, but the methods, the narratives and their defining subject, the artist? Is the tendency towards an art history merely revised by social and historical research which continues to ask questions about what artists do and why and what pictures mean and how?

Ways of analysing so-called 'works of art' have in fact undergone considerable transformation in recent years under the combined pressures of a revamped Marxism, the debates within and between structuralism and post-structuralism, the intervention of psychoanalytical theories and the impact of feminism. A particular focus of revision has been the centrality of the artist to the study of works of art. Indeed art history has been defined as a humanist discourse enshrining its belief in individual human agency in its dominant written and exhibited forms, the monograph, the catalogue raisonné, the one person exhibit, and in its primarily narrative and psycho-biographical emphases. The artist is thus perceived as a sign articulating a range of ideologies which invest that figure symbolically with social meaning. This combines a superior value for the masculinity it signifies and validates a Western European mode of individuality superior to (i.e. more creative than) those of other world cultures. Race, class and gender have, therefore, all been excavated as part of the ideologies around the artist.

Furthermore there has been criticism of those social histories of art which remain committed to objects, even when objects are treated as carriers of significant ideologies, they are analysed, according to Nicholas Green and Frank Mort, as still drawing on the 'conventions of mainstream art history'.[3] These serve to reinforce the uniqueness and specialness of the object. Their alternative mode of practice involves to some extent abandoning these defining practices of art history altogether. They advocated that the current domain of art history be displaced by the study of visual representations within discursive formations so that neither objects nor artists are taken as having the priority or significance that is explained by use of supporting historical documentation or using other materials as comparative reference. The object of study is thus radically different, dispersed, freed from the hierarchy of art object-historical background-comparative material, within which art history is defined as a discipline.

> Visual representations need to be seen as part of an interlocking set of histories which involve multiple relations and dependencies across a range of fields and social practices...We must hold onto this point *at the moment of our analysis*, which should not be directed at any single object, image or sub-domain (art criticism, patronage), but upon the play of interlocking social processes.[4]

Nicholas Green's subsequent work on the discourses of nature in bourgeois culture during the early nineteenth century and their complex reworking in the cultural politics and economics of the Third Republic justified his redefinition of his project as a cultural historian. Discourses on urbanism and nature were not used to elucidate the project of Barbizon landscape painters, but the practice and consumption of landscape painting

was identified as one instance, one moment or site, articulating in a specific and specifiable way, a complex of practices and discourses on nature and the city which ultimately functioned to define the bourgeoisie as a social class through its cultural modes.[5] Furthermore, Nicholas Green has contributed a historical understanding of the formation of art historical discourse in the intersection of what he calls the biographical strategy of art criticism and the emergent economy of art marketing and dealership in the Third Republic.[6] Yet the cogency of such a Foucauldian model for cultural analysis should not leave us blind to the implications of failing to engage with the cultural discourses and representations produced by art history in which their narratives of modern art and modern artists remain unchallenged.

There are opposing tendencies, however, within the camp critical of such modernist stories. Charles Harrison and Fred Orton, for instance, state categorically their continuing interest in the canon of artists art history has validated for study:

> Nor do we seek to justify a revision of the canon of high art. If, as we suggest...
> the concept of 'quality' might fruitfully be replaced by some potentially more
> open and explanatory explanation for merit in art, it would not necessarily
> follow that the latter would have to be applied to any different range of objects.
> We are interested in art, and in the art which has proved most interesting... Nor
> do we seek to redefine or extend that interest in terms of an interest in 'cultural
> production' or 'visual ideology' or 'signifying practices' or whatever.[7]

In their article[8] Fred Orton and John Christie address the other basic facet of art history. The individual artist is re-examined in the light of critiques of the monograph, art history's typical form of research, writing and teaching. They distinguish between the monograph, 'decisively compromised with its Subject (capital S) and the biographical narrative, which is unavoidable'.[9] They address the issue of the expressivity of art objects. In traditional art historical accounts these are explained monographically, i.e. 'over-individualised accounts of artistic creation and reductive explanations in terms of talent or genius'. But they want to harness the social history of art's concern with historical specificity of production and consumption of meanings by means of which art objects acquire their expressivity in terms of historically locatable discursive contexts (both at the moment of production and later moments of production). What makes biography indispensable to this is that people/persons are ontologically prior to all this. There is an echo here of Marx's assertion that people make history, though not in circumstances they choose. So how do we understand that productive activity of a specifiable historical person making the art/statement/text?

Critical theory has made subjects unknowable and biographies unwritable, claim Christie and Orton. Critical theory gives us a 'pluralized subject', 'dispersed, decentred, deconstructed'. Biographies (note the plural) of artists can be written as 'a pattern of possibilities'.[10] In addition, because of the fact that human subjects are both narratable (we can tell stories about them) and narrating (art historians for instance tell stories),

attention will also focus on the historically and culturally specific conditions of production, consumption and effects of the biographers' writings and statements.

This argument leaves open a space for authors – author artists and author/writers – as agents acting in a world of statements, meanings and discursive contexts. But as what? To what do these names refer? The originating subjects as historical agents, the effects of specific texts, the particular but none the less socially structured moments of class, race, and gender specific subjectivities? Furthermore, how are we to write with the consciousness of the complex functions and confused status of the author?

II

I want to write a book on Van Gogh. I have a lot invested there. It has cost a great deal of money to equip myself with the *Complete Letters* in three languages and the facsimile editions, with the catalogue raisonné and its updates, alternatives, with the steady stream of catalogues of major exhibitions. I also have a symbolic investment. I gained my professional certification, my doctorate, by advancing a quite novel reading of Van Gogh. I was at the time under the influence of a new kind of art history, the social history of art. As a result, I wanted to intervene in modernist art history and show the world that Van Gogh was not an isolated and maddened genius, but an explicable historical figure operating within social and historical determinations as a calculating and ambitious modernist. But my thesis was constrained by its trying to be a model of social history of art – lots of class and ideology, little in the way of gender, nothing about race or sexuality. One footnote on p. 305 mentioned sexuality and cited Foucault. Mine was a compelling argument that threw considerable light on the formation of avant-garde culture across the axis of city and country by studying a would-be but ultimately inadequate modernist. I think I might call the book I shall write *The Case Against Van Gogh: The Cities and Countries of Modernism.*

But I had also been reading a lot of other things. Discourse theory for instance. I had also just written a book on 'women, art and ideology'.[11] This made me turn my attention to reading art history itself as an ideological discourse. I also began to read art history 'as a woman'. I no longer wanted to improve or revise art history. I became involved in, and then distanced by, its sexual politics. In the same year as my PhD was completed, I published an analysis of the construction of the governing terms art and artist in art history.[12] I found an interesting connection between the way men artists were written about and the way women were not.[13] I used Van Gogh as a case study of the mythology of the great artist. I claimed that the job art history did was in fact to produce the artist as the cause and explanation of art. After providing so comprehensive a critique of the monograph and art history's preoccupation with the artist, I do not think that I can really write a monograph any more.

III

But what about my position as an author writing as a woman in this debate? Feminist cultural historians have not been afraid to operate in, as well as on, the dominant art histories – partly to reinscribe the participation of women as producers and consumers of culture, and partly to identify the effects of sexual difference within the very structures of art practice, its texts, images and discourses.

As a result of both these imperatives, monographic studies of women artists are being produced as well as re-readings of major moments and formations such as the Renaissance and modernism. Terms such as representation and sexuality, that originated in attempts to analyse popular culture, now function to interrogate high culture for its ideological and political effects.[14] But what about the status of the artist when she is a woman? Does it make sense to push her off the stage when she never really had a part in the play?

Writing in relation to literary studies, Nancy K. Miller argues that feminists will naturally welcome the assassination of the Author, 'canonized, anthologized, institutionalized, who excludes the less well-known works of women and minority writers from the canon, and who, by his authority, justifies this exclusion'.[15] But then she qualifies her embrace of the 'death of the author': 'I will argue, in this paper, that the postmodernist decision that the author is dead, and subjective agency along with him, does not necessarily work for women and prematurely forecloses the question of identity for them.' Women's relation to origin, institution and production, to integrity and textuality, desire and authority is structurally different, argues Miller.[16] But if this is true of women authors/artists whom we might study, is it not true of ourselves as women authoring art historical discourses in which we are forced to ponder the weight of authority attached to the men we study in relation to the relative lack of authority acquired by the texts we write about them? If feminist writers reconsider the issue of authorship by attempting the relocation of women in the schemes of official knowledge, we should also reappraise the effects of women writing about authoritative, canonical artists, 'writing and reading as women', that is to say against the grain of the dominant assumptions of our cultures and their discourses.

Could I make, therefore, a *feminist* intervention in the monograph and the Author by writing a critical, and indeed self-critical text about a canonical modernist?

IV

I have decided to try and write using my Van Gogh material. It won't be about Van Gogh. It is about doing art history from somewhere outside art history which isn't *cultural studies* or *new art history* or *social history of art* or *feminist art history*. But I have to work out to what I shall be referring if I use the word Van Gogh (as in the phrases: Van Gogh did this; Van Gogh's painting, for instance). I have made a start at sorting this out. In an essay in *Art History* on 'Van Gogh and the Poor Slaves', I felt the need to justify writing on a painting made by a historical artist in the canon.[17] In two

dense paragraphs I noted the possibilities before me:

1) The painting as text: this involved locating a painting within a semantic field on which the particular text depended for any meaning it might or might not have achieved at the historical moment of its circulation.

2) The painting as a product of social and historical processes of artistic and ideological production: this displaces the intention and individual creative purpose of the traditionally conceived artist.

One of the historically specific conditions of the production of such paintings as *The Potato Eaters* (fig. 10), however, could be shown to have been a highly motivated producer, who made works not for commission, or within the context of an already valorised career structure. The type of artist Vincent van Gogh came to be, and indeed, conceived himself to be according to certain kinds of narrative, autobiographical evidence as well as the fact of the kind of practice labelled with the name Van Gogh, all this was a historical effect of specifically new market conditions and the ideological response to these conditions of their existence of the subcultural fraction we know as the avant-garde that was responsible for the modernist project Van Gogh aimed to join. As a feature of capitalisation and commodification of artistic production in the later nineteenth century, the intensely individualised character and ideology of modernist art-making has to be grasped as a contributing factor, a social and historical condition of the possibility of such works existing at all – let alone in whatever form. I was left, therefore, with the necessity to work out to what *Van Gogh* might refer in my texts and these were, as Christie and Orton presume, plural and fractured signifieds.

Van Gogh could refer to a historically located producer, functioning within emerging structures of artistic production, consumption and related discourses such as art criticism, art history, but also biography and especially autobiography – the presentation/narration of a self as part and parcel of the production and anticipated consumption of art works. The multi-faceted shaping of an individual style/identity/commodity for sale and circulation in market conditions demanded both reference to the wider structures of which they would be an instance and the particular articulation they would effect.

This second version of an agent I could work with was conceived in terms borrowed from film theory. Film theory's notion of *auteurs* as effects of texts to which a name was retroactively applied as a means of classification, and intelligibility suggested that I signal this author effect by the device 'Van Gogh'. 'Van Gogh' signifies a set of procedures, resources, competences, stylistics and effects which are collectively recognised only at the point of consumption or art historical analysis – a consumption mediated and heavily determined by art criticism and art history, both of which effectively do the classification and identification that determine the meanings signified by the *auteur* name.

Finally, and to some extent quite incompatibly, I could consider the issue through the prism of psychoanalytic notions of subjectivity. In that sense, I might name a historically

specific subject Van Gogh as an effect of the socio-psychic patterns by which all subjects are apparently produced, while, at the same time, tracking the peculiarities of his specific trajectory across these constituting processes. This would mean that the subject Van Gogh was read again not as an already constituted point of production of meaning, but rather 'Van Gogh' would be read symptomatically off the written inscriptions and visual traces. Paintings, drawings and letters function as sites of subjectivity-in-process, as performances, as enactments riven by unconscious pressures and limits. They are not reflections or expressions of a given and coherent subjectivity prior to the work. Rather their status becomes that of unforeseen and yet complex texts generated from a subject position which is fractured, unstable, discontinuous and contradictory, a position classed, sexed, raced, yet always eluding fixity and exceeding such orderings because of its divided as well as contradicted character, and because of the particular relations that subsist between subjectivity and signs, semiosis.

Implicit in these several definitions were a whole host of debates about authorship and the subjects that were raging outside art history. Barthes, Foucault, Lacan – the odd bedfellows pulled in several, opposing directions. It seemed appropriate to return to these germane debates. On the one hand, I could draw some support for the project to demythologise the idea of the artist prevalent in art history by looking to Barthes's proposition about the 'death of the author'. Barthes replaced the author with text, however, with writing, but without history. The critical art historians I have mentioned were all still preoccupied with the historical character of artistic production, so the turn to Barthes might present other problems.

Foucault obliges us to acknowledge that even once we have exploded the bourgeois myths sustaining the cult of the author, we are still left to understand the potency of that figure in organising knowledge in the West. Author names are one of the major ways we consume our cultural patrimony, know our history, and legally establish intellectual property. What are its historical functions? What would it do to break up the unities of the author – the *oeuvre*, the book, the artist him/herself? This sounds like what I did fifteen years ago, doing discourse analysis on art history – how does the artist as a sexed idea function in art historical writing to secure authority and value to certain kinds of texts while denying both to other texts not so labelled (i.e. by women, who were not included in the sign artist)? Could Foucault's sense of the historicity of authorship as a function of power be related to my sense of the historically specific agency of avant–gardism? What about Walter Benjamin's polemic on the Author as producer?[18] Does that allow for a way to study not 'artists' but producers in their historical particularity that could only be grasped and defined against the ground of social relations of production?

I wanted the opportunity to revisit these texts and clarify the terms in which it might be possible to write the book. If not, I have to decide it is unjustifiable theoretically – impossible, but inevitable.

V Roland Barthes, *The Death of the Author,* 1968

This text has to be understood in the context of debates around contemporary literature, *le nouvel roman* and modernism. It is an attempt to come to terms with historical and not purely philosophical issues. That is the production of a range of novels in which an authoritative author was no longer being produced in the manner of writing. Barthes's text registers a shift from one system of literary production and the way it enshrined authors and another. In no sense does the theory imagine the end of actual producers, writing, (or for that matter painting or film-making). This text is about a system of relations of writing and reading associated with the textual effects of the classic realist novel. The reader in that system is addressed, indeed invoked as witness to the author's statements, by the way the novel is written. The reader is produced as a witness to a world simply but authoritatively demonstrated, delivered or described by the author from whom the writing appears directly to emanate. This author effect as we shall have to call it is buttressed up with, and indeed is an articulation of, notions of power and legitimacy, the Subject (Capital S).

Barthes identified a breakdown of that authority of enunciation – someone who knows and someone who can speak so that we may learn and understand how the world is, what people are like. In the modernist/post-modernist system, the reader encounters instead a more fragmented and diversified text. Coherence is achieved, if at all, only at the point of consumption: the reader. The reader ceases to be merely a latecoming witness to the world the novel fabricated, but becomes the critical site at which the many threads of a text momentarily, but precariously, combine. In that too famous phrase: 'The birth of the reader must be at the cost of the death of the author'.[19]

Implicit in Barthes's new anatomy of modern writing systems is the shift from notions of the *work of art* to the *text.* The object-like quality of the term work is displaced in favour of a sense of productivity. 'We know now that a text is not single line of words releasing a single "theological" meaning' (the message of the ultimate Author – God), but a multidimensional space in which a variety of writings, none of them original, blend and clash.[20] At this point the personalised qualities of art as self-expression evaporate before the play of textual elements which are the property of the writing/painting culture, not of an individual. It is only through this common currency that readers are able to enter the game of literature/art that is a play of signs on the territory of the text. Structuralist propositions about the way we are captured in and for language are relevant here to indicate the shape of Barthes's arguments and its effects.

In linguistic theory, the first person noun, I, is a function of a place in a language system. It cannot be the signifier of a unified self outside of language who merely borrows it to express that self. Any first person statement is always systemic and 'textual'. The addressee, the 'you' who complements the 'I' for a statement to be made, is also textually posited. An ideological notion of the priority of the author as an originating moment, a subject who pre-exists and predates the text, and knows in

advance what is to be expressed, or is, at least, the site of experiences which language merely struggles to articulate, is radically displaced by the structuralist view. Meaning is an effect of a textual system in which the only site of coherence is what comes after the event of language, of 'writing' – a point which the writing must achieve to be meaningful, a point for the convergence of the writing – namely the reader. This reader is posited as 'without history, biography, psychology' for we are talking about a place not a person, an effect; the destination created by writing is not personalised. The reader is that someone 'who holds together in a single field all the traces by which the written text is constituted'.[21]

This stress on 'writing' (*écriture* in French), furthermore, destroys the claims of the creative originator. Writing is not a personal property or expressive medium for the creative self. It is cultural, social, historical, a field of codes and conventions in which meaning is produced through the play of its signs, within its traditions, through its connotative systems over which no one person can claim mastery. Barthes concludes:

> Thus is revealed the total existence of writing: the text is made up of multiple
> writings, drawn from many cultures, and reentering into mutual relations of
> dialogue, parody and contestation, but there is one place where this multiplicity is
> focussed and that place is the reader, not as was hitherto said, the author. [22]

Finally the Barthesian system displaces the hidden corollary of the myth of the creative originator/author/God – the Critic. As a result of the change of the system Author/reader, modes of interpretation must change. The Critic was part of the Author system and its chief ideologue. Through the myth of the Author, the Critic constructed a role as mere interpreter of a given content. The Critic posited an Author who then served as 'a limit on the text, a final signified'. In the multiple play of signs and codes within a text (as opposed to the created content of a work), Barthes argues that nothing is to be deciphered by privileged mediators (i.e. critics or art historians for that matter). Everything is to be disentangled. The work of appreciative consumption via the self-appointed expert is displaced by competing, critical readings.

Finally this argument is shaped by the specific notions of subjectivity characteristic of the literary practices associated with modernism. The lack of a textually inscribed authority called the author is an effect of a historically determined loss of faith amongst writers in their right/ability to claim authority, to masquerade as author – the knowing Subject. Barthes's clarification of the condition of modern authorship is not about that which inhibits people from writing novels. He is specifying what prevents modernist writers from presenting that activity from a position of authority. This makes the question deeply political.

Barthes does not ever discuss in this connection the social conditions of production of individual writers. He is attempting to formulate an ideological shift between systems – or formations for the production of literature and its consumption. One formation

privileged the author who was subordinated ultimately to the Critic. The second system displaces both Author and Critic. While stressing the textual activity of writing, it creates a specific significance for reading. The individuation of the *personae dramatis* as The Reader, The Author, The Critic has a somewhat distorting effect because we easily try to personalise these positions and are tempted to place ourselves in them. The real significance of Barthes's text is the differences drawn out between two systems of literary production and their ideological effects.

What relevance has Barthes's essay for art history?[23] In the visual arts and art history, we have not witnessed that massive loss of faith in the ideology of the artist/creator; not until perhaps the 1960s-70s when conceptual art and its radical variants made a self-onscious critique of the claims of authorship and the status of art as object or statement. It would be possible, however, to note two quite opposing trends in modernism in relation to the status ascribed to its authors/creative artists. On the one hand, there is Harold Rosenberg's reading of American abstract art of the 1940s and 1950s, in which the artist is considered as an agent, acting in the real world.[24] In the writings of Clement Greenberg on the same cultural activities, there is some room to discern a differently conceived suspension of the artist as expressive subject of art in favour of an analysis of 'painting' as something akin to *écriture* (writing, from Barthes's text). Greenberg's concept of 'painting' almost functions like a Barthesian textual system.

There are also other moments in modernism which could be read symptomatically for an awareness of the suspension of the author as Subject, in Surrealist experiments with automatic writing, and in the ideologies of productivism and Marxism operative in Soviet art production in the 1920s and in the moment of Brecht and Benjamin in Weimar in the 1930s, for instance. These instances are, however, paralleled by the persistence of the author-centred system, signified by expressionism and by the cult of the artist that is economically backed through the mechanisms of the art market.[25] In place of cinema's 'Politique des auteurs', visual art retains more than any other art world an *economy of authority*.[26]

While Barthes's analysis of the great author shift in literary modernism has theoretical implications for art history, its major effect is simply to reveal just how central the author system remains to the mass of critical, art historical and art practical discourses and to the production, economic consumption and historical appraisal of the visual arts. With the artist as a much more profoundly centred ideological figure and required instrument of economic organisation, critiques are much more muffled.

VI

Art history is, however, much changed since 1980, let alone since 1968. We should more correctly speak of art histories, or histories of art for the stories and anti-narratives are now definitively plural. Even within that which can still be called mainstream (biggest funding and publication), there have been noticeable shifts. For instance the Van Gogh

of art history has altered significantly in the decade since I completed my PhD. My work, I now realise is part and parcel of the changed landscape of Van Gogh studies which regularly surface in *Art History* or *Art Bulletin* or *Arts Magazine*.[27]

Financial investment in Van Gogh has accelerated to achieve fantastic prices for his paintings. The new sober art historical version of Van Gogh generated in art history in the 1980s has contributed to this revaluation. The value attributed to the pathetic, pathological but maddened eccentric has been enhanced by solid art historical work that puts Van Gogh back into the company of the explicably great artists.

In November 1987 a painting by Van Gogh, *Irises* (1889), was sold at Christie's for $53.9 million. To date it is the most expensive painting ever sold. It was sold to a private buyer in Australia. The previous year *Sunflowers* (1888) had fetched another record sum when bought by a Japanese corporation. This economic investment has been matched/prepared for in art history. Whereas there have been major retrospective exhibitions over the last two decades celebrating the centenaries of the nineteent-century 'founders of modernism' – Millet 1975, Courbet 1977, Pissarro 1982, Manet 1983, Renoir 1985, Degas, 1987, Morisot 1987, Gauguin 1988 – Van Gogh has been the topic of no less than eight major exhibitions:

> 1980 Amsterdam: *Van Gogh in His Dutch Years: Views of City and Country by Van Gogh and his Contemporaries 1870/90*
> 1981 Toronto & Amsterdam: *Van Gogh and the Birth of Cloisonism*
> 1984 New York: *Van Gogh in Arles*
> 1986 New York: *Van Gogh in St Rémy and Auvers*
> 1988 's-Hertogenbosch: *Van Gogh in Brabant*
> 1988 Paris: *Van Gogh à Paris*
> 1990 Amsterdam: *Van Gogh Paintings*
> 1990 Otterlo: *Van Gogh Drawings*

Ronald Pickvance dedicated the Arles exhibition to 444 days, 15 months of Van Gogh's work which he declared was the 'zenith, climax, greatest flowering of Van Gogh's decade of artistic creativity'.[28] He called the show he curated an unashamedly one-man, one-place show. Pickvance's text is shaped by the Van Gogh to which it seemingly defers, but which the text is always in the process of producing as the justification for selections, emphases and omissions otherwise not acknowledged: 'The selection for the most part attempts not only to reflect Van Gogh's own categorisations but also the choices he himself might have made.' Van Gogh exists in this text only as someone who makes paintings and drawings. Pickvance minimises personality and dismisses mental disability as significant factors. His Van Gogh is a dedicated craftsman. Chronologies are scrupulously reconstituted to enable each work to be situated in this continuing production line. Chronology thus becomes the only guide. Van Gogh is the product of charting the making of art works through letters and the appearance of the

paintings and drawings themselves.

This 'Van Gogh' is altogether less heady stuff than the popular and mythic versions more commonly circulated.[29] Pickvance invites us to appraise Van Gogh's exclusively aesthetic sensibilities and discern exclusively aesthetic purposes and enjoy exclusively aesthetic effects. But for all the paraphernalia of rigorous and self-controlled scholarship, the isolated individual creative subject is as central to this narrative as it is to the other texts comprising the Van Gogh literature. No effort at historical examination is made. There is nothing beyond the narrow confines of the artistic biography. No sense of institutional, structural, economic pressures or limits influences these still personalised stories. There is no sense even that the biographical is a site of historical inscription of social formations and their negotiation. The generalised human being of Irving Stone's *Lust for Life* (1935) is replaced by the specifically artistic individual who stands as bulwark against any dilution of art's absolute autonomy and aesthetic value. Great Art, however, needs Great Artists to make it. Pickvance's job is to remake Van Gogh to fit this necessity, to reclaim him for art history in slightly altered terms: no longer a maddened genius but a calculating craftsman. Art history serves to provide the justification for celebrating or admiring art. As Raymond Williams wrote in 1973, almost all forms of contemporary critical theory are theories of consumption: 'That is to say, they are concerned with understanding an object in such a way that it can profitably or correctly be consumed.'[30] To underline this point, I can mention a film series on which I have been involved. By providing a critical reading of the politics of sex and race that structure the work of Gauguin, I was understood merely to be showing that he was a bad artist, and not worthy of his place in the film, which, by implicit assumption, was intended to explain the individual contributions of great artists to the art of the West. Two paradigms were in conflict. One provides that we study the visual arts because they are likable (art history is there is to explain how and why to like what); the other suggests that we study culture historically to understand the conditions of its production and the meanings resulting from those relations of production within a framework of history. In this second model, examining the ideological and semantic field within which artistic practices are produced and received is justified by the simple historical fact of it having occurred. The first model allows for some rather Whiggish concept of history as the narrative of progress and enlightenment in which art at least is safe from what now contaminates the discipline of History itself – all that social, labour, feminist, black, third world stuff. Kenneth Clark's *Civilisation* encapsulates the ideological function of art history in aesthetising the past and justifying thereby the present. To like art as opposed to being interested in visual representations historically is a critical distinction. It may even be an important distinction between art history and whatever else we are in process of producing in our different modes of study of its celebrated (? sanctified) objects.

Pickvance's texts on Van Gogh were slightly defensive. He had to justify his choices within the art histories now on offer. He knows the literature, but, for him, only the

monograph and the catalogue raisonné can produce the proper Van Gogh. The *oeuvre* forms a necessary unity composed of defined groups of chronologically related works. For this reason, Pickvance refuses to isolate for special study individual paintings such as *Starry Night* (1889, New York, Museum of Modern Art). This work generated several major case studies by Boime and Soth in the 1980s.[31] The case study brings art history closer to the textual focus of critical literary theory after 'the death of the author' whose key sites of re-invention are precisely the monograph and catalogue. But in art history, the text resurrects the author. Soth's essay is a careful piece of art historical research, attempting to understand the sources and resources used by Van Gogh in the making of this painting. Those unfamiliar with Van Gogh studies won't necessarily appreciate how rarely Van Gogh works are studied in this way. But Soth's conclusion once again exposes the power of the Van Gogh myth. Having traced the painting's sources to a project for a religious picture based on the Garden of Gethsemane, Soth concludes:

> The 'starry night' Van Gogh had in his head for the *Agony in the Garden* became I believe the exalted *Starry Night* of St Rémy... The desire in 1888 to paint a starry night as an image of consolation and the attempt in 1888 to paint the consolation in the Garden of Gethsemane unconsciously merged and became the *Starry Night* of 1889. Van Gogh projected its emotional content on to nature and created a sublimated image of his deepest religious feelings. At its most profound level, the *Starry Night is Van Gogh's agony*. [my emphasis] [32]

Craig Owens has usefully drawn art historians' attention to Derrida's essay on a debate between the philosopher Martin Heidegger and the art historian Meyer Schapiro over the meaning of a painting of a pair of shoes by Van Gogh. Although the two differed over whether the painting represented Van Gogh's shoes or those of an old peasant woman, the point Derrida stressed is that the process of interpretation of a painting consists in finding an answer to the questions: to whom do they refer? Whom do they represent? Owens goes on to argue that art history's humanism exists precisely in this process of substitution. The major absence, for that which what's on canvas is merely the stand-in, is, most commonly, the artist, invented as the limit of signification, *the* meaning.[33] Owens's argument intersects with debates on authorship in its conclusion. There he contrasts post-modernist artists' interrogation of the strategies of representation and their implication in power networks of society to the modernist discourse which secures art's expressivity by reference to the someone who authors the expression. He argues that the historical relevance and significance of paintings/images lies in their relation to the prevailing systems of representation that images articulate, not to the author's originality, which Owens shows is the typical concern of art historians. For example, authority is invested in images such as Velasquez's *Las Meninas*, but it is not the privilege of the painter – rather of the sovereign (the point of power) whom the painting represents in order to signify relations of sovereignty through the complex play of vision and gaze.[34]

This example poses the polarities of the cult of the author and the examination of the text. Van Gogh's images and letters have functioned to secure the former. Nowhere is this more obvious than in Paul Cox's film *Vincent* (1988) in which an actor John Hurt reads extracts of the letters as if speaking directly to the audience over a chronological sequence of filmed paintings and drawings which chart Van Gogh through various places and stages before he self-destructs and ends the film. These same materials could be appropriated for Barthes's *écriture* or textuality. This would demand a critical analysis of the letter or image as inscription, not of a person, but within the available systems of representation and, potentially going beyond Barthes, social relations. The art historian(?), ceasing to function as the mythic Critic, could then take up the place of Barthes's reader as the point at which the potential meanings of the text converge and are open to contested interpretation. Instead, therefore, of using these evidences to construe a single authorial voice, a coherent creative subject, both explicable and likable, the result would be to track a fractured and dispersed subjectivity which is an effect of the texts themselves producing a discontinuous set of statements, variously addressed, highly motivated, yet inevitably failing.

But Barthes's reader had no history, biography or psychology because, as I have stressed, in that high structuralist moment of the writing of the essay, he was defining, in necessarily abstract terms, a system. But, unlike literary criticism, art history poses itself as a historical discipline and the writers of critical/social/feminist histories of art are conscientious about locating their readership and reconstructing a historical reading position. So how does the textual connect back with the historical? The model of the social history of art has already been arraigned for its preoccupation with named canonical authors from Manet to Pollock. Yet one such art historian, T. J. Clark, accused for studying Manet and Courbet, has also shifted ground. In *The Painting of Modern Life* (1984), the history offered may use author names, but the artists are not the focus. The topic of this history is Paris (as represented or configured in the art of Manet and his followers). The book is about the myths of modernity and their oblique relation to the emergence of a specifically modernist painting engaging with modernity. The book tracks the conditions of their production and the inflections on them within the systematic restructuring of urban space and its social relations (Haussmannisation). Paintings by Manet achieve their historical significance in terms of a reading across the texts in which 'Paris' was figured. Manet's paintings are a part of what Clark named a 'battlefield of representations'. It would be foolish to deny, however, the fact that the text is art historical and that Manet or Monet do emerge as Lukacsian representatives of their times or classes, decisively forging a pictorial language to distil some vivid though not uncritical way of representing the relations between capitalism and consumption, the spectacle and pleasure.

The 'Van Gogh' I want to define enters this art historical problematic of the formation of modernism in the city, but obliquely. The failure of Van Gogh's project is what makes it historically revealing, not its success at such Lukacsian distillation. But

whatever sense I can make of what should better be called the project 'Van Gogh', would depend upon all this new work on early modernism and its terms of reference for comprehending that cultural moment in a manner radically different from heroic sagas of so-called Impressionists. I wonder, is it simply a matter of abandoning all anxieties and accepting that to write a book about Van Gogh is merely to make a minor contribution to what remains in terms of mainstream art history a rather marginal revision? Might it be sufficient to establish Van Gogh's place in a post-Clark landscape of avant-garde painting in Paris in the 1880s?

Yet whatever it is that defines this series of works and documents and events as particular, the otherness of Van Gogh, as I could call it, pulls against such easy collusion with revisionist or social modernism, histories of which which remain focused on Paris as the epicentre, primarily concerned with issues of class and a studious negligence of factors of sex or race. The concept of ideology functioning without recourse to theories of the social construction of sexed subjectivities precludes the kinds of questions feminists need to pose. It would be attractive and easy to produce a social history of Van Gogh but it would require a kind of transvestism in which the concern to 'write as a woman' would be entirely stifled.

The production of the visual and literary texts of 'Van Gogh', furthermore, entangled a much broader network of discourses and cultural projects that are ignored and marginalised in the great modernist narratives. Victorian philanthropy, English illustration, European literatures, colonialism through to agricultural and industrial developments, to the specificities of marketing and art publishing in the 1870s and 1880s. These are familiar to social histories, brought forward out of the background to form the deep structures of which art is a product. But, leaning on structuralist models, we know that such deep structures, while determining, exist only in and through their social articulations. Van Gogh's work is the *parole*/event, the enunciation and performance of its conditions of existence. This selected set of texts becomes a specific configuration whose meanings do not reside either in art history's individual author or in a historical materialist *écriture*, the text of social history. Specificity as a site of representation might be what the singular author name 'Van Gogh' refers to, and this is where the second major text on authorship may be of some help driving a wedge between the proper name and the author name to enable us to consider to what a name refers us.

VII Michel Foucault, 'What is an Author?', 1969

Foucault's paper 'What is an Author?' was given as a lecture to the Collège de France on 22 February 1969.[35] It was clearly a response to Barthes's assassination of the author the previous, historic year. Foucault suggests that the structuralist emphasis on the text, on *écriture*, has merely displaced the author, and appropriated its authority. Barthes's essay has done invaluable service as a profound attempt to elaborate the conditions of

any text. It can, however, be said to transpose the characteristics of the author to a kind of transcendental anonymity. 'Writing' itself becomes the structural 'author' of meaning. Textuality authors itself.

The post-structuralist project is to get beyond these remnants of the traditions of the nineteenth century. In *The Archaeology of Knowledge*, for instance, Foucault mounted an important critique of the whole baggage of humanist disciplines with their preoccupations with origins, developments, and traditions. These many forms of continuity express a fundamentally theological philosophy. The question of where things come from implies that there is an end point of enquiry, an origin of meaning, be it God or Writing. Both are aspects of the same desire to close down, limit, and fix that are still operative in structuralism. This worry aside, Foucault accepts the burden of radical anti-humanist thought that assumes that, along with God and Man, the Author has died as a determining figure in high level cultural discourse and practice. None the less, we are left with a job of examining the space it left: the *function* of the author, socially, culturally, historically. Foucault puts many themes into play. Those which are relevant here can be briefly addressed.

Foucault drives a wedge between the proper name of a historical person and an author name. This leaves us still with the possibility of a socio-historical analysis of the producer. Such possibilities have to be kept separate from studying what in fact author names do in Western culture and what are the conditions for the kind of individuality they construct and signal. Authorship, according to Foucault, is a historical formation that is inscribed across a range of concerns with authenticity, individuality, continuity, biography, notions of creativity, all of which always point to something outside, and prior to, the actual texts. Foucault opposes this with the suggestion that the author is a function, a way of defining and classifying groups of texts and setting them in relation to other texts (to form the *oeuvre* for instance). The author is, therefore, posterior to the text, not an origin. Authorship, furthermore, is selectively applied, and thus only privileges selected discourses. Discourse which has an author name is circulated and consumed in Western culture in a particular manner. The name of the author refers to the status of this discourse within society and culture.

> in our culture we can say that the name of the author is a variable that
> accompanies only certain texts to the exclusion of others; a private letter may
> have a signatory, but not an author; and similarly an anonymous poster attached
> to a wall may have a writer but he/she cannot be an author. In this sense the
> function of an author is to characterize the existence, circulation and operation of
> certain discourses within society. [36]

The word author is part of the chain of *authority*. Authorship has culturally specific effects and rationales. We can thus understand the nature of the resistance to reinscribing women artists into art history. Women are not considered Authors. As writers they are merely scribblers; as painters, they are daubers and amateurs. These

differential terms form the ways in which women's cultural activity is acknowledged, but denied a cultural status; sometimes signified by genius but generally effected by names not functioning as author names, i.e. designations of culturally valid and authorised statements. Women artists, for instance, are never credited with originating movements, making innovations, leading tendencies, creating ideas etc.

Moreover, the artists of world cultures beyond Europe are not deemed to be authors. All cultures have cultural producers but not all cultures, and not all epochs in Western culture, have 'authors'. The link between authorship, authority and power is critical here. Through the hegemony of Western culture in the world, other cultures are classified negatively, as inferior in relation to the assumed value of the authority of the named, i.e. authored, discourse. There are very complex issues involved here in terms of the ways in which Western academic and political writings as well as anthropologies and art histories have represented the discourses of world cultures. Western orders of discourse are valorised in terms of individuality and rationality against which standard Western discourses acquire authority to define different orders of discourse as either lacking, or indecipherable as examples of reason or philosophy or art. For instance, if one contrasts the status of historical statements and their authority in two cultures, we find the legitimacy and truth value of historical statements made by the historians, the *griots*, of Western African societies is secured through a collective knowledge constantly circulated and publicly displayed. The *griot* is a specialist by virtue of extraordinary skills of memory and recitation, but that expertise does not give authority to his statements if they contradict the collective memories of the community he serves.

In the West, the attribution of power to those with specialist skills makes us view their knowledges as authoritative. The sign of that authority is the author name and the exercise of power is facilitated by it. This has immense implications for European studies of cultures other than its own.

Foucault's essay provides two further areas of special relevance in art history. The author function is not formed spontaneously through the 'simple attribution of a discourse to an individual'. Foucault writes of a complex operation to 'construct the rational entity' we call an author. This was my project in the article in 1980, analysing the discourses in art history, psychiatry, popular romantic fiction and Hollywood film, through which the artistic subject 'Van Gogh' was produced in the early years of this century.[37] Moreover, different kinds of author are constructed for different discourses and practices. The poet is unlike the philosopher and both differ from the artist. This suggests we attend to the specific vocabularies around artists to discern the historically variable, generic features of artistic authorship. Clarity and logic may define an author in philosophy, inspiration and intuition in poetry, mastery and passion in visual arts. All these terms are furthermore ideologically inflected, inscribing over and over again the hierarchical valencies of gender, race and class. Heavy-drinking machismo, wearing Levis and Doc Martens, signifies artistic Bohemia in New York in the1950s, in contrast to the dominant bourgeois codes of masculinity. A class-specific masculinity is

appropriated out of context to support the public and self-representation of a fractional cultural practice.[38] Yet, as June Wayne has pointed out, the male artist is, in other senses, feminised by art. He doesn't do a proper job, earns little money and his failure to manage worldly matters is condoned by tolerance of a necessary if infantile egotism.[39]

The main contribution of Foucault's text is to specify the author as a function: a function of discourse which is at the same time a specification of the subject, a particular, discursive construction of what this culture defines a subject to be legally and at the level of statement. This conclusion marks the difference from Barthes's structuralism. In the latter argument, while certain myths about the Author are debunked, Writing or textuality substitute themselves, and thus writing becomes effectively as much a system as the old author as creator was. There is an origin and there are meanings. Post-structuralist critiques aim to disturb precisely those (smuggled back) unities and fixities. Both Author and Writing are displaced onto socially ordered languages or discourses. The cornerstones of post-structuralist theory are propositions concerning the relations between language, subjectivity and social organisation/power. In the humanist model, the intention of the speaker who is presumed to be fully present to himself, guarantees that statements have meaning (they emanate from his mind) and secures what meaning they have. In that formulation, if you can confirm the speaking subject as presence or the artist as present in the work, you can claim the work embodies the artist's intention. Structuralism shifted the terms to make language the system which speaks its subjects. We speak because, inserted into the chain of signifiers, we borrow the forms of language to articulate ourselves in its terms, occupying the positions for speaking it defines, and thus any meaning produced is radically other. Not an expression of a unique person, Language is understood as the very system which constructs our illusion of being and acting as a subject. Thus, within the structuralist universe, we move from essential meanings and private truths to conventional meaning and socially constructed realities.

Language here remains a highly abstract notion. With Foucault's work in particular, the term discourse comes into use to signal that Language always operates through historically specifiable patterns, or arrangements of statements which are produced through social practices (medicine, psychiatry, art history). Discourses form larger combinations as discursive practices which are institutionalised (hospitals, asylums, prisons, universities, museums). Discourses diversely produce the object they study (health and illness, madness, crime, art). Textuality is thus radically rethought as social, as the site of competing discourses which have constituting social effects, distributing subjects in relations of power. The discourse on criminality, for instance, defines the criminal, the guard and the socially correcting expert whose relative relations of power are produced in the institution of prison. In the case of madness, the asylum defines the mad and the sane, not just as inmate versus warden, but at the level of subjectivity. Meaning is contingent on the discursive contexts in which signs, texts and forms of subjectivisation are produced. Texts operate in relation to other texts and within this

field some statements, some discourses are invested heavily with authority in relation to the existing configurations of power that are articulated through the competing field of discourses: the meanings they produce, the objects they define and, of course, the subjects they produce. Foucault writes:

> But the subject should not be entirely abandoned. It should be reconsidered not to restore the theme of an originating subject, but to seize its functions, its intervention in discourse, and its system of dependencies. We should suspend the typical questions: how does a free subject penetrate the density of things and endow them with meaning... Rather we should ask: under what conditions and through what forms can an entity like the subject appear in the order of discourse; what position does it occupy; what functions does it exhibit; what rules does it follow in each type of discourse? In short, the subject (and its substitutes) must be stripped of its creative role and analysed as a complex and variable function of discourse. [40]

'Van Gogh' can now be re-approached as an author function, an artist-subject constructed through the historically changing discourses of twentieth-century art history, art criticism, the art market and latterly Hollywood cinema. But the author name Van Gogh also refers to a historical person constructed as a subject socially in the discursive practices and their institutional sites constituting the Dutch Protestant bourgeoisie, and later the avant-garde subculture in Europe in the 1880s. In a sense, all three converge, historically.

Nicholas Green's research showed that emergent art historical discourse in the 1870s generated a specific focus on the individual biographical subject of the artist in the era of the Third Republic. There were, of course, older traditions on which writing the life of artists drew, going back to mediaeval lives of the saints, and classical histories and then Vasari's *Vite*. But studying the appearance and specific discursive effects of the kinds of biographies published on the French landscape painters such as Rousseau and Millet in 1870s/80s in terms of increasingly important market economy in art and of the professionalisation of art history, Green contrasted the practice of a formal eulogy on the death of an academician in which the artist was valued in his relation to tradition with that emerging in books by Burty on Rousseau and Sensier on Millet. These offered highly personalised, eye-witness accounts by friends, excerpts from diaries and letters, a claim for the truth of the picture of the artist's personality based on intimacy with the person as he lived and worked. Green argued:

> that the individualising schema was formulated from the 1860s through the discursive twinning of biographical narrative with a pre-existent aesthetic code in which the relations between the painter and that which was rendered into paint were constructed as transparent. The vocabulary of perception, sensation, and

expression permeating contemporary critical and theoretical art writing, consistently registered the transparency of the artist/nature couplet, drawing on the currency of experimental science to come to terms with it... In the process [of expanding nature from landscape and peasants to refer to the artist's total relationship with the world], the biographical approach and its corollary, the cult of creative individualism, became dominant throughout the later nineteenth century art worlds, official as well as avant-garde.[41]

In any historical account of the conditions of art production we should, therefore, include the prevailing representations of the artist through which the occupants of the artist-subject position would have understood themselves and thence operated in the discursive field called art practice. However mythic these ideas about being the artist were, their circulation as forms of writing about and consuming art reciprocally constructed the subjectivity of the artist, or in other terms, the author position with which the producer identifies. Walter Benjamin's arguments, made in the 1930s, against radical bourgeois who made politically sympathetic art works without simultaneously reconsidering their place in the overall social relations of production, suggests a further way to understand how artists might socially redefine their position as producers within a set of material social relations, instead of as 'artist', a term which inscribes bourgeois ideologies.

The implications of this for contemporary feminist art producers needs no underlining. One of the continuing conflicts within the women artists' community is between those who aspire to occupy the subject/author place of 'the artist', i.e. who want permission to be that sort of person, expressing themselves as women; and those who define their feminist project as a strategic practice requiring precisely Benjamin's notion of 'author as producer', a tactical understanding of the relations of cultural production and the discursive and institutional conditions of contesting its preferred meanings.

In the self-conscious avant-garde circles of the later nineteenth century, would-be producers of art negotiated their practice in the terms on offer, or, as with the anarchist Neo-impressionists, they looked to other social stereotypes in order to define themselves in political difference from the dominant bourgeois terms. Cultural mythologies about the artist, therefore, affect the way the producers perform their occupation, perceive themselves, understand their practice.

Avant-garde culture was symptomatic of an economic shift which affected artistic production, leading it towards capitalist conditions and relations. The artist became one of capitalism's typical private producers, artisanally producing commodities on spec for an uncertain market. The hitherto major producers of art, agents by commission, Church, State, Court or aristocratic élite were replaced by a non-commissioning but hungry market that relies on the initiative of the private producer to provide the goods which then may or may not become saleable. Notions of the artist as creator which have a long tradition since the Renaissance at least were significantly transformed by

capitalism's colonisation of cultural production. Without an intending agent, i.e. someone who intends to produce, there would not be the texts or the paintings. The point of initiation is not the inner necessity of the artist against all odds; this is the subjectively experienced myth of the conditions of capitalist market production where the private entrepreneur and his marketing manager, the dealer, and publicist, the critic are in constant and unpredictable negotiation with the buying publics. Again clarity is required. This is not to find ourselves back with the artist as originator of meaning, but as merely one of the causes of the works' existence. The so-called freedom of the market, its pressures for individualised commodities which must nevertheless change to offer constant novelty also provides a new space for individual initiative. These privately produced statements can only have meaning, or aspire to it within the discursive contexts of their domain, art, subdomain, avant-garde art. There are basic ground rules for playing the game. Individuality, in this context, easily becomes a matter of stylistics, packaging. These conditions of artistic production in the capitalist era are mythically represented back to the privatised producer in terms of the self-generating, creative individual marking of his contributions to art with the singularity of his artistic signature.

In the letters of Van Gogh, we can discern the inscription of that set of pressures and limits: in the insistence on relations with a market economy repudiated in the name of dedication to a highly individuated art practice; valorised, on the other hand, by participating in a tradition called modern art in which public acceptance is to be judged in terms of prices paid for Millet at the sales; and fantasies of a world of art-loving people for whom money is not an issue. But in addition we can begin to notice how the recurring themes and syntaxes of his art practice itself (city and country, studios of the South, simple peasants, agriculture, money versus health in nature, suburbs and the consolations of village life, etc.) function as conditioned, mediated, displaced representation of the contradictions of art-making in the conditions of late nineteenth-century capitalism.

This leads to yet another intervention in the authorship debate – not from literary studies nor historiography and philosophy, but film studies – the author as system that determines the form and effect of actual texts – books, paintings, films.

VIII

Tactically, the abolition of the author in high cultural domains such as art and literature has been progressive. But in popular culture, the absence of authored discourse devalued it. Authorship functioned as an ideological boundary between Culture and popular culture. The *Politique des auteurs* was a critical practice developed by French *cinéastes* in the 1950s-60s to validate a range of Hollywood movies they liked by isolating from the collective production team of the Hollywood studio system (capitalist production at its most self-evident), the director as artistic originator of that which they valued in the films they then read as texts. These film critics tried to construct authored discourse for

production cinema. This trend in film studies produced artistic authority for John Ford, Raoul Walsh, Alfred Hitchcock, Vincente Minelli, Douglas Sirk, for instance, as film-makers with specific visions, styles and messages. In a critical response to a series of articles on teaching a John Ford film in *Screen Education* in 1976, Geoffrey Nowell Smith confirmed that auteurism had been an enabling device in studying Hollywood cinema. Constructing a series of films into an *oeuvre*, designated by a named author, shaped, if it was not the condition for, cultural appropriation of texts. Nowell Smith suggested that discourse made intelligible by its author name is a means for the text to become part of the consumer's ideological property.[42] The meaning and the pleasure of cinema is in part mediated by our knowing that we are going to see a John Ford or a Renoir film – the name containing our memories of previous pleasures and expectations of the kind of aesthetic and intellectual experience on offer. Thus far, we are still close to Foucault. But, by referring to Peter Wollen who suggested that we distinguish between the historical person, John Ford, and 'John Ford', the author construed from analysis of the texts that person helped to make as a director, who is an effect of the texts, makes it quite clear that this is not a reversion to treating the author as personal subject of the text. Translate this distinction back to the project in hand: Van Gogh was the Dutch fellow with red hair and a bad temper who sliced his ear in an epileptic seizure. 'Van Gogh' is a way of defining a set of procedures, competences, effects, concerns, stylistics that can only be derived from a structuralist analysis of the texts collectively known by that name. The semiotic terminologies of film theory talk about the author as a code, or subcode, i.e. patterns or paradigms associated with content. 'John Ford's' films are obsessed with conflicts between the West as a garden and the West as a desert, with civilisation and wildness, with community and individual actions. In 'Van Gogh's' case, I might talk about the tensions between country and city, idealised past and distressing present, confined bourgeois and bestial peasantry.

But there are also author codes of 'expression' as well as content. These patterns of form, manner, colour, composition are not absolutely individual. They are generic, belonging to the moment, movement, cultural fraction, current and possible cultural languages. But in the texts designated as a group by the author name 'Van Gogh', we discern a specific arrangement, management, formulation, variation, qualification within them. While identifying through discourse analysis the cultural resources and materials used in art practices historically, we have also to define particular configurations which result within one specific practice.

An author effect is inscribed across all dimensions of the text. Geoffrey Nowell Smith, therefore, suggests that the author factor is not merely one of the subcodes of which a text is produced but its defining system. The accumulation of the various author-qualified subcodes into a system produces for the viewer/reader/analyst a subject of enunciation – where the meaning and effects of a film or a group of paintings seem to come from. When we refer to 'Van Gogh', we refer to that experience, that effect of someone saying something to us through a definable set of ways of painting and choices

of subject. What we are consuming, however, is not the subject that this system seems to produce, but this system, this pattern or arrangement of the culturally authored components filtered through a historical particularity. Specificity is possible. The author name in quotation marks ensures a way out of the structuralist trap of the system smuggled back as anonymous originator – an Author as Structure. We are still in a post-structuralist universe of the text as socially and historically mediated discourse and productive of its subjects, producers as well as consumers. But we can grasp, and tentatively define, the configurations of the text and the sense of being addressed by someone in particular by seeing the author produced as an after-effect of the text/painting which, retrospectively, at the point we read or see it, confers upon it some specific identity, a systematic quality which allows us to know this work in its particularities and differences.

IX

Thus I come to the issue of the singularity of a subject and another theorisation of subjectivity, structure and the social: psychoanalysis. Post-structuralist readings of Freudian theory have paid especial attention to its inflections of the relations between subject, language and society. While sharing with other post-structuralisms the notion of the subject as an effect of inscription into language as the Symbolic or authoritative order of a culture, psychoanalysis focuses more specifically on the processes by which subjects are formed as sexed, speaking subjects.

Freud's major theoretical texts are paralleled by case studies in which he tells stories: 'it still strikes me as strange that the case histories I should write read like short stories and that, as one might say, they lack the serious stamp of science'.[43] The writing of a life is the only form through which Freud's sense of the history of the subject could become a text. But it was not a linear biography, following some developmental pattern from birth to maturity and death. Rather Freud's case studies are like reports of an archaeological dig, travelling many times across the same terrain of a subject, but at different age strata, with different overlays of memory, later revisions, producing a complex picture of the process of subjectivity through time, but also in depth, constructed through accumulated representations, all of which are subjected to syntactical and narrative alteration as the memories of the process of formation are caught up in the process of repression and the unconscious. I have begun to use Freud's case study of the Wolf Man in work on Van Gogh's drawing of a peasant woman bending. The drawing is certainly not a mere record of Van Gogh's looking at a peasant woman. Equally, the image is not the direct deposit of Van Gogh's unconscious fantasies that collapse the distinction between women and animals. The page is a screen onto which many pictures are simultaneously being projected. The working relation between a hired, impoverished peasant woman and the bourgeois artist abrogating to himself the right to look and the need to see differently in order to produce a distinctly styled drawing that, none the less, would be read in affiliation with the genre and the tradition

to which it aimed to belong, created a site for the enactment of the uneven, conflicted and divided dimensions of a white, Protestant, Dutch subjectivity. The drawing can be read for the ways it is fractured across competing registers of the Symbolic order, in which the body is bloated and debased, punished for its lack and threatening castration, and the Imaginary, in which the body enlarges in a promise of lost maternal plenitude, the generosity of infantile experiences of its peasant nurses who cared for the little boy's body and stimulated its unformulated, as yet unsexed and oscillating, sexualities and subjectivities.

This drawing does not mean either Van Gogh or the peasant (remember Heidegger and Schapiro). There is no thing, subject or meaning, to be deciphered and extracted. In the process of manufacture, it was a screen for, a site of a real social relations (bourgeois artist/peasant woman) and of fantasy (in which that body signified across the history of this masculine subject). As text, it is an inscription of processes of the making of masculine bourgeois subjects articulated through the cultural languages already circulating for the representation and negotiation of masculine sexuality through the sign of the peasant woman (rural genre). But its singularity – its 'Van Goghness' – is probably the way the failure of the latter (its affinity with the aesthetically managed forms of rural genre that contained and veiled the sexual burden of its content) exposed the insistence of that troubled psychic freight and left its traces in the inconsistencies of the body's composition, the uneven distribution of interest and the intensity of the graphic systems used to work through what this sight in his studio allowed into play.[44]

It is, therefore, possible to consider subjectivity in relation to cultural production, to style, to those aesthetic effects which in the end are the means of transmission of significance, pleasure, meaning. But in the place of the controlling, mastering unity signalled by the Author as authority, we read the texts for the traces of the fractured and inconsistent subjectivity, classed, gendered, raced, i.e. socially manufactured within specifiable formations, that is articulated through the visual codes of his culture and that inscribes across those texts both the particular and the general social patterns of which all subjects are but an effect.

X

So returning to my question about writing a book about Van Gogh, I find that I have not got clear of the artist as referent.

A thorough-going structuralist position would assassinate the author and consider a series of texts: writing or painting being the author. A social historical approach would resist the ahistorical formalism of structuralist semiotics and consider the conditions of production, with a socially determined, ideologically determined subject as producer. But the Foucauldian insight that the author has a social and ideological function demands that we face up to that space: the author is part of the way discourses work in their social distribution of power. Historical study of the discourses on authorship confirms that the performance of the author function was one of the conditions of

existence of the texts I want to study. Finally the patterns of themes and syntaxes we recognise in a series of texts, and define by an author name, can be theorised as simultaneously particular and social through psychoanalytical notions of the history of the subject. Trying to take all these on board, I find myself returning to a formulation from Marxist cultural materialism. Rejecting bourgeois consumption of works of art as objects, and turning away from structuralist notions of autonomous text, Raymond Williams elaborated the idea of art as a *practice*. Williams was, of course, arguing more against reductive Marxist accounts of cultural practices within the model of base and superstructure which denied any agency to culture and its practitioners who were simply the determined reflections of economic foundations. Any critic, Marxist or bourgeois, who treats art works as objects, will try to explain the object by breaking it down into its components. These will be outside the work, in the artist, or in the social base. Instead of looking for the 'components of a product', Williams considers the character and the conditions of a practice. Art is not objects caused by someone or something. Culture is practice, that is, it is one of the social activities of which object/texts are both the effect and the actual forms. Cultural practices operate in a tension between collective modes and individual projects.

> That is to say, the irreducibly individual projects that particular works are, may come in experience and in analysis to show resemblances which allow us to group them into collective modes. These are by no means always genres... But as we discover the nature of a particular practice, and the nature of the relation between an individual project and a collective mode, we find that we are analyzing, as two forms of the same process, both its active composition and its conditions of composition, and in either direction this is a complex of extending active relationships. [45]

Practices are the product of knowing, intending and self-conscious agents. They are also played over by the deep structures of unconscious formations both at the individual and collective, social level. Thus, using this concept of 'the conditions of a practice', it will be possible, and necessary, to calculate socially and personally calibrated intention. A credible scenario for historical agency will depend on identifying the discursive frameworks in which it is possible to conjecture about strategies and behaviours of artists or writers. This is not because I assume I can ever know what the historical Van Gogh really thought. I can, however, reconstruct the public field of probabilities in which his practice took shape and place. These conjectures are not based on ideological fabrications of the discrete, self-possessed, private individual but on historical research into conditions of existence of the subject and the text as a practice.

'Van Gogh' defines a practice in history, composed of making paintings, writing letters, reading books, visiting art galleries, moving from place to place, entering into social relations, and so forth. There is no real place for traditional biography as we have

known it, but that historical practice – the writing of biography, the living in anticipation of it, the producing of documents like the letters to facilitate it, and an internalisation of the habits and frameworks of bourgeois subjectivity that biography inscribes – functions as one kind of evidence if read across the play of the individual project and the collective mode. The history of the particular person is one of the multiple histories that must come into play in the study of art as practice. The practice can be read at, at least, two levels. It is symptomatic of a historical *langue* (that is, the system without which there is no meaning at all) called avant-gardism. It is also an instance of *parole* (that is, the particular enunciations or speech acts which alone allow us to perceive that there is a *langue* that makes this individual realisations of it possible), one concrete articulation of the contradictions which comprised avant-gardism.

I can move away from the legacy of Marxism and structuralism (via Althusserian theories of ideology) which would mean trying to establish some fixity of what the practice 'Van Gogh' was about. Instead I shall have to represent it as a series of manoeuvres which encountered and intersected with the formations of the Dutch and Parisian avant-garde in an oblique fashion. The study of this 'Van Gogh' becomes historically useful by throwing into relief those cultural formations precisely through the degree that Van Gogh was incapable of accommodating his practice to them and normalising their protocols and concerns. The book will then be about the transitions and discontinuities of early European modernism in the 1880-90s grasped through the discontinuities, disruptions and failures which are what I shall produce as 'Van Gogh'.

Notes

1. R. Barthes, 'The Death of the Author' (1968) trans. in R. Barthes, *Image Music Text*, ed. S. Heath, London: Fontana, 1977, p. 143.

2. Norman Bryson, *Vision and Painting: The Logic of the Gaze*, London: Macmillan, 1983, p. xi and *Calligraphy*, Cambridge: Cambridge University Press, 1988, passim, makes this claim, though Bryson's argument indicates his failure to recognise the work of all those who, for instance, have been producing and writing for *Block* for the last ten years. But it is probably correct to suggest that, in the main, the mainstream art history has not been seriously affected. See also a positive rejection of the possibility of entering into debate with alternatives in R. Wollheim, *Painting as an Art*, London: Thames and Hudson, 1987, p. 10.

3. N. Green and F. Mort, 'Visual Representation and Cultural Politics', *Block*, no 7, 1982.

4. Ibid., p. 60.

5. N. Green, *The Spectacle of Nature*, Manchester: Manchester University Press, 1990.

6. N. Green, 'Dealing in Temperaments: Economic Transformations of the Artistic Field in France during the Second Half of the Nineteenth Century', *Art History*, vol. 10, no. 1, 1987, pp. 59-78.

7. C. Harrison and F. Orton, *Modernism, Criticism, Realism*, New York: Harper Rowe, 1984, p. xix.

8. Reprinted here as Chapter 12.

9. J. Christie and F. Orton, 'Writing on a Text of a Life', *Art History*, vol. 11, no. 4, 1988, p. 558-9.

10. Ibid., pp. 560-1.

11. R. Parker and G. Pollock, *Old Mistresses: Women, Art & Ideology*, London: Pandora Books, 1981 and 1995.

12. G. Pollock, 'Artists, Mythologies and Media...' *Screen*, vol. 21, no. 3, 1981.

13. See also Linda Nochlin's texts 'Why Have There Been No Great Women Artists?' in E. Baker and T. Hess, *Art and*

Sexual Politics, London: Macmillan, 1973 and 'The Depoliticization of Courbet...' *October* 1982, no. 22 in which she asks the companion question, 'Why Have there been Great Male ones?'

14. See for instance *Dealing with Degas: The Representation of Women and the Politics of Vision*, ed. R. Kendall and G. Pollock, London: Pandora, 1992.

15. Nancy K. Miller, 'Changing the Subject: Authorship, Writing and Reading' in Teresa de Lauretis (ed.), *Feminist Studies/ Critical Studies,* London: Macmillan, 1986, p. 104.

16. Ibid., both quotes p. 106.

17. G Pollock, 'Van Gogh and the Poor Slaves', *Art History,* vol. 11, no. 3, 1988.

18. W Benjamin, 'The Author as Producer', *Understanding Brecht*, London: New Left Books, 1977

19. Roland Barthes, op.cit., 148.

20. Ibid., p. 146. See also R. Barthes, 'From Work to Text' in *Image Music Text*, London: Fontana, 1977.

21. Ibid., p. 148.

22. Ibid.

23. M. Nesbitt, 'What is an Author?', *Yale French Studies*, 1987, no. 73, p. 229ff. locates the legal and economic aspects of authorship within the context of an expanded definition of culture which has many important ramifications for studies of the author of visual representations.

24. See Fred Orton on Rosenberg in Chapter 9.

25. M. Kelly on the revival of gestural expressionism and the revitalisation of the market in 'Reviewing Modernist Criticism', *Screen*, vol. 22, no. 3, 1982.

26. *Politique des auteurs* refers to the attempt by French film-makers and critics to gain critical recognition for Hollywood cinema. Dismissed as mass culture because it was not the product of an individual artist, the French critics tried to make directors such as Ford, Walsh and Hitchcock into authors by arguing that their films could be studied as a body of work which revealed a pattern of concerns, thematics and stylistic devices. See J. Caughie, *Theories of Authorship*, London: Routledge, 1981.

27. These are too numerous to list but a check of their annual indices will list works by Zemel, Murray, Soth, Boime, Sund, Pickvance and Pollock.

28. R. Pickvance, *Van Gogh in Arles*, New York: Metropolitan Museum of Art, 1984, p. 11. The founder of this scrupulously scholarly approach to Van Gogh is Mark Roskill whose book *Van Gogh, Gauguin and the Impressionist Circle,* London: Thames and Hudson was published in 1970.

29. See for instance W. Udhe, *Van Gogh* [1951] Oxford: Phaidon Press, new edition, with notes by Griselda Pollock, 1981.

30. R. Williams, 'Base and Superstructure in Contemporary Marxist Cultural Theory', in *Problems in Materialism*, London: Verso, 1980, p. 46.

31. Chapter VII in my PhD 'Vincent van Gogh and Dutch Art', London University 1980; A. Boime, 'Van Gogh's Starry Night A History of Matter and a Matter of History'; *Arts Magazine*, December 1989, vol. 59, no. 4; L. Soth. 'Van Gogh's Agony', *Art Bulletin*, 1986, vol. LXVIII, no. 2.

32. See L. Soth, in previous note. See also J. Sund, 'Van Gogh's Portraits, *Art History*, 1988, vol. 11, no. 2, in which the later portraits are examined and Sund concludes that the 'portraits are not so much reflections of his sitters as vehicles for his own reflections on modern life' p. 266, and she adds that the series of portraits read better as encoded reflections of self. Although Sund may be right to say that Van Gogh's portraits are more than pictures of the sitter, it does not follow, except in art historical logic, that the signified of the portraits thus becomes Van Gogh himself. Research always leads us through art history back to its imagined cause – a self-generating, possessive individual artist.

33. C. Owens, 'Representation, Appropriation and Power', *Art in America*, May 1982, pp. 9-21.

34. The reference is to M. Foucault's essay on the Velasquez painting in *The Order of Things*, London: Tavistock, 1970.

35. M. Foucault, 'What is an Author?', *Screen*, 1979, vol. 20, no. 1, reprinted from M. Foucault, *Language, Counter–Memory and Practice*, ed. Colin Gordon, Oxford: Basil Blackwell, 1977.

36. Ibid., p. 19

37. G. Pollock, 'Artists, Media and Mythologies...', *Screen*, 1980, vol. 21, no. 3. See also C. Zemel, *The Making of a*

Legend: *Van Gogh Criticism 1890-1920*, Ann Arbor: UMI Research Press, 1980 and E. Lipton, *Picasso Criticism 1910–1939: The Making of An Artist Hero*, New York: Garland, 1976.

38. Though this should not be overstated as the Abstract Expressionists appear in the famous photograph of 'The Irascibles' in suits and ties. Fionna Barber's work on de Kooning and the T-shirt reveals a complex pattern of dress codes and photographic rhetorics at work in this period. Paper given at Association of Art Historians, 'Identities' conference, London, Tate Gallery, April 1993.

39. J. Wayne, 'The Male Artist as Stereotypical Female', *Art Journal*, 1973, vol. 32.

40. Foucault, op. cit., p. 28.

41. N. Green, 'Dealing in Temperaments', *Art History*, 1987, vol. 10, no. 1, p. 71.

42. G. Nowell Smith, 'Six Authors in Pursuit of The Searchers', *Screen*, 1976, vol. 17, no. 1, reprinted in J Caughie, *Theories of Authorship*, London: Routledge, 1981.

43. S. Freud, Standard Edition of the *Complete Psychological Works*, ed. J. Strachey, London: Hogarth Press, 1953-74, vol. 2, pp. 160–1.

44. This analysis forms the opening chapter of my forthcoming book, *Differencing the Canon: Feminist Desire and the Writing of Art's Histories*, Routledge, 1996.

45. R. Williams, *'Base and Superstructure in Marxist Cultural Theory'*, Problems in Materialism, London: Verso Books, 1980, p. 48.

Index

A

abstract art 160, 161, 276, 277, 324
Abstract Expressionism/Expressionists 144, 247, 250, 269, 289n, 300, 301, 303, 308
 and *avant-garde* 143
 and the Cold War 205, 213, 214, 244
 development of 142
 Greenberg and 152
 historical moment 224, 248, 256
 the indexical and iconical in 203n
 and Marxism 215
 and MoMA 214
 Rosenberg and 173, 177, 178
 and sadism 258
 as the 'triumph' of American painting 218n
abstract painting 156, 233, 242, 256
abstract purism 156-7
abstraction 119, 161, 211
academic theory 108
academicism 153, 155
the Academy 121
the act of painting 201n
action 187, 191, 194
Action Painter 172, 173
action painting 191, 192, 193, 195, 202n
 American 186, 187, 188
 meaning 196
 politics of 178
Actors' Studio 227
Adorno, Theodor W. x
Advancing American Art exhibition (cancelled) 209-10, 212, 213, 216n
aesthetic judgement 89
 disinterestedness of 93
Agee, James 199n
agency xx, 178, 316, 319, 321, 324, 339
Ajalbert, Jean 75-6
 Paris banlieu - Sur Le Vif 75
 Les Provinces 75-6
Alexandrianism 153
Alley, Ronald 308
Allied Artists 210
Althusser, Louis xiii, xiv, 209, 216n, 305, 340

American Abstract Artists Association 145
American Artists Professional League 210
American Enterprise Institute 208
American Federation of Arts 212, 296
American Scene 161
American Security Council 208
American Writers' Congress 181, 182, 197n
'American-Type' Painters 213
'American'/'Americanness' 186, 187, 190, 201n
Americanism 244
Anderson, Benedict 136, 140n
Anderson, Perry xiii
Anquetin, Louis 120, 121, 122
 Avenue de Clichy: Five O'Clock in the Evening 117, 118, 120, 121
 The Mower at Noon: Summer 117, 118, 120, 121, 122
Antal, Frederick x, xii, xix
anthropology xiii
Antin, David 303-5
Antoine, Jules 120-21
Antwerp 10, 20, 23
Apollinaire, Guillaume 186
Apollo of the Belvedere ix
Argenteuil 65, 130
Arles 10, 29, 30, 31, 35, 36, 74
Arnold, Eve 235, 290n
art
 abstract 160, 161, 276, 277, 324
 and art history v
 the artist as symbol of 241
 avant-garde 20, 29, 335
 conflating act and art 252
 describing a discontinuum of practices 54
 and dying 294n
 expression in 302, 311
 Expressionist 300
 feminist 334
 Japanese 36, 118
 language of 301
 market economy in 333
 modern *see* modern art

D

J

K

N